HANDBOOK OF

Handbook of
MODERN BRITISH PAINTING
AND PRINTMAKING
1900–1990

Second edition

Edited by
ALAN WINDSOR

ASHGATE

First edition, *Handbook of Modern British Painting 1900–1980*, published 1992 by Scolar Press

Second edition published by
Ashgate Publishing Limited
Gower House
Croft Road
Aldershot
Hants GU11 3HR
England

Ashgate Publishing Company
Old Post Road
Brookfield
Vermont 05036–9704
USA

British Library Cataloguing-in-Publication data

Handbook of modern British painting and printmaking, 1900–1990. – Second ed.
 1.Painting, Modern – 20th century – Great Britain – Handbooks, manuals, etc. 2.Painting, British – Handbooks, manuals etc. 3.Prints, British – Handbooks, manuals, etc. 4.Prints, British – 20th century – Great Britain – Handbooks, manuals, etc.
 I.Windsor, Alan
 759.2

Library of Congress Cataloguing-in-Publication data

Handbook of modern British painting and printmaking, 1900–1990 /
 edited by Alan Windsor.
Second edition of Handbook of modern British painting, 1900–1980,
 of 1992.
 ISBN 1–85928–427–2 (hb : acid-free paper)
 1. Art, British—Handbooks, manuals, etc. 2. Art, Modern—20th century—Great Britain—Handbooks, manuals, etc. I. Windsor, Alan.
 II. Handbook of modern British painting, 1900–1980.
 N6768.H26 1998
 760'.0942—dc21 98-9977
 CIP
ISBN 1 85928 427 2

Printed on acid-free paper

Typeset in Sabon by Saxon Graphics Limited, Derby and printed in Great Britain by MPG Books Ltd. Bodmin.

Introduction

The aim of this new, revised and updated edition of the handbook is to provide a portable, alphabetical guide to modern British painting and printmaking, 1900–1990. The time-scale has been extended ten years, and artists who were or are primarily known as etchers, engravers or lithographers have been included.

Artists have been included if:

- (at one end of the time-scale) they had finished their training by 1900 and were beginning their professional career;

- they had (at the other end of the time-scale) established themselves professionally on the national scene by 1990;

- they were or are British, or, if foreign born, they either became naturalized citizens or resided in Britain and exhibited here long enough for their presence here to be significant for British art;

- although better known as sculptors, printmakers etc., or for some newer category of artistic activity, their oeuvre includes a significant amount of painting or coloured graphic work. Sculptors, environmental, installation and performance artists will be found in the forthcoming companion Ashgate volume, *A Handbook of Modern British Sculpture, 1900–1990*.

Inevitably, there are artists who do not fit neatly into these categories. Of the earlier artists, some have been included, even if they were well established by 1900, because of their stature, their style or their influence; others, born before 1900 and who lived well into this century, have been left out. The entries for earlier artists, even those of great distinction, and for those best known as sculptors, have on the whole been kept short, as other reference books may be expected to have done them justice.

How to use the Handbook

The biographical outline of each artist is designed to make the salient facts about the artist's career known; where and when they were born, when they died, where they trained, who and what influenced them, where they travelled and what honours or distinctions they were awarded. The brief characterization of the artists' work is intended to help the reader to confirm or to anticipate what is typical of that artist's painting.

Wherever possible, after 'LIT', one or two suggestions have been made for further reading about the artist. The literature cited does not include other dictionaries, nor, necessarily, any of the sources of reference used for writing the entry in this Handbook.

The names of artists, groups, schools etc. are shown in small capitals in the text of the entries to draw attention to entries on those subjects which will be found in alphabetical order in the body of the Handbook.

A number of Schools of Art, Groups, Societies and Galleries have had a considerable influence on the development of modern art in Britain. Entries will be found on the most prominent among them, as well as on those British patrons, organizations and critics who have played a leading role during the period.

AW

Acknowledgements

By far the greatest number of entries in this Handbook have been written by Carol Fitzgerald, whose initials (CF) will be found at the end of each entry she has contributed. Other entries have been written by Shelagh Denny ('HD'), Delia Evans (DE), Joanne King (JK), Laura Nicholson (LMN), Linda Palmer (LP), Kate Skelton (KS), Gabriel Summers (GS), Mary Wilkinson (MW) and myself. I have written all the new entries in this edition.

I should like to thank those who have undertaken research and who have written entries for this Handbook, and on their behalf thank those individuals, museums, galleries and libraries who have been so helpful to them, especially the staff of the Tate Gallery Library and Archives, the Victoria and Albert Museum and the Royal Academy.

AW

Abbreviations

An asterisk * denotes that there is an entry in the Handbook on this subject.

A	Associate
AA	Architectural Association
AAA	Allied Artists' Association*
AIA	Artists' International Association*
AWG	Art Workers' Guild*
BWS	British Watercolour Society
CAS	Contemporary Art Society*
F	Fellow
GI	Royal Glasgow Institute of Fine Arts
H	Honorary Member
ICA	Institute of Contemporary Arts*
IS	International Society of Sculptors, Painters and Gravers
IWM	Imperial War Museum*
LAA	Liverpool Academy of Arts
LG	London Group*
MAFA	Manchester Academy of Fine Arts
NA	National Academy of Design (New York)
NBA	North British Academy
NEAC	New English Art Club*
NPS	National Portrait Society
NS	National Society of Painters, Sculptors and Gravers
NSA	New Society of Artists
P	President
PS	Pastel Society
RA	Royal Academy* Royal Academician
RBA	Royal Society of British Artists*
RBC	Royal British Colonial Society of Artists
RBS	Royal Society of British Sculptors

RBSA	Royal Birmingham Society of Artists
RCA	Royal College of Art*
R.Cam.A.	Royal Cambrian Academy
RE	Royal Society of Painter-Etchers and Engravers, Royal Society of Painter-Printmakers*
RHA	Royal Hibernian Academy
RI	Royal Institute of Painters in Watercolours*
RIBA	Royal Institute of British Architects
RMS	Royal Society of Miniature Painters
ROI	Royal Institute of Oil Painters
RP	Royal Society of Portrait Painters
RSA	Royal Scottish Academy
RSW	Royal Scottish Society of Painters in Watercolours
RUA	Royal Ulster Academy
RWA	Royal West of England Academy
RWS	Royal Society of Painters in Watercolours*
SC	Senefelder Club*
SGA	Society of Graphic Artists
SM	Society of Miniaturists
SMP	Society of Mural Painters
SSA	Society of Scottish Artists
SSWA	Scottish Society of Women Artists
SWA	Society of Women Artists*
SWE	Society of Wood Engravers*
UA	United Artists
VP	Vice-president
WAAC	War Artists' Advisory Committee
WIAC	Women's International Art Club

A

ABERCROMBIE, Douglas (b. 1934). Painter of abstracts in acrylic. Born in Glasgow, he studied at GLASGOW SCHOOL OF ART 1952–6, and the RCA where he won a Carnegie Travelling Scholarship. He travelled with Bertram Mills Circus in 1957, and from 1958 to 1963 worked as a painter and designer for Glasgow Citizens Theatre. In 1964 he moved to London and worked at the Royal Opera House, Covent Garden. Between 1965 and 1967 he worked in Spain and in 1967 he returned to London. He held his first solo exhibition in 1958 at the 57 Gallery, Edinburgh, and he subsequently exhibited regularly in Scotland, London, the provinces and abroad. Influenced by American abstract painting, his works are built up to create an overall textured surface and the gestural, intuitive sweeps of paint become the form and subject, implying the movement and energy of natural forces. CF

Académie Julian: Julian's Academy. Founded in 1873 by the artist Rodolphe Julian (1839–1907) the Académie developed from the opening of a teaching studio in the Passage des Panoramas off the Bld. Montmartre in 1868. Julian gradually acquired a number of studios in different parts of Paris, as a purely commercial venture. Open to all, male and female, on payment of fees (40fr. per month in the 1870s), a model, tuition, experience and contacts were provided. Students began drawing from plaster casts and graduated to the life-room for drawing or painting. Celebrated academic artists such as Bouguereau, Lefèbvre, Robert-Fleury, Constant and Boulanger were contracted by Julian as visiting tutors. Students were prepared for entry into the Ecole des Beaux-Arts or for submission of works to the Salon if this was their aim. There were competitions and even medals awarded. Scores of young English artists, along with other foreigners, attended Julian's.
LIT: 'New Light on the Académie Julian', Catherine Fehrer in *Gazette des Beaux-Arts*, May–June 1984, and *Julian's Academy*. Shepherd Gallery, New York, 1989. AW

ACKERMANN, Arthur Gerald, RI (1876–1960). Painter of landscapes, marines and townscapes in watercolours. He studied at HEATHERLEY'S, WESTMINSTER SCHOOL OF ART and the RA SCHOOLS where he won the Creswick Prize and the Landseer Scholarship. He exhibited at the RA, RBA, ROI, and the RI where he was elected a member in 1912. He also showed at London galleries, principally the FINE ART SOCIETY and the LEICESTER GALLERIES, in the provinces and in Scotland. His work is represented in public collections including Norwich Castle Museum. He painted widely throughout Britain but many of his works depict Blakeney, Norfolk, where he lived from the early 1940s. His watercolours, particularly those of Blakeney, reveal his mastery of reflections and transparent washes of colour, e.g. *Sailing near Blakeney, Norfolk* (Nottingham Museum and Art Gallery). CF

ACKLING, Roger (b. 1947). An artist in mixed media, he was trained at ST MARTIN'S. His first solo exhibition was at the Lisson Gallery in 1981. He draws by focussing the rays of the sun onto wood or paper – sometimes found materials – in order to burn precise marks and forms. AW

ACKROYD, Norman, RA (b. 1938). A painter, etcher and engraver, born in Leeds, he studied at Leeds and at the RCA. He taught for many years at MANCHESTER COLLEGE OF ART. He paints in encaustic and the subject-matter of his work is often that of northern British landscape. His *Harewood Suite* (1996) treats the British coastline in aquatint. The TATE holds several works, including *Gentle Rainstorm* (1974). AW

ADAM, Patrick William, RSA (1854–1929). Painter of interiors, landscapes and figures in oils and pastels. He studied at the RSA Schools under George Paul Chalmers and WILLIAM MACTAGGART winning the Maclaine Watters Medal for painting from life. He exhibited mainly at the RSA (RSA 1897), the GI and the RA from 1878 to 1929, and he also showed at the RHA, in Liverpool, Manchester and in London galleries including the Goupil Gallery and the FINE ART SOCIETY. A founder member of the Society of Eight, his work is represented in collections including Aberdeen Art Gallery. Initially exhibiting figures and genre subjects, in 1889 he exhibited paintings of Venice and in 1908 he began to depict interiors in a painterly, sensitive style which captured a sense of space, light and atmosphere.
LIT: *Interior Paintings by Patrick W. Adam RSA*, Patrick J. Ford, Glasgow, 1920; 'Patrick W. Adam RSA. A Painter of Interiors', A. Stodart Walker, *Studio*, Vol.LIX, p.169. CF

1

ADAMS, Danton, F., FIAL, MIAMA (b. 1904). Painter and writer on art. He studied at Putney and CHELSEA schools of art and exhibited at the RA in 1945, at the RP, ROI, RWS, RBA and the Paris Salon. President and Founder of the Wimbledon Art Group, he studied the relationship between particular colours and musical notes in order to establish a method of creating colour harmonies.
LIT: *Musical Colour*, Danton Adams, Douglas and Gilson, London, 1960. CF

ADAMS, Harry William, RBA, RBSA (1868–1947). Painter of landscapes, particularly of winter scenes, in oils and watercolours. He spent eight years as a decorative artist for the Royal Worcester Porcelain Factory before studying at the ACADÉMIE JULIAN, Paris, 1895–6. He exhibited at the RA between 1896 and 1927 and also showed work at the RBA (member 1912), the RCA, the New Gallery, London, and in Birmingham, Liverpool and Manchester. In 1900 the CHANTREY BEQUEST purchased *Winter's Sleep*. He taught life drawing at Worcester Technical College and many of his landscapes are of the Worcester countryside. His atmospheric, quiet paintings achieve a lyrical evocation of winter's appearance and light. CF

ADAMS, Norman, RA (b. 1927). Born in London, he went to Harrow Art School and following imprisonment and farm labour as a conscientious objector 1946–8, he attended the ROYAL COLLEGE 1948–51. He has designed for the Ballet (*A Mirror for Witches*, 1952) and has executed murals, considering those for St Anselm's Church, Kennington to be his 'major achievement'. His work has passed through phases, but always having a mystical, elemental quality and expressive brushwork on a large scale, dealing with landscapes, figures and signs.
LIT: *Colour Chart of a Way*, Norman Adams, Royal Academy, 1988. AW

ADAMS, Tony (b. 1936). Painter of figures and portraits. After working in foundry management and serving in the RAF he studied at CHELSEA SCHOOL OF ART from 1956 and at the University of Bristol from 1961. He held his first solo exhibition at Arthur Tooth & Sons, London, 1976. He has travelled and taught widely and his work includes subjects which use details from great paintings combined with elements of modern subject matter.

LIT: *Tony Adams. First Exhibition of Paintings*, catalogue, Arthur Tooth & Sons, London, 1976. CF

ADAMS, William Dacres, NPS (1864–1951). Painter of landscapes, portraits, figures, architectural and country subjects in oils and watercolours. Educated at Radley College and Exeter College, Oxford, he studied art under HERKOMER at Bushey and in Munich. He exhibited at the RA, ROI and the FINE ART SOCIETY as well as the New Gallery and the LEICESTER GALLERIES, London. An Associate of Société Nationale des Beaux-Arts, he showed his work in Paris in 1937 and 1939. He gained success in particular with his portraits and watercolours, and works such as *The New Hat*, shown in 1908 at the RA. CF

ADDISON, Eileen (b. 1906). Painter of landscapes, architecture and flowers in watercolours. She studied at Leeds College of Art under Harold Holden and Douglas S. Andrews and exhibited with a wide range of societies including the RI, RWS, and RBA, as well as at several one-man shows. She taught Interior and Colour Design at Regent Street Polytechnic 1942–51. In 1956 she became Hon. Sec. and Treasurer of the Association of Sussex Artists and from 1967 of the Society of Sussex Painters. CF

ADENAY, Bernard, LG (1878–1966). Painter and textile designer. He studied at the RA SCHOOLS 1892–7, at the ACADÉMIE JULIAN for a year, and at the SLADE in 1912. His Cézanne-inspired paintings were included in the second Post-Impressionist Exhibition organized by his mentor ROGER FRY. (*Toy Sailing Boats, The Round Pond*, 1911, is in the TATE; *The Window*, 1923, in Manchester City Art Gallery.) He was a founder member of the LONDON GROUP and its President between 1921 and 1923. His first marriage was to the painter and textile designer Noël Gilford, and his second to THÉRÈSE LESSORE, who left him to marry SICKERT in 1926. He was Head of the Design School at the CENTRAL SCHOOL 1930–47. AW

ADLER, Jankel (1895–1949). Painter of portraits, figures and still-life in oils, gouache and watercolours. Born in Poland, he studied at the School of Applied Arts, Barmen, Germany, in 1916. A member of 'Das Junge Rheinland' and associated with socialist and avant-garde groups in Berlin, Düsseldorf and Cologne, he exhibited

from 1918 in Poland and Germany. Forced to leave Germany by the rise of the Nazis, he settled in France and later in Glasgow where he exhibited in 1941, renewed his friendship with JOSEF HERMAN, was associated with the New Art Club and the New Scottish Group and influenced MACBRYDE and COLQUHOUN. In 1943 he settled in London, subsequently exhibiting there and in Paris, Dublin and New York. His work is represented in many collections including MOMA, New York. During the 1920s he experimented with techniques, often mixing sand with paint, and was influenced by Cubism and Picasso. In the 1930s he made more abstract works but later returned to figurative subjects. He sought to combine the humanistic, symbolic qualities of his Jewish background with the progressive formal developments of European painting.
LIT: *Jankel Adler*, Stanley William Hayter, Nicholson & Watson, London, 1948; *Jankel Adler 1895–1949*, catalogue, Städtische Kunsthalle, Düsseldorf, 1985; articles in *Artibus et Historiae* (Italy), Vol.9, No.17, 1988, and *Bildende Kunst* (East Germany), Pt.3, 1972. CF

ADNAMS, Marion. Painter of natural objects and landscapes in oils. After reading Modern Languages at Nottingham University and teaching French and English she began to paint in 1937 and became Lecturer in Art at Derby Training College. She exhibited with the Midland Group and at the Royal Society of Artists, Birmingham. In 1971 a retrospective exhibition of her work was held at the Midland Group Gallery, Nottingham. Influenced by Magritte and PAUL NASH, she paints small natural forms and animals, accurately depicted in surreal juxtapositions and often in a melancholy, deserted setting. Her paintings reflect her Christian beliefs and she considers them contemplative in character. In 1964 she painted murals in the church at Stapenhill and her work of the 1960s shows the influence of Provence where she then lived.
LIT: Essay by Ray Gosling in the catalogue of the retrospective exhibition, Nottingham, 1971; 'The Art of Marion Adnams', S.D. Cleveland, *Studio*, Vol.128, 1944, p.120. CF

ADSHEAD, Mary (1904–1995). Decorative painter of murals and painter of figures, architecture, gardens and flowers in watercolours; also a designer of stamps. She attended the SLADE SCHOOL OF ART under TONKS 1922–5, and exhib-

ited at many London galleries, the RA and the NEAC where she became an Associate in 1930. In 1924 she was chosen by Tonks for a mural commission with REX WHISTLER and her later murals included work for Lord Beaverbrook, 1928, the London Underground, 1928, and Selfridges Restaurant, 1950. In the 1960s she developed her interest in mosaics and in house portraiture. She married the artist STEPHEN BONE. Her work reveals a decorative and linear style which emphasizes formalized shapes and rhythms.
LIT: Exhibition catalogue, Sally Hunter Fine Art, May-June 1986. CF

AGAR, Eileen (1904–1991). Surrealist painter of a wide range of subject matter in oils, collages, assemblages, gouache, found objects and mixed media. Born in Buenos Aires, Argentina, she first studied art with the sculptor Leon Underwood where fellow students included MOORE, HERMES and RODNEY THOMAS; between 1925 and 1926 she studied at the SLADE SCHOOL under TONKS. In 1924 she travelled to Paris and Spain where she was influenced by Goya and El Greco; she lived in Paris 1928–30. She exhibited at many London galleries, including the HANOVER and the REDFERN, and in Rome. In 1934 she became a member of the LG. In 1936 her work was selected by ROLAND PENROSE and HERBERT READ to be included in the International SURREALIST Exhibition with other English artists such as PAUL NASH and HENRY MOORE. Her work also appeared in the International Surrealist Exhibition in New York 1936–7, and in Tokyo, Paris and Amsterdam 1937–8. Retrospective exhibitions of her work have been held in 1964 (Brook Street Gallery, London), and in 1971 at the Commonwealth Art Gallery, London. Exhibitions of selected works have also been held at the NEW ART CENTRE in 1975 and 1977. Established as the leading British woman Surrealist, her early work was abstract, reflecting the influence of Cubism and of Brancusi in its simple forms. From the early 1930s she was aware of Surrealism, using unusual coalitions of objects and forms. Through her friendship with Paul Nash, whom she met in 1935, her work was brought to the attention of Read and Penrose, and Nash also confirmed her own interest in the role of natural objects. From 1937, her use of found objects and collages was further strengthened by her friendship with Picasso. Agar believed in the combination of intuition, controlled emotion and intellect and whilst she used

automatic techniques she tempered this with her desire for order and form, e.g. *Quadriga*, 1936. Nash described the 'poetic mystery' of her work which often used objects and images from the sea and shore, as well as making allusions to the ancient world. Her work established a feminine quality, which could be attractive and sometimes whimsical. Later work became more abstract whilst retaining surreal elements.
LIT: *A Look at my Life*, Eileen Agar, Methuen, 1988; *Five Women Painters*, Oxford, 1989. CF

Agnew's. Thos. Agnew & Sons Ltd were founded in 1817. They deal in Old Masters but also represent the work of some contemporary artists such as BERNARD DUNSTAN and PETER BROOK. Their galleries are at Old Bond Street and 3 Albermarle Street. AW

AIKEN, John Macdonald, RSA, RI, ARE, ARCA (1880–1961). Painter of portraits and landscapes in watercolour; etcher and designer of stained glass. He studied art at Gray's School of Art, Aberdeen, and at the RCA under Gerald Moira, and also in Florence. He exhibited at the RSA and RA, as well as RSW, RI and RP; he also showed in London galleries. He was elected ARE in 1924, RSA in 1935 and RI in 1944. In 1928 he gained a silver medal at the Paris Salon and he continued to exhibit there from 1929 to 1935. He was Head of Gray's School of Art 1911–14. In *Portrait of the Artist and his Wife in the Studio*, 1910, he shows a careful delineation of detail and character with controlled colour applied so that the texture of the canvas is visible in places.
LIT: *Edwardian Portraits*, K. McConky, Antique Collectors Club. CF

AINSWORTH, Mark (b. 1934). Abstract artist painting in acrylic. He attended Blackpool College of Art and Ravensbourne College of Art, worked at Butlers Wharf 1977–8, and studied at the RA SCHOOLS 1978–80. He has exhibited with the LONDON GROUP, NEW CONTEMPORARIES, at JOHN MOORES LIVERPOOL EXHIBITION 1978, and at the RA. His strong, vigorously painted abstracts contrast blocks of tone and colour, giving a sense of weight, gesture and balance, e.g. *Sentinel*, 1979.
LIT: Catalogue for *Artists Working in East London*, Whitechapel Summer Exhibition, London, 1979. CF

AIRY, Anna, RI, ROI, RP, RE, PS (1882–1964). Painter of figures, portraits and flowers in oils, watercolours, pen and pastels; etcher. She studied at the SLADE SCHOOL 1899–1903, under BROWN, STEER, RUSSELL and TONKS, winning the Slade scholarship in 1902 and the Melville Nettleship Prize in 1900, 1901 and 1902. She exhibited widely, showing at the RA from 1905 to 1956, in London societies and galleries, in Scotland, the provinces, the Paris Salon and international exhibitions. Elected PS in 1906, ROI in 1909, RP in 1913, RE in 1914 and RI in 1918, her work is represented in collections including the IMPERIAL WAR MUSEUM. Her publications include *Making a Start in Art*, London, 1951, and she was President of the Ipswich Art Club and Museums. She was married to the artist Geoffrey Buckingham Pocock. Her widely varied subjects range from delicate sprays of flowers to more impressionistic oils and war paintings of munitions factories.
LIT: *Anna Airy RI, ROI, RE*, exhibition catalogue, Ipswich Art Club (Ipswich Borough Council), 1985; 'Anna Airy: Drawings of Fruit, Flowers and Foliage', *Studio*, Vol.LXIV, p.189. CF

AITCHISON, Craigie, RA (b. 1926). Born in Scotland, he attended the SLADE 1952–4. In 1954 he was one of 'Six Young Contemporaries' at GIMPEL FILS; in 1955 he was awarded an Italian Government Scholarship, and his first one-man show was at the BEAUX ARTS in 1959. In 1970 he won the Edwin Austin Abbey Premier Scholarship, and in 1974 won third prize at the 9th JOHN MOORES. His poetic, luminous and delicately painted canvases are often on religious themes, but include portraits, landscapes and animals.
LIT: *Craigie Aitchison*, exhibition catalogue, Serpentine Gallery, London, 1981; Introduction by Patrick Kinmonth, exhibition catalogue, Albemarle Gallery, 1987. AW

AITKEN, John Ernest. RSW, ARWA, ARBC, BWS, R.Cam.A., LAA, MAFA (1881–1957). Painter of landscapes and coastal subjects in watercolours. Son of the marine painter James Aitken, he studied with his father and at MANCHESTER, Liverpool and Wallasey Schools of Art. He exhibited mainly in Liverpool, at the R.Cam.A., the RSW (member 1929) and the RI, but he also showed at the RA, the RSA, in London galleries and the provinces. A member of the Liverpool and Manchester Academies, his work is represented in collections including the Birkenhead Art Gallery. His detailed work recorded a wide range of British and European locations. CF

ALDIN, Cecil (Charles Windsor, 1870–1935). Lithographer and etcher. Trained at Albert Moore's studio and the NATIONAL ART TRAINING SCHOOL (RCA). Known for his animal and sporting subjects, as well as for topographical views.

AW

ALDRIDGE, Eileen (b. 1916). Painter of portraits, figures, landscapes and townscapes in oils and watercolours; illustrator and printmaker. She studied at Kingston School of Art, at the London Polytechnic and has exhibited at the RA from 1944 to 1973, at the LG, NEAC, RP, the WIAC and in the provinces. Her work is represented in collections in the USA and on the continent. Married to the artist William Ware with whom she published a book on eighteenth-century porcelain, she has written and illustrated books for the Medici Society. Her stylized work includes scenes such as *Café Tables, Ischia*, and *Under Brighton Pier*.
LIT: Exhibition catalogue, The Grange, Rottingdean, Sussex, 1967.

CF

ALDRIDGE, John Arthur Malcolm,RA (1905–1984). Landscape painter, also illustrator and textile designer. Usual media: oils and watercolours. Educated at Uppingham School and Corpus Christi College, Oxford, he started to teach himself to paint whilst at Oxford and travelled in France, Spain, Italy and Germany. In 1933 he moved to Great Bardfield in Essex and the countryside there became the subject for much of his work. In 1931 he was invited by BEN NICHOLSON to exhibit with the SEVEN AND FIVE SOCIETY, from which he resigned in 1934. His first one-man show was in 1933 at the LEICESTER GALLERIES and he continued to show there until 1947, thereafter exhibiting at major London galleries including the UPPER GROSVENOR GALLERY 1968–71, the Radlett Gallery, and the NEW GRAFTON GALLERY. In 1934 his work appeared at the Venice Biennale and is represented in many public collections throughout Britain. In 1949 he was invited by COLDSTREAM to teach at the SLADE. In 1938 he associated with EDWARD BAWDEN in designing wallpapers and in the early 1930s he established a firm friendship with Robert Graves, whom he visited in Majorca. Other friends included JOHN NASH, Laura Riding, Norman Cameron and CEDRIC MORRIS. His straightforward view of the countryside is balanced by a strong sense of design and the use of unusual colour effects. His earlier work shows a concern for more detailed description, e.g. *The Pink Farm*,

1940 (ARTS COUNCIL COLLECTION), whilst some later canvases reveal a broader touch, e.g. *Farmyard in Snow*, 1956. His paintings of Majorca reflect the intensity and rhythm of that landscape.
LIT: *Great Bardfield Artists*, Colin MacInnes, 1975; the catalogue for his exhibition at Upper Grosvenor Gallery, 1971, with an introduction by John Betjeman.

CF

ALEXANDER, Edwin, RSA, RSW, RWS, SSA (1870–1926). Painter of animals, flowers, desert scenes and landscapes in watercolour on a variety of fabrics and paper. Born in Edinburgh, the eldest son of ROBERT ALEXANDER, RA, who influenced his early training, he studied at the Royal Institution, Edinburgh, 1887–8, and with Frémiet in Paris in 1891. In 1887 he visited Tangier with his father and JOSEPH CRAWHALL who was to influence his work. Between 1892 and 1896 he visited Egypt and in 1904 he settled in Scotland. He was elected ARSA in 1902, RWS in 1910, RSW in 1911, and RSA in 1913. In 1914 he became a tutor at EDINBURGH COLLEGE OF ART. Best known for his bird and animal studies, his work reflects his knowledge of Japanese art in its selectivity and arrangement. His simplicity of effect was aided by his choice of surface which established tone and texture.
LIT: The article on OWS Club, IV, 1926, by James Paterson; FINE ART SOCIETY catalogue, Edinburgh Festival, 1985.

CF

ALEXANDER, Harry (b. 1905). Painter of non-figurative images in gouache and egg tempera. He studied at Trinity College, Cambridge, and worked in Africa, Canada and London before working as a farmer for about thirty years. His non-figurative painting was encouraged by Hugh Griffiths and influenced by his observation of countryside, the changing seasons and the patterns of nature.
LIT: Exhibition catalogue, County Town Gallery, Southover, Lewes, 1962.

CF

ALEXANDER, Herbert, RWS, RBC, FRGS (1874–1946). Painter of landscapes and figures in watercolours and oils. Born in London, he studied with HERKOMER at Bushey and at the SLADE SCHOOL. He exhibited mainly at the RWS (ARWS 1905, RWS 1927) and also showed in London galleries including the Dudley and New Dudley Gallery, at the ROI, at the RA in 1906, 1909 and 1934, in Scotland and the provinces. His work is represented in collections including

the Ulster Museum and amongst his publications was *The Life and Work of Benjamin Haughton RBA* (published privately in 1937). His idyllic, pastoral landscapes, many depicting the Kentish countryside around Cranbroook, combined detail with atmospheric colour.

LIT: 'The Work of Mr Herbert Alexander', Laurence Housman, *The Studio*, Vol.31, pp.301-12. CF

ALEXANDER, Norman (b. 1915). Painter of cityscapes and landscapes in oils. Self-taught as a painter, he held solo exhibitions at the REDFERN GALLERY in 1954 and 1958, showed at the RA in 1956 and 1957 and has exhibited at the NEAC and in group exhibitions at the LEICESTER GALLERIES. His work is represented in collections including the Toledo Art Gallery, Ohio. His paintings such as *Towards Millbank* (Lord Beaverbrook Collection) use simple, broad forms which move the subject towards abstraction.

LIT: *Norman Alexander*, exhibition catalogue, Arthur Jeffress Gallery, London, 1959. CF

ALEXANDER, Robert G.D. (1875–1945). Painter of Essex landscapes, river and coastal scenes in watercolours and oils. He attended evening classes at Hornsea School of Art where he was influenced by H.B. Brabazon, and later at the SLADE under TONKS. His work was also influenced by MARK FISHER and GEORGE CLAUSEN. He pursued a career in the City whilst painting in his spare time and he exhibited at the NEAC and in 1922 at the GROSVENOR GALLERIES. Exhibitions of his work were held at the Parkin Gallery in 1977, 1979 and 1981, and examples of his work are in the BM, V & A, Ashmolean and Fitzwilliam museums. He painted directly on the spot and his watercolours show rapid brushwork, fresh colour and simplicity of means. Aware of the English nineteenth-century tradition, he captured the light and atmosphere of the countryside with directness and economy.

LIT: The Introductions to the Parkin Gallery Exhibitions. CF

ALLAN, Alexander, RWS (1914–1972). Painter of landscapes, portraits and still-life in oils, watercolours, gouache and pastels. Born in Dundee, he attended the Dundee College of Art (under J. McIntosh Patrick), Hospitalfield and the WESTMINSTER SCHOOL OF ART. A member of the GLASGOW GROUP, he exhibited at the RSA and RA. Elected RSW in 1965, he had a number of one-man shows and is represented in public collections. In 1968 he won an Award from the Scottish Arts Council and he lectured at Dundee College of Art. His RA exhibits included *Landscape with Flowers*, 1943, and *A Prospect in East Fife*, 1960. CF

ALLAN, Robert Weir, RWS, RSW, RBC, NEAC, ROI (1852–1942). Painter of coastal subjects and landscapes in oils and watercolours; etcher and mezzotinter. Born in Glasgow, he studied in Paris at the Ecole des Beaux-Arts 1875–80, under Cabanel, and at the ACADÉMIE JULIAN. He worked with ARTHUR MELVILLE and in the early 1880s painted with W.Y. MACGREGOR at Portsoy. He settled in London in 1881 and subsequently travelled extensively, visiting India in 1891–2 and Japan in 1907. He exhibited at the GI from 1873, at the RA from 1875 to 1935, and widely in galleries and societies including the RWS (ARWS 1887, RWS 1896, VPRWS 1908–10), the RSW (member 1880), the NEAC (member 1886), at the RSA, in Liverpool and abroad. His work is represented in collections including Manchester City Art Gallery. Influenced by Lepage and the Impressionists, his works are characterized by painterly handling and atmospheric treatment of motif, particularly the Scottish coast. His fluid watercolour technique influenced that of ARTHUR MELVILLE.

LIT: 'Robert Weir Allan and his Work', Mrs Arthur Bell, *Studio*, Vol.23, pp.228–37; 'Robert W. Allan's Recent Paintings and Drawings', Martin Wood, *Studio*, Vol.46, 1909, pp.89–100. CF

ALLEN, Alistair (b. 1947). Pop artist. He studied at CHELSEA SCHOOL OF ART and held his first solo exhibition at the Galerie Aesthetica, Stockholm, and his first London show at the Hulton Gallery in 1970. He has subsequently shown in the Art Spectrum Exhibition and at the Gallery Petit in London in 1972. His work has included images based on cut-out copy book headings and Victorian printed material.

LIT: *Arts Review* (UK), Vol.24, pt.12, 17 June 1972, p.368. CF

ALLEN, Colin (b. 1926). Painter of landscapes and coastal subjects. Born in Cardiff, he studied at Cardiff College of Art and the RCA, winning a major travelling scholarship to France, Spain and Italy in 1953. He has exhibited at the RA from 1959 to 1963, at the RSA and in galleries including the PICCADILLY and Prospect Galleries in London and the Howard Roberts Gallery in

Cardiff (1961 and 1967). His work is contained in collections including Carlisle Art Gallery and in 1953 he represented the RCA in the World Cultural Exhibition. He was Head of the Department of Fine Art, Carlisle College of Art. Many of his paintings depict scenes of Spain and Majorca as well as British landscape. CF

ALLEN, Elizabeth (1883–1967). Naive artist of sewn patchwork pictures. After a life of poverty during which she worked as a seamstress, her work was discovered in 1966 and exhibited at CRANE KALMAN Gallery, London, 1966, 1967 and 1973. The 1966 exhibition travelled in Great Britain. She also exhibited at Fleischer Arnhalt Gallery, LA, 1968, and La Boétie, NY, as well as Munich and Barcelona. Her pictures often have biblical, magical and fantastic subjects and they show her sense of pictorial structure and strong colour in their combinations of different cloths. LIT: The Introduction by Patrick Heron in the catalogue for the Graves Art Gallery, Sheffield, 1966. CF

ALLEN, Harry Epworth, RBA, PS (1894–1958). Painter of landscapes in tempera, oils, pastels and watercolours. Born in Sheffield, he attended evening classes at Sheffield Technical School of Art. He turned to art full time in 1931, becoming a member of the Yorkshire Group of Artists and the Sheffield Association of Artists. He exhibited at the RA and RSBA 1933–5, becoming an Associate in 1935. In 1986 a retrospective exhibition was held at the Graves Art Gallery, Sheffield. Influenced by LEWIS, SPENCER and ROBERTS, he balanced observation and design in adapting observed forms to achieve a rhythm of line and colour. His Derbyshire landscapes, painted in tempera, have a matt surface built up from dry stippled pigment. LIT: See his article on 'Decorative Landscape Painting', *The Artist*, 1942. CF

ALLEN, Kathleen (b. 1906). Born in London, she attended the RCA, teaching art in schools in Kent and Warwickshire during the 1930s and also painting murals for schools. In 1936 she took a studio in Fetter Lane in the city of London, and returned to study 1936–7, this time at the SLADE. During the Second World War her studio was bombed and much of her earlier work was lost. She continued to teach in London schools whilst recording war work for the WAAC part-time. She was exhibitions secretary of the AIA, 1938–48, and from 1946 until she retired in 1966, she taught at GOLDSMITHS' COLLEGE. Her subject matter is taken from the urban society in which she lives. LIT: *Kathleen Allen. A Retrospective Exhibition*, catalogue, South London Art Gallery, 1983. AW

ALLEN, Richard (b. 1933). Abstract artist in a variety of media including acrylic, dyes, collage, silk screen and etching. He studied at Worcester School of Art in 1955 and BATH ACADEMY OF ART from 1957. In 1960 he was awarded an Italian Government Scholarship to study in Italy. He has held various teaching posts in England and was Artist in Residence at Sussex University in 1967 and Exhibitions Consultant to the Polytechnic of Central London in 1974. His international exhibitions include the 1967–9 ICA 'British Artists' which toured America. His best known works are his large hard-edge optical paintings which involve a series of identical forms and their layering. He has carried out seven commissions in relation to architecture. LIT: Interview by Clifford McLucas, exhibition catalogue, Aberystwyth Arts Centre, October 1983. MW

ALLEN, William Herbert, RBA, ARCA, RWS, RSA (1863–1943). Landscape artist in watercolours, oils, chalk and pencil. In 1884 he entered the RCA where he won gold, silver and bronze medals and, in 1888, a travelling scholarship. He exhibited mainly at the RBA as well as at the RA and London galleries. He was elected RWS in 1903, RBA in 1904 and RSA in 1931. In 1889 he became a teacher at Farnham School of Art and between 1904 and 1927 Director of Study and Teaching of Art in Farnham. From 1890 onwards he travelled abroad regularly, painting and carrying out commissions for major museums. His work records rural scenes, many in Hampshire and Surrey, and ranges from sketches painted outside with great immediacy to finished works carefully detailed and built up by small coloured touches. LIT: See catalogue of his work, Hampshire CC, 1989. CF

Allied Artists Association. The AAA was formed in 1908 by FRANK RUTTER in answer to the demand amongst artists connected with SICKERT'S studio and others from abroad who sought an independent, open annual exhibition for progressive artists. Rutter was supported by Sickert, GORE, LUCIEN PISSARRO, WALTER BAYES, STEER and ROUSSEL and Association members included

GILMAN, GINNER and AUGUSTUS JOHN. Modelled on the Salon des Indépendants, Paris, the AAA was a co-operative, democratic venture with each subscriber entitled to exhibit five works at the annual exhibition, although due to numbers (the opening exhibition had listed over 3,000 works) this was later reduced to three. Held first at the Albert Hall, 1908–16, and later at the Grafton Galleries, 1916–20, the annual exhibition of the 'London Salon' played an important role in showing both British and foreign work. It was through the AAA that the work of Bayes, BEVAN and Ginner came to the notice of the FITZROY STREET GROUP; it introduced the British public to less well known art such as Russian and Indian work and it acted as a forum for new developments, exhibiting the work of Kandinsky for the first time in London in 1909, 1910 and 1911, and showing work by EPSTEIN in 1910.
LIT: Exhibition catalogue, the Twelfth London Salon, the Grafton Galleries, London, July 1920.
CF

ALLINSON, Adrian Paul, ROI, RBA, LG, PS (1890–1959). Painter of landscapes, townscapes and flowers in oils and watercolours; sculptor, poster designer, stage designer (Beecham Opera Company) and caricaturist. Between 1910 and 1912 he studied at the SLADE SCHOOL under TONKS, STEER, BROWN and RUSSELL, winning the Slade Scholarship. He later trained in Paris and Munich. He exhibited at the RA, NEAC and LG, as well as other societies and London galleries, including the REDFERN and LEICESTER. He taught at WESTMINSTER SCHOOL OF ART and in 1914 became a member of the LG. He was elected RBA in 1933 and ROI in 1936. Most well known as a landscapist, his work uses strongly modelled, stylized shapes in contrasting tone and colour.
LIT: See Allinson's autobiography *Painter's Pilgrimage*; memorial exhibition catalogue, RSWC Galleries, 1962.
CF

ALSTON, Rowland Wright (1895–1958). Painter of landscapes, figures, portraits and birds in oils and watercolours. He studied at the SLADE SCHOOL, the RCA and with Alfred William Rich and exhibited at the NEAC and at the RA in 1945. He was Drawing Master at Haileybury, Herts, before being appointed Curator of the Watts Gallery, Compton. His publications include *The Mind and Work of G.F. Watts*, London, 1929, *The Rudiments of Figure Drawing*, Pitman & Sons, London, 1933, and *Painter's Idiom: A Technical Approach to*

Painting, Staples Press, London, 1954. His work ranged from rural landscapes to observant studies of birds in watercolours.
LIT: *Arts Review* (UK), Vol.33, 27 February 1981, p.69; *Connoisseur* (UK), Vol.206, No.829, March 1981, p.175.
CF

AMIES, Anthony (b. 1945). Painter of seascapes and landscapes in oils. He studied at the SLADE SCHOOL 1964–70, winning the Tonks, Summer Competition and Etching prizes. He has exhibited widely in London galleries, including BROWSE AND DARBY and the Camden Arts Centre, and in the provinces. In 1977 he won an ARTS COUNCIL Award and in 1988 became Hon. Friend, University of London. His work has been purchased by the CHANTREY BEQUEST and appears in public collections. Working in the English tradition, he paints directly, working from studies made out-of-doors.
CF

ANDERSON, Alfred Charles Stanley, CBE, RE (1884–1966). Etcher and engraver, painter. The son of an engraver, and at first his apprentice, he was later a student at Bristol, at the RCA under SIR FRANK SHORT, and at GOLDSMITHS' COLLEGE. Country scenes and rural activities and crafts were his main subjects, as well as studies of the darker side of urban life. His work is in the British Museum, the V & A and elsewhere. At GOLDSMITHS' he taught DRURY, TANNER and SUTHERLAND, among many others.
LIT: 'The Etchings and Engravings of Stanley Anderson', M. Hardie, *Printmakers Quarterly*, Vol. XX No.3, July 1933, p.221.
AW

ANDERSON, Charles Goldsborough (1865–1936). Portrait painter in oils. Born in Tynemouth, Northumberland, he trained at the RA SCHOOLS. His paintings were exhibited at the RBA, ROI and at the RA 1888–1917, he also showed at the New Gallery, London and at the GRAFTON GALLERIES, 1901 and 1904. In 1910 he was commissioned to paint a panel for the Royal Exchange. Although mainly exhibiting portraits his RA work included subjects such as *Firelight Fancies* and *A Favourite Study*, 1905.
CF

ANDERSON, James Bell, RSA (1886–1938). Painter of portraits, landscapes and still-life, usual medium: oils. Born in Edinburgh, he attended the Allan Fraser Art College, Arbroath, under George Harcourt, EDINBURGH SCHOOL OF ART, Hospitalfield, and JULIAN'S Academy in Paris with Jean Paul Laurens. By 1910 he had

opened a studio in Glasgow for portrait painting. Exhibiting mainly in Scotland at the RSA and the Glasgow Institute of Fine Arts, he also showed at the RA in 1913, 1928 and 1930. He became ARSA in 1932 and RSA in 1938 and was also a member of the Glasgow Arts Club. He was known mainly as a portraitist, e.g. *Portrait of Rt. Hon. Alexander Ure, KC, MP*, 1913. CF

ANDERTON, Tom (1894–1956). Painter in oils and watercolours. Born in Preston, he worked in Lancaster and Preston and exhibited between 1921 and 1928 at the Walker Art Gallery, Liverpool, and in Manchester. His work included landscape scenes such as *In Woodland Pasture* and some scenes of Cornwall. CF

ANDREAE, Conrad Rudolf (1871–1956). Painter of townscapes, landscapes and seaside subjects in watercolours. Born in London, he studied at the SLADE SCHOOL under BROWN, where he was awarded a first-class certificate for figure painting, and at the ACADÉMIE JULIAN, Paris, under J.P. Laurens and Benjamin Constant. He lived in Brighton, Sussex, and exhibited at the RA in 1926, 1935, 1936 and 1940, and showed in Liverpool and the provinces. Honorary Secretary of the Brighton Arts Club, many of his works show Brighton and its neighbourhood, some of which he exhibited in 1925 at Hove Public Library, but he also painted French scenes. He was noted for his draughtsmanship and the bright, lyrical character of his work. CF

ANDREWS, Michael (1928–1995). A painter of portraits, landscapes, seascapes, townscapes and nudes in oils and acrylics. Born in Norwich, he studied part-time at Norwich School of Art, then at the SLADE 1949–53, following military service in Egypt. In 1953 he was awarded the ROME PRIZE, and a picture painted when a student at the Slade, *The Man Who Suddenly Fell Over* (1952), was bought by the TATE at his first one-man show at the BEAUX ARTS GALLERY in 1958. He also took the leading part in two remarkable films by Lorenza Mazzetti when a student. He taught at Norwich (1959), CHELSEA (1960) and the Slade (1963–6) Schools of Art, living in London until 1977 then moving to Norfolk. He usually exhibited at the Anthony d'Offay Gallery. His work was always figurative, being both scrupulously observed and concerned with human and animal behaviour and with relationships; central issues were identity and awareness, his subjects taking on a numinous or symbolic quality. He sometimes used literary sources of inspiration and adapted photographic images, employing a range of technical approaches – spraying and printing paint, with impressive virtuosity. A visit to Ayers Rock in Australia in 1983 inspired some of his best-known pictures. LIT: *Michael Andrews*, exhibition catalogue, Arts Council, 1980. MW

ANDREWS, Sybil (1898–1992). Born in Suffolk, she studied at HEATHERLEY'S, and is best known for her work in linocuts with CLAUDE FLIGHT at the GROSVENOR SCHOOL OF MODERN ART. LIT: *Sybil Andrews, Paintings and Graphic Work*, exhibition catalogue, Michael Parkin Gallery, 1980. *Sybil Andrews, Colour Linocuts*, Peter White, Glenbow Museum, Calgary, 1982. AW

The Anglo-French Art Centre. Founded in St John's Wood in London in 1945 by Alfred Rozelaar Green (b. 1917) who had studied at the ACADÉMIE JULIAN. The Art Centre closed in 1951. Among its pupils were BREON O'CASEY and BIRGIT SKIÖLD. AW

ANREP, Boris (1883–1969). Mosaicist and painter. Born in St Petersburg, he first studied law before travelling in Russia and the Near East and visiting Italy and France with Steletsky. In 1908 he settled in Paris and attended the ACADÉMIE JULIAN under Laurens and the ateliers La Palette and Grand Chaumière. In Paris he met HENRY LAMB and AUGUSTUS JOHN who encouraged his mosaic work and gave him his first commission in 1919 (a work now in the V & A). Between 1910 and 1911 he attended EDINBURGH COLLEGE OF ART and in 1916 he settled in London. He exhibited with the LG and received many mosaic commissions including those for the TATE GALLERY, the National Gallery and Westminster Cathedral. He also organized, and wrote the preface for, the Russian Group in the Second Post-Impressionist Exhibition. He was interested in Byzantine mosaics and Russian icons. His painting is represented in the Tate Gallery: *Nude and Ruins*, 1944. LIT: *Boris Anrep: The National Gallery Mosaics*, Angelina Morhange, 1979. CF

APPELBEE, Leonard, ARCA (b.1914). Painter of landscapes, still-life and some portraits, in oils. He studied at GOLDSMITHS' COLLEGE OF ART 1931–4, and at the RCA under BARNETT FREEDMAN 1935–8. After army service 1940–6, he had his first one-man show at the LEICESTER

GALLERIES 1948, where he continued to exhibit. He showed at the RA in 1947 and exhibited there regularly from 1956. In 1940 his painting *Landscape, Meadle* was purchased by the CHANTREY BEQUEST. His paintings are broadly worked using angular areas of paint which simplify form and establish a feeling of solidity, e.g. *King Crab*, 1938 (TATE GALLERY). In portraits the head is painted in greater detail than other areas, so focusing the viewer's attention. CF

APPERLEY, George Owen Wynne, RI, FRSA (1884–1960). Painter of landscapes and figures in watercolours and oils. Largely self taught, he spent some time with HERKOMER at Bushey and from 1907 made regular painting trips to Italy, France, Belgium and Holland. Between 1906 and 1915 he had a series of solo exhibitions in London in leading galleries and from 1905 he exhibited at the RA and RI as well as showing abroad. He was elected RI in 1913 and in 1916 he settled in Spain, holding regular exhibitions there. He was elected Member of Real Academia de San Telmo and in 1945 received the Order of Alfonso X. His early watercolours are quiet in mood with washes conveying a sense of light; his Spanish work could be very strongly coloured and decorative, e.g. *Talavera*, 1924–5.
LIT: *The Last Romantics*, Barbican Art Gallery, London, 1989; 'Impressions of Granada', *Studio*, Vol.LXXXV, p.80. CF

APPLEYARD, Fred, RWA (1874–1963). Painter of subject pictures, landscapes, portraits and decorative paintings in oils. Born in Middlesborough, he studied at Scarborough School of Art under Albert Strange, at the RCA and at the RA SCHOOLS, winning the Creswick Prize, the Turner Gold Medal and three scholarships. He worked in South Africa from 1910 to 1912 and after the First World War he settled in Hampshire. He exhibited mainly at the RA where he showed from 1900 to 1935, at the RWA (member 1926) from 1918 to *c.*1950, in Glasgow, Liverpool and Manchester. In 1915 his painting *A Secret*, *c.*1914, was purchased by the CHANTREY BEQUEST for the TATE GALLERY. His decorative commissions included work for the RA Refreshment Room in 1903. His varied, poetic paintings, including scenes of figure groups in landscape such as *Moonrise and Memories*, RA 1918, used a dappled application of paint to suggest aspects of outdoor light.

LIT: *Studio*, Vol.XIX, pp.123–4; *Fred Appleyard, RWA*, exhibition notes, Southampton Museum and Art Gallery, 1977–8. CF

APPLEYARD, Joseph (1908–1960). Painter of horses and racing subjects in oils and watercolours; illustrator. Beginning his career in advertising he first studied art in evening classes at Leeds College of Art 1925–32, and made painting his career during the 1930s. He exhibited at the RBA, Doncaster Art Club and in the provinces, having several one-man shows. He taught at Leeds College of Art and at Swarthmore Centre, Leeds, and he produced illustrations on country subjects for *The Dalesman* and *Yorkshire Post*. His representational, detailed work reflected his knowledge of his subject, giving an accurate account of events as well as appearance, e.g. *Finish of the St Leger Stakes, 1959*, commissioned by Doncaster Museum. CF

ARCHER, Frank Joseph, RE, ARCA (1912–1995). A painter and etcher, he studied at Eastbourne School of Art 1928–32, and at the RCA 1934–8; he won the PRIX DE ROME for engraving in 1938. He taught at Eastbourne School of Art, and later became Head of Fine Art at Kingston. He was active in the RWS and the Royal Society of Painter-Etchers. His figurative paintings (*Fountain of Youth*, 1949) used notes of sharp colour and passages of flattened impasto with clearly defined edges, reflecting his interest in medieval stained glass and mosaics. AW

ARDIZZONE, Charlotte, NEAC, NDD (b. 1943). Painter of flowers, landscapes, still-life and seascapes in oils, watercolours and mixed media; printmaker. She studied at ST MARTIN's and at the BYAM SHAW School of Art under MAURICE DE SAUSMAREZ, subsequently working in Italy, and has exhibited in London galleries including the Drian Galleries 1970–7, Blond Fine Art and the CURWEN GALLERY. She also exhibits at the Bohun Gallery, Henley, at the RA and with the NEAC. Her work is represented in collections including the National Gallery of Victoria, Australia, and the Nuffield Foundation. Her softly coloured paintings, often depicting a few carefully selected objects, combine a gentle, painterly approach with detailed observation.
LIT: 'My Approach to Painting', C. Ardizzone, *Artist* (UK), Vol.94, pt.6, June 1979, pp.18–20; *Arts Review* (UK), Vol.31, 30 March 1979, p.148. CF

ARDIZZONE, Edward Jeffrey Irving, CBE, RA (1900–1979). Painter of figures and humorous genre; illustrator and author. His usual media were pen, watercolour, ink and wash; oil was a medium he abandoned early. Edward Ardizzone was largely self-taught. From 1919 to 1926 he attended night classes at WESTMINSTER SCHOOL OF ART, under BERNARD MENINSKY and WALTER BAYES. In 1927 he visited Germany, Austria and Italy. In 1942–3, as an OFFICIAL WAR ARTIST, he went to North Africa and from 1943 to 1945 to Sicily, Italy, Normandy and Germany. In 1952 *The Blackbird in Lilac* was published, his first book in collaboration with James Reeves. Ardizzone usually exhibited at the RA, with his main gallery being the Leger and, after 1958, the MAYOR GALLERY. In 1948 he taught at CAMBERWELL SCHOOL OF ART AND CRAFTS and from 1953 to 1961 at the RCA. He was made Royal Designer for Industry in 1974. The prizes Ardizzone won were for his literary contributions: in 1955 he was awarded the Carnegie Medal of the British Library Association, in 1956 the Hans Christian Andersen Medal of The International Board on Books for Young People and also in that year *Tim All Alone* became the first book to win The British Library Association's Kate Greenaway Award for the year's most distinguished work in book illustration. He received many commissions throughout his life, including a watercolour of the Queen's Coronation in 1953. In 1954, on the recommendation of SIR JOHN ROTHENSTEIN, he was commissioned to execute a drawing of Sir Winston Churchill for presentation to him by the Press Gallery. His other activities include terracottas and designs for china, menus, invitation and Christmas cards. He constantly observed life; the clarity of his drawings was achieved by his vigorous use of line and strong shadows.
LIT: *The Young Ardizzone: An Autobiographical Fragment*, Edward Ardizzone, Studio Vista, 1970; *Diary of a War Artist*, Edward Ardizzone, 1970; *Edward Ardizzone*, Gabriel White, Bodley Head, 1979. MW

ARDIZZONE, Philip (1931–1978). Eldest son of the artist EDWARD ARDIZZONE. His main media were painting, using oil on board, and etching. Trained at the SLADE SCHOOL 1952–5, he became a regular exhibitor at the Royal Academy Summer Show. He also taught foundation students at Colchester School of Art. MW

ARIS, Ernest Alfred, SGA (1882–1963). Painter of portraits and book illustrator. Son of the artist Alfred Aris, he studied at Bradford School of Art under Charles Stephenson and at the RCA under MOIRA and Chambers. He exhibited at the RI, RWS, RBA and in the provinces and he was elected SGA in 1943. Initially a portraitist, he became a popular illustrator of many children's books, particularly those depicting animals such as *A Bold Bad Bunny*, 1920, and *The Ernest Aris Nature Series*, 1948. He also worked for periodicals including Cassell's Children's Annual.
LIT: *The Art of the Pen*, Ernest Aris, Pen in Hand Publishing Co., 1948. CF

ARMFIELD, Diana M, ARA, RWS, NEAC, RWA, MSIA (b. 1920). Painter of landscapes and flowers; textile and wallpaper designer. She studied at the CENTRAL SCHOOL OF ART under Adeney, 1948–50, and at the SLADE SCHOOL under SCHWABE and ORMROD. She exhibited in 1974 at the Rye Art Gallery and she has shown regularly at BROWSE & DARBY since 1979. She has also exhibited at the RA since 1965 and shown in the provinces and abroad. Her work is represented in collections including the V & A. She has taught at the BYAM SHAW SCHOOL OF ART since 1959, she was Governor of the Federation of British Artists in 1981 and in 1985 was Artist in Residence, Perth, Australia. Married to the artist BERNARD DUNSTAN, she works in London, Wales, France and Italy. Her painting is harmonic and painterly.
LIT: Exhibition catalogue, Browse & Darby, London, 1987; retrospective exhibition catalogue, Oriel 31, Davies Memorial Gallery, Newton Powys, 1988. CF

ARMFIELD, Maxwell Ashby, RWS (1882–1972). Painter of figures and landscapes in tempera and watercolours; writer, illustrator and designer. He trained at Birmingham School of Art, in Paris and Italy. From 1908 he had regular solo exhibitions and showed at the RA, LG, NEAC and at London galleries and abroad. He became RWS in 1941 and an Hon. Member in 1961. Whilst in America he was influenced by the theories of JAY HAMBIDGE, and he also wrote many books including *Manual of Tempera Painting*, 1930. Influenced by the Pre-Raphaelites, the Symbolists and G.F. Watts, his early romantic and symbolic works used a finely brushed style, e.g. *The Secret Rose*, 1904. Later works reflected his study of oriental and Japanese art, the influence of Cézanne and Van Gogh and the designs of the American Indians.

LIT: *Homage to Maxwell Armfield*, Fine Art Society catalogue, 1970. CF

ARMFIELD, Stuart Maxwell (b. 1916). Painter of boats, flowers and a variety of subjects in tempera. He trained at the West of England College of Art and worked as an assistant director at Ealing Film Studios and in Paris. Since 1949 he has lived in Polperro. He has exhibited at the RA, RWS, RI and with the St Ives Society of Artists and the Newlyn Society of Artists. He has shown in the provinces and abroad. His painting style reflects his interest in technical detail and precision, e.g. *Cow Parsley Calvary*, 1958. CF

ARMOUR, George Denholm, OBE (1864–1949). Painter and illustrator of horses and hunting scenes in watercolours, bodycolour and black and white. He attended EDINBURGH SCHOOL OF ART and the RSA Schools from 1880 to 1888, winning many prizes. He met Robert Alexander who accompanied him on a trip to Tangier where, on a subsequent visit, he met JOSEPH CRAWHALL who influenced his work. His illustrations were widely published and he exhibited at the RA, RSA and GI, as well as at the LEICESTER GALLERIES and other London galleries. Awarded the OBE in 1919, he travelled extensively and his thorough knowledge of horses and hunting is reflected in his work. This captures the essence of animals and riders with economy and ranges from widely hatched drawings to technically gifted watercolours which demonstrate a sure sense of line and balance of tone.
LIT: 'Remounts Colonel with a Sketchpad: the Sporting Life of G.D. Armour', J.N.P. Watson, *Country Life* (UK), Vol.163, No.4215, p.1101. CF

ARMOUR, Mary Nicol Neill, RSA, RSW (b. 1902). Painter of landscapes, still-life and flowers in oils and watercolours. She studied at GLASGOW SCHOOL OF ART under FORRESTER WILSON and GREIFFENHAGEN 1920–25, and in the early 1930s exhibited at the GI and RSA, thereafter exhibiting regularly. In the 1950s she taught at GLASGOW SCHOOL OF ART. In 1937 she won the Guthrie Prize and was elected RSW in 1956, RSA in 1958 and RGI in 1977. In 1980 she was awarded LLD, Glasgow, and in 1983 became Hon. President, Glasgow Institute of Fine Arts. Her early work was vigorous and subdued in colour; in the 1950s lighter colour and freer brushmarks were apparent and this development continued, e.g. *Still-life with Nailsea Vase*, 1985.

LIT: Retrospective exhibition catalogue, Fine Art Society, 1986. CF

ARMSTRONG, John, ARA (1893–1973). After Oxford, he studied at ST JOHN'S WOOD SCHOOL OF ART (1913–14, and briefly after his war service 1914–18). His first one-man show was at the LEICESTER GALLERIES in 1928, but he often exhibited at the LEFEVRE until 1951. He worked for the theatre, in 1931 designing the sets and costumes for the ballet *Façade*, and worked on nine films for Alexander Korda (1933–53). In 1933 he became a member of UNIT ONE, and also completed eight murals for Shell-Mex. He worked for the WAR ARTISTS BOARD 1940–4, painted *The Storm* for the Festival of Britain, 1951, and decorated the ceiling of the Bristol Council Chamber in 1955. His paintings are Surrealist in character.
LIT: 'Painters Purpose', John Armstrong, *Studio*, March 1958. AW

ARNOLD, Ann (b. 1936). Born in Newcastle-on-Tyne, she studied at Epsom School of Art 1956–9. She was a Founder Member of the Association of Art Therapists, and of the BROTHERHOOD OF RURALISTS (1975). She has had one-man shows at the Bath Festival Gallery, 1979, at the NEW GRAFTON GALLERY, 1981, and elsewhere; she has also shared exhibitions with her husband Graham Arnold, whom she married in 1961. They are both now represented by the PICCADILLY GALLERY. She exhibited at the RA from 1963 to 1977, and shows with the Ruralists. She featured in the 1977 BBC TV film on the Group. She paints detailed landscapes, gardens and still-lives, and had a picture (*Miranda*) in the 'Definitive Nude' exhibition at Peter Blake's Retrospective at the TATE in 1983.
AW

ARNOLD, Graham (b. 1932). Born in Beckenham, he attended Beckenham School of Art 1947–52, and the RCA 1955–8. He has taught at Ravensbourne College 1971–3, at Kingston and at the RA SCHOOLS. A Founder Member of the BROTHERHOOD OF RURALISTS, he has shown regularly with them, at the RA, and elsewhere. His first London one-man show was at the PICCADILLY GALLERY in 1983, but he has had numerous provincial shows apart from those shared with his wife ANN ARNOLD. His work is in public collections such as the RA, Bristol City Art Gallery and Liverpool University. AW

Art & Language. A group of artists which came to include an international membership, rising to

about 30 during the 1970s, which was formed in 1968 concurrently with the publication of the journal *Art-Language*. The group at first comprised TERRY ATKINSON (b. 1939, studied at Barnsley and the SLADE) who left in 1975, Michael Baldwin (b. 1945, studied at Coventry), David Bainbridge (b. 1941, studied at ST MARTIN'S) and Harold Hurrell (b. 1940, studied at Sheffield). In 1961, Joseph Kosuth (born in the USA in 1945) became editor of *Art-Language*, and Charles Harrison (b. 1942, studied at Cambridge University and the Courtauld Institute) became general editor of the Press. Art & Language set out to subvert the idea of 'art for art's sake', and the romantic cult of the individual; for that reason all work produced by the members from 1973 has been subsumed under the name of the group. Much of this activity has been in the form of printed texts, usually philosophical inquiries into the dependence of the visual arts on language, both for expression and understanding. These texts are often analytical in character, based on conversations and discussions. Posters, diagrams, flags and, since *c.*1979, paintings have also been produced, but the paintings are ironic parodies of conventional approaches, accompanied by a text or title, rather than pictures to be taken at face value.
LIT: *A Provisional History of Art & Language*, C. Harrison and F. Orton, Paris, 1982.　　AW

Art Workers Guild. Founded in 1884 to bring together artists, craftsmen and architects, the objects of the Guild are to advance education in all the visual arts and crafts by means of exhibitions (ceased 1905), lectures and meetings, and to foster high standards of design and craftsmanship. Members still meet fortnightly for a lecture or demonstration at their Hall, 6 Queen Square, Bloomsbury.
LIT: *Beauty's Awakening*, catalogue, Brighton Museum, 1984.　　AW

The Artists International Association (AIA). This was formed in 1933 by about 20 committed left-wing artists and writers, founder members including Clifford Rowe, Ronald and PERCY HORTON, Peggy Argus, PEARL BINDER, JAMES BOSWELL, EDWARD ARDIZZONE, HANS FEIBUSCH and Misha Black. They resolved to oppose 'The Imperialist war on the Soviet Union, Fascism and colonial oppression' with their art, and to hold fortnightly discussions on communism. The first exhibition, 'The Social Scene' was held in premises in Charlotte Street, the home of many subse-

quent exhibitions, although some were held in Frith Street, Grosvenor Street and elsewhere. An important show, 'Artists against Fascism and War' was held in 1935 in Soho Square, and included work by ROBERT MEDLEY, PAUL NASH and HENRY MOORE. By the end of the war there were over 1000 members; in 1947 CLAUDE ROGERS found the premises at 15 Lisle Street in which to establish the AIA Gallery, and where it flourished until 1971 when the lease expired. By 1951 non-figurative work was shown, and in 1953 a new constitution abandoned any further real commitment on the part of members to a social or socialist purpose.
LIT: *Art For A Purpose: The Artists International Association, 1933–53*, Robert Radford, London, 1987.　　AW

ARTO de HAROUTUNIAN (1940–1987). Painter of figures, still-life, landscapes and townscapes in acrylic and watercolours; architect and writer. Born in Syria, he studied architecture at Manchester University and has exhibited as a painter since 1964 in London, abroad and in the provinces, particularly at the Colin Jellicoe Gallery, Manchester. His work is represented in public collections abroad including the Sarian Academy of Arts, Syria. His paintings combine strong colour with a sinuous and precise line.
LIT: *Arts Review* (UK), Vol.25, pt.7, April 1973, p.222.　　CF

Arts Council of Great Britain. Incorporated under Royal Charter in 1945, 'to develop a greater knowledge, understanding and practise of the fine arts exclusively, and in particular to increase the accessibility of the fine arts to the public', the Council consists of not more than 16 members appointed by the Secretary of State for Education and Science. Its main activity where the visual arts are concerned is in the organization and circulation of exhibitions, and the publication of catalogues. It is the central grant-making organization for the arts in Britain, although most awards to individuals have now been transferred to the Regional Arts Associations. It possesses an important collection of painting and sculpture (which does not have a permanent home), and also supports galleries on a regular basis, such as the Whitechapel in London, Kettle's Yard, Cambridge and the Museum of Modern Art in Oxford.　　AW

ARUNDEL, James (b. 1875). Landscape, portrait and still-life painter in oils. Born in Bradford, he

studied at the Bradford Arts Club and between 1933 and 1938 exhibited at the RA, the Walker Art Gallery, Liverpool, and the BEAUX ARTS GALLERY, London. His work ranges from solidly painted landscape, e.g. *Landscape, 1931* (Manchester City Art Gallery), where broad painting establishes a balance between impasto marks and representational demands, and the more broken technique of works such as *The Beach. Brittany, 1932.* CF

ASHTON, Sir John William, HROI, OBE (1881–1963). Painter of coastal scenes, landscapes and townscapes in oils. Born in York, son of James Ashton, he studied with his father in Australia before working at St Ives in 1900 under JULIUS OLSSON and ALGERNON TALMAGE. He then studied in Paris at the ACADÉMIE JULIAN, working with Bouguereau, Ferrier, Baschet and Schommer. In 1905 he returned to Australia but he continued to make frequent trips to Europe and he exhibited at the RA, ROI (ROI 1913, HROI 1949), the RBA, the IS, the Goupil Gallery, in Liverpool and at the Paris Salon. He held his first Australian exhibition in 1906. His work is represented in collections including the Art Gallery of New South Wales where he was Director from 1937 to 1944. He was awarded an OBE in 1941 and was knighted in 1960. Influenced by his training in St Ives and by Monet, his work is strongly coloured and directly painted, often using the palette knife.
LIT: 'Will Ashton's Paintings', Hans Heysen, *Art in Australia*, Third Series, No.28, June 1929; 'Sir John William Ashton OBE, ROI', Erik Langker, *Art Gallery of New South Wales Quarterly*, Vol.9, No.2, January 1968. CF

ASKEW, Victor, ROI, RS (b. 1909). Painter of landscapes and townscapes in oils, watercolours and pastels. Born in Yorkshire, he studied at Sheffield School of Art (evening classes) 1923–6 and in 1932 began to work in London. He exhibited at the RA 1944–61 and held his first solo exhibition at the Frost and Reed Galleries in 1949. Elected ROI in 1950, his painting *The Artist's Studio, St John's Wood, 1948*, was purchased by the CHANTREY BEQUEST for the TATE GALLERY in 1948. In 1949 he was awarded a Diploma at the Paris Salon. His broad technique was instinctive and swift; using a palette knife he rapidly established an accurate and subtle record of his subject. CF

ASPINWALL, Reginald, A.R.Cam.A. (1858–1921). Painter of landscapes and coastal subjects in oils and watercolours. He lived in Lancaster and exhibited at the RA from 1884 to 1908, at the R.Cam.A., the RBA, the RI and in the provinces. His work is represented in collections including Lancaster Museum. His exhibited subjects include scenes such as *Home with the Evening Tide*, RA 1886, *A Yorkshire Stream*, RA 1889, and *A Romantic Pool on the Eden, Kirkby Stephen*, RA 1908. CF

Atelier 17. A studio for printmakers set up by STANLEY HAYTER was given the name when he established it at 17 rue Campagne-Premier in Paris in 1933. He attracted Giacometti, Picasso, Tanguy, Miró, Arp and Ernst as well as JULIAN TREVELYAN, JOHN BUCKLAND-WRIGHT, ANTHONY GROSS and many other English artists to work there in a spirit of collaborative inquiry and technical experiment. When set up in New York in 1940, Pollock, de Kooning and Rothko were among the American artists drawn to work there. By 1950 Hayter had re-established the Atelier in Paris, and continued to run it until his death in 1988. Although primarily an influence on printmaking, Atelier 17 was also a centre of cross-fertilization of artistic approaches between painters of many nationalities. AW

ATKINSON, Conrad (b. 1940). Artist in a variety of media including text, photography, documentary evidence, poster work and painted elements. Born at Cleator Moor, Cumbria, he studied at Carlisle College of Art 1957–61, Liverpool College of Art 1961–2, and at the RA SCHOOLS under Townsend, 1962–5. He exhibited at the City of Manchester Art Gallery in 1967 and has subsequently shown in London galleries including the ICA in 1972, 1974 and 1981, and at the SERPENTINE in 1978, and in international exhibitions. He has played an active role in arts administration, having been Visual Arts Adviser to the GLC, 1982–6. From 1986 to 1987 he was Artist in Residence at the University of Edinburgh and his work is represented in collections including the TATE GALLERY. A Socialist, activist artist, his work confronts contemporary social and political issues such as the strike at Brannans and the tension in Northern Ireland.
LIT: *Conrad Atkinson. Picturing the System*, eds Caroline Tisdall and Sandy Nairne, Pluto Press/ICA, London, 1981; *Conrad Atkinson*.

Everywhere Oblique, exhibition catalogue, Talbor Rice Gallery, University of Edinburgh, 1987. CF

ATKINSON, Lawrence (1873–1931). VORTICIST and abstract painter and sculptor. Born in Manchester, he studied music in Paris and Berlin, subsequently becoming a performer and singing teacher in London and Liverpool. He then studied painting at La Palette, Paris, under Fergusson, exhibiting at the Stafford Gallery, London (with DISMORR) in 1912 and at the AAA in 1913. Associated with the REBEL ART CENTRE and influenced by WYNDHAM LEWIS, he signed the Vorticist Manifesto and exhibited in the Vorticist Exhibition 1915. He exhibited abstract works at the LG 1916–19, and he continued to pursue his radical artistic interests, showing 'Abstract Sculpture and Painting' at the Eldar Gallery in 1921. Whilst his early work was fauvist in style, under the influence of Lewis and Cubism he evolved a clear, geometrical form of abstraction. Close to the Vorticists in some works and retaining the angularity of their forms, he was, however, more restrained both in colour and construction.
LIT: *The New Art,* Horace Shipp, London, 1922; *Vorticism and Abstract Art in the First Machine Age,* Richard Cork, Gordon Fraser, London, 1976. CF

ATKINSON, Sophia Mildred (1880–1972). Painter of landscapes and gardens. Born in Newcastle upon Tyne, she studied art under R.G. Hatton at Armstrong College, Newcastle, and exhibited at the RI in 1905. After the First World War she travelled in India and Austria, subsequently emigrating to Canada where she painted the Rocky Mountains and the Eastern Seaboard. She later returned to Britain and settled in Edinburgh. CF

ATKINSON, Terry (b.1939). Born at Thurnscoe in Yorkshire, he attended Barnsley School of Art 1959–60, and then the SLADE 1960–4. In 1964 he formed Fine Artz with John Bowstead, Roger Jeffs and Bernard Jennings, producing such collaborative works as *Action Chair.* He has taught at Birmingham College of Art, Lanchester Polytechnic and Leeds University, and worked on a Community Education Videotape project in Coventry with a Gulbenkian Fellowship, 1975–7. Visits to New York since 1967 have resulted in many collaborations; from 1968 to 1975 he took a leading role in the international ART AND LANGUAGE group; from 1973 individual works were subsumed under that name. Texts, pamphlets, posters, drawings, snapshots, prints and paintings were concerned with the exposure of politically manipulative concepts and patterns of language affecting thought. From 1983 many paintings have dealt with war, imperialism and nuclear weapons, often using his family as models.
LIT: *Terry Atkinson: Work 1977–83,* catalogue, Whitechapel Art Gallery, 1983. AW

ATWOOD, Clare, NEAC, NS, ASWA (1866–1962). Painter of portraits, townscapes, interiors, still-life and flowers in oils. She studied at WESTMINSTER SCHOOL OF ART under Nightingale and the SLADE under BROWN and TONKS, exhibiting at the NEAC from 1893 (member 1912) and at the RA until 1948. Represented in collections including the Museum of London, her portraits often depict sitters in their own surroundings and her work includes theatrical interiors and scenes of industrial life. CF

AUERBACH, Frank (b. 1931). Painter of portraits, nudes, construction sites and urban landscapes in oils (particularly of Primrose Hill, London); draughtsman in charcoal. Born in Berlin, he came to England in 1939, studying at Hampstead Garden Suburb Institute 1947, under BOMBERG at the Borough Polytechnic 1947–8, at ST MARTIN'S SCHOOL OF ART 1948–52, and at the RCA 1952–5, where he was awarded a Silver Medal and First Class Honours. He held his first solo exhibition in 1956 at the BEAUX ARTS GALLERY, where he continued to exhibit until 1963, subsequently showing regularly at MARLBOROUGH FINE ART, London. He has exhibited internationally and in group shows since 1958, and his work is represented in public collections here and abroad including the TATE GALLERY and MOMA, NY. He taught at a number of art schools including the SLADE until 1958 and has worked at the same studio in London since 1954. Amongst his awards is the Golden Lion Award, Venice Biennale 1986. His painting depicts particular subjects to which he repeatedly returns. Working thickly with oils and painting from the subject, his work is an exploration which goes beyond surface representation. In earlier canvases each rethinking was painted over

the last and the surface acquired the depth of a relief, but more recently he has scraped paint away before repainting. In early works the surface is dense and sombre but latterly it has become more varied with graphic, independent and vital marks. His interest in past art is reflected in his reinterpretation of works particularly by Rembrandt and Titian.

LIT: The catalogue for the Hayward Gallery, 1978; the interview in *Art and Artists*,(UK), June 1986; *Frank Auerbach*, Robert Hughes, Thames and Hudson, 1990. CF

AUMONIER, James, RI, ROI, NEAC, PS (1832–1911). Painter of pastoral landscapes including animals in oils, watercolours and pastels. Born in Camberwell, London, he attended evening classes at Birkbeck Institute, Marlborough House, and the SOUTH KENSINGTON ART SCHOOL whilst working as a calico print designer. His painting was encouraged and aided by W.M. Wyllie and Lionel Smythe and he frequently worked with James Charles. He made his first trip abroad in 1891 when he visited Venice. He exhibited at the NEAC (member 1887), at the RA from 1870 to 1911, the RI (ARI 1876, RI 1879), the ROI, (member 1909) and widely in societies and galleries, particularly the Goupil Gallery. He also won medals at many international exhibitions including the 1889 Paris Exhibition. His work is represented in collections including the TATE GALLERY. His poetic, quiet views of the country, many depicting Sussex, became fuller in colour and more dramatic later in his life.

LIT: 'James Aumonier and his Work', Mrs Arthur Bell, *Studio*, Vol.20, pp.141–8; memorial exhibition catalogue, Goupil Gallery, London, 1912. CF

AUSTEN, Winifred Marie Louise, RI, RE, SWA, FZS (1876–1964). Painter of birds and animals in oils and watercolours; etcher and book illustrator. Born in Ramsgate, Kent, she studied under Mrs Jopling Rowe and C.E. Swan and exhibited mainly at the LEICESTER GALLERIES, the RE (member 1922), the RI (member 1933) and at the RA 1899–1961. She also exhibited in other societies and galleries including the SWA (member 1905) and at the FINE ART SOCIETY. Her work is represented in public collections including the Bradford Art Gallery and her illustrations include *Birds Ashore and Aforeshore* (Patrick Chalmers). Her work was accurately observed and finely painted, combining naturalism with a sense of design. CF

AUSTIN, Frederick, ARE (1902–1990). A wood and copper engraver and etcher, a brother of ROBERT AUSTIN. He studied at Leicester College of Art and at the RCA. In 1927 he won the PRIX DE ROME for his engraving *Flight Into Egypt*. He taught at Blackheath, Putney, Croydon, Kingston and Epsom schools of art, as well as in Ontario, Canada, where he lived for some years. His rural scenes are imaginative in their composition, and gentle, if precise, in atmosphere. AW

AUSTIN, Robert Sargent, PRE, PRWS, RA (1895–1973). Engraver, painter of figures, landscapes, townscapes and flowers in watercolours; draughtsman and illustrator. He studied at Leicester School of Art 1909–13, and at the RCA under FRANK SHORT, 1913–15 and 1919–22. He won a ROME SCHOLARSHIP in engraving and worked in Italy from 1922 to 1925. He was elected to the Faculty of the BRITISH SCHOOL IN ROME in 1926 and on his return to England taught at the RCA under MALCOLM OSBORNE, where he remained until 1955. He exhibited mainly at the RE (ARE 1921, RE 1928, PRE 1962), the RWS (ARWS 1930, RWS 1934, PRWS 1956) and at the RA from 1921 to 1974 (ARA 1939, RA 1949) as well as in London galleries including Colnaghi & Co., in the provinces and in Scotland. His work is represented in collections including the TATE GALLERY. His prints, influenced by Dürer, combine sculptural form, naturalistic detail and a complex surface whilst his watercolours present an elegant, more simply expressed image.

LIT: *A Catalogue of Etchings and Engravings by Robert Austin RE, 1913–1919*, Campbell Dodgson, The Twenty-one Gallery, London, 1930; *Robert Austin RA, PRE, PRWS, 1895–1973*, exhibition catalogue, Ashmolean Museum, Oxford, 1980. CF

AYLING, George, SMA (1887–1960). Painter of docks, harbours, river scenes, landscapes and figures in oils and watercolours; designer of posters and book jackets. After working for seven years as an oar and scull maker and as a woodworker, he took up painting and studied at Putney School of Art 1912. He exhibited mainly at the ROI, RI and at the RA 1912–60, also showing at the SMA, NEAC, in the provinces and at the Paris Salon. Many of his works depict the Port of London and the Thames, giving an atmospheric account of the subject and the effects of light and reflections, e.g. *Ready to Sail, Surrey Docks*. CF

AYRES, Gillian, OBE, RA (b. 1930). Abstract painter in acrylics and in oils on canvas or hardboard. She studied at CAMBERWELL SCHOOL OF ART 1946–50 and exhibited in the first YOUNG CONTEMPORARIES. From 1951 to 1959 she was working part-time at the AIA Gallery, sharing the job with the painter HENRY MUNDY, whom she married, and where she met artists with similar ideas, such as ROGER HILTON. In 1960 she took part in the 'SITUATION' exhibition at the RBA Galleries. She has shown regularly since 1965 at the Kasmin/Knoedler Gallery and also at the RA. She has held three main teaching posts: at BATH ACADEMY OF ART 1959–65, at ST MARTIN'S 1966–78, where she was appointed Senior Lecturer in 1976, and at Winchester School of Art, as Head of Painting, 1978–81. Prizes and awards include the Japan International Art Promotion Association's award in 1963 at the Tokyo Biennale. In 1975 she received an ARTS COUNCIL Bursary and in 1979 a Purchase Award from the Arts Council. *Wells,* a tondo, won her a prize at the JOHN MOORES LIVERPOOL EXHIBITION in 1982. In 1966 she took part in the exhibition 'Aspects of New British Art' which toured New Zealand and Australia. Early in her career, in 1957, she received a commission from the architect Michael Greenwood to paint a mural on panels in the dining-room of South Hampstead School. This was her first experience of large-scale work (which she has continued to practice), then being influenced by photographs of Jackson Pollock painting on the floor. It was the physicality of such work that related to her own interests. Ayres applies her paint in bold individual strokes by both brush and hands with use of strong polychromatic colour. Paint and colour are manipulated for their own qualities and the feelings they evoke.
LIT: Introduction to catalogue, Tim Hilton, Museum of Modern Art, Oxford, 1981; 'Gillian Ayres', Matthew Collings, *Flash Art*, Nos 94–5, January-February 1980. MW

AYRTON, Michael, RBA (1921–1975). Sculptor, painter in a variety of media and printmaker of figures and landscapes; illustrator, draughtsman, theatrical designer; film maker, writer and art critic. He studied at art schools in London, lived in Vienna in 1936 and between 1937 and 1939 spent long periods in France, sharing a studio with JOHN MINTON in Paris where they studied with Eugène Berman. He also worked in de Chirico's studio and in 1938 went to Les Baux with Minton and Michael Middleton. He travelled widely throughout his life, particularly in France, Italy and Greece, and he first exhibited with Minton in 1942 at the LEICESTER GALLERIES. He subsequently showed regularly in London galleries (including the REDFERN) and internationally. His work is represented in public collections including the TATE GALLERY and MOMA, NY. His work is characterized by its range: he illustrated many books and his interest in theatre design was stimulated by collaborations with Minton and Constant Lambert. As a film maker he worked with Basil Wright and his own writing ranged from novels to art criticism. In Vienna in 1936 he was influenced by Flemish art but later in the mid 1940s his neo-romantic landscapes show the influence of SUTHERLAND and NASH. He began to sculpt in bronze in the early 1950s, receiving some advice from HENRY MOORE, and visited Cumae in 1956–7 and Greece in 1958, turning to Greek myth as his principal source of inspiration, particularly the legends of Daedalus and Icarus, the Minotaur and the image of the maze. His powerful style sought to reinterpret mythological ideas in terms of the figure.
LIT: See his own publications including *Drawings and Sculpture*, Cory, Adams & Mackay, 1962; *The Testament of Daedalus*, Methuen, 1962. CF

B

BACON, Francis (1909–1992). Born of English parents in Dublin, he had little conventional education, and in 1925 came to London where he started as an interior decorator and designer of furniture. He visited Paris and Berlin, 1927–8, and began to paint, taking up oils in 1928. Self-taught, he was advised by his friend ROY DE MAISTRE. By 1931 he was painting full-time, and had a *Crucifixion* reproduced in Herbert Read's book *Art Now*. He lost confidence during the later 1930s and worked in Civil Defence during the war, resuming painting about 1944. His *Three Studies for Figures at the Base of a Crucifixion*, 1944 (TATE), created a sensation when shown at the LEFEVRE GALLERY in 1945. Since the mid-1950s his work has been regularly exhibited internationally (Grand Palais, Paris, 1972; the Museum of Modern Art, New York, 1975; the Tate Gallery, 1985) and acquired by most major muse-

ums around the world. He painted portraits of friends, figure compositions and fantasies including animals, often in intense colour, and usually suggesting involuntary movement. Executed with a bewildering technical virtuosity, his work tended to become more freely painted, but his essential subject – a pessimistic view of the human condition – did not fundamentally change over the years. He used famous paintings by former artists, stills from films and published photographs as a source of inspiration; the resultant images are dionysian, violent and pathetic, evocative of alienation, horror and suffering.

LIT: *Interviews with Francis Bacon*, David Sylvester, Thames & Hudson, 1980; *Francis Bacon*, Michel Leiris, Thames & Hudson, 1987.
AW

BADMIN, Stanley Roy, RWS, RE, ARCA (1906–1989). Painter of the English countryside and architecture in watercolours; illustrator, etcher and lithographer. He studied at CAMBERWELL SCHOOL OF ART and at the RCA under SCHWABE, MILLARD and TRISTRAM. He exhibited mainly at the FINE ART SOCIETY, the 21 Gallery, the RWS, RE and at the RA 1930–68. Elected RE and RWS in 1935, his work is represented in public collections including the V & A. He worked for the RECORDING BRITAIN Scheme and his many illustrations include the *Shell Guide to Trees and Shrubs*, numerous Puffin Picture Books and *Highways and Byways in Essex*, Macmillan and Co., 1939. His finely detailed work accurately recorded the appearance and life of the country as well as some London scenes.

LIT: *S.R. Badmin and the English Landscape*, Chris Beetles, Collins, 1985. CF

BAILEY, Alfred Charles (b. 1883). Landscape painter in watercolours. Son of the engineer Wilfred Bailey, he studied at Brighton School of Art and with Louis Grier. He exhibited mainly at the Goupil Gallery but also showed at the RBA, IS, LS and the REDFERN GALLERY. Between 1909 and 1919 he lived at St Ives and was a member of the St Ives Arts Club. His work was reproduced in *Apollo* and *Design and Drawing*.
CF

BAILLIE, William, SSA, PRSW, RSA, GI (b. 1923). Painter of flowers, landscapes, townscapes and still-life in watercolours and oils. Born in Edinburgh, he studied at EDINBURGH COLLEGE OF ART 1941–2 and 1947–50, and in 1955 he visited Canada where he travelled widely and worked with A.Y. Jackson. He has exhibited regularly in Scotland and was elected SSA in 1951, RSW in 1963, PRSW in 1974, RSA in 1979 and GI in 1986, and he has also shown at the Scottish Gallery, Edinburgh, in 1982 and 1986. He has exhibited in London, including Gallery 10, and internationally. His work is represented in the Scottish National Gallery of Modern Art, Edinburgh. He uses a fluid technique and rich colour.

LIT: *Arts Review*, Vol.27, No.7, p.188, 4 April 1975. CF

BAINES, Frederick Harry (1910–1995). A painter of landscapes, portraits and figure compositions, he was trained at MANCHESTER SCHOOL OF ART, and first worked in the theatre with Joan Littlewood. He also painted murals for public buildings including part of the ceiling of Buxton Opera House. During the Second World War he served in India, and his first one-man show was at India House following his demobilization, when he settled in London. He travelled in France, Greece and Italy, where he became friendly with Renato Guttuso, who influenced both his style in some degree and his commitment to political expression in art; he became a member of the Communist Party for a period. His work figured in the 'Forgotten Fifties' exhibition (1984) at Sheffield Art Gallery and the Camden Art Centre. His work approach was bold, straightforward, and founded on firm draughtsmanship.
AW

BAIRD, Edward McEwan (1904–1949). Painter of portraits, figures and landscapes in oils, watercolours, tempera, pastels and chalk. Born in Montrose, Scotland, where he lived and worked, he studied at GLASGOW SCHOOL OF ART 1923–7, winning the Newbery Medal and a travelling scholarship to Italy. He exhibited at the RA in 1932, 1940 and 1941 and his work is represented in collections including Glasgow Art Gallery. His work was little known until 1968 when an exhibition was organized by the Scottish Arts Council. An OFFICIAL WAR ARTIST in the Second World War, he was married to Anne Fairweather in 1945. His work was influenced by Renaissance painting and later by his interest in SURREALISM and optics. Intellectually controlled and detailed, his work was meticulously painted and often re-worked.

LIT: Exhibition catalogues for the Scottish Arts Council, Edinburgh, 1968, and for the Montrose Public Library, 1981. CF

BAKER, Charles Henry Collins, NEAC (1880–1959). Painter of landscapes and coastal scenes in oils; author and art critic. He studied at the RA SCHOOLS and exhibited mainly at the NEAC (member 1921, Hon. Secretary 1921–5) as well as at the LS, the RA in 1907, in Manchester and at the GROSVENOR GALLERY. His work is represented in collections including the Manchester City Art Gallery. Art critic for *Outlook* and the *Saturday Review*, he was Surveyor of Pictures to HM the King, Keeper and Secretary of the National Gallery, 1914–32, and from 1932 Head of Research at the Huntington Library, California. In 1949 he returned to England. His many publications on art range from studies on painters such as *Lely and Kneller* (Philip Allan, London, 1922) to catalogues of major collections. His paintings depicted subjects with a sense of design and clarity of form. CF

BAKER, Gladys Marguerite, SWA (b. 1889). Painter of figures, portraits and still-life in oils; decorator. Born in Bloomsbury she was educated at Queen's College, London, ST JOHN'S WOOD SCHOOL OF ART and the RA SCHOOLS where she won a graphic prize and a silver medal for composition in colour. She exhibited at the RA, RI, RBA and NPS, as well as the IS and SWA where she became a member in 1932. She also showed her work in the provinces as well as New York and Stockholm. Her paintings range from atmospheric and fluid oil studies to RA paintings such as *The Restaurant* which records an everyday scene with some detail and humour. CF

BALL, Martin, LG (b. 1948). Painter of non-figurative work in acrylic and mixed media. He studied at Loughborough College of Art 1966–7, the CENTRAL SCHOOL 1967–70, and the RCA 1970–3, and he has exhibited in London galleries since 1974, including the Ian Birksted Gallery in 1979, as well as at the RA and the LG (member 1981). He has shown in the provinces, including the Axiom Galleries, Cheltenham, in 1984, and widely in group exhibitions. His work is represented in collections including the Ashmolean Museum, Oxford. He has taught at Newcastle Polytechnic since 1979 and his many awards include a scholarship to Kent State University, Ohio, in 1972. His painterly work combines geometric forms with gestural, intuitive brushmarks.
LIT: 'Viewpoints', *Artscribe* (UK), No.5, pp.14–15, February 1977; exhibition catalogue, Ikon Gallery, Birmingham, 1979. CF

BALL, Robert, RBSA, ARE, ARCA, FRSA (b. 1918). Painter of landscapes, figures and architecture in oils; etcher and engraver. He attended Birmingham Junior School of Art, Birmingham College of Art under H. Smith 1933–40, and the RCA under R. Austin and M. Osborne 1940–2. In 1937 he won a British Institution Scholarship in Engraving. He exhibited in Birmingham and at the RA, RE, NEAC and RBSA, being elected ARE in 1943, ARBSA in 1943, RBSA in 1949 and FRSA in 1950. He taught painting, drawing and anatomy at Birmingham College of Art 1942–53, and in 1953 he became Principal of Stroud School of Art. He exhibited at the RA 1939–85 as a painter and engraver, showing oils, aquatints and wood engravings many of landscape subjects, e.g. *Mrs Barclay's Pond, Harborne*, RA, 1953. CF

BALL, Robin, ARCA (1910–1979). Painter of figures in oils, watercolours and collages. He studied at Hastings School of Art and the RCA. He exhibited at the RA and in London and provincial galleries. His work is represented in public collections (e.g. IWM). He taught at West Surrey College of Art 1946–75. His early work recorded contemporary life in an organized style. Later works used oil and collage to establish rich texture and colour.
LIT: See the exhibition catalogue, Connaught Brown, London, 1987. CF

BALLARD, Arthur (1915–1994). Best known as a painter of abstracted landscapes, he first studied at Liverpool College of Art. He saw active service in the Middle East during the Second World War, and joined the staff of the Liverpool College afterwards, where he taught until his retirement. His topographical studies were included in the post-war 'Recording Merseyside' exhibition at the Bluecoat School. A cottage he bought in North Wales was the base from which he painted dark, austere and powerful stylized landscapes (for example, *Farm*, c.1950, Walker Art Gallery). He exhibited regularly until the early 1960s at ROLAND, BROWSE & DELBANCO; the increasingly de Staël-influenced abstraction of his work following a six-month sabbatical in Paris (1957) attracted many collectors. During the later 1960s his work changed, influenced by Pop Art, as in his *Punch and Judy* series. Among the students he encouraged were Stuart Sutcliffe and John Lennon. AW

BALMFORD, Hurst (b. 1871). Painter of landscapes and portraits in oils and watercolours.

Born in Huddersfield, he attended the RCA, London, and the ACADÉMIE JULIAN, Paris. He exhibited in London at the RA and in Scotland at the RSA as well as in the provinces. He was Head of Morecambe School of Art and for a time he lived at St Ives where he painted Cornish landscapes. A *Cornish Creek*, 1934–39 (Manchester City Art Gallery), shows his strong treatment of a picturesque scene in which concern for detail and recession is combined with confident technique and a sense of surface design. CF

BANKS, Robert, MC (b. 1911). Painter of architecture and gardens in watercolours. First trained as an architect, he studied at the Architectural Association, London, and then served with the Royal Horse Artillery. Until 1957 he worked as an architect and town planner and in 1959 he had his first solo exhibition at the LEICESTER GALLERIES. Since then he has exhibited at leading London galleries as well as in New York, Rome and Gallipoli. His paintings reflect his architectural training: they show churches and streets, often in Italy, represented with great exactitude. Some works are 'baroque fantasies' placing actual buildings and details in new combinations, but all are unpeopled and strongly lit.
LIT: See the exhibition review in *Apollo*, April 1980. CF

Bankside Gallery. Home to the ROYAL WATERCOLOUR SOCIETY and the ROYAL SOCIETY OF PAINTER-PRINTMAKERS, it is situated on the Thames opposite St Paul's Cathedral. Regular exhibitions of member's works are held, as well as a full programme of other exhibitions, lectures, demonstrations and events. There is a small bookshop, and an important archive (access on application to the Director) which is a major resource for the history of British art.
AW

BANTING, John (1902–1972). Painter of Surrealist works in a wide range of media; designer and stage designer. He studied with MENINSKY at WESTMINSTER SCHOOL OF ART 1921, and then in Paris. In 1925 he was associated with the Bloomsbury Group and in 1927 exhibited with the LG. He also showed his work at the Wertheim, Cooling and Storran galleries, London. In 1930 he met Duchamp, Breton, Giacometti and Crevel in Paris and on his return NASH noted the influence of surrealism on his work. In 1936 he exhibited at the International SURREALIST Exhibitions in London and New

York, and also in Paris in 1938. After the war he was associated with the English Surrealists and the later part of his life was spent in Hastings. His early work was influenced by Picasso, Braque and Gris but he quickly evolved his own repertoire of forms and subjects: plants, bones, shells and feathers etc. often constructed into strange figures, e.g. *Conversation Piece* (TATE GALLERY). He experimented widely with techniques and also produced abstracts and more naturalistic works. Banting made blue-prints (1931–2) using an architect's printer; he also did etchings and linocuts at the same period.
LIT: Catalogue, Oliver Bradbury and James Birch Fine Art, 1983. CF

BARCLAY, Sir Colville, Bart., MA (b. 1913). Painter of landscapes in oils and watercolours. Educated at Eton, Oxford and RUSKIN SCHOOL, Oxford. He has exhibited at the RA, RBA, LG and in the provinces. In his *Landscape*, 1958 (ARTS COUNCIL Collection), the subject is suggested by blocks of colour, establishing the basic structure and spatial relationships of the landscape. CF

BARCLAY, John Rankine (1884–1962). Painter of landscapes, street scenes and interiors in oils and watercolours; etcher. He was born in Edinburgh and studied with Alick Riddell Sturrock (winning both the Carnegie Travelling Scholarship and the Guthrie Award), and in Europe. He exhibited mainly in Scotland at the RSA, the RSW and the GI, but he also exhibited at the RA and by 1937 was living in St Ives. His paintings, often showing figures in a setting, include such subjects as *Paris Dance Hall*, 1921, which seeks to record the movement and light of the complex scene. CF

BARKAS, Henry Dawson, ARCA (1858–1924). Painter of landscapes and coastal subjects in watercolours. He studied at BATH SCHOOL OF ART in 1875 and won a scholarship to the RCA. He exhibited mainly at the FINE ART SOCIETY, London, and also showed at the RA from 1901 to 1919, at the Dudley Gallery and the RI. He was Head of the School of Science and Art, Reading, before founding an art school there in 1894. His atmospheric watercolours depicted East Anglia, Yorkshire and the South Coast and his 1912 exhibition of 'English Pleasure Resorts' at the Fine Art Society, included subjects such as *The Fisherman's Quay*, *Whitby*, and *A Bright Morning*, *Swanage*. CF

BARKER, Jack (1895–1937). Painter of landscapes in watercolours and some oils. A part-time painter for much of his life, he retired from his pork pie and sausage business at Ilkeston, Derbyshire, in 1936 and settled in Hampshire where he devoted his last year to painting. He held his first solo exhibition in 1934 at the Ward Gallery, London. His assured technique was influenced by the work of Cotman.
LIT: Memorial exhibition catalogue, Ward Gallery, London, 1938. CF

BARKER, John Edward (1889–1953). Painter in oils and watercolours. He studied at BATH SCHOOL OF ART 1905–10, and at the Old Camden School of Art, London, 1910–13. He exhibited in Lancashire and Wales and was Head of Art at the Bacup and Rawtenstall Grammar School. He lived at Rossendale, Lancashire. CF

BARKER, Margaret Dorothy (b. 1907). Painter of figures in oils. She studied at the RCA under Professor SCHWABE 1925–9, and exhibited at the NEAC. In 1929, whilst she was still a student, her painting Any Morning was purchased by the CHANTREY BEQUEST from the NEAC. Her painting shows an everyday scene at home, constructed simply across the canvas using formalized shapes and adopting the device of an open door to show a secondary scene beyond. CF

BARKER, Wright, RBA (d. 1941). Painter of animals, figures, country and classical subjects in oils. He lived in Mansfield and Harrogate and exhibited mainly at the RA and RBA 1885–1935. His paintings of classical subjects are detailed and exact, minutely describing figures, architecture and decoration in a clear, tight technique, e.g. his paintings of Circe, 1904–12. The animal and country subjects appear broader in treatment but are still fully resolved and modelled, giving a convincing account of appearance, texture and weather, e.g. In the Highlands, 1894, and Branding the Flock, 1901. CF

BARLOW, Gillian (b. 1944). She studied painting at the SLADE 1962–3, and History of Art at the University of Sussex 1967–72. Her portraits and figure compositions combine precise draughtsmanship with some spatial ambiguity.
AW

BARLOW, John Noble, ROI, RWA, RBA (1861–1917). Painter of landscapes, coastal scenes and genre in oils and watercolours. Born in Manchester, he studied in Paris with Constant Lefèbvre and Delance. In 1887 he became an American citizen but continued to work and exhibit in Europe. He exhibited at the Paris Salon in 1889, 1890 and 1899, being awarded a third class medal, and at the Exposition Universelle 1900. In England his work appeared at the RA, ROI and RBA as well as in the provinces. Between 1893 and 1917 he lived and worked in St Ives, Cornwall. His work shows the influence of the nineteenth-century French landscape tradition as well as the influence of Cornish painters. In works such as Early Spring, Lamorna Valley, 1909, atmospheric effects of light and colour create a lyrical, gentle painting. He also painted some night scenes, e.g. Moonlight, Midnight Toilers, a coastal subject. CF

BARNARD, Gwen, WIAC (b. 1912). Painter of figurative and non-figurative work in oils and gouache; lithographer. She studied at CHELSEA SCHOOL OF ART 1931–5, at the EUSTON ROAD SCHOOL under COLDSTREAM, PASMORE and ROGERS, and she exhibited with the Twenties Group, at the ROI and at the Goupil Salon from 1934 to 1939. She held solo exhibitions in London galleries from 1947, including the AIA Gallery and Camden Arts Centre, and has shown abroad. In 1955 she illustrated The Shape of the River; the London Thames by Eugene Walter, Gaberbocchus Press. Initially her landscape and topographical paintings were influenced by the Euston Road painters, but in the 1950s she turned to non-figurative work and made monoprints with the aid of rollers, a technique which she continued when she returned to oil painting c.1957. Her later work included figurative subjects.
LIT: Exhibition catalogue, New End Gallery, London, 1963. CF

BARNDEN, Hugh (b. 1948). Painter of interiors, landscapes and figures in oils, pastelist. Born in Oxfordshire, he worked for some years with John Makepeace as a furniture designer and maker before studying at the RCA between 1968 and 1971. He has worked exclusively as a painter since the mid-1970s and he held his first solo exhibition in Amsterdam in 1978. He has exhibited regularly at the Francis Kyle Gallery, London, since 1982 and in 1983 he showed in New York. His work, which reflects his wide travel, often returns to particular themes, e.g. lake views seen through windows, painted with clarity and harmony in clear colour.

LIT: Exhibition card for Hugh Barnden, Francis Kyle Gallery, London, 1990. CF

BARNES, Archibald George, RI, ROI, RP (b. 1887). Portrait and figure painter in oils. He studied at ST JOHN'S WOOD SCHOOL OF ART and at the RA SCHOOLS. He exhibited at the RA from 1913 and was elected RP in 1923, RI in 1924 and ROI in 1925. He also showed at the FINE ART SOCIETY as well as London and provincial galleries. His work is represented in public collections. His formal portraits give an observant, objective account of his sitter, e.g. *Portrait of Lloyd George*, more informal works celebrate the shine of light on the surface of forms and the decorative colour of flowers with an easy impressionistic technique. His concern with the play of light is evident in his work *Head of a Boy* (Manchester City Art Gallery). CF

BARNS-GRAHAM, Wilhelmina (b. 1912). Painter of abstracts and landscapes in oils and a wide range of media. She studied at EDINBURGH COLLEGE OF ART 1932–7, and went to St Ives in 1940 where she met BORLASE SMART, NICHOLSON, HEPWORTH and Gabo. She joined the Newlyn and St Ives societies, exhibited with the CRYPT GROUP 1947, and was a founder member of the PENWITH SOCIETY 1949. She has exhibited widely, recently at the Gillian Jason Gallery, London. She taught at Leeds School of Art 1956–7. Her early simplified Cornish landscapes were influenced by WALLIS in their use of greys and greens. Her work gradually discarded figuration, at first retaining and transforming landscape reference, e.g. *Grindelwald Glacier*, 1950, then becoming more conceptually abstract, e.g. *Red Form* (TATE GALLERY). Recent work has become freer in form with open references to landscape, but all her paintings show her sense of structure and power as a colourist.
LIT: See catalogue for Crawford Centre for the Arts, 1982; an interview with the artist, *Art Monthly*, July/August, 1981, W. *Barns-Graham Retrospective 1940–1988*, exhibition catalogue, City of Edinburgh Museums and Art Galleries, 1989. CF

BARRACLOUGH, James P., ROI (d. 1942). Painter of portraits in oils. He lived and worked in London and exhibited mainly at the RA and ROI, becoming a member in 1922. He also showed in the provinces, particularly at Matthews and Brooke's Gallery, Bradford. Amongst his best known works are *Bedtime* and

The Artist's Wife, and paintings such as *Portrait of a Little Girl in Blue*, 1925, show his ability to paint broadly and his interest in effects of light on the figure. CF

BARRETT, Tom (b. 1936). Painter of landscapes in oils. He studied at Norwich School of Art and Reading University where he was appointed lecturer in Fine Art in 1968. He has exhibited in Bristol, Cheltenham and at Austin/Desmond Fine Art, London, as well as in major group exhibitions. A prizewinner in the Southern Arts/Granada TV Competition, his figurative paintings are mostly concerned with the light and atmosphere of locations like the Salisbury Plain and the Dorset coast.
LIT: Exhibition catalogue, Austin/Desmond, 1990. CF

BARRINGTON-BROWNE, William Ellis (1908–1985). Painter of sporting scenes in oils; illustrator. He was the son of the pastellist H. Needeham-Browne and was educated at Repton School and Pembroke College, Cambridge, where he read architecture. He studied art in Venice and at the ACADÉMIE JULIAN, Paris, and exhibited in London at the Tryon and Moorland galleries. For ten years he was art master at Cheltenham College and he illustrated many books by John Moore and Eric Taverner. His most characteristic subjects were fishing, shooting and stalking scenes and his own knowledge and experience as a sportsman is reflected in his work. CF

BARTLETT, Paul Thomas, RBA (b. 1955). A painter, he studied at Falmouth (1973–6) and the RA SCHOOLS (1977–80). He has won many prizes and awards since being awarded the TURNER Gold Medal in 1978, and has taught at Sutton Coldfield and at Birmingham. From making expressionistic linocuts and impasto paintings he has developed landscape, portrait and self-analytical themes using flat illusionistic detail, some using the lay figure or the life model as a starting-point (*Looking At You*, 1997). AW

BARTLETT, Stephen, ARCA, FSD-C, FRSA (b. 1942). Painter of landscapes and still-life in oils, gouache and watercolours, his work also includes painted and incised plaster plaques. He studied at the RCA 1960–5, under Misha Black, winning a travelling scholarship to Italy and a Research Fellowship at the RCA 1965–6. From 1968 to 1980 he was co-founder and partner of BIB

Design Consultants. He has held solo exhibitions in London galleries including the Wraxhall Gallery in 1982, and the Berkeley Square Gallery in 1988, and has shown widely in group exhibitions. He has exhibited at the RA since 1986 and his work is represented in collections including Oxford University. His painting, influenced by Japanese art, Turner, the Cubists and NICHOLSON, selects particular, observed details from the subject, sometimes only partially revealing the image. LIT: *Arts Review* (UK), Vol.35, No.21, 28 October 1983, p.599; exhibition catalogue, Berkeley Square Gallery, London, 1988. CF

BARTON, Leonard, ARCA, FRSA, FSAE (1893–1971). Painter of landscapes in watercolours, pastels and oils; commercial designer. Between 1905 and 1915 he studied at art schools in Accrington, Blackburn and Bury and from 1915 to 1921 he attended the RCA under ROTHENSTEIN and ROBERT ANNING BELL. He exhibited mainly in Lancashire and before teaching he worked as a designer. He taught at Eastbourne Art School 1921–5, at Cambridge School of Art 1925–9 and from 1929 at Lancaster and Morecambe College of Arts and Crafts. Between 1917 and 1919 he served in the RAF as an artist in the Air Ministry. CF

BASKETT, Charles Edward, ARE (1845–1929). Painter of landscapes and still-life in oils; etcher. Born in Colchester, Essex, he studied art under HERKOMER. Between 1872 and 1893 he exhibited at the RA, and he also showed with the RBA and the RE, becoming ARE in 1892. He taught art and lived in Suffolk. His still-life painting could be very elaborate, formally arranged and detailed, e.g. *A Still-Life of Fruit and a Bird's Nest on a Table*, 1882. His RA exhibits ranged from views of London to country scenes such as *An Old English Stable*, 1894. CF

BASKETT, Charles Henry, RE (1872–1953). Painter, etcher and aquatinter of coastal scenes and landscapes; draughtsman. Born in Colchester, the son of Charles E. Baskett, ARE, he attended Colchester and Lambeth Schools of Art and studied charcoal drawing with Frank Mura. He exhibited mainly at the RE (ARE 1911, RE 1918), at the Walker Art Gallery, Liverpool, and at the RA where he showed from 1910 to 1930. He also exhibited in London galleries the provinces and Scotland. He was Principal of Chelmsford School of Science and Art until 1932 and he later lived in Southampton. He made his first aquatints in 1910

and his work was often inspired by sea and river subjects, depicting scenes of the West Country, Sussex and the East Coast. LIT: *The Aquatints of C.H. Baskett RE*, exhibition catalogue, N.W. Lott and H.J. Gerrish Ltd, The Old Rectory, Marlborough, Wiltshire, December 1985. CF

BASSINGTHWAIGHTE, Lewin (b. 1928). Painter of figures and interiors in oils, also working in mixed media, relief and collage. He studied at the RCA 1950–3, and has taught at CHELSEA SCHOOL OF ART. He has exhibited at London galleries, including the PICCADILLY GALLERY, in the provinces and abroad. His work is represented in public collections. His paintings portray children and women with great simplicity of form and some humour, often set against the geometric forms of interiors. CF

BATE, H. Francis, NEAC (1853–1950). Painter of landscapes, figures and flowers in oils. He studied at the RCA and under Verlat at the Antwerp Academy of Arts in 1883. He exhibited in London galleries from 1885, showing mainly at the NEAC (member 1887, Hon. Treasurer 1886–1919, Hon. Secretary 1888–1919). He also showed with the London Impressionists in 1889 and his work is represented in collections including Reading Museum and Art Gallery. Before his move to Reading in 1895 he held classes at the Applegarth Studio, Brook Green, where his pupils included ROGER FRY. Influenced by Impressionism, his strongly-coloured work reflected his interest in observed light and broken colour. LIT: *The Naturalistic School of Painting*, Francis Bate, The Artist, London, 1887 (second edition); 'Private Schools of Art. The Studio of Mr Francis Bate and the South West London Polytechnic', *Studio*, Vol.7, pp.226–35. CF

BATEMAN, Henry Mayo (1887–1970). Illustrator, caricaturist and painter in oils and watercolours. He attended the WESTMINSTER SCHOOL OF ART, GOLDSMITHS' INSTITUTE and studied from 1904 to 1907 with Charles van Havermaet on the advice of John Hassall. He contributed to many magazines, including *Tatler* from 1904, produced theatrical posters, book illustrations and published books including *Considered Trifles: A Book of Drawings*, Hutchinson, London, 1934, and *H.M. Bateman by Himself*, Collins, 1937. He retired in 1939 and subsequently concentrated on painting. Best known as a graphic artist, particularly for *The*

Man Who... series, he exhibited in London galleries including the LEICESTER GALLERIES and the Langton Galleries, and showed at the RA in 1933. His work is represented in collections including the V & A. His graphic work was influenced by Caran d'Ache and 'Simplicissimus' and his paintings include Spanish subjects exhibited at the Leicester Galleries in 1936.
LIT: *The Man Who... and Other Drawings*, John Jensen, Eyre Methuen, London, 1975; *The Man Who Was H.M. Bateman*, A. Anderson, Webb & Bower, Exeter, 1982. CF

BATES, Frederick Davenport (b. 1867). Painter of portraits, landscapes and religious subjects in oils. He studied in Paris under Bouguereau, Robert Henry and Doucet, at the L'Académie Royale des Beaux-Arts, Antwerp, and in Brussels. He exhibited in England and Europe and painted in the Middle East, travelling in Tunisia, Egypt, Palestine and Turkey. Works such as *North African Children Sailing on the Nile* demonstrate his interest in accurate local colour and light effects as well as his lively, realistic technique.
 CF

BATES, Robert (b. 1943). Painter of landscapes and figures in watercolours; etcher and lithographer. He studied at Birmingham College of Art and the RCA and has exhibited in London galleries, particularly Lumley Cazalet. He has shown in the USA and is represented in public collections. His tiny, meticulously painted works, sometimes with painted borders, weave realistic objects and figures into evocative, magical scenes.
LIT: See the introduction by Marina Vaizey, Lumley Cazalet, 1978. CF

Bath Academy of Art, Corsham Court, Wiltshire. Established in 1946 by Lord METHUEN (the artist Paul Ayshford) and directed by Clifford and Rosemary ELLIS, the Academy was situated at Lord Methuen's home, Corsham Court, as well as at Beechfield and possessing houses in Bath itself. It incorporated a school of art which had been in existence since 1852 (and where SICKERT had been a visitor), and a residential college for art teachers. Painting and sculpture were the central studies, alongside such subjects as printmaking, film, music and drama. The qualifications awarded were those recognized by the Government. Very much a community, the Academy acquired a unique reputation for excellence, as influential artists including AYRES, DENNY, FROY, HEATH, HODGKIN, SCOTT and others taught numerous students who later distinguished themselves in turn. AW

BATTEN, John Dickson (1860–1932). Painter of figures in oils, tempera and fresco; book illustrator, colour print artist and designer of craftwork. He studied at the SLADE SCHOOL under Legros where his contemporaries included HOLROYD and STRANG. He exhibited at the RA, at the GROSVENOR GALLERY, the New Gallery, with the Arts and Crafts Exhibition Society and in the provinces. His work is represented in public collections. With F. Morley Fletcher he introduced the Japanese method of colour woodcuts into this country and he revived the quattrocento method of gilding. He was Honorary Secretary of the ART WORKERS GUILD and the Society of Painters in Tempera. Most well known for his illustrations of fairy tales, his paintings were detailed, romantic and ornate, often using gilding. His tempera work was admired for the purity of its colour.
LIT: Memorial exhibition catalogue, Art Workers Guild, 1933; *The Last Romantics*, Arts Council, 1989; 'The Practice of Tempera Painting', John D. Batten, *Studio*, Vol.84, 1922, p.298. CF

BATTERSBY, Martin (b. 1920). Painter of *trompe-l'œil* works in oils and acrylic; lithographer, interior and stage designer, writer and collector. He studied architecture at Regent Street Polytechnic and subsequently worked in the studios of Gill and Reigate. He studied at RADA and worked as a stage designer for productions at the Old Vic, Stratford-upon-Avon, Covent Garden and Glyndebourne. In 1940 he held his first solo exhibition at the Brook Street Gallery and he has subsequently exhibited in London galleries (including the Ebury Gallery), and in New York. His work is represented in collections including Brighton Art Gallery. He has written on Art Deco and Art Nouveau and in 1974 published *Trompe-L'œil: The Eye Deceived* (Academy). His meticulous works include paintings on Art Nouveau themes.
LIT: Exhibition catalogue, Ebury Gallery, 1982; interview in *Arts Review* (UK), Vol.34, pt.6, March 1982. CF

BAUMER, Lewis Christopher Edward, RI, PS (1870–1963). Painter of portraits, still-life, figures and flowers in oils, watercolours and pastels; illustrator, etcher and *Punch* artist. He studied at the RCA, ST JOHN'S WOOD SCHOOL OF ART and at the RA SCHOOLS. He showed his work at

the RA, RI and at the FINE ART SOCIETY, as well as leading London galleries. He became RI in 1921. His work was reproduced in *Punch* and the *Tatler* and his book illustrations included Thackeray's *Vanity Fair* and Washington Irving's *Old Christmas*. His paintings were stylized and elegant with an emphasis on contour, e.g. *Portrait of Noel Streatfeild*, 1926. CF

BAWDEN, Edward, RA (1903–1989). Commercial artist, printmaker, illustrator, painter of murals and subjects in watercolour. With a strong sense of craftsmanship he had a ready facility in many techniques. Graphic and linear in quality, his work is often characterized by narrative or delicate humour. Inspired in watercolour by the techniques of printmaking, he had a feeling for pattern and texture, often working watercolour upon non-absorbent paper and later applying crayon. Born in Essex, Bawden attended Cambridge School of Art 1919–21, and later the RCA 1922–5, where his diploma was in book illustration. Here, inspired by PAUL NASH, he was introduced to the CURWEN PRESS, and early produced posters for London Underground. His important friendship with ERIC RAVILIOUS saw fruit in the Morley College Mural 1928–9 – a collaborative venture – and watercolour experiments at Great Bardfield in the early 1930s. In 1939 he attempted the commercial printing of wallpaper from linoleum blocks. As an OFFICIAL WAR ARTIST he travelled widely, and was present at Dunkirk. Subsequent travel – Sicily 1952, Persia 1966 – contributed to wide-ranging subject matter. In the 1950s and 1960s he produced many public murals – notably at the Festival of Britain, 1952, and for the P&O liner *Oronsay*. Teaching periodically from the 1930s at GOLDSMITHS', the RCA and RA SCHOOLS, he was guest instructor at the Banff School of Fine Art, Canada 1949–50. Exhibiting since 1926, his first one-man show was at ZWEMMER'S Gallery 1933. He was a Trustee of the TATE 1951–6. Early interested in Victorian illustration, he has illustrated many books including *Gulliver's Travels*, 1948. He lived at Saffron Walden from 1970.
LIT: *Edward Bawden*, Douglas Percy Bliss, Pendomer Press, 1979; *Edward Bawden: War Artist*, ed. Ruari McLean, Scolar Press, 1989. GS

BAXTER, Thomas Tennant, NEAC (1894–1947). Painter of portraits, interiors, landscapes and animal subjects in oils. Born in Paris he was educated at Eton and studied art at the SLADE SCHOOL where he gained first prize for figure painting and drawing and second prize for head painting. He exhibited regularly at the NEAC and became a member in 1920. He showed his work at the RA 1923–40 as well as at a number of London galleries. His exhibited works encompassed a wide range of subjects including portraiture such as *Portrait of Miss Nancy Tennant*, RA 1923. CF

BAYES, Walter John, RWS (1869–1956). Painter in oil and watercolour of figure subjects, interiors, still-life and landscapes; decorative artist and writer. Inspired by French art, Bayes' work had an Impressionist freedom in handling, always tempered by an intellectual sense of design and concern for qualities of craftsmanship. SICKERT wrote of him, 'There is something of the scientific spirit of the nineteenth century about Mr Bayes'. Although a founder member of the CAMDEN TOWN GROUP in 1911, he never developed the thick impasto technique of some of his contemporaries. Born in London, the son of A.W. Bayes, the painter and illustrator, from 1886 he attended classes at the City and Guilds Institute, Finsbury, and in 1892 entered the WESTMINSTER SCHOOL OF ART. A regular visitor to France, in 1894 he studied briefly at the ACADÉMIE JULIAN. Latterly he painted much on the Continent and in North Africa. A founder member of the ALLIED ARTISTS' ASSOCIATION in 1908, he was in close contact with Sickert's circle at FITZROY STREET. Still supporting the NEAC, Bayes was simultaneously a founder member of the Camden Town Group in 1911, and exhibited at the Carfax that year – subsequently holding one-man shows there 1913, 1915. From 1913 to 1915 he was a member of the LONDON GROUP. Exhibiting at the RA from 1890, the NEAC from 1892, he later showed at the Goupil and LEICESTER GALLERIES. He began his writing career in the 1890s, and from 1906 to 1916 was art critic to the *Athenaeum*. Principal of Westminster School of Art 1918–34, he later taught at Reading and Lancaster. The author of several works on art, his illustrated, informal travel book *A Painter's Baggage*, 1932, is the most self revealing. GS

BAYNES, Keith Stuart, NEAC, LG (1887–1977). Painted a wide variety of subjects including interiors, landscapes, flowers, still-life and figures. Influenced by ROGER FRY'S teaching and the Ecole de Paris, and in the 1930s by Dufy's liberation of colour and form, Baynes' work was strongly Francophile. His entering the SLADE in 1912 was

preceded by trips to France, to Jamaica and to Holland where he saw the work of Van Gogh. In 1915 he established important contacts with SICKERT and GILMAN, and from 1919 with the circle surrounding VANESSA BELL and DUNCAN GRANT. Often practising in France, he was encouraged by painters such as Friesz, Marchand and later Dufy. Strongly coloured and calligraphic, his paintings served to illustrate several books including J.M. Scott's *Vineyards of France*, 1950. A major retrospective was held at The Minories, Colchester, in 1969. GS

BEACH, Adrian Gillespie, ARCA, RS. Painter of portraits, landscapes and architectural subjects; mural painter. Usual medium oils. His work was shown at the RA 1950–67, at the Cooling Galleries and at Abington Museum, Northampton in 1963. His paintings range from studies of cellars and vaults to mural decorations for a chapel, as well as landscape in England, Portugal and Southern Spain, e.g. *The Adam Vaults beneath the Adelphi*, 1960, and *Dust and Heat in the Duoro*. CF

BEADLE, James Prinsep Barnes, RBA (1863–1947). Painter of historical and military subjects, portraits, animals and landscapes in oils. Born in Calcutta into a military family, he studied art at the SLADE SCHOOL under Legros, at the Ecole des Beaux-Arts, Paris, under Cabanel, and in London with G.F. Watts. He exhibited his work mainly at the RA, from 1884, the FINE ART SOCIETY, RBA and at London galleries. His paintings also appeared at the Paris Salon and he won a bronze medal at the 1889 Paris Universal Exhibition. He was commissioned by the Senior Service Club for a war memorial painting and his work is represented in a number of public collections. His paintings show military scenes with exactitude and descriptive detail but he could also capture the excitement of his subject in a painterly way, e.g. *Saving the Guns at Maiwand, 1880*, 1893 (National Army Museum). CF

BEATON, Sir Cecil, CBE (1904–1980). Fashion, society and royal photographer; theatrical and film designer; painter of portraits in watercolours and oils; draughtsman, caricaturist and writer. Educated at St John's College, Cambridge, he studied art at the SLADE SCHOOL at the age of 50. He exhibited from 1925, showing photographs, designs and paintings in London galleries and abroad. His work is represented in collections including the NPG, London. He was awarded a CBE in 1957 and a Knighthood in 1972. His painting was influenced by Tcheltichew and AUGUSTUS JOHN and later in life by HOCKNEY and PROCKTOR.
LIT: *Cecil Beaton's Diaries*, Weidenfeld and Nicolson, 1961–78; *Cecil Beaton*, catalogue, Barbican Art Gallery, London, 1986; *Beaton in Vogue*, Josephine Ross, Thames & Hudson, 1986. CF

BEATTIE, Basil (b. 1935). Painter of abstracts in oils and acrylic. He attended the RA SCHOOLS 1957–61 and had his first one-man show in 1967, Greenwich Theatre Gallery. Since then he has exhibited with the LG, at the RA and in London and provincial galleries as well as in numerous group exhibitions. In 1976 he received an ARTS COUNCIL Award and in 1987 an Athena Arts Award. Since 1987 he has taught at GOLDSMITHS' COLLEGE. Early paintings were canvases of uninterrupted areas of a single colour but later works included 'heraldic' shapes, becoming complex in their accumulation of hieroglyphic marks and solid forms. The paint in these works is thickly brushed, smeared and vigorously applied. CF

BEATTIE, Christine (b. 1945). Abstract artist working in acrylic, watercolours, pastels and collages. She studied at MANCHESTER COLLEGE OF ART AND DESIGN 1963–7, and at CHELSEA SCHOOL OF ART 1967–8. She has exhibited in many group exhibitions and her work is represented in public collections, including the ARTS COUNCIL COLLECTION. She has taught at High Wycombe School of Art. Her abstracts present controlled and restrained areas which explore the relationship between particular colours and between stretched and unstretched fabrics. CF

BEAUCHAMP, Charles (b. 1949). Born in London, he attended CHELSEA SCHOOL OF ART for a year in 1967. He travelled widely in the Far East, 1968–9, and studied at ATELIER 17 in Paris 1971–2. Since 1974 he has exhibited at GIMPEL FILS. His compositions are disturbing fantasies painted with a realist technique.
LIT: 'Portrait of an artist', D.S. Higgins, in *Wider Aspects of English*, No.3, Cassell, 1974, pp.133–9; *The Nude Male*, Margaret Walters, Paddington Press, New York and London, 1978, p.14. AW

Beaux Arts Gallery. This Gallery was opened in 1923 by Major Frederick Lessore, SICKERT'S brother-in-law, a portrait sculptor. The seventh

exhibition of the Seven and Five was held there in January 1927, CHRISTOPHER WOOD shared his first exhibition there with BEN NICHOLSON in the same year, and BARBARA HEPWORTH first exhibited there in 1928. HELEN LESSORE took over running the Gallery at the death of her husband in 1951. Many artists who were chosen by her for their first one-man shows were notable for their commitment to paint from strongly autobiographical sources of inspiration. During the 1950s she recognized and encouraged JOHN BRATBY, JACK SMITH, DERRICK GREAVES and EDWARD MIDDLEDITCH (the so-called 'Kitchen Sink School'), BACON, FREUD, AUERBACH, ANDREWS and KOSSOFF (the so-called 'School of London'). Characteristic of this phase of the Gallery were London-based artists expressing their response to the outside world with a gritty, often harsh and disturbing realism. The Gallery closed in 1965. The name has been revived for a Cork Street gallery (an offshoot of the gallery of the same name established thirteen years previously in Bath); it opened in 1993. AW

BEER, Richard (b. 1928). Painter in oils; etcher and aquatinter of architectural subjects and townscapes; stage designer. He studied at the SLADE SCHOOL 1945–50, winning a French Government Scholarship to work in Paris at ATELIER 17 with HAYTER. He has travelled widely, particularly in Italy, and has held solo exhibitions in London galleries since 1958, including the Parkin Gallery. He has shown at the RA since 1957 and his work is represented in collections including the V & A. In 1955 he designed for Cranko's ballet *The Lady and the Fool*, Covent Garden, and in 1970 illustrated *Ten Wren Churches* by John Betjeman, Alecto. Teacher of printmaking at CHELSEA SCHOOL OF ART and founder member of the Printmakers Council, his strong draughtsmanship is inspired in particular by Italian subjects.
LIT: 'Richard Beer', R. Simmons, *Arts Review* (UK), Vol.31, pt.7, 13 April 1979, p.193; *Richard Beer in France and Italy. Oils and Drawings since 1978*, exhibition catalogue, Parkin Gallery, London, 1982. CF

BEETON, Alan Edmund, ARA, NPS (1880–1942). Painter of portraits and figures in oils. He was educated at Charterhouse and Trinity College Cambridge, and studied art in London and Paris. He exhibited at the RA, 1923–42, and also showed his work at the London Salon, the GROSVENOR GALLERY and in

Scotland, Liverpool, Venice and Pittsburg, USA. In 1915 he became NPS and in 1938 ARA. His work is represented in Oldham Art Gallery and in the Fitzwilliam Museum, Cambridge. In 1931 *Decomposing* was purchased by the CHANTREY BEQUEST. His meticulous painting shows his interest in tonal gradation, the effect of light and the depiction of form. His later work became more exact in its representation and control. CF

BEHRENS, Tim (b. 1937). Painter of figures, interiors, portraits and still-life in acrylics, oils and watercolours. He studied at the SLADE SCHOOL 1954–8, subsequently travelling in France, Spain, Greece and Italy where he settled in 1970. He exhibited at the BEAUX ARTS GALLERY in 1960, 1962 and 1964 and later showed in London galleries including William Darby and in Italy. His work in the 1960s depicted painterly, expressionistic figures and portraits, whilst later subjects combined a greater degree of realism with aspects of Surrealism. He has written a book: *The Monument*, Cardinal, 1988.
LIT: Exhibition catalogue, William Darby Gallery, London, 1974; *T. Behrens*, Introduction by Patrick Creagh, exhibition catalogue. Galleria 88, Rome, 1973. CF

BELL, Arthur Clive Howard (1881–1964). Art and literary critic, Clive Bell was one of the Bloomsbury Group; he married VANESSA BELL (neé Stephen) in 1907, met ROGER FRY in 1910 and, through his enthusiasm for modern French painting, became a leading authority on contemporary art. His many books included *Art* (1914) which was widely influential, with its notorious use of the term 'significant form' which he coined in order to explain the difference between simplified, emotionally charged, as opposed to merely detailed, descriptive, images.
LIT: *The Bloomsbury Group: A Collection of Memoirs, Commentary and Criticism*. S.P. Rosenbaum (ed.), London, 1975. AW

BELL, Graham (1910–1943). Figurative painter of portraits, abstracts, landscapes, townscapes and still-life in oils; critic. Born in the Transvaal he initially worked in a bank and on a farm before studying art at Durban Art School. He came to England in 1931, became a pupil of DUNCAN GRANT, and also copied paintings in the National Gallery. In the early 1930s he became a part of a small group of painters including COLDSTREAM, GEOFFREY TIBBLE, VICTOR PASMORE and RODRIGO MOYNIHAN who experimented with

abstraction; in 1934 Bell showed in the exhibition 'Objective Abstraction' at the ZWEMMER GALLERY. From 1934 to 1937 he abandoned painting for journalism and contributed to the *New Statesman, The Listener* and *The Left Review; The Artist and His Public* was published in 1939. Bell was one of the founder members of the EUSTON ROAD SCHOOL in 1937, along with Coldstream, Pasmore and CLAUDE ROGERS and with them joined the AIA. Bell became the most active member politically and intellectually. His paintings reflect these concerns being painted with keen observation and without emotional overtones whilst still maintaining a poetic quality. This can be clearly seen in his urban works painted on a trip to Bolton with Coldstream, as well as in his still-lifes, nudes and landscapes. In 1939 he volunteered for war service and in 1943 as a pilot officer he was killed in a plane crash.
LIT: *Paintings of Graham Bell*, Kenneth Clark, Lund Humphries, 1947; *The Euston Road School*, Bruce Laughton, Scolar Press, 1986. MW

BELL, Laura Anning (1867–1950). Portraitist in pastels. Born in France of English parents she studied in Paris with Robert Fleury and at the SLADE with Legros. She exhibited first under the name Richard-Troncy and later married ROBERT ANNING BELL. She showed at the Paris Salon from 1897, winning a bronze medal in 1913 and a silver medal in 1920. From 1921 she also exhibited at the RA, the FINE ART SOCIETY, the Ridley Art Club and the SOCIETY OF WOMEN ARTISTS. Her portrait of Miss Annie Horniman, TATE GALLERY, establishes a strong, direct profile and a sure grasp of character. CF

BELL, Quentin (1910–1996). Painter, sculptor, ceramist and author. Born in Bloomsbury, the son of CLIVE and VANESSA BELL, he studied art in Paris (with Fernand Léger and Jean Marchand), in Rome and (for ceramics) with Gordon Forsyth in Burslem. His first one-man show was in 1935. He was Lecturer in Art Education at King's College, Newcastle, 1952–60, Senior Lecturer, 1960–2, and then Professor, 1962–7, of Fine Art at Leeds University, Slade Professor at Oxford, 1964–5, and Professor of History and Theory of Art at Sussex University, 1967–75. As a painter and as a decorative artist, his work reflects the tradition of his parentage and training. The writer of many authoritative books (e.g. *Ruskin*, 1963) as well as a biography of his aunt Virginia Woolf in two volumes (1972), he had a considerable influence on the aesthetic education of this country.

LIT: *Bloomsbury*, Quentin Bell, Weidenfeld & Nicholson, 1986. AW

BELL, Robert Anning, RA, RWS, RBC, NEAC (1863–1933). Painter of figures, landscapes and religious works in oils, tempera and watercolours. Designer of relief sculpture, mosaics and stained glass. After studying architecture he turned to painting and attended WESTMINSTER SCHOOL OF ART under FRED BROWN, the RA SCHOOLS, 1881, was a pupil of WALTER CRANE and worked in Paris under Aimé Morot. In London he worked with George Frampton making hand-coloured reliefs inspired by Della Robbia and he was associated with Rathbone's Della Robbia Pottery, making designs for their work. From 1885 he exhibited at the RA, and from 1888 at the NEAC. He showed widely in numerous London societies and galleries as well as in the provinces. He became NEAC in 1892, RWS in 1904 and RA in 1922. He was awarded Hon. ARIBA in 1916 and LLD, Glasgow, in 1923. He became Master of the ART WORKERS GUILD and was a member of the Arts and Crafts Exhibition Society and of the International Society. He taught at UC, Liverpool, GLASGOW SCHOOL OF ART and was Professor of Design, RCA 1918–24. His mosaic work includes designs for the Houses of Parliament and Westminster Cathedral and three of his paintings were purchased by the CHANTREY BEQUEST. In 1934 a memorial exhibition was held at the FINE ART SOCIETY. His preferred medium was watercolour but he had a wide ranging interest in the arts and crafts movement. His paintings show his imaginative treatment of subject matter, e.g. *The Arrow*, 1909, and a style which weaves Pre-Raphaelite influence and a wide range of references into a poetic, delicate and lyrical whole.
LIT: *Merseyside Painters*, Walker Art Gallery, 1978; *The Last Romantics*, Barbican Art Gallery, London, 1989; *Studio*, Volume 49, 1910. CF

BELL, Trevor (b. 1930). Painter of abstracts in oils and various media. Born in Leeds, he studied at Leeds College of Art 1947–52, and after a period of work in London, taught at Harrogate, 1953–5. He then moved, on the advice of TERRY FROST, to St Ives, where he became a member of the PENWITH SOCIETY. He won an Italian Government Scholarship in 1958, and a prize at the Paris Biennale in 1959. He was Gregory Fellow at Leeds University, 1960–3, and in 1970 moved to Canada. Between 1972 and 1973 he was Visiting Professor at Florida State University,

and, becoming Professor of Painting at Tallahassee, Florida, in 1972, settled there. His early work was often Picassoesque in character, and included portraits and northern landscapes, but from 1956 developed towards landscape-derived abstraction. From 1964 to 1966 he created shaped canvases, approaching sculpture, and in form resembling shields, masks, fans and kites; after 1973, his paintings in intense vibrant colour were inspired by Space Launchings (e.g. *Burn*, 1973), consisting of three related vertical trapezoidal canvases) and by skyscapes, horizontal in format. In the 1980s his canvases have often been rounded, and, following visits to India, suggestive of Tantric themes, deeper in colour and painterly in handling. His first North American exhibition was at the Corcoran Gallery in 1973, and he has since exhibited world-wide, his work being in many national and international collections.
LIT: *Expanding Themes*, Introduction by John Meyer, exhibition catalogue, Ft Lauderdale, Florida, 1989. AW

BELL, Vanessa, LG (1879–1961). Painter of portraits, figures and still-life in oils, designer of fabrics, pottery, book jackets and interior decorations. Daughter of Sir Leslie Stephen and sister of Virgina Woolf, she studied art under SIR ARTHUR COPE and at the RA SCHOOLS under JOHN SINGER SARGENT. In 1907 she married CLIVE BELL and worked mainly in London, Sussex and France. She exhibited first at the New Gallery 1905, and at the NEAC, the AAA and at numerous London galleries. She became a member of the LG in 1919 and her work was exhibited at the second Post-Impressionist Exhibition 1912. A central figure in the Bloomsbury Group, she founded the FRIDAY CLUB, 1905, and was influenced by ROGER FRY and by DUNCAN GRANT. As co-director of the OMEGA WORKSHOPS she carried out many decorative projects, particularly with Duncan Grant. The impact of Post-Impressionism caused a radical change in her work: she began to use large forms outlined in black and reduced the composition to an arrangement of flat areas of colour, so showing everything in its most basic form, e.g. *Studland Beach*, 1912–1913 (TATE GALLERY). Influenced by Matisse she established a leading role as a colourist before 1920 with painting that combined broken brush marks with areas of clear colour, e.g. *Mrs Mary Hutchinson*, 1914 (Tate Gallery). Between 1914 and 1915 she produced some pure abstracts but later returned to a more traditional naturalism and greater realism in

works that centred around her friends, still-life and landscapes.
LIT: *Vanessa Bell*, Frances Spalding, 1983; the Arts Council memorial exhibition catalogue, 1964. CF

BELLANY, John, RA (b. 1942). Born in Port Seton, Scotland, he studied at EDINBURGH COLLEGE OF ART 1960–5, and then visited Holland and Belgium with a travelling scholarship, his first one-man exhibition being held at the Dromidaris Gallery in Holland. Between 1965 and 1968 he studied at the RCA. In 1974 he became Head of Painting at Croydon College of Art. He is best known for figure compositions, many influenced by FRANCIS BACON and by Max Beckmann's allegorical style (*Totentanz*, 1974) with humans, animals and hybrid creatures grouped in doom-laden compositions, often with autobiographical references recognizable. He has also painted many portraits, and immediately before and after major surgery in hospital (1988), painted and drew remarkable scenes relating to his illness, operation and convalescence. His colour is usually sharp and acidic, roughly applied in flat and scumbled passages, and his drawing is often self-consciously naive; his work includes some very large drawings and etchings.
LIT: *John Bellany, Paintings, Watercolours and Drawings, 1964–86*, exhibition catalogue, Scottish National Gallery of Modern Art, 1986. AW

BELLEROCHE, Count Albert Gustavas de, NEAC (1864–1944). Painter of portraits and figures in oils; draughtsman and lithographer. Born in Swansea, he spent his youth in Paris where he studied art under Carolus Duran and knew Zola, Lautrec, Renoir and Degas. He made frequent trips to England and was a close friend of SARGENT and BRANGWYN. He settled in London in 1911 and from 1918 to 1940 lived at Rustington, Sussex. He exhibited in Vienna in 1903, at the Salon d'Automne, Paris, in 1904 and showed in London at the NEAC from 1894 to 1899 (member 1894), at the Goupil Gallery in 1903 and thereafter in London galleries, in New York and on the continent. His work is represented in collections including the V & A. His elegant paintings share some characteristics with those of Manet and Degas and use rich, muted colour and a fluent technique.
LIT: *Albert de Belleroche*, A.M. Hind, The Commodore Press, London, 1943; *Selected Lithographs of Albert Belleroche*, exhibition cata-

logue, Richard Reed Armstrong Gallery, Chicago, 1989. CF

BELLINGHAM-SMITH, Elinor (1906–1988). Painter of landscape, still-life and figures in oils and watercolours. She studied at the SLADE SCHOOL under TONKS where her contemporaries included COLDSTREAM, ROGERS, TIBBLE, TOWNSEND and MOYNIHAN, whom she married. From 1948 she exhibited regularly at the LEICESTER GALLERIES and at the LG from 1931 and the RA from 1948. Recently she showed at the NEW ART CENTRE and NEW GRAFTON GALLERY. Her work is represented in public collections, including the TATE. In 1951 she was awarded a Festival of Britain Purchase Prize. Her landscape paintings evoke cool English scenes with a brief, liquid web of touches, whilst her pictures of children in landscape have a nostalgic atmosphere.
LIT: *Tribute to Elinor Bellingham-Smith*, Aldeburgh Festival catalogue, 1989; memorial exhibition catalogue, New Grafton Gallery, 1989. CF

BENGER, Berenger, RBA, R.Cam.A. (1868–1935). Painter of landscapes in oils and watercolours. Born in Tetbury, Gloucestershire, he studied at the Antwerp Academy under Verlat and exhibited at the RA from 1890 to 1935, at the R.Cam.A., the RBA (ARBA 1925, RBA 1927), at the RI and NWS from 1884 and in London galleries, particularly at Walker's Gallery where a memorial exhibition was held in 1935. He also showed at the LS, in Liverpool and Manchester. He travelled widely in Europe and visited Norway, the USA and South Africa where he died. His poetic, atmospheric works depicted rural scenes such as *A Damp Day in the Wye Valley*, RA 1984, and many subjects from Sussex where he lived later in life. CF

BENJAMIN, Anthony (b. 1931). Non-figurative painter; printmaker and sculptor. He began by studying engineering science but in 1951 was in Paris studying with Léger and from 1951 to 1955 at Regent Street Polytechnic where he was awarded the Silver Medal for painting. He was awarded French Government Scholarships for painting and printmaking in 1956 and 1958–9. In 1959 he was awarded an Italian Government Fellowship and studied in Italy from 1960 to 1961. Widely exhibited in both Great Britain and abroad, he was a prize winner at the 1968–70 Biennale, Cracow, Poland. He has held various teaching posts in England and Canada. Among his best known

works are his later, nearly minimalist sculptures in wood and marble, such as *Zig-Zag*, 1976, with its repetition of almost identical forms.
LIT: Exhibition catalogue by Norbert Lynton, Grabowski Gallery, London, 1962. MW

BENNETT, Frank Moss (1874–1953). Painter of historical and genre subjects, portraits, interiors and buildings in oils and watercolours; illustrator. He studied at ST JOHN'S WOOD SCHOOL OF ART, the SLADE and the RA SCHOOLS, winning a travelling scholarship and a gold medal in 1900 for *Death of Ladas*. He exhibited mainly at the RA between 1898 and 1928, at the ROI, RI, Dudley Gallery, London, in Liverpool and Birmingham as well as the Paris Salon. His work is represented in collections including the NPG, London. His detailed work was widely reproduced and he was well known for subjects such as *Queen Elizabeth and Sir Francis Drake*, 1942. He also painted in France, Belgium and Italy.
LIT: Christie's sale catalogue, South Kensington, London, 19 November 1987. CF

BENNETT, Michael (b. 1934). A painter, he studied at Lancaster and Leicester Colleges of Art. His first one-man show was at Birmingham University in 1966, and he became Lecturer in Painting at Bretton Hall College of Education in that year. In 1971 he gave up teaching to live and work in Seascale, Cumbria. His large semi-abstracts are based on nature (*Mountain: Rising Cloud VII*, 1973). AW

BENOIS, Nadia, NEAC (1896–1975). Painter of landscapes, still-life and flowers in oils, pastels and watercolours; stage designer. Born in Russia where her father was Royal Architect to the Czar and President of the St Petersburg Academy of Arts, she was the niece of both Albert Benois and Alexander Benois. She studied art at a private art school in St Petersburg under Jacovleff, Choukhaieff and Alexander Benois, leaving Russia in 1920. Her first solo exhibition was in 1924 at the Little Gallery, London, and from 1929 she showed regularly with the NEAC, becoming a member in 1937. She exhibited at many London galleries including the Goupil Gallery and her work is represented in public collections including the TATE GALLERY. Influenced by Cézanne and Van Gogh, her strongly painted canvases reflect her sense of design.
LIT: 'In the Studio of Nadia Benois', Sybil Vincent, *Studio*, Vol.112, 1936, p.260; 'How to

Look at Flower Painting', Nadia Benois, *Studio*, Vol.113, 1937, p.257. CF

BERG, Adrian, RA (b. 1929). He was born in London and educated at Charterhouse, Caius College Cambridge and Trinity College Dublin before training from 1955 to 1961 at ST MARTIN'S, CHELSEA and the ROYAL COLLEGE. He won a number of prizes and awards including an Abbey Minor and a French Government Scholarship. From 1964 to 1975 he had regular one-man shows at Arthur Tooth & Sons; since, he has shown at Waddington's and at the PICCADILLY GALLERY. He has had many one-man exhibitions in galleries in Britain and abroad, including a retrospective 'Paintings 1955–1980' at Rochdale Art Gallery in 1980, another 'Paintings 1977–86' that was shown at the SERPENTINE GALLERY and at the Walker Art Gallery, Liverpool. He has participated in many group exhibitions, including the Royal Academy since he was first invited in 1970. He has won prizes at the JOHN MOORES LIVERPOOL EXHIBITION (Minor Prize, 1980; 3rd Prize, 1982–3), at the Tolley Cobbold National Exhibition (Major Prize, 1981), and elsewhere. His work is in many public, private and corporate collections. He taught at the CENTRAL SCHOOL, CAMBERWELL and, more recently, at the RCA, where he was Senior Tutor. His pictures are vigorously painted in oils, sometimes strongly coloured and patterned.
LIT: Berg has published several statements on his work (in the guide to John Moores Liverpool Exhibition 12, 1980, and in Exhibition 13 and 14 catalogues, 1982/3 and 1985); *Adrian Berg: Paintings 1977–1986*, exhibition catalogue, Arts Council, 1986. AW

BERGER, John (b. 1926). Essayist, art critic and novelist. After training to be a painter, Berger soon turned to art criticism, and established his reputation with a column in the *New Statesman* during the 1950s. He opposed the influence of abstract expressionism coming from America, advocating instead socialist realism where it was to be found in European art. He was never narrowly dogmatic, however. His stimulating books *The Success and Failure of Picasso* (1965), and *Ways of Seeing* (1973), reached a wide audience. He has since then become celebrated as a novelist.
LIT: *Seeing Berger*, Peter Fuller, London, 1980. AW

BERGMAN, Stephanie (b. 1946). Painter of still-life and abstracts using painted, cut and sewn canvas; artist in ceramics and bronze. She studied at ST MARTIN'S SCHOOL OF ART 1963–7, and held her first solo exhibition in 1973 at Garage Art Ltd, London. She subsequently exhibited in the provinces and in London, most recently at the Nigel Greenwood Gallery. In 1975–6 she was the recipient of a Gulbenkian Foundation Award and of a Crafts Council Bursary in 1986. Her work is represented in collections including the ARTS COUNCIL of Great Britain.
LIT: Exhibition catalogue, Crafts Council Gallery, London, 1984. CF

BERLIN, Sven (b. 1911). A painter, sculptor and writer, he was born in London of Anglo/Swedish parentage. He was at first an engineering apprentice, then attended Beckenham School of Art for one year, and then became a professional Adagio dancer, partnered by his first wife, Helga. Their stage career together lasted nine years. He settled in Cornwall in 1938, attending Redruth and Camborne Schools of Art, and became friendly with HEPWORTH, NICHOLSON and the potter BERNARD LEACH. He left St Ives in 1951 to travel in the New Forest and elsewhere in a horse-drawn wagon. Some of his drawings and water-colours are reminiscent of the work of Picabia or Duchamp, a founder member of the PENWITH SOCIETY: his painting has affinities with Surrealist abstraction. He wrote a study, *Alfred Wallis, The Primitive* (Nicholson and Watson, 1949) and several novels including *The Dark Monarch*, 1962. In 1963 he moved to the Isle of Wight, and since 1975 has lived and worked in Dorset.
LIT: *'Svenologue' and Chronology*, Sven Berlin, exhibition catalogue, Belgrave Gallery, 1989. AW

BERRIE, John Archibald Alexander, R.Cam.A. (1887–1962). Painter of portraits and landscapes in oils. Born in Manchester, he studied at Liverpool School of Art, at Bushey under Marmaduke Flower, in London and in Paris. He exhibited mainly in Liverpool and at the R.Cam.A. (A.R.Cam.A. 1912, R.Cam.A. 1922), but he also showed at the RA between 1924 and 1932 and at Walker's Art Gallery where he held a solo exhibition in 1936. His work is represented in collections including the Walker Art Gallery, Liverpool. President of the Liver Sketching Club in 1915, he travelled widely abroad and his accomplished, realistic portraits included members of the Royal Family, e.g. *H.M. The King, Colonel in Chief The King's (Liverpool) Regiment*, RA 1931. CF

BETTS, James Anthony, Professor, ARCA (1897–1980). Painter and draughtsman of figures and landscapes, usual medium oils. He studied at Bradford School of Art and the RCA, exhibiting in London and abroad. He taught widely, from 1933 to 1963 at Reading University, becoming Professor in 1943. His work was based on sure draughtsmanship and sought the basic structure of the subject, expressing this through blocked areas of restrained colour. His landscapes are characterized by their subtle range of cool greens. CF

BEVAN, Graham (b. 1935). Painter of non-figurative subjects mainly based on nature in oil on canvas. He studied at the SLADE SCHOOL OF ART 1956–60, where he was awarded the Wilson Steer prize, and in 1960 he was awarded the University of London Post-Graduate Studentship in Fine Art which gave him a further year at the Slade. He lectured in Fine Art and supervised Creative Design at Sheffield College of Art 1961–3. Bevan has exhibited at YOUNG CONTEMPORARIES and LONDON GROUP shows as well as in ARTS COUNCIL touring exhibitions. MW

BEVAN, Oliver (b. 1941). Painter of figurative and non-figurative images in oils and a range of media; kinetic artist, collagist, photographer and printmaker. He studied at the RCA 1960–4, and exhibited at the Grabowski Gallery in 1965, 1967 and 1969. He has subsequently exhibited in galleries including Angela Flowers and the Odette Gilbert Gallery, in the provinces and abroad. His work is represented in collections including the CONTEMPORARY ARTS SOCIETY. From 1977 to 1979 he taught at the University of Saskatchewan, Canada. His varied work has moved from abstraction and kinetics to paintings of cityscapes influenced by Matisse, Delaunay and Cubism.
LIT: *The Farringdon Paintings*, catalogue, Rochdale Art Gallery, 1983; *Oliver Bevan*, catalogue, Drumcroon Arts Centre, Wigan, 1986. CF

BEVAN, Robert Polhill, NEAC, LG (1865–1925). Painter of horses, market scenes and landscapes in oils and watercolours. Born in Hove, he studied art with Alfred Pearce, at WESTMINSTER SCHOOL OF ART under FRED BROWN, 1888, and at the ACADÉMIE JULIAN in Paris. In 1891 he visited Spain and studied Velazquez and Goya and subsequently visited Tangiers with JOSEPH CRAWHALL and GEORGE DENHOLM ARMOUR. In 1890–1 and 1893–4 he was at Pont-Aven where on his second visit he met Gauguin and Renoir and saw the work of

Cézanne. On his return to England he worked for a time at Hawkbridge, Exmoor, before settling in London in 1900. He married STANISLAWA DE KARLOWSKA and from 1899 made regular visits to Poland. His first solo exhibition was at Baillie Gallery 1905. In 1908 he exhibited at AAA and his work was seen by GORE and GILMAN; as a result he joined the FITZROY STREET GROUP. He was a founder member of the CAMDEN TOWN GROUP 1911, the LONDON GROUP 1913, and the CUMBERLAND MARKET GROUP 1915. From 1910 he exhibited at the NEAC, becoming a member in 1922. He also showed at leading London galleries and at the Post-Impressionist and Futurist Exhibition organized by FRANK RUTTER. Memorial exhibitions were held at Goupil Gallery and Brighton Art Gallery 1926, and in 1934 *Horse Sale at the Barbican* was purchased by the CHANTREY BEQUEST. His innovative early work was influenced by Gauguin in its fluid technique and intensity of colour, e.g. *The Courtyard*, 1903–4, and his work was unusual at the time for its use of pure colour. Between 1906 and 1909 he used a divisionist technique which enabled him to produce a more controlled image whilst retaining the use of bright colour, e.g. the Cab Yard series. In 1912–13 he painted with Gore and Gilman and his works evolved a flatter technique in which figures and objects were clearly delineated, forming an overall patterning effect with clear, contrasting areas of conceptual colour. The late works also show an increasing angularity of forms. Bevan also executed some 40 prints, which, apart from three etchings and a wood engraving, translated a number of his compositions with great originality into the medium of lithography.
LIT: *Robert Bevan A Memoir by his Son*, R.A. Bevan, London, 1965; catalogue for Colnaghi & Co., 1961; catalogue for the Centenary Exhibition, Ashmolean, Oxford, and Colnaghi's, 1965; *The Camden Town Group*, Wendy Baron, Scolar Press, 1979. CF

BEVAN, Tony (b. 1951). Painter of non-traditional portraiture in oils and acrylic. He studied at Bradford School of Art 1968–71, at GOLDSMITHS' 1971–4, and at the SLADE SCHOOL OF ART 1974–6. He usually exhibits at Matt's Gallery, London. His main subject is man's condition in general: not that of a specific individual. He uses the solitary figure to reveal social alienation by focusing on the most expressive areas of face and hands, by the use of black contours and by the emphasis on texture achieved by the application of thick areas of pigment on to the canvas.

LIT: 'Tony Bevan at Matt's', Mike Archer, *Artscribe*, January/February 1987; *Tony Bevan – Paintings 1980–1987*, exhibition catalogue, ICA, 1988 MW

BICAT, André, OBE (b. 1909). Painter of landscapes in oils and watercolours, sculptor, etcher and lithographer. He worked as a scenic designer for the theatre 1931–40. After war service he exhibited at the RA and at London galleries, including the LEICESTER GALLERIES where he exhibited between 1949 and 1970. In 1966 a retrospective exhibition was held at the Reading Art Gallery and more recently he has shown at the Bohun Gallery, Henley. His work is represented in many public collections and between 1966 and 1974 he was Tutor at the RCA. His spontaneous work evokes a sense of place in a rhythmic and colourful style which retains the main elements of the landscape within a flowing technique.
LIT: *Arts Review* (UK), Vol.27, No.11, May 1975. CF

BIEGEL, Peter (1913–1987). Painter of racing and hunting subjects in oils, pencil and watercolours; book illustrator. He studied at the Lucy Kemp-Welch School of Animal Painting, Bushey, from 1938 until the war, subsequently spending two terms at the Bournemouth School of Art before becoming LIONEL EDWARDS's only pupil at his studio in Buckshott, Hampshire. From the late 1960s he painted regularly in the USA and he worked in Ireland, Italy and France. He held his first solo exhibition at the Roland Ward Gallery, London, thereafter exhibiting at the Tryon Gallery. His paintings are represented in many private collections and his illustrations include novels by Colin Davy and his own publication *Booted and Spurred: An Anthology of Riding*, 1950. Influenced by Edwards, who taught him to work rapidly, his style was, however, freer in technique.
LIT: *Racing Pictures by Peter Biegel*, Michael Joseph, 1983. CF

BIGGS, John R. (1909–1990). A wood engraver, he studied at Derby School of Art and at the CENTRAL SCHOOL under NOEL ROOKE. In 1938 he illustrated *Robinson Crusoe* for ROBERT GIBBINGS's Penguin Illustrated Classics series. He travelled in Europe and America, and was greatly influenced by his visit to Russia. His strong, dark works, mostly figure compositions, have a notable feeling for pattern.
LIT: *A Foot in Two Camps*, John R. Briggs, Brighton, 1989. AW

BILBO, Jack (Hugo Baruch, 1907–1967). Painter, sculptor, author and gallery owner. Born in Berlin, he was self-taught as a painter and sculptor. He came to London in 1936, and had a one-man show at the Arlington Gallery. Following internment on the IOM in 1940, and service in the Pioneer Corps, from which he was invalided out, he opened the Modern Art Gallery in Baker Street; it later moved to Charles II Street. SCHWITTERS, ADLER, HERMAN and EPSTEIN were regular visitors, and many young artists were shown, including SVEN BERLIN, EILEEN AGAR and CERI RICHARDS, throughout the most difficult and dangerous period in central London. The gallery continued until 1948. Bilbo's cement sculptures were extravagantly flamboyant, and his painting was bizarre, often gruesome in feeling, and reflected his enthusiasm for SURREALISM.
LIT: *Jack Bilbo by Jack Bilbo. An autobiography*, The Modern Art Gallery Ltd, London, 1948; retrospective exhibition catalogue, England & Co., London, 1988 AW

BILLINGHURST, Alfred John, RBA (1880–1963). Painter of landscapes, figures and portraits in oils and watercolours. He studied at the SLADE SCHOOL 1899–1902, at GOLDSMITHS' INSTITUTE in 1900, where he won the King's Prize, and in Paris at the ACADÉMIE JULIAN in 1902, the Ecole des Beaux-Arts under Laurent in 1903, and at the Atelier Cormon. He exhibited mainly at the RBA (member 1921) where he held solo exhibitions; he also showed at the RA, LS, ROI, RI, RP, in London galleries and the Paris Salon. His work is represented in some public collections including the Plymouth Art Gallery. His broadly painted work includes bright pictures of the seaside and French landscape subjects such as *Snow near Ypres Canal*, RA 1920. CF

BINDER, Douglas (b. 1941). Painter of figures and of non-figurative work in oils and gouache. He studied at Bradford College of Art 1957–61, at the RCA (where contemporaries included HOCKNEY and CAULFIELD), and in Italy. He held his first solo exhibition in 1966 and subsequently showed in London galleries (including the Whitechapel), in the provinces and in America. He has taught widely and in 1985 became the Director of the Dean Clough Contemporary Art Gallery, Halifax. Initially influenced by POP ART and Caulfield, his later strongly painted work is often based on other paintings.

LIT: 'Doug Binder in Conversation with Sally Bulgin', *Artist* (UK), Vol.104, pt6, June 1989. CF

BINDER, Pearl (b. 1904). Illustrator and painter of figures and townscapes in gouache, ink and pastels; lithographer, collagist, costume designer, broadcaster and author. She studied at MANCHESTER SCHOOL OF ART in 1924, worked in Paris and studied lithography at the CENTRAL SCHOOL under A.S. HARTRICK in 1928. She held solo exhibitions in London galleries including the Moffat Gallery in 1928, and the Mermaid Theatre in 1973, and her work is represented in collections including the V & A. A founder member of the AIA in 1933, her work was published in *Left Review* and her books include *The English Inside Out*, Weidenfeld & Nicolson, 1961. She has illustrated many books including Gérard de Nerval's *Aurélia*, Chatto & Windus, 1932, and her varied work often reflects her extensive travel and interest in children, costume and primitive art, particularly that of Africa, India and Polynesia.
LIT: *People and Places*, exhibition catalogue, Brighton Festival, Brighton Art Gallery, 1968.
CF

BINYON, Helen (1904–1979). A wood engraver, illustrator and puppeteer. She studied at the RCA under PAUL NASH and E.W. TRISTRAM, at the Académie de la Grande Chaumière in Paris, and at the CENTRAL SCHOOL under W.P. ROBINS. In 1938 she illustrated *Pride and Prejudice* for ROBERT GIBBINGS's Penguin Illustrated Classics. From 1950–65 she taught at BATH ACADEMY OF ART. Her engravings of figures have a stylized, slightly cubist approach. She published *A Biography of Eric Ravillious* in 1983. AW

BIRCH, David, ROI (1895–1968). Painter of landscapes and portraits in oils; illustrator. He studied at Epsom School of Art and at GOLDSMITHS' COLLEGE OF ART, exhibiting at the RA, RSA, and NEAC. His work is represented in some public collections including Brighton Art Gallery. From 1930 he was Principal of Epsom and Ewell School of Art. His English landscapes include panoramic views.
LIT: *Painting Panorama*, David Birch, Artists Publishing Co. CF

BIRCH, Samuel John Lamorna, RA, RWS, RWA, RBC (1869–1955). Painter of landscapes and seascapes of Cornwall in oils and watercolours. Born in Cheshire, he took a variety of jobs, painting in his free time and making regular visits to Cornwall from 1889. He spent a year at the ATELIER COLAROSSI, Paris, 1895–6, and subsequently settled at Lamorna, Cornwall, taking the name Lamorna to distinguish himself from Lionel Birch. A close friend of the KNIGHTS and STANHOPE FORBES, he exhibited regularly at the RA from 1893 (RA 1934) and at the RWS from 1899 (member 1914). He showed widely in London galleries, particularly the FINE ART SOCIETY, and abroad, and in 1938 *St Ives, Cornwall* was purchased by the CHANTREY BEQUEST for the TATE GALLERY. Initially influenced by Forbes and the French painters, his work often concentrated on the effects of light on water, developing a bright, varied palette that mirrored the rapid changes of landscape colour. He made many fine pencil drawings, lightly coloured with wash.
LIT: Retrospective exhibition catalogue, Galerie George, London, 1986; 'Watercolours and Oil Paintings by S.J. Lamorna Birch', Arthur Reddie, *Studio*, Vol.LXIV, p.169. CF

BIRLEY, Sir Oswald Hornby Joseph, RP, ROI, NPS, IS (1880–1952). Painter of portraits, figures, landscapes and townscapes in oils. Born in Auckland, New Zealand, he was educated at Harrow, Trinity College, Cambridge, and studied art in Dresden, Florence, Paris (at the ACADÉMIE JULIAN under Marcel Baschet) and at ST JOHN'S WOOD SCHOOL OF ART. Later in his life he travelled in the Far East and India. He exhibited mainly at the RP (member 1912), at the RA between 1904 and 1945, at the RSA and the ROI (member 1906); in London galleries including Agnew's; in Scotland; in the provinces and at the Paris Salon. His work is represented in public collections including the NPG, London. He was knighted in 1949. Influenced by Velazquez whom he studied in Spain, his work shares some characteristics with that of SARGENT. Amongst his sitters were members of the Royal Family including His Majesty King George V, 1928, and many leading dancers. Later in his life he painted with Sir Winston Churchill.
LIT: 'The Painting of Oswald Birley', Arthur Reddie, *Studio*, Vol.65, 1915; Christie's sale catalogue, Charleston Manor, Alfriston, Sussex, 3 October 1980. CF

BISHOP, Edward, RBA, NEAC (b. 1902). Painter of figures, interiors, landscapes, still-life and domestic architecture in oils and pastels; lithographer and graphic designer. He studied at the CENTRAL SCHOOL under HARTRICK, F.W. JACKSON, MENINSKY and NOEL ROOKE and has

exhibited in London galleries including the LEICESTER Galleries and Wildensteins, at the RA from 1941, at the RBA (member 1950) and the NEAC (member 1960). His work is represented in collections including Nottingham Art Gallery. His gentle, perceptive works include scenes painted around Camden Town and interiors such as *Café Interior with a Screen*, RA 1988. CF

BISHOP, Henry, RA, NEAC, ROI (1868–1939). Painter of landscapes, coastal scenes and townscapes in oils. Born in London, he attended the SLADE SCHOOL under Legros and the Atelier Cormon in Paris, subsequently studying *plein-air* painting with Alexander Harrison in Brittany. He exhibited at the RA from 1906 to 1939 (RA 1939) and held his first solo exhibition at the Goupil Gallery in 1913. He showed widely in London galleries including the LEICESTER GALLERIES, and in societies including the NEAC from 1915 (member 1929–34) and the ROI (member 1912). In 1933 his painting *Shakespeare's Cliff, Dover* was purchased by the CHANTREY BEQUEST for the TATE GALLERY. Initially he painted figures and portraits in Cornwall but he was greatly influenced by living in southern Europe and Morocco and sought to interpret southern light, colour and life in his broadly painted, direct works. CF

BISSILL, George William (1896–1973). Figure and landscape artist in oils, watercolours and woodcuts; furniture and poster designer. His early years were spent at Langley Mill, Nottingham, where he worked as a miner. After a short period at Nottingham School of Art 1920–1. he worked as a pavement artist in London from 1922 and in 1925 he worked in Paris. In 1923/4 he was commissioned by the Arts League of Service for a series of drawings of miners and he subsequently exhibited in London galleries, particularly at the REDFERN, the RA from 1940 to 1969, at the NEAC, the LG and in Manchester. His work is represented in collections including the TATE GALLERY. His wide-ranging, strongly constructed work includes mining scenes which show the influence of Cubism and VORTICISM.
LIT: *G.W. Bissill, an Appreciation*, Arnold Haskell, exhibition catalogue, Redfern Gallery, London, *c.*1926; *George Bissill 1896–1973*, exhibition catalogue, Belgrave Gallery, London, 1979. CF

BLACK, Arthur John, HROI, RBC, PS, NSA (1855–1936). Painter of landscapes, figures and coastal scenes in oils and watercolours; mural

and scene painter. Born in Nottingham, he studied in Paris under Constant and exhibited at the ROI (ROI 1917, HROI 1932), at the RA between 1882 and 1923, at the RI, NEAC and Baillie's Gallery as well as in Nottingham and the provinces. Elected NSA in 1881 and RBC in 1918, he also showed at the Paris Salon. He painted mural decorations for His Majesty's Theatre and The Coronet Theatre, London, and his paintings range from imaginative fairy subjects such as *A Fairy Swirl*, 1898, to more realistic coastal subjects such as *Volunteers*, 1904, which shares some characteristics with the NEWLYN SCHOOL. CF

BLACKADDER, Elizabeth, OBE, RA, RSA, RWWS, Hon.D.Litt. (b. 1931). Born in Falkirk, she studied at Edinburgh University and at EDINBURGH COLLEGE OF ART. She is a member of the Royal Scottish Society of Painters in Watercolour, the Society of Scottish Artists and the Royal Glasgow Institute. She is Honorary Fellow of the Royal Incorporation of Architects in Scotland. A painter in oils and watercolours, as well as a prolific printmaker (etchings and lithographs), she exhibits with the societies listed above, and has had many one-man shows since 1959. In London she has been represented by the Mercury Gallery since 1965. She has travelled in Italy, France and Japan. She was a Lecturer at Edinburgh from 1962 to 1986. Her painting and graphic work is remarkable for the orchestration of small evocative images and marks over a wide general field, sometimes closely derived from still-life assemblages, flowers or landscapes, sometimes using collage, gold leaf or other mixed media, and sometimes verging on the abstract; often her pictures have extended passages over which all these elements are scattered in seemingly loose, informal arrangements. She has executed some portrait commissions: *Molly Hunter* (Scottish National Portrait Gallery); *Lady Mitchison* (National Portrait Gallery, London). Her work is in many other public collections in Britain and the United States, including the TATE GALLERY, the Scottish National Museum of Modern Art in Edinburgh, Glasgow Museum and Art Gallery and the Museum of Modern Art, New York.
LIT: *Elizabeth Blackadder*, Judith Bumpus, Phaidon, 1988. AW

BLACKBURN, David, (b. 1939). A painter and printmaker, he studied at Huddersfield, then at the RCA. LORD CLARK was a patron in 1962; in 1963 he travelled widely in Europe, before visit-

ing Australia 1963–6. He has since lived for periods there, but also back in England and in the USA. In 1970 he had a retrospective at the Mappin Gallery, Sheffield. His highly abstracted pastels, inspired by landscapes, have vibrant colour and networks of dark lines, sometimes with collaged elements.
LIT: *David Blackburn, Light and Landscape*, Peter Fuller, Yale Center For British Art, 1989. AW

BLAKE, Peter, RA (b. 1932). Born in Dartford, he studied at Gravesend Technical College and School of Art 1946–51, and, following military service, at the RCA 1953–6. He travelled widely in Europe on a Leverhulme research award to study popular art, 1956–7. In 1959 he began a series of collages, adapted with painted elements, featuring pop singers, performers and pin-up girls, often slightly dated, and with a nostalgic element developed from his earlier, autobiographical paintings in which adolescent boys wearing badges and with comics were depicted in naive detail in a technique reminiscent of the Pre-Raphaelites. He won a Junior Prize at the 1961 JOHN MOORES EXHIBITION. During the 1960s his art related closely to the pop music world (he designed the record sleeve cover for the Beatles' *Sgt. Pepper*, and has since done others for Band Aid and Live Aid concert albums), but in 1975 became a founder member of the BROTHERHOOD OF RURALISTS, working on myths of country life. His images are never spontaneous, but result from lengthy work processes, some being left incomplete. He has taught at ST MARTIN'S, Harrow and Walthamstow Schools of Art, and at the RCA. A pioneer of the Pop Art movement, he was made ARA in 1974 and RA in 1981. He had a major retrospective at the TATE GALLERY in 1983.
LIT: *Peter Blake*, exhibition catalogue, Tate Gallery, 1983. MW

BLAKER, Michael, ARE, RE (b. 1928). Painter and etcher, he studied at Brighton College of Art. His gently composed landscapes and townscapes, sometimes with figures, are often of French subjects and are in the tradition of Post-Impressionist French painting. AW

BLAMEY, Norman, RA, ROI (b. 1914). An objective painter of portraits, still-lifes and urban subjects. Born in London, he was trained at the Regent Street Polytechnic 1931–7, where he later taught (1945–63) before teaching at CHELSEA. His subjects are essentially domestic; carefully controlled, drawn and planned before painting.

His painstaking and analytical technique has been mainly focused on his home, family and Church (Old St Pancras). He often sets a small mirror reflection of himself into his paintings of interiors. AW

BLAMPIED, Edmund, RBA, RE (1886–1966). Painter of landscapes, figures and flowers in oils, watercolours and pen and wash; etcher, lithographer, illustrator and clay modeller. Born in Jersey, he studied at LAMBETH SCHOOL OF ART from 1903, later studying etching with Walter Seymour at Bolt Court in 1912 and working at lithography with MALCOLM OSBORNE. He was also advised by A.S. HARTRICK. He travelled in Europe during the 1920s but he is particularly associated with Jersey. He exhibited mainly at the RE (member 1921), the LEICESTER GALLERIES where he held his first major solo exhibition in 1920, at LEFEVRE & Son, the RBA (member 1938) and in Jersey. He also showed at the RA, in Scotland, the provinces and France and he exhibited with the SENEFELDER CLUB from 1921 (member 1923). He was awarded a gold medal for lithography at the Paris International Exhibition of 1925 and his work is represented in collections including the States of Jersey and the Walker Art Gallery, Liverpool. His numerous illustrations include books such as *Black Beauty*, Jarrolds, 1922, and his commissions include stamp designs for Jersey. Acknowledged as an etcher of lively, tonally rich work, he was influenced by Rembrandt and Dürer and his later, often humorous depictions of life and character share some qualities with the work of Daumier and Gavarni. His paintings were also fresh and vital, and all his work was realized with economy of means and spontaneity.
LIT: *A Complete Catalogue of the Etchings and Drypoints of Edmund Blampied*, Campbell Dodgson, Hatton & Truscott Smith, 1926; *Edmund Blampied: A Biography of the Artist*, Marguerite Syvret, Robin Garton Ltd, London, 1986. CF

BLAND, Emily Beatrice, NEAC (1864–1951). Painter of flowers and landscapes in oils and watercolours. Born in Lincolnshire, she studied at Lincoln School of Art under A.G. Webster and at the SLADE SCHOOL under BROWN and TONKS 1892–4. She exhibited widely both in societies and galleries, showing at the NEAC from 1897 (member 1926) and at the RA from 1906 to 1950. She exhibited many works at the LEICESTER GALLERIES (where she held her first solo exhibi-

tion in 1922), at the REDFERN, the Goupil Galleries and the FINE ART SOCIETY. Two of her paintings were purchased by the CHANTREY BEQUEST for the TATE GALLERY in 1929 and 1938. Her paintings depict flowers and landscape in a lively and broad style. CF

BLATHERWICK, Lily (1859–1934). Painter in watercolours and lithographer. A founder member of the RSW, her lithographs of plants and flowers were executed in a versatile and technically adventurous manner. She married A.S. HARTRICK, and moved to London in 1907. AW

BLISS, Douglas Percy, ARCA, SWE, RBA (1900–1984). Painter of landscapes in watercolours and oils; wood engraver, illustrator and art critic. He studied at the RCA under ROTHENSTEIN 1922–5, where he met BAWDEN and RAVILIOUS with whom he exhibited in 1927 at the St George's Gallery. He subsequently showed regularly in London galleries, including the REID & LEFEVRE GALLERY, in societies including the NEAC, the SWE (member 1934), the RA, the RBA (member 1939), in Scotland and the provinces. His work is represented in public collections including the TATE GALLERY. From 1946 to 1964 he was Director of the GLASGOW SCHOOL OF ART and in 1964 he was awarded an Hon.D.A. from MANCHESTER COLLEGE OF ART. His first published wood engravings were for *Border Ballads*, OUP, 1926, and in 1928 he published a history of wood engraving. His linear work uses bold tonal contrasts, cool colour and elegant line.
LIT: Catalogue, Blond Fine Art, London, 1990 CF

BLOCH, Martin (1883–1954). Painter of landscapes and figures in oils. Born in Neisse, Silesia, he studied under Corinth and held his first solo exhibition in Berlin in 1911. In 1934 he settled in England and in 1938 opened a school of painting with DE MAISTRE. He exhibited and taught in London and abroad and his work is represented in public collections including the TATE GALLERY. Influenced by Matisse, Munch, Nolde and Ensor, his expressionist work used rich colour and energetic brushmarks.
LIT: Memorial exhibition catalogue, Arts Council, 1957. CF

BLOMFIELD, Charles James (*c.*1856–1920). Painter in oils; architect. Son of Sir Arthur William Blomfield, he exhibited at the LEICESTER GALLERIES and at the RA as an architect from 1895 to 1918. His painted work includes landscapes of New Zealand such as *New Zealand Lake Scene*, 1893. CF

BLOND, Maxwell (b. 1943). Painter of abstract and figurative images in oils and watercolours; sculptor and woodcut artist. Born in Liverpool, he studied at BATH ACADEMY OF ART 1961–2, Liverpool College of Art 1962–3, and at the SLADE 1963–5, and he has exhibited in London galleries, including Blond Fine Art since 1978, in Liverpool, at the LG and in Germany. He turned to figurative painting *c.*1981, depicting figures in angular forms and sharp colours influenced by Beckmann and the Expressionists.
LIT: *Arts Review* (UK), Vol.34, 12 March 1982, p.129; *Recent Paintings*, catalogue, Bede Gallery, Jarrow, Tyne & Wear, 1984. CF

BLOW, Sandra, RA (b. 1923). Born in London, she studied at ST MARTIN'S 1942–6, at the RA SCHOOLS 1946–7, and at the Academia di Belle Arte, Rome, 1947–8. She had her first solo exhibition at GIMPEL FILS in 1951, and has since exhibited widely nationally and internationally. She taught at the RCA for many years after 1961, and was elected ARA in 1971 and RA in 1978. Her non-figurative work is usually large in scale, dynamic, gestural and impulsive in form, and has often included collaged elements of flat or textured colour, sometimes even in combination with loose polythene sheet and other materials. Her paintings are represented in many public collections including those of the ARTS COUNCIL, the TATE and the V & A. AW

BODLEY, Josselin (1893–1976). Painter of landscapes and buildings in oils and some watercolours. Son of the historian J.E.C. Bodley, he was educated at Eton and in Paris, served with the King's Royal Rifles in the 1914–1918 War and was awarded the Military Cross in 1918. He lived in France for many years and exhibited there at the Paris Salons, 1921–7, and at the Galerie Berheim-Jeune where a retrospective exhibition was held in 1975. In London he exhibited at the LEICESTER GALLERIES, 1933, 1935 and 1937, and at the BEAUX ARTS GALLERY, 1938. He also showed in Berlin and the USA and his work is represented in collections including Manchester City Art Gallery. In 1936 he became a Chevalier of the Légion d'Honneur. His paintings were formal and clear, sometimes with a surrealistic sense of emptiness and desertion.

LIT: Retrospective exhibition catalogue, Galerie Bernheim-Jeune, Paris, 1975. CF

BOMBERG, David (1890–1957). Born in Birmingham of Polish-Jewish immigrant parents, he was brought up in London. He was apprenticed to a lithographer, and went to night classes conducted by WALTER BAYES at the City and Guilds Institute. He broke his indentures in order to attend evening classes at the WESTMINSTER SCHOOL OF ART under SICKERT and with Lethaby at the CENTRAL SCHOOL. The Jewish Educational Aid Society enabled him to go to the SLADE 1911–13, winning the TONKS Prize for a drawing of fellow student ISAAC ROSENBERG. He visited Paris with JACOB EPSTEIN in 1913, meeting Picasso, Derain, Modigliani and others. A founder member of the LONDON GROUP, his first one-man show was at the CHENIL GALLERY in 1914: *The Mud Bath* and *In The Hold*, two highly abstracted, radically geometricized pictures, aroused much interest and praise from FRY, Hulme and others. Although his approach was very close to that of the VORTICISTS, with whom he exhibited in 1915, he avoided any formal connection with them. He was in the army, 1915–19, serving at the Front in 1916 (the year in which he married) and, following the submission of cubist studies which were rejected, he painted an austerely realistic picture (*Sappers at Work,* 1918–19) for the Canadian War Records Office. He wrote some poetry, affected by the death in action of his brother. His artistic reputation remained high after the war but he sold little and suffered acute financial hardship. He lived in Hampshire, 1920–2, gradually modifying his radically geometric approach to form, and then, helped by MUIRHEAD BONE, worked for the Zionist Organization in Palestine, 1923–7. On his return, his meticulously detailed realistic studies and more thickly painted free sketches were received with critical acclaim but hardly sold. From 1930, he travelled widely (The USSR, Morocco and Greece, staying in Spain 1934–5) with LILIAN HOLT, who was to become his second wife. During the Second World War he became an OFFICIAL WAR ARTIST (*Underground Bomb Store,* 1942) and began teaching part-time (Hammersmith, Battersea, Clapham, Dagenham, The Bartlett School and elsewhere), most notably at the Borough Polytechnic, 1945–53. With his pupils there he formed THE BOROUGH GROUP, 1947–9, and the Borough Bottega in 1953. In 1954 he moved to Spain, where he remained until he fell ill and was brought back to London via

Gibraltar. His later, powerful, thickly painted oils strongly influenced such pupils as AUERBACH, KOSSOFF and CREFFIELD.
LIT: *David Bomberg,* William Lipke, Evelyn, Adams & Mackay, 1967; *David Bomberg,* Richard Cork, Yale, 1987. AW

BOND, Henry (b. 1966). Studied art at Farnham, then at GOLDSMITHS'. His first one-man show, *Documents* was with Liam Gillick at Karsten Schubert Gallery in 1991. His work has been of texts accompanied by photographs implying a social comment, such as a documentation of the sale of Lot 127 at Sotheby's on 22 November 1990. AW

BONE, Charles, PRI, FRSA, HFCA, ARCA, FBI (b. 1926). Painter of landscapes and coastal scenes mainly in watercolours but also in oils and tempera; mural painter; critic. He attended Farnham School of Art and the RCA and he has exhibited widely in galleries including the Medici Galleries, at the RI, and at the RA from 1972. Director of the Royal Institute Galleries, Piccadilly until 1970, his mural commissions include work at Sutton Place for Paul Getty. Winner of a Hunting Group Prize for watercolour in 1984, he is married to the sculptor Sheila Mitchell. His atmospheric topographical scenes are influenced by Impressionism and British landscape painters including Constable. During the 1950s he experimented with semi-abstraction but later returned to figuration.
LIT: *Art Review* (UK), Vol.26, pt.24, 29 November 1974, p.722; *Recent Painting by Charles Bone PRI and Sculpture by Sheila Mitchell FRBS*, exhibition catalogue, Medici Galleries, London, 1985; *Charles Bone's Waverley*, Ashgate Editions, 1991. CF

BONE, Sir Muirhead, NEAC, HRWS, HRSW, HRSA, HARIBA (1876–1953). Etcher, draughtsman and painter of architectural subjects, landscapes and some portraits; illustrator. Trained as an architect, he studied art under Archibald Kay at GLASGOW SCHOOL OF ART and settled in London in 1901, making an extended visit to Italy in 1910–12. He exhibited mainly in London galleries, at the NEAC (member 1902) and in Scotland and he also showed at the RA from 1900 to 1953. His work is represented in collections including the TATE GALLERY. A founder member of the Society of 12, he was the first OFFICIAL WAR ARTIST in 1916 and a Trustee of the Tate and National Galleries and the IMPERIAL

WAR MUSEUM. He was knighted in 1937. Best known for his etchings and drypoints of urban scenes influenced by Piranesi, his work ranges from drawings made on the Western Front to watercolours of Spanish landscape.
LIT: *Catalogue Raisonné of Etchings and Drypoints by Muirhead Bone*, Campbell Dodgson, Obach, 1909; *Muirhead Bone. Portrait of the Artist*, exhibition catalogue, Crawford Centre for the Arts, St Andrews, and Glasgow Art Gallery, 1986–7. CF

BONE, Stephen (1904–1958). Figurative painter of landscapes; art critic and illustrator. His usual media were oil on board or canvas, watercolours, pastels and wood engraving. Having trained at the SLADE SCHOOL 1922–4, he travelled extensively in Europe, visiting Spain with his father, Sir Muirhead Bone. He had some early one-man show successes and exhibited with the NEAC from 1920. He held many official appointments, becoming an OFFICIAL WAR ARTIST attached to the Navy from 1943 to 1945. His early landscapes were bright and small in scale; he worked quickly to capture changes, imbuing everyday scenes with their own character. From the late 1940s he began a new career as an art critic, later becoming broadcaster for BBC programmes such as 'The Critics'. His early painting success, however, was not maintained and later works reflected growing dissatisfaction. He was married to the artist MARY ADSHEAD.
LIT: *Albion: An Artist's Britain*, S. Bone, A & C Black, London, 1939; *Sylvester Bone*, exhibition catalogue, Sally Hunter Fine Art, London, October 1986. MW

BOOTH, James William, R.Cam.A. (1867–1953). Painter of landscapes and agricultural scenes in oils and watercolours. Born in Manchester, he later lived near Scarborough and in London. He exhibited mainly at the R.Cam.A., and also showed at the RA between 1896 and 1935, in Manchester, Liverpool and Birmingham. His work is represented in collections including Manchester City Art Gallery. His earlier work was in oils but he later turned more to watercolours. Many of his paintings depict equestrian or farming subjects such as *Ploughing*, RA 1898. CF

BOREEL, Wendela, ARE, NS (1895–1985). Painter in watercolours and oils and etcher of figures, townscapes, landscapes and portraits. Born in France, where she returned to live in 1935, she studied at the SLADE SCHOOL from 1911 under

TONKS, where she met MARJORIE LILLY and CHRISTIANA CUTTER, and at the WESTMINSTER TECHNICAL INSTITUTE under SICKERT for whom she subsequently acted as assistant. She held her first solo exhibition at the Walker Gallery, London, in 1919, and she exhibited at the LG, NEAC, RA, AAA and RE (ARE 1923), in London galleries including the REDFERN, and abroad. Her work is represented in collections including the V & A. Her work was influenced by Sickert both in painting and etching.
LIT: *The Sickert Women and the Sickert Girls*, catalogue, Parkin Gallery, London, 1974; *Wendela Boreel*, catalogue, Parkin Gallery, London, 1980. CF

BORLASE, Deidre, ARCA (b. 1925). Painter of flowers, landscapes, still-life and townscapes in oils and watercolours; etcher. Born in London, she studied at Bromley School of Art and at the RCA. Married to the artist FREDERICK BRILL, she began printmaking at Morley College in 1977 and has exhibited in London galleries including David Thompson's Gallery and the Sandford Gallery, at the NEAC and at the RA from 1947. Her work is represented in collections including the Graves Art Gallery, Sheffield. Her subjects include gardens and landscapes painted around her home at Carperby, Wensleydale.
LIT: *Deidre Borlase ARCA, Paintings and Prints*, exhibition catalogue, Chandler Gallery, Leyburn, Yorkshire, 1981. CF

BORNFRIEND, Jacob (1904–1976). Painter of still-life, landscapes, figures and non-figurative works in oils, tempera, collage and pastels. Born in Zborov, Czechoslovakia, he studied at the Academy of Fine Arts, Prague, 1930–5, under Willi Nowak, and exhibited in Prague from 1931, holding his first solo exhibition there in 1936. In 1939 he settled in England and held his first London exhibition at the Czechoslovak Institute in 1945. He exhibited regularly at ROLAND, BROWSE & DELBANCO from 1950 to 1964, subsequently showing in Sweden and in London galleries including the Ben Uri Gallery in 1974. His work is represented in collections including the TATE GALLERY. In 1957 he executed a large mural for the Jews College, London. His figurative work showed the influence of Cubism and Surrealism and shared some characteristics with the work of ADLER. His non-figurative work abstracted forms from the visible world.
LIT: *Jacob Bornfriend*, exhibition catalogue, Bedford Way Gallery, University of London

Institute of Education, 1980; *Jacob Bornfriend 1904–1976*, Bochum Museum, GFR, 1986. CF

The Borough Group. The Borough Group was officially formed in January 1948 by artists who had studied with DAVID BOMBERG at the Borough Polytechnic. The aim of the Group was to represent Bomberg's approach to painting through their work and to promote exhibitions of his work and greater understanding of his teaching. David Bomberg was the first President and the founder members were: Leslie Marr, Dinora Mendleson, Lilian Holt (Bomberg) CLIFF HOLDEN, Edna Mann, Dorothy Missen, Len Missen, DOROTHY MEAD and Peter Richmond. When in 1947 a number of Bomberg's students had exhibited at the Archer Gallery, London, they had called themselves the 'Borough Group' and it was decided to retain this title. The Group held permanent exhibitions at Leslie Marr's Bookshop 'The Bookworm' and in 1948 exhibited at the Archer Gallery and at the LCC Embankment Exhibition. In 1949 they also organized exhibitions at the Arcade Gallery and at Brasenose College, Oxford. The Group was dissolved in the early 1950s. In 1953, however, the 'Borough Bottega' was formed by students and associates of Bomberg. The eight founder members were: David and Lilian Bomberg, Dinora Mendleson, Richard Michelmore, Cecil Bailey, Ian Gordon, Anthony Hatwell and Gustave Metzger. The aim of the Bottega was to make known Bomberg's work and teaching. They organized exhibitions at the Berkeley Gallery in 1953, at Black Hall, Oxford in 1954 and at the Heffer Gallery, Cambridge, in 1954, where the Bottega exhibitions included work by Bomberg from 1915 to 1953. In 1955 the Bottega also exhibited at Walker's Gallery. Their exhibitions showed the work of guest exhibitors including Roy Oxlade, Leslie Marr, Garth Scott, DENIS CREFFIELD and David Scott.
LIT: Exhibition catalogue for the first Borough Group exhibition, the Archer Gallery, London, June 1947; exhibition catalogue for the third exhibition of the Borough Group, the Archer Gallery, London, March 1949. CF

BOSHIER, Derek (b. 1937). Painter of figurative and non-figurative images in oils; conceptual artist working with photography, ready-made material, text, film, constructions and collage; designer. He studied at Yeovil School of Art 1953–7, and at the RCA 1959–62, where he was a contemporary of DAVID HOCKNEY. In 1962 he spent a year in India and in 1980 he settled in Houston, Texas. He exhibited at the Grabowski Gallery in 1962 with FRANK BOWLING and he has subsequently exhibited in London galleries including Angela Flowers and Edward Totah, internationally and in many group exhibitions. His work is represented in collections including the V & A and MOMA, New York. Since 1980 he has taught at the University of Houston, Texas. His early Pop-inspired work was figurative but he subsequently turned to non-figurative work, concentrating on conceptual art that reflected contemporary events. In the later 1970s he returned to painting, depicting expressive, boldly painted figures and landscape, often exploring aspects of contemporary American society.
LIT: *Derek Boshier. Texas Works*, exhibition catalogue, ICA, London, 1982; *Derek Boshier. Selected Drawings 1960–1982*, exhibition catalogue, Bluecoat Gallery, Liverpool, 1983; 'A Letter from Derek Boshier', *Art Monthly* (UK), No.90, October 1985, pp.3–4. CF

BOSWELL, James, ARCA (1906–1971). Graphic Artist, illustrator, lithographer and painter of landscapes, seascapes and non-figurative works in oils, oil and sand, pva and watercolours. Born in New Zealand, he studied at the Elam School of Art, New Zealand, in 1924, and at the RCA, London, 1925–9. Between 1927 and 1932 he exhibited in London galleries, at the SENEFELDER CLUB and the LG, but in 1932 he gave up painting, joined the Communist Party and concentrated on graphic work. A founder member of the AIA in 1933, and Art Editor of *Left Review*, 1934–8, from 1933 to 1939 he produced lithographs with JAMES FITTON. Between 1936 and 1941 and 1945 and 1947 he was Art Director for Shell Petroleum Co. and during the Second World War he served with the RAMC. He was Art Editor of *Lilliput* 1947–50, from 1951 to 1969 he edited the house journal of J. Sainsbury Ltd., and in 1951 he was commissioned for a mural for the Festival of Britain. He resumed painting in the 1940s, exhibiting in London galleries, at the RA from 1945 to 1960, at the LG and the Paris Salon. His work is represented in collections including the TATE GALLERY. His earlier graphic work was influenced by Grosz, whilst his painting was influenced by Abstract Expressionism in the 1950s.
LIT: *The Artist's Dilemma*, James Boswell, Bodley Head, London, 1947; *Boswell's London*, William Feaver, Wildwood House, London, 1978; *James Boswell 1906–1971*, catalogue, Nottingham University Art Gallery, 1976. CF

BOTTOMLEY, Albert Ernest, RBA, R.Cam.A. (1873–1950). Painter of landscapes, townscapes and coastal scenes in oils and tempera. Born in Leeds, he studied under Edwin Tindall RBA, and later lived in Guildford and Reigate, Surrey. He exhibited mainly at the RBA (ARBA 1919, RBA 1921), at the R.Cam.A., and at the RA between 1900 and 1944. He also showed at the ROI, NEAC, RHA, RI, in Scotland, the provinces and in London galleries including the Goupil Gallery. His work is represented in collections including Leeds City Art Gallery. His paintings included atmospheric beach scenes such as *Rhyl* (Leeds Art Gallery), and subjects such as *An Autumn Day near Derwent Water*, RA 1904. CF

BOTTOMLEY, Frederick (1883–1960). Painter of landscapes, townscapes and coastal scenes in oils and watercolours. He trained at the SLADE SCHOOL and between 1931 and 1939 lived at St Ives where he was a member of the St Ives Art Club. He later lived at Stratford-upon-Avon. He exhibited at the RA between 1931 and 1944, at the ROI and in Birmingham. His representational paintings included oils of London scenes such as *Trafalgar Square*, views of Southport and of St Ives such as *The Harbour, St Ives*, RA 1941. CF

BOTTOMLEY, Peter, ARE (b. 1927). Painter in oils, watercolours and gouache; printmaker. He studied at Doncaster School of Art under T.A. Anderson, 1942–5, and at the RCA under ROBERT AUSTIN, 1948–52. He exhibited at the RA between 1951 and 1954, both as an engraver and painter, and he was elected ARE in 1952. He has taught at Derby College of Art and his exhibited titles include *With Snow on High Ground*, RA 1952, and *Forgotten Corner*, RA 1953. CF

BOURDILLON, Frank W., NEAC (1852–1921). Painter of landscapes, genre and historical subjects in oils. Initially he worked as a coffee planter in India before coming to England and studying at the SLADE SCHOOL and in Paris from 1883 to 1884. In 1884 he settled in Oxford, in 1886 worked at Polperro, Cornwall, and in 1887 moved to Newlyn where he remained until 1892. A close friend of NORMAN GARSTIN and STANHOPE FORBES, in 1892 he gave up painting to become a missionary in India. He exhibited at the RA from 1882 to 1892, and showed at the RBA, RHA, ROI, NEAC (member 1887–90), in Scotland, London galleries and the provinces.

His work is represented in collections including the Art Gallery of New South Wales, Australia (*On Bideford Sands*, 1889). His sensitive work included interiors of Newlyn such as *The Jubilee Hat*, 1887, and Elizabethan scenes which combined his interest in Elizabethan history and *plein-air* painting.
LIT: *Painting in Newlyn 1880–1930*, Caroline Fox and Francis Greenacre, exhibition catalogue, Barbican Art Gallery, London, 1985. CF

BOUVERIE-HOYTON, Edward (1900–1988). A painter, best known for his etchings, who studied at GOLDSMITHS' COLLEGE under STANLEY ANDERSON, MALCOLM OSBORNE and F.L. GRIGGS. A contemporary there of GRAHAM SUTHERLAND, he won the PRIX DE ROME in 1926, and was Principal of Penzance School of Art, 1941–56. A retrospective of his linear, Surrealist work was held at the New Gallery, St Ives, in 1987. He was married to INEZ HOYTON. AW

BOWEN, Denis, ARCA (b. 1921). Painter of abstracts in oils; printmaker. He studied at the RCA and held his first solo exhibition in 1956 at the New Vision Centre Gallery, subsequently showing in London, the provinces and abroad. His work is represented in collections including the TATE GALLERY. He was a co-founder of the Free Painters Group in 1952, co-founder and Director of the New Vision Centre Gallery 1956–66, founder member (with JOHN BELLANY) of 'Celtic Vision', 1982, and associated with Yugoslav artists through his membership of International Art Critics. He has taught widely in England and Canada. In the 1950s he painted tachiste abstract works and in the 1970s his technical experiments produced the *Psychedelic Black Light* paintings. Later work returned to a freer style and brighter palette.
LIT: 'Denis Bowen Speaks', *One* (UK), No.6, May-June 1975; exhibition catalogue for the 2nd retrospective exhibition, Huddersfield Art Gallery, 1989. CF

BOWEN, Owen, P.R.Cam.A., ROI (1873–1967). Painter of landscapes and flowers in oils and watercolours. Born in Leeds, he studied at Leeds School of Art under Gilbert Foster and at Foster's studio in Leeds. He worked as a pottery designer and lithographer before taking up painting and he exhibited at Leeds from 1890 and at the RA between 1892 and 1945. He also showed at the R.Cam.A. (R.Cam.A. 1916, President 1947–54), at the ROI (ROI 1916), at

the RSA, GI, RHA, RI, in London galleries and the provinces. His work is represented in collections including Leeds City Art Gallery. He painted mainly in Yorkshire as well as in Holland, Austria, Norway and Scotland, and he founded the Leeds School of Painting, later called the Owen Bowen School of Painting. His exhibited works included subjects such as *Shades of Evening in Skiddaw Forest*, RA 1896, and *An Upland Village, Wharfedale*, RA 1939.
CF

BOWEY, Olwyn, RA (b. 1936). Painter of portraits and landscapes in oils, watercolours and gouache. She attended West Hartlepool School of Art and the RCA 1955–60, being awarded the Abbey Minor Scholarship. A regular exhibitor at the RA since 1963, she also showed at the ZWEMMER GALLERY (1960) and LEICESTER GALLERIES. Elected ARA in 1968, her work is in the tradition of English landscape art. Her love of the countryside is evident, as she chooses to depict the intimate everyday scenes of nature rather than the grandiose or spectacular, creating personal works instilled with poetic feeling. Her portraiture also reveals her keen observation, as well as her drawing skill and sympathy with the sitter. Her portraits include those of Lady Antonia Fraser, Lord Longford, Bryan Guinness and Harold Pinter.
MW

BOWLING, Frank (b. 1936). A painter, born in Bantica, Guyana, who came to Britain in 1950. He studied at the RCA and the SLADE SCHOOL 1959–63. In 1962 he had his first one-man show at the Grabowski Gallery. His earlier work was vigorously expressive, and included still-lifes and figures. During the 1960s he painted more flatly and with intense colour. He taught at CAMBERWELL and at Reading University (1963–4) and in 1966 moved to New York. He returned to London in 1974, and had a retrospective of his work from 1967–77 at the Acme Gallery in 1977, as well as an exhibition of recent work, which continues to use passages of near-abstraction in compositions drawn from subject-matter inspired by his immediate personal experiences and relationships.
AW

BOWYER, William, RA, RWS, RP (b. 1926). Born in Leek, he attended Burslem School of Art and then the RCA. From 1970 to 1981 he was Head of Fine Art at Maidstone College of Art. He is Hon. Secretary of the NEAC. His landscapes and portraits are executed in vigorously

contrasted tones and colours, and his work is represented in the NPG and the TATE.
AW

BOX, E. (1919–1988). Painter of figures, animals, birds and landscapes in oils. E. Box was the name taken by Eden Fleming when she began to paint in the late 1940s. She attended Regent Street Polytechnic but was mainly self-taught as an artist. She first exhibited in 1949 at the HANOVER GALLERY and subsequently showed in London galleries, New York, Rome and in the provinces. Her work is represented in collections including the TATE GALLERY. She was married to Professor Marston Fleming with whom she travelled widely. Her slowly painted works evoke the image of an earthly paradise depicted in an innocent, naive manner using strong colour and curious discrepancies in scale.
LIT: *Gentle Friends, the Paintings of E. Box*, Robert Melville, Arthur Jeffress and André Deutsch; *Paintings by E. Box, A Retrospective Exhibition*, catalogue, David Carritt Ltd, London, 1981.
CF

BOYD, Theodore Penleigh (1890–1923). Painter of landscapes and coastal scenes in oils and watercolours. He studied at the Art Gallery Schools, Melbourne, Australia, and came to England in 1911. He served with the AIF in the First World War and was gassed at Ypres, later publishing drawings and descriptions of the Western Front. He exhibited at the RA in 1912 and is represented in several Australian public collections. His work includes scenes painted at St Ives.
LIT: *Salvage. Pictures and Impressions of the Western Front*, Penleigh Boyd, Australian War Memorial, Canberra, 1893 (facsimile edition first published in 1918).
CF

BOYLE, Alicia, RBA (b. 1909). Painter in oils and watercolours of landscapes, portraits and figure compositions. Born in Bangkok, she was brought up in Limavady, Co. Derry, and educated in London. She studied at Clapham Art College for four years and then at the BYAM SHAW SCHOOL, where she was influenced by the teaching of ERNEST JACKSON. She first exhibited at the RA in 1932. She painted a mural decoration for the Nurses Home of the Great Ormond Street Hospital in 1934, and in 1939 visited Greece. She taught in Northampton during the war, and has since exhibited widely in London and in Ireland, visiting Spain in 1955; she moved permanently to Ireland in 1971. Her work is painterly and concerned with colour and

draughtsmanship; her imaginative subjects include a series on Sweeny, the seventh century Irish King, and themes from Joyce.
LIT: Exhibition catalogue, Crawford Municipal Art Gallery, Cork, 1988. AW

BOYLE, Mark (b. 1934). With his wife JOAN HILLS he makes reliefs of the suface of the earth, from points chosen at random, which are between painting and sculpture in having the closest possible fidelity to the colour and texture of the original. AW

BRABY, Dorothea (1909–1987). A portrait painter, wood engraver and illustrator. She studied at the CENTRAL SCHOOL under JOHN FARLEIGH, in Florence under Mafori-Savini, at HEATHERLEY'S and at the Grande Chaumière in Paris. Between 1937 and 1955 she worked extensively for the Golden Cockerel Press. Her wood engravings have a strong, sensual, rhythmic orchestration of black and white. She became a full-time social worker in 1959.
LIT: *The Way of Wood Engraving,* Dorothea Braby, London, 1953. AW

BRADBURY, Arthur Royce, ARWA (b. 1892). Painter of marines, landscapes, portraits and nudes in oils, watercolours and pastels; etcher. After serving as a cadet in the Mercantile Marine, he studied art at ST JOHN'S WOOD SCHOOL, winning a scholarship to the RA SCHOOLS. He served with the Dorset Regiment in the First World War and from 1930 made some voyages in the barquentine *Waterwitch.* He exhibited mainly at Walker's Gallery, London, at the RA between 1913 and 1948, at the RI and RWA. He also showed at the ROI, RBA, and in Liverpool and Brighton. His work is represented in the National Maritime Museum, Greenwich. He was Art Master at Pembroke Lodge and Wimborne Grammar Schools and his work appeared in journals such as *Yachting Monthly.* His paintings ranged from depictions of sailing ships such as *On the Deck of the* Waterwitch, RA 1940, to strongly modelled and coloured nudes. CF

BRADLEY, Cuthbert (1861–1943). Painter of equestrian and hunting subjects in oils and watercolours; illustrator and writer. He studied at King's College, London, and worked as an architect before settling at Folkingham in 1895. Self-taught as an artist, he exhibited at the LS and in Nottingham and his work is represented in collections including the Walker Art Gallery, Liverpool. As a journalist he published under the name 'Whipster' and contributed to periodicals such as *The Field.* He wrote and illustrated books including *Fox Hunting from Shire to Shire,* Routledge, 1912, and his knowledge of the horse and hunting is demonstrated in his lively paintings.
LIT: 'Polo in Paint and Bronze', J.N.P. Watson, *Country Life* (UK), Vol.162, 17 November 1977. CF

BRADLEY, Helen, MBE (1900–1979). Naive painter of figures and scenes depicting the world of her childhood in oils; writer. Born at Lees, nr Oldham, she studied embroidery and jewellery at Oldham School of Art but did not begin to paint until she was 65. She exhibited at the Mercury Gallery, London, from 1966, at the RA, in the provinces and in Los Angeles, USA. Her publications include *And Miss Carter Wore Pink: Scenes from an Edwardian Childhood,* Jonathan Cape, London, 1971. Admired by LOWRY, her bright, anecdotal work was influenced by Persian, Indian and Chinese art, Turner and the Dutch painters, particularly Avercamp. She employed an individual technique, often depicting detail by scraping paint away with the end of a brush.
LIT: *Helen Bradley,* John Stafford, Oldham Libraries, Art Galleries and Museums, 1974; *Commemorative Exhibition of Helen Bradley MBE 1900–1979,* exhibition catalogue, W.H. Patterson Fine Arts Ltd, London, 1981. CF

BRADLEY, Martin (b. 1931). Painter of figurative and non-figurative images in oils, gouache and watercolours. After running away to sea when he was 14, he took up painting and he has lived in London and Paris, travelling extensively in India and the Far East between 1962 and 1972. He held his first solo exhibition in 1954 at GIMPEL FILS, London, and he has subsequently exhibited regularly in London galleries (most recently with Birch & Conran and England & Co.), at the Galerie Rive Gauche, Paris, from 1960 to 1983, and in Sweden. His work is represented in collections including MOMA, New York. Initially influenced by American comic strips, his work mixes elements of oriental calligraphy, graffiti and figurative images and shares some characteristics with the work of Klee, Ernst and Tobey.
LIT: *Martin Bradley: Fated to Paint,* Bill Hopkins, Editions GKM Siwert Bergenström, Malmö, Sweden, 1988; *Martin Bradley Paintings 1950–1970,* exhibition catalogue, England & Co., London, 1988. CF

BRADSHAW, Brian, ARCA (b. 1923). Landscape painter in oil, watercolour and gouache; etcher. He studied at Bolton and MANCHESTER Schools of Art, and at the RCA 1948–51, receiving the PRIX DE ROME for engraving in 1951 as well as the Silver Medal of the RCA. Bradshaw exhibited at the RA, RE and LEICESTER GALLERIES as well as in South Africa, Italy and America. In 1960 he was appointed Professor of Fine Art, Rhodes University, Grahamstown, South Africa. He was also an art critic for the *Bolton Evening News* and Hon. Secretary of the Parliamentary Committee on Art Education. His landscapes use colour and brushstroke to reveal the underlying spirit of place. When in Britain, Snowdonia and Lancashire were frequently his subjects. MW

BRAMMER, Leonard Griffith, ARE, RE (b. 1906). Painter and etcher. Born in Burslem, he first studied at the Burslem School of Art (1923–6) then at the RCA from 1926–31. He became Supervisor of Arts and Crafts for Stoke-on-Trent Education Authority 1952–69. He is best known for his sombre and powerful etchings of the industries of the Five Towns. His drawing *The Two Ovens* (1931) is in the TATE GALLERY. AW

BRANGWYN, Sir Frank William, RA, RWS, PRBA, RE, HRSA (1867–1956). A painter, etcher and lithographer, born in Bruges of Welsh parents. Self-taught as an artist, he was apprenticed to William Morris, 1882–4, and later retained an interest in applied art (ceramics and textiles) whilst becoming celebrated for large paintings and murals (The Royal Exchange, 1906, Skinner's Hall, 1909). He travelled widely in Europe, the Balkans, the Near and the Far East, and gained an international reputation. He depicted architectural subjects, marines, figure compositions and industrial scenes, in a powerful, decorative and sonorous neo-baroque style. He was an OFFICIAL WAR ARTIST during the First World War. A retrospective in 1924 was opened by the Prime Minister, Ramsay MacDonald. In 1930 he executed mural panels for the House of Lords, which were refused and which are now in Swansea. There is a permanent collection of his works in the Brangwyn Museum, Bruges.
LIT: *Frank Brangwyn Centenary*, exhibition catalogue, National Museum of Wales, 1967. AW

BRANWHITE, Charles Brooke, HRWA (1851–1929). Painter of landscapes and coastal scenes particularly of the West Country in watercolours and oils. Son of Charles Branwhite ARWS, he studied with his father and at the SOUTH KENSINGTON SCHOOL OF ART. He lived in Bristol and he exhibited from 1873, showing at the RWA, in Birmingham and Liverpool, at the RCA, RI, GI, RBA, at the RA from 1902 to 1919, at the ROI, in Manchester and at the Paris Salon. He was elected RWA in 1913 and HRWA in 1922 and his work is represented in collections including the Bristol Museum and Art Gallery. He was Hon. Secretary of the Bristol Academy of Fine Arts and his works often depicted Bristol scenes such as *The Floating Harbour, Bristol – Winter*, RA 1904, as well as West Country and Welsh landscapes. CF

BRATBY, John Randall, RA (1928–1992). Painter of still-life, flowers, portraiture, figure and landscape compositions; usual media being oils on canvas or hardboard. He was trained at Kingston School of Art 1949–50, and the RCA 1951–4, where he won the Abbey Minor Scholarship, the Italian Government Scholarship and RCA Minor Travelling Scholarship. In 1953 he married the artist JEAN COOKE. He had his first one-man show at the BEAUX ARTS GALLERY in 1954. He was one of the realist painters of what was known as the 'Kitchen Sink School'. Later he exhibited at the ZWEMMER GALLERY. He usually exhibited at the RA, but his official dealer was the Thackeray Gallery. In 1955 he won a prize at the Daily Express 'Young Artists' exhibition, exhibited at the 1956 Venice Biennale and won a Guggenheim Award, jointly with BEN NICHOLSON, in 1958. He taught at Carlisle College of Art in 1956 and at the RCA 1957–8. In 1957 he received first prize in the Junior Section of the JOHN MOORES LIVERPOOL EXHIBITION. In 1957–8 he was commissioned to design the sets for the film *The Horse's Mouth*, and also undertook various murals such as *Golgotha* at St Martin's Chapel, Lancaster (1965), and for the Frankfurt Finance House in 1969. He was elected ARA in 1959 and RA in 1971. He published *Breakdown* in 1960 (which he illustrated), and other novels. John Bratby is best-known as a painter of his immediate surroundings. His technique was impulsive with use of thick paint and lively brushstrokes; colour was strong but form was more significant with interest in linear rhythms and patterns. His later work became lighter in mood reflecting a new enjoyment in nature.
LIT: *Breakdown*, John Bratby, 1960; *Painters of Today: John Bratby*, Alan Clutton-Brock. MW

BREAKWELL, Ian (b. 1943). Painter and artist working in film, photography and performance; diarist. He studied at Derby College of Art and has exhibited regularly in London galleries including Angela Flowers from 1971 and at the Anthony Reynolds Gallery since 1985, in the provinces and abroad. His work is represented in the TATE GALLERY. From 1980 to 1981 he was Artist in Residence at King's College, Cambridge, and in 1983 he was awarded the Brinkley Scholarship, Norwich School of Art. His stylized, simplified paintings often present mask-like portraits and figures reflecting aspects of contemporary society. LIT: *Ian Breakwell's Diary 1964–1985*, Pluto Press, London, 1986; *The Artist's Dream*, Ian Breakwell, Serpent's Tail Ltd, London, *c*.1988.
CF

BRENNAN, Helene, BA (b. 1950). Painter of landscapes in oils and watercolours. Born in Eire, she studied Fine Art at MANCHESTER POLYTECHNIC 1970–5, and held her first solo exhibition in 1982 at the Contact Theatre, Manchester. She has subsequently held regular exhibitions in Manchester, including the Central Library in 1989, and she has exhibited at the Colin Jellicoe Gallery since 1988. Her recent work depicts scenes from Morocco and Southern Turkey, in warm, rich colour.
CF

BRETT, The Hon. Dorothy Eugenie (1883–1977). Painter of figures in oils. Daughter of the 2nd Viscount Esher, she studied at the SLADE SCHOOL where her contemporaries included GERTLER, DORA CARRINGTON and STANLEY SPENCER. She was associated with the Bloomsbury circle, with Lady Ottoline Morrell, Katherine Mansfield and John Middleton Murry. In 1924 she went to New Mexico with D.H. Lawrence and his wife, remaining there to paint after their return. She exhibited at the GROSVENOR GALLERY, the NEAC, and in many American galleries. Retrospectives of her work include the exhibition at Taos (New Mexico) Gallery of Contemporary Art in 1980. Her work is represented in collections including the TATE Gallery. In America, her mystical, symbolic work was concerned with the life and ceremonies of the Pueblo Indians. LIT: *Lawrence and Brett: A Friendship*, Dorothy Brett, Lippincott, New York, 1933; *Brett: From Bloomsbury to New Mexico*, Sean Hignett, Hodder & Stoughton, London, 1984.
CF

BRETT, Simon (b. 1943). Painter and wood engraver. He studied at ST MARTIN'S, and lived as a painter in New Mexico and in Provence before teaching at Marlborough College. *Under The Skylight* (*c*. 1992) is a homage to EUAN UGLOW; his engravings are usually imaginative and thematic. He is currently Chairman of the SOCIETY OF WOOD ENGRAVERS.
AW

BREWSTER, Martyn (b. 1952). He is a painter and printmaker who studied at Hertfordshire (1970–1) and Brighton (1971–5). Influenced then and subsequently by his tutor, DENNIS CREFFIELD, his first solo exhibition was in the Watford Centre Library Gallery in 1977. He has since exhibited widely in this country (regularly since 1992 at the Jill George Gallery) and in the USA. Using rich impasto, his intensely coloured, emotional and informal abstracts often develop obliquely from a landscape or seascape source. LIT: *Martyn Brewster*, Simon Olding, Scolar Press, 1997.
AW

BRICE, Edward Kington, RBSA (1860–1948). Painter of mythological subjects, figures, landscapes and gardens in oils, gouache and watercolours. Born in Edgbaston, he studied at Birmingham School of Art and exhibited mainly in Birmingham becoming ARBSA in 1907 and RBSA in 1920. He also showed at the RA in 1893, at the RCA, in Liverpool and in Manchester. Most widely known for his mythological scenes, particularly of Neptune and his horses, the Sun Chariot and Nautilus, his other work included views of Worcestershire (where he lived) and detailed watercolours of cottages and gardens.
CF

BRICK, Michael (b. 1946). Painter of figurative and non-figurative images in acrylic. He studied art at Newcastle University 1964–8, where he worked as a studio demonstrator 1968–71, and he has exhibited in provincial and London galleries including the SERPENTINE GALLERY in 1971, and the Anne Berthoud Gallery in 1981. His work is represented in the ARTS COUNCIL Collection. Between 1972 and 1973 he was Grenada Arts Fellow, University of York, and since 1973 he has taught at Leeds University and Lanchester Polytechnic. His work has explored the image of a grid related to abstract areas of colour and to the human figure. LIT: Exhibition catalogue, Serpentine Gallery, London, 1971; exhibition review, Francis Spalding, *Arts Review* (UK), Vol.33, pt.20, 9 October 1981.
CF

BRILL, Frederick, ARCA (1920–1984). His main subject was landscape, particularly of the Yorkshire Dales. He studied at Hammersmith School of Art 1934–9, at the SLADE SCHOOL 1940–1 and the RCA 1941–5, where he was awarded a medal for distinction in painting. Brill never separated his own work from his teaching and is closely associated with CHELSEA SCHOOL OF ART where he lectured from 1951 to 1963, becoming Head of Painting 1963–5, and Principal 1965–79. He exhibited mainly at the RA, RBA, London Group and NEAC. Preliminary sketches and works from nature were a fundamental part of his oeuvre, which revealed his interest in the classical spirit of painting. Brill wrote many articles, as well as books such as *Henri Matisse*, Paul Hamlyn, 1967, and *J.M.W. Turner, Peace, Burial at Sea*, Cassell, 1969.
LIT: Memorial exhibition catalogue, Chelsea School of Art, 1985. MW

BRILL, Reginald (1902–1974). Painter of landscapes and figure subjects in both oil and watercolour. He studied at ST MARTIN'S, and at the SLADE SCHOOL under TONKS 1921–4. In 1927 he won the PRIX DE ROME and studied at the British School 1927–9; in 1930 he was working in Cairo. He mainly exhibited at the RA and LEICESTER GALLERIES as well as in East Anglia. Principal of Kingston School of Art (1934) he planned a large-scale project on the 'Martyrdom of Man'.
LIT: He published two books on art: *Modern Painting* in 1946 and *Art as a Career* in 1962.
MW

BRISCOE, Arthur John Trevor, RI, RE (1873–1943). Painter of seascapes and ships in oils and watercolours; etcher. Born in Birkenhead, he studied at the SLADE SCHOOL under FRED BROWN and at the ACADÉMIE JULIAN in Paris. He was friendly with JAMES MCBEY. He exhibited much of his work at the FINE ART SOCIETY but also showed in other London galleries, at the RA between 1926 and 1941, at the RE, RI, RBA, NEAC and in Liverpool. He was elected RE in 1933 and RI in 1935. An experienced yachtsman, he published a *Handbook of Sailing* under the name of Clove Hitch. Many of his subjects depict sailing boats and their crews in heavy seas and his etchings reveal his ability to capture the drama of the elements through an economical use of linear detail on a light ground. His paintings have a similar sense of movement and atmosphere, e.g. *Fishing Boats and Seagulls*, 1929 (Fine Art Society).

LIT: *Arthur Briscoe Marine Artist: His Life and Work*, Alex A. Hurst, Teredo Books, 1974. CF

BRISLEY, Stuart (b. 1933). Painter, sculptor and performance artist, his media including photo-works and text, installation, film and video. He studied at Guildford School of Art 1949–54, and at the RCA 1956–9. Brisley then received a Bavarian State Scholarship and studied at the Munich Academy 1959–60, and from 1960 to 1964 received the Fulbright Travel award, being at Florida State University 1960–2. In 1973 he collaborated with Ken Macmillan on the film *Arbeit macht Frei*. He has exhibited at the ICA and TATE GALLERY, as well as in Sydney, Berlin, Vienna and Warsaw. He taught part time at the SLADE SCHOOL and at Maidstone and Nottingham colleges of art. In 1973/4 he received DAAD Berlin Artists Programme Award. Brisley's reputation is founded on his performances and events, to which he devoted himself from 1968, being well established in this field by the mid 1970s both in Britain and abroad. Such performances are 'Moments of Decision/Indecision' 1975 at Teatra Studio, Warsaw, and 'Survival in Alien Circumstances', 1977, at 'Documenta 6', Kassel. His main concern is related to socialist theory and practice, and how politics affect and alienate the individual. This is often revealed to the spectator by Brisley pushing himself beyond ordinary physical limits.
LIT: *Stuart Brisley: A Retrospective Exhibition*, catalogue, ICA, 1981. MW

BRISTOWE, Ethel Susan Graham (1866–1952). Painter of flowers and figures in watercolours and oils. Née Ethel Paterson, she studied watercolour painting with Claude Hayes and between 1899 and 1934 she exhibited mainly at the Dudley Gallery and at the Moderne Gallery. She held an exhibition entitled 'Flowers and Fancies' at Walker's Gallery in 1934, and later exhibited in Paris, Berlin, Rome and Stockholm. Her paintings included fluid watercolours of figures in interiors; subjects such as *The Bold Princess* and *La Dame aux Camélias*.
LIT: 'Mrs Sydney Bristowe's Watercolours', C. Lewis Hind, *Studio*, Vol.52, p.290. CF

The British Council. Founded in 1934, it exists, under the terms of its charter (1940), to promote a wider knowledge of Britain and the English language abroad. The Council organizes visits and exhibitions to foreign countries of British artists, and possesses an important collection which has been built up since 1948.

LIT: *The British Council Collection*, J. Andrews, The British Council, 1984. AW

The British Independent Society. A short-lived group founded by RAYMOND COXON, HENRY MOORE and LEON UNDERWOOD in 1927. The Society held one exhibition at the REDFERN GALLERY, London, in June 1928 with the theme 'Gentlemen prefer Blondes' from the Anita Loos novel. VIVIAN PITCHFORTH was included in the exhibitors. CF

British School at Rome. The British School at Rome was founded as a School of Archaeology in 1901 and enlarged by Royal Charter in 1912. Housed in a building designed by Sir Edwin Lutyens on the Via Antonio Gramsci, it serves as a centre for research into the Humanities and the practice of Fine Art and Architecture and it includes studios, workshops and a library. Five Rome Scholarships are awarded to students annually, one in each of the following subject areas: Architecture, Painting, Printmaking, Sculpture and Classical Studies, and the Scholarships are held for one academic year during which the students live and work at the School. Other scholarships and grants are administered through the School, including the Abbey Major Scholarship. The first Director of the School was G.McN. Rushforth (1901–2). CF

BROCKBANK, Albert Ernest, RBA, R.Cam.A., PLAA (1862–1958). Painter of landscapes, genre and portraits in oils. Born in Liverpool, he studied at Liverpool School of Art, in London and at the ACADÉMIE JULIAN, Paris. He exhibited mainly in Liverpool, but also showed at the RA, RBA, RI, R.Cam.A., in Manchester and in Birmingham. His work is represented in some public collections including the Walker Art Gallery, Liverpool. He was President of the Liverpool Academy of Arts from 1912 to 1924, and of the Liver Sketching Club. His paintings combine naturalistic detail with a poetic sensibility to effects of atmosphere and light as in *Dusk in the Dunes*, 1886, and *Picking Daffodils above the Village*, 1897. CF

BROCKHURST, Gerald Leslie, RA, RP, RE (1890–1978). Painter of portraits in oils; etcher and lithographer. Born in Birmingham, he attended Birmingham School of Art where his contemporaries included William Eggison, Cyril Lavenstein and HENRY RUSHBURY with whom he maintained a long friendship. In 1907 he went to the RA SCHOOLS, winning gold medals and (in 1913) a travelling scholarship to Paris and Italy where he was influenced by Italian quattrocento painting. In 1914 he married Anáis Folin, began etching and in 1915 and 1916 he painted with AUGUSTUS JOHN. From 1915 to 1920 he lived in Ireland where he secured the patronage of Oliver St John Gogarty and in 1919 he held his first solo exhibition at the CHENIL GALLERY, London. He exhibited in London galleries, particularly the Chenil, at the RE (member 1921), and at the RA 1915–53 (becoming ARA in 1928 and RA in 1937). In 1928 as a visitor to the RA Schools he met Kathleen Woodward (Dorette) whom he later married and in 1939 they settled in America. After this move he exhibited at Knoedler's and Portraits Inc., New York. His work is represented in public collections including the Lady Lever Art Gallery, Port Sunlight (*Jeunesse Dorée*, 1934). His early work was influenced by Botticelli, Piero della Francesca and Leonardo and also reflects aspects of John's style (*Ranunculus*, Sheffield City Art Gallery). His later work became more powerfully modelled, intensely observed, dramatic in light and compelling in its depiction of realistic appearance. He is best known for his portraits of Dorette.
LIT: *A Dream of Fair Women*, exhibition catalogue, Sheffield, City Art Galleries, and NPG, London, 1986–7. CF

BRODZKY, Horace (1885–1969). Painter and draughtsman of figures and portraits, biographer, editor, graphic and stage designer; his media included etching and linocuts. Born in Kew, Melbourne, Australia, he began his training in the drawing class at Melbourne National Gallery. In 1904 he left Australia for San Francisco and in 1906 he arrived in New York where he enrolled at the National Academy of Design. He left New York for London in 1908. He attended the City and Guilds Art School, Kennington, briefly in 1911. In 1912 he was art director of *Modern Society*. He went on a painting trip to Italy and Sicily with John Gould Fletcher where he was influenced by the work of Piero Della Francesca, as seen in his use of frontal views and foreshortened perspective. In 1913 he met HENRI GAUDIER-BRZESKA and sat for a bust; he wrote Gaudier's biography in 1933. In 1914 he became a member of the London Group, and from 1915 to 1923 he lived in New York, exhibiting there and making friends with Jules Pascin. In 1946 his biography of Pascin was published; in 1948 he became Art Editor to *The Antique Dealer and*

Collector's Guide. In 1966 a retrospective exhibition was held at the Mercury Gallery, London, and the following year one was held at Macy's Gallery, New York. Brodzky's graphic work includes designs for endpapers for the *Modern Library* in 1919 and various book dust jackets such as *Instigations* by Ezra Pound. He was the first serious artist to produce linocuts in Great Britain, 1912. Brodzky's painting was associated with Vorticism, his subjects being mainly genre, such as the *Gardener*, 1914; his drawings were of a different nature, the best known being his pen drawings of the nude. He used a single fluid line, the views chosen often being extremely foreshortened. His portrait-caricatures reveal an accuracy achieved with economy of line.
LIT: *Horace Brodsky*, Henry Lew, Melbourne, 1987; *Horace Brodsky*, exhibition catalogue, Introduction by Francis Spalding, Boundary Gallery, 1989. MW

BROOK, Raymond Peter RBA (b. 1927). A painter in oils and printmaker, born at Holmfirth in Yorkshire. He studied at Huddersfield and Thanet Schools of Art, and at GOLDSMITHS' COLLEGE. He taught for a period at Sowerby Bridge Grammar School, and exhibited regularly at the RA, the NEAC and the RBA. Living at Brighouse, much of his inspiration is drawn from the cities and landscapes of the industrial North. His exclusive agent is AGNEW & SON, and he has work in public collections in Great Britain (The V & A, Wakefield Art Gallery, Leeds City Art Gallery) and abroad (in the USA, Switzerland, South Africa and Australia) as well as in many private collections. AW

BROOKER, William (1918–1983). Figurative painter of interiors, nudes, townscapes and still-lifes in oils. He studied at Croydon School of Art until 1939, and after serving in the Royal Artillery during the war he studied at CHELSEA SCHOOL OF ART 1947–8. In 1968 he travelled in Zambia and in 1971 in the United States. His first one-man show was at Arthur Tooth & Sons in 1955 and this became his usual gallery; he also showed at the RA, LEICESTER GALLERIES and at JOHN MOORES EXHIBITIONS, Liverpool. From 1949 to 1953, he taught at BATH ACADEMY OF ART and was Senior Lecturer in painting at the Willesden School of Art, later to become Senior Lecturer in painting at the CENTRAL SCHOOL and then Principal of the Wimbledon School of Art. In 1968 the British Council arranged a joint exhibition for Brooker and WILLIAM SCOTT in Lusaka,

and Brooker had a one-man show in 1971 at Villiers, Paddington, New South Wales, Australia. Brooker's best known works are his still-lifes from the late 1950s onwards, such as *Eleusis*; these developed from his earlier interiors, nudes and townscapes which were painted in the CAMDEN TOWN/EUSTON ROAD tradition. His palette was always tonal, painted in soft edges and textures, and he was always interested in unusual shapes and angles. This became increasingly important as formal composition took over from subject matter, with objects not being simply depicted in their own right, but used to describe the space surrounding them.
LIT: Preface by Edward Mullins, exhibition catalogue, Arthur Tooth & Sons Ltd, London, 1964. MW

BROOKS, Jacob (b. 1877). Painter of landscapes, genre and portraits in oils; poster and ceramic designer. Born in Birmingham, he was a student at Birmingham School of Art, the Antwerp Academy and in Cape Town, South Africa. He exhibited at the RA between 1907 and 1913, at the RI, in Liverpool and in Glasgow, but he mostly showed his work in Birmingham. He painted on the continent and in South Africa and his subjects range from genre scenes such as *Blowing Bubbles*, to landscapes such as *The Poppy Field* exhibited at the RA in 1908. CF

The Brotherhood of Ruralists. The Brotherhood of Ruralists was formed early in 1975 by ANN ARNOLD, GRAHAM ARNOLD, PETER BLAKE, JANN HAWORTH, ANNIE OVENDEN, GRAHAM OVENDEN and DAVID INSHAW. Each member had made the decision to move from the town, and they considered that they were close to vital qualities in the tradition of English painting and photography, particularly that of the mid-nineteenth-century. Paintings, drawings, photographs and tapestries were shown jointly. AW

BROWN, Frederick, NEAC (1851–1941). Landscape, genre and portrait painter mainly in oil. Showing strong Francophile tendencies he exhibited with STEER and SICKERT in 1889 under the title 'The London Impressionists'. His preferred landscape subjects (the Severn or Wye Valley) betray an affinity with English Romanticism. Born at Chelmsford, the son of an art teacher, Brown studied for eight years at the Teachers Training Department of South Kensington. From 1877 to 1892 he taught at the WESTMINSTER SCHOOL OF ART, while furthering

his own study at JULIAN'S, Paris, 1883–4. Prominent in the formation of the NEAC, Brown, succeeding Legros, acted as SLADE Professor 1892–1918, forming with TONKS and Steer an influential triumvirate. He assembled an extensive collection of Modern British art.

LIT: 'Wander Years', F. Brown, *Artwork*, Autumn 1930. CF

BROWN, Glenn (b. 1966). A painter, he studied at Norwich, BATH and GOLDSMITHS'. He was included in the 1989 and 1990 'BT New Contemporaries', and in 1994 his work was in the 'Here and Now' show at the SERPENTINE. His first solo exhibition was at Karsten Schubert in 1995. His paintings appropriate well-known works and reconstruct them to resemble enlarged reproductions smoothly printed on canvas, but subtly transformed and often vulgarized in colour. Pictures by Dali, Appel and AUERBACH have been so treated: *Dali-Christ*, 1992, is typical. AW

BROWN, Henry Harris, RP, NPS (1864–1948). Painter of portraits and some figure subjects in oils. Born in Northampton, he studied in Paris under Bouguereau and Fleury and exhibited mainly at the RP (member 1900) and at the RA from 1889. He also exhibited at the New Gallery, the RHA, RBA, the FINE ART SOCIETY and in the provinces. He showed at the Paris Salon and worked in Canada and the USA where an exhibition of his portraits was held at the Galleries of Reinhardt & Son, New York, in 1917. In 1902 his portrait of Mrs Boyd was purchased by the French Government for the Luxembourg and whilst he was best known as a portraitist, e.g. *Robert Threshie Reid, Lord Loreburn* (Inner Temple), his work also included subjects such as *Isabella and the Pot of Basil*, RA 1895. CF

BROWN, Hugh Boycott (b. 1909). Painter of landscapes and coastal scenes mainly in oils. Son of the watercolourist Robert Brown, he studied at the Margaret Frobisher School, in evening classes at Watford School of Art, and at HEATHERLEY'S under Frederick Whiting and Bernard Adams. In the 1930s he worked in East Anglia and established friendships with DAVID BIRCH and JOHN ARNESBY BROWN who influenced his work. He exhibited at the RBA, RI, ROI, and at the RA in 1935, and he has shown in London galleries, regularly in East Anglia and at the Mystic Maritime Gallery, Mystic, Connecticut, USA. From 1929 to 1941 and 1946 to 1970 he taught at the Royal Masonic Junior School,

Bushey, and in 1970 he retired to Suffolk. He has worked widely abroad and his direct, spontaneous style is influenced by Boudin and the Impressionists. He paints outside, capturing the sudden changes in light and colour.

LIT: 'Painting River and Coastal Scenes with a Pochade Box', Hugh Boycott Brown, *The Artist* (UK), March, April and May 1975; *Hugh Boycott Brown*, exhibition catalogue, Belgrave Gallery, London, 1986. CF

BROWN, Sir John Alfred Arnesby, RA, HRBA, PNSA (1866–1955). Painter of landscapes in oils. Born in Nottingham, he studied with Andrew MacCallum in Nottingham and under HERKOMER at Bushey from 1889 to 1892. He worked in Norfolk and at St Ives where he was a member of the St Ives Arts Club, and in 1910 he settled in Chelsea, subsequently spending his winters there and his summers in Norfolk. He exhibited at the RA from 1891 to 1942 (ARA 1903, RA 1915) and also showed at the RBA (RBA 1896, HRBA 1937), at the RHA, widely in London galleries, in Scotland and internationally including the Venice Biennale of 1934. A retrospective of his work was held in 1935 at Norwich Castle Museum where a memorial exhibition was also held in 1959. His work is represented in collections including the TATE GALLERY which purchased his work through the CHANTREY BEQUEST in 1901, 1910 and 1919. He was married to the painter Mia Edwards and he was knighted in 1938. His painting, influenced by the Barbizon artists and Impressionism, was noted for its treatment of skies and the sympathetic depiction of animals in the countryside.

LIT: 'The Work of Arnesby Brown', *Studio*, Vol.XX, pp.213–16; 'The Recent Work of Arnesby Brown', Charles Marriott, *Studio*, Vol.LXXI, pp.129–37.

 CF

BROWN, Lilian (*fl.* 1928–1940). She painted in a Post-Impressionist manner, being influenced by the CAMDEN TOWN GROUP. She spent a year studying under SPENCER GORE and then, probably as a mature student, she trained at the RCA 1928–32. She was awarded the ROME SCHOLARSHIP for mural painting. In 1987 she was included in an exhibition at the Fairhurst Gallery, London, entitled 'Three Ladies of Quality'. MW

BROWN, Samuel John Milton, P.R.Cam.A., PLAA (1873–1965). Painter of seascapes and

coastal subjects in watercolours. He won a Liverpool Council Scholarship to study at Liverpool School of Art under John Finnie 1888–1900, and he exhibited in Liverpool, at the R.Cam.A., the RI and in Birmingham. He was President of the Liverpool Academy of Artists, the Liver Sketching Club and of the Flintshire Art Society. Influenced by Somerscales and de Martino, his paintings were exact and naturalistic giving an evocative picture of sailing ships and ocean liners. CF

BROWN, William Marshall, RSA, RSW (1863–1936). Painter of figures in landscapes or coastal scenes and portraits in oils. He worked at wood engraving and book illustration and attended the RSA SCHOOLS 1884–8, winning the Chelmers Bursary and the Stewart Prize. He painted widely in Scotland but also in France, Holland and Belgium. He exhibited mainly in Scotland, at the RSA (RSA 1928), the RSW (RSW 1929), and at the GI. He also showed at the RA, the RCA and in Liverpool. His work ranges from detailed scenes of Scottish life such as *When the Boats Come in*, 1904 (exhibited at the RSA in 1907), to more lyrical studies of children such as *Looking out to Sea*, where the figures are integrated into the surrounding beach scene by colour and handling. CF

BROWNING, Amy Katherine, RP, ROI, SWA, ARCA (1882–1978). Painter of portraits, figures and flowers in oils, watercolours and tempera. She was a pupil of GERALD MOIRA and trained at the RCA (becoming ARCA in 1905), and in Paris. She exhibited widely, showing many works at the ROI, RA and SWA, as well as exhibiting at other societies including the NEAC and RP, in London galleries, the provinces and Scotland. She was elected ROI in 1915 and SWA in 1922 and her work is represented in several public collections. She was awarded a silver medal at the Paris Salon of 1912 and a gold medal in 1922. Her work ranged from naturalistic portraits to subjects such as *Love Under the Oaks* and *The Hammock Swing* (exhibited at the RA in 1940 and 1961). She married T.C. DUGDALE.
LIT: 'T.C. Dugdale and A.K. Browning', Enid Gibson, *Studio*, Vol.134, 1947, p.64. CF

Browse & Darby, see ROLAND, BROWSE & DELBANCO

BRUHL, Louis Burleigh, RBA, R.Cam.A., LAA, RI, PBWS (1861–1942). Painter of landscapes in watercolours; illustrator. Born in Baghdad and educated in Vienna, he was a self-taught artist who began to paint in his late 20s. He exhibited in London from 1889, showing principally at the RBA, the Dudley and New Dudley Gallery and Walker's Gallery. He also exhibited at the FINE ART SOCIETY, the RI, ROI, the RA between 1891 and 1928, in Liverpool and in Glasgow. His work is represented in some public collections including the V & A. President of the Dudley Art Society and the Constable Sketching Club and Vice-President of the Yarmouth Art Society and the Toynbee Hall Art Society, his illustration work included *Essex* by A.R. Hope, 1909. His landscapes, often with dramatic skies, range from detailed works with thickly built up watercolours and scratched highlights to looser, fluid studies in wash.
LIT: Catalogue for Christchurch Mansion, Ipswich, 1988. CF

BRUNSDON, John (b. 1933). Etcher and painter of landscapes. Born in Cheltenham, he studied at Cheltenham College of Art 1949–53, and at the RCA 1955–8. He held his first solo exhibition in Sweden in 1965 and he has subsequently exhibited in London galleries (including the William Weston Gallery), in the provinces (showing in Manchester at the Colin Jellicoe Gallery), and abroad. His work is represented internationally in collections including the TATE GALLERY and MOMA, New York. His work combines precise, rhythmical line with an instinctive use of colour.
LIT: Exhibition catalogue, William Weston Gallery, London, 1974; *Art Review* (UK), Vol.25, No.6, 24 March 1973. CF

BRYDEN, Robert, RE (1865–1939). A wood engraver, etcher and sculptor. Born in Ayrshire, he studied at the Ayr Academy, then at the RCA and RA SCHOOLS. He travelled widely around the Mediterranean, as far as Egypt. His folio of thirty-three large woodcuts, *Portraits of Men of Letters of the Nineteenth Century* was published in 1899 by Dent. He played a leading part in the revival of wood engraving. AW

BUCHANAN, Anne (b. 1919). She attended Worthing School of Art, then studied at CAMBERWELL 1948–53. She has exhibited with the LONDON GROUP, at the AIA (*Psycho-Mythological Paintings*, 1971) was included in 'British Painting '74' at the Hayward, and had a major exhibition at the Meridian House International in Washington in 1979. Her landscapes with figures

have occasionally been inspired by everyday experience, but she is best-known for loosely-painted subject-pictures taken from Ovid's *Metamorphoses* and other sources of classical mythology (for example *Leda and the Swan*, 1963–7).

LIT: Exhibition catalogue for the AIA Exhibition, 1971; Introduction by ANDREW FORGE. AW

BUCKLEY, Stephen (b. 1944). Born in Leicester, he studied at Newcastle (1962–7) and Reading (1967–9) Universities. His first one-man exhibition was in 1970 at Nigel Greenwood's, and he taught 1969–71 at Canterbury, Leeds and CHELSEA. He was Artist-in-Residence 1972–4 at Kings College, Cambridge. He has regularly exhibited at the JOHN MOORES LIVERPOOL EXHIBITION, and was a prizewinner in 1974; since then he has exhibited widely in Europe and America. His highly abstracted, richly textured works (occasionally evolved from figurative drawings) are usually very irregular in format, sometimes with canvas, cotton duck or paper woven into rectangles, and incorporating unusual materials (netting, wire, laths, pins, thread, shoepolish, encaustic, graphite) as well as acrylic or oil paint. He is represented in many national and international collections.

LIT: *Stephen Buckley: Many Angles*, Marco Livingstone, MOMA, Oxford, 1985. AW

BUDAY, George, RE SWE (1907–1990). A wood engraver and watercolour painter. Born in Hungary, he studied at Szeged University, and when visiting England as a student was inspired to start wood engraving. Following graduation he was awarded a ROME SCHOLARSHIP in 1936. He lectured at Franz Josef University 1934–41, and subsequently settled permanently in England. Influenced by German Expressionism, his vivid and highly stylized engravings are typified by the series *Timon of Athens* (1940). AW

BUDD, Herbert Ashwin, ROI, ARCA (1881–1950). Painter of portraits, genre, landscapes and townscapes in oils. Born in Staffordshire, he studied at the Hanley School of Art and at the RCA under MOIRA, 1903–8. He lived in London and exhibited mainly at the ROI (member 1922), at the RA from 1908 to 1948, at the RP and NEAC as well as in the provinces, Scotland and in some London galleries. In 1927 he was awarded an Hon. Mention at the Paris Salon. Married to the artist Helen Margaret Mackenzie, from 1929 to 1949 he taught at ST MARTIN'S SCHOOL OF ART. His wide-ranging subject matter includes scenes such as *Morning Walk – Group Portrait*, RA 1910, *Night Scene, Piccadilly Circus*, RA 1924, and *The Boating Party*, RA 1939. CF

BUDGEN, Francis Spencer (1882–1971). Painter, sculptor and writer. Born in Crowhurst, Surrey, he was a self-taught artist who lived in Switzerland for some time, exhibiting during the 1920s in Basle, Berne, Heidelberg, Mannheim and Zurich. He also showed at the ROI and at the Goupil Gallery, London, but later in his career he concentrated more on writing. A friend of James Joyce whose portrait he painted in 1919, he published *James Joyce and the Making of Ulysses*, New York, 1934. His work is represented in some American collections and in the National Gallery of Ireland.

LIT: *Myself When Young*, Frank Budgen, OUP, London, 1970. CF

BUHLER, Michael (b. 1940). Painter of landscapes, figures and townscapes in oils and acrylic. The son of ROBERT BUHLER, he studied at the RCA 1959–63, under WEIGHT, DE GREY, SPEAR and COLIN HAYES. He has exhibited at the RA since 1971 and has held solo exhibitions since 1963, at the NEW ART CENTRE in 1966 and 1971, and at Fanny Foxon, London, in 1982. Represented in collections including the BM and the ARTS COUNCIL, he has taught in the provinces and London. His figurative work uses abstracted, geometric shapes which have a diagrammatic simplicity and flatness. CF

BUHLER, Robert, RA (1916–1989). Of Swiss parentage, he trained in Zurich and Basle before being encouraged by KEITH VAUGHAN to study at ST MARTIN'S and later at the RCA, where he stayed for a few months in 1937. He concentrated mainly on portraiture (his sitters included Stephen Spender, John Betjeman and Arthur Koestler) although he also painted still-lifes and landscapes. His sober, close-toned work used harmonious colour, influenced by SICKERT and by the EUSTON ROAD SCHOOL. Elected ARA in 1947 at the age of thirty, and RA in 1956, he taught for many years at the RCA. His work is in the collections of the ARTS COUNCIL, the TATE and the National Portrait Gallery.

LIT: *Robert Buhler*, Colin Hayes, Weidenfeld & Nicholson, 1986. AW

BULLARD, Paul, ARCA (b. 1918). Painter of figures, portraits, landscapes and townscapes in oils.

He studied at Clapham School of Art 1934–8, and at the RCA 1938–47, and exhibited at the RA from 1948 to 1965, at the NEAC, the LG and widely in galleries. From 1948 to 1958 he taught at Woolwich Polytechnic and from 1958 to 1977 he taught at CAMBERWELL SCHOOL OF ART. His painterly, realistic work ranges from scenes observed as a POW in Libya to subjects such as *Chelsea Flower Show*, RA 1953, and *Allotment Gardens*, RA 1964.

LIT: *Camberwell Artists of the 40s and 50s*, exhibition catalogue, The Belgrave Gallery, London, 1988. CF

BUNDY, Edgar, ARA, RI, ROI, RBA, RBC (1862–1922). Painter of historical and genre subjects in oils and watercolours. Born in Brighton, he was self-taught as a painter, encouraged by Alfred Stevens. He exhibited mainly at the RI (RI 1891, VPRI 1915), at the ROI, (ROI 1892), at the RA between 1881 and 1922 (ARA 1915), and in Liverpool. He also showed in London galleries, at the RBA (RBA 1891), the RCA and RHA. A member of the Langham Sketching Club, in 1905 his painting *The Morning of Sedgemoor* was purchased by the CHANTREY BEQUEST for the TATE GALLERY and in 1915 he painted *The Landings of the Canadians in France, 1915* for the Canadian War Memorial. His painterly, yet detailed work included some North African subjects painted between 1920 and 1922. CF

BURGESS, Arthur James Wetherall, RI, ROI, VPSMA, ARBC (1879–1957). Marine painter in oils and watercolours; illustrator. Born in New South Wales, he studied in Sydney before settling in England in 1901 and subsequently studying at St Ives. He exhibited at the RA from 1904 to 1945, at the ROI (ROI 1913), the RI (RI 1916), at the RBA, RHA, in the provinces, Scotland and at the Paris Salon. A founder member of the SMA and a member of the Langham Sketching Club, his work is represented in collections including the National Maritime Museum, Greenwich. During the First World War he worked for the Australian Government. From 1922 to 1930 he was Art Editor for *Brassey's Naval and Shipping Annual*; his exhibited works included subjects such as *The Grand Fleet sails from Scapa*, RA 1919. A memorial exhibition of his work was held at the RWS Galleries in 1958. CF

BURGIN, Victor (b. 1941). An artist using texts and photographs as media; writer of theoretical articles. He was trained at the RCA 1962–5, and

at Yale University School of Art and Architecture 1965–7. Since 1970 he has had regular one-man shows in Europe and the US; his usual gallery being the John Webber Gallery in New York. In 1973 he became Senior Lecturer in the History and Theory of the Visual Arts at Central London Polytechnic and from 1976 he has lectured at Yale, Princeton and UCLA. In 1980 he became Picker Professor at Colgate University, New York. Burgin has been awarded two fellowships: in 1976–7 he received the US/UK Bicentennial Arts Exchange Fellowship, and in 1978–9 the DAAD German Fellowship in Berlin. Victor Burgin is a conceptual artist; communication methods and their reinterpretation are his main concern as painting and sculpture seem to him to be too detached from the real world. In his early works he replaced the traditional form of the art object with psychological form, as written instructions for making the object become the work of art itself. He then began to use photographs and texts together as these are the most common forms of communication. Many of these are based on advertisements and serve to comment on the contemporary society, such as *A Promise of Tradition*, 1976.

LIT: *Victor Burgin: Work and Commentary*, Latimer, London, 1973; *Between*, Victor Burgin, Basil Blackwell and the ICA, 1986. MW

BURLEIGH, Charles H.H., ROI (1875–1956). Painter of landscapes, interiors and flowers in watercolours and oils. He lived at Brighton and Hove and exhibited mainly at the ROI (ROI 1915) and at the RA from 1897 to 1948. He also showed at the RBA, LS, RI and RHA, as well as in some London and provincial galleries. In 1923 he exhibited with his wife, Mrs Averil Burleigh, at Hove Public Library. His paintings include French and Italian subjects but also many of Brighton and Sussex including *Interior of Brighton Pavilion Showing Wounded Indians* (IMPERIAL WAR MUSEUM), and *The Flower Market, Brighton*, exhibited in 1923. CF

BURN, Rodney, RA (1899–1984). Figure and landscape painter, mostly in oils, he trained at the SLADE SCHOOL 1918–22, where he won six major prizes including the 1921 Summer Composition Prize. He travelled widely in Britain before the war and later visited France, Spain, Venice and the Greek Islands. He exhibited with the NEAC from 1923, becoming a member in 1926. He frequently exhibited at the Goupil and French Galleries and at the RA from 1945. From

1929 to 1931 he was an assistant teacher at the RCA becoming a tutor there 1946–65. Between 1931 and 1934 he became Joint Director, with ROBIN GUTHRIE, of Painting and Drawing, Boston Museum School of Fine Arts, USA, and from 1947 to 1979 he was Drawing and Painting Master at the City and Guilds School of Art, London. During the war, 1940–5, Burn served in the Camouflage Directorate. His best-known works are his London subjects, such as *Battersea Park*, 1949, views of Venice, and the beach scenes which he painted throughout his life. His colour was fresh and the works have a sensitivity and spontaneity revealing his love for the world he observed.

LIT: Introduction by Richard Carline, retrospective exhibition catalogue, Fieldbourne Galleries, 1976. MW

BURNETT, Cecil Ross, RI, PS (1872–1933). Painter of landscapes, portraits, figures and flowers in oils, watercolours and pastels. He studied at Blackheath School of Art under Joseph Hill from 1888, at WESTMINSTER SCHOOL and at the RA SCHOOLS from 1892, winning the Turner Gold Medal, first prize for portrait painting and a scholarship. He exhibited mainly at the RI (member 1910), but he also showed at the RA between 1896 and 1929, and at the ROI, RBA, LS, RP, RSW, GI and in the provinces. In 1898 he founded the Sidcup School of Art and was Principal there for some years; he was also a member of the Langham Sketching Club from 1907. He worked at Amberley, Sussex, and his painting often depicted farming subjects such as *Gathering Rhubarb* as well as Sussex landscapes such as *September Evening, Sussex*, RA 1913. CF

BURNS, Robert, ARSA (1869–1941). Painter of figures, landscapes and portraits in watercolours and oils; illustrator, designer and decorative painter. Born in Edinburgh, he attended evening classes at GLASGOW SCHOOL OF ART where contemporaries included CHARLES RENNIE MACKINTOSH, studied at the WESTMINSTER SCHOOL OF ART under FRED BROWN in 1889 and attended the Académie Délécluse, Paris, where he became interested in Japanese prints. From 1892 to 1902 he worked as a designer in a wide range of media. Closely associated with the Celtic Revival, he taught at Geddes' School of Art and produced Art Nouveau illustrations for *The Evergreen*. He exhibited at the SSA (PSSA 1901) and at the RSA (ARSA 1902–20) as well as in Glasgow, at the RHA and RSW, in London and

the provinces. His work is represented in collections including the National Gallery of Scotland. From 1908 to 1919 he was Head of Painting at EDINBURGH COLLEGE OF ART. His figure paintings were influenced by the Symbolists, but after 1920 he concentrated on decorative and graphic art and on watercolours, making a sketching trip to Morocco in 1921 and illustrating four books including *Scots Ballads by Robert Burns, Limner*, 1939. His illustrations on vellum had a medieval richness and brilliance.

LIT: *Robert Burns 1869–1941. Artist and Designer*, exhibition catalogue, Bourne Fine Art, Edinburgh, 1982–3; *Robert Burns, Limner*, exhibition catalogue, Fine Art Society, Edinburgh, 1976. CF

BURRA, Edward (1905–1976). Privately educated, he studied at CHELSEA POLYTECHNIC 1921–3, and at the RCA 1923–5. He subsequently lived much of the rest of his life at his parent's house near Rye. There in 1927 he met PAUL NASH who showed him avant-garde periodicals in which he saw work by artists such as George Grosz; he was stimulated by them to make collages and drawings (and a few woodcuts) in a dadaist spirit. He travelled (to Paris, Toulon, New York and Boston) as often as his poor health (rheumatic arthritis) permitted, spending much of his time in the low bars, nightclubs, dance-halls and cinemas from which he drew inspiration for his paintings, which were almost always in watercolour. These were often, later in his life, very large in scale as he pieced separately painted sheets of paper together. His first one-man show was at the LEICESTER GALLERIES in 1930. He exhibited at the 'Art Now' and UNIT ONE exhibitions at the MAYOR GALLERY in 1933 and 1934, and in the International SURREALIST Exhibition of 1936. He visited Mexico in 1938 and, affected by the Spanish Civil War and the Second World War, increasingly painted sombre, menacing compositions suggesting cruel religious rites. His illustrations, and his sets and costumes for various ballets (for example *Miracle in The Gorbals*, 1944) were very successful. He exhibited at the LEFEVRE GALLERY from 1952, turning his attention to still-life and landscape subjects. A retrospective exhibition was held at the Hayward Gallery in 1985.

LIT: *Edward Burra: Complete Catalogue*, Andrew Causey, Phaidon Press, 1985; his prints are discussed in *Avant-Garde British Printmaking, 1914–1960*, Frances Carey and Anthony Griffiths, BMP, 1990. AW

BURROUGH, Thomas Hedley Bruce, RWA, TD, FRIBA (b. 1910). Architect and painter in watercolours. Born in Newport, Monmouthshire, he studied at the RWA School of Architecture 1928–32, and married the artist Helen Burrough. His publications on architecture include *South German Baroque*, Alec Tiranti Ltd, London, 1956. CF

BURROUGHES, Dorothy Mary (d. 1963). Painter and linocut artist. She studied at the SLADE, HEATHERLEY'S and in Germany. *The Cloud* (1925) is typical of her clear and vigorous style. AW

BUSSY, Simon-Albert (1869/70–1954). French painter of portraits, landscapes and animals, mainly in pastel or watercolour. Born in Dôle, he won a scholarship to the Ecole des Arts Décoratifs in Paris in 1886 and in 1890 went to the Ecole des Beaux-Arts where he studied under E. Delaunay and Gustave Moreau. In 1903 he married Dorothea Strachey and spent his summers in England and Scotland, living for a period in London. He exhibited regularly at the LEICESTER GALLERIES. He made portraits of the Bloomsbury circle, but his later work became almost exclusively concerned with landscape and studies of animals, fishes and birds. He spent much time sketching in London Zoo, and then, in his studio, working up the small highly personal studies into paintings.
LIT: Monograph by Francois Fosca; Introduction by André Gide, exhibition catalogue, Leicester Galleries, October 1949. MW

BUTLER, Lady Elizabeth Southerden, RI, HSWA (1846–1933). Painter of military subjects in oils and watercolours. Born in Lausanne, née Thompson, she was the sister of Alice Meynell and she studied with W. Standish at SOUTH KENSINGTON SCHOOL OF ART in 1866 and in 1869 with Giuseppe Bellucci in Florence. She exhibited at the RA from 1873 to 1920 and in 1874 her exhibit *The Roll Call* established her popularity. Her work was influenced by French painters including Detaille and Meissonier and depicted both contemporary and historical military action.
LIT: *An Autobiography*, Lady Butler, Constable & Co., London, 1922; *Lady Butler. Battle Artist 1846–1933*, Paul Usherwood and Jenny Spencer-Smith, catalogue, National Army Museum, (Alan Sutton), London, 1987. CF

BUTLER, George Edmund, RWA (1872–1936). Painter of portraits and figures in oils and watercolours; etcher. Born in Southampton, he studied at Lambeth School of Art, at the ACADÉMIE JULIAN, Paris, and at the Antwerp Academy. He exhibited at the RA from 1904 to 1923, at the RWA (member 1912), the LS, the RHA, in Liverpool and Scotland. He received an Hon. Mention at the Paris Salon and his work is represented in collections including Bristol Art Gallery. An OFFICIAL WAR ARTIST with the New Zealand Expeditionary Force, he was also Art Master at Clifton College, Bristol. His work ranged from poetic, imaginative subjects such as *The Golden Dustman*, RA 1911, to gently observed subjects such as *Two Children Riding Donkeys at the Edge of a Moor*, 1912. CF

BUTLER, Mildred Anne, RWS (1858–1941). Painter of landscapes, genre, animals and birds in watercolours and some oils. Born in Co. Kilkenny, Ireland, she studied with Paul Jacob Naftel in 1886, at WESTMINSTER SCHOOL OF ART with FRANK CALDERON and during the summers of 1894 and 1895 with NORMAN GARSTIN at Newlyn where she established friendships with LUKE FILDES and STANHOPE FORBES. She subsequently lived and worked at Kilmurry, Co. Kilkenny, and she exhibited at the Dudley and New Dudley Gallery, at the RWS (ARWS 1896, RWS 1937), at the SWA, the RA from 1889 to 1913, the RHA, RBA, WSI, in London galleries (including the LEICESTER GALLERIES), and in the provinces. Her painting *The Morning Bath* was purchased for the TATE GALLERY by the CHANTREY BEQUEST in 1896. She often painted outside with realistic detail and in later work used broad washes of strong colour.
LIT: *Mildred Anne Butler*, exhibition catalogue, Kilkenny Castle, Ireland, the Bank of Ireland, Dublin and Christie', London, 1981; *Mildred Anne Butler*, Christie's sale catalogue, London, 13 October 1981. CF

BUTTERFIELD, Francis (b. 1905). Painter of figures, landscapes and non-figurative works in oils. Born in Bradford, Yorkshire, he studied at evening classes under Henry Butler at Bradford School of Art whilst working at woolstapling. In 1929 he turned to painting full-time. He exhibited first at the ZWEMMER GALLERY in 1934, and subsequently at the LEICESTER GALLERIES in 1937. A member of the SEVEN AND FIVE SOCIETY, he exhibited with them in 1935, showing abstract works. He is represented in collections including Sheffield and Leeds Art Galleries.

LIT: *First Exhibition of Oil Paintings and Drawings by Francis Butterfield*, exhibition catalogue, Zwemmer Gallery, London, 1934.　CF

BUTTERWORTH, John, NDD, ATD (b. 1945). Painter and printmaker of non-figurative images in a range of media including oils, acrylic, gouache and collage. He studied at Rochdale 1961–3, Newport 1963–5, and Cardiff 1965–6, Colleges of Art, and has exhibited in galleries including Southampton Art Gallery and widely in group exhibitions. His work is represented in collections including the University of Surrey where he exhibited in 1981. He has taught at Southampton College of Higher Education since 1979. Influenced by the process of papermaking, his recent work has used coloured paper pulp and handmade paper, combining elements of letterforms, drawn lines and collage into non-figurative images.
LIT: *5 from the Region*, exhibition catalogue, South Hill Park Arts Centre, Bracknell, Berks, 1980; *Paper Works*, Southampton Art Gallery, Southampton, 1983.　CF

Byam Shaw and Vicat Cole School of Art. This was founded in 1911 by John Liston BYAM SHAW in partnership with REX VICAT COLE, on Campden Hill, Kensington. One of the most influential teachers was ERNEST JACKSON, who was Principal, 1926–40. It has remained a successful private art school as the Byam Shaw School of Art (Farm Lane) and the Byam Shaw School of Drawing and Painting Ltd (70 Campden Street).　AW

BYATT, Edwin, RI (1888–1948). Painter of landscapes, coastal scenes and flowers. He was apprenticed to a lithographer at fifteen and later worked as a commercial artist in the studio of James Haworth & Brother. He exhibited at the RA from 1925 to 1945, at the RI (member 1933), at the ROI, in Liverpool and at the Paris Salon. His work includes paintings of St Ives such as *Low Tide, St Ives Harbour*, RA 1937, as well as flower studies such as *Bowl of Mixed Flowers*, RA 1942.　CF

C

CADDICK, Kathleen (b. 1937). Best known as a printmaker, she studied at High Wycombe 1950–8. She has had exhibitions at Heal's

Mansard Gallery, 1968, 1971 and 1974, and many other galleries nationally since then. her landscapes are typically concerned with the patterns of branches of trees.　AW

CADELL, Francis Campbell Boileau, RSA, RSW (1883–1937). Painter of landscapes, interiors, still-life and figures in oils and watercolours. He studied at the RSA Schools 1897–9, at the ACADÉMIE JULIAN, Paris (on the Advice of ARTHUR MELVILLE), 1899–1903, and in Munich. He established a studio in Edinburgh in 1909, visited Venice in 1910 and made regular painting trips to Iona from 1912. A close friend of PEPLOE who painted with him on Iona, he was a founder member of the Society of Eight in 1912. He first exhibited at the Paris Salon in 1899, at the RSA and SSA from 1902 and held a solo exhibition at Doig, Wilson & Wheatley, Edinburgh, in 1908. He subsequently exhibited regularly in Edinburgh and Glasgow galleries and showed in London galleries from 1923. Elected RSW in 1935 and RSA in 1936, his work is represented in collections including Glasgow Art Gallery and Museum. Before the war he developed the fluid handling and bright colour associated with all the Scottish Colourists but later work became firmer in structure and handling, particularly in interiors and still-life, and used more solid areas of pure colour often painted on unprimed board.
LIT: *Cadell. The Life and Work of a Scottish Colourist*, Tom Hewlett, The Portland Gallery and Bourne Fine Art, Edinburgh, 1988; centenary exhibition catalogue, Fine Art Society, London, 1983; *The Scottish Colourists*, Roger Billcliffe, John Murray, 1989.　CF

CADENHEAD, James, RSA, RSW, NEAC (1858–1927). Painter of landscapes and some portraits in oils and watercolours; etcher and black and white artist. He studied at the RSA Schools and in 1882 at Duran's Atelier in Paris. In 1884 he returned to Aberdeen and settled in Edinburgh in 1891. He exhibited mainly in Scotland at the RSA (ARSA 1902, RSA 1921), at the RSW (RSW 1893) and at the GI, and he also showed at the NEAC (member 1887), in London galleries and in the provinces. His work is represented in collections including Aberdeen Art Gallery. Chairman of the SSA and a committee member of the Scottish Modern Arts Association, his illustrative work appeared in *The Evergreen*. Initially influenced by Cazin and French painting, his later work reflected his interest in Japanese art.

LIT: *Studio*, Vol.48, pp.233–4; 'A Scottish Landscape Painter: James Cadenhead', A. Stodart Walker, *Studio*, Vol.55, pp.10–20.　　CF

CADENHEAD, William, DA, SSA (b. 1934). Painter of landscapes, particularly mountain scenes, in oils and watercolours. He studied at Dundee College of Art 1951–5, and spent the summer of 1955 at Hospitalfield College, Arbroath. In 1956 he travelled in Europe and from 1957 to 1961 he attended the RA SCHOOLS. He held his first solo exhibition in 1958 at the Meffan Institute, Forfar, and he has subsequently exhibited regularly in galleries including The Scottish Gallery, Edinburgh, at the SSA (member 1969), at the RSA and RSW. His work is represented in collections including the Scottish Arts Council and since 1971 he has lectured full-time at Duncan of Jordanstone College of Art, Dundee. He paints on location, responding to changes in light and colour.
LIT: *William Cadenhead*, exhibition card, The Scottish Gallery, Edinburgh, 1983.　　CF

CAFFIERI, Hector, RI, RBA, ROI (1847–1932). Painter of genre, particularly of French fisherfolk, landscapes and flowers in watercolours and oils. Born in Cheltenham, he spent the earlier part of his life in England before settling and working in Boulogne. He studied in Paris under Lefevre and Bonnat and exhibited mainly at the RBA (member 1876) and the RI (member 1885, retired 1920), at the RA from 1875 to 1918, at the ROI (member 1894) as well as in Scotland, London galleries (including the Continental Gallery), the provinces and the Paris Salon. His work is represented in collections including Warrington Museum. He is best known for his delicate, impressionistic studies of fisherfolk such as *Mussel-Gatherers*, RA 1892.
LIT: *Opening Exhibition*, exhibition catalogue, Richard Hagen Ltd, Broadway, Worcs., 1985.　　CF

CALDERON, William Frank, ROI (1865–1943). Painter of figures, portraits, landscapes and sporting subjects in oils; illustrator. He studied at the SLADE SCHOOL under Legros and was the Founder and Principal of the School of Animal Painting in Kensington, 1894–1916. He spent some time in Italy after the First World War. He exhibited mainly at the RA between 1881 and 1923 and also showed at the ROI (ROI 1891), the RBA, RP and GI as well as in London and provincial galleries and at the Paris Salon where

he won a gold medal in 1906. His work is represented in national collections. He contributed to *Black and White*, and illustrated *Reynard the Fox*, Macmillan & Co., London, 1895. He lectured on animal anatomy at the RA SCHOOLS and his work ranged from subject pictures such as *How Four Queens Found Sir Lancelot Sleeping*, RA 1908, to sporting scenes and equestrian portraits.
LIT: *Animal Painting and Anatomy*, William Frank Calderon, London, 1936.　　CF

CALLEREY, Simon (b. 1960). He completed his studies at Cardiff College of Art in 1983, and attracted attention at the WHITECHAPEL OPEN. His first solo exhibition was at the Free Trade Wharf in 1991. He was a prizewinner in the 1993 JOHN MOORES 18 EXHIBITION, and has exhibited in Italy and Germany as well as regularly at Anderson O'Day in London. His large abstracts usually feature soft parallel vertical lines on a subtle ground.　　AW

Camberwell School of Arts and Crafts. Founded in 1898 in Peckham Road, Camberwell, the School had a dramatically successful period immediately after the Second World War, when WILLIAM JOHNSTONE, Principal since 1938, brought together a number of artists who had been associated with the EUSTON ROAD SCHOOL before the war – COLDSTREAM, ROGERS, GOWING, CARTER, TOWNSEND and others – as well as BLOCH, MINTON, ARDIZZONE and VAUGHAN. They and their students had a fundamental influence on the subsequent development of art in Britain.
LIT: *Jubilee – Camberwell School of Arts and Crafts, 1898–1948*, exhibition catalogue, *Camberwell School of Arts and Crafts: Its Students and Teachers 1943–1960*, Geoffrey Hassell, London, 1995.　　AW

Camden Town Group (1911–*c*.1913). A group of the most advanced painters belonging to the FITZROY STREET CIRCLE who, in 1911, set up a formal exhibiting society in face of renewed hostility from the NEAC following the Post-Impressionist Exhibition of 1910. Membership was limited to sixteen and expressly excluded women. Its name, proposed by SICKERT, acknowledged the drab area he frequently featured in his paintings. Leading members, who were experimenting with Post-Impressionist techniques, were SPENCER GORE (President), HAROLD GILMAN, CHARLES GINNER and ROBERT BEVAN. Other diverse talents were WYNDHAM LEWIS,

LUCIEN PISSARRO, AUGUSTUS JOHN and MAXWELL GORDON LIGHTFOOT. Arthur Clifton lent the basement of the Carfax Gallery for the first exhibition in June 1911, and each member was allowed to submit four works (Bevan showed *Cab Yard at Night* and Gore *Stage Sunrise, the Alhambra*). They held two further exhibitions in December 1911 and December 1912, both at the same venue. During 1912 Gore, Ginner and Wyndham Lewis together with EPSTEIN (who joined in 1914), decorated Madame Strindberg's Soho theatre club 'The Cave of the Golden Calf', in a Fauve style. The Group, reabsorbed into the Fitzroy Street Group towards the end of 1913, was involved with selecting an exhibition 'English Post-Impressionists, Cubists and others' at Brighton, 1913–14. This diverse group of very talented men contributed to the foundation of the Modern Movement in Britain.
LIT: *The Painters of Camden Town, 1905–1920*, Christie's exhibition catalogue, 1988; *The Camden Town Group*, W. Baron, Scolar Press, London, 1979. DE

CAMERON, Sir David Young, RA, RSA, RWS, RSW, RE (1865–1945). Painter of landscapes and townscapes in oils and watercolours; etcher and illustrator. Born in Glasgow and associated with the GLASGOW SCHOOL, he first studied art at evening classes before attending the Royal Institution, Edinburgh. He exhibited widely in galleries and societies, particularly at the FINE ART SOCIETY, Connell & Son, the RA, RE, GI and in Liverpool. He was elected RE in 1895, RWS in 1915, RSA in 1918 and RA in 1920 and his work is represented internationally in collections including the TATE GALLERY. From 1917 to 1918 he was an OFFICIAL WAR ARTIST for the Canadian Government. Trustee of the National Gallery of Scotland, the National Gallery and the Tate Gallery, he was knighted in 1924 and in 1933 was appointed the King's Painter and Limner in Scotland. He was awarded an LLD from Glasgow in 1911, Manchester in 1923 and from Cambridge in 1928. Acknowledged as an etcher, particularly of deep-toned Scottish landscapes, his paintings were, like his etchings, influenced by artists such as Rembrandt, Meryon and Whistler and they present a deliberate, unified and clearly constructed image.
LIT: *David Young Cameron: An Illustrated Catalogue of his Etchings and Drypoints*, Frank Rinder, Jackson, Wylie & Co., Glasgow, 1932; *Sir David Young Cameron: Centenary Exhibition*, catalogue, Arts Council, 1965; 'The Paintings of

D.Y. Cameron', A. Stodart Walker, *Studio*, Vol.LV, p.255. CF

CAMERON, Katharine, RSW, ARE, FRSA, CIAL (1874–1965). Painter of flowers, figures and landscapes in watercolours and gouache; etcher and book illustrator. Sister of DAVID YOUNG CAMERON, she studied at GLASGOW SCHOOL OF ART under NEWBERY and at the ATELIER COLAROSSI, Paris, under Courtois and Prinet in 1902. She exhibited at the RSA from 1894 and at the RA from 1921, showed widely in London, Scotland and Liverpool, and was elected RSW in 1897, ARE in 1920 and FRSA in 1950. Her work is represented in collections including the TATE GALLERY. Influenced by the GLASGOW SCHOOL and by Japanese prints, she contributed to *The Yellow Book* in 1897, illustrated fairy stories and romantic subjects, many for the publishers T.C. and E.C. Jack (Edinburgh), and executed delicate flower studies.
LIT: 'The Romantic Watercolours of Miss Cameron', H.C. Marillier, *Art Journal*, 1900, p.149. CF

CAMP, Jeffery Bruce, RA, LG (b.1923). Painter of figures and landscapes in oils. He studied at EDINBURGH COLLEGE OF ART 1914–44, winning a Travelling Scholarship and the David Murray Bursary. His first solo exhibition was in 1959, BEAUX ARTS GALLERY, and he has since exhibited in numerous London galleries. His work appears in many public collections. He was elected member of the LONDON GROUP 1961, and he taught at the SLADE SCHOOL 1963–74. In early work he evoked a dream-like atmosphere in a technique which he called touch painting. Sometimes using shaped canvases with painted borders, from 1969 images of cliffs and figures frequently appeared and this conjunction of nudes with landscape created an imaginative and fantastic language, a quality which continued in paintings of London and of Venice. In these works elongated strokes swirl across the canvas, revealing form and establishing an atmospheric colour harmony.
LIT: See his book *Draw: How to Master the Art*, André Deutsch, 1981; catalogue, Royal Albert Memorial Museum, Exeter, 1988. CF

CAMPBELL, Catriona (b. 1940). Painter. She studied at GLASGOW SCHOOL OF ART 1957–61, and her teachers included her father, IAN CAMPBELL and David Donaldson. While a student she won the Somerville Shanks Prize for portraiture, and since has been awarded the Scottish

Society of Women Artists Founder's Prize and the Anne Redpath Award. She exhibits regularly at the RSA, the GI and the RP; her work is in public and private collections world-wide. Active as a portrait painter, she treats a wide range of observed subjects, almost always in oils, in the tradition of the SCOTTISH COLOURISTS. She is a particularly enthusiastic recorder of scenes from the world of horse racing. AW

CAMPBELL, George F., RHA (1917–1979). Painter of a wide variety of subject matter including landscapes and figures in oils and water-colours; stained glass designer. Born in Arklow, Ireland, he was educated in Belfast and Dublin and studied at La Grande Chaumière, Paris. He exhibited at the RHA, in Dublin galleries including the Ritchie Hendriks Gallery, in London, Belfast, New York, Boston, Spain and South Africa. His work is represented in collections including Dublin Municipal Gallery and his stained glass designs included work for Galway Cathedral. His expressive, figurative paintings depict Irish and Spanish subjects.
LIT: Exhibition catalogue, Arts Council Gallery, Belfast, 1973. CF

CAMPBELL, Ian (1902–1984). Painter. He was trained at GLASGOW SCHOOL OF ART 1921–26, taught by MAURICE GREIFFENHAGEN, the final year being Diploma. As a student he was award-ed the Haldane Travelling Scholarship. He taught at various schools in Glasgow, and after-wards, 1937–68, at Dollar Academy, Clackmannonshire. He exhibited at the RA, the ROI, the RSW, the RSA (where in 1931 he won the Guthrie Award), at the Royal Glasgow Institute and the SSA. His portraits, for which he is best known, were sensitive and straightforward (The National Portrait Gallery has a drawing of Archbishop Cosmo Lang), and his accomplished, romantic figure compositions often treated of recondite themes. AW

CAMPBELL, Steven (b. 1954). A painter, he studied at GLASGOW SCHOOL OF ART 1978–82, after having been a steel works engineer. He exhibited first at Barbara Toll Fine Arts, New York, in 1983, and lived five years in New York before returning to Glasgow. His bizarre, Surrealist allegories are boldly figurative, and often based on literature. AW

CAMPION, Oliver (b. 1928). Painter of land-scapes, still-life and portraits in oils. He studied

at the CENTRAL SCHOOL OF ART and at the SLADE SCHOOL. He has held solo exhibitions at the MAYOR GALLERY and at the NEW GRAFTON GALLERY where he has exhibited since 1975. His work is represented in collections including the City of Leicester and University College, London. His rich and colourful works include landscapes of France and still-life subjects. CF

CANNEY, Michael Richard Ladd (b. 1923). Painter of landscapes, coastal subjects, still-life, portraits and abstracts in oils and alkyd; con-structivist, collagist and maker of reliefs; broad-caster and writer on art. Born in Falmouth, between 1940 and 1942 he studied at Redruth and Penzance Schools of Art and at St Ives School of Painting. He met NICHOLSON, HEPWORTH, Gabo and Leach; between 1947 and 1951 he studied at GOLDSMITHS' COLLEGE OF ART and got to know KENNETH MARTIN who influenced his reliefs. He subsequently studied at Hospitalfield, Arbroath, and worked with DENIS MITCHELL in St Ives. Secretary of Newlyn Society of Artists and Curator of Newlyn Art Gallery, 1956–64, in 1984 he settled in Italy. He has exhibited regu-larly in Cornwall, the provinces and abroad and solo exhibitions include those at the Newlyn Art Gallery in 1983, and the Belgrave Gallery, London, in 1990. His work is represented in col-lections including Plymouth Art Gallery. From 1965 to 1966 he was Gallery Director and Lecturer at the University of California, Santa Barbara, and from 1966 to 1983 he lectured at the West of England College of Art, Bristol. His early figurative work showed the influence of Cubism and in the 1950s he started to make reliefs and his work became progressively more abstract. From the 1970s it has been based on constructivist principles and on divisions of the square.
LIT: Catalogues for the Newlyn Art Gallery, 1983, and the Belgrave Gallery, London, 1990; *Constructivist Forum*, No.8, February 1989, p.20. CF

CARDER, Malcolm (b. 1936). Artist working in collage, drawing and a variety of media including ink on film. He studied at Kingston College of Art 1955–9, and has exhibited in London gal-leries and internationally. His work is represent-ed in public collections. He has taught at Plymouth and Farnham colleges of art and at Portsmouth School of Architecture. His work explores ideas for non-verbal communication systems. CF

CARLINE, George F., RBA (1855–1920). Painter of landscapes, genre and portraits in oils and watercolours. Father of SYDNEY, HILDA and RICHARD CARLINE, he studied at HEATHERLEY'S in 1882, at Antwerp and at the ACADÉMIE JULIAN, Paris, in 1885. He worked in Switzerland and Italy and exhibited mainly at the RBA (member 1904) and at the Dowdeswell Gallery where in 1896 he held an exhibition entitled 'The Home of our English Wild Flowers'. He also showed at the RA from 1886, at the RI, ROI, RP, in Scotland and the provinces. His work is represented in collections including the V & A. He produced illustrations for books, e.g. *Oxford* by Andrew Lang, 1915, and his work includes delicate genre figures such as *An Apron Full of Meadow Flowers*, 1890 (ROI 1891). Later he was influenced by impressionism and made some experiments with non-figurative images.
LIT: *The Carline Family*, exhibition catalogue, LEICESTER GALLERIES, London, 1971. CF

CARLINE, Hilda Anne (1889–1950). Painter of landscapes in oils. Daughter of GEORGE F. CARLINE, she studied at Tudor-Hart's school in Hampstead and in 1918 at the SLADE SCHOOL where she won prizes in painting. In 1919 she met STANLEY SPENCER whom she married in 1925. In 1937 they were divorced and later her health deteriorated. She exhibited between 1920 and 1944 at the NEAC, at the Baillie and Goupil Galleries and between 1935 and 1944 at the RA. Her work is represented in collections including Preston Art Gallery. Her earlier, painterly work was influenced by Post-Impressionism and Expressionism, using strong colour and simplified forms; later she was influenced by Stanley Spencer and her work also became more poetic in mood.
LIT: *The Carline Family*, exhibition catalogue, the LEICESTER GALLERIES, London, 1971; *The Spencers and the Carlines*, exhibition catalogue, the Morley Gallery, London, 1980 and touring. CF

CARLINE, Nancy (b. 1909). She was born in London, and attended the SLADE SCHOOL under TONKS and GWYNNE-JONES, and worked at Sadlers Wells, 1933–5, later studying stage design with VLADIMIR POLUNIN. She has exhibited with the LONDON GROUP, the AIA, the NEAC and at the RA. She went to the EUSTON ROAD SCHOOL and married RICHARD CARLINE.
LIT: *Nancy Carline*, exhibition catalogue, Camden Arts Centre, 1985. AW

CARLINE, Richard, NEAC, LG (1896–1980). Painter of landscapes, aerial views and figures in oils and watercolours. Brother of SYDNEY CARLINE, he studied in Paris and at the SLADE, exhibiting mainly at the NEAC and the Goupil Gallery. He was an OFFICIAL WAR ARTIST recording the war from the air in France and the Middle East. His forceful paintings employed formalized and repeated shapes, e.g. *Seashore*, 1920 (TATE GALLERY).
LIT: *Richard and Sydney Carline*, catalogue, IMPERIAL WAR MUSEUM, 1973; *Draw They Must: A History of Teaching and Examining of Art*, Richard Carline, London, 1968. CF

CARLINE, Sydney William, LG (1888–1929). Painter of landscapes, aerial views and portraits; medallist, etcher and illustrator. Brother of RICHARD CARLINE, he studied at the SLADE under TONKS 1907–1910, meeting NEVINSON, WADSWORTH, GERTLER and STANLEY SPENCER. In Paris in 1912 he was influenced by the Cubists. From 1920 he exhibited at the Goupil Gallery and also showed at the NEAC, RA, LG and in the provinces. His work is represented in public collections. He was an OFFICIAL WAR ARTIST with the RAF recording war as seen from the air, and Master of RUSKIN SCHOOL, Oxford 1922–9. His war paintings explore the compositional possibilities of aerial views, whilst his landscapes reveal his sense of drama, e.g. *The Trail of War*, 1919 (York City Art Gallery).
LIT: *Richard and Sydney Carline*, catalogue, IMPERIAL WAR MUSEUM, 1973. CF

CARPANINI, Professor David Lawrence, RBA, RWA, RE, NEAC, RCA (b. 1946). Painter and printmaker. He was born in Abergwynfi, Glamorgan, and trained at Gloucester College of Art, the RCA and Reading University. His first solo exhibition was at the John Hansard Gallery at the University of Southampton in 1972. Two television films have been made about his work (one being *David Carpanini* HTV, 1987) which powerfully evokes the villages and chapels of the valleys of South Wales (The *St Gabriels* series, 1997, for example). In 1995 he became President of the ROYAL SOCIETY OF PAINTER-PRINTMAKERS.
AW

CARR, Henry Marvell, RA, RP, RBA, ARCA (1894–1970). Painter of portraits and landscapes in oils and watercolours; author. He attended Leeds College of Art under Haywood Rider where fellow students included HENRY

MOORE, and the RCA under ROTHENSTEIN. He exhibited at the RA, becoming a member in 1966, at the NEAC, RP and RBA, as well as London and provincial galleries. He taught at Beckenham Art School for many years, becoming Principal in the 1930s. From 1942 to 1945 he was an OFFICIAL WAR ARTIST, painting a series of generals including Eisenhower. In 1956 he was awarded a gold medal at the Paris Salon. Primarily a portraitist, his sitters included King Feisal and Admiral Cunningham, and his work captures the energy and spirit of his subjects. His less formal paintings range from studies of his children to loose, fluid and technically confident watercolours.
LIT: See his own book *Portrait Painting*, 1952; memorial exhibition catalogue, Zaydler Gallery, 1972. CF

CARR, Thomas, ARWS, NEAC (b. 1909). Painter of landscapes and figures in oils and watercolours, He studied under TONKS at the SLADE and worked in Italy. In 1936 he exhibited with PASMORE and ROGERS and he also showed in the 1941 EUSTON ROAD Group Exhibition. He exhibited at the RA, RWS and NEAC as well as London galleries. A particular friend of GRAHAM BELL, they painted together in Dublin and Dover and influenced each other's work. His paintings range from lyrical landscapes to scenes which reflect both Impressionism and the Euston Road School. He experimented with abstraction but returned to figure painting.
LIT: Retrospective exhibition catalogue, Arts Council of Northern Ireland, 1983. CF

CARRINGTON, Dora (1893–1932). Painter of portraits, landscapes and figures in oils; decorator and wood engraver. She studied at the SLADE under TONKS and BROWN 1910–14, where she met NEVINSON AND GERTLER. From 1917 she lived with Lytton Strachey and in 1921 she married Ralph Partridge. Associated with the Bloomsbury Group, she exhibited at the NEAC, designed for the Hogarth Press and later concentrated on decorative work. Influenced by those she knew, including Tonks, NASH and Gertler, her best work was produced whilst living with Strachey. Her portraits sensitively convey her sitter's character, e.g. *Lytton Strachey Reading*, 1918, whilst her landscapes show naivety of presentation and form.
LIT: *Carrington: Paintings, Drawings and Decoration*, N. Carrington, 1978; *Carrington*, Gretchen Gerzina, OUP, 1990. CF

CARRINGTON, Leonora (b. 1917). Painter of Surrealist figures and subjects in oils and tempera, writer. She was born in Lancashire and studied at the Academy opened by Ozenfant in London 1936. She was in London during the first International SURREALIST Exhibition and a year later, 1937, she met Max Ernst and went with him to Paris, exhibiting with the Surrealists there in 1938. Since then she has exhibited in all the major Surrealist exhibitions. With the German invasion of France and the internment of Ernst she went to Spain where she suffered a breakdown. Her account of this was published in 1943 entitled *En Bas*. In 1939 she moved to New York and later settled in Mexico, becoming a Mexican citizen in 1942. In 1944 she met EDWARD JAMES and from 1948 she has exhibited internationally. In 1975–6 a retrospective exhibition of her work took place in New York. From 1939 she published stories which created an imaginary, fantastic world and her name appears frequently in Surrealist publications, her work being published in *View* and *VVV*. She has also published novels. Her paintings create a separate world peopled by strange figures represented with discrepancies of scale and a Bosch-like sense of the fantastic. Her early work, admired by Breton and Eluard, is brightly coloured, and often in tempera which gives a Flemish character to the rocky landscapes and cities that she painted. Later work is darker, employing jewel-like colours in smaller areas.
LIT: Retrospective exhibition catalogue, Center for Inter-American Relations, New York, 1976; the Artist's own writings. CF

CARSTAIRS, John Paddy (1916–1970). Painter of figures and townscapes in watercolours, tempera, gouache and oils; novelist and film director. Educated at Repton, London University and the SLADE SCHOOL of Art, he had his first London exhibition in 1949 and he subsequently exhibited at major London galleries including the REDFERN, Leger and John Whibley galleries. He also showed at the RA, RBA, at the Paris Salon and in the provinces, and his work is represented in public collections. Many of his subjects are scenes of the South of France and the crowded streets and ports that he shows echo Dufy in their combination of colour and line. Similar preoccupations are evident in his English scenes such as *At the Races*, 1951. Some paintings display a greater simplicity of form and flattening of space, so giving a naive quality to his work, e.g. *Venice*, 1970.
LIT: Catalogue, John Whibley Gallery, 1970. CF

CARTER, B.A.R. (b. 1909). Painter of figures, landscapes and still-life in oils. He first studied modern languages before attending the CENTRAL SCHOOL OF ARTS AND CRAFTS 1932–4, and the EUSTON ROAD SCHOOL 1938–9. He exhibited with the LG from 1948 and his work is represented in public collections. He taught at CAMBERWELL SCHOOL OF ART 1945–8, at the SLADE from 1949 and was subsequently appointed Professor of Perspective, RA SCHOOLS. He has published on the history, theory and practice of perspective. His paintings are not unlike those of COLDSTREAM, although reference marks are usually painted out, his approach being in the Euston Road tradition of unsensational realism, e.g. *Nude Model, c.*1961 (TATE GALLERY). His concern with perspective is reflected in subjects such as *Roofs at Swiss Cottage,* 1952, ARTS COUNCIL Collection.
LIT: *The Euston Road School,* Bruce Laughton, Scolar Press, 1986. CF

CARTER, Frederick, ARE (1885–1967). Painter, writer, etcher and wood engraver. Born in Bradford and initially trained as a civil engineer, he abandoned that profession in favour of art. He studied in Paris, Antwerp and in London under SIR FRANK SHORT. He exhibited regularly at the RA. His technically brilliant etchings range in subject from esoteric and morbid *fin de siècle* symbolism (*The Embankment,* or *The Sphinx,* 1910), to SICKERT-influenced works like *Augustus John and William Nicholson at the Café Royal* (1926). He etched some portraits in the 1930s, including a notable one of D.H. Lawrence, for whom he illustrated *Apocalypse.* He wrote a number of articles on art and symbolism, and *The Dragon of the Alchemists* 1926.
LIT: 'Frederick Carter', H. Furst, *Print Collector's Quarterly,* Vol. XX, 1933, p.347. AW

CARTER, John (b. 1942). An artist who works between painting and sculpture, he attended Twickenham School of Art 1958–9, Kingston 1959–63, and in 1963 was awarded a Leverhulme Scholarship to travel to Italy; he stayed in the BRITISH SCHOOL AT ROME in 1964. His first solo exhibition was at the REDFERN GALLERY in 1968. He was for a period assistant to the painter and sculptor BRYAN KNEALE, and in 1981 he was a prizewinner in the Tolly Cobbold exhibition. He has taught at CHELSEA and at the University of Reading, and has exhibited widely, nationally and internationally. His abstract constructions have mostly been geometric, wall-mounted reliefs with colour playing a major role, and with acrylic mixed with marble powder contributing to the ambiguity of their status as paintings or sculpture, as well as to their subtle interplay of intersecting forms. AW

CARTER, William, RP, RBA (1863–1939). Painter of portraits, animals and still-life in oils, artist in chalk and charcoal. Son of the animal painter Samuel John Carter and brother of Howard Carter the Egyptologist, he studied at the RA SCHOOLS where he won many awards. He exhibited mainly at the RA between 1883 and 1938 where he showed mostly portraits, and he also exhibited at the RBA (member 1884), the RP (member 1915), the LS, NEAC, in some London galleries, in Liverpool and at the Paris Salon between 1889 and 1908. His work is represented in collections including the TATE GALLERY (*The Refectory Table,* purchased by the CHANTREY BEQUEST in 1937). CF

CASBOLT, Wyn (1915–1963). Painter in oils and gouache; printmaker and pen artist. She studied at the SLADE under SCHWABE and NORMAN JANES and exhibited at the WIAC, at the REDFERN GALLERY, Newbury Art Society and in Holland. CF

CASSON, Sir Hugh Maxwell, CH, KCVO, MA, RA, RDI, RIBA, FSIA, Hon. Dr. RCA (b. 1910). Architect and painter of architecture in watercolours; environmental and theatre designer; illustrator, author and lecturer. He studied architecture at Cambridge, the British School in Athens and the Bartlett School, University College, London. He has exhibited at the RA (becoming President in 1976), in London and provincial galleries. From 1948 to 1951 he was Director of Architecture, Festival of Britain, and from 1953 to 1975, Professor of Environmental Design, RCA. Knighted in 1952, KCVO in 1978 and CH in 1985, he has been concerned with numerous conservation and Fine Art bodies and closely associated with exhibition and festival design. His watercolours have an elegant simplicity, conveying scenes with pale washes of colour and touches of sharp line.
LIT: *Hugh Casson's Oxford,* Phaidon, 1988. CF

CAST, Jesse Dale, RP (1900–1976). He studied at the School of Building, Brighton 1914–17, then 1917–20 attended life classes at ST MARTIN'S and at CAMBERWELL, whilst working for Maples, the furniture store. From 1922–6 he went to the SLADE, where he won many prizes.

He lived in Bruges, and then in Majorca 1926–30, later teaching at Harrow, at the CENTRAL and at Hornsey until his retirement. His precise, severe draughtsmanship served him as a brilliant portraitist; *Miss Beatrice M. Dale Cast* (1950 and *c.* 1964) is in the TATE. AW

CAULFIELD, Patrick, RA (b. 1936). Painter of interiors and still-life in acrylic, gloss paint and oils; printmaker. He studied at CHELSEA SCHOOL OF ART 1956–9, and at the RCA 1959–63. In 1965 he had his first solo exhibition at the Robert Fraser Gallery and has subsequently exhibited nationally in leading galleries, including Waddington Galleries from 1969. He has exhibited internationally and in numerous group exhibitions both here and abroad. In 1981, a retrospective exhibition of his work was held at the TATE GALLERY. He has taught at Chelsea School of Art since 1963 and in 1965 he was awarded 'Prix des Jeunes Artistes' (Graphics), Paris Biennale. In response to Pop Art he sought his own European-based range of imagery concerned with visual clichés and commonplace objects, sometimes with exotic touches. Influenced by Léger and Stuart Davis he evolved a style that reflected his search for a precise and objective language, e.g. *Santa Margherita Ligure*, 1964, with its flat colour areas, absence of modelling or shadow and use of black outlines. Later paintings showed complete interiors containing familiar objects and popular décor and these works combined flat colour and even surface tension with perspectival description and precise light. Recent works show greater complexity using styles in an objective manner so that the technique of paintings such as *Still-Life: Maroochydore*, 1980–1, ranges from details of photo-realism to flat, outlined patterns and shapes.
LIT: Retrospective exhibition catalogue, Tate Gallery, 1981; *Patrick Caulfield*, Christopher Finch, Penguin Books, 1971. CF

Central School of Arts and Crafts. Conceived by the London County Council's Technical Education Board, it opened in 1896 under the direction of the sculptor George Frampton and the architect W.R. Lethaby (both members of the ART WORKERS' GUILD). Lethaby was appointed Principal in 1902. All courses were at first in Applied Art and were part-time. Distinguished teachers have included Cockerell (bookbinding), GILL (sculpture and engraving), Johnston (lettering), May Morris (embroidery)

and Wilson (metalwork). In 1908 the School moved from Regent Street to its present building, designed by W.E. Riley, in Southampton Row. Many distinguished graduates in Fine and Applied Art have maintained its status to the present day. It is now part, with ST MARTIN'S, of the London Institute. AW

CHADWICK, Ernest Albert, RI, R.Cam.A., RBSA (1876–1955). Painter of landscapes and flowers in watercolours; draughtsman and wood engraver. Son of John William Chadwick, he studied at Birmingham Municipal School of Art and exhibited mainly in Birmingham, at the RA, RCA, RI and at Walkers Gallery, London. He became RBSA in 1912, R.Cam.A. in 1929 and RI in 1939. His watercolour style was detailed and realistic but not hard. Work such as *The Harbour, Mousehole, Cornwall* (City of Birmingham Art Gallery), show the sense of structure underlying his work and its gentle appearance. CF

CHADWICK, Tom (1915–1942). Wood engraver and watercolourist. He studied at the GROSVENOR SCHOOL and later taught at the WESTMINSTER SCHOOL OF ART, where the latest developments in modern art were encouraged. He travelled to Italy and Spain in the 1930s, sources of much of his imagery. AW

CHAIMOWICZ, Marc Camille (b. 1945). Performance and installation artist usually working with photographs, video, text and everyday objects. Born in Paris, he studied at Ealing, CAMBERWELL and the SLADE Schools of Art. He has appeared in one-man shows and group exhibitions nationally and internationally. Both his performances and his more object-orientated work invite the spectator to question fundamental beliefs about experience and creativity.
LIT: *Past Imperfect: Marc Camille Chaimowicz*, Jean Fisher, 1983. CF

CHAMBERLAIN, Brenda (1912–1971). Born in Bangor, Wales, she studied at the RA SCHOOLS 1931–6. She worked in Wales for most of her life, apart from living on the Island of Hydra, 1962–7. She exhibited at GIMPEL FILS (1950–5) at ZWEMMER'S (1962) and had touring exhibitions with the Welsh Arts Council.
LIT: *Brenda Chamberlain*, exhibition catalogue, Mostyn Art Gallery, Llandudno, 1988. AW

CHAMPNEYS, Walpole (1879–1961). Born in Surrey, he studied at Teddington School of Art

(1906–07), then at the SOUTH KENSINGTON School of Art (1907–10). He also studied anatomy at King's College Hospital (1910–11), and met WALTER BAYES and ROBERT BEVAN at Life classes at Bolt Court. He designed book jackets and covers, and posters for London Transport, before undertaking mural decorations for churches, cinemas and the British pavilion of the *Exposition des Arts Décoratifs* of 1925 in Paris, following his appointment as Master of the Decorative Course at the Architectural Association (1923–7). He was a consultant on the interior design of the Shakespeare Memorial Theatre, Stratford, and designed the drop-curtain in a cubist style. Whilst carrying out these and other major public commissions, he painted small watercolours of seascapes and architectural subjects, as well as occasional figure compositions, his approach being imbued with cubist and Surrealist formal abstraction.

LIT: Catalogue of the retrospective exhibition at the Minories, Colchester, 1977.　　　　AW

CHANDRA, Avinash (b. 1931). Painter of townscapes and figures in oils, watercolours and ink; designer of murals and glass sculpture. He studied at Delhi Polytechnic 1947–52, and in 1956 settled in London. He has exhibited widely and his work is represented in many public collections. He taught at Delhi Polytechnic 1953–6, and in 1954 won first prize in the National Exhibition of Art, New Delhi. His paintings are grounded in Indian art. Early work showed complex townscapes portrayed in semi-geometric shapes and hot colour. Subsequent work became freer with sensual, erotic forms conveyed by flowing, energetic lines.

LIT: The catalogue for his exhibition at the Lyttleton Theatre, London, 1982; 'Conversation with Avinash Chandra', *Third Text* (UK), n. 3–4, 1988.　　　　CF

The Chantrey Bequest. The sculptor Sir Francis Chantrey (1781–1841) desired to establish 'A public national collection of British Fine Art in Painting and Sculpture executed within the shores of Great Britain'. He left, in the terms of his will, investments totalling some £105000 to be administered, after the death of his wife, by five Trustees, two of whom were to be the President and the Treasurer of the RA. The aim was to purchase works of art for the nation: it was hoped that a special gallery would be built, but this has never happened. Trustees of the Royal Academy are still responsible for the selection of works, and those of the TATE GALLERY for their preservation and exhibition, a relationship which has occasionally given rise to tensions, although today the Trustees of the Tate have an informal influence on the choice of works purchased. Chantrey's will did not stipulate that the work had to be by British born artists, and so a Derain, for example, has been bought, as have works by most leading British artists working since 1877, when the first purchases were made.

LIT: *Within These Shores: A Selection of Works from the Chantrey Bequest, 1883–1985*, exhibition catalogue, Tate Gallery, 1989.　　　　AW

CHAPLIN, Stephen (b. 1934). Painter in oils of semi-abstract scenes based on everyday events. He studied at the SLADE SCHOOL and the COURTAULD INSTITUTE OF ART 1952–8, and became Lecturer in Art History, Leeds University 1966, and Visiting Fellow in Painting, Newcastle University. He has exhibited in London and in the provinces. His paintings are concerned with the way people's lives shape their surroundings and the games that they play in measured enclosures.　　　　CF

CHAPMAN, George (b. 1908). Etcher. Attended Gravesend School of Art, and later worked for Jack Beddington at Shell, and for London Transport. He undertook further training at the SLADE and the RCA. During the 1950s he made his first etching with MICHAEL ROTHENSTEIN at Great Bardfield; his first one-man show was at the PICCADILLY GALLERY in 1956. His flat, formal, strongly textured style was applied to scenes of Welsh mining; the *Rhondda Suite* was commissioned by Robert Erskine. A BBC *Monitor* film was made on him 1960–1.　　　　AW

CHAPMAN, Max (b. 1911). Painter of abstracts, portraits and figurative subjects in oils and emulsion; printmaker, collagist, art critic and illustrator. He trained at the BYAM SHAW SCHOOL 1927–30, under ERNEST JACKSON, RICKETTS and SHANNON, winning a travelling scholarship to Italy in 1930. From 1936 he frequently worked in Newlyn and he held his first solo exhibition in 1939 at the Storran Gallery, subsequently exhibiting in London galleries (including the Camden Arts Centre), at the LG, RA, RBA, GI, in Paris and in group exhibitions and most recently he has been associated with the Belgrave Gallery. After the war he worked in paper collage and wash and his non-figurative work was influenced by Abstract Expressionism, particularly by Jackson Pollock. In the 1970s he also produced portraits and small figurative paintings.

LIT: Article in *North London Press*, 23 August 1968; exhibition catalogue, Camden Arts Centre, London, 1981; exhibition review in *Arts Review* (UK), Vol.33, No.24, 4 December 1981. CF

CHARLTON, Alan (b. 1948). Minimalist painter working in acrylic on canvas. He trained at Sheffield, CAMBERWELL and the RA SCHOOLS and has exhibited at Nigel Greenwood Gallery and the Lisson Gallery. He has shown internationally and is represented in public collections. His work, often in series, ranges from incised canvases to 'line' and 'panel' paintings, sometimes in tonal gradations of the same colour.
LIT: The catalogue for Palais des Beaux-Arts de Charleroi, 1988. CF

CHARLTON, Evan (1904–1984). Painter of figures, landscapes and interiors in oils. After studying chemistry at UC London, he attended the SLADE SCHOOL under TONKS, STEER and SCHWABE 1930–3. His first solo exhibition was in 1934 at Paleer Gallery and he subsequently exhibited at the NEAC, in London, Wales and the provinces. His work appeared in many group shows and public collections. Retrospective exhibitions took place at the National Museum of Wales 1975, and Newport Museum and Art Gallery 1981. He taught at the West of England College of Art, 1935–8, and was Head of Cardiff School of Art 1938–45. After work as a war artist he became HM Inspector of Art in Wales and Staff Inspector in England and Wales from 1945 to 1966. He was married to the artist FELICITY CHARLTON. His paintings create a personal world composed of reassembled pieces of reality. Rich interiors, architecture and figures, often of young women, are painted in traditional techniques with great use of glazes. His semi-surreal scenes create a realistic illusion which expressed the tensions of the age.
LIT: *Last Paintings*, exhibition catalogue, National Museum of Wales, 1985. CF

CHARLTON, Felicity (b. 1913). Painter of landscapes, figures and interiors in oils. She studied at the West of England College of Art 1932–7, and has exhibited at the RWA and widely in Wales. Her work is represented in collections including the National Museum of Wales. Her paintings present evocative and poetic scenes in which figures and their environment create particular moods and a sense of a personal reality.
LIT: *Evan and Felicity Charlton. Recent Paintings*, exhibition catalogue, Oriel Gallery, Cardiff, 1981. CF

CHARLTON, George J., NEAC (1899–1979). Painter of landscapes, coastal scenes and genre in oils and watercolours; draughtsman and illustrator. He won a scholarship to the SLADE SCHOOL in 1914 and from 1917 to 1919 served in France. He painted in Holland in the 1920s and subsequently worked widely in England, particularly at Leonard Stanley, Gloucestershire. A friend of GERTLER, STANLEY SPENCER and SCHWABE, he exhibited mainly at the NEAC from 1916 (member 1926, Hon. Treasurer 1958) and at the REDFERN GALLERY where he held his first solo exhibition in 1924. He also showed in London galleries including the BEAUX ARTS in 1951, and in the provinces. He taught at the Slade, 1919–62, and at Willesden School of Art. His main preoccupations were the depiction of the English scene with wit and characterization and landscape painting which showed the influence of Pissarro and Sisley. His drawing *Elephants* (*c*.1924) is in the TATE.
LIT: *The English Scene. Watercolours by George Charlton*, exhibition catalogue, Beaux Arts Gallery, London, 1951; retrospective exhibition catalogue, Highgate Gallery, London, 1982. CF

CHASE, Michael (b. 1915). Painter of landscapes in watercolours. Son of William A. Chase, he started painting in the late 1940s, attending evening classes at Hornsey, the CENTRAL and CHELSEA Schools of Art 1948–51; he then stopped painting in the late 1950s, resuming again in 1976. He has exhibited in galleries since 1951, including Anthony Dawson, London, in 1979 and 1981, and at the RA and his work is represented in collections including the Graves Art Gallery, Sheffield. From 1966 to 1974 he was Curator of The Minories, Colchester, and he was married to the artist VALERIE THORNTON. Influenced by PAUL NASH, his expressive work uses watercolour in a bold, painterly manner reflecting the patterns and forces of nature.
LIT: *Michael Chase, Paintings in Watercolour*, exhibition catalogue, Anthony Dawson, Barnes, London, 1979; *Michael Chase, Paintings in Watercolour*, The Minories, Colchester, 1981. CF

CHEESE, Bernard, RE (b. 1925). Lithographer. Studied at the RCA 1947–50, and became Secretary of the SENEFELDER CLUB in 1951. He taught printmaking at ST MARTIN'S, GOLDSMITHS' and the CENTRAL schools of art. Many of his atmospheric cameos of modern life have affinities with the approach and subject-matter of

SICKERT. His works are in many public collections, including Leeds City Art galleries.　AW

CHEESE, Chloë (b. 1952). Painter of still-life in watercolours, pastel, crayon and ink; printmaker and illustrator. She studied at Cambridge School of Art 1970–3, at the RCA and in Paris 1973–6. A friend of EDWARD BAWDEN, she has exhibited in London galleries including the CURWEN and Thumb Galleries, in Japan and in group exhibitions; her work is represented in collections including Sheffield City Art Gallery. Her awards include the Lloyds Printmakers Prize, 1981. Her elegant, understated work has been influenced by Oriental art and life.
LIT: 'Cheese goes Japanese', *Honey*, (UK), June 1981, p.61; 'Chloë Cheese', interview, *Arts Review* (UK), Vol.31, pt.18, 14 September 1979, p.471.　CF

CHEESMAN, Harold, RWS, FRSA (1915–1982). Born in Rye, he studied at Hastings School of Art 1932–5, and at the RCA 1935–8. He was awarded a Postgraduate Year at the RCA. From 1940 to 1946 he served in the army, and was commissioned in 1943. In 1946 he was appointed to the staff of Farnham School of Art; subsequently he became Head of Painting, Head of Fine Art, and eventually, Vice-Principal. He retired from teaching in 1978. He exhibited at ZWEMMERS in 1958, 1961 and 1964, and in many group shows (RA, NEAC). Landscape painting in oils, watercolour and gouache became an almost exclusive preoccupation, evoking, in closely related tones, the countryside of the Surrey/Hampshire border. His work is in the TATE GALLERY, the IMPERIAL WAR MUSEUM and the City Art Galleries of Eastbourne, Nottingham, Plymouth and Melbourne, Australia.
LIT: Statement in retrospective exhibition catalogue, West Surrey College of Art and Design, November 1980; William Calvert, *Art News & Review*, Vol.10, Sept. 1958.　AW

The 'Chelsea Art School'. A joint venture by WILLIAM ORPEN and AUGUSTUS JOHN, it opened in 1903 at Nos 4 and 5 Rossetti Studios in Flood Street. Jack Knewstub (a brother-in-law of Orpen's, and a son of Rossetti's assistant) acted as secretary and general manager. It was open to both sexes, for three terms a year, with classes in Drawing and Painting from Life, Still-Life, Figure Composition, Landscape and Decorative Painting. Gwen Salmond acted as 'Lady Superintendent', and other ex-SLADE people were brought in to give lectures and demonstrations. It was not a financial success; by 1907 John's interest in it had faded and the School faded away also.　AW

Chelsea School of Art (also formerly Chelsea Polytechnic) was founded in 1882, and is now Chelsea College of Art and Design, and part of the LONDON INSTITUTE along with CENTRAL and ST MARTIN'S. The Fine Art studios are situated in Manresa Road, and a policy of employing distinguished practising artists has been traditional. Among former students were PAUL NASH, and later PATRICK CAULFIELD and JOHN BERGER; former teachers have included HENRY MOORE, GRAHAM SUTHERLAND and HOWARD HODGKIN.　AW

CHESTON, Charles Sidney, RWS, RE, NEAC (1882–1960). Painter of architecture and landscapes in watercolours and oils, etcher. He studied at the SLADE SCHOOL 1899–1902, and exhibited at the NEAC from 1910, becoming a member in 1916. In 1929 his first one-man show was at Colnaghi & Co. and he also exhibited at AGNEW & SONS and the Alpine Club Gallery. He became ARE in 1927 and RWS in 1933 and his work is represented in public collections including the TATE GALLERY. His etchings show a Rembrandtesque range of tone and texture whilst his paintings of French, Italian and English scenes vary from precise articulation of town scenes to evocative and atmospheric views, e.g. *Autumn Afternoon, Durham* (Trustees of RSW).
LIT: 'The Etchings of C.S. Cheston', *Print Collector's Quarterly*, XVI, 1929, p. 287.　CF

CHESTON, Evelyn, NEAC (1875–1929). Painter of landscapes and some flowers in oils and watercolours. Born in Sheffield, née Davy, she attended the Royal Female School of Art 1892–4, the SLADE SCHOOL 1894–9, and classes given by Walter W. Russell in 1902. In 1904 she married CHARLES CHESTON and she exhibited mainly at the NEAC from 1906 (member 1908), as well as at London galleries, the IS and in Manchester. Her work is represented in the TATE GALLERY. Her fresh, vital landscapes, often depicting Dorset and the Cotswolds, expressed a sense of movement and life. She seldom used a medium with oils but would paint into colour scrubbed on to the canvas.
LIT: *Evelyn Cheston*, Charles Cheston, Faber & Faber, London, 1931; *Paintings and Drawings by Evelyn Cheston*, exhibition catalogue, Mappin Art Gallery, Sheffield, 1931.　CF

CHOWNE, Gerard, NEAC (1875–1917). Painter of landscapes, flowers and portraits in oils and watercolours. He studied at the SLADE SCHOOL under BROWN 1893–9, in Paris and Rome. He exhibited at the NEAC from 1903, becoming a member in 1905, also at London galleries including the Carfax where he had his first solo exhibition 1911. He taught at Liverpool University 1905–8, and founded the Sandon Studios, Liverpool. He travelled extensively and died whilst serving with the Salonika Force. A memorial exhibition was held at the NEAC in 1917–18. His painting style was free and expressive and flower studies such as *Polyanthus* (Manchester City Art Gallery), express an enjoyment of beauty in their fresh colour and abundance.
LIT: *Studio*, Vol.54, p.140. CF

CHRISTOPHERSON, John (1921–1996). A painter of abstracts and small dream-like townscapes, he was an administrator with various institutions until resigning from the Civil Service in 1959. He then started painting full-time. Self-taught, he was influenced by his contacts at first with Jack Beddington at Shell-Mex, then with Jean Dubuffet (by correspondence) and with JACOB EPSTEIN. His flat, simplified, geometric and often highly textured compositions of buildings and streets were inspired by Hampstead and his native Blackheath. He exhibited from 1961 at the LEICESTER GALLERIES, and elsewhere, including England & Co. AW

CHURCH, Katherine (b. 1910). Painter of figures, flowers, still-life, landscapes and portraits in oils, watercolours and mixed media. She trained at the Brighton School of Art 1928–30, the RA SCHOOLS 1930–3, and at the SLADE SCHOOL 1933–4, and held a solo exhibition at the Wertheim Gallery in 1933. She subsequently showed in London galleries (including the LEFEVRE and the Parkin Gallery), at the RA from 1933, at the NEAC, the LG and the RP. Her work is represented in collections including the National Museum of Wales. Married to the writer Anthony West, she formed friendships with JOHN PIPER, IVON HITCHENS and TREVELYANS and her work shows some characteristics of English neo-romanticism as well as the influence of Cézanne and Van Gogh.
LIT: *Katherine Church: A Retrospective Exhibition, Paintings from 1936–1988*, The Duncalfe Galleries, Harrogate, 1988. CF

CINA, Colin (b. 1943). Painter of abstracts in acrylic. He studied at GLASGOW SCHOOL OF ART 1961–3, and the CENTRAL SCHOOL OF ART 1963–6. In 1966 he won a travel bursary to the USA. Since 1967 he has taught widely and exhibited in numerous galleries and group exhibitions. His work is represented in public collections. Early paintings reflect his interest in visual illusion, later work established a grid of coloured chevrons and verticals on a single-coloured or mottled ground. In the 1980s freer, independent geometric forms and lines appear against a patterned ground.
LIT: Exhibition catalogue, Third Eye Centre, Glasgow, 1975. CF

Circle. ('An International Survey of Constructive Art.') A collection of essays and photographs of work by leading architects and abstract artists, edited by the architect J.L. Martin, the sculptor Naum Gabo and the painter BEN NICHOLSON, in 1937. It was in part intended to counter the influence of Surrealism but essentially was designed to establish a basis for debate on abstraction and constructivism in painting, sculpture and architecture.
LIT: *Circle: Constructive Art in Britain*, catalogue, Kettle's Yard, Cambridge, 1982. AW

CLAPCOTT, Helen (b. 1952). A painter of urban landscapes and industrial scenes, particularly around Stockport, usually in tempera. She studied at Liverpool School of Art and later won the David Murray travelling scholarship, visiting Morocco. She exhibits at the RA, and has had one-man shows at Salford City Art Galleries, at Stockport Art Gallery, at the Ginnel Gallery, Manchester in 1984, and two at the New Ashgate Gallery, Farnham, 1983 and 1989. AW

CLARE, Oliver (*c.*1853–1927). Painter of fruit and flowers in oils. Son of George Clare and brother of VINCENT CLARE, both of whom also painted still-life of fruit and flowers, he lived in London in 1883, and Birmingham in 1886. He exhibited between 1883 and 1908, showing mainly in Birmingham but also exhibiting at the RA in 1883, at the RCA, RBA, GI, in Liverpool and Manchester. His work often depicted still-life set against the background of a mossy bank, sometimes including baskets of flowers and birds' nests in the tradition of William Henry Hunt.
LIT: 'Flower Show', J. Samuels, *Antique Collector* (UK), Vol.52, pt.5, May 1981, pp.64–7. CF

CLAUSE

CLARE, Vincent (*c.*1855–1925). Painter of fruit and flowers in oils. Son of George Clare and younger brother of OLIVER CLARE, he lived in London and exhibited between 1888 and 1897, showing at the Walker Art Gallery, Liverpool. His painting was very similar to that of his brother, often setting his subject against a bank of moss and continuing the flower and birds nest subjects associated with William Henry Hunt.
LIT: 'Flower Show', J. Samuels, *Antique Collector* (UK), Vol.52, pt.5, May 1981, pp.64–7. CF

CLARK, Baron, of Saltwood: Kenneth Mackenzie Clark, OM, CH, KCB (1903–1983). Educated at Winchester and Oxford, Kenneth Clark worked with Bernard Berenson at I Tatti, 1926–8, became Keeper of the Department of Fine Art in the Ashmolean, 1931–3, Director of the National Gallery, 1934–45, Slade Professor of Fine Art at Oxford, 1946–50, and Chairman of the ARTS COUNCIL, 1953–60. As an art historian, he wrote on many subjects from the period of the Italian Renaissance onwards, but his importance to the development of modern art in this country is incalculable. As well as a popular lecturer and a broadcaster on radio and TV, he was a great collector, patron and source of encouragement at all levels, from the chairmanship of boards and committees to the personal financial support of individual artists, having been particularly friendly with MOORE, SUTHERLAND and PIPER. He was awarded a life peerage in 1969.
LIT: *Another Part of the Wood*, autobiography, J. Murray, 1974; *The Other Half, a Self Portrait*, J. Murray, 1977; *Kenneth Clark*, Meryle Secrest, 1984. AW

CLARK, James, RI, ROI, RBC, NEAC (1858–1943). Painter of figures, portraits, landscapes and flowers in oils and watercolours; book illustrator, fresco painter and stained glass designer. He studied at Hartlepool, at the RCA from 1877 to 1889, in Paris under Bonnat and at the Ecole des Beaux-Arts under Gérome in 1880. He travelled to Jerusalem and the Middle East in 1886 and 1896. He exhibited at the RA from 1881 to 1938, at the NEAC (member 1886), the ROI (member 1891) and the RI (member 1903) as well as at the RP, RBA, in London galleries, the provinces and Scotland. His work is represented in collections including the Laing Art Gallery, Newcastle. His paintings also included Eastern and Biblical scenes such as *Hagar and Ishmael*, RA 1881, and his use of bright colour and strong light was influenced by his visits to the Middle East.
LIT: 'The Work of James Clark', A.L. Baldry, *Studio*, Vol.XIV, pp.153–61. CF

CLARK, John Cosmo, CBE, RA, RWS, NEAC (1897–1967). Painter of landscapes and figures in oils and watercolours. Son of JAMES CLARK, RI, he studied at GOLDSMITHS' COLLEGE OF ART 1912–14 and 1918, and also at the ACADÉMIE JULIAN, Paris 1918–19. Between 1919 and 1921 he attended the RA SCHOOLS, winning a travelling scholarship and a gold medal. His first solo exhibition was in 1926 at XXI Gallery and he subsequently exhibited mainly at the RA as well as major London galleries, the Paris Salon and the International Exhibition, Venice. His work is represented in several public collections. He became a member of the NEAC in 1946, RWS in 1952 and RA in 1958. In 1955 he was awarded a CBE. He taught at CAMBERWELL SCHOOL OF ART and in 1983 a retrospective exhibition of his work took place at the Bankside Gallery, London. He was married to the artist Jean Manson Wymer. His figure paintings, many of canal and London life, reveal his lively integration of figures and surroundings, e.g. *Dancing in a South London Pub in Wartime*, 1945. CF

CLARKE, William Hanna (1882–1924). Painter of landscapes and figures in oils and watercolours. He worked and exhibited mainly in Scotland, showing at the GI, RSA and RSW. His work often depicted rustic scenes of British country life that reflected the influence of French nineteenth century painting. His watercolour technique could be very free, using washes to convey the whole scene. In oil paintings such as *The Edge of the Wood* he used close-toned light colour and a textured application of pigment. CF

CLAUSE, William Lionel, NEAC (1887–1946). Painter of landscapes, figures and portraits in oils. Born in Middleton, Lancashire, he studied at the SLADE SCHOOL under TONKS and BROWN. He had his first one-man show in 1929 at the Goupil Gallery and he exhibited mainly at the NEAC, where he became a member in 1929 and later Honorary Secretary and Treasurer. He also exhibited at Colnaghi & Co. and his work is represented in public collections. His work ranges from the depiction of rustic figures to realistic portraiture and later in his work he developed a technique influenced by the Impressionists. CF

CLAUSEN, Sir George, RA, ROI, RI, RWS (1852–1944). Painter of rural subjects and landscapes in oil, watercolour and pastel; Clausen also painted portraits, interiors, nudes, murals and occasionally allegories. From 1867 to 1873 he was employed by Messrs Trollope, a firm of Chelsea decorators. Commissioned to carry out decorative work at the house of the painter Edwin Long, Clausen became employed as a researcher of historical detail for Long's paintings. From 1867 he attended evening classes at South Kensington. On Long's advice, Clausen visited Holland and Belgium in 1875, and began painting Dutch subjects. Unsuccessful in his attempt to enter Gérome's atelier, 1876, Clausen set up studio in London, where his work showed the influence of his contacts with Tissot, Marcus Stone and Whistler. Inspired by the work of Bastien-Lepage and moving to the country – Berkshire and later Essex – Clausen increasingly adopted rural themes, and the technique of 'across-form' painting with a square-headed brush. Studying the Hertfordshire peasantry, Clausen also worked regularly in France, painting in Brittany with STANHOPE FORBES 1882, and studying at JULIAN'S under Bouguereau 1883. In 1888 Clausen published his article 'Bastien-Lepage and Modern Realism'. Increasingly attracted to Millet during the 1890s, Clausen's renderings of field labour became correspondingly monumental. Inspired by Degas, he also produced many pastels. Widely travelled in France, Hungary 1894, and Italy 1898 and 1903, Clausen held his first one man exhibition at the Goupil Gallery in 1902, later exhibiting at the LEICESTER 1909, 1912. Succeeding Val Prinsep as Professor of Painting at the RA 1903, Clausen's lectures, urging traditional study of the Old Masters, were published as *Aims and Ideals in Art*, 1906. Elected RA in 1908, his public activities included involvement with the ART WORKERS' GUILD. Large scale works and murals followed; his WAR COMMISSIONS including *In the Gun Factory at Woolwich Arsenal*, 1918, and *Returning to the Reconquered Land*, 1919. He executed murals at High Royd, Huddersfield 1919, and St Stephen's Hall, Palace of Westminster 1927. Latterly often working in Essex at sunrise, Clausen continued to produce evocative canvases and small scale watercolours exploring the effects of light.
LIT: *Sir George Clausen RA*, K. McConkey, exhibition catalogue, Bradford Art Gallery, 1980. GS

CLAY, Elizabeth Campbell Fisher (1871–1959). Painter of portraits, landscapes and flowers in watercolours and oils. Born in West Dedham, Massachusetts, née Fisher, she attended Boston Art Academy from *c.*1899 and the Art Students League in New York where she worked under William Merritt Chase and Robert Henri. She later worked with Henri in Paris, Madrid, Holland and Normandy. In 1909 she married Howard Clay and subsequently lived in England; she studied further with ALEXANDER JAMIESON. Between 1914 and 1918 she worked at Whitby, Runswick Bay, Wales and the Isle of Man and she later painted in France and Germany. She held a solo exhibition in Boston in 1908 and exhibited in England at the RA in 1931 and 1937, at the RCA, SWA, NEAC and in Manchester and Yorkshire. A member of the Halifax Art Society, her painterly works ranged from portraits of children to gardens and coastal views and she began to paint flowers *c.*1933.
LIT: Biographical Notes, Monica Clay, Christie's sale catalogue, South Kensington, London, 21 July 1988. CF

CLAYTON, Harold (1896–1979). Painter of flowers, landscapes and townscapes; wood engraver. Born in London, he studied at Hackney, Harrow, Hornsey and ST MARTIN'S Schools of Art, working under Norman James RE, and he exhibited at the RA in 1931 and 1932, showing *Ventimiglia* (wood engraving) in 1931, *Farm on the Harrow Weald* and *St James Park* in 1932. His work included formal, detailed flower paintings often depicting flower arrangements against a simple stone ledge and view of the sky. CF

CLOUGH, Prunella (b. 1919). Painter of landscapes and industrial subjects in oils. She trained at CHELSEA SCHOOL OF ART 1938–9, and from 1940 to 1945 worked in clerical and draughtsman's jobs. Between 1946 and 1949 she painted in London and East Anglia and in 1947 she had her first solo exhibition at the Leger Gallery. She has since exhibited at leading London galleries including the LEICESTER, GROSVENOR, NEW ART CENTRE and Annely Juda Fine Art, as well as internationally. Her work has been widely shown in group exhibitions and is represented in many public collections, including the TATE GALLERY. In 1960 a retrospective exhibition was held at the Whitechapel Gallery, London, and in 1976 an ARTS COUNCIL exhibition was held at the

SERPENTINE GALLERY. Her early work was associated with English neo-romanticism but it also had affinities with French painting. In the 1950s her paintings of industrial subjects grew out of her concern to reinterpret figure painting free from its traditional associations. In later work figures disappear and landscape becomes her main subject. She is concerned with the memory of a scene and is drawn to geometric forms in landscape. Her colours are usually warm and muted, close-toned and strongly textured. Her distillation and selection of forms moves her work towards abstraction whilst retaining the initial reference to landscape. She explains her concerns as a partiality for the trace rather than the direct frontal confrontation. Her most recent work displays the range of her personal vocabulary and beauty of form and surface.
LIT: The catalogues of her exhibitions at Warwick Arts Trust, 1982, and Annely Juda Fine Art, 1989. CF

CLUTTON-BROCK, Alan (1904–1960). Painter of landscapes and flowers in oils and watercolours; writer and art critic. He studied art at WESTMINSTER SCHOOL OF ART and exhibited at the RA and LG as well as at London galleries. From 1945 he was art critic of *The Times*; he published on art history and in 1949 became a Trustee of the National Gallery. He painted directly from nature using an impressionistic technique and often recorded the countryside of Essex and Suffolk. CF

COATES, George James, ROI, RP, NPS, IS, SSN (1869–1930). Painter of portraits and figures in oils and watercolours. Born in Melbourne, Australia, he studied at North Melbourne Art School and at the National Gallery Drawing School. In 1897 he won a travelling scholarship to England and from 1898 to 1900 he worked at the ACADÉMIE JULIAN, under J.P. Laurens and Dagnan-Bouveret. He exhibited at the Salon from 1898 (Hon. Mention 1910), the RA from 1902, at the ROI, (ROI 1915), RP (RP 1915), at the LS, in London and provincial galleries and in Scotland. He held a solo exhibition in Melbourne in 1913, subsequently exhibiting there and in Sydney. A founder member of the London Portrait Society in 1928, his work is represented in collections including the TATE GALLERY. He was married to DORA MEESON. His sensitive, harmonious work was based on his strong draughtsmanship.

LIT: *George Coates: His Art and His Life*, Dora Meeson Coates, 1937; memorial exhibition catalogue, New Burlington Galleries, London, 1931.
CF

COATES, Thomas J., PRBA, NEAC, RWS, RP (b. 1941). Painter of landscapes, townscapes and portraits in oils and watercolours. He studied at Bournville and Birmingham colleges of art 1956–61. From 1961 to 1964 he attended the RA SCHOOLS winning several prizes and scholarships. He exhibited at the RA, RBA, becoming President in 1988, and in many one-man exhibitions at leading galleries including the NEW GRAFTON GALLERY. He has won many awards including the De Lazlo Medal and first and third prizes in the Sunday Times Watercolour Exhibitions of 1988 and 1989. His oils and watercolours capture effects of weather and light within a realistic mode. Recent paintings of India show intensified colour and effects of chiaroscuro. CF

CODRINGTON, Isabel (1874–1943). Painter of figures, interiors and still-life, miniaturist and etcher, usual medium, oils. She studied at the RA SCHOOLS where she won two medals, and exhibited at the RA, RBA, the FINE ART SOCIETY, Colnaghi and Co. and other London and provincial galleries. She also showed at the Paris Salon and received an Honourable Mention in 1923. Her work is represented in several public collections. For a time she exhibited under the name of Pyke-Nott, but used Codrington after 1918. Her paintings range from quiet interiors (e.g. *Evening*, Manchester City Art Gallery) to genre and figure subjects painted with a theatrical air in warm colours and realistic detail, sometimes showing Mediterranean scenes, e.g. *The Fruit Sellers*.
LIT: 'The Art of Isabel Codrington', *Studio*, Vol.XC, p.212. CF

COHEN, Alfred (b. 1920). Painter of figures, landscapes, townscapes and flowers in oils. Born in Chicago, he studied at the Art Institute of Chicago and at the Académie de la Grande Chaumière, Paris. After working in Europe he settled in London in 1960, and has exhibited at ROLAND, BROWSE & DELBANCO and other London and provincial galleries. His work is represented in public collections. His paintings are strong, bright and expressive with a direct technique.
LIT: Exhibition catalogue, Arts Council of Northern Ireland, 1985; *La Commedia dell'Arte*, Alfred Cohen, 1963. CF

COHEN, Bernard (b. 1933). Painter of abstracts in acrylic, oils and mixed media. Younger brother of HAROLD COHEN, he trained at ST MARTIN'S SCHOOL OF ART and the SLADE 1951–4, and spent two years in France, Spain and Italy. His first London solo exhibition was in 1958, GIMPEL FILS GALLERY, and he has exhibited regularly at the WADDINGTON GALLERIES, at major galleries here and abroad, and his work has appeared in numerous group exhibitions and public collections. In 1972 a retrospective exhibition was held at the Hayward Gallery. He has taught at many art schools and since 1988 has held the Slade Chair of Fine Art. He has used a variety of abstract means to express his interest in the process of painting and has been influenced by Jackson Pollock and American painting. Earlier work sometimes took the shape of string-like coils and used spray techniques whilst recent work is constructed of many parts and processes in order to express the clarity of appearance and the ambiguity of experience.
LIT: Exhibition catalogues for the Hayward Gallery, 1972, and Waddington Galleries, 1990. CF

COHEN, Harold (b. 1928). Painter of abstracts in oils, tempera and acrylic; designer of computer art. Elder brother of BERNARD COHEN, he studied at the SLADE 1948–52, visited Italy in 1952 and held his first London solo exhibition in 1954, GIMPEL FILS GALLERY. He has exhibited widely, nationally and internationally, and his works have been included in many group exhibitions and public collections. From 1959 to 1961 he worked in America and he has taught and lectured widely. Influenced by Barnett Newman, his early work was constructed in bands of colour. Later paintings became freer and complex, concerned with the significance of mark making and ambiguity. His interest in computers and the nature of drawing led him to develop a computer-controlled drawing machine and to produce computer-generated paintings.
LIT: The catalogues for his exhibitions at the Whitechapel Art Gallery, 1965, and the TATE GALLERY, 1983. CF

COKE, Dorothy Josephine, RWS, NEAC (1897–1979). Painter of landscapes, figures, townscapes, portraits and animals in watercolours and oils; wood engraver. She studied at the SLADE SCHOOL under MCEVOY, TONKS, STEER and RUSSELL, 1914–18, and exhibited mainly at the NEAC (member 1920) and RWS (RWS 1941) as well as at the RA from 1933 to 1941 and the SWA. Her work is represented in collections including the IMPERIAL WAR MUSEUM. From 1939 she lived at Rottingdean, Sussex, and in 1940 she was commissioned to draw the Women's Services. From 1945 to 1967 she taught at Brighton College of Art and her work combines strong draughtsmanship with freedom of handling.
LIT: *Dorothy Coke RWS, NEAC: Paintings, Drawings and Woodcuts,* exhibition catalogue, Brighton Polytechnic, 1981. CF

COKER, Peter Godfrey, RA (b. 1926). Painter of landscapes, figures and still-life in oils and watercolours; etcher. He studied at ST MARTIN'S SCHOOL OF ART where he was influenced by PITCHFORTH and STROUDLEY and in 1950 he attended the RCA. In 1949 and 1950 he travelled to Italy and Paris where he looked closely at the work of Courbet. He exhibited at ZWEMMER'S Gallery in 1956 and subsequently exhibited at the RA, the GROSVENOR and Thackeray Galleries and Gallery 10. He became RA in 1972. His work has been represented in many group exhibitions and public collections including the TATE GALLERY. In 1976 he won an ARTS COUNCIL Award. His early realism was influenced by Lorjou and de Staël and his subjects of butchers and dead animals were painted in thick impasto with strong lines. Later landscapes retained his commitment to realism and expressionistic impasto technique whilst also reflecting the role of drawing and sense of place in his work. Recent painting shows greater economy of means, delicacy of touch and atmospheric effects.
LIT: The retrospective exhibition catalogues for The Minories, Colchester, 1972, and Chelmsford and Essex Museum, 1978. CF

COLDSTREAM, Sir William Menzies, LG (1908–1987). Painter in oil of portraits, nudes, landscapes, townscapes and still-life. Early inspired by Cézanne, Coldstream's work was above all concerned with real appearances, and their rendering with detachment and objectivity – 'prose painting'. Always working directly from the model, he wrote in 1937, 'I find I lose interest unless I let myself be ruled by what I see'. His use of straight brushstrokes and parallel hatchings was, in his post-war work, increasingly complemented by a complex of brightly coloured accents – reference points achieved through conscientious measurement against the brush held in the outstretched hand. Born at Belford, Northumberland, the son of a doctor, his family

moved to London in 1910. Educated privately, with early hopes of becoming a medical student, he began drawing seriously in 1925. Attending the SLADE SCHOOL 1926–9, he exhibited at the NEAC from 1928, and the LG from 1929 (member 1934). With CLAUDE ROGERS and VICTOR PASMORE, Coldstream was a founder member of the EUSTON ROAD SCHOOL of Drawing and Painting in 1937. At the same time he executed an important series of portraits of his friends and contemporaries such as W.H. Auden and Stephen Spender, based upon his principles of disciplined observation. Concerned to give social meaning to his realist style, he worked temporarily with film (GPO Film Unit) in the 1930s. However, the financial backing of SIR KENNETH CLARK enabled him to return to full-time painting in 1937. He joined the Royal Artillery in 1940 and later (1943), worked as an OFFICIAL WAR ARTIST in the Middle East and Italy. He taught at CAMBERWELL from 1945, and was appointed Slade Professor in 1949. Often working from Slade models, Coldstream returned in the 1950s to the theme of the nude, which he had last treated in 1938. He was knighted in 1956.
LIT: *The Euston Road School,* Bruce Laughton, Scolar Press, 1986; *The Paintings of William Coldstream 1908–1987,* Lawrence Gowing and David Sylvester, TATE GALLERY, 1990. GS

COLE, Rex Vicat, ROI, RBC, RBA (1870–1940). Painter of landscapes and architecture in oils; writer. The son of George Vicat Cole, RA, he studied with his father and at ST JOHN'S WOOD SCHOOL OF ART. He exhibited at the RA, became RBA in 1900, ROI in 1929, and showed at the Dowdeswell Galleries as well as at other galleries and societies and at the Paris Salon. He was co-founder of the BYAM SHAW AND VICAT COLE SCHOOL OF ART with Shaw, and published books, most notably *British Trees,* 1904–6. His work ranged from Edwardian landscapes to more austere studies of canals and classically constructed paintings of London parks. He produced paintings of London architecture and informal landscape studies which had a *plein-air* character and unmannered simplicity.
LIT: *The Cole Family,* Portsmouth City Museum and Art Gallery catalogue, 1988. CF

COLLIER, the Hon. John, ROI, RP, OBE (1850–1934). Painter of portraits, subject pictures and landscapes in oils. Son of Lord Monkswell, he studied at the SLADE SCHOOL under Poynter, in Paris under J.P. Laurens and in

Munich. Encouraged by Millais and Alma Tadema, he exhibited widely, mainly at the RP (RP 1891, VPRP 1899), at the RA from 1874 to 1934 and the ROI (member 1910). He also showed in London galleries (including the LEICESTER where he held a solo exhibition in 1915), in the provinces and Scotland. A retrospective exhibition was held at Sunderland Art Gallery, 1921–2, and his work is represented in collections including the TATE GALLERY. Author of three books on painting, he was awarded an OBE in 1921. Well known as a portraitist, his popular subject pictures included both historical subjects influenced by Alma Tadema and contemporary dramas of upper-class life which shared some characteristics with those of Orchardson, e.g. *The Prodigal Daughter,* 1903 (Usher Gallery, Lincoln).
LIT: *The Art of Portrait Painting,* John Collier, Cassell, London, 1905; 'The Hon. John Collier', W.H. Pollock, *The Art Annual,* Virtue & Co., London, 1914. CF

COLLINS, Cecil (1908–1989). A painter of visionary and fantastic pictures. He studied at Plymouth School of Art 1923–7, and at the RCA 1927–31. Influenced by William Blake, by Klee and by the SURREALISTS, his work was concerned with his religious and spiritual inquiry. His book *The Vision of the Fool* was published in 1947. A retrospective exhibition was held at the TATE GALLERY in 1989.
LIT: *Cecil Collins,* exhibition catalogue, with an essay by Judith Collins, Tate Gallery, 1989. AW

COLLINS, Elisabeth (b. 1905). Born Elisabeth Ramsden in Yorkshire, she attended Leeds College of Art and then the RCA, where she studied sculpture, and met and married CECIL COLLINS whilst she was still a student. She lived at Dartington Hall *c.* 1937–45, and then settled in Cambridge. Her painting is modest in scale, usually in gouache, and establishes gentle Surrealist fantasies. She had a retrospective exhibition at the Albemarle Gallery in 1989. AW

COLLINS, William Wiehe, RI, RBC (1862–1951). Painter of landscapes, figures, naval and architectural subjects in oils and watercolours. He studied at Lambeth School of Art 1884–5, and at the ACADÉMIE JULIAN, Paris, 1886–7, and exhibited at the RA from 1890 to 1918. He showed widely in London galleries (including the FINE ART SOCIETY in 1901, the LEICESTER GALLERIES in 1905, Walkers Gallery in

1909 and the Abbey Gallery in 1927), and he exhibited at the RI (RI 1898), ROI, RBA, RHA and LS, as well as in the provinces. His book illustrations include *The Green Roads of England* by R.H. Cox, 1914, and publications on the cathedrals of England, Spain and Italy. His wide-ranging subject matter included old cottages and ancient buildings of Wessex and RA exhibits such as *Anzac. 25th April 1915*, RA 1918. CF

COLQUHOUN, Ithell, DFA (1906–1988). Surrealist artist in oils, constructions and collages; writer and poet. Born in Shillong, Assam, she studied at the SLADE SCHOOL, in Paris and in Athens. During the 1930s she lived in Paris and London and was influenced by Dali and Breton whom she met in 1939. Associated with the English SURREALISTS, she exhibited in 'Living Art in England' at the LONDON GALLERY in 1939. She held a number of solo exhibitions in London galleries from 1936, including the MAYOR GALLERY, the London Gallery and the FINE ART SOCIETY, and she showed abroad and in the provinces, particularly in Cornwall. Her work is represented in collections including the TATE GALLERY. She published articles and poems in the *London Bulletin* and during the 1940s experimented with automatic techniques, publishing on them in *Enquiry*, Oct-Nov 1949, and in *Athene*, May 1952. She made regular visits to Cornwall, where she subsequently settled, and published topographical books including *The Living Stones, Cornwall*, 1957. In later work she was influenced by SCHWITTERS in her use of collage and she worked with enamel paint and automatic processes to evolve her *Convulsive Landscapes*. She also researched into the occult and alchemy.
LIT: *Ithell Colquhoun: Paintings and Drawings 1930–1940*, Michael Parkin Fine Art, 1977; *Surrealism: Ithell Colquhoun. Paintings, Drawings and Collages 1936–1976*, Newlyn Orion Gallery, 1977. CF

COLQUHOUN, Robert (1914–1962). Scottish figure painter in oil and watercolour; lithographer and theatrical designer. He was educated at Kilmarnock Academy and won a scholarship to the GLASGOW SCHOOL OF ART 1933–8, where he studied under Hugh Crawford and Ian Fleming and met his inseparable companion ROBERT MACBRYDE. 'The two Roberts', as they were known, visited Paris and Italy 1938–9, Colquhoun on a travelling scholarship. He served in the RAMC 1940–1, until he was invalided out. In 1941 he settled in London with MacBryde,

sharing a studio for a while with JOHN MINTON. JANKEL ADLER, an artist who was to affect Colquhoun's style, took a neighbouring studio. Colquhoun and MacBryde first exhibited together in 1942 at the LEFEVRE GALLERY, and his first one-man show in 1943 was also at the Lefevre, where he continued to exhibit regularly from 1943 to 1950. The 1947 exhibition was perhaps the highpoint of his painting career. *Woman with Leaping Cat* (TATE GALLERY), *Woman with Birdcage* (Bradford Art Gallery), *Two Scotswomen* (Museum of Modern Art, New York), demonstrate his main interest: the human figure and animals, and reveal the influence of late Cubism, especially that of Picasso. In his early work he confined his use of colour to warm ambers and greens; later he turned to more brilliant, even harsh colours. From 1947, with MacBryde, he moved more and more into lithography. Living in Lewes, Sussex 1947–9, they produced drawings and lithographs for the Miller's Press. In 1948 he began working with MacBryde on the sets and costumes of Massine's ballet *Donald of the Burthens*, performed at Covent Garden 1951. The designs were exhibited at the REDFERN GALLERY in 1952. He also designed for *King Lear* at Stratford in 1953. In 1949 he and MacBryde visited Italy, and this provided him with material for his 1950 exhibition at the LEFEVRE. They lived in Essex from 1950 and returned to London in 1954. Colquhoun's work was now mainly drawings, watercolours and monotypes which he exhibited at the Redfern Gallery in 1954 and the Parton Gallery in 1957. A major retrospective exhibition was held at the Whitechapel Gallery in 1958. The last joint exhibition was held at the Kaplan Gallery in 1960.
LIT: *Robert Colquhoun*, exhibition catalogue by Bryan Robertson, Whitechapel Gallery, London, 1958; *Robert Colquhoun*, exhibition catalogue by Andrew Brown, City of Edinburgh Museums, 1981. KS

COMPTON, Edward Theodore (1849–1921). Painter of mountain landscapes in oils and watercolours; illustrator. Father of EDWARD HARRISON COMPTON, he initially painted English landscape before living and working in Germany and Austria. He exhibited regularly in England, showing at the RA from 1880 to 1914, in galleries including the FINE ART SOCIETY and the Alpine Club, at the RHA, RBA, in the provinces and Scotland. His work is represented in collections including Manchester City Art Gallery. He travelled widely, but much of his work depicts

the higher regions of the Alps and was often reproduced in guides to the region.
LIT: *Edward T. Compton, Das Skizzenbuch einer Eifelwanderung im Jahre 1868*, exhibition catalogue, Wallraf-Richartz-Museum, Köln, 1985; *E.T. Compton. Maler und Bergsteiger zwischen Fels und Firn*, Ernst Bernt, Rosenheim, 1982.CF

CONDER, Charles Edward, NEAC (1868–1909). Painter of landscapes, figures and portraits in oils and in watercolours on silk; lithographer, decorative and fan painter; illustrator. Born in London, he studied art in Australia and in Paris at the ACADÉMIE JULIAN and the Atelier Cormon. A friend of Lautrec, WILLIAM ROTHENSTEIN and Anquetin, he settled in London in 1897 but made frequent trips abroad. He exhibited at the NEAC from 1893 to 1902 (member 1901) and held his first London solo at the Carfax Gallery in 1899. A founder member of the Society of 12, 1904, he exhibited widely and his work is represented in collections including the TATE GALLERY. Best known for his watercolours on silk and his fan paintings, his *fin de siècle* style was influenced by Anquetin, Beardsley, Whistler and Watteau.
LIT: *Charles Conder, his Life and Works*, Frank Gibson, John Lane, the Bodley Head, London, 1914; *The Life and Death of Conder*, John Rothenstein, Dent, London, 1938. CF

CONNARD, Philip, CVO, RA, RWS (1875–1958). Painter of decorative landscapes, portraits and interiors in oils; later of landscapes in watercolour. Originally a house painter, but after attending evening classes he won a scholarship for textile design to the RCA. In 1898 he went to the ACADÉMIE JULIAN in Paris with £100 prize from the British Institute. Due to lack of funds he returned to London and taught at the LAMBETH SCHOOL OF ART. He exhibited at the NEAC from 1906 (member 1909) and became a lifelong friend of STEER. Though best known as a landscape painter up to the 1930s he was a founder member of the NPS in 1911. Invalided out of the war he served as a naval WAR ARTIST in 1918. In the same year he was elected ARA without having submitted any work, becoming a full RA in 1925. His one-man exhibitions were mainly held at Barbizon House. Connard's commissions included murals in the Doll's House room at Windsor Castle, two panels for the main ballroom of the Viceroy's House in Delhi and a large decorative panel on the subject of 'England' for the liner *Queen Mary*. Taking up watercolours in middle

life he left behind the brilliant colour of his early oil landscapes and explored the delicate, subtle effects of atmosphere. He was made a full member of RWS in 1934. He was Keeper of the RA 1945–9 and appointed CVO in 1950.
LIT: *The Times* Obituary, 9 December 1958; *Watercolours & Drawings by P. Connard*, exhibition catalogue, Studio One Gallery, Oxford, 1975. KS

CONRADE, Alfred Charles (1863–1955). Painter of architectural subjects in watercolours, also some oils, pastel and tempera. Born in Leeds, he studied at Düsseldorf Academy, in Paris and Madrid. He travelled widely in Europe and Japan and exhibited mainly at the Dudley and New Dudley Gallery, at the RA from 1914 to 1933, and showed at the RIBA and on the continent. His work is represented in collections including the BM, London, and was reproduced in journals including *Architectural Review*. From 1911 to 1914 he was chief artist at the White City. His detailed, delicate work includes English, European and Japanese architectural studies such as *Nayasan Moon Temple, Kobo*, 1912, which combines watercolour with pen and brown ink. CF

CONROY, Stephen (b. 1964). A painter who trained at GLASGOW SCHOOL OF ART, his first one-man exhibition was in Dunbarton in 1986. His smoothly-painted figure groups, typically of dark-suited businessmen in interiors, evoke a brooding atmosphere of unexplained tension. AW

Contemporary Art Society. The Society was founded in 1910 to acquire works from living artists for gift or loan to public art galleries. The funds come mostly from the voluntary subscriptions of members.
LIT: *British Contemporary Art, 1910–1990*, Judith Collins and others, Herbert Press, 1991. AW

COOK, Barrie (b. 1929). Painter of non-figurative work in acrylic and oils and wax. Between 1949 and 1954 he studied at Birmingham College of Art and he held his first solo exhibition at the Herbert Art Gallery, Coventry, in 1966. He has subsequently exhibited in London galleries including the Camden Arts Centre, 1969 and 1971, and the Whitechapel, 1975, in Wales including the National Museum of Wales, 1988, in the provinces and abroad. His work is represented in collections including the TATE GALLERY. From 1969 to 1974 he was Head of Fine Art,

Stourbridge College of Art, between 1974 and 1977 he taught at Cardiff College of Art, from 1979 to 1983 he was Head of Fine Art, Birmingham Polytechnic, and since 1983 he has worked as an artist in Wales. Between 1977 and 1978 he was Gregynog Fellow, University of Wales. His earlier work included large-scale paintings using a vertical bar motif in a restricted palette and spray technique, his later work has become more descriptive and organic using wax mixed with oil paint.
LIT: *Barrie Cook. Gregynog Fellow 1978*, catalogue, Welsh Arts Council, Cardiff, 1978; retrospective exhibition catalogue, Ikon Gallery, Birmingham, 1986. CF

COOK, Ebenezer Wake (1843–1926). Painter of landscapes and interiors in watercolours. Born in Malden, he studied in Paris under N. Chevalier and worked both in England and abroad, often in Switzerland and Italy. He exhibited mainly at the FINE ART SOCIETY, at the Dudley and the New Dudley Gallery and at the RA from 1875 to 1926. He also showed at the RBA, RI and in the provinces and his work is represented in collections including the V & A. He taught VANESSA BELL. His decorative work included views of the Italian Lakes, paintings of the Thames and more broadly painted sketches such as *Harvesting a Cornfield* (Norwich Castle Museum).
LIT: *Anarchism in Art and Chaos in Criticism*, E.W. Cook, London, 1904; *Retrogression in Art and the Suicide of the Royal Academy*, E.W. Cook, Hutchinson, London, 1924. CF

COOK, Richard (b. 1947). Painter of figures and landscapes in oils; draughtsman and printmaker. He studied at ST MARTIN'S SCHOOL OF ART 1966–70, at the RCA 1970–3, and spent two years working with LEON KOSSOFF. Since 1985 he has lived in Cornwall. In 1976 he was selected for 'The Human Clay', Hayward Gallery; he has shown regularly in group exhibitions and held solos in 1981 at House, London, and in 1989 at the Odette Gilbert Gallery. His work is represented in collections including the ARTS COUNCIL and the BM. His painting shares some characteristics with that of KOSSOFF and BOMBERG, decisively painted in impasto, and subject to a process of elimination and repainting.
LIT: Exhibition catalogue, Odette Gilbert Gallery, 1989; *Design Weekly*, Vol.4, No.20, 19 May 1989. CF

COOKE, Jean E., RA (b. 1927). Painter of portraits and still-life in oils. Also a sculptor and potter. She studied at the CENTRAL SCHOOL OF ARTS AND CRAFTS, CAMBERWELL, City and Guilds and GOLDSMITHS' COLLEGE; NDD sculpture 1949. She set up a pottery workshop in Seaford 1950–3, and in 1953 married the artist JOHN BRATBY and attended the RCA where she concentrated on painting rather than potting. She accompanied her husband when he travelled to Italy on a scholarship. Her paintings reflect the things around her: the sea (she stays at Birling Gap, Sussex), her garden in London, still-life, portraits of her family and herself. Her first one-man show was at the Establishment Club in 1963. The RA has shown her work since 1956; she was made ARA 1965 and full member 1972. She lectured at the RCA 1964–74 and has been a governor of the CENTRAL SCHOOL OF ART since 1984.
LIT: 'Images of Jean Cooke, RA', Leonie Grayeff, *The Artist*, February 1980. KS

COOP, Hubert, RBA (1872–1953). Painter of landscapes and coastal scenes in oils and watercolours. He worked initially as a draughtsman in a Birmingham railway carriage works, studied in Birmingham and Wolverhampton and subsequently took up painting, working in Wales, Yorkshire, Kent and the West Country. He exhibited mainly in Liverpool, at the RBA (member 1897) and at the RA from 1897 to 1918, and showed in Birmingham, the RCA, RI and at the FINE ART SOCIETY. His work often depicted aspects of the sea and fishing communities, such as *Harvest of the Sea*, RA 1900, and *The Estuary, an Ebb Tide*, RA 1918, capturing the light, atmosphere and activity of the coast. CF

COOPER, Alfred Egerton, RBA, ARCA (1883–1974). Painter of portraits, figures, flowers, landscapes, townscapes and sporting subjects in oils, gouache, watercolours and pastels; mural painter. He studied at Bilston School of Art and at the RCA, gaining his diploma in 1911. From 1914 to 1918 he served with the Artists' Rifles. He exhibited mainly at the RBA (ARBA 1921, RBA 1923) and regularly at the RA from 1911, as well as at the RP, NEAC, RI, ROI, in London galleries including the LEICESTER, in Scotland and the provinces. His work is represented in collections including the NPG, London. Best known as a portraitist (*Winston Churchill*, 1943) and landscape painter, he painted a wide range of subjects

from flowers to *A Cricket Match at Lords*, 1938, and racing subjects, and his work included decisive, strongly painted preparatory sketches such as those for *Derby Day* exhibited in 1934 at Leger & Son.
LIT: *Paintings by A. Egerton Cooper RBA*, exhibition catalogue, Art Gallery, Colombo, Ceylon, 1951. CF

COOPER, Alfred Heaton (1863–1929). Painter of landscapes, particularly of mountainous subjects and the Lake District, in watercolours. He trained as an accountant until the age of twenty-one and then studied at WESTMINSTER SCHOOL OF ART. In 1891 he painted in Norway and subsequently settled in the Lake District where he established a studio and gallery, first at Coniston in 1907 and later in Ambleside. He exhibited mainly in Liverpool and at the RA between 1907 and 1925, and showed at the RI, ROI, in the provinces and London galleries. Father of WILLIAM HEATON COOPER, in 1904 he illustrated *The English Lakes* for Blacks of London, subsequently illustrating twelve of their publications. His evocative paintings, depicting Norway, Switzerland and the Lake District, convey particular effects of light, colour and weather.
LIT: *Watercolour Drawings by A.H. Cooper*, exhibition catalogue, Cheltenham Municipal Art Gallery, 1924; *A. Heaton Cooper, W. Heaton Cooper & J. Heaton Cooper*, exhibition catalogue, Abbot Hall Art Gallery, Kendal, 1979. CF

COOPER, Eileen (b. 1953). She studied at GOLDSMITHS' COLLEGE 1971–4, and the RCA 1974–7. Her first solo exhibition was in 1979, and she has exhibited widely since (Blond Fine Art, 1985, for example). Her broadly painted, heavily outlined figures evoke male/female relationships from a woman's point of view. AW

COOPER, Gerald (1898–1975). Painter of flowers, landscapes and figures in oils. He studied at West Bromwich School of Art and at the RCA from 1920 to 1923. He exhibited mainly at the RA where he showed regularly from 1930, and at the NEAC and in Liverpool. He was married to the artist Muriel Minter and he taught at Wimbledon School of Art from 1924, becoming Principal in 1930 until 1964. His early work depicted landscapes, figures and farm scenes but he subsequently specialized in finely drawn, detailed and elegant flower compositions.

LIT: *The Flowerpiece through the Centuries XVII–XX*, Richard Green Gallery, London, 1989. CF

COOPER, William Heaton, RI (b. 1903). Landscape painter in watercolour; illustrator and writer. Trained with his father, the landscape painter A. HEATON COOPER, and at the RA Schools 1922–5. He exhibited at the RA, RBA and RI. He was elected RI in 1953 and was also President of the Lake Artists Society for eleven years. Although he has travelled to Switzerland, France, Italy, Norway, Greece and South America, almost all of his work portrays his birthplace, the English Lakelands. His paintings reflect the changing light and seasons of the many mountains and lakes, e.g. *After Sunset, Grasmere*, *Rydal Water in June* and *Winter Sun, Buttermere*. A rock climber in his youth, he has illustrated ten rock climbing guides to the Lake District. He has also written and illustrated five books: *Hills of Lakeland*, *Tarns of Lakeland*, *Lakeland Portraits*, *The Lakes* and *Mountain Painter*. He exhibits his work and that of his family and the sculptures of his late wife Ophelia Gordon Bell at his studio in Grasmere.
LIT: *Mountain Painter: an Autobiography*, W. Heaton Cooper, F. Peters, 1984; 'W. Heaton Cooper: an appreciation', Vera Pragnell, *Creative Art*, April 1928. KS

COPE, Sir Arthur Stockdale, RP, RA, KCVO (1857–1940). Painter of portraits and landscapes in oils. Son of Charles West Cope RA, he studied at Carey's and at the RA SCHOOLS and exhibited mainly at the RA where he showed regularly from 1876 to 1935 (ARA 1899, RA 1910). He also exhibited at the RP (member 1900), the ROI, RI, in the provinces, Scotland and at the Paris Salon. His work is represented in collections including the NPG, London. Knighted in 1917, he became KCVO in 1927. His portraits included members of the Royal Family and many well-known figures and his work was frequently reproduced in the *Studio*, e.g. *The Rev. William Rogers*, 1895 (*Studio*, Vol.5, p.118) and *Vice-Admiral Sir John Fisher* (*Studio*, Vol.29, p.42). Pupils at his South Kensington art school included NINA HAMNETT and VANESSA BELL. CF

COPLEY, John, PRBA, NS, ARE (1875–1950). Born in Manchester, he studied at MANCHESTER SCHOOL OF ART, in the studio of Watson Nicol and ARTHUR COPE and at the RA Schools. He spent three years in Italy, and later, taking up

lithography in 1907, became Hon. Secretary of the SENEFELDER CLUB (1910–1916). He lived in London for most of his life, and painted stylish and sensual portraits, figure compositions of a symbolist character ('Men and Mountains', 1934) and studies of groups ('Chamber Music': both these oil paintings are in Manchester City Art Gallery). A retrospective exhibition was held at Agnew's in 1990. AW

COPNALL, John (b. 1928). Painter of abstracts in acrylic. He studied at the AA School of Architecture 1945–6, and at the RA SCHOOLS 1949–54. From 1955 to 1968 he lived in Spain and he held his first solo exhibition at the PICCADILLY GALLERY in 1955 and subsequently exhibited there until 1961. He has shown since in London galleries, most recently at Austin/Desmond Fine Art, in the provinces and abroad. His work is represented in collections including Aberdeen Art Gallery and the ARTS COUNCIL of Great Britain, and he has taught since 1973 at the CENTRAL SCHOOL OF ART. He turned from figurative to abstract work in Spain where he was influenced by de Staël, using found objects, texture and a range of materials. From 1968 he made acrylic works in clear colour producing stripe paintings in the 1970s and later more gestural and formal images such as the star paintings. His most recent work uses full saturated colour.
LIT: Exhibition catalogue, Austin/Desmond Fine Art, London, 1989. CF

COPPING, Harold (1863–1932). Illustrator and painter of subject pictures. Born in London, he studied at the RA SCHOOLS winning the Landseer Scholarship to Paris. He travelled in Palestine and Egypt in order to study for his Bible illustrations and he also sketched in Canada. He exhibited mainly at the RA from 1885 to 1904, but he also showed at the RI, RBA, in Manchester and in Liverpool. His accomplished illustrations, often in watercolours, ranged from works by Dickens to *The Golden Land*, Hodder & Stoughton, 1911, illustrating the experiences of British settlers in Canada. He was, however, best known for his illustrations to the Bible in 1910. His RA pictures included subjects such as *My Love has gone a Sailing*, 1896, and *Romeo's Last Farewell*, 1902.
LIT: *English Illustration: The Nineties*, James Thorpe, Faber & Faber, 1935; 'Postcard Dickensiana 1900–1920[prime], G.E. Miller, *Dickensian* (USA), No.376, Vol.71, May 1975, pp.91–4. CF

Courtauld Institute of Art. The first institution to be established in this country for the study of the history of art, it was founded in 1931 in London University with an endowment from Samuel Courtauld (1876–1947). The following year he made over the lease of 20 Portman Square, along with the gift of a unique collection of nineteenth-century French pictures, to house the Institute: a cardinal event in the history of English taste. In 1959 the pictures, along with the Lee Collection of Old Masters, the Fry Collection of early twentieth-century art, the Witt Collection of Drawings and the Gambier-Parry Collection of Italian Paintings, were displayed in new galleries in Woburn Square; today both the Institute and the Collections, along with the Princes Gate Collection of Old Masters and the Spooner Collection of English Watercolours, are reunited at Somerset House in the Strand (the gallery open to the public), forming one of the most important centres for the study and appreciation of art in the world.
LIT: *The Courtauld Collection. A Catalogue and Introduction*, Douglas Cooper, The Athlone Press, 1954. AW

COWARD, Sir Noël (1899–1973). Writer of plays, films and songs; actor and director; painter of landscapes, coastal scenes and figures in oils and watercolours. Self-taught as a painter, he was encouraged by Sir Winston Churchill, Edward Molyneux and DEREK HILL. Many of his vivid, simplified scenes of Jamaica share some characteristics with those of MESSEL, BEATON and HOCKNEY.
LIT: *The Diaries of Noël Coward*, edited by Sheridan Morley, London, 1982; *Out in the Midday Sun. The Paintings of Noël Coward*, Sheridan Morley, Phaidon and Christie's, 1988. CF

COWERN, Raymond Teague, RA, RWS, RE, RWA, RBSA, ARCA (b. 1913). Painter of landscapes and architecture in tempera and watercolours; etcher. He trained at the CENTRAL SCHOOL OF ART, Birmingham, the RCA School of Engraving 1931–5, and at the BRITISH SCHOOL IN ROME as a Rome Scholar in engraving 1937–9. Between 1935 and 1936 he worked with the Sakkarah Expedition of the Oriental Institute of Chicago. He exhibited at the RA, becoming RA in 1968, at the RE, RSA and RWS, as well as in Birmingham and Glasgow. His work is also represented in public collections. He served in the army 1940–6, and in 1940 was commissioned by the Pilgrim's Trust for RECORDING BRITAIN.

Between 1946 and 1958 he taught in London and Brighton, where he revived the teaching of etching. He was Principal of Brighton College of Art 1958–70, and Associate Director and Dean, Faculty of Art and Design, Brighton Polytechnic 1970–4. He also designed murals for L.G. Harris & Co. His painting and etching concentrated on visual accuracy. Works such as *Incoming Tide, Whitehaven*, tempera, 1983, show how he could order complex detail within a highly structured scene.
LIT: Retrospective exhibition catalogue, Brighton Polytechnic Gallery, 1977. CF

COWIE, James, RSA (1886–1956). Painter of portraits, figures, landscapes and still-life in oils, watercolours, gouache and pastels. Born in Aberdeenshire, he read English at Aberdeen University from 1906 and attended the United Free Church Training College where he was influenced by James Hector. In 1909 he became Art Master at Fraserburgh Academy before studying at the GLASGOW SCHOOL OF ART from 1912. A conscientious objector in the First World War, he subsequently taught at Bellshill Academy near Glasgow. He held his first solo exhibition at the McLellan Galleries, Glasgow, in 1935, and exhibited in Scottish galleries, at the RSA (ARSA 1936, RSA 1943), at the GI, the RA between 1923 and 1945, at the NEAC and in the provinces. His work is represented in collections including the Scottish National Gallery of Modern Art. In 1935 he was appointed Head of Painting, Grays School of Art, Aberdeen, and in 1937 Warden of the Patrick Allen Fraser School of Art, Arbroath. An influential teacher, his own work was initially informed by Renaissance painting and later by SURREALISM using an exact, formal approach based on his detailed draughtsman- ship.
LIT: *James Cowie*, R. Calvocoressi, Scottish National Gallery of Modern Art, Edinburgh, 1979; *James Cowie*, Cordelia Oliver, University Press, Edinburgh, 1980. CF

COWPER, Frank Cadogan, RA, RWS, RP, ABA (1877–1958). Painter of religious, historical and genre subjects, portraits and landscapes in oils, tempera and watercolours. He studied at ST JOHN'S WOOD SCHOOL OF ART in 1896, the RA SCHOOLS 1897–1902, and with E.A. Abbey. He exhibited mainly at the RA as well as at the RWS and other societies and galleries. He became RWS in 1911, RP in 1921 and RA in 1934. His work is represented in many public collections including the TATE GALLERY which purchased

paintings through the CHANTREY BEQUEST in 1905 and 1914. In 1908 he painted a Tudor scene for the decorations in the East Corridor, Houses of Parliament. Influenced by the exhibitions of Ford Madox Brown in 1896, Millais and Rossetti in 1898, his work sought to continue the Pre-Raphaelite style in its attention to detail and reference to Italian art, as well as to PRB painting, e.g. *St Agnes in Prison receiving the Shining White Garment*, 1905. Later work showed his growing preoccupation with the opulence of materials and settings. His portraits had a more fashionable character.
LIT: *The Last Romantics*, Barbican Art Gallery, London, 1989. CF

COX, Garstin, ARWA (1892–1933). Painter of landscapes in oils. Born in Camborne, Cornwall, the son of William Cox, he studied at Camborne Art School, at Lamorna near Newlyn, and at St Ives where he worked under J. NOBLE BARLOW. He exhibited at the RA in 1912 and 1919, at the RWA (ARWA 1924) and in Liverpool. A member of the Newlyn Society of Artists, 1925, his work is represented in collections including Johannesburg Art Gallery, SA. His exhibited works include subjects such as *The Coming of Spring*, RA 1912, and *Woodland Memory*, RA 1919. CF

COXON, Raymond James, LG, ARCA, (1896–1997). Painter of landscapes, figures, portraits and non-representational works in oils and watercolours; writer. He studied at Leeds College of Art and the RCA 1921–5, where contemporaries included MOORE, BAWDEN, RAVILIOUS, FREEDMAN, and EDNA GINESI whom he married in 1926. He attended Underwood's classes with PITCHFORTH and Moore. He visited France with Moore in 1922 and together they founded the BRITISH INDEPENDENT SOCIETY in 1927. He exhibited with the LAA and at the LEICESTER GALLERIES and other London galleries. He became a member of the LG in 1931 and a member of the CHISWICK GROUP in 1938. His work is represented in public collections including the TATE GALLERY. Between 1940 and 1945 he was an OFFICIAL WAR ARTIST and he taught widely until 1971. His early painting was influenced by Cézanne and his work ranged from sensitive portraits to non-representational paintings based on natural form.
LIT: Retrospective exhibition catalogue, Stoke-on-Trent Art Gallery, 1987. CF

CRAIG, Barry, RP, NEA (1902–1951). Landscape and portrait painter in oils. Educated

at Rugby and studied at the SLADE under TONKS. He taught at Michaelis School, Cape Town 1926–33 and was a teacher at ST MARTIN'S SCHOOL OF ART up to 1950 except years 1941–3 when he worked in the Camouflage Unit, Leamington Spa. From 1934 he exhibited at the RA, NEAC (elected 1946) and RP (elected 1949).
LIT: *Barry Craig 1902–51*, first retrospective exhibition catalogue, New Art Centre, 1987; Appreciation by Hugh Casson; obituary by Robin Darwin, *The Times*, 7 February 1951. KS

CRAIG, Edward Anthony (b. 1904). Painter of landscapes, etcher, engraver and illustrator. Son of Edward Gordon Craig, he studied art in Italy from 1917 to 1926 and exhibited at the REDFERN GALLERY and St George's Gallery, London. He was founder and President of the GRUBB GROUP of artists which first exhibited in 1928. He produced woodcut illustrations for books as well as paintings. He signed his works Edward Carrick. CF

CRAIG, James Humbert, RHA (1878–1944). Landscape painter in oils. Educated at Bangor Grammar School and Model School, Belfast, he was mainly self-taught. He gave up a career in his father's tea business in order to paint. Early on he visited the USA and also travelled to France, Switzerland and Spain. However, his paintings are chiefly of his homeland, Ireland. His work depicts the mountainous landscapes, river estuaries and seasons of Antrim, Donegal and Connemara. He was elected ARHA in 1925 and became RHA in 1928. He exhibited at the FINE ART SOCIETY five times between 1928 and 1937 and at the RHA regularly 1915–44, also showing at the Glasgow Institute. A posthumous exhibition was held at the RHA in 1945.
LIT: 'Two Ulster Artists', J.B. Meehan, *Colour*, Vol. 1, December 1925. CF

CRAIG-MARTIN, Michael (b. 1941). Conceptual artist working with installations, ready-made objects, texts and paintings. He attended Yale School of Art 1964–6, and in 1966 settled in England. He has shown at the Rowan Gallery and from 1982 at the WADDINGTON GALLERIES, also in many solo and group exhibitions. His work is represented in public collections including the TATE GALLERY. He has taught at BATH ACADEMY, CANTERBURY and GOLDSMITHS' colleges of art. He became Millard Professor of Fine Art at Goldsmiths' in 1994. Influenced by Robert Morris and Donald Judd, his early installations and ready-made objects invited spectators to question what they saw. In the 1970s his interest centred on wall drawings and later the domestic subject-matter of these works were made up in steel rods with painted and real elements. Recently his work has presented objects directly, in order to 'make art without transformation of the material'.
LIT: Exhibition catalogue, Whitechapel Art Gallery, 1989–90. CF

CRANE, Walter, RWS, RI (1845–1915). Book illustrator; painter of figures and landscapes in oils, tempera and watercolours; decorative painter, designer of wallpaper, stained glass, ceramics and scenery; teacher and writer. Born in Liverpool, he was apprenticed to the wood engraver W.J. Linton and attended evening classes at HEATHERLEY'S. Closely associated with Socialism and the Arts and Crafts Movement, from 1893 to 1897 he was Director of Design at MANCHESTER SCHOOL OF ART and from 1898 to 1899 Principal of the RCA. His many and influential publications include *The Bases of Design*, 1898, and *Line and Form*, 1900. His prolific illustrative work helped to establish the Aesthetic Style of the 1870s and 1880s and his paintings were initially influenced by Burne-Jones, whilst later more symbolic and allegorical subjects adopted a flatter, more stylized manner.
LIT: *The Art of Walter Crane*, P.G. Konody, London, 1902; *An Artist's Reminiscences*, Walter Crane, Methuen, 1907; *Walter Crane, Artist, Designer and Socialist*, exhibition catalogue, Whitworth Art Gallery, Manchester, 1989. CF

CRAWFORD, Hugh Adam, RSA (b. 1898). Painter of portraits, interiors and some abstracts in oils; mural designer. He studied at GLASGOW SCHOOL OF ART 1919–23, and at the CENTRAL and ST MARTIN'S schools, London, 1924–5. He exhibited mainly in Scotland, becoming RSA in 1958, exhibiting at the GI and galleries in Edinburgh and Glasgow. His work is represented in public collections in Scotland. He was an influential teacher at the Glasgow and Grays schools of art and as Principal, Duncan of Jordanstone College of Art 1954–64, his students included COLQUHOUN, MACBRYDE and EARDLEY. He designed murals for the Empire Exhibition and the Scottish Brewers. His painting was formally strong and often slowly resolved, ranging from painterly works, e.g. *Kathleen Reading*, 1935, to stylized paintings of interiors, e.g. *Sleeping Cat*, 1965.

LIT: *Crawford and Company*, exhibition catalogue, Third Eye Centre, Glasgow, 1978. CF

CRAWHALL, Joseph, RWS, NEAC (1861–1913). Painter of birds and animals in watercolours. Born in Northumberland, he studied in Glasgow and was associated with the GLASGOW SCHOOL, working with E.A. WALTON, GUTHRIE and HENRY in the 1880s. In 1882 he studied with Aimé Morot in Paris and from 1884 to 1893 frequently spent periods in Tangier where he met G.D. ARMOUR. He also knew Charles Keene. He held his first solo exhibition at Alex Reid's Gallery, Glasgow, in 1894 and exhibited at W.B. Paterson's Gallery, London, in 1912. He also showed at the RSA, RSW, GI, NEAC (member 1909–13), the RWS (member 1887–93), at the IS and in the provinces. His work is represented in collections including the TATE GALLERY. A perfectionist who destroyed much of his work, he was influenced by Oriental art and by Whistler, depicting his subjects from memory with great economy, clarity and balance. LIT: *Joseph Crawhall: The Man and the Artist*, Adrian Bury, Charles Skilton Ltd, London, 1958; *Joseph Crawhall*, Vivien Hamilton, John Murray, 1990. CF

CRAXTON, John, RA (b. 1922). Painter of figures and landscapes in oils and tempera, theatrical designer and illustrator. The son of the composer Harold Craxton, his interest in art was evident whilst a student at Betteshanger. He later attended drawing classes at the Académie de la Grande Chaumière, Paris in 1939, WESTMINSTER ART SCHOOL and the CENTRAL SCHOOL OF ART under P.F. Millard. He also attended GOLDSMITHS' COLLEGE 1941–2. In 1941 he met Peter Watson and between 1942 and 1944 he shared a studio with LUCIAN FREUD. In 1943 he worked in Pembrokeshire with GRAHAM SUTHERLAND and in 1946 he made his first visit to Greece where he was deeply affected by the light, the people and the landscape. Thereafter he divided his time between London, Greece and travelling extensively. In 1960 he rented a house on Crete and that became a permanent base apart from a voluntary exile between 1970 and 1976. His first solo exhibition was in 1942 (Swiss Cottage Café), and he has subsequently exhibited at the LEICESTER GALLERIES, at other London galleries and in Athens and Crete. His work is represented in many public collections including the TATE GALLERY. In 1951 he designed sets and costumes for the ballet *Daphnis and Chloë*, choreographed by Ashton,

and in 1966 for Apollo, Covent Garden. His early work was influenced by Sutherland and also by the example of Samuel Palmer. Gradually during the 1940s his work became more formally structured, reflecting his interest in Picasso, Miró and Cubism. Seeing abstraction as too limited for his needs, he abandoned classical perspective and aimed at a clear statement using line in order to make volume expressive. In Greece the example of Byzantine mosaics and the work of Ghika reinforced his use of line, a restricted range of clear colour, patterning and clarity of detail, e.g. *Landscape, Hydra* (Arts Council Collection). Recent work has continued this decorative, cubist style, capturing in clear colours the flicker of sunlight on figures and landscape. LIT: The catalogue for the retrospective exhibition, Whitechapel Art Gallery, 1967; exhibition catalogue, Christopher Hull Gallery, 1985. CF

CREALOCK, John Mansfield, RP (1871–1959). Painter of portraits, figures and townscapes in oils. Educated at Sandhurst he served in the Boer War and studied art at the ACADÉMIE JULIAN, Paris 1901–4. He subsequently exhibited at the RA, RHA and RP as well as with other societies and leading London galleries. He also exhibited in Paris and his work is represented in several public collections. He became RP in 1918, and Associé of the Paris Salon, and a Sociétaire of the Société Nationale des Beaux-Arts in 1927. His formal portraiture shows his firm depiction of character, e.g. *Geoffrey Lawrence Oaksey, 1st Baron*, Inner Temple. He also produced fashionable, elegantly posed portraits of women and some studies of old Parisian streets. CF

CREFFIELD, Dennis, LG (b. 1931). Painter of figures, landscapes and flowers in oils, draughtsman in charcoal and ink. Born in London, he studied at the Borough Polytechnic with BOMBERG in 1948 and later at the SLADE 1957–61, winning the Steer Prize in 1960. He was elected to the BOROUGH GROUP in 1949 and exhibited with them in the March and Summer exhibitions that year. In 1954 he also showed with the Borough Bottega as an invited guest. He has exhibited with the LONDON GROUP, becoming a member in 1962, and at London galleries, including the Seven Dials Gallery and the Wraxall Gallery, and in the provinces. Influenced by Bomberg's teaching of the 'spirit of the mass', his work employs expressive, violent lines and forms to convey both the subject and his reaction

to it. His charcoal drawings show the same dramatic force and the building up of form from an accumulation of marks.

LIT: *Drawings by Dennis Creffield: English Cathedrals*, Winchester Gallery, Winchester, South Bank Centre, London, 1988.　　　CF

CREME, Benjamin (b. 1922). Painter of landscapes in oils, illustrator, theatrical and film designer. Between 1941 and 1943 he studied with JANKEL ADLER and in 1946 settled in London. He has exhibited in France, America and in London galleries as well as in many group exhibitions. Early landscape work reflected the influence of Adler, Picasso and particularly SUTHERLAND, showing interlocked shapes painted in strong colours. Later work moved towards greater abstraction and expressiveness.

LIT: The exhibition catalogue for England & Co., 1988.　　　CF

CROSBIE, William (b. 1915). Born in Hankow, China of Scottish parents, he was brought up there until 1926. He attended GLASGOW SCHOOL OF ART (1932–35) after a period of work as a salesman. He was awarded the Haldane Travelling Scholarship and enrolled at the Ecole des Beaux-Arts in Paris, entering the studio of Fernand Léger. He also took drawing lessons under the sculptor Maillol, and studied the History of Art at the Sorbonne. He visited Spain during the Civil War (1936) and in 1939 was employed in Egypt copying ancient friezes. His first one-man show was in Glasgow in 1939. During the Second World War he served in the Merchant Navy. After the war he painted murals (Festival of Britain, 1951), did book illustration and designed the sets for Eric Chisholm's ballet 'The Earth Shapers'. His notable portrait of Hugh MacDiarmid, a friend, was painted in 1943. He has had retrospective exhibitions at Aitken Dott's, The Scottish Gallery (1980) and at Ewan Mundy and Celia Philo, Glasgow and London, in 1990. His warm and painterly portraits, still-lifes, nudes and imaginative compositions frequently reflect cubist and Surrealist influences.

LIT: Exhibition Catalogue, William Crosbie, Retrospective, Mundy & Philo, Glasgow & London 1991. Exhibition Catalogue, William Crosbie, Retrospective; Ewan Mundy and Celia Philo, 1990.　　　AW

CROSS, Tom (b. 1931). Painter of landscapes and architecture in acrylic and gouache. He stud-ied at MANCHESTER SCHOOL OF ART and the SLADE, and has exhibited in London, the provinces and abroad. His work is represented in public collections. A member of the PENWITH SOCIETY 1976 and the LG 1978, he taught at Reading University and was Principal, Falmouth School of Art 1976–87. His publications include *Painting the Warmth of the Sun*, 1984 and *The Shining Sands: Artists in Newlyn and St Ives, 1880–1930*, Falmouth, 1995. His current landscapes depict the area around the Helford River, Cornwall, and move between abstraction and observation.　　　CF

CROWLEY, Graham (b. 1950). He studied at ST MARTIN'S 1968–72 and THE ROYAL COLLEGE 1972–5. He was artist in Residence at Oxford University in 1982–3. From 1976 to 1987 he frequently exhibited at the JOHN MOORES, LIVERPOOL, (prizewinner, 1987) and the Tolley Cobbold (prizewinner 1983). His first London one-man show was at the Air Gallery in 1982. He has represented British art abroad in a number of touring exhibitions: Switzerland, 1982, in the USA and Australia, 1988, and at the Venice Biennale, 1984. His work is in a number of public collections, and he has executed mural projects; such as that for the Brompton Hospital, 1982, and Chandler's Ford Library, 1983.

LIT: 'Graham Crowley', Robert Ayers, *Artscribe*, No. 40; 'Painted Dreams', Judith Higgens, *Art News*, February 1988.　　　AW

CROZIER, William, ARSA (1897–1930). Painter of landscapes and townscapes in oils and watercolours; etcher and illustrator. He studied at EDINBURGH COLLEGE OF ART from *c.*1915, winning a travelling scholarship to work in Italy and France where he studied in Paris with André Lhote. A friend of WILLIAM MACTAGGART with whom he shared a studio in Edinburgh and travelled in France, Italy and the Netherlands, he exhibited mainly at the RSA (ARSA 1930) from 1920 and at the SSA from 1922. He also showed at the RSW, in Glasgow and Liverpool, and his work is represented in Glasgow Art Gallery. Influenced by Lhote, his work depicts landscapes and views of Edinburgh with a strong sense of construction.

LIT: *Scottish Art Since 1900*, exhibition catalogue, Scottish National Gallery of Modern Art, Edinburgh, and the Barbican Gallery, London, 1989–90.　　　CF

CROZIER, William (b. 1933). Painter of landscapes and still-life in oils. He studied at GLASGOW SCHOOL OF ART 1949–53, and has worked in France, Spain and Ireland. He has exhibited in leading London galleries, in the provinces and abroad, and been represented in many group shows and public collections. In 1960 he won first prize, Primo Lissone, Milan. In 1979 he worked in New York and later became Head of Fine Art, Winchester School of Art. His vivid work presents a heightened account of nature with its starting point in observation.
LIT: The catalogue for Cunningham Knowler Fine Art, 1985; interview in *Artlog*, no.6, 1979.
CF

The Crypt Group. The first exhibition of the Crypt Group was held in July 1946 in the crypt of the Mariners' Chapel, St Ives. The Chapel had been acquired for the St Ives Society of Artists in 1945 to provide additional exhibition space. In order to resolve the disputes between the 'advanced' members of the society and the more traditional artists over the inclusion of abstract work in the Society's exhibitions, the idea was promoted by PETER LANYON that the 'modern' artists should show their work separately. The first exhibition included 105 works by SVEN BERLIN, JOHN WELLS, Peter Lanyon, BRYAN WYNTER and Guido Morris. Two more exhibitions of the Crypt Group followed, in August 1947 when they were joined by BARNS-GRAHAM and in August 1948 when Kit Barker, DAVID HAUGHTON, ADRIAN RYAN and PATRICK HERON also showed their work. CF

CULBERT, Bill (b. 1935). Born in New Zealand, he has been based in England since he attended the RCA (1957–60) after study in New Zealand. He taught 1960–1 at Hornsey College of Art, and was fellow in Fine Art, Nottingham University, 1962. He has moved from painting and sculpture to exploring the use of holographs.
LIT:*Bill Culbert, Selected Works, 1968–88*, exhibition catalogue, ICA, 1986. AW

CULLIMORE, Michael (b. 1936). Painter of landscapes, flowers and figures in oils, watercolours, gouache and mixed media. He studied at Swindon and at GOLDSMITHS' and worked in Wales from 1962 to 1984, subsequently settling in Wiltshire. He held his first solo exhibition in 1980 at the AIR Gallery; since 1986 he has shown at Austin/Desmond Fine Art. He has exhibited in

group exhibitions since 1968 and his work is represented in collections including the National Museum of Wales. From 1973 to 1983 he was Curator of the University College of North Wales Art Gallery. His painting, which reflects the influence of DAVID JONES, PAUL NASH and Blake, ranges from lyrical landscape to paintings based on mythological, biblical or poetic themes.
LIT: Exhibition catalogue, Aberystwyth Arts Centre, 1983; exhibition catalogue, Austin/Desmond Fine Art, Brookside Farm, Winkfield Road, Berkshire, 1986. CF

Cumberland Market Group. Formed by BEVAN, GILMAN and GINNER in 1914, it was joined by JOHN NASH and meetings were attended (on Saturdays at Bevan's Cumberland Market Studio), by McKNIGHT KAUFFER and NEVINSON among others; an exhibition was mounted by William Marchant in the Spring of 1915 at the Goupil Gallery. The Group also met in the 'Grey Room' above the Gallery. They shared an interest in sober, urban realism of subject-matter painted in strong colour and boldly delineated forms. AW

CUMING, Fred, RA (b. 1930). Landscape, seascape, townscape and interior painter. Works chiefly in oils and watercolours but also produces prints and drawings. He trained at Sidcup School of Art 1945–9 and the RA SCHOOLS 1951–5, doing National Service 1949–51. In 1955 he was awarded the Abbey Minor Travel Scholarship to Italy. He has exhibited at the RA since 1953, becoming ARA in 1969 and RA in 1974. He was elected to the NEAC in 1960. His first one-man show was in 1971 at the New Metropole Arts Centre, Folkestone, where he has since held other shows. He exhibited at the NEW GRAFTON GALLERY, London 1983/85/87/88. In 1977 he was joint winner of the Grand Prix, Contemporary Art Award, Monte Carlo, and 1986 winner of the Sir Brinsby Ford Award, NEAC. Cuming's work is inspired by everyday scenes and objects (often marine): a harbour, figure on the beach, marshland or a flowerpiece. He works on a small scale concentrating on the use of light and tone.
LIT: F. Cuming, in *Painters Progress: Art School Year in 12 Lessons*, ed. Ian Simpson, Allen Lane, 1983; exhibition catalogues for New Grafton Gallery, 1983–8. KS

CUMMING, Diana (b. 1929). Painter of figures in oils. She studied at the SLADE SCHOOL 1950–4,

winning first prize for summer composition in 1951. She won a number of travelling scholarships and in 1954 worked in Paris. She was also awarded a ROME SCHOLARSHIP 1954–6. She exhibited at the BEAUX ARTS GALLERY in 1964, and subsequently at leading galleries including the Minories, Colchester, and the SERPENTINE, London. Her work has been well represented in group exhibitions and public collections. She presents an idiosyncratic and humorous view of her subjects which are shown simply in a stylized and sometimes naive manner, e.g. *Adam*, 1956. Her paintings vary from biblical scenes to portraits and figures of musicians and footballers.
LIT: The exhibition catalogue for the Serpentine Gallery, 1978. CF

CUMMING, James, PSSA, RSA (1922–1991). Born in Dunfermline, Cumming attended EDINBURGH COLLEGE OF ART, where his studies (which included sculpture) were interrupted for five years during the Second World War which he spent in the RAFVR, training as a pilot and subsequently flying in the USA, the Middle and the Far East. Following the completion of his training, he spent fourteen months at Callanish on the Isle of Lewis, which led to a long series of Hebridean paintings. His carefully-wrought, sensitively-coloured compositions of tinkers and crofters employed expressive stylizations, although for a long period after 1962 he abandoned figuration and painted pictures on themes inspired by microbiology before returning to the more obviously representational. A typical work is *The Lewis Poacher*, 1965. He taught at Edinburgh College of Art from 1952 to 1980, broadcast and wrote film scripts. He became a member of the RSW and ARSA in 1962, won an International Scholarship in the Humanities from Harvard University in 1964, and, elected RSA in 1970, served as Treasurer in 1973, and Secretary from 1978 to 1980.
LIT: *James Cumming*, exhibition catalogue, Festival Exhibition, The Scottish Gallery, Edinburgh, 1985; *James Cumming, Retrospective Exhibition, Paintings 1984–1987*, Middlesbrough Art Gallery, 1987. AW

CUNDALL, Charles Ernest, RA, RWS (1890–1971). Landscape, townscape and portrait painter in oils and watercolours; designed lustreware for Pilkington's pottery and also stained glass. He studied at MANCHESTER SCHOOL OF ART, the RCA 1912–14 and 1918, the SLADE 1919–20, and in Paris. He served with the Royal Fusiliers

during the war and travelled extensively to Italy, Sweden, France, Russia, Spain, USA and Canada. He exhibited at the RA from 1918; elected ARA in 1937 and RA in 1944. His first one- man show was held at Colnaghi's in 1927. He was elected to the NEAC in 1924, RP in 1933, ARWS in 1935 and RWS in 1941, and was OFFICIAL WAR ARTIST 1940–5. Skilled in portraying crowd scenes he observed ordinary people in everyday settings, painting in low and warm tones. Queen Mary bought his painting *Coronation Day 1937* which she later gave to George VI.
LIT: Exhibition catalogue, Foreword by Muirhead Bone, 1926, Colnaghi Gallery, London. KS

CUNDELL, Nora Lucy Mowbray (1889–1948). Painter of figures, landscapes and flowers in oil and watercolour. Granddaughter of Henry Cundell, the artist, she was encouraged to paint by her father. She studied at Blackheath Art School, at WESTMINSTER under SICKERT and at the SLADE SCHOOL, 1911–14 and 1919. In 1914 she was awarded the Melvill Nettleship Prize for figure composition. Her first one-man show was at the REDFERN GALLERY in 1925. She exhibited at the RA, NEAC and the Paris Salon and was a member of the National Society of Painters, Sculptors, and Printmakers, 1930. In 1940 she wrote and illustrated *Unsentimental Journey*, an account of a visit to Arizona, USA, where she met the writer J.B. Priestley. After her death a memorial exhibition was held at the RBA in September 1949. The TATE GALLERY has her *Smiling Woman*, acquired in 1923.
LIT: Memorial exhibition catalogue, RBA Galleries, 1949. KS

CUNEO, Terence Tenison, CBE, CVO (1907–1996). Painter of portraits and of ceremonial, military and engineering subjects. Born in London, both his parents being artists, he studied at CHELSEA and the SLADE Schools of Art. He exhibited at the RA, ROI, RP, the Paris Salon, and held many one-man shows. He travelled widely in the Far East, Africa, Canada and the USA (where he worked with and painted cowboys) and was well-known for official portraits: of HM The Queen, Edward Heath, Field Marshall Montgomery and many other notables. He was a member of the WAAC during the Second World War. LMN

CUNINGHAM, Vera, RBA, LG (1897–1955). Painter of figures, portraits, flowers and land-

scapes in oils and gouache. She studied for a short period at the CENTRAL SCHOOL OF ART and exhibited with the LG in 1922 (member 1927). She held her first solo exhibition at the Bloomsbury Gallery in 1929 and she showed at the RBA, WIAC, the RA and in London galleries. She also exhibited in Paris at the Salon des Indépendants and held three solo exhibitions at the Raymond Creuze Gallery. Her work is represented in collections including Manchester City Art Gallery. A model for MATTHEW SMITH, her early work shows his influence whilst later imaginative and visionary paintings reflect her admiration for El Greco and Tintoretto.
LIT: Memorial exhibition catalogue, Lefevre Gallery, London, 1956; *Vera Cuningham*, Raymond Creuze, Paris, 1984. CF

CURLING, Peter (b. 1955). Painter of equestrian subjects in oils and watercolours. Born in Waterford, Ireland, he studied in Florence with Signorina Simi from 1972 to 1974 and in 1974 in the Camargue with John Skeaping. He held his first solo exhibition in 1970 in Lambourne, Berkshire, and he has subsequently exhibited in Ireland, New York and in London at the Tryon Gallery. His racing pictures are noted for their expression of action and movement.
LIT: *The Racehorse in Twentieth Century Art*, Claude Berry, The Sportsman's Press, London, 1989; *Country Life* (UK), No.4344, Vol.168, 20 November 1980, p.1888. CF

CURRIE, John S. (*c.*1884–1914). Painter of figures and portraits in oils and tempera; draughtsman. He studied at Newcastle under Lyme School of Art, the Hanley School of Art 1904, the RCA 1905–6, and at the SLADE from 1910 where he became a close friend of GERTLER and of GAUDIER-BRZESKA. In 1907 he was Master of Life Drawing at Bristol School of Art. In 1912 he was living with Dolly Henry whom he shot dead in October 1914, subsequently committing suicide. He exhibited at the RA, the FRIDAY CLUB, the NEAC (member 1914) and held his first solo exhibition at the CHENIL GALLERY in 1913. His work is represented in the TATE GALLERY. His work was influenced by early Italian painting, Post-Impressionism and VORTICISM.
LIT: *John Currie, Paintings and Drawings 1905–1914*, exhibition catalogue, City Museum and Art Gallery, Stoke on Trent, 1980–1; *Mark Gertler: Selected Letters*, ed. Noel Carrington, Rupert Hart-Davis, London, 1965. CF

CURRIE, Kenneth (b. 1960). A painter, etcher and sculptor, he was at Paisley College 1977–8, and then attended GLASGOW SCHOOL OF ART 1978–83. His first solo exhibition at Glasgow Arts Centre was entitled *Art and Social Commitment*. In 1987 he executed a mural for the People's Palace Museum in Glasgow, on the theme of Scottish labour history, and in 1991 became a visiting tutor at the School of Art. In 1992 he exhibited at the Art Institute of Chicago, and in 1995 he received a commission for the Glasgow Royal Concert Hall. His grim and powerful works often depict the victims of violence and persecution, as in *Study for Night and Death*, 1995–6. AW

CURSITER, Stanley, RSA, RSW, LLD, CBE (1887–1976). Painter of landscapes, figures and portraits in oils and watercolours; lithographer. Born in Kirkwall, Orkney, he studied at EDINBURGH COLLEGE OF ART and at the RCA under Lethaby. During the First World War he served in France and in 1919 he travelled to Cassis and Avignon, returning to Edinburgh in 1920. He held his first solo exhibition in Orkney in 1910 and he subsequently exhibited at the RSA (ARSA 1927, RSA 1938), at the RSW (RSW 1914), at the SSA, GI, at the RA from 1921 to 1939, and in London and provincial galleries. His work is represented in collections including the Scottish National Gallery of Modern Art. In 1913 he arranged the exhibition of Post-Impressionism at the SSA, and from 1924 to 1948 he was Keeper and then Director of the National Galleries of Scotland. He published books on PEPLOE in 1947, and on Scottish Art in 1949 and his autobiography *Looking Back* was published privately. In 1948 he became HM Painter and Limner in Scotland and he was awarded a CBE. His painterly, fluent work includes some canvases painted in 1913 which were influenced by Severini and Boccioni.
LIT: Retrospective exhibition catalogue, Aitken Dott & Son, Edinburgh, 1979; centenary exhibition catalogue, Pier Arts Centre, Stromness, Orkney, 1987. CF

The Curwen Press, Studio and Gallery. The Curwen Press was begun at Plaistow, London, by the Reverend John Curwen, in order to publish music (1863–1916). His grandson Harold Spedding Curwen served his apprenticeship as a printer with the firm, followed by a year in Leipzig, and then studied lettering under Ernest Johnston at the CENTRAL SCHOOL. He reorganized

the Press, introduced and designed new typefaces, and began to work with artists such as CLAUD LOVAT FRASER, ERIC GILL, EDWARD BAWDEN and ALBERT RUTHERSTON. Curwen later developed printing with celluloid stencils; they were brilliantly used by MCKNIGHT KAUFFER and PAUL NASH, whose *Urne Buriall* was published in 1932. In 1937 the Press broke away from the music publishing side. Oliver Simon, trained and employed by Curwen, and later a Director, produced a magazine of the graphic arts, *Signature*, which carried articles by artists such as SUTHERLAND and PIPER. In 1958, Timothy Simon, the son of Oliver, with the Hon. Robert Erskine, opened a lithographic studio for artists, with STANLEY JONES as manager. A great many distinguished artists have subsequently worked with this studio. The Curwen Gallery shows work by artists associated with the Press, including painting and sculpture.
LIT: *Artists at Curwen*, Pat Gilmour, TATE GALLERY, 1977. AW

CUTTER Christiana (1893–1969). Painter of figures, landscapes and interiors in oils. Born in Wisbech, Cambridgeshire, she studied at the SLADE SCHOOL where she met MARJORIE LILLY in 1911 (whose brother, George, she married in 1919). She exhibited at the LG and the NEAC and held joint shows in 1922 with WENDELA BOREEL and Marjorie Lilly at the Walker Gallery, London. Her work was influenced by SICKERT.
LIT: *The Sickert Women and the Sickert Girls*, exhibition catalogue, Michael Parkin Fine Art, London, 1974. CF

D

DACRE, Winifred see NICHOLSON, WINIFRED

DAGLISH, Eric Fitch, RE (1894–1964). Painter and wood engraver. He was educated at the Universities of London and Bonn, and in 1919 met PAUL NASH, who introduced him to wood-engraving. His prints of birds, animals and plants are in many public collections. As a naturalist he was the author of many books, which were illustrated by his own work. AW

D'AGUILAR, Michael (b. 1928). Painter of landscapes, portraits and figures in oils and pastels. Brother of PAUL D'AGUILAR, he spent his early life in Spain and attended the RA SCHOOLS 1948–53, under RUSHBURY and FLEETWOOD WALKER, win-

ning medals, the Armitage Prize and the Leverhulme Scholarship. He also studied under Eric O'Dea and Basil Johnson. He held his first solo exhibition at the Temple Gallery in 1961 and has subsequently shown in London galleries including the NEW GRAFTON GALLERY, in the provinces and abroad. He has shown at the RA since 1953, at the RBA and NEAC and his work is represented in collections including Bradford City Art Gallery. Influenced by Impressionism, his spontaneous work includes landscapes of France and England.
LIT: Exhibition catalogue, Lad Lane Gallery, Dublin, 1976; *Post Impressionists from Richmond*, exhibition notes, Gallery One-Eleven, Berkhamsted, 1991. CF

D'AGUILAR, Paul (b. 1927). Painter of landscapes, animals, figures and townscapes in oils and watercolours. Brother of MICHAEL D'AGUILAR, he trained at the RA SCHOOLS 1948–53, under RUSHBURY, DRING and FLEETWOOD WALKER, winning medals and the Royal Academy and Leverhulme Scholarships. He held his first solo exhibition in 1952 at the Irving Gallery and he has subsequently exhibited in London galleries including the Langton, 1973 and 1976, at the RA from 1955 to 1969, at the NS, NEAC, RBA, LG and abroad. His work has been purchased by the Leicestershire and Bradford Education Committees. From 1960 to 1962 he worked as a critic and in 1965 published a book on the nude (Studio Vista). His work includes Greek and Italian landscape and uses simplified forms.
LIT: *Arts Review* (UK), Vol.25, pt7, 7 April 1973, p.220, and Vol.28, pt10, 14 May 1976, p.243. CF

DAINTREY, Adrian Maurice, RWA (1902–1988). Painter of portraits, figures, landscapes and murals; critic. He studied at the SLADE SCHOOL under TONKS and in Paris. He exhibited widely, at the RA, NEAC and other leading London and provincial galleries. From 1953 to 1961 he was art critic to *Punch* and in 1963 published his autobiography *I Must Say* (Chatto and Windus). LMN

DANIELS, Barry (b. 1931). Painter in oils, gouache and watercolours. He studied at Gravesend School of Art and at the SLADE 1950–4, winning the Abbey Minor Scholarship and a French State Scholarship to work in France, Italy and Spain. He has exhibited at the YOUNG CONTEMPORARIES, the LG, at the ICA in

1955 ('Eight Young Painters') and at ROLAND, BROWSE AND DELBANCO. His work is represented in the ARTS COUNCIL COLLECTION (*Abstract*, *c*.1951–4, gouache) and in the collection of Nottingham University. CF

DANNATT, George (b. 1915). A painter and photographer born in London. He first qualified as a surveyor, and, after military service, began to write music criticism; he was self-taught as an artist, retiring in 1969 to concentrate on painting, photography and music. He first showed at the Penwith Gallery, St Ives, in 1970, and he also regularly shows with the Newlyn Society, of whom he is a member. He has had one-man shows in London, Basle and Cuxhaven. His precisely painted and textured abstract paintings and reliefs are geometric in composition, using warm, carefully modulated earth colours.
LIT: *One Way of Seeing*, George Dannatt, Hobnob Press, Salisbury, 1990. AW

DARWIN, Sir Robin, CBE, RA, RSA, PRWA, NEAC (1910–1974). Landscape, still-life and figure painter. He was educated at Eton, Cambridge and the SLADE SCHOOL. Becoming Principal of the RCA in 1948, he developed it into one of the most powerful influences on art and industrial design in the country. He exhibited his carefully-wrought, close-toned paintings at the RA (ARA 1966, RA 1972) and with other societies, having many one-man shows. In 1954 he was made CBE and he was knighted in 1964.
LIT: *The Royal College of Art*, Christopher Frayling, Barrie & Jenkins, 1987. LMN

DAVENPORT, Ian (b. 1966). He studied at Northwich and GOLDSMITHS'. His first one-man show was at WADDINGTON'S in 1990, but he attracted attention at HIRST's 'Freeze' exhibition in 1988. His abstract panels are often achieved with poured paint.
LIT: *Ian Davenport*, Norman Rosenthal, Waddington Gallery, 1990. AW

DAVIDSON, Allan Douglas, ROI, RBA, ARMS (1873–1932). Painter of portraits and figures in oils. Son of the painter Thomas Davidson, he studied at the RA SCHOOLS where he won silver and bronze medals and the Armitage Prize, and at the ACADÉMIE JULIAN, Paris. He lived in London and later in his life at Walberswick, Suffolk. He exhibited mainly at the RBA and the ROI as well as at the RA from 1898 to 1931. His work was also shown in London galleries including the

LEICESTER and the REDFERN, at the RMS, the GI, in Liverpool and Manchester. A member of the Langham Sketching Club, he was elected RBA in 1901, and ARMS and ROI in 1920. He taught at the LCC CENTRAL SCHOOL OF ART AND CRAFTS and he was commissioned to paint a work for the Queen's Doll's House. His work ranged from formal portraiture to subjects such as *Lady Godiva* exhibited at the RA in 1905. CF

DAVIDSON, Daniel Pender (1885–1933). Painter of portraits, figures, landscapes and still-life in oils; decorative and scenic painter. Born in Camelon, Scotland, he studied at GLASGOW SCHOOL OF ART, in Brussels and in Munich. He exhibited in Liverpool, at the RA in 1918, in Paris and Belgium and his work included imaginative, decorative subjects such as *Le Jardin d'Eve* exhibited in Liverpool in 1925. CF

DAVIE, Alan (b. 1920). Born in Grangemouth, he attended EDINBURGH COLLEGE OF ART 1937–40, making jewellery as well as painting. After Military Service 1940–6, he taught children, and for a period was a professional jazz musician. (He has since given concerts, recitals and has made a record.) He travelled widely in Europe 1947–9. In 1950 he had the first of many one-man shows at GIMPEL FILS. From 1956 to 1959 he was Gregory Fellow at Leeds University. He has broadcast and lectured on his own work, and taught at the CENTRAL SCHOOL 1959–60. His brightly-coloured and richly patterned paintings are alive with symbols and signs, evoking primitive magic, religion and eroticism. He has work in many major museum collections world-wide, and won prizes at the VII Biennale in São Paolo in 1963, at Cracow in 1966 and elsewhere.
LIT: *Alan Davie*, Alan Bowness, 1967; *Alan Davie*, catalogue, City of Aberdeen Art Gallery, 1977. AW

DAVIES, Adrian (b. 1943). Born in Swansea, he attended Swansea College of Art 1961–5, becoming technical assistant there from 1965 to 1966. From 1973 to 1978 he was Lecturer in Fine Art at Hereford College of Education and during 1978–80 was on a two year secondment to the Department of Fine Art, University of Reading. One-man exhibitions include Swansea in 1964 (at the National Eisteddfod), and in 1975 he took part in 'Four Artists from Hereford' at the Malvern Festival Theatre and at the Royal National Eisteddfod Exhibition in Cardiff. During 1974 he designed and supervised Art

workshops in Ludlow and in 1976 he instigated work in Hereford Cathedral to celebrate its thirteen hundredth centenary. LMN

DAVIES, David, ROI (1864–1939). Painter of landscapes and coastal scenes in oils and watercolours. Born in Ballarat West, Victoria, Australia, he studied locally under J.F. Martell and Thomas Price before attending the Gallery School, Melbourne, under McCubbin and Folingsby, 1887–90.·He subsequently studied in Paris at the ACADÉMIE JULIAN in 1891, worked in St Ives, Cornwall, in 1892 and possibly visited Venice before revisiting Australia (1893–7). In 1898 he returned to Cornwall, later living in London and Wales. He exhibited at the ROI (member 1920), the RI, NEAC, at the RA from 1899 to 1906, at the Ridley Art Club and in Australia between 1911 and 1912 and in 1926. His work is represented in collections including the National Gallery of Victoria, Australia. His painterly work, including a series of nocturnes painted between 1893 and 1897, captured particular effects of light and colour.
LIT: 'David Davies 1864–1939', C. Sparks, *Art & Australia* (Australia), Vol.16, pt.1, September 1978; *Golden Summers – Heidelberg and Beyond*, exhibition catalogue, National Gallery of Victoria, Australia, 1985–1986. CF

DAVIES, Peter. (b. 1960). Born in Edinburgh, he graduated from GOLDSMITHS' in 1996. He has recently worked on text paintings; his thoughts on technique, style and on artists past and present are written on the canvas in different colours. *Text Painting* (1996) is typical. AW

DAVIS, Lady Mary (1866–1941). Painter of fans in watercolours on silk and of landscapes. Born in London, née Halford, she studied at the Ridley Art School and exhibited mainly at the Ridley Art Club and the LEICESTER GALLERIES. She also showed at the ROI, IS, at the RA in 1896 and in London galleries. In 1914 she held a joint exhibition with CHARLES CONDER at the Colnaghi & Obach Gallery, New York. Her work is represented in collections including the TATE GALLERY and her impressionistic work was influenced by Conder. CF

DAVISON, Francis (1919–1984). Collagist, painter and poet. Born in London, he read English and Anthropology at Cambridge and began to paint in the mid-1940s. In 1948 he married MARGARET MELLIS and between 1948 and 1950 they lived in France, subsequently returning to England and settling in Suffolk. He began to make collages in 1952 but apart from exhibiting some work at ROLAND, BROWSE AND DELBANCO in 1955 he was virtually unknown until the ARTS COUNCIL exhibition of his work in 1983. A life-long friend of PATRICK HERON, his early paintings were semi-representational. When he gave up painting for collage he produced non-figurative images which were made with used paper, torn rather than cut. He built up rhythmic, complex compositions which combined spontaneity, control, richness of colour and spatial movement.
LIT: Retrospective exhibition catalogue, Hayward Gallery, London, 1983; retrospective exhibition catalogue, REDFERN GALLERY, London, 1986. CF

DAWSON, Montague J., RSMA, FRSA (1895–1973). Painter of marines in oils and watercolours; illustrator. Born in Chiswick, he worked as an illustrator for *The Sphere* and during the First World War he met C. Napier Hemy who influenced his painting. He exhibited at the RA from 1917 to 1936, in London galleries, particularly Frost and Reid from the 1920s, and at the SMA from 1946 to 1964. His work is represented in collections including the National Maritime Museum, Greenwich, and the Royal Naval Museum, Portsmouth. His evocative, knowledgeable work often depicted sailing ships in turbulent seas and historical scenes such as *The Battle of Trafalgar*.
LIT: *Montague Dawson RSMA, FRSA*, L.G.G. Ramsey, F. Lewis, Leigh-on-Sea, 1967. CF

DAWSON, Norman, ARCA (1902–1960). Painter of easel and mural paintings, printmaker, decorator and ceramic artist. Educated in Bruges and at Glasgow University, he studied art at the RCA. He won prizes for design, and a travelling scholarship which took him to Paris, Rome and Florence in the company of HENRY MOORE. A ROME SCHOLARSHIP finalist, he studied etching under SIR FRANK SHORT. Elected in 1933 to the LG he there exhibited work considered Surrealist, such as the collage *Blue Mouth of Paradise* (1937) and *Before the New Atlantic State* (1938), which was framed in barbed wire. A versatile and inventive artist, he varied his style with great facility and also painted a number of uncontroversial decorations in grand London houses. AW

DEAN, Catherine (1905–1983). Painter of still-life and landscapes in oils, watercolours, gouache

and pastels. She studied at Liverpool School of Art 1921–6, and at the RCA 1926–9, where in 1927 she met ALBERT HOUTHUESEN whom she married in 1931. In 1940 her painting *Sheep's Skull and Ferns* (1935) was acquired by the TATE GALLERY; she held her first solo exhibition at the Mercury Gallery, London, in 1982. She taught at Blackheath and CAMBERWELL Schools of Art and from 1939 to 1968 at St Gabriel's Teacher Training College. Her gentle paintings include many still-life subjects of flowers, fruit and vegetables.
LIT: *Arts Review* (UK), Vol.34, pt.3, 29 January 1982, p.43. CF

DEAN, Frank, RBA (1865–1947). Painter of landscapes and genre in oils and watercolours. Born in Leeds, he studied at the SLADE SCHOOL under Legros and in Paris with Boulanger and Lefèbvre from 1882 to 1886. In 1887 he returned to Leeds, later living in London, Sussex and Hertfordshire. He travelled to the Middle East, India, Switzerland and Ireland, and he exhibited mainly at the FINE ART SOCIETY and at the RA between 1887 and 1914. He also showed at the RBA (RBA 1895–7), the RI, ROI, NEAC, in the provinces and in Scotland. His work is represented in collections including the Leeds City Art Gallery. Many of his paintings depicted bright oriental scenes such as *A Wayside Shop, India*, RA 1910, whilst his English paintings included subjects such as *A Sussex Pastoral*, RA 1899, and *At the Piano* (Leeds Art Gallery).
LIT: *Studio*, Vol.39, 1907, p.164; *Studio*, Vol.49, 1910, pp.47–8 and p.51. CF

DEBENHAM, Alison (1903–1967). Painter of figures, portraits, landscapes, interiors and flowers in oils, watercolours, tempera and mixed media. Daughter of Sir Ernest Debenham, she studied at the SLADE SCHOOL 1921–6, lived in Paris in 1928 and from 1929 in the South of France where she worked with SIMON BUSSY through whom she met Matisse and de Segonzac. She was married to the artist René Leplat in 1930. In 1936 she returned to England. She exhibited in Paris in 1932 and in London from 1935 at the ZWEMMER, Storran and Adams Galleries and in mixed shows with the EUSTON ROAD SCHOOL. A memorial exhibition was held at the Richmond Hill Gallery in 1968. Her fresh, spontaneous paintings often depicted her immediate surroundings, her family and friends.
LIT: *Alison Debenham 1903–1967*, Belgrave Gallery, London, 1976. CF

DE BREANSKI, Alfred Fontville, RBA (1877–1945). Painter of landscapes, loch and river scenes in oils. Born in London, the son of Alfred De Breanski and the brother of Gustave De Breanski, the marine painter, he studied at ST MARTIN'S SCHOOL OF ART under Cecil Rea and in Paris under Whistler. He exhibited mainly at the RBA (RBA 1890), and at the RA from 1904 as well as the ROI, RI, RCA and RHA, in London galleries, the provinces and Scotland. Influenced by his father, his atmospheric landscapes depict the Scottish Highlands and Welsh subjects as well as scenes of the Thames. CF

DE FRANCIA, Peter (b. 1921). Figurative painter and draughtsman born in Beaulieu, France. He studied at the Academy in Brussels 1938–40, and at the SLADE SCHOOL. He taught at ST MARTIN'S, GOLDSMITHS' and the RCA (Professor of Painting 1973–86). He has had many one-man shows in Britain, Europe and the USA. His vigorous work is often motivated by his political views, and shows the influence of Picasso, Grosz and Guttuso.
LIT: *Peter de Francia, Painter and Professor*, catalogue, Camden Arts Centre, 1987. LMN

DE GLEHN, Wilfrid Gabriel, RA, RP, NEAC (1870–1951). Painter of portraits, landscapes, marines and figures in oils and watercolours; stained glass designer. He studied at the RCA c.1889, in 1890 enrolled at the Ecole des Beaux-Arts, Paris, and from 1891 assisted SARGENT and Edwin Austin Abbey with the Boston Public Library murals, dividing his time between France and England. He travelled widely, often with Sargent, and was a friend of TONKS and STEER. He exhibited at the NEAC from 1894 (member 1900), at the Salon from 1895, at the RA from 1896 to 1951 (ARA 1923, RA 1932) and at the RP (member 1904). He held his first solo exhibition at the Carfax Gallery in 1908, subsequently showing widely elsewhere. His work is represented in collections including the TATE GALLERY. Influenced by Sargent and the Impressionists, particularly Monet, his work was vividly brushed using an abbreviated notation and vibrant colour.
LIT: 'The Paintings of Wilfrid G. von Glehn', T. Martin Wood, *The Studio*, Vol.LVI, 1912, pp.3–10; *Wilfrid de Glehn: A Painter's Journey*, Laura Wortley, The Studio Fine Art Publications, c.1989. CF

DE GREY, Roger, PRA (1918–1995). Painter in oils and watercolour of interiors and landscapes;

de Grey also painted nudes. Often favouring a light palette, he used square faceted brushwork with vibrant effect. Born at Penn, Buckinghamshire, a nephew of SPENCER GORE, he was educated at Eton College before studying at CHELSEA SCHOOL OF ART 1936–9. Serving with the Royal West Kent Yeomanry 1939–42 and the RAC 1942–5, he continued his studies at Chelsea after the war 1946–7. He exhibited widely in London and the provinces holding one-man exhibitions at AGNEW'S, 1954, the LEICESTER GALLERIES, 1967, and at Nottingham University, 1966, and Bury St Edmunds, 1979. An exhibitor at the RA from 1947, he was elected member in 1969, Treasurer in 1976 and PRA in 1984. Teaching at Kings College, University of Newcastle 1947–53, where he was latterly Master of Painting, de Grey taught in London at the RCA under ROBIN DARWIN from 1953 and in 1973 became Principal of the City and Guilds of London Art School, where he initiated a variety of courses in conservation and the decorative arts. Elected a Senior Fellow of the RCA in 1985, de Grey held numerous Advisory and Trustee posts, notably of the RA Trust, National Portrait Gallery and the Open College of the Arts. His draughtsmanship was sharp and precise, and yet his use of colour carefully harmonized and close in tone, was equivocal in the relationship between focus and ambiguity. Married in 1942 to the artist Flavia Irwin, he gave the 1986 Reynolds Lecture. GS

DE LASZLO, Philip Alexius, FRBA, RP, NPS (1869–1937). Society portrait painter, often favoured by royalty, de Laszlo also painted landscapes, townscapes, still-life and flower paintings. With a dashing handling of oil paint, he was gifted in capturing the elegance or the stately pomp of his celebrated sitters. Born in Budapest, Hungary, the son of an unsuccessful business man, he was in 1879, so inspired by the sight of Munkácsy's picture *Christ before Pilate*, that he determined on becoming an artist. He worked with a theatrical scene painter, Lehmann, in 1880, before becoming a workshop apprentice to an architectural sculptor, Vogel. A short apprenticeship as a porcelain painter ensued before study at the Budapest School of Arts and Crafts 1884–5, the National Academy of Arts 1885–9, and the Royal Bavarian Academy of Art, Munich, 1889–90 and 1891–2. Travelling to Paris in 1890, he enrolled at the ACADÉMIE JULIAN 1890–1, and met the painter Munkácsy. Returning to Munich and winning a silver medal for his com-

position *Hofbräuhaus* in 1892, de Laszlo was inspired by the example of the wealthy and successful society portrait painter F. von Lenbach. Frequently working in Vienna until 1904, de Laszlo swiftly gained a European reputation. Travelling to England in 1904 on a commission, he finally settled in this country in 1907, when he held his first London one-man show at the FINE ART SOCIETY, and won a commission to paint Edward VII. Naturalized British in August 1914, he nevertheless did not escape internment (1917–18). His career restored, de Laszlo travelled much in Europe in the 1920s, painting many crowned heads, including King Fuad (Cairo, 1929). An international exhibitor, de Laszlo showed frequently in London at the RA, RP, Dowdeswells and Agnew's.
LIT: *Portrait of a Painter*, O. Rutter, 1939. GS

DE MAISTRE, Roy see MAISTRE, ROY DE

DEMARCO, Richard (b. 1930). A painter, gallery director and arts administrator who has had a considerable influence on the direction of art in Scotland, through his championing of many novel manifestations of the avant-garde, especially those in the tradition of Dada, Surrealism, fantasy and the conceptual. He attended EDINBURGH COLLEGE OF ART 1949–53, studying mural painting under LEONARD ROSOMAN in addition to graphic design. He has painted murals and done graphic work, and has exhibited in a number of Scottish societies (RSA, SSA, RSW), generally showing topographical work of a remarkably conventional nature when compared to the art with which he is identified as an entrepreneur. AW

DENBY, Philippa (b. 1938). Painter of landscapes and flowers in oils and gouache; sculptor of figures in bronze. She studied at the CENTRAL SCHOOL OF ART and has exhibited in provincial and London galleries including the Marjorie Parr, the Clarendon and the Fine Art Trade Guild Galleries. Her sculpture often depicts female figures, lovers and couples, whilst her paintings range from impressionistic, broadly painted canvases to more precise, detailed studies.
LIT: *Philippa Denby, Paintings and Sculptures*, exhibition catalogue, the Fine Art Trade Guild Gallery, London, 1986; 'Philippa Denby', *The Fine Art Trade Guild Journal*, September 1986.
CF

DENNY, Robyn (b. 1930). A painter of abstracts and constructions in various media including oil,

acrylic, collage and screenprints. He studied at ST MARTIN'S SCHOOL OF ART and the RCA. His first one-man exhibitions were in 1958 at Gallery One and GIMPEL FILS. Between 1961 and 1985, he had 43 further one-man exhibitions throughout the world including a major retrospective at the TATE GALLERY in 1973 which was toured throughout Europe by the British Council. Principal Lecturer at the SLADE SCHOOL OF ART, Visiting Lecturer at the BATH ACADEMY and Visiting Professor at the Minneapolis Institute of Fine Art, he was appointed to the Art Advisory Panel of the ARTS COUNCIL OF GREAT BRITAIN in 1966, and he has given one of the WILLIAM TOWNSEND Memorial Lectures. He won awards from the Gulbenkian Foundation and the Italian Government, and was prize-winner at exhibitions in Lugano, Llubjana and the JOHN MOORES LIVERPOOL exhibition. His work is represented in many public collections including the Museum of Modern Art, NY, the Tate Gallery and the Victoria and Albert Museum. His earlier abstract paintings were hard-edged compositions in closely related, flat painted colours; his more recent work uses painterly brushwork. Numerous public commissions include: Austin Reed Ltd, London (mixed media mural); St Thomas's Hospital, London (a series of six large enamel panels); IBM Headquarters, UK (a large enamel screen); London Transport, Embankment station (vitreous enamel panels on all platforms and intersections).

LIT: *Robyn Denny*, catalogue with an introduction by Robert Kudielka, Tate Gallery, 1973; *Robyn Denny*, David Thompson, Penguin New Art, No.3. HD

DENT, Robert Stanley Gorrell, RE, RWA, ARCA (b. 1909). Painter of landscapes, coastal scenes and townscapes in watercolours; etcher. He studied at Newport School of Art and at the RCA under OSBORNE and AUSTIN (diploma 1933) winning the British Institution Scholarship in Engraving. He exhibited at the RA from 1932 to 1965, at the RE (ARE 1935, RE 1946), at the RWA (ARWA 1951, RWA 1954), at the RSA and Cooling & Sons Gallery. His work is represented in collections including the Trustees of the RWS. He was Principal at Gloucester College of Art, 1950–74, and his paintings include views of Cheltenham as well as Welsh subjects. CF

DERHAM, Brigid (b. 1943). She studied at the SLADE SCHOOL, gaining a number of important prizes and scholarships: the Walter Neurath Prize, the Ian Stevenson Travelling Scholarship, an Italian State Scholarship and a Boise Travelling Scholarship. Her work reflects her travels. From 1974 she has taught at BYAM SHAW School and occasionally at the Slade. Her first one-man show was at the NEW ARTS CENTRE in 1971. LMN

DE SAUSMAREZ, Lionel Maurice, ARA, RBA, NEAC, ARCA (1915–1969). Portrait painter who studied at the RCA 1936–9, and exhibited at the RA, RBA, NEAC, LG and the LEICESTER GALLERIES. He was elected NEAC in 1950, RBA in 1952 and ARA in 1964. He became Head of Department of Fine Art at the University of Leeds in 1950. He was an important teacher of creative approaches to composition and design. LMN

DESMET, Anne (b. 1964). She studied painting and printmaking at the RUSKIN SCHOOL, and at the CENTRAL SCHOOL. She was a ROME SCHOLAR 1989–90, and has since taught engraving at the RA SCHOOLS. Her wood engravings, such as *Tompieme's Daughter* and *A Second Development* (c.1990) are often in a series of blocks so juxtaposed as to demonstrate the transformation of an image through progressive changes. She also makes coloured linocuts (*Bishopsgate, London in the 1990s*, 1997) AW

DETMOLD, Charles Maurice, ARE (1883–1908). Etcher and painter in watercolours of birds and animals. Twin brother of EDWARD JULIUS DETMOLD, he studied animals from life and was largely self-taught. He exhibited at the RA and RI from 1897 and showed at the FINE ART SOCIETY in 1900 with his brother. He exhibited also at the RE (ARE 1905), the NEAC, the IS and in Glasgow and his work is represented in collections including the BM, London. He collaborated closely with his brother on etchings and illustrations including *Pictures from Birdland*, J.M. Dent, 1899, and his work was influenced by Dürer and Japanese prints. He committed suicide in 1908.

LIT: 'Maurice and Edward Detmold', Campbell Dodgson, *The Print Collectors Quarterly*, December 1922, pp.373–405; *Charles Maurice and Edward Julius Detmold*, centenary exhibition catalogue, Heslington Hall, York, University of Nottingham, and the Natural History Museum, London, 1983–4. CF

DETMOLD, Edward Julius, ARE (1883–1957). Etcher, painter in watercolours and illustrator of

birds, animals, insects, flowers and some imaginative subjects. The twin brother of CHARLES MAURICE DETMOLD, and also self-taught, he exhibited from 1897 at the RA and the RI. He also showed in London galleries including the Arlington and Brook Street Galleries, the FINE ART SOCIETY, the NEAC and the RE (ARE 1905). His work is represented in collections including the BM, London. He collaborated with his brother on etchings and illustrations including *The Jungle Book* by Rudyard Kipling, Macmillan, 1908. His work was influenced by Dürer, Japanese art and the Art Nouveau, combining great detail, naturalism and stylization. In 1921 he published *Life* (J.M. Dent), a book of philosophical meditations. During the 1930s he withdrew from society, committing suicide in 1957. LIT: 'A Note on Mr Edward Detmold's Drawings and Etchings of Animal Life', T. Martin Wood, *The Studio*, Vol.5, 1911, pp.289–96; *The Fantastic Creatures of E.J. Detmold*, edited by David Larkin, Pan Books, London, 1976; see also literature for Charles Maurice Detmold above. CF

DEVAS, Anthony, ARA, RP, NEAC (1911–1958). Well known as a fashionable portrait painter in oil, Devas also painted landscapes, flower pieces, nudes and genre subjects. Adopting a craftsmanlike approach, his style is characterized by an elegant delicacy and lightness of touch. Born at Bromley, Kent and educated at Repton, he attended the SLADE under TONKS, 1927–30. As a member of the EUSTON ROAD GROUP, his early promise was noted by his contemporaries MOYNIHAN and COLDSTREAM. Resident at Paulton's Square in the late 1930s, his career as a portrait painter culminated in 1957 with his commission to paint the Queen for the Honourable Artillery Company. Exhibiting at the RA from 1940 he held one-man exhibitions regularly at the LEICESTER GALLERIES and was elected RP in 1945. In 1931 he married his Slade contemporary Nicolette Macnamarra, whose later autobiography *Two Flamboyant Fathers*, 1966 contains much biographical detail on Devas. AGNEW'S held a Memorial exhibition in 1959. GS

DEWHURST, Wynford, RBA (1864–1941). Painter of landscapes in oils and pastels. He studied in Paris under Gérôme, *c.*1891, and worked for much of his life in France where he was a close friend of Armand Guillaumin. He exhibited mainly at the RBA (member 1901), at the Baillie Gallery and the FINE ART SOCIETY, as well as at

the RA from 1914 to 1926, the NEAC in 1909 and 1910, at the LS and in the provinces. His work is represented in collections including Manchester and Bradford Art Galleries. Influenced by Monet, his work used broken brushmarks and colour in order to capture particular fleeting light effects, e.g. *Sunrise effect: Valley of La Creuse*, RA 1916. LIT: *Impressionist Painting: Its Genesis and Development*, Wynford Dewhurst, George Newnes Ltd, London, 1904. CF

DICKSEE, Sir Frank Bernard, PRA, HRSA, RI, HROI, HRE, RP, KCVO (1853–1928). Painter of portraits, romantic, historical and contemporary genre in oils and watercolours; illustrator. Son of Thomas Francis Dicksee, he studied at the RA SCHOOLS from 1871 and exhibited widely, mainly showing at the RA from 1876 to 1929 (ARA 1881, RA 1891, PRA 1924–8). He was elected RI in 1891, HROI in 1898, HRMS in 1925 and RP in 1926. His work is represented in collections including the TATE GALLERY. He was knighted in 1925 and awarded the KCVO in 1927. An opponent of modern art, his imaginative work was influenced by the Pre-Raphaelites, Leighton and Watts. LIT: 'Mr Frank Dicksee ARA', Sydney Hodges, *Magazine of Art*, 1887, p.218; *Frank Dicksee RA, his Life and Work*, E. Rimbault Dibdin, Virtue & Co., London, 1905. CF

DICKSEE, Herbert Thomas, RE (1862–1942). Painter of genre and animals in oils; etcher and mezzotinter. Son of Thomas Francis Dicksee and brother of SIR FRANK DICKSEE, he studied at the SLADE SCHOOL winning medals for painting and drawing from life and a Slade Scholarship. He exhibited mainly at the RE (member 1885) and at the RA from 1885 to 1933 as a painter and engraver. He also showed at the FINE ART SOCIETY, the RI, ROI, in the provinces and Glasgow and his work is represented in collections including the Witt Library, University of London. His work ranged from genre scenes such as *The Grandfather at the Grave of Little Nell*. *The Old Curiosity Shop*, RA 1887, to many paintings of lions, e.g. *The Dying Lion*, RA 1888. CF

DICKSON, Dr Jennifer, RA, RE (b. 1936). Printmaker. Born in South Africa, she studied at GOLDSMITHS' and at S.W. HAYTER's ATELIER 17 in Paris. Having taught in England for many years, she became Professor in the Faculty of Fine Arts, Concordia University, Montreal, and later

moved to Ottawa. She has published many suites of prints, which use complex printing techniques including the use of photography. AW

DILWORTH, Norman (b. 1933). Painter and sculptor. Born in Wigan, he studied at the SLADE SCHOOL 1953–6, and was awarded a French Government Scholarship in 1956–7. He has taught at CAMBERWELL and CHELSEA Schools of Art. In 1971 he won a competition for a sculpture for Haverfordwest, and another in 1973 for a work of art associated with water, for the Crown Offices, Cardiff. One-man exhibitions have been at the Redmark Gallery in 1968, the Galerie Nouvelles Images, The Hague, in 1970, the Lucy Milton Gallery in 1973, and at Lydia Megert, Bern, in 1981. He was in 'Eight + Eight' (Annely Juda 1980) and the Hayward exhibition 'Pier and Ocean: Construction in the Art of the Seventies'.
LIT: *Norman Dilworth, Sculpture and Reliefs*, catalogue, South East London Gallery, 1981. LMN

DINKEL, Ernest Michael, RWS, ARWA, ARCA (1894–1983). Painter of landscapes, biblical scenes and figures in oils, watercolours and tempera; draughtsman, sculptor, glass engraver and designer. Born in Huddersfield, he studied at Huddersfield School of Art and at the RCA 1921–5, where contemporaries included HENRY MOORE. He won the Owen Jones Travelling Scholarship and worked in Rome; he exhibited at the NEAC from 1927 and at the RA from 1927 to 1976. He also showed at the RWS (ARWS 1939, RWS 1957), at the RWA and in Liverpool. His work is represented in collections including the TATE GALLERY (*The Deluge*, 1929). From 1925 to 1940 he taught at the RCA, from 1940 to 1947 he was Head of Stourbridge School of Art and from 1947 to 1961 he was Head of the School of Design, EDINBURGH COLLEGE OF ART. His many design commissions include an engraved glass for presentation to Sir Malcolm Sargent. His interest in a wide range of activity was stimulated by the example of the Italian Masters; amongst contemporaries he most admired GRAHAM SUTHERLAND.
LIT: *Paintings, Sculpture, Engraved Glass etc. by Michael Dinkel*, exhibition catalogue, Cheltenham Art Gallery, 1980. CF

DISMORR, Jessica (1885–1939). She studied in Paris at the Atelier La Palette 1900–13. Friendly with WYNDHAM LEWIS, she signed the VORTICIST Manifesto in 1914, and exhibited at the Vorticist Exhibition in 1915; in *Blast* No.2, her geometric abstraction *The Engine Design* was reproduced, and she was active at the REBEL ART CENTRE: she also showed in 1920 with Lewis's Group X. Her first solo exhibition was at the MAYOR GALLERY in 1925. She was a member of the LONDON GROUP (1926), the SEVEN AND FIVE SOCIETY, and later exhibited with Abstraction-Création. The TATE GALLERY possesses an abstract composition.
LIT: *Vorticism and Abstract Art in the First Machine Age*, Richard Cork, Gordon Fraser, 1976. LMN

DIXON, Charles Edward, RI (1872–1934). Painter of marines and some townscapes in watercolours; illustrator. Son of Alfred Dixon, he exhibited mainly at Walker's Gallery, the RI (member 1900) and at the RA from 1889 to 1920. A member of the Langham Sketching Club, he also showed in the provinces and Scotland and his work is represented in collections including the National Maritime Museum, Greenwich. He produced illustrations for journals including the *Graphic*, 1900–10, and the *Sphere* and in 1901 he illustrated C.N. Robinson's *Britannia's Bulwarks*. His work included large-scale watercolours and complex scenes depicting many vessels such as *Shipping on the Thames below St Paul's*, 1930. A keen yachtsman and friend of Sir Thomas Lipton, he recorded scenes of the America's Cup Races and his work combined accuracy with a sense of movement and technical freedom.
LIT: *Charles Dixon RI*, exhibition catalogue, The Hampton Hill Gallery, London, 1973. CF

DIXON, Harry, FRBS (1861–1942). Painter of animals, figures and landscapes in oils and watercolours; sculptor, etcher and illustrator. He studied at the West London School of Art, at HEATHERLEY'S *c.*1880, and at the ACADÉMIE JULIAN, Paris, *c.*1883–7. He exhibited mainly at the RA from 1885 to 1928, at the New Gallery from 1895, the ROI, RBA, RI, in the provinces and Scotland. Elected FRBS in 1904, he also exhibited abroad and his watercolour *Lions*, RA 1891, was purchased by the CHANTREY BEQUEST for the TATE GALLERY. He illustrated a number of books including *Human Anatomy for Art Students* by Sir Alfred Fripp. His work included mythological subjects, often with animals, and more straightforward animal studies, often depicting lions. CF

DOBSON, Cowan, RBA (b. 1893). Painter of portraits in oils and watercolours. Born in

Bradford, the son of H.J. Dobson RSW, RCA, he studied at EDINBURGH COLLEGE OF ART and exhibited in Scotland at the GI, RSA and RSW, and in England at the RA from 1913 to 1959, at the RBA (ARBA 1919, RBA 1922), at the RCA, RP, the FINE ART SOCIETY and in Liverpool. His work is represented in collections including the United Services and Royal Aero Club (*Amy Johnson* and *Admiral Earl Beatty*, 1936). His painterly, realistic work included portrait studies in watercolours. CF

DOBSON, Martin (b. 1947). Painter of steam railways and landscapes in oils, chalk and pastels; photographer. Self-taught as a painter, solo exhibitions of his work include those at Manchester and Salford University Library in 1979, and at the Colin Jellicoe Gallery, Manchester, in 1988, where he has exhibited since 1972. He has exhibited regularly in group exhibitions in London and the provinces. His early work concentrated on the railways but from the early 1980s he also turned to landscape, both in painting and photography, particularly of the Lake District.
LIT: *The Landscape of the Railway and the Industrial Town*, exhibition catalogue, Colin Jellicoe Gallery, Manchester, 1981. CF

DODD, Charles Tattershall, ARCA (1861–1951). Painter of landscapes, townscapes, flowers, genre and portraits in oils and watercolours; sculptor. Son of Charles Tattershall Dodd, 1815–1878, he studied at the RCA and exhibited at the RA between 1892 and 1947, at the RI, ROI, and at the Walker Art Gallery, Liverpool. Founder of the Tunbridge Wells Art Club in 1934, his work is represented in the V & A. He taught at the RCA, from 1886 to 1895 he was Head of the Hartley Institute, Southampton, and in 1904 he was appointed Art Master at Tonbridge School (like his father before him) where he stayed until 1927. His paintings recorded both English and European subjects.
LIT: 'Artist Family of Tunbridge Wells', R.G.A. Sandbach, *Country Life* (UK), Vol.156, No.4027, 5 September 1974, pp.644–6. CF

DODD, Francis H., RA, RWS, NEAC, RE (1874–1949). Painter of portraits, landscapes, townscapes and genre in oils, watercolours and pastels; draughtsman and etcher. Born in Holyhead, Anglesey, he studied at GLASGOW SCHOOL OF ART under Archibald Kay and FRANCIS NEWBERY, winning the Haldane Scholarship to work in France and Italy. He set-

tled in Manchester and established a studio in 1895; in 1904 he moved to London. He exhibited mainly at the NEAC from 1894 (member 1904, Hon. Treasurer 1919–20, Hon. Secretary 1919–21), at the RP (member 1909), the RWS (ARWS 1923, RWS 1929) and regularly at the RA between 1923 and 1949 (ARA 1927, RA 1935). He also showed widely in London galleries, in the provinces and Scotland. His work is represented in many collections including the TATE GALLERY and Manchester City Art Gallery. Brother-in-law of SIR MUIRHEAD BONE, in 1917 he was the second OFFICIAL WAR ARTIST to be appointed and he was subsequently sent to France. Between 1928 and 1935 he was a Trustee of the Tate Gallery. His perceptive depiction of personalities was demonstrated in his portraits of generals and admirals of the First World War and in subjects such as *Interrogation* (IMPERIAL WAR MUSEUM). A realistic, precise draughtsman, his well-constructed paintings included scenes of suburban London.
LIT: *Generals of the British Army. Portraits in Colour by Francis Dodd* and *Admirals of the British Navy. Portraits in Colour by Francis Dodd*, Country Life, London, 1917; *Francis Dodd*, memorial exhibition catalogue, South London Fine Art Gallery, London, 1950. CF

DODGSON, John Arthur, PLG (1890–1969). Painter of landscapes, still-life, figures and flowers in oils, watercolours and gouache; draughtsman. Born in India, he studied at the SLADE SCHOOL under TONKS, 1913–15, and held his first solo exhibition at the Claridge Gallery in 1928. He exhibited with the LAA (member 1932), with the LG, (member 1947, President 1950–2), at the Cooling & Sons Gallery in 1933 with CLAUDE ROGERS and at the BEAUX ARTS GALLERY in 1959. His work is represented in collections including the TATE GALLERY. Associated with members of the EUSTON ROAD SCHOOL, from 1946 to 1950 he taught at CAMBERWELL and from 1951 to 1958 at CHELSEA Schools of Art. Whilst his drawing shared some characteristics with those of the Euston Road artists, his slowly evolved paintings were influenced by Symbolism and Post-Impressionism, establishing a balanced surface of interrelated shape and colour, form and imagination.
LIT: *John Dodgson 1890–1969*, exhibition catalogue, South London Art Gallery, London, 1971; *The Euston Road School*, Bruce Laughton, Scolar Press, 1986. CF

DOLBY, James Taylor, RE (1909–1975). A painter, etcher, wood engraver and lithographer. He was trained at Keighley and at the RCA 1929–32. He taught at Bournemouth School of Art, and, having achieved a Yacht Master's Certificate, joined the RNVR in 1938, serving as Captain during the Second World War. He was Principal of Blackburn School of Art 1947–69. A member of the SENEFELDER CLUB from 1937, his subject-matter was often that of the sea; his wood engraving *Mine Layer* (1945) typically radiates light on the sea, using a fine net of cross-hatched lines.　　　　　　　　　　　　　　　AW

DOLLMAN, John Charles, RWS, RI, ROI, RBC (1851–1934). Painter of historical subjects and animals in oils and watercolours; black and white artist. He studied at the RCA and at the RA SCHOOLS and exhibited mainly at the RA between 1872 and 1934, at the RI (member 1886), the ROI (member 1887) and at the FINE ART SOCIETY where he exhibited in 1906. He also showed in Scotland and the provinces and his work is represented in collections including Manchester Art Gallery. He contributed to *The Graphic* between 1880 and 1888 and his paintings ranged from realistic animal studies such as *Two Pointers*, 1874, to subjects taken from literature.
LIT: *English Influences on Van Gogh*, catalogue, University of Nottingham Art Gallery, Arts Council, 1974–5.　　　　　　　　　CF

DONAGH, Rita (b. 1939). Painter, often using oils and pencil together; creator of large drawings; printmaker. Born in Staffordshire, she studied at Newcastle University 1959–62, and has taught at Newcastle, Reading, the SLADE and GOLDSMITHS'. She is married to RICHARD HAMILTON and was a Trustee of the TATE GALLERY, 1977–84. She has exhibited at JPL Fine Arts in 1979, at the Round House Gallery in 1980 ('Irish Art in the Seventies: The International Connection'), at the CURWEN, and more recently with Nigel Greenwood in 1984. Her work, usually highly abstracted, often explores political, moral, social and intellectual problems.
LIT: *Rita Donagh, Paintings and Drawings*, catalogue, Whitworth Art Gallery, Manchester, 1977; *A Cellular Maze*, catalogue, ICA, 1984.　LMN

DONALDSON, Antony (b. 1939). Painter and photographer, who first studied at the Regent Street Polytechnic then at the SLADE 1958–63, during which time he exhibited at the YOUNG CONTEMPORARIES. In 1962 his first exhibition was at the Rowan Gallery, from which a picture was bought by the TATE. He won Second Prize in the JOHN MOORES EXHIBITION in 1963, and in 1966 was awarded a Harkness Fellowship in the USA. He has exhibited widely nationally and internationally, his work deriving from the imagery of domestic and popular culture.　　　　LMN

DOS SANTOS, Professor Bartholomeu (b. 1931). Printmaker. Born in Lisbon, he attended Lisbon Art School 1952–5, and then trained at the SLADE under ANTHONY GROSS 1956–8. He was a lecturer at the Slade in 1961, and eventually became professor, in charge of printmaking, until his retirement in 1996. An influential teacher, his technically brilliant etchings have been concerned with fantasy, female figures and musical themes incorporating letters and musical notation. He had a major retrospective in Lisbon at the Gulbenkian Foundation in 1989.　　AW

DOW, Thomas Millie, RSW, NEAC, ROI (1848–1919). Painter of landscapes, flowers and allegorical figures in oils, watercolours and pastels. Born in Dysart, Fife, he studied at the Ecole des Beaux-Arts, Paris, under Gérôme before 1879, at Carolus Duran's Atelier and at the ACADÉMIE JULIAN. In the early 1880s he painted at Grez with JOHN LAVERY, ALEXANDER ROCHE and William Stott of Oldham who influenced the style and content of his work. He visited the USA in 1883–4, and subsequently settled in Glasgow where he was associated with the GLASGOW SCHOOL. In 1895 he left Scotland for Cornwall where he settled at St Ives. He exhibited mainly at the GI from 1880, at the RSA and RSW (member 1885), and in Liverpool; he also showed at the NEAC (member 1887), the ROI (member 1903), the RBA, in London galleries and the provinces. His work is represented in collections including Manchester Art Gallery. His harmonic, softly coloured work included allegorical figures so combining imaginative subjects with naturalistic detail.
LIT: 'The Work of T. Millie Dow', N. Garstin, *Studio*, Vol.10, 1897, pp.144–52; *The Glasgow Boys*, Roger Billcliffe, John Murray, London, 1985.　　　　　　　　　　　　　　CF

DOWLING, Jane (b. 1925). She studied at the SLADE 1943–6, at the RUSKIN SCHOOL OF ART 1946–9, at BYAM SHAW 1959–61, and at the CENTRAL SCHOOL OF ART 1961–3. She has taught at Byam Shaw and Maidstone Colleges of Art and at the ROYAL ACADEMY SCHOOLS. She has exhibit-

ed at the Royal Academy since 1961 and has had five shows at the NEW GRAFTON GALLERY. In 1985 she was in the joint ARTS COUNCIL Touring Exhibition with her husband PETER GREENHAM. Other major exhibitions include: 'The Glass of Vision', Chichester, 1987, 'The Long Perspective', AGNEW'S, 1987 and 'A Personal Choice' by Sir Brinsley Ford, King's Lynn, 1988. Several works have been bought by the Farringdon Trust. LMN

DOWNIE, John Patrick, RSW (1871–1945). Painter of portraits, genre and landscapes in oils and watercolours. Educated in Glasgow, he studied art at the SLADE SCHOOL in 1889 and in Paris, exhibited mainly in Scotland at the GI, RSW (member 1903) and at the RSA. He also showed in Manchester, Liverpool and in London at the RP and NEAC. His genre subjects included gentle domestic scenes such as *News from Afar*, 1904, and *Baby Sitting*, 1919, and his fluid watercolours were influenced by the Hague School in technique.
LIT: *Scottish Watercolours 1740–1940*, Julian Halsby, Batsford, London, 1986. CF

DOWNS, Edgar, ROI (1876–1963). Painter of animals, coastal and country subjects in oils and watercolours. Born and educated in Birkenhead, he studied art at Munich Academy of Arts where he won a silver medal and he exhibited mainly at the ROI (member 1920), at the RA between 1907 and 1925 and at the Dudley and New Dudley Gallery. He also showed at the CHENIL GALLERY, the RI, RCA and in Liverpool. A member of the London Sketch Club, his strongly painted and coloured works were influenced by Post-Impressionism. CF

DOWNTON, John (1906–1991). An artist in tempera, he studied at Queen's College Cambridge 1925–8, and at the SLADE, 1928–9. A gifted amateur violinist, his precise drawings and paintings were inspired by Italian Renaissance art. AW

DRAPER, Herbert James, RBC (1863/4–1920). Painter of historical, mythological and imaginative subject pictures, portraits and some landscapes in oils; decorative painter and illustrator. He studied at ST JOHN'S WOOD SCHOOL OF ART and at the RA SCHOOLS from 1884, winning the Landseer Scholarship in 1890 and studying in Paris at the ACADÉMIE JULIAN and in Rome. He exhibited regularly at the RA between 1887 and

1920 and showed widely in London societies and galleries including the LEICESTER GALLERIES where he exhibited in 1913, in the provinces and in Scotland. His work is represented in collections including the TATE GALLERY (*The Lament for Icarus*, purchased by the CHANTREY BEQUEST in 1898) and his decorative work includes a ceiling for the Livery Hall of the Draper's Company, London, in 1903. His imaginative (although more vigorous) work shared some characteristics with that of Waterhouse and his paintings often depicted subjects connected with the sea such as *The Sea Maiden*, RA 1894.
LIT: 'The Sea Maiden: A Painting by Herbert J. Draper', *Studio*, Vol.III, pp.162–4; *The Last Romantics*, exhibition catalogue, Barbican Art Gallery, London, 1989. CF

DREW, Pamela (1910–1989). A painter in oils and watercolour. Born in Burnley, she studied under Dorothy Baker, at the GROSVENOR SCHOOL OF MODERN ART under IAIN MACNAB, and in Paris. She recorded the war effort for the Air Ministry during the Second World War, and has work in the IMPERIAL WAR MUSEUM. Her paintings of aircraft have a sober strength and painterly realism. Her last major exhibition was at the Abbott Hall Art Gallery, Kendal, in 1982. AW

DRING, William, RA, RWS, RP (1904–1990). Born in London, Dring studied at the SLADE where he won prizes for decorative painting and figure drawing. He worked subsequently in oils, pastels and watercolours. He taught at Southampton and at the RA SCHOOLS until 1940, when he became an OFFICIAL WAR ARTIST. He was commissioned to paint many portraits including those of Sir Oliver Franks, 1962, and the Prince of Wales, 1973; he also recorded ceremonial occasions. His work is realistic, smoothly painted and restrained in colour and composition. He exhibited at the RA from 1928 and occasionally at AGNEW'S. AW

DRUMMOND, Malcolm, LG (1880–1945). Painter of urban scenes, figures and interiors in oils and watercolours. He read History at Christchurch College, Oxford, 1899–1903, before studying at the SLADE SCHOOL 1903–7, and at the WESTMINSTER SCHOOL OF ART under SICKERT 1908. He attended Sickert's etching class in 1909 and in 1910 was one of the first pupils at Sickert's School at Rowlandson House where his contemporaries included SYLVIA GOSSE and

AMBROSE MCEVOY. He was associated with the FITZROY STREET CIRCLE 1910–11, and exhibited at the AAA in 1910 where his work was praised by FRANK RUTTER. He was a member of the CAMDEN TOWN GROUP 1911–12, and a founder member of the LONDON GROUP where he exhibited from 1913 to 1932 and was treasurer in 1921. He never held a solo exhibition but memorial exhibitions included those at the LG in 1945 and the REDFERN GALLERY in 1946. His work is represented in public collections including the TATE GALLERY. Between 1915 and 1919 he worked on munitions and at the War Office and from 1925 to 1931 he taught at Westminster School of Art. Apart from his easel paintings he also produced an altarpiece for St Peter's Church, Edinburgh, 1922, and the Stations of the Cross for the Church of the Holy Name, Birkenhead, 1926. His work shows the influence of Sickert both in subject and in his earlier style. A friend of GINNER, GORE and the BEVANS, he was also influenced by the first Post-Impressionist Exhibition and in subsequent work developed a flatter style using high colour revealing his strong sense of pattern and interest in unusual viewpoints, e.g. *Hammersmith Palais de Dance*, 1920.
LIT: Exhibition catalogue for the Arts Council Exhibition, 1963/4; exhibition catalogue for the Maltzahn Gallery, 1974. CF

DRURY, Alfred Paul Dalou, PRE, NS (1903–1984). Etcher of portraits and landscapes; painter and draughtsman. Son of the sculptor Alfred Drury, he attended GOLDSMITHS' COLLEGE 1921–5, studying etching under MALCOLM OSBORNE; there he met GRAHAM SUTHERLAND. In 1924 he won a British Institute Scholarship in Engraving and he held his first solo exhibition in 1929 at the XXI Gallery. He exhibited at the RA from 1924, at the RE, where he was a member in 1929 and President from 1970 to 1975, and in British galleries and abroad. His work is represented in public collections including the BM. He taught widely and from 1937 to 1969 was first a lecturer and later Principal at Goldsmiths' College. His work was encouraged by FREDERICK GRIGGS and influenced by Dürer and Rembrandt; it is detailed, varied in tone and texture and based on assured draughtsmanship.
LIT: Exhibition catalogue for Goldsmiths' College Gallery, 1984; catalogue of prints published by Garton and Cooke, 1984. CF

DRYSDALE, Sir George Russell (b. 1912). Painter of landscapes and figures in oils and watercolours; draughtsman. Born in Bognor Regis, Sussex, his family settled in Australia in 1923. In 1932 he travelled to Europe, but in 1935 enrolled at George Bell's School in Melbourne, Australia, where he formed a friendship with Purves Smith and was influenced by Bell and Fairweather. In 1938 he attended IAIN MACNAB'S GROSVENOR SCHOOL, London, and La Grande Chaumière, Paris, where he studied works by Matisse, Braque, Derain and Soutine. In 1940 he settled in Vaucluse, Sydney, and held his first solo exhibition at the Macquarie Galleries in 1942. He joined the Society of Artists and in 1950 and 1958 showed at the LEICESTER GALLERIES, London. He subsequently exhibited in London, Australia and internationally and his work is represented in many public collections including the TATE GALLERY. His early paintings were of semi-abstract still-life, but from 1939 he painted the Australian land and its inhabitants in intense, glowing visions which analyse the essential qualities of his subjects in a style influenced by Soutine, the Surrealists and Picasso.
LIT: *Russell Drysdale*, L. Klepac, London, 1983. CF

DUBERY, Fred, (b. 1926). Painter of interiors, still-life and landscapes in oils. He studied at Croydon School of Art 1949–50, and at the RCA 1950–3, and has exhibited in London from 1957, most recently at the NEW GRAFTON GALLERY. He has shown at the RA since 1950 and has exhibited with the LG and NEAC. He has taught at the RA SCHOOLS since 1964 and in 1984 was appointed Professor of Perspective at the RA. His evocative paintings, many of his native Suffolk, give an intimate and poetic character to everyday scenes. CF

DUBSKY, Mario (1939–1985). Born in London, he attended the SLADE SCHOOL in 1956, and continued there as a postgraduate until 1961. From 1962 to 1963 he taught painting part-time at an ESN School and at Morley College, and in 1963 he was awarded the Abbey Major Rome Scholarship. During 1965–9 he taught at CAMBERWELL SCHOOL OF ARTS AND CRAFTS, Wimbledon College of Art and Brighton College of Art. His first one-man exhibition was in 1969 at the GROSVENOR GALLERY, and in the same year he was awarded a Harkness Fellowship to the USA. On return to Britain he was visiting tutor at Camberwell and the CENTRAL SCHOOL before returning to live in New York in 1973. His work moved from figuration to abstraction and back, finally concerning obsessive homo-erotic themes.

LIT: *Mario Dubsky: Paintings and Drawings, 1973–84*, catalogue, South London Art Gallery, 1984.　　　　　　　　　　　　　　　LMN

DUGDALE, Thomas Cantrell, RA, ROI, RP, NS, IS (1880–1952). Painter of portraits, genre, landscapes and townscapes in oils, tempera and watercolours; textile designer and decorator. Born in Blackburn, Lancashire, he studied at the MANCHESTER SCHOOL OF ART, the RCA, the City and Guilds School, Kennington, and in Paris at the Académies JULIAN and Colarossi. Winner of a British Institution Painting Scholarship, he exhibited at the RA from 1901 to 1953, at the NEAC, ROI, RP, RHA and RSA, and was elected ROI in 1910, RP in 1925, IS in 1926 and RA in 1943. He also showed in London galleries including the LEICESTER GALLERIES where in 1919 he held a solo exhibition of works painted in Palestine, Syria and Egypt where he had served during the 1914–18 war in the Yeomanry. He also exhibited abroad, winning a silver medal at the Paris Salon of 1921 and a gold medal in the Paris Exhibition of Decorative Arts of 1925. His work is represented in many public collections including the TATE GALLERY (*The Red Jacket, c.*1923) and the IMPERIAL WAR MUSEUM. He was art advisor to the Tootal Broadhurst Lee Company and married to the artist Amy K. Browning. Best known as a portraitist whose sitters included HRH The Duchess of Gloucester, 1938, his work ranges from desert war scenes to broadly painted views of London streets. All his work is marked by its direct realism, tonal control and lively technique.
LIT: 'T.C. Dugdale', J.W. Stephens, *Studio*, Vol.XCII, p.329; 'T.C. Dugdale and A.K. Browning', Enid Gibson, *Studio*, Vol.134, 1947, p.64　　　　　　　　　　　　　　　CF

DUGGER, John (b. 1948). A Californian-born artist who has lived and worked in Europe, particularly London, for many years. He has travelled widely (Africa, South East Asia, China) and was associated in the early 1970s with DAVID MEDALLA on a number of projects, paintings and events with a political message. He set up Banner Arts Projects in North London in 1976, creating 'portable murals without walls' which draw upon popular, socially committed art as a source of inspiration for both style and subject-matter.　　　AW

DUNBAR, Evelyn Mary, NEAC, ARCA (1906–1960). Portrait, landscape and figure painter who exhibited from 1931 to 1940. She studied at Rochester, CHELSEA, and at the RCA 1929–33. She carried out decorations at Brockley School, Kent, from 1933 to 1936, became a member of the Society of Mural Painters and was an OFFICIAL WAR ARTIST 1940–5, when she painted women's activities, particularly featuring the Land Army. She was a member of the NEAC 1945–8, and from 1950 she was visiting teacher at the RUSKIN SCHOOL of Drawing. She painted a mural at Bletchley Training College, 1958–60, and she usually exhibited at the Goupil Gallery.　　　LMN

DUNCAN, John McKirdy, RSA, RSW (1866–1945). Painter of historical, mythological and legendary scenes and some landscapes in oils, tempera and watercolours; decorative painter, illustrator and stained glass designer. After working for a publisher in London he studied art in Antwerp under Verlat, in Düsseldorf and in Rome where he was influenced by Michelangelo. From 1892 he was associated in Edinburgh with Patrick Geddes and the Celtic Revival, touring America with Geddes in 1899. He exhibited mainly in Scotland and the RSA and RSW, becoming a member in 1923 and 1930 respectively. His work is represented in some public collections, particularly in Scotland. Between 1892 and 1900 he was Director of Geddes' School of Art, Edinburgh, and from 1900 to 1902 he was Associate Professor of Art, Chicago University. He produced illustrative work for *The Evergreen* and mural projects inspired by the Celtic Revival. His symbolist paintings use Celtic decorative motifs and reflect the influence of the Pre-Raphaelites. He also painted small landscapes, many of the islands of Barra, Eriskay and Iona.
LIT: Exhibition catalogues for the City of Edinburgh Art Centre, 1986, and Bourne Fine Art, 1983.　　　　　　　　　　　　　　　CF

DUNCAN, Mary (1885–*c.*1967). Painter of landscapes and still-life in oils; etcher. Born in Bromley, she studied at Bromley School of Art, at the SLADE and in Paris. Later in her life she lived and worked in Cornwall and she exhibited mainly at the RHA and also showed at the RA from 1929 to 1946, at the NEAC, ROI, in London galleries, the provinces and Scotland. Her work is represented in collections including Plymouth Art Gallery. Her exhibited subjects include scenes such as *Milking Time at Globbens*, RA 1932, and *Cornish Farm*, RA 1946.　　　CF

DUNKLEY, Keith, RWS (b. 1942). Painter of buildings, gardens and landscapes in acrylic. He

studied at Kingston School of Art (Diploma 1964), and at the RCA 1964–7. He has held solo exhibitions in London and the provinces, including the Church Street Gallery, Stow-on-the-Wold, and has shown at the RA, RSA and RWS. Between 1969 and 1973 he taught at Sheridan College, Toronto, Canada, and in 1973 he settled in the Scottish Borders, where he paints full-time. His realistic, closely observed work presents details of his subjects, often from unusual viewpoints, with strong draughtsmanship and colour. LIT: Catalogue for the group exhibition of contemporary paintings and bronzes, Church Street Gallery, Stow-on-the-Wold, June, 1991. CF

DUNLOP, Ronald Ossory, RA, RBA, NEAC, LG (1894–1973). Painter in oils of figures, portraits, landscapes, flowers and still-life. Born in Dublin, he attended evening classes at the Wimbledon School of Art and also studied at MANCHESTER SCHOOL OF ART and in Paris. He joined the NEAC, the RBA in 1930, he became ARA in 1939 (RA in 1950), and he was a member of the LONDON GROUP. In 1923 he founded the 'Emotionist Group of Writers and Artists'. His first one-man show was held in 1928 at the REDFERN GALLERY. Examples of his directly painted work include *Lifeboat, Walberswick*, which was purchased by the CHANTREY BEQUEST in 1937, and *Rosalind Iden as Ophelia*, 1940. He is represented in many public collections and wrote several books on the technique of painting.
LMN

DUNN, Anne (b. 1929). A painter of abstract and near-abstract works in oil on canvas, gouache and collage. She studied at CHELSEA POLYTECHNIC 1947–9, and at the ACADÉMIE JULIAN in 1952. She has lived and worked in France, as well as in the USA and Canada, and was first married to MICHAEL WISHART (with whose work her own has a certain affinity) and then to RODRIGO MOYNIHAN. Using dripped, splashed and scumbled paint, her work moves in and out of complete abstraction (for example *City landscape No.1*, 1959, Arts Council). She was editor (1964–8) of *Art and Literature*. AW

DUNSTAN, Bernard, RA, RWA, NEAC (b. 1920). Painter in oils of figure subjects. He studied at BYAM SHAW under ERNEST JACKSON and at the SLADE SCHOOL 1939–41. He exhibited at the RA and other leading London and provincial galleries. He held ten one-man shows at ROLAND BROWSE AND DELBANCO. He is represented in many public collections both at home and abroad. Elected ARA in 1959 and RA in 1968, his approach and subject-matter is reminiscent of the work of Bonnard or Vuillard. He published *Starting to Paint Portraits, Starting to Paint Still-Life* and *Composing Your Pictures*.
LIT: *The Paintings of Bernard Dunstan*, Bernard Dunstan, Newton Abbott, 1993. LMN

DU PLESSIS, H.E., LG (b. 1894). Painter of landscapes, figures, interiors and still-life in oils and watercolours. Born in South Africa, he worked as a London correspondent for South African newspapers. Self-taught as a painter, he began to paint in the late 1920s and exhibited mainly at the Goupil Gallery where he held a solo exhibition in 1929, at AGNEW & SONS and at the LG (member 1929). Represented in Southampton Art Gallery, his paintings, often on a small scale, represent scenes such as *Back Window in Bloomsbury*, in a fluid, lively technique.
LIT: Exhibition catalogue, Roland Browse & Delbanco, London, 1947. CF

DURRANT, Jennifer, RA (b. 1942). A painter, she studied 1959–63 at Brighton, then at The SLADE 1963–6. She won an Abbey Minor scholarship in 1964, and her first solo exhibition was at the University of Surrey in 1975. She was Artist in Residence at Somerville College, Oxford 1979–80, and had a major exhibition at the SERPENTINE in 1987. She incorporates images from direct experience in compositions which may include motifs from tribal and eastern art, often brushing, rubbing, texturing and staining egg and pebble-shaped forms. *We Are All Passengers* (1989–90) is characteristic; her works are in the TATE and many other national and international collections. AW

E

EADIE, Ian Gilbert Marr (1913–1973). Painter of figures, landscapes and portraits in oils and watercolours; draughtsman, etcher and mural painter. He studied at Dundee College of Art 1931–6, winning a travelling scholarship to work in Italy and at the Ecole des Beaux-Arts, Paris, and in 1939 he studied under GERTLER at the WESTMINSTER SCHOOL OF ART. He exhibited from 1938 at the RSA, RP, RWS, RA and in Liverpool, he held a solo exhibition in Dundee in 1947 and subsequently exhibited regularly in Scottish gal-

leries and showed with the SSA, the GI and the Dundee Art Society. He taught at Dundee College of Art from 1939. His work ranged from murals (mostly in Scotland) and accurate records of World War II scenes (IMPERIAL WAR MUSEUM) to etchings of architectural subjects.
LIT: *Ian Eadie. War Drawings. 51st Highland Division*, catalogue, The Scottish Gallery, Edinburgh, 1986. CF

EADIE, Robert, RSW (1877–1954). Painter of landscapes, portraits, street and beach scenes in oils and watercolours; lithographer and poster artist. He studied at GLASGOW SCHOOL OF ART, in Munich and in Paris. Between 1912 and 1940 he exhibited mainly in Scotland at the GI, the RSW (member 1917) and the RSA. He also exhibited in Liverpool, Manchester, at the RA and the Paris Salon. His work is represented in public collections including Glasgow Art Gallery. His varied work includes watercolour studies of figures by the sea. CF

EARDLEY, Joan Kathleen Harding, RSA (1921–1963). Painter of figures, landscapes and seascapes in oils. She trained at GLASGOW SCHOOL OF ART, 1940–3 and 1948, under Hugh Adam Crawford, and at Hospitalfield House, Arbroath, under JAMES COWIE. In 1948 she was awarded a travelling scholarship to Paris and Italy. She exhibited at SSA, the RSA (becoming a member in 1963), and at the GI as well as in other Scottish and English galleries. In 1949 she began to teach at Glasgow School of Art and she took her painting subjects from the Glasgow slums, concentrating on children, often shown against graffiti-covered walls. In 1956 she moved to Catterline on the coast and painted landscape and seascape. Her powerful, expressionistic paintings sought an equivalent for her experience of nature and later semi-abstract works are grounded in specific natural conditions and particular places.
LIT: *Joan Eardley*, William Buchanan, Edinburgh University Press, 1976; *Joan Eardley RSA*, Cordelia Oliver, Mainstream Publishing, 1988. CF

EARL, Maud (d. 1943). Painter of animals in oils. She studied art with her father, the animal painter George Earl, and exhibited at the RA from 1884, at the FINE ART SOCIETY, in the provinces and at the Paris Salon. She painted the dogs belonging to Queen Victoria and King Edward VII and her work was often engraved.

Some of her paintings show the influence of Couldery and they range from animal portraits to scenes showing dogs working and set against landscape, e.g. *Spaniels and a Labrador on the Edge of a Wood*, 1892. Her technique could be painterly although always concerned to capture the appearance and character of her subject. CF

The East London Art Club was founded by John Cooper in 1925. A friend of SICKERT, he was the Club's first President and other members included Elwin Hawthorne who had worked in Sickert's studio. WILLIAM COLDSTREAM exhibited with the Group in 1930. CF

EASYDORCHIK, Edwin (b. 1949). Abstract painter in mixed media. He studied at the CENTRAL SCHOOL OF ART, 1968–71, winning a travelling scholarship to Italy, and at the University of Newcastle. He has exhibited in London, the provinces and in many group exhibitions. His work is represented in public collections and in 1979 he won an ARTS COUNCIL Purchase Award. He has taught at Newcastle Polytechnic. His sensitively coloured, carefully controlled work, often using stencilled forms, explores the relationship between the three dimensional reality of an object and its representation in two dimensions. CF

ECCLESTONE, Harry Norman, OBE, PPRE, RWS, RWA. (b. 1923). A painter and engraver. He studied under ANDREW FREETH in Bilston, then at Birmingham 1939–42, and at the RCA 1947–51. Some of his etchings were SICKERT-inspired theatre subjects, and others were industrial landscapes such as *The Tip* (1957). AW

Edinburgh College of Art. The foundation effectively began in 1906 when a new building was decided upon to house the Royal Institution School and the School of Applied Art (which was merged with it), together in the city centre. The first half of this building was ready in 1909. The Scottish Education Department authorized the College to award Diplomas in Drawing & Painting, Design and Crafts, Sculpture and Architecture. A bequest from the estate of Mr Andrew Grant of Pitcorthie was received in 1931, establishing a scholarship fund which today provides some thirteen endowments for students to undertake travel and research, making Edinburgh one of the best endowed institutions of its kind in Europe. In 1945 a five-year course was introduced which led to a degree of MA (Hons) in Fine

Art; today, all other courses at the College lead to Full Heriot-Watt University awards, and the Schools of Art and Design are a joint Faculty of the University and the College. AW

EDMONDS, Michael (b. 1926). Painter, sculptor, collage, relief and mural artist. He spent his early years in Dorset before service in the Welsh coalmines between 1944 and 1947. In 1953 he qualified as an architect. He has exhibited in galleries including the Drian Galleries, London, and his work is represented in collections including the CONTEMPORARY ART SOCIETY. He was a founder member of the 56 Group and has been Vice-president of the Society of Christian Artists. His work, which uses man-made and found objects, reflects his interest in space science and archaeology.
LIT: Exhibition catalogue for the Drian Galleries, London, 1962. CF

EDWARDS, Cyril Walduck, RI, RBA (b. 1902). Painter of marines, still-life and landscapes in oils and watercolours. He trained at Regent Street Polytechnic, lived in London and later at Malvern, Worcestershire. He exhibited mainly at the RBA (member 1935) and the RI (member 1936) but he also showed at the RA from 1926 to 1948, at the RCA, ROI, RSA, in Birmingham, Liverpool and at the Paris Salon. His work is represented in collections including the Laing Art Gallery, Newcastle. His marine subjects often depicted scenes in docks such as *Avonmouth Docks*, RA 1938. CF

EDWARDS, John (b. 1938). Painter of abstracts and semi-abstracts in acrylic and oils. He studied at Hornsey College of Art and has exhibited at the Rowan Gallery, London, since 1967, as well as in the USA and in group exhibitions. He has taught widely and in 1976 was Artist in Residence, Syracuse University, New York. Before 1981 he showed large, bold paintings using a restricted range of active shapes. Recent work is smaller in scale and based on still-life.
LIT: *British Art Now*, catalogue, Guggenheim Museum, New York, 1980. CF

EDWARDS, John D. (b. 1952). A painter in oils, who studied at the CENTRAL SCHOOL under JOHN HOYLAND and PATRICK HERON. In 1973 he was President of the 'New Contemporaries'. He travelled widely in Europe and the USA, 1975–9, and has been an assistant to the sculptor Barry Flanagan. His first one-man exhibition was at the

Odette Gilbert Gallery in 1985. His work is in the tradition of the St Ives painters, using clear fresh colour applied informally to establish simplified compositions of the sea, boats and domestic subject-matter. AW

EDWARDS, Lionel Dalhousie Robertson, RI, R.Cam.A. (1878–1966). Painter of equestrian subjects, paricularly hunting scenes, in watercolours and oils; illustrator. He studied under A.S. Cope at SOUTH KENSINGTON, at HEATHERLEY'S and with FRANK CALDERON and worked for journals including the *Graphic* and *Punch*. He travelled to Tangier and Gibraltar in 1912 and during the First World War served with the Army Remount Service. He exhibited at the R.Cam.A. (member 1926), the RI (member 1927), in London galleries and at the RA in 1931. A member of the London Sketch Club, his work is represented in many private collections and he illustrated numerous books including *My Hunting Sketch Book* (two volumes, London, 1928 and 1930). Best known as a painter in watercolours, he was influenced by GILBERT HOLIDAY and admired G.D. ARMOUR. His painting combined his knowledge of horses and hunting with atmospheric landscape painting.
LIT: *Reminiscences of a Sporting Artist*, Lionel Edwards, Putnam, London, 1947; *Lionel Edwards, Master of the Sporting Scene*, J.N.P. Watson, The Sportsman's Press, London, 1986. CF

EGGINTON, Frank J., R.Cam.A. (b. 1908). Landscape painter in watercolours and oils. Son of the artist Wycliffe Egginton, he exhibited mainly at the FINE ART SOCIETY which held solo exhibitions of his watercolours. He also exhibited at the RCA, RHA, RI and in the provinces. He lived in County Donegal, Ireland, for a number of years and many of his watercolours are of the Irish countryside. His painting could be well defined and contrasted in response to particular weather effects, e.g. *Blacksod Bay, Co. Mayo*, 1949. In other, softer works a great emphasis is placed on the sky and the atmospheric view of mountains and clouds. CF

EGGINTON, Wycliffe, RI, R.Cam.A. (1875–1951). Landscape painter in watercolours and oils. He was born in Birmingham and educated in Birmingham and Wallasey. He exhibited mainly at the FINE ART SOCIETY as well as Walker's Art Gallery, the RCA, RA, RI, RHA, the Paris Salon and in the provinces. He became RI in

1913 and R.Cam.A in 1926. His work is represented in public collections. He painted in Ireland and England, particularly at Dartmoor, and he employed a wet technique which was used by the followers of Cox and de Wint, e.g. *Drover and Sheep in a Windswept Landscape* (Coll. Harrow School). In some works, traces of pencil drawing are visible through the watercolour. CF

EHRLICH, Georg, Professor, RBA, RA (1897–1966). Sculptor of figures and animals in bronze, draughtsman, etcher and painter in watercolours. Born in Austria, he studied at the Vienna Kunstgewerberschule, 1912–15, began to make prints and drawings in 1918 and held his first solo exhibition of lithographs in 1919. Moving to Munich, he met Hans Goltz and Elizabeth Bergner and later went to Berlin where he exhibited with Barlach, KOKOSCHKA and Lehmbruck in 1922. He started to sculpt in 1926 and received his first public commission in 1928. In 1930 he married Bettina Bauer and in 1937 moved to England, becoming a British citizen in 1947. In London he exhibited at the RA, becoming RA in 1963, having held his first London solo exhibition in 1939 at the Matthiesen Gallery. His work was exhibited regularly both nationally and internationally and is represented in many public collections including the TATE GALLERY. He has won many awards and received numerous commissions including the memorial *Pax* for the Coventry Garden of Rest, 1945. Initially his reputation was founded on his expressionist graphic work. Influenced by Lehmbruck and Georges Minne, his early sculpture concentrated on figures, particularly those of children. In 1944 he began to produce animal subjects which reflected his interest in the antique, e.g. *Large Head of a Bull*, 1954. His sculpture is characterized by expressive simplification of form, interest in silhouette and the response of surfaces to light. His drawings range from naturalistic outline sketches to conceptual ideas for sculpture, and his watercolours reveal his quick response to observed effects.
LIT: *Georg Ehrlich*, Erica Tietze-Conrat, B.T. Batsford Ltd, 1956; catalogue for the Bruton Gallery, Somerset, 1978. CF

ELLIS, Clifford (1907–1985). Designer of posters, book jackets, murals and mosaics, watercolour artist and teacher. He attended ST MARTIN'S SCHOOL OF ART, Regent Street Polytechnic and London University. His design work, often in collaboration with his wife Rosemary Ellis, was commissioned by major companies. A member of Bath Society of Artists he also took part in the RECORDING BRITAIN SCHEME. From 1946 to 1972 he was founder and Director of the BATH ACADEMY OF ART. His painting reflected his interest in organized shape and design.
LIT: *Corsham, a Celebration*, exhibition catalogue, Michael Parkin Gallery, 1989. CF

ELWELL, Frederick William, RA, ROI, RP (1870–1958). Painter of interiors, genre, landscape and architecture in oils. Born in Yorkshire the son of the wood carver James Elwell, he studied at Lincoln School of Art and in 1887 won the Gibney Scholarship to study at the Academy Schools in Antwerp. He also attended the ACADÉMIE JULIAN in Paris. He exhibited at the RA from 1895 as well as at the ROI, RSA, in the provinces and at the Paris Salon from 1894. His work is represented in public collections and in the Beverley Art Gallery, Yorkshire. He became ROI in 1917, RP in 1933 and RA in 1938. In 1919 his painting *The Beverley Arms Kitchen*, 1919, was purchased by the TATE GALLERY through the CHANTREY BEQUEST. His detailed, descriptive scenes reflect the nineteenth-century genre tradition and a knowledge of Dutch painting. His work shows his keen grasp of light effects and interest in the social connotations of his subjects, e.g. *Refugees in my Studio*, 1915, and *The Bailiff Man*, RA 1949 (Newport Museum and Art Gallery). CF

ELWES, Simon, RA, RP, NS (1902–1975). Painter of portraits in oils. He studied at the SLADE SCHOOL under TONKS, 1918–21, and in Paris under André Simon and André Lhote until 1926. He lived in London and New York and exhibited mainly at the RP (member 1934, VPRP 1953) and at the RA between 1927 and 1976 (ARA 1956, RA 1967), as well as showing at the GI, in Liverpool at the Paris Salon (where he won a silver medal in 1948) and in New York. His work is represented in collections including Dundee Art Gallery and the Metropolitan Museum, New York. An OFFICIAL WAR ARTIST for the Indian Command and the SEAC in the Second World War, he was President of the Catholic Guild of Artists and Chairman of the Artists of Chelsea. His elegant, painterly work depicted many notable figures including members of the Royal Family.
LIT: *Simon Elwes. Exhibition of Portraits*, catalogue, Knoedler & Co. Inc., New York, 1938. CF

ELWYN, John, ARCA (John Elwyn Davies, 1916–1997). Painter of figures and semi-abstracts in oils, gouache and collages. He attended the Carmarthen School of Art, 1935–7, the West of England College of Art, 1937–8, and the RCA, 1938–40 and 1946–7. He exhibited at the RA, NEAC and in London galleries including the LEICESTER GALLERIES where he had his first solo exhibition in London in 1965. He also exhibited in the provinces and abroad and his work is represented in public collections. In 1960 and 1975 BBC TV Wales made programmes about his work. From 1953 to 1976 he was tutor at Winchester School of Art and his work was commissioned by major companies. In 1956 he was awarded the National Eisteddfod Gold Medal. His figure paintings show solidly painted, rounded figure forms and his semi-abstract works use organic and rhythmic shapes with titles that retain the landscape or flower references, e.g. *Garden* and *Seedflight*. There was a Retrospective at the National Library of Wales in 1996. CF

EMANUEL, Frank Lewis, SMA, PSGA (1865/6–1948). Painter of interiors, architecture and landscapes in oils and watercolours; draughtsman, printmaker and writer. He studied at the SLADE under Legros and at the ACADÉMIE JULIAN under Bouguereau and T. Robert-Fleury. He exhibited mainly at the RA but also with numerous societies and at the Paris Salon. His work is represented in public collections and in 1912 the TATE GALLERY purchased *Kensington Interior* through the CHANTREY BEQUEST. He taught etching at the CENTRAL SCHOOL and his activities in the art world were wide ranging. He travelled extensively and produced topographical watercolours, drawings and etchings. His oil paintings range from tonally controlled studies of interiors to more lyrical paintings of seascapes. LIT: *The Illustrators of Montmartre*, Frank Lewis Emanuel, 1903; *Etching and Etchings*, Frank Lewis Emanuel, 1930. CF

EMANUEL, John (b. 1930). Painter of figures in oils, gouache and mixed media. Born in Lancashire, he started to paint in 1962 without any formal training and he has painted full-time since 1976. He lives in St Ives where he exhibited at the Wills Lane Gallery in 1975 and 1976. He has subsequently shown in Cornwall and in London galleries, particularly at the Montpelier Studio since 1979, in the provinces and abroad. His monumental figures are simply and strongly drawn. In oils he uses an impasto technique and

his later work is more dramatic and varied in colour. LIT: *Arts Review* (UK), Vol.36, pt.21, 9 November 1984, p.552. CF

EMIN, Tracey (b. 1963). An artist in various media, she studied art at Maidstone and the RCA. Her first solo show 'My Major Retrospective' was in 1994 at White Cube, and in 1995 she opened the Tracey Emin Museum in the Waterloo Road. She achieved some notoriety in that year with *Everyone I've Ever Slept With (1963–1995)*, a tent embroidered with the names of those concerned. She has made paintings, etchings, drawings and videos, and writes books and poetry. She has so far wished to document her life without respecting conventional taboos. AW

ENGLAND, Frederick John NDD, ATC, IAG, MFPS (b. 1939). Painter of landscapes and portraits, particularly of musicians, in oils, acrylic and watercolours; lithographer and etcher. He studied at Brighton College of Art, in Norway and at the SLADE. He has exhibited internationally and his work is represented in collections including the City of Stoke-on-Trent Art Gallery. Director of England's Gallery, Leek, President of the Society of Staffordshire Artists and Lecturer at Leek School of Art, he has won silver (1969) and gold (1975) medals at the Paris Salon and is an associate of the Société des Artistes Français. His painterly, figurative work shares some stylistic characteristics with that of de Staël and Monet. LIT: *International Arts Bulletin*, Monte Carlo, November 1990. CF

ENGLISH, Grace, SWA (1891–1956). Painter of figures and portraits in oils and watercolours; illustrator and etcher. Born in London, she first studied painting in Paris and Karlsruhe, Germany, where she met I.A.R. Wylie and illustrated her book on the Black Forest. Returning to England she attended the SLADE SCHOOL under BROWN and TONKS 1912–14, and studied etching at SOUTH KENSINGTON under SIR FRANK SHORT in 1921. She exhibited at the RA, NEAC and SWA as well as London galleries and other societies. A member of SWA and the WIAC, she received an honorable mention in the painting section of the Société des Artistes Français in 1948. Her work reflects the influence of ETHEL WALKER, Renoir and the Impressionists, e.g. *Mona* (Leeds City Art Gallery). LIT: Memorial exhibition catalogue, RWS Galleries, 1957. CF

ENNESS, Augustus William, RBA (1876–1948). Painter of landscapes, townscapes and flowers in oils. He exhibited mainly at the RBA, ROI and at the FINE ART SOCIETY; he also showed at the RA and at London and provincial galleries. His English subjects, often showing masses of foliage and flowers in a landscape, balance the demands of representational painting and a broad, painterly application of pigment. The simplification of detail is also apparent in work painted abroad, e.g. *The Casino, Monte Carlo*, 1924, which conveys a sense of sunlight and space. CF

EPSTEIN, Sir Jacob (1880–1959). Celebrated as a sculptor, Epstein also painted a substantial number of watercolours unrelated to sculptural projects. In 1932 he exhibited sixty watercolour drawings on Old Testament subjects at the REDFERN GALLERY. Shortly afterwards, when renting a house (Deerhurst) on the edge of Epping Forest, and perhaps inspired by the work of the young art student Isabel Nicholas (later RAWSTHORNE) who was with him there, he began to paint many watercolours of the forest. A major exhibition of them was held at Tooth's in November 1933. All were sold. One was bought by London Transport and subsequently used as an Underground poster. Epstein had a further exhibition of his paintings at the REDFERN in 1934, and another at Tooth's in 1936 of flower paintings (a subject initially stimulated by a commission for a series from Ascher and Velker, a Dutch firm of dealers). These large works (he executed several hundred) are notable for their vigour and strength of colour. His approach had affinities with the work of MATTHEW SMITH, of whose paintings he then had a large collection. He also painted, without assistants, the drop-curtain of the ballet *David* (1936) presented by Markova-Dolin Ballet at the Duke of York's theatre. This depicted ten episodes from the life of King David, in monumental form and saturated colour. In 1938 he exhibited thirty-seven drawings illustrating Baudelaire's *Fleurs du Mal*. He continued to paint on and off for the rest of his life. AW

ERNEST, John, (b. 1922). Artist working with reliefs and constructions in a variety of media; painter of some abstracts. Born in Philadelphia, USA, from 1946 to 1951 he lived and worked in Sweden and Paris. In 1951 he moved to London and studied sculpture at ST MARTIN'S SCHOOL OF ART 1952–6. From 1954 he was associated with the group who centred around PASMORE and which included the MARTINS, ANTHONY HILL,

ADRIAN HEATH and ROBERT ADAMS. He made his first construction in the mid 1950s and exhibited with the group in 1954 and 1956. He has since exhibited in London and in numerous group exhibitions. In the 1970s he exhibited with the SYSTEMS GROUP. Between 1960 and 1965 he taught at BATH ACADEMY OF ART and subsequently at CHELSEA SCHOOL OF ART. Commissions include work for the International Union of Architects Congress, 1961. His work reflects his interest in mathematical and scientific ideas, for example his construction based on models of the Moebius Strip *c*.1970.
LIT: Exhibition catalogue, Institute of Contemporary Arts, 1964. CF

ETCHELLS, Frederick, LG, FRIBA (1886–1973). Architect; painter of figures, still-life and portraits in tempera and watercolours; designer and illustrator. Son of the engineer J.C. Etchells, he studied at the RCA *c*.1908–11, and in Paris between 1911 and 1914 where he was influenced by the work of Modigliani, Picasso and Braque. Initially associated with the Bloomsbury Group and a member of the FRIDAY CLUB, he collaborated with FRY and GRANT in the murals for the Borough Polytechnic and with Grant on murals for Virginia Woolf. In 1913 he exhibited in Fry's second Post-Impressionist exhibition, showing six paintings, and also with the GRAFTON GROUP. Through his friendship with GINNER and the Grafton Group he met WYNDHAM LEWIS and was attracted to some aspects of his avant-garde work. In 1913 he joined the OMEGA WORKSHOPS, designing rugs and textiles, but a year later he left, with Wyndham Lewis and others, following the 'Ideal Home' rumpus. As a designer for the Omega Workshops, Etchells produced some of the most successful work, particularly in textiles. Thereafter he was associated with the REBEL ART CENTRE, was a founder member of the LONDON GROUP and exhibited at RUTTER'S Post-Impressionist and Futurist exhibition, all in 1913. He showed work in the London and New York VORTICIST exhibitions, 1915 and 1917, provided illustrations for *Blast*, and exhibited with GROUP X in 1920. He then concentrated on architecture and his work includes the Crawford's Advertising Agency building, Holborn, London. He translated Le Corbusier's *Vers une Architecture* into English and was co-author of *The Architectural Setting of Anglican Worship* with G.W.O. Addleshaw. In painting his work reflected and combined a number of influences from the post-impressionism of the Bloomsbury Group to the

more radical ideas of Lewis on cubism and distortion. Early paintings, e.g. *The Dead Mole, c.*1912, combine a number of styles including pointillism and the mannered elongation of figures. By 1914 he was more clearly influenced by analytical cubism and the mechanized forms of the Vorticists, e.g. *Progression*, 1914–15, a non-figurative work. This style did not develop and he returned to a more conservative figuration, e.g. *Armistice Day*, 1918–19.

LIT: *Vorticism and Abstract Art in the Machine Age*, Richard Cork, Gordon Fraser, 1976; the obituary by John Betjeman, *Architectural Review*, Oct. 1973. CF

EURICH, Richard Ernst, RA, NEAC (b. 1903). Painter of marines, coastal scenes, landscapes, figures and still-life in oils. Born in Yorkshire, he studied at Bradford School of Art under H. Butler 1920–4, and at the SLADE SCHOOL under TONKS 1924–6. Whilst at the Slade he concentrated on drawing and he was particularly influenced by the work of Turner as well as Cézanne, Constable and Dürer. In 1929 he met CHRISTOPHER WOOD who influenced his painting and Sir Edward Marsh who introduced him to ERIC GILL. Through their interest he held his first solo exhibition of drawings at the Goupil Gallery in 1929. Thereafter he exhibited mainly at the Goupil and REDFERN galleries as well as at the RA (member 1952) and NEAC (member 1943). From 1949 he taught at CAMBERWELL SCHOOL OF ART and during the war he was an OFFICIAL WAR ARTIST with the Admiralty, recording the war at sea. His work is represented in many public collections, including the TATE GALLERY. His painting was influenced by his knowledge of the Yorkshire coast and countryside and whilst his early drawings were very detailed and finished, his paintings used a broad technique. The need for realism in his war pictures necessitated a change of style and this work, often panoramic in scope, recorded complex events in detail, e.g. *The Landing at Dieppe, 19th August 1942* (Tate Gallery). Turning to landscape after the war he showed simpler subjects and later scenes of the seashore employed a frieze-like composition of figures and sea in strong, bright colour, e.g. *Chesil Beach*, 1979 (Coll. FINE ART SOCIETY).

LIT: The catalogues for the retrospective exhibitions at the Bradford City Art Gallery, 1951 and 1980. CF

Euston Road School. Founded in October 1937 as a 'School of Drawing and Painting'; first in Fitzroy Street, London, and then in the Euston Road (from whence it acquired its popular name). The three artists who set it up were COLDSTREAM, ROGERS and PASMORE. In reaction to Surrealism and non-figurative abstraction, the School concentrated on observation, working from the model. Among artists who either taught or studied there were BELL (GRAHAM), MOYNIHAN, DEVAS, GOWING, FEW, HULBERT, BELLINGHAM-SMITH, CARTER and STOKES. The School closed in 1939, but despite its short existence, the term 'Euston Road' has continued to be used for a certain kind of painterly, disciplined realism, and the sustained vitality of so many of those associated with it has had a lasting influence on the development of British painting – in the first instance through the post-war teaching at CAMBERWELL and the SLADE Schools.

LIT: *The Euston Road School*, Bruce Laughton, Scolar Press, 1986. AW

EVANS, Garth, (b. 1934). Artist making reliefs and sculpture in a variety of media; draughtsman and printmaker. He studied at MANCHESTER COLLEGE OF ART, at the SLADE, and has exhibited in leading galleries, including the Rowan Gallery, and in many group exhibitions. His work appears in public collections and he has won many awards and taught widely. His clear, resolved work is concerned with the individuality of objects and he uses colour to emphasize the character of each piece.

LIT: Exhibition catalogue, Yale Center for British Art, New Haven, 1988. CF

EVANS, Merlyn Oliver, LG (1910–1973). Painter of Surrealist and abstract works in tempera and oils; printmaker and sculptor. Born in Cardiff, he attended the GLASGOW SCHOOL OF ART and the RCA under ROTHENSTEIN. In 1931 he won a Haldane Travelling Scholarship and worked in Paris, Berlin, Italy and Copenhagen, seeing works by Feininger, Klee and Kandinsky. In 1932 he was awarded a Royal Exhibition, RCA, and he then studied stone carving and primitive art in museums. Between 1934 and 1936 he met many artists, including Mondrian, Moholy Nagy and Kandinsky and he also began to make engravings, being influenced by S.W. HAYTER. In 1936 he exhibited with the LG and in the London SURREALIST exhibition. From 1938 to 1946 he taught and exhibited in Durban, South Africa. He showed at London galleries, including St George's Gallery and the LEICESTER GALLERIES,

and in many group exhibitions. In 1967 a retrospective exhibition was held at the Art Institute, Chicago, and his work is represented in many public collections. His paintings are often semi-figurative and retain stylistic elements of analytical cubism, vorticism and the work of both de Chirico and WYNDHAM LEWIS. Concerned with the emotional qualities of shape, he often uses forms in an anthropomorphic way sometimes reflecting political events or violence and conflict, e.g.*The Supplicants*. In the 1950s he experimented with centrifugal and centripetal composition; his later work became more monumental in form. His technique was precise and sharp with clearly defined forms and for that reason he favoured the use of tempera and engraving.

LIT: Retrospective exhibition catalogues for the Whitechapel Art Gallery, 1956, and the MAYOR and REDFERN GALLERIES, 1988. CF

EVANS, Peter, RSBA (b. 1943). Painter of landscapes and urban subjects, many from South-West France. Born in Birmingham, he studied at Birmingham College of Art from 1960, and turned to painting and making abstract constructions when on an exhibition design course. Between 1966 and 1984 he was a dealer in Fine Art, whilst continuing to paint and after 1978 turned to realism, usually painting with near-photographic exactitude. AW

EVES, Reginald, RA, RI, ROI, RP, RBA (1876–1941). Painter of portraits, landscapes and architecture in oils and watercolours. He studied at the SLADE SCHOOL (where he won a Slade Studentship) under Legros, BROWN and TONKS. He then settled in Yorkshire and between 1895 and 1900 painted at Holwick, Teesdale. From 1900 he settled in London and spent long periods studying and copying paintings, particularly the work of Turner, as well as Rembrandt, Velazquez, Titian and Van Dyck. He was encouraged by Brabazon and SARGENT and his friendship with Sargent lasted many years. In 1911 his portrait of Lord Cozens Hardy brought him public recognition and he was invited by LAVERY and SHANNON to join the Royal Portrait Society. He exhibited at the RA, RBA, RP and ROI, as well as other London societies and galleries. His first solo exhibition was in 1935 at Knoedler's Gallery, and he became RA in 1939, RBA in 1909, RP in 1913 and ROI in 1915. At the Paris Salon he won silver and gold medals and in 1937 his portrait of Max Beerbohm was purchased by the CHANTREY BEQUEST. His work is in several

public collections. Between 1940 and 1941 he was an OFFICIAL WAR ARTIST and he was married to the artist Bertha Papillon. His portraits are characterized by their sense of lively attention and quick grasp of character portrayed in an expressive and painterly technique. His landscapes show a similar ability to establish essential effects. His watercolour technique was admired by Brabazon and Sargent for its transparent washes and clarity.

LIT: *The Art of Reginald Eves*, Adrian Bury, 1940; memorial exhibition catalogue, RBA Galleries, 1947. CF

EWART, David Shanks, ARSA (1901–1965). Painter of portraits in oils. Born in Glasgow, he attended the GLASGOW SCHOOL OF ART from 1919 and in 1924 won a travelling scholarship, studying in France and Italy. He exhibited mainly at the RSA, becoming ARSA in 1934; he also showed at the RA, GI, in the provinces and abroad. In 1926 he won the Guthrie Award and in 1927 the Lauder Award and his work is represented in several public collections. His portraits were detailed and smoothly painted giving a precise and forceful account of character, e.g. the portrait of Sir Geoffrey Callender, National Maritime Museum, Greenwich. CF

EYTON, Anthony, LG, RA (b. 1923). Painter of figures, coast scenes, architecture, landscapes and interiors in oils and watercolours. Between 1936 and 1941 he was taught by COLDSTREAM at Cranford and by BETTS at Reading University. He studied at CAMBERWELL SCHOOL OF ART where he was influenced by JOHN DODGSON 1942–7, and from 1951 to 1953 he studied at the BRITISH SCHOOL AT ROME, winning the Abbey Major Scholarship. He exhibited with the LG in 1952, at the RA from 1954 (becoming ARA in 1976) and in 1955 had a solo exhibition at St George's Gallery. He has subsequently exhibited in major galleries including the NEW ART CENTRE, BROWSE AND DARBY, and the NEW GRAFTON GALLERY. He has taught at the University of Newcastle and from 1955 at CAMBERWELL SCHOOL OF ART. Between 1969 and 1971 he was Head of Painting, St Lawrence College, Kingston, Ontario, and he has travelled widely. In 1971 he won a Kingston Whig Standard Award, in 1972 he was a prizewinner at the JOHN MOORES EXHIBITION and in 1975 he won first prize in the 2nd British International Drawing Biennale, Middlesborough. In 1982 he was commissioned to paint military subjects in Hong Kong for the

Artistic Records Committee. His work seeks an authentic record evolved from the truthful scrutiny of the subject. Working in the EUSTON ROAD tradition of depicting everyday scenes in a straightforward manner, his work shows a particular interest in the combination of people in streets and interiors and in the effect of light upon form both in revealing and dissolving objects. His treatment of light adapts to the particular qualities of different environments.

LIT: Eyton's articles in *The Artist*, March, April and May 1969; retrospective exhibition catalogue, South London Art Gallery, 1980. CF

F

FAIRCLOUGH, Michael, RE (b. 1940). Painter and printmaker of landscapes and seascapes. He studied at Kingston School of Art under his father WILFRED FAIRCLOUGH and from 1964 to 1966 was a ROME SCHOLAR in engraving. In 1967 he worked with HAYTER at ATELIER 17, Paris and is married to MARY MALENOIR. He has exhibited at the RA and his work is represented in public collections. He has won various prizes and became a RE in 1973. He taught at Belfast School of Art and for a period at West Surrey College of Art. His work ranges from oil painting to aquatints, reducing his subject to subtle areas of colour. He created a cement relief for the GPO in 1971, and he was commissioned to paint five Scottish landscapes which were reproduced on postage stamps issued in 1981. CF

FAIRCLOUGH, Wilfred, RWS, RE, ARCA (1907–1996). Painter and engraver of landscapes, architecture and town scenes. He attended the RCA 1931–4, and from 1934 to 1937 was a ROME SCHOLAR in engraving. He exhibited at the RA, RE, RSA, in the provinces and abroad. He became RE in 1946 and RWS in 1968, from 1962 he was Principal, Kingston College of Art, and Assistant Director, Kingston Polytechnic. His etchings, in the technical tradition of Meryon, depict a wide range of subjects, from musical occasions to architectural studies, often in Italy. His watercolours are mostly detailed and clearly articulated landscapes.

LIT: *The Etchings of Wilfred Fairclough*, Ian Lowe, Scolar Press, 1990. CF

FAIRFAX-LUCY, Edmund, NEAC (b. 1945). Painter of interiors, still-life and landscapes in oils. He studied at the City and Guilds of London Art School and at the RA SCHOOLS 1967–70, winning the David Murray Travelling Scholarship 1966, 1967 and 1969. He has exhibited at the RA since 1967 and at the NEW GRAFTON GALLERY since his first solo exhibition there in 1971. His quiet paintings use simple components and particular effects of light, e.g. *A Teacup*, 1973 (Brinsley Ford Collection). CF

FAIRHURST, Jack Leslie, ARCA (b. 1905). Painter of portraits in oils; draughtsman. Son of Enoch Fairhurst, RMS, he studied at CAMBERWELL SCHOOL OF ART under ROTHENSTEIN and SCHWABE 1919–23, and at the RCA 1923–7. He exhibited at the RA and at leading galleries and he was a member of the Ridley Art Club, the South London Group, the Richmond Art Group and the Society of Fulham Artists. CF

FAIRWEATHER, Ian, (1891–1974). Painter of figures and semi-abstract works in gouache and plastic paint. He studied at the SLADE SCHOOL OF ART and then travelled extensively leading a nomadic and reclusive life. In the 1930s he travelled to Canada, China, Bali, Ceylon and Australia. Between 1939 and 1942 he served in the British Army in India and after returning to Australia attempted a raft journey to Timor in 1952. He later settled in Queensland. He has exhibited at the REDFERN GALLERY, London, and in Australia, and his work is represented in public collections including the TATE GALLERY. His paintings, using earth colours, unite oriental and occidental influences. His early paintings were figurative and decorative, later work evolved a linear, abstracted style which revealed his knowledge of Chinese art and calligraphy.

LIT: Article by James Gleeson, *New South Wales Quarterly*, July 1965. CF

FANNER, Alice Maude (1865–1930). Painter of marines and landscapes in oils and watercolours. She studied at the SLADE and Richmond schools of art, winning certificates and prizes for landscape and portraiture. She also studied with JULIUS OLSSON at St Ives, worked in Paris and in 1918 visited South Africa. She exhibited mainly at the NEAC, RA and RHA and at the Goupil Gallery and Walker's Art Gallery as well as at other galleries and societies and abroad. She taught at Richmond School of Art. Her work was awarded a gold and two silver medals from the Carnegie Institute, Pittsburg. She painted many yachting subjects which capture the excitement

of movement and weather in lively colours. Other works, e.g. *Spring in Hyde Park*, are light toned and impressionistic.
LIT: 'Alice Fanner's Lyrical Painting', C. Lewis Hind, *Studio*, Vol. 66, 1916. CF

FARLEIGH, John, RBA, RE, LG, SMP, SWE, CBE (1900–1965). Painter of landscapes, architecture and figures in oils, watercolours and pastels; illustrator and wood engraver. He studied at the CENTRAL SCHOOL OF ART 1919–22, and exhibited at the RA, RE and galleries including the LEICESTER GALLERIES and the REDFERN GALLERY. Member of the LG in 1927 and RE in 1948, he taught at Rugby School 1922–4, and at the Central School from 1924. Founder of the Crafts Centre, London, he was awarded a CBE in 1949 and was married to the artist Elsie Wooden. Best known as an illustrator, particularly of the work of G.B. Shaw, he preferred to work from very free designs so retaining the freshness of image in the final illustration.
LIT: See Farleigh's autobiography *Graven Image*, 1940, and the collection of his notes *It Never Dies*, Sylvan Press, 1946. CF

FARMER, Bernard (b. 1919). Painter of abstracts. He studied at CHELSEA POLYTECHNIC School of Art and held a solo exhibition in 1956 at the AIA Gallery where he exhibited between 1954 and 1969. He has subsequently exhibited in London galleries, including Angela Flowers (where he has shown in mixed exhibitions since 1972 and held a solo in 1982), in the provinces and abroad. His work is represented in collections including the ARTS COUNCIL. His earlier painting used simple abstract figures on a plain ground whilst in more recent works the forms have extended over the surface, creating a simple, refined statement.
LIT: Exhibition catalogue, Heal's Art Gallery, London 1964; 'One Man Show', review by William Packer, *Art & Artists* (UK), July 1982. CF

FARRELL, Anthony (b. 1945). A painter, he studied at CAMBERWELL, 1963–5, and at the RA SCHOOLS 1965–8. His first solo exhibition was at Brunel University in 1972. Some of his studies of bathers at Southend are in the collection of the ARTS COUNCIL. AW

FARTHING, Stephen (b. 1950). Born in London, he studied at ST MARTIN'S SCHOOL OF ART 1968–73, and at the ROYAL COLLEGE

1973–6. He won an Abbey Major Scholarship in 1976 which took him to the BRITISH SCHOOL IN ROME for a year. From 1980 to 1985 he was a visiting lecturer at the RCA, and in 1985 was Head of Department of Fine Art at West Surrey College of Art. In 1989 he was appointed Master of the RUSKIN SCHOOL, Oxford. His first one-man exhibition was at the Royal College of Art in 1977, since when he has had a number including one at the New Ashgate Gallery, Farnham, in 1984. Since 1984 he has usually exhibited at Edward Totah. He won prizes at the JOHN MOORES LIVERPOOL exhibitions in 1976. 1980 and 1982. He has exhibited in Rome, Paris, Stockholm and Baghdad as well as in Australia, and in numerous national and touring exhibitions in Britain. He represented Britain at the São Paolo Biennale in 1989. His work is in many national, public and university collections. His painting is often characterized by a remarkable virtuosity in the handling of the surface and in the creation of complex images with overlapping and interpenetrating contours. His subject matter ranges very widely but usually embodies an element of criticism or comment on modern life.
LIT: 'Stephen Farthing at the Arnolfini, Bristol', review by Tessa Sidey, *Arts Review*, May 1984, p.240; 'Stephen Farthing', Martin Holman, *London Magazine*, July 1984, pp.85–9. AW

FEDARB, Daphne, RBA, NS, WIAC (b. 1912). Painter of landscapes and still-life in oils, watercolours, gouache and pen and ink. She studied at Beckenham School of Art 1928–30, and at the SLADE 1931–4, and exhibited at the FINE ART SOCIETY in 1935 (having married ERNEST FEDARB), at the RBA (member 1948), at the RA from 1940, in London galleries, the NEAC, LG, SWA, in the provinces and abroad. A member of the National Society, 1940–55, and the WIAC, 1955–68, her prizes include the De Lazlo Medal, RBA, in 1982. Her work was initially influenced by GERTLER and later by Bonnard.
LIT: *Daphne and Ernest Fedarb*, exhibition catalogue, Sally Hunter Fine Art, London, 1986. CF

FEDARB, Ernest (b. 1905). Painter of landscapes and still-life in watercolours. He studied at the Sidney Cooper School of Art, at Beckenham School of Art under JOWETT and with PITCHFORTH and HENRY CARR. He exhibited at the RBA in 1926, with DAPHNE FEDARB at the FINE ART SOCIETY in 1935 and he has subsequently shown regularly in London and provincial galleries. A member of the National Society

of Painter, Sculptors, Engravers and Potters, 1934, and President, 1985, he taught at Westminster and Hammersmith Schools of Art. His work combines simplified notation with a sense of structure.
LIT: *Daphne and Ernest Fedarb*, exhibition catalogue, Sally Hunter Fine Art, London, 1986. CF

FEDDEN, Mary, LG, PRWA, RA (b. 1915). Painter of still-life, flowers and animals in oils, watercolours, gouache and collages; muralist. She studied at the SLADE SCHOOL under SCHWABE 1932–6, and has exhibited at the RWA, with the LG (becoming a member between 1962 and 1964) and with the WIAC. She has also shown at major London galleries including the REDFERN GALLERY 1953–67, the Hamet Gallery 1970–3, and the NEW GRAFTON GALLERY from 1975. Her work has appeared in the provinces, in group exhibitions and in many public collections, including the TATE GALLERY. Between 1958 and 1964 she taught at the RCA and from 1965 to 1970 at the Yehudi Menuhin School. She was Chairman of the WIAC 1956–8, and in 1984 was elected President of the RWA. Her mural commissions include work for the Festival of Britain, 1951, the P&O Liner *Canberra*, 1961, and work for Charing Cross Hospital, 1980, in collaboration with her husband JULIAN TREVELYAN. Her work has strongly painted, simplified forms presented with an innocence of vision. Often still-life elements are set against windows or other framing devices and combined with landscape. All her subjects are executed in an expressive technique and a sophisticated range of clear colours applied in bold areas.
LIT: See Fedden's two articles about her work in the *Artist* (UK), Vol. 99, October and November 1984; article in *The Green Book*, Vol. 3, no. 4, 1990; *Mary Fedden*, Mel Gooding, Scolar Press, 1995. CF

FEIBUSCH, Hans, LG (b. 1898). Painter of mural and easel paintings of religious subjects, figures, landscapes and still-life in oils and gouache; lithographer and sculptor. Born in Frankfurt, he studied at the Berlin Academy, in Italy between 1921 and 1923 and in Paris under André Lhote and Othon Friesz 1923–5. In 1933 he settled in England and produced mural commissions for architects including E. Maxwell Fry. From 1939 he painted many murals for English churches, including St Wilfred's Church, Brighton. In the 1970s he concentrated on landscapes and in 1975 he began to sculpt. He has

exhibited mainly at the LEFEVRE GALLERY from 1934, at the LG (member 1934), and at the RA from 1944. He has shown in London and provincial galleries and his work is represented in collections including Leeds City Art Gallery. His early work was influenced by expressionist and formalist painting but later under the influence of Italian art he adopted a more classic style using strong colour.
LIT: *Mural Painting*, Hans Feibusch, Adam & Charles Black, London, 1946; *Hans Feibusch: Ein Frankfurter Maler*, catalogue, Historisches Museum, Frankfurt am Main, 1986. CF

FEILER, Paul (b. 1918). Painter of non-figurative images in oils. Born in Frankfurt, he studied at the SLADE SCHOOL 1936–9, subsequently settling in Cornwall where he was associated with the St Ives painters, particularly with PETER LANYON. He exhibited at the REDFERN GALLERY from 1953 to 1959, at the RA from 1943 to 1972, and has shown in provincial and London galleries and abroad. His work is represented in collections including the TATE GALLERY. From 1946 to 1975 he taught at the West of England College of Art, Bristol. Initially influenced by Cézanne and by his Cornish environment, in the mid-1960s connections with landscape disappeared from his work and he has worked since then with a restricted range of geometric forms.
LIT: Catalogues: *Paul Feiler. Paintings and Screenprints 1951–1980*, Crawford Centre for the Arts, St Andrews, 1981; *Paul Feiler. Paintings and Related Works on Paper*, Austin/Desmond Fine Art, London, 1990. CF

FEILD, E. Maurice (1905–1988). Painter of figures, portraits (especially of children) and landscapes in oils and watercolours; lithographer, etcher and wood engraver. He studied at the SLADE SCHOOL under TONKS, 1924–6, and in the late 1930s sometimes worked with the EUSTON ROAD painters. He exhibited at the LG, at the Cooling and Walker's Galleries and in 1948 held a solo exhibition at the City Art Gallery, Worcester. His work is represented in the NPG, London. In the 1920s he taught at Downs School, Colwall, with W.H. Auden, and at the Slade where he returned to teach in 1950 under COLDSTREAM. He later taught at St Albans School of Art. His figurative work was perceptive and realistic.
LIT: *Maurice Feild. Drawings and Paintings 1926–1970*, catalogue, Upper Grosvenor Galleries, London, 1970. CF

FELL, Sheila, RA (1931–1979). Painter of landscapes in oils. Born in Aspatria, Cumberland, she attended the Carlisle School of Art 1948–50, and ST MARTIN'S SCHOOL OF ART 1950–3, under PITCHFORTH and NAPPER. In 1955 she had her first solo exhibition at the BEAUX ARTS GALLERY; she continued to exhibit there as well as in London and provincial galleries, and at the RA, becoming ARA in 1969 and RA in 1974. Her work has been represented in major group exhibitions and in public collections, including the TATE GALLERY through a CHANTREY BEQUEST purchase. From 1960 she taught at CHELSEA SCHOOL OF ART. She won numerous awards including a Boise Travelling Scholarship to France, Italy and Greece, 1958, and ARTS COUNCIL Awards in 1967 and 1976. Her painting was rooted in the Cumberland landscape. Early in her career she was encouraged by LOWRY who purchased her work. Her early works were composed of a strong linear element and vigorous brush marks whilst later work revealed a freer and more open treatment of form. In technique and attitude to subject her painting has affinities with Van Gogh's, conveying the sense of man's role in landscape. In later painting the pigment became thinner and the effect more lyrical. Her use of colour varied from periods of subdued ochres and yellows to works in brighter hues. Certain themes recur in her *oeuvre* and in her last paintings two themes predominate: winter and Cumbrian cottages. There is also a greater emphasis placed on the sky in later paintings, e.g. *Potato Picking – Clouds*, 1979.
LIT: Exhibition catalogue, Abbot Hall Art Gallery, Kendal, 1981. CF

FERGUSON, Malcolm Alastair Percy, ARWA (b. 1913). Painter of religious subjects, landscapes and figures in oils, watercolours and tempera. He studied at Croydon School of Art 1936–9, and at the SLADE SCHOOL in 1939 and 1948–51. He has exhibited at the RA from 1949 and has also shown at the RWA, RI, RP, NEAC, in the provinces and at the Paris Salon. He was elected ARWA in 1965. His exhibited paintings range from subjects such as *Lazarus*, 1955 and *Flight into Egypt*, 1959, to English scenes such as *Bembridge Harbour*, 1974. CF

FERGUSSON, John Duncan, RBA, LLD (1874–1961). Painter of landscapes and figures in oils; sculptor. Born in Leith, Scotland, he had no formal training but made annual visits to France from the mid-1890s, also travelling to Spain in 1899 and Morocco in 1901. He worked at the Atelier Colarossi, Paris, painted with S.J. PEPLOE and settled in France from 1907 to 1914 where his friends included Segonzac and Margaret Morris whom he later married. He lived in London from 1914 to 1929, in Paris from 1929 and from 1940 to 1961 in Glasgow. He exhibited mainly at the RBA (member 1903) and at the Baillie Galleries where he held his first solo exhibition in 1905. He showed widely in London galleries and abroad and in 1925 he exhibited with the other SCOTTISH COLOURISTS in Paris and London. His work is represented in collections including the TATE GALLERY. He was Art Editor of *Rhythm* in 1911, Founder of the New Art Club, Glasgow, 1940, from which emerged the New Scottish Group, 1942; Art Editor of *Scottish Art and Letters* and author of *Modern Scottish Painting*, Maclellan, 1943. Initially influenced by the Glasgow School and by Whistler, in France he was influenced by the Fauves and from 1910 he developed a personal style emphasizing rhythmic forms and sensuous line, often used to depict the nude.
LIT: Memorial exhibition catalogue, Scottish Arts Council, 1961–2; centenary exhibition catalogue, Fine Art Society, London, 1974; *The Art of J.D. Fergusson*, Margaret Morris, Blackie, Glasgow and London, 1974. CF

FERRY, David (b.1957). He is a painter and printmaker who studied at Blackpool, CAMBERWELL and the SLADE. His first one-man show was at the Grundy Art Gallery in Blackpool in 1982; his work powerfully expresses the fear and destruction of warfare. AW

FEW, Elsie, RWA, LG (1909–1980). Painter of landscapes, figures and still-life; collagist and teacher. Born in Jamaica, she studied at the SLADE SCHOOL, at the Bartlett School of Architecture 1929–31, and abroad 1931–2. In 1937 she married CLAUDE ROGERS and between 1937 and 1939 occasionally worked at the EUSTON ROAD SCHOOL. She exhibited at the LG (member 1943) and the RWA (member 1950), showed with PASMORE and Rogers in 1936 at the Burnett Webster Gallery, and exhibited in London galleries including the Annexe Gallery. Her work is represented in the TATE GALLERY. From 1949 to 1969 she was Head of Art, Gipsy Hill College. Her earlier painting was influenced by the Euston Road School and in 1968 she began to concentrate on abstract collages which reflected her interest in texture and subtle colour.

LIT: Catalogue, Whitechapel Art Gallery, London, 1973; memorial exhibition catalogue, Bury St Edmunds Art Gallery, 1981. CF

FIELDING, Brian (1933–1987). Painter of figurative and non-figurative images, often related to still-life, in oils and acrylic. Born in Sheffield, he attended Sheffield College of Art 1950–4, and the RCA 1954–7, winning an Abbey Minor Scholarship to work in Italy and France in 1958. He exhibited at the Hibbert Gallery, Sheffield, in 1958 and subsequently showed in provincial and London galleries, including the Rowan and St Paul's Galleries, at the RA from 1956, and in group exhibitions after 1960. His work is represented in collections including the ARTS COUNCIL (GB). He taught at Leicester School of Art and at Ravensbourne College of Art until 1982. Influenced in the 1950s by Abstract Expressionism, his work was conditioned by his interest in Japanese art and Zen Buddhism, seeking restraint and formal purity. In the early 1980s his work became more varied in character, using the approach of a still-life painter in presentation of forms.
LIT: 'Brian Fielding's Paintings', M. Billam, *Artscribe* (UK), No.37, October 1982, pp.44–9; *Brian Fielding. New Paintings and Paintings 1960–1983*, catalogue, Mappin Art Gallery, Sheffield, 1986, and travelling. CF

The Fine Art Society. The gallery, at 148 New Bond Street (which has a branch in Edinburgh, opened in 1973), was founded in 1876, and deals principally in British art from 1850. An important tradition of their ten exhibitions per year are loan exhibitions and surveys for which authoritative catalogues are prepared. Living artists represented include EURICH and ROSOMAN. AW

FINER, Stephen (b.1949). His first one-man show was at Four Vine Lane, London, 1981, but he exhibited in mixed shows for some years before that date, and was featured in 'British Art 1940–1980' at the Hayward Gallery in 1980. His work is in the ARTS COUNCIL the BRITISH COUNCIL and the CAS collections, as well as in private collections. He paints figures and heads in a loose, expressive and highly abstracted manner.
LIT: *Catalogue Introduction*, William Packer, exhibition catalogue, Berkeley Square Gallery, July 1989. AW

FINN, Michael (b. 1921). Painter of abstracts in a range of media including watercolour, crayon,

pencil, gouache and pva; maker of collages and constructions; printmaker. He has exhibited in various galleries including the Festival Gallery, Bath, in 1978, and his non-figurative work often depicts simple shapes which have their roots in landscape and figures. CF

FINZI, Joy (1907–1991). Born in London, Joyce Amy Black married the composer Gerald Finzi in 1933 after studying sculpture and ceramics at the CENTRAL SCHOOL. She later developed as a painter and particularly as a draughtsman, making many portrait studies of well-known artists, writers and musicians (for example, *Ralph Vaughan Williams*, 1947, NPG).
LIT: *In That Place*, Joyce Finzi, Libanus Press, Marlborough, 1987. AW

FISH, Anne Harriet, FCIAD (d. 1964). Painter in oils and watercolours; illustrator and black and white artist; textile designer. She studied under Orchardson and Hassall, at the London School of Art and in Paris; she exhibited mainly at the FINE ART SOCIETY, the LS and at the RA in 1933. She lived in St Ives and was a member of the PENWITH SOCIETY OF ARTISTS, the Newlyn Society of Artists and the St Ives Old Society of Artists. She contributed to many publications, especially in the 1920s and 1930s, including *Vogue*, *Tatler* and *Vanity Fair*, and her book illustrations include work by Lady Kitty Vincent and *Tatlings* by Sydney Tremayne, David & Charles, 1979. Best known as a black and white artist, her economical, satirical style was influenced by Beardsley and Art Deco.
LIT: *Comic Art in England*, C. Veth, 1930. CF

FISHER, Samuel Melton, RA, RWA, PS, RP, RI, ROI (*c.*1860–1939). Painter of genre, portraits, figures and flowers in oils; pastellist. He studied at Lambeth School of Art, with Bonnaffé in Paris and at the RA SCHOOLS 1876–81, winning a travelling scholarship to Italy. He lived in Venice for ten years, subsequently settling in London *c.*1895. He exhibited at the RA from 1878 to 1940 (ARA 1917, RA 1924) and showed widely in galleries and societies, being elected ROI in 1888, VPROI in 1898, RP in 1900 and RI in 1936. A member of the Society of 25 Artists, in 1898 his painting *In Realms of Fancy* was purchased by the CHANTREY BEQUEST for the TATE GALLERY. He was the father of the artist Stefani Melton Fisher. In Italy he painted mainly contemporary genre scenes but on returning to London he concentrated more on

poetic, imaginative subjects and delicate figures and portraits.

LIT: 'The Paintings of S. Melton Fisher', A.L. Baldry, *The Studio*, Vol.42, pp.173–82. CF

FISHER, Sandra (1947–1994). Painter, born in New York, she studied first in Los Angeles, before moving to London where she taught in various art schools. Her first solo exhibition was at the Coracle Press Gallery in 1982. She married R.B. KITAJ in 1983. Her strong, uninhibited figurative paintings often dealt with male/female relationships. AW

FISHER, Stefani Melton, RI, ROI, PS (b. 1891). Painter of portraits in oils; wood engraver. Son of Samuel Melton Fisher, he studied at the BYAM SHAW AND VICAT COLE School of Art, where he later taught, and at the RA SCHOOLS. He exhibited at the RA, ROI (member 1925), RI, in London galleries including Walker's Gallery, in the provinces and Scotland. He was Art Master at Dulwich College. CF

FISHER, William Mark, RA, RI, NEAC, ROI (1841–1923). Painter of landscapes in oils and watercolours. Born in Boston, USA, he studied at the Lowell Institute, Boston, under George Innes and in 1861 under Gleyre and Corot in Paris. He settled in England in 1872 but continued to make trips abroad, visiting France, Holland, Algiers and Morocco. He exhibited mainly at the NEAC (member 1886), at the RA between 1872 and 1923 (ARA 1911, RA 1919), and at the LEICESTER GALLERIES. He also showed widely in London galleries and societies, being elected RI in 1881 and ROI in 1883, and in the provinces, in Scotland and abroad. His work is represented in collections including the V & A. He was the father of MARGARET FISHER PROUT. After initially painting portraits and figures he concentrated on landscape, being influenced by Corot and Boudin and later by Sisley (whom he knew) and Monet. Admired by SICKERT, his work was noted for its freshness and depiction of outdoor light.

LIT: *Mark Fisher and Margaret Fisher Prout*, Vincent Lines, London, 1966; memorial exhibition catalogue, Leicester Galleries, London, 1924. CF

FISHWICK, Clifford, ATD (1923–1997). Painter of works based on landscape in oils, watercolours and gouache; lithographer and mural painter. He studied at Liverpool College of Art 1940–2 and 1946–7, and in New York, and held a solo exhi-

bition in 1957 at St George's Gallery, London. He subsequently exhibited regularly, particularly in the West Country where he showed in galleries including the Royal Albert Memorial Museum, Exeter, and at the RWA. He was a member of the Newlyn Society of Artists and his work is represented in collections including Exeter and Plymouth Art Galleries. From 1958 to 1984 he was Principal of Exeter College of Art. His works originated from the sensations aroused by coast or landscape. He was an accomplished rock climber and yachtsman.

LIT: *Arts Review* (UK), Vol.30, pt.22, 10 November 1978, p.614. CF

FITTON, James, RA (1899–1982). Figurative painter of a wide range of subjects; graphic designer and illustrator. Usual painting medium: oils. He studied at MANCHESTER SCHOOL OF ART and the CENTRAL SCHOOL OF ART, London, under A.S. HARTRICK. His first one-man show was held in 1933 at Arthur Tooth & Sons, but his main exhibition outlet was the RA. He was a member of the NEAC and between 1932 and 1952 of the LG. In 1933 he was a founder member of the ARTISTS INTERNATIONAL ASSOCIATION and exhibited in the Graphic Art Exhibition, Moscow, 1935. In the 1930s he taught lithography at the Central School. He was elected ARA in 1944 and RA in 1954, served on the Art Panel of the ARTS COUNCIL, and in 1957 was a member of the CHANTREY BEQUEST purchasing committee. From 1969 to 1975 he was a Trustee of the BM and between 1970 and 1982 Honorary Surveyor Dulwich College Picture Gallery. Fitton's graphic work was varied, ranging from cartoons showing the influence of Grosz, to his commercial work for London Transport and the Ministry of Food which revealed his simple, entertaining and strongly coloured designs. In 1951 he was commissioned to paint murals for the Festival of Britain (Seaside Section). Fitton's paintings reflect his draughtsmanship, sense of design and wit. They range from works influenced by SICKERT to domestic interiors reflecting the EUSTON ROAD SCHOOL, as well as some landscapes and port scenes. Later work was more illustrative and humorous, whilst his last self-portrait *Looking at Les Fauves*, 1981, revealed a more emotional response and stronger expressive colour.

LIT: *James Fitton, RA 1899–1982*, exhibition catalogue, Dulwich Picture Gallery, 1986–7; *James Fitton, RA, 1899–1982*, catalogue, Oldham Art Gallery, 1983. CF

Fitzroy Street Group (1907–1913). A loosely affiliated circle who gathered around SICKERT after his return from France in late 1905. The nucleus consisted of the ROTHENSTEINS, RUSSELL, GORE and GILMAN. Frustration with the increasing conservatism of the NEAC and a desire to exchange views and exhibit informally encouraged them, in 1907, to form a cooperative at 18 Fitzroy Street. ETHEL SANDS, NAN HUDSON, GEORGE THOMSON and LUCIEN PISSARRO were founder members. In 1908, less progressive members were replaced by three younger artists: MALCOLM DRUMMOND, DOMAN J. TURNER and WILLIAM RATCLIFFE. AUGUSTUS JOHN, DERWENT LEES and JAMES DICKSON INNES also attended meetings, and talented painters such as WALTER BAYES and ROBERT BEVAN were recruited via AAA exhibitions. By 1910 the reputation of the Group, which then included MANSON and HENRY LAMB, was such that it led to greater cooperation with the NEAC. Representative of the work of the Group were the dispassionately observed urban landscapes which became known as Camden Town painting and owed much to Sickert's intimate interiors such as *Mornington Crescent Nude*, c.1907. Many members had first-hand knowledge of European developments which resulted in the introduction of a heightened palette and thick paint applied with broken brushstrokes.
LIT: *The Painters of Camden Town, 1905–1920*, Christie's exhibition catalogue, 1988; *The Camden Town Group*, Wendy Baron, Scolar Press, 1979. DE

FLEETWOOD-WALKER, Bernard, RA, RWS, RP, ROI, NEAC, PRBSA (1893–1965). Painter of portraits, including children, in oils and watercolours; draughtsman. Great-grandson of Cornelius Varley, he was born in Birmingham and studied as a goldsmith before attending Birmingham School of Art. He worked under HENRY RUSHBURY and GERALD BROCKHURST, and studied in London and in Paris under Fleury. During the First World War he served with the Artists' Rifles. He exhibited at the RA from 1925 to 1965 (ARA 1946, RA 1956) and was elected ARBSA in 1924, ROI, in 1932, ARWS in 1940, RP in 1945, RWS in 1946 and NEAC in 1950. He also exhibited at the Paris Salon where he was awarded bronze and silver medals and his work is represented in many collections including Birmingham Museum and Art Gallery. He taught at Birmingham College of Art from 1929 and after his retirement he settled in Chelsea and was

appointed Assistant Keeper of the RA SCHOOLS. His portraiture was characterized by its formal strength, humanity and intensity of perception. Whilst in his earlier work he concentrated on formal design, seeing the picture as a collection of forms, in later works he conveyed a more instant overall image.
LIT: Memorial exhibition catalogue, Royal Birmingham Society of Artists, Birmingham, 1966. CF

FLEMING, Ian, RSA, RSW, RWA (b. 1906). Painter of landscapes, townscapes and portraits in oils and watercolours; etcher and engraver. He studied at GLASGOW SCHOOL OF ART 1924–9, under Chika Macnab and CHARLES MURRAY, at the RCA under AUSTIN and OSBORNE, in Paris and in Spain. He exhibited mainly at the RSA (ARSA 1947, RSA 1956), at the GI, the RSW (member 1946) and at the RA from 1934 to 1946. His work is represented in Dundee Art Gallery. He taught at Glasgow School of Art, 1931–40 and 1946–8, at Hospitalfield, 1948–54: From 1954 to 1972 he was Principal of Grays School of Art, Aberdeen, and in 1974 he became Chairman of Peacock Printmakers. Influenced as a printmaker by Dürer, Meryon, BONE and Whistler, in the 1970s he produced semi-abstract compositions including text.
LIT: Retrospective exhibition catalogue, Artspace Galleries, Aberdeen, 1980; *Ian Fleming. Graphic Work*, catalogue, Scottish Arts Council, Aberdeen Art Gallery, 1983. CF

FLIGHT, W. Claude, RBA (1881–1955). Linocut and woodcut artist; painter of figures, landscapes and townscapes in oils and watercolours; interior designer and illustrator. He studied at HEATHERLEY'S 1913–14 and from 1918 and exhibited at the RA in 1921, in Paris in 1922 and in London at the RBA from 1923 (ARBA 1923, RBA 1925), regularly at the REDFERN GALLERY and abroad. A member of the SEVEN AND FIVE SOCIETY in 1923, and of the GRUBB GROUP in 1928, his work is represented in collections including the V & A. He collaborated with Edith Lawrence, taught at the GROSVENOR SCHOOL OF MODERN ART, wrote about and organized exhibitions on linocuts. Influenced by Cubism, Futurism and VORTICISM, his work expressed dynamic rhythm through bold, simple forms.
LIT: *The Art and Craft of Linocutting and Printing*, Claude Flight, Batsford, 1934; *Claude Flight and Edith Lawrence*, catalogue, Parkin Gallery, London, 1973. *Linocuts of the Machine*

Age: Claude Flight and the Grosvenor School, Stephen Coppel, Scolar Press, 1995.　　CF

FLINT, Francis Murray Russell, ROI, ARWS, RSW, SMA (b. 1915). Painter of landscapes, townscapes, marines and figures in oils and watercolour. Son of WILLIAM RUSSELL FLINT, he studied at the GROSVENOR SCHOOL OF MODERN ART, the RA SCHOOLS and in Paris. He served in the RNVR from 1938 and was an OFFICIAL WAR ARTIST in the Far East. He exhibited at the RA between 1937 and 1969, at the RWS, RSW, SMA, ROI, in the provinces, particularly at the Ralph Lewis Gallery, Brighton, and abroad. His work is represented in collections including the IMPERIAL WAR MUSEUM. He was Art Master at Hurstpierpoint College, Sussex, and author of *Watercolour for Beginners*, 1953, and *Watercolour Out of Doors*, 1958 (*How to do it* series, Studio Publications). His subjects are taken from Britain and Europe and his watercolours reveal his atmospheric use of wash and texture (e.g. *Wet Sands at Polzeath*, Collection of the Trustees of the RWS).
LIT: *Works by Francis Russell Flint*, exhibition catalogue, P/S Tattershall Castle, February 1976.　　CF

FLINT, Sir William Russell, RA, PRWS, RSW (1880–1969). Painter of landscapes and figures; illustrator. Usual media: watercolours and oils. From 1895 he studied at the Royal Institute School of Art, Edinburgh, and in 1900 at HEATHERLEY'S School, London. From 1912 to 1913 he visited Italy and began etching which he then studied at Hammersmith School of Art. He travelled widely and worked in Belgium, Holland, Spain, France, Italy and Switzerland. He was elected ARWS in 1914, RWS in 1917, RE in 1931, ARA and RA in 1924 and 1933, and PRWS from 1936–54. He became a Trustee of the RA in 1943. In 1913 he was awarded a silver medal at the Paris Salon for illustrations to *Morte d'Arthur*. As a painter he is best known for watercolours of nude and semi-nude women with Spanish or gypsy settings. These works, and his many landscapes, show great technical facility and are characterized by their overall coolness of tone, direct handling, interest in light and clarity of effect.
LIT: *In Pursuit: An Autobiography*, London, 1970; *More than Shadows: Biography of W. Russell Flint*, Arnold Palmer, London, 1943. CF

FLOWER, Charles Edwin, BWS, NSA (b. 1871). Painter of architecture and landscapes in water-colours; engraver, lithographer and illustrator. He exhibited at the RA, RBA, in Birmingham and Liverpool and he was a founder member of the BWS and the NSA. Married to the artist Alice Flower, neé Perry, he illustrated *Old Time Paris* by G.F. Edwards, 1908, and *No. 10 Downing Street* by C.E. Pascoe, 1908. His work is represented in some public collections including the London Museum and he carried out a number of commissions for the Royal Family. His exhibited work, much of it wood engravings, include subjects such as *Trafalgar Square*, RA 1932, and *Wallingford Bridge*, RA 1948.　　CF

FLOYD, Donald H. (1892–1965). Painter of landscapes in oils. He lived in Plymouth, 1914, near Newport, 1920, at Chepstow, 1932, and Tintern, 1940, and exhibited mainly at the RA between 1920 and 1950, as well as at Liverpool and Birmingham. His exhibited subjects included: *Sunshine After Snow*, RA 1929, *Ice Floes on the Wye*, RA 1940, and *Silvery Morning, Catbrook*, RA 1950.　　CF

FOLKES, Peter Leonard, VPRI, RWA (b. 1923). Painter of landscapes, figures, townscapes and imaginative subjects in oils, watercolours, acrylic, gouache and tempera. He trained at the West of England College of Art under George Sweet 1941–2 and 1947–50, and in 1963 was awarded a Goldsmiths' Travelling Scholarship to the USA. He has exhibited in London, the provinces and New York and has shown at the RA since 1951, at the RWA (member 1959), at the RBA and the RI (member 1969, council member 1971). His work is represented in the ARTS COUNCIL Collection and he was Head of Fine Art, Southampton Institute of Higher Education. His work ranges from observed landscape to imaginative, figurative subjects with themes, e.g. *Tombstones* and *Uniforms*.　　CF

FORBES, Elizabeth Adela Stanhope, ARWS, RE (1859–1912). Painter of figures, particularly children, in landscapes and interiors in oils, watercolours, gouache and pastels; etcher. Elizabeth Armstrong was born in Ottawa, Canada, and studied first in London at SOUTH KENSINGTON before attending the Art Students' League of New York, USA. In 1882 she worked in Brittany, moved to London in 1883 where she knew Whistler and SICKERT, and in 1884 worked at Zandvoort, Holland. In 1885 she settled in Newlyn, working in London and St Ives before her marriage to STANHOPE FORBES in 1889. In 1891 she worked

with him in Brittany and they subsequently founded a School of Art in NEWLYN in 1899. She exhibited at the RWS and the RA from 1883 and held solo exhibitions of her work in London galleries. She abandoned etching in 1886 and concentrated on painting. Influenced by Bastien-Lepage and the Newlyn *plein-air* painters, her works reveal her observant draughtsmanship and study of light.
LIT: *Painting in Newlyn 1880–1930*, Barbican Art Gallery, 1985; 'The Paintings and Etchings of Mrs Stanhope Forbes', *Studio*, Vol.IV, p.186. CF

FORBES, Stanhope Alexander, RA, NEAC (1857–1947). Painter of genre, landscapes, coastal scenes and figures in oils. Born in Dublin he studied at LAMBETH SCHOOL OF ART, the RA SCHOOLS 1876–8, and with Bonnat in Paris. In 1881 he painted with LA THANGUE in Brittany and became committed to *plein-air* painting. He settled in Newlyn in 1884, where he was followed by other artists including TUKE, LANGLEY and CHEVALLIER TAYLER, and where he was recognized as the leader of the NEWLYN SCHOOL. In 1889 he married the artist Elizabeth Armstrong, worked with her in Brittany in 1891 and subsequently founded the Newlyn School of Art with her in 1899. He exhibited at the RA from 1878 and the success of his painting *A Fish Sale on a Cornish Beach*, 1885, established the Newlyn School. He was an original member of the NEAC and was elected ARA in 1892 and RA in 1910. His work is represented in public collections including the TATE GALLERY. His realistic depictions of Cornish subjects were first influenced by Bastien-Lepage and La Thangue, concentrating on tonal values and showing the atmosphere and light around forms. After 1910 his work became lighter and more colourful.
LIT: *Painting in Newlyn 1880–1930*, Barbican Art Gallery, 1985; *Stanhope A. Forbes and Elizabeth S. Forbes*, Mrs Lionel Birch, London, 1906; 'The Works of Stanhope Forbes ARA', Norman Garstin, *Studio*, Vol.23, 1901, p.81.CF

FORBES, Vivian, IS (1891–1937). Painter of figures, imaginative and historical scenes and portraits in oils and watercolours; decorative painter. He studied with GLYN PHILPOT at the CHELSEA POLYTECHNIC and in Paris and exhibited at the IS from 1919 (member 1925), the RA from 1920, and held his first solo exhibition in Chicago in 1921. He subsequently held solo exhibitions in London, showing mainly at the FINE ART SOCIETY and the REDFERN GALLERY. Through Philpot's help he acquired commissions

for a mural in St Stephen's Hall, Westminster, 1928, and for the Viceroy's House, New Delhi, 1930. His work is represented in public collections including the TATE GALLERY. His small watercolours, many made in the 1930s, reveal his use of a brittle contour line combined with bold washes of hot, deep colour, e.g. *Ariadne on Naxos*, 1937. CF

FORBES-ROBERTSON, Eric J. (1865–1935). Painter of landscapes and figures in oils. He studied at the ACADÉMIE JULIAN, Paris, in 1885, and in 1890 visited Pont-Aven, possibly with BEVAN, and stayed at the Villa Julia until 1894. He formed friendships with Séguin, Jan Verkade, Sérusier, Filiger and Alfred Jarry and he met Gauguin who painted his portrait in 1894. In 1900 he returned to England but continued to make visits to France. He exhibited at London galleries from 1885, at the RA, RBA, LS and ROI, and at the AAA from 1911. He exhibited in Paris in 1894 and his work is represented in public collections including the TATE GALLERY. He contributed to *L'Ymagier* in 1895, and to the *Mercure de France* in 1899. In Brittany he was strongly influenced by Gauguin in colour and composition but his work also reflected the painting of Séguin and Jarry (*Great Expectations*, 1894). His later work used a strong, art-nouveau line and showed some affinity to the work of Munch.
LIT: 'Echoes from Pont-Aven', D. Sutton, *Apollo*, May 1964. CF

FORGE, Andrew Murray, PLG (b. 1923). Painter of abstracts in oils; writer on art. He studied at CAMBERWELL under COLDSTREAM, PASMORE, ROGERS and MARTIN and has exhibited at the LG where he was President from 1965 to 1971. He has shown at the AIA, London, in America, and his work is represented in the TATE GALLERY. A Trustee of the Tate and the National Galleries, since 1975 he has been Dean of Yale School of Art, New Haven, USA. His painting has developed from expressive semi-abstracts to restrained abstracts using the simple elements of dots and dashes of colour to condense and analyse the experience of place and light.
LIT: See his own publications including *Paul Klee*, 1953; catalogue for the Studio School and Ruggiero Gallery, New York, 1989. CF

FORRESTER, John (b. 1922). Painter of abstracts; collagist and constructivist. Born in New Zealand, he first exhibited in Auckland in 1946 and came to England in 1953, working at St

Ives. A member of the PENWITH SOCIETY, he exhibited constructions at the GIMPEL FILS GALLERY, London, in 1955, and from 1954 to 1958 was official advisor to the Project Park Hill redevelopment of Sheffield. Since 1958 he has lived and exhibited in Italy and Paris. His abstract paintings, influenced by city architecture and graffiti, use written marks and figurative details painted in a stern, limited colour range. CF

FORSTER, Noel (b. 1932). Painter of abstracts in acrylic on linen or silk. He studied at Newcastle University and held his first solo exhibition at the AIA Gallery in 1964. He subsequently exhibited in London galleries, in the provinces and abroad and has shown at the RA and in group exhibitions since 1962. His work is represented in public collections including the ARTS COUNCIL Collection. From 1970 to 1971 he was Visiting Professor at Minneapolis College of Art; from 1971 to 1975 he taught at the SLADE and CENTRAL Schools; from 1975 to 1976 he was Artist in Residence, Balliol College, Oxford, and in 1979 he was Artist in Residence at Les Sables d'Olonne. Amongst his prizes are a Gulbenkian Award, 1976–8, and a JOHN MOORES Prize, 1978. His work, based on observation of light and colour relationships, uses a freehand grid made by repeated touches of colour painted with either hand on flat supports or on scrolls of material. These grids, open to the 'creative error' of the process, raise questions about the edge of the work and the nature of illusion and the identity of the art object.
LIT: Catalogue for MOMA, Oxford, 1976. CF

FORSYTH, Gordon Mitchell, RI, ARCA (1879–1952). Painter of architecture and landscape in oils and watercolours; stained glass and pottery designer. He trained at Grays School of Art, Aberdeen, and at the RCA winning a travelling scholarship in design. He exhibited mainly at the RI (member 1927), and at the RA between 1922 and 1948, but he also showed in London and provincial galleries. His work is represented in public collections including Leeds City Art Gallery. He was Designer for Pilkington Tile and Pottery Co., advisor to the British Pottery Manufacturers Federation and Art Director at the City of Stoke-on-Trent School of Art. He exhibited many paintings of French subjects and his strong sense of the rhythm of architectural forms is revealed in works such as *Rue de la Cordonnerie, Caudebec*, 1927 (Eton College Collection).

LIT: *Art and Craft of the Potter*, G.M. Forsyth, Chapman & Hall Ltd, London, 1934. CF

FORTESCUE, William Banks, RWA, RBSA (*c*.1855–1924). Painter of genre, landscape and still-life in oils. He lived in Newlyn and St Ives, Cornwall, and also worked in Venice in 1883/4. He exhibited at the RBSA from 1875 to 1900 (becoming ARBSA in 1884 and RBSA in 1899), and he also showed in London galleries from 1880, at the RA from 1887, at the LS, RI and ROI, in the provinces (particularly in Southport) and in Scotland. His work is represented in some public collections including the Atkinson Museum and Art Gallery, Southport. His genre and landscape scenes of Cornwall reflect the realism and *plein-air* concerns of the Cornish painters.
LIT: *Artists of the Newlyn School 1800–1900*, Caroline Fox and Francis Greenacre, catalogue, Newlyn Art Gallery, 1979. CF

FORTESCUE-BRICKDALE, Eleanor, ROI, RWS (1871–1945). Painter of imaginative and historical subjects in watercolours and oils; book illustrator and stained glass designer. She studied at the Crystal Palace School of Art under Herbert Bone and at the RA SCHOOLS. She made frequent trips to France and Italy. She exhibited at the RA from 1896 to 1932 and showed at the RWS and in London galleries, particularly the LEICESTER GALLERIES and the Dowdeswell Gallery where she held her first solo exhibition in 1901 entitled 'Such Stuff as Dreams are Made of'. She was elected ROI in 1902 and RWS in 1919. Amongst her many commissions for illustrations was Hodder and Stoughton's edition of *Idylls of the King*, 1911, and from 1911 she taught at the BYAM SHAW SCHOOL. After the war she produced designs for stained glass memorial windows. She was influenced by the Pre-Raphaelites, the early Italians, by Byam Shaw and later by her work in stained glass. Her delicately painted work is intricately detailed and poetic.
LIT: Centenary exhibition catalogue, Ashmolean Museum, Oxford, 1972–3; 'Some Watercolours by Eleanor Brickdale', *Studio*, Vol.XXIII, p.31. CF

FOX-PITT, Douglas, LG (1864–1922). Painter of townscapes, interiors, landscapes and figures in watercolours; illustrator. Son of General Fox Pitt-Rivers, he attended the Bartlett School of Architecture 1881–2 and 1889–90, and the SLADE SCHOOL. He worked with WALTER TAYLOR

in France and on numerous trips abroad; he also travelled to Morocco with Count Sternberg, illustrating Sternberg's *The Barbarians of Morocco*. In 1911 he settled in Brighton, possibly working there with SICKERT, and during the war depicted the soldiers billeted in the town. In 1921 he painted with Sickert in Dieppe. He exhibited at the RBA from 1907, at the Carfax Gallery with Taylor in 1911, at the 'Camden Town and Others' exhibition, Brighton, 1913, with the LG (where he was Treasurer in 1920) and at the NEAC, the Abbey Gallery and in other London galleries. His work is represented in public collections including the IMPERIAL WAR MUSEUM. He used clear forms defined with a strong contour line and after the war, influenced by Cézanne and Taylor, he used lighter colour. In his late work he turned to Sickertian subjects such as interiors and the circus.
LIT: *Brighton Yesterdays*, catalogue, Maltzahn Gallery, London, 1973. CF

FRAMPTON, Edward Reginald, ROI, RBA (1872–1923). Painter of religious and symbolic subjects and landscapes in oils and tempera; mural painter. He studied at WESTMINSTER SCHOOL OF ART before working for his father, a stained glass artist, and travelling to Italy and France where he worked for some time in Brittany. He exhibited at the ROI (member 1904), at the RBA (member 1896) as well as at the TEMPERA SOCIETY and ART WORKER'S GUILD. He showed at the RA between 1895 and 1923, in London galleries and at the Paris Salon and his work is represented in public collections including the V & A. Influenced by Puvis de Chavannes, Burne-Jones and stained glass design, his painting used a flat, decorative style. He turned to tempera in 1907 producing works of greater clarity and lightness and he applied his formalized, patterned style to later landscapes, stressing the repeating rhythms and shapes of natural forms.
LIT: 'The Painting of Reginald Frampton, ROI', *Studio*, Vol.75, 1918; *The Last Romantics*, catalogue, Barbican Art Gallery, London, 1989. CF

FRAMPTON, George Vernon Meredith, RA (1894–1984). A painter of portraits and still-life. He was the only son of the sculptor Sir George Frampton. He studied at the RA SCHOOLS from 1913. A member of the ART WORKERS' GUILD, he placed great emphasis on craftsmanship, painting coolly precise portraits in still, immaculately composed settings (*Portrait of a Young Woman*, 1935, Tate Gallery). After 1948 he ceased paint-

ing owing to defective eyesight, and was not brought back to public attention until two years before his death.
LIT: *Meredith Frampton*, exhibition catalogue, Tate Gallery, 1982, Introduction by Richard Morphet. AW

FRANCIS, Mark (b. 1962). He graduated from CHELSEA in 1986. His paintings are based on microbiological photographs of charged cellular structures. His large black, white and grey canvases, sometimes with muted touches of colour, are filled with softly smudged clusters or all-over colonies of similar blurred marks. He has had one-man shows in New York and Paris as well as in London. AW

FRASER, Claud Lovat (1890–1921). Painter, book illustrator and theatrical designer; commercial artist and draughtsman in reed pen and watercolours of figures and landscapes. He spent six months at WESTMINSTER SCHOOL OF ART under SICKERT in 1911. In 1912 he founded *At the Sign of the Flying Fame* with Ralph Hodgson and Holbrook Jackson and he also met Edward Gordon Craig who became a lifelong friend. Many of his illustrations and book jackets were produced for The Poetry Bookshop and after 1917 he turned more to theatrical design, producing the influential designs for Craig's *As You Like It* in 1919, and Playfair's *The Beggar's Opera* in 1920. Retrospective exhibitions of his work include those at the Ashmolean Museum, Oxford, in 1968, and at the V & A in 1969, and he is represented in public collections including the TATE GALLERY. His work was characterized by clarity and economy, its use of tonal contrast and silhouette and its expressive, conceptual colour.
LIT: *Claude Lovat Fraser*, John Drinkwater and Albert Rutherston, Heinemann, London, 1923; *Claude Lovat Fraser*, exhibition catalogue, V & A, 1969; exhibition catalogue, Rosenbach Foundation Museum, Philadelphia, 1971/2. CF

FRASER, Donald Hamilton, RA (b. 1929). Painter of landscapes, seascapes, still-life and ballet subjects, working in oils and screenprints. He studied at ST MARTIN'S SCHOOL OF ART 1949–52, and then in Paris 1952–4, and has exhibited at GIMPEL FILS, London, Rosenberg, NY, CCA Galleries, London and USA, and the Bohun Galleries, Henley. ARA in 1957 and RA in 1986, from 1975 to 1987 he was Honorary Secretary and then Chairman of the Artists General Benevolent Institution, and from 1958 to 1983 he was Tutor and then Fellow at the

RCA. In 1986 he became a member of the Royal Fine Arts Commission. His bold semi-abstract paintings, influenced by de Staël, use large areas of bright colour which are texturally rich and which simplify and intensify the subject. The more realistic ballet and figure studies limit colour, relying on strong lines to capture the pose and movement of the figure.

LIT: Fraser's book on Gauguin, *Vision After the Sermon*, London, 1969; *Dancers*, Fraser, D.H., Phaidon Press, London, 1987. CF

FRAZER, William Miller, RSA, PSSA, RSW (1864–1961). Painter of landscapes in oils. Born in Scone, Perthshire, he studied at the RSA Schools, Edinburgh, winning the Keith Prize, and in Paris. In the 1890s he travelled widely on the continent and he exhibited mainly in Scotland, showing at the RSA, GI and RSW; he also exhibited in London and the provinces. Elected PSSA in 1908, ARSA in 1909 and RSA in 1924, he was President of the Scottish Arts Club in 1926. He worked in East Lothian, Norfolk and Machrihanish and was influenced by the work of Robert Noble (1857–1917). His pastoral landscapes are atmospheric and painterly, sharing characteristics with other East Lothian artists.

LIT: *William Darling McKay RSA. The Pastoral Tradition in East Lothian*, catalogue, Bourne Fine Art, London, 1985. CF

FREEDMAN, Barnett, CBE (1901–1958). Painter of portraits, landscapes and naval scenes; illustrator and designer. Usual media: oils, colour lithography and watercolours. He studied at ST MARTIN'S SCHOOL OF ART and the RCA, and had his first one-man exhibition in 1928 at the Literary Book Company. A member of the NEAC, Freedman taught at the RCA and at RUSKIN SCHOOL, Oxford. In 1940 he was made an OFFICIAL WAR ARTIST and painted the coastal defences, ships, submarines and naval portraits. He achieved great success as a colour lithographer in book jackets and illustrations, e.g. *War and Peace*, 1937. In 1935 he designed the George V Jubilee postage stamp. His paintings reveal his interest in detail and character, e.g. *Street Scene*, 1939 (Tate Gallery).

LIT: *Barnett Freedman 1901–1958*, Arts Council exhibition catalogue, London, 1958; *Barnett Freedman*, Jonathan Mayne, Art and Technics, London, 1948. CF

FREETH, Hubert Andrew, RA, PRWS, RP, RE, RBA (1912–1986). Painter in oils and water-colours, etcher and draughtsman, of portraits, townscapes, landscapes and figures. He studied at Birmingham School of Art 1929–36, winning a ROME SCHOLARSHIP in Engraving 1936–9. He exhibited at the RA from 1935 to 1987 (ARA 1955, RA 1965), at the RE (ARE 1937, RE 1946), the RWS (ARWS 1948, RWS 1955, PRWS 1974–6), the RP (member 1949), the RBA, in London galleries and in Birmingham. His work is represented in collections including the NPG, London, and his commissions included a series of drawings of coal miners for the National Coal Board, 1947–51. Best known as a perceptive draughtsman-etcher and portraitist, his humane work included broadly brushed oils and watercolours which employed washes of colour over pen drawing.

LIT: *Two Birmingham Painter-Etchers: R.T. Cowern and H.A. Freeth*, exhibition catalogue, Birmingham Museum and Art Gallery, 1988; 'Tribute to Andrew Freeth RA', *RA The Magazine for the Friends of the Royal Academy*, No.11, Summer 1986, p.34. CF

FREETH, Peter, RA (b. 1938). Printmaker. He studied at the SLADE 1956–60, and won the PRIX DE ROME in 1960. His aquatints are often focussed on the melancholy and drama of city life and architecture (for example *If I Forget Thee O Birmingham: Wheeler Street Clearances*, 1997); many include letterforms and texts within the composition. AW

FRENCH, Annie (1872–1965). Painter of figures in watercolours; designer and illustrator. She studied at GLASGOW SCHOOL OF ART under NEWBERY and in 1914 married the artist George Wooliscroft Rhead and settled in London. She exhibited mainly at the RA between 1906 and 1924, in Liverpool, at the GI and RSA and her work is represented in collections including the V & A. Between 1909 and 1914 she taught at Glasgow School of Art. Her delicate, intricate work was influenced by Art Nouveau.

LIT: *The Last Romantics*, catalogue, Barbican Art Gallery, London, 1989; *Scottish Art Since 1900*, catalogue, Scottish National Gallery of Modern Art, Edinburgh, 1989. CF

FREUD, Lucian (b. 1922). Painter of portraits, nudes, still-life, interiors and urban scenes. Usual medium: oils. Born in Berlin, grandson of Sigmund Freud, he came to England in 1932 and trained at the CENTRAL SCHOOL OF ARTS AND CRAFTS and later at GOLDSMITHS' COLLEGE

SCHOOL; he also studied with CEDRIC MORRIS. In 1939 he associated with Stephen Spender and David Kentish in Wales and during the 1940s he established a firm friendship with FRANCIS BACON. In 1942 he began to work full time as an artist. In 1944 he held his first exhibition at the LEFEVRE GALLERY and thereafter showed at various London galleries including the London Gallery, 1948–51, MARLBOROUGH FINE ART, 1958–68, Anthony d'Offay, from 1972, and in numerous group exhibitions. In 1974 and 1988 retrospective exhibitions of his work were shown at the Hayward Gallery, London. Internationally his paintings have been exhibited in Paris, Vancouver, Tokyo, Yale, Denmark, Venice and California. In 1954 he exhibited at the Venice Biennale with NICHOLSON and Bacon and the 1988 Retrospective Exhibition toured Washington, Paris and Berlin. In 1951 his *Interior at Paddington* was a prize winner in the Festival of Britain Competition. Freud's early painting reflects his love of drawing in its meticulously observed, claustrophobic detail and unswerving realism, often overlaid with an uncanny atmosphere. In these works the colour was bleached, the paint surface smooth, and the light conceived as a revealer of detail, e.g. *Girl with a White Dog*, 1951–2 (TATE GALLERY). Later in the 1960s the modelling of form became more plastic, colour stronger and the handling more painterly, and recent work has united his interest in paint texture and physicality with precision of contour. Portraits, mostly paintings of family and friends, reveal Freud's search for physical truth, e.g. the series of portraits of his mother, 1971–3. Similarly his naked figures offer no concession to the tradition of the nude but share the same uncompromising vision and intensity.
LIT: *Lucian Freud. Paintings*, Robert Hughes, Thames and Hudson, 1987; *Lucian Freud*, Lawrence Gowing, Thames and Hudson, 1982.
CF

Friday Club. The Friday Club was organized by VANESSA BELL and included CLARE ATWOOD, EDNA CLARKE HALL, MARK GERTLER, J.D. INNES, DERWENT LEES, and HENRY LAMB. The first exhibition was held in November 1905, and the Club has been described as 'one of the liveliest exhibiting groups before the First World War'. From 1910 until 1918 it was at the Alpine Club Gallery, but in 1913 Vanessa Bell, ROGER FRY and DUNCAN GRANT established a splinter society, the Grafton Group, and abstained thereafter from exhibiting with the Club; in 1914

BOMBERG, ETCHELLS, NEVINSON, WADSWORTH, MENINSKY, JOHN and PAUL NASH were members: by 1921 BEVAN, GINNER and C.R. MACKINTOSH also joined. The last exhibition was held in 1922.
LIT: 'The Friday Club', Richard Shone, *Burlington Magazine*, Vol.CXVII, May 1975.
AW

FRIEDEBERGER, Klaus (b. 1922). Painter of figurative and abstract works in oils; printmaker and graphic designer. Born in Berlin, he studied at East Sydney Technical College, Australia, 1947–50, and subsequently settled in England. He held his first solo exhibition in London in 1963 at the Hamilton Galleries and has exhibited since then in London, the provinces and abroad. His earlier work depicted children in a stylized, semi-abstract manner whilst more recent paintings are painterly, expressionistic abstracts. CF

FROST, Terry, Professor, LG, RA (b. 1915). Painter of abstracts in acrylic, oils, collage and a range of media. Encouraged to paint by ADRIAN HEATH whilst a POW, he studied at the ST IVES and CAMBERWELL Schools of Art and in 1951 worked as an assistant to BARBARA HEPWORTH. After living in St Ives he moved to Newlyn in 1974. A member of the PENWITH SOCIETY and the LG, he has exhibited at many London galleries, including the LEICESTER GALLERIES, the WADDINGTON GALLERY and most recently Austin/Desmond and the MAYOR GALLERY. Retrospective exhibitions of his work were held at the Laing Gallery, Newcastle, 1964, which subsequently toured America, and the Serpentine Gallery, 1977. He taught at BATH ACADEMY, San José University, California, and was Gregory Fellow at Leeds University and Fellow in Fine Art at Newcastle University. From 1964 to 1981 he taught at Reading University, becoming Professor in 1977 and Professor Emeritus on his retirement. In 1977 he was awarded an Hon. Doctor of Laws, CNAA. His paintings, influenced by the Cornish environment, use simple shapes painted directly on to the canvas in strong vibrating colour which reflects his experience of natural phenomena. Earlier canvases placed greater emphasis on linear movement (*Black Arrow*, 1960), later colour played a structural role, creating tension and movement between forms. A recurring theme is that of the sun (*3 Suns, April 1985*).
LIT: *Nine Abstract Artists*, Lawrence Alloway, London, 1954; *Terry Frost*, David Lewis, Scolar Press, 1994; catalogue for the Mayor Gallery, London, 1990. CF

FROY, Martin, Professor (b. 1926). Painter of landscapes, figures and interior scenes in acrylic, watercolours, collages and assemblages. Between 1948 and 1951 he studied at the SLADE SCHOOL under Professors SCHWABE and COLDSTREAM and he has exhibited his work at the NEAC, LG, the Hanover Gallery, London, and throughout the country. In 1983 a retrospective exhibition was held at the SERPENTINE GALLERY, London. From 1951 to 1954 he was Gregory Fellow in Painting, Leeds University, in 1963 he gained a Leverhulme Research award and in 1965 a Sabbatical Award from the ARTS COUNCIL. He taught at BATH ACADEMY, was Head of Painting at CHELSEA SCHOOL OF ART, and in 1972 became Professor of Fine Art, University of Reading. He has been a Trustee of the National Gallery and the TATE. Commissions include mosaic decoration, Belgrade Theatre, Coventry and murals for Morley College, London. His work has developed from broadly painted nude studies to paintings which are constructed by a complex surface of strongly coloured painterly marks. These combine the appearance and associations of the subject with a methodical treatment of light, space and form. This process transforms the appearance of things and moves the painting towards semi-abstraction.
LIT: *Martin Froy. Paintings, constructions, drawings 1968–82*, Arts Council, Serpentine Gallery, 1983. CF

FRY, Anthony (b. 1927). Painter of landscapes, nudes and figures in oils, mixed media and collages. He studied at EDINBURGH COLLEGE OF ART and CAMBERWELL SCHOOL OF ART under COLDSTREAM, PASMORE and ROGERS. In 1950 he won the ROME PRIZE and in 1961 he was awarded the Harkness Fellowship. His first one-man show was in 1955 at St George's Gallery and he has subsequently exhibited at the LEICESTER GALLERIES, NEW ART CENTRE and BROWSE AND DARBY, London. A member of the LG and RWA, he has taught at BATH ACADEMY, Camberwell School of Art and CHELSEA SCHOOL OF ART. He was a prize winner at JOHN MOORES LIVERPOOL COMPETITION, 1957, and was included in the Guggenheim International Award Exhibition, 1960. Earlier works used broad and painterly areas of colour and light accented by strong linear marks, e.g. *Landscape*, 1955 (Arts Council Collection). Later paintings show bright shapes of visibly brushed Mediterranean colour and simplicity of construction. With the perspectival space flattened, colour both creates space and emphasizes the canvas surface. CF

FRY, Roger Elliot (1866–1934). Critic; painter of landscapes, portraits and still-life; designer. Usual medium: oils. Educated at Clifton College and Kings College Cambridge, he took a science degree before studying art under Francis Bate and then at the ACADÉMIE JULIAN, Paris. A member of the NEAC and LG, he wrote articles for *Athenaeum*, the *Monthly Review*, and the *Burlington Magazine* of which he was editor from 1910 to 1919. Between 1905 and 1910 he was Director of the Metropolitan Museum, NY, and in 1913 he founded the OMEGA WORKSHOPS, collaborating with such artists as DUNCAN GRANT, VANESSA BELL and WYNDHAM LEWIS. Fry himself contributed pottery, textile and furniture designs. In 1933 he became SLADE Professor of Fine Art, Cambridge. Most influential as a writer and critic, he was instrumental in introducing modern French and British painting, in particular Cézanne, to the British public. He arranged two important exhibitions: that of 1910, which showed Manet and the Post-Impressionists at the Grafton Galleries, and that of 1912, which included work by English, French and Russian artists of the younger generation and included Cubist works. In his writings Fry stressed the importance of formal qualities over subject matter. His works include *Vision and Design*, 1920, a monograph of Cézanne, 1927, and lectures on French and British art, 1932, 1934 and 1939. His earliest paintings reflect his admiration of Claude but in 1910 he was influenced both by Fauve and Cubist painting and his work developed angular forms, strong outlines and rectilinear areas of colour, e.g. *River with Poplars*, 1912 (TATE GALLERY), and *White Road with Farm*, c.1912. During the 1920s and 1930s these influences were softened by his interest in an all pervading light and close toned colour. Fry's preference was for the straightforward and undemonstrative in painting and his best portraits reflect this in their honesty and direct handling. His desire for structure and his characteristic generalization of forms is apparent in all his work, the later paintings become more naturalistic and lyrical, integrating light and form, e.g. *Chiswick House* (Manchester Art Gallery).
LIT: See Fry's own writings; *Letters of Roger Fry*, ed. Denys Sutton, 1972; and two biographies: Q. Bell, 1964; *Roger Fry: Art and Life*, F. Spalding, Granada, 1980. CF

FUCHS, Emil, RBA (1866–1929). Sculptor and portrait painter. Born in Vienna, he studied at the Imperial Academy of Fine Arts, Vienna, and in Berlin, winning a travelling scholarship to

Rome in 1890. In 1897 he settled in London and later in his life he lived in New York. He exhibited at the RA between 1898 and 1914 and his wide circle of friends encompassed musicians such as Paderewski and his patrons included members of the Royal Family. He received some painting tuition from SARGENT who influenced his portrait style.

LIT: *With Pencil, Brush and Chisel. The Life of an Artist*, Emil Fuchs, G.P. Putnam's & Sons, New York and London, 1925. CF

FULLER, Leonard John, ROI, R.Cam.A. (1891–1973). Painter of portraits, landscapes, figures and still-life in oils. He studied at Clapham School of Art under Nightingale, 1908–12, and at the RA SCHOOLS under SARGENT, CLAUSEN and ORPEN, 1912–14, winning the British Institute Scholarship in 1913. In 1917 he met BORLASE SMART during army service and in 1938 he founded the St Ives School of Painting. He exhibited at the RA from 1919, in London societies and at the Paris Salon and was elected ROI in 1932 and R.Cam.A. in 1939. His work is represented in some public collections including Plymouth Art Gallery. He taught at ST JOHN'S WOOD SCHOOL OF ART, 1922–32, and at Dulwich College, 1926–38. He was Chairman of St Ives Society of Artists, 1942–9, and founder member, first Chairman and Hon. Secretary of the PENWITH SOCIETY OF ARTISTS. His lively work ranged from portraits to scenes of contemporary life.

LIT: *St Ives 1939–1964*, exhibition catalogue, Tate Gallery, 1985. CF

FURNIVAL, John (b. 1933). Painter. He studied at Wimbledon, and after serving in the Royal Fusiliers, at the RCA. He taught at Gloucester College of Art, and there his friendship with DOM SYLVESTER HOUÉDARD interested him in *lettrisme*, the relationship between printing, typography and poetry. His first one-man show was at the Arnolfini, Bristol, in 1972. AW

FURSE, Roger (b. 1913). Theatrical and film designer, painter in watercolours, gouache and oils. Born at Ightham, Kent, he studied at the SLADE SCHOOL under TONKS, 1920–4, and in Paris until 1927. He subsequently worked in the USA until 1932 when he returned to England and concentrated on stage design. He exhibited in Paris at the Salon d'Automne, and at the Berkeley and LEICESTER Galleries in London. He designed for Sir Lawrence Olivier both on stage and film, including the film production of *Henry V*, and his

theatrical work included *King Lear* for the Old Vic in 1940 and 1946, *The Prospect Before Us* for Sadler's Wells Ballet and *The Eve of St Agnes* for the Ballets Russes in 1950.

LIT: *Designs for Hamlet*, exhibition catalogue, Leicester Galleries, London, 1948. CF

FUSSELL, Michael (1927–1974). Painter of landscapes, seascapes, still-life and abstracts. Usual media: oils, collages and mixed media. He trained at ST MARTIN'S SCHOOL OF ART and the RCA, London. He exhibited at various galleries including the BEAUX ARTS and in 1962 the HANOVER, as well as in the JOHN MOORES EXHIBITION and at the Whitechapel Art Gallery. He taught at St Martin's and from 1964 was Head of Fine Art, Wimbledon School of Art. In the 1950s he painted serious, simplified and almost abstract paintings. The growing abstraction of these works led to the White Paintings of the 1960s in which tissues soaked in white paint were spread on to the canvas and manipulated to achieve the fissures and rhythms of natural forces, e.g. *Skywards*, c.1961 (Tate Gallery).

LIT: Three essays published on his work in *Michael Fussell. A Retrospective Exhibition of Paintings and Drawings*, Arts Council, London, 1976. CF

G

GABAIN, Ethel Leontine, RBA, ROI, VP, SWA (1883–1950). Lithographer, painter of portraits and figures; etcher. She studied at the SLADE SCHOOL, the CENTRAL SCHOOL OF ART and in Paris. In 1913 she married JOHN COPLEY. She exhibited regularly at the RA, RBA, ROI, SWA and NEAC as well as the Goupil Gallery and, from 1915, Colnaghi & Co. In 1932 she was elected RBA and in 1934 and 1935 she became SWA and ROI. Awarded the De Laszlo Silver Medal in 1933, in 1940 she became an OFFICIAL WAR ARTIST. A founder member of the SENEFELDER CLUB, her work is characterized by selective, elegant design and her use of light. Many works, influenced by French Art, show women in intimate interiors, but her war art was less decorative and more detailed. Her prints show her technical mastery and her painterly approach to lithography.

LIT: Exhibition catalogue of work by Gabain and Copley, Garton and Cooke, 1985; *The Lithographs of John Copley and Ethel Gabain*,

Harold J.L. Wright, Albert Roullier Art Galleries, Chicago, 1924. CF

GAMMON, Reginald William, RWA, ROI (1894–1997). Painter of landscapes in oils and watercolours. He studied art with Frank Paterson, 1910–14, and began his career as an illustrator, contributing to publications such as *Punch* and the *News Chronicle*. He exhibited at the RWA, RA, RI, NEAC and in London galleries, notably the NEW GRAFTON GALLERY. Elected RWA and ROI in 1966, his work is represented in collections including the ARTS COUNCIL (Wales) and Manchester City Art Gallery. In 1985 a retrospective exhibition of his work was held at the RWA. His painting, influenced by Gauguin, used bright bold colour and concentrated on scenes of farm workers, peasants, reapers and country subjects.
LIT: Retrospective exhibition catalogue, RWA, 1985; *One Man's Furrow – 90 Years of Country Living*, Reginald Gammon, Webb & Bowyer, 1990. CF

GARDINER, Clive (1891–1960). Painter in oils and watercolours; muralist. Born in Blackburn, he studied at the SLADE 1909–12, and the RA SCHOOLS 1913–14. He exhibited at the NEAC and the RA, and was Headmaster, then Principal, of GOLDSMITHS' COLLEGE, 1929–57. He painted murals for the Students' Union of London University, along with BETTY SWANWICK; his paintings were influenced by Cubism.
LIT: *Clive Gardiner, 1891–1960*, exhibition catalogue, South London Art Gallery, 1967. AW

GARDINER, Stanley Horace, ABWS, NSA (1887–1952). Painter of landscapes in oils. First apprenticed to a house painter, he won a scholarship to Reading University as an art student and later attended Allan Fraser College, Arbroath. He then spent a year in America. After the First World War he settled in Lamorna, Cornwall, after meeting LAMORNA BIRCH. Later he ran a small school of art at Lily Cottage, Lamorna Valley. From 1927 to 1947 he exhibited at the RA and also showed at the RWA, the Irish Salon, RSA and at galleries in London and the provinces. His first one-man show was at the FINE ART SOCIETY in 1939. He was an assistant teacher at University College, Reading, and winner of the Wells Prize. The subjects of his painting were influenced by Lamorna Birch and the painters at Lamorna. He was interested in showing particular times of day and used broken brushstrokes to record effects of light and colour, e.g. *Rickyard, Boswarthen*. CF

GARRETT, Albert Charles, ROI (b. 1915). Oil painter and wood engraver. From 1947–9 he attended CAMBERWELL SCHOOL OF ART under COLDSTREAM, PASMORE, HERMES and BUCKLAND-WRIGHT. He then studied at the ANGLO-FRENCH ART CENTRE 1949–50, and the SLADE SCHOOL 1950–1. He exhibited at the SOCIETY OF WOOD ENGRAVERS, the ROI, the Society of FREE PAINTERS AND SCULPTORS and at leading London galleries. He showed regularly in Paris, winning both silver and gold medals, as well as throughout Europe and in Canada. In 1967 he was President of the Society of Wood Engravers and in 1971 Chairman of the Federation of British Artists, and Fellow of the RSA. He published on scientific subjects and on wood engraving, his most significant work being *A History of British Wood Engraving*, 1978. His work was experimental and innovative, he made abstract engravings and developed a collage technique using hand-made Japanese papers. CF

GARSIDE, Oswald, RI, R.Cam.A., RBC, RWA (1879–1942). Painter of landscapes in watercolours. Born in Southport, he took up art at the age of 23, attending Warrington School of Art and winning a scholarship to work at the ACADÉMIE JULIAN in Paris, and in Italy. He exhibited at the RA from 1902, at the RI (member 1916), the R.Cam.A. (member 1924), the RBC (member 1925), the RSBA, the Walker Art Gallery, Liverpool, and at the Paris Salon. His work is represented in several public collections including Warrington Museum and Art Gallery. President of the Midland Sketching Club and Director of the Artists General Benevolent Institution, he was commissioned for a watercolour for the Queen's Dolls House. He painted in Britain (particularly in Lancashire and Cheshire), Italy and Holland, often depicting waterways and beaches. He developed a method of blending his colours by using a stippled technique.
LIT: *Landscape Painting in Watercolour*, Oswald Garside, 1929. CF

GARSTIN, Alethea, RWA (1894–1978). Painter of portraits, animals, coastal and town scenes in oils. She studied with her father, NORMAN GARSTIN, attended HEATHERLEY'S for a short period and made frequent trips abroad. A friend of DOD PROCTER and ALFRED WALLIS, she lived in Penzance and exhibited in London galleries

including the Alpine, Walker's and Adams Galleries, at the RA from 1912 to 1945, the RWA (ARWA 1949, RWA 1965), the NEAC, RP, RI, SWA, in the provinces and in France. Her work is represented in collections including Bristol Art Gallery. She worked directly on to toned canvas using small square brushstrokes in restrained colour.

LIT: *Norman and Alethea Garstin*, exhibition catalogue, Penwith Gallery, St Ives, 1978 and travelling; *Painting in Newlyn*, exhibition catalogue, Barbican Art Gallery, London, 1985. CF

GARSTIN, Norman, RBC, NEAC (1847–1926). Painter of genre and landscapes in oils and watercolours. Born in Ireland, he studied at Verlat's Academy in Antwerp in 1878, under Carolus Duran in Paris c.1880–3, and subsequently travelled to Italy in 1884 and Morocco in 1886. He settled in Newlyn in 1886, later moving to Penzance, and exhibited widely, showing in London galleries including Walker's and the FINE ART SOCIETY, at the RBA from 1882 to 1889, at the RA from 1883 to 1923, the NEAC (member 1887), and in other leading societies and galleries in London and in the provinces. His work is represented in the TATE GALLERY. A teacher, writer and lecturer on painting, his work was influenced by Japanese art, Whistler and Manet, e.g. *The Rain it Raineth Every Day*, 1889 (Coll. Penzance Charter Trustees). His later work included costume genre and scenes of upper-class life.

LIT: *Norman and Alethea Garstin*, exhibition catalogue, Penwith Gallery, St Ives, 1978 and travelling; *Painting in Newlyn*, exhibition catalogue, Barbican Art Gallery, London, 1985. CF

GARWOOD, Tirzah (Eileen Lucy, 1908–1951). Painter in oils; collagist; wood engraver. She attended Eastbourne School of Art 1925–8, where she met and married ERIC RAVILIOUS who was then teaching wood engraving. Best known for her prints and work for the Golden Cockerel Press, her paintings were based on subjects taken from her everyday domestic and environmental experience.

LIT: Exhibition catalogue, Towner Art Gallery, 1987. AW

GASCOYNE, George, RE (1862–1933). Painter of landscapes. genre, religious and literary subjects in oils; etcher. He studied at the SLADE under Legros where he won a scholarship and silver medals, and exhibited principally at the RE (member 1885), at the Ridley Art Club and at the

RA from 1884 to 1925. He also showed at the ROI, NEAC, RBA, in the provinces and in Scotland. His strongly painted subjects included scenes such as *The Work of the Fields*, RA 1913.
LIT: *Studio*, Vol.63, p.144. CF

GAUDIER-BRZESKA, Henri (1891–1915). Sculptor and draughtsman of figures, animals and abstracts in pen and ink, pastel and pencil. Born in France, Henri Gaudier came to England in 1906. Self-taught as an artist he visited Holland, Belgium and Germany in 1909 and by 1910 had settled in Paris where he met Sophie Brzeska. In 1911 they moved to London and he began to use her name. By 1913 he had established a studio in Putney, met Middleton Murry and Ezra Pound and, from October, worked at the OMEGA WORKSHOPS. During this period he met BRODZKY, WYNDHAM LEWIS and T.E. Hulme. He exhibited at the AAA and with the Grafton Group in 1914, and was a founder member of the LG. From 1914 he was associated with the VORTICISTS, contributing to *Blast*, nos. I and II, and to the Vorticist Exhibition, 1915. Having joined the army he was killed in France in June 1915. A memorial exhibition was held in 1918 at the LEICESTER GALLERIES, and retrospective exhibitions by the ARTS COUNCIL in 1956–7 and 1983. He was influenced early by Classical art, Rodin and the development of Fauvism and Cubism. In Paris during the year of Picasso's second exhibition, he also assimilated ideas from Brancusi, Epstein and from tribal art. Like Pound he believed in the image as the centre of energy and movement, stressed the need for simplification and that form both expressed and contained emotion. The most naturally gifted of the Vorticists, he infused their 'mechanism' with the vitality of living form. His sculpture, most of it carved, reflects his versatility and innovation in its range from Cubist abstraction to primitivism, e.g. *Red Stone Dancer*, 1913 (TATE GALLERY), with its use of geometric simplification and tribal art, and *Seated Woman*, 1914 (Centre Pompidou, Paris), which demonstrates warmer, more naturalistic and monumental forms. His drawings, many of birds and animals, contain energy and vitality in the simplest way, using wiry and nervous lines which in some cases test the contour for sculpture. These drawings range from the representation of the subject by outline to the formalized investigation of planes and movement, e.g. *Two Horses*, 1914. Some of his strongly coloured pastels, in addition to portraiture, show him experimenting with pure abstraction. He also did a linocut and some etching.

LIT: *Gaudier-Brzeska. A Memoir*, E. Pound, London, 1916; *Gaudier-Brzeska*, H.S. Ede, Heinemann, 1930; *Burning to Speak: The Life and Art of Henri Gaudier-Brzeska*, Roger Cole, Phaidon, 1978. CF

GAULD, David, RSA (1865–1936). Painter of landscapes, portraits, cattle and allegorical subjects in oils; designer of stained glass. Born in Glasgow, he attended the GLASGOW SCHOOL OF ART 1882–5 and 1889, and studied in France. In 1896 he painted at Grez in France. His first exhibition was at the Paisley Art Institute in 1885 and thereafter he exhibited at the GI, RSA and Connell and Sons Gallery, his work also appearing in the Vienna Seccession in the 1890s. He was elected RSA in 1924. Associated with the Glasgow artists, early work was influenced by Hornel and Henry, but some later work reflected his stained glass designs, e.g. *St Agnes*, which has stylistic affinities with the work of his friend CHARLES RENNIE MACKINTOSH. His landscapes, particularly those from Grez, were more naturalistic and cool toned but all the work shared a similar thickly applied paint surface.
LIT: *The Glasgow Boys*, Roger Billcliffe, 1985; *Scottish Art and Letters*, September-November 1903. CF

GAUNT, William, BA (b. 1900). Writer, critic and painter of townscapes, figures and landscapes in watercolours, pen and ink. The son of artist William Gaunt, he attended the RUSKIN SCHOOL whilst at Worcester College, Oxford. Later he studied at WESTMINSTER SCHOOL OF ART UNDER BAYES and MENINSKY 1924–5, meeting NASH, SARGENT, DUNCAN GRANT and Virginia Woolf. In the 1930s he travelled in Greece, Palestine and Egypt. He exhibited at the RA and at major London galleries and he wrote on a wide range of subjects from *The Pre-Raphaelite Tragedy*, 1941, to *Court Painting in England*, 1930. His observant, sometimes amusing watercolours and drawings record London scenes and his friends without malice, e.g. *Portrait of Wyndham Lewis, 1934*.
LIT: See Gaunt's own writings and the retrospective exhibition catalogue, The Minories, Colchester, 1975. CF

GEAR, William, RA, DA, LG (1915–1997). Painter of abstracts in oils, watercolours and gouache. Born in Fife, Scotland, from 1936–7 he studied art at Edinburgh University with GILLIES, MAXWELL and MCTAGGART. He won a travelling scholarship to Paris and worked at the ACADÉMIE COLAROSSI under Léger. Between 1937 and 1938 he travelled in Italy, Greece and the Balkans and during war service he exhibited abroad. Between 1947 and 1950 he lived in Paris and then settled in England, visiting America in 1957 and 1959. In Paris he worked with the COBRA Group, exhibiting with them in Copenhagen and Amsterdam. Not only was he associated with the School of Paris but he was also aware of developments in American art, meeting Milton Rosnick, Marcarelli and Rothko in Paris, and in 1949 exhibiting with Jackson Pollock. From 1948 he exhibited at GIMPEL FILS Gallery, London, and his work has appeared nationally and internationally, including the Venice Biennale, 1954. Between 1954 and 1985 a number of retrospective exhibitions were held. A member of the LG in 1953, between 1958 and 1964 he was Curator of the Towner Art Gallery, Eastbourne, and from 1964 to 1975 Head of Fine Art, Birmingham Polytechnic. In 1951 he was awarded a Festival of Britain Purchase Prize and in 1975 the Lorne Fellowship. He was elected RA in 1995. In his early Cubist-abstract paintings a dark armature supported coloured areas, often with a figurative reference. His work progressively became freer, exploring the contrast between dark support, light and colour, the armature fragmenting and becoming balanced by the optical pattern of light. A natural colourist, Gear described his works as 'statements of kinship with the natural world'.
LIT: Exhibition catalogue, Gimpel Fils, 1961. CF

GENTLEMAN, David, RDI (b. 1930). Painter and draughtsman of townscapes, landscapes and figures in watercolours; illustrator, designer and graphic artist. Trained at the RCA, where he also taught, he has travelled widely and from 1970 has exhibited at the Mercury Gallery. His work ranges from stamp design to mural design and since 1967 he has produced lithographs of architectural and landscape subjects both in England and abroad. His watercolours show great detail in a concise and graphic style.
LIT: *David Gentleman's Britain*, 1982; *David Gentleman's London*, 1985. CF

GEORGE, Adrian (b. 1946). Painter and draughtsman. He studied at Cirencester and the RCA. He is best known for his portraits and his accomplished studies of the nude and of dancers. AW

GEORGE, Patrick, Professor, LG (b. 1923). Painter of portraits and landscapes in oils. He attended EDINBURGH COLLEGE OF ART 1941–2, and CAMBERWELL SCHOOL OF ART under COLDSTREAM and MONNINGTON 1946–9. He has exhibited at London galleries, including BROWSE AND DARBY, and a retrospective exhibition was held at the SERPENTINE GALLERY in 1980. From 1948 he has exhibited with the LG, becoming a member in 1957. He taught at the SLADE, where he gained a personal chair in 1983, and in Nigeria. From 1985 to 1987 he was Slade Professor. His painting, firmly based on drawing, is slowly evolved using small reference marks to plot the spatial relationship between forms, yet retaining a broadness and simplicity of effect. LIT: Catalogue, Serpentine Gallery, 1980. CF

GEORGIADIS, Nicolas (b. 1925). Abstract painter in oils and mixed media; stage designer. Born in Athens, he attended the SLADE SCHOOL OF ART 1953–5, where he taught in 1965. He has exhibited at leading London galleries, shown in the 1966 Biennale, and designed for many major opera houses. His early paintings used organic forms but later work became angular and hard-edged using rectilinear and tubular shapes in bright metallic colours. CF

GERE, Charles March, RA, RWS, RBSA, NEAC (1869–1959). Painter of landscapes, figures and portraits in tempera, oils and watercolours; decorator and book illustrator. He studied at Birmingham School of Art under R.E. Taylor and later in Italy. Exhibiting at the RA, NEAC and numerous societies, he became RBSA in 1906, NEAC in 1911, RWS in 1927 and RA in 1939. He taught at Birmingham School of Art and was a founder member of the Birmingham Group of Artists and Craftsmen with MARGARET GERE. His work covered a wide range of activities from murals to illustrations for the Kelmscott Press and Ashdene Press. His early work was influenced by Italian and Pre-Raphaelite painting, but later he produced mainly landscapes, many of the Cotswolds and Italy, in a decorative and lyrical style. LIT: Memorial exhibition catalogue, Gloucester, 1963; 'The Landscape Painting of Charles Gere', Oakley Hurst, *Studio*, Vol.LIX, p.87. CF

GERE, Margaret, NEAC (1878–1965). Painter of figures, flowers and landscapes in watercolours, tempera and oils. She studied at Birmingham School of Art under Taylor and CHARLES GERE, her brother. In 1900 she went to Italy and in 1905 attended the SLADE. She exhibited first at Carfax & Co. Gallery in 1912, and thereafter showed regularly at the NEAC, the FINE ART SOCIETY and other London galleries. NEAC in 1925, she was a founder member of the Birmingham Group of Artists and Craftsmen with Charles Gere. Her early tempera subject pictures were painted in a careful, detailed manner. Later work was freer and her flower studies painted on glass were her most popular work. Her tempera portraits reflect her Italian studies, e.g. *Mrs Alfred Thornton* (Manchester Art Gallery). LIT: Exhibition catalogue, Cheltenham Art Gallery, 1984. CF

GERRARD, Charles Robert, RBA, ROI, ARCA, FRSA, JP (1892-*c*.1964/71). Painter of portraits, interiors, still-life and flowers in oils. Born in Antwerp he studied at Lancaster School of Art, and at the RCA under MOIRA and ANNING BELL. He exhibited at the RBA, NEAC and RA, as well as at Cooling & Sons Gallery, the REDFERN GALLERY, the French Gallery and abroad. He became RBA in 1931 and ROI in 1935. He worked in France, Belgium, Italy and India where he was Director of the Sir Jamsetji Jeejeebhoy School of Art, Bombay, and Art Advisor to the Government. He published illustrations of Hindu and Muslim art. His RA exhibits ranged from views of India to flower studies. CF

GERTLER, Mark, LG, NEAC (1891–1939). Painter of portraits, figures, nudes, still-life and landscapes in oils. Born in London into a Polish-Jewish family, he attended Regent Street Polytechnic. With the encouragement of ROTHENSTEIN he was financed by the Jewish Educational Aid Society to study at the SLADE under TONKS 1908–12, where amongst his contemporaries were NEVINSON, SPENCER and DORA CARRINGTON, with whom he had a long relationship. He won a Slade Scholarship in 1909, Slade prizes in 1910 and in 1912 was awarded a British Institution Scholarship. In 1914 he met D.H. Lawrence, Middleton Murry, Lytton Strachey and Lady Ottoline Morrell. From 1915 he made many visits to Garsington Manor and throughout his career made visits to France. Between 1912 and 1914 he was a member of the NEAC and he was elected LG in 1915. He exhibited at the CHENIL GALLERIES from 1912, the Goupil Gallery, where he had his first one-man show in 1921, and at the LEICESTER GALLERIES, London.

In 1911 *The Artist's Mother* was purchased by the CHANTREY BEQUEST. After suffering from TB and depression he committed suicide in 1939. A memorial exhibition was held at the Leicester Galleries in 1941. His first works were clearly painted realistic portraits, many of the Jewish community of Whitechapel. His style changed under the impact of Post-Impressionism, Vorticism and Picasso. Realistic detail gave way to stylized form, shallow space and surface patterning. His use of mechanistic form reached its height in works such as the sharply-coloured *Merry-Go-Round*, 1916, which has affinities with the work of Nevinson. Gertler admired Stanley Spencer and shared with him a degree of representational naïvety. Towards the 1920s the influence of Cézanne and Renoir changed his work: he returned to painting from nature, concentrating on single figures which combined voluptuous form with a surface activated by the curve and play of lines, e.g. *Young Girlhood*, 1923. In the 1930s he produced some monumental figures inspired by Picasso, e.g. *The Mandolinist*, 1934. Throughout his career he applied paint thickly and with a cultivated naivety, and in his later works he adopted the use of the palette knife.
LIT: *Selected Letters*, ed. Noel Carrington, 1965; *Mark Gertler*, John Woodeson, 1972. CF

GIARDELLI, Arthur (b. 1911). He studied at the RUSKIN SCHOOL OF ART in addition to his degree at Oxford, and later with CEDRIC MORRIS. His abstract paintings, collages and reliefs are in national collections including the ARTS COUNCIL, National Museum of Wales, Keble College, Oxford, and elsewhere.
LIT: *Artists in Wales*, M. Stephens (ed.), Gwasg Gomer, 1971. AW

GIBB, Harry Phelan (1870–1948). Painter of flowers, landscapes, figures and architecture in oils and watercolours; potter. He studied art in Newcastle, Paris (under Laurens and Bouguereau), Antwerp and Munich. He lived in Paris for many years and exhibited there at the Salon d'Automne and Galerie Bernheim-Jeune. In London he showed at the Baillie Gallery, Alpine Club Gallery, the London Salon and Carfax & Co. Gallery. He exhibited at the RHA and RSA and in New York. In 1909 he was made Sociétaire Salon d'Automne. Influenced by Cézanne and Van Gogh his own work employed a rapid, sketch-like watercolour technique (e.g. *Belgrave Square and Wilton Crescent*, 1928, TATE GALLERY) and an impressionistic use of oils. CF

GIBBINGS, Robert John, ARE (1889–1958). Wood engraver, sculptor, typographer and author, born in Cork, Ireland. Educated at University College, Cork, he studied art at the SLADE from 1912, and under NOEL ROOKE at the CENTRAL SCHOOL. He was at Gallipoli and Salamanca in the First World War, and was invalided out in 1918. He directed the Golden Cockerel Press from 1924–33. He travelled to Tahiti in 1929 and to the West Indies in 1932; much work resulted from these journeys. He was the editor of the Penguin series of Illustrated Classics in 1938, and gave commissions to many leading wood engravers. His own work illustrated his books, such as *Sweet Thames Run Softly* (Dent, 1940) and *Till I End My Song* (Dent, 1957). He lived for some years near Reading, where today the University (at which he taught) has an archive devoted to his work.
LIT: *Aspects of the Work of Robert Gibbings*, University of Reading, 1975. AW

GIBBS, Evelyn, RE (Lady Willatt, 1905–1991). An etcher and wood engraver, she trained at Liverpool School of Art and at the RCA, then won the ROME PRIZE for Engraving in 1929. She taught at GOLDSMITHS' COLLEGE, and wrote an influential book, *The Teaching of Art in Schools* (1931). She founded the highly successful Midlands Group when teaching in Northampton during the Second World War. She married Hugh Willatt, who became Secretary General to the ARTS COUNCIL. Her earlier work was of a Rossetti-like Pre-Raphaelite intensity (*The Graveside* 1928) but later subjects were drawn from life on Gozo, Malta (*Gozo Fields*, 1977; TATE GALLERY). AW

GIBBS, Jonathan (b. 1953). A painter, collagist and wood engraver. He studied at Lowestoft, the CENTRAL SCHOOL and the SLADE. He won a Boise Scholarship to Italy 1979, and had his first one-man show at the Ikon, Birmingham. He has made engravings in chalk drawings done on heavy duty paper, and highly abstracted wood engravings of still-life and other subjects. AW

GIBSON, William Alfred (1866–1931). Painter of landscapes, coastal scenes and figures in oils. Born in Glasgow, he studied at the National Training College there and worked in Britain and on the Continent. A member of the Glasgow Art Club, he exhibited mainly at the GI, the FINE ART SOCIETY, the RSA and in Liverpool, as well as showing at Manchester and at the RA in 1898,

1899 and 1919. Represented in Bradford Art Gallery (*A Dutch Canal*), his impressionistic work was noted for its range from rich Scottish landscape to cool-toned coastal subjects. LIT: *Studio*, Vol.43, pp.138, 319 and 323; *Studio*, Vol.57, pp. 156 and 159. CF

GIFFARD, Colin Carmichael, RWA (b. 1915). Painter in oils, acrylic and mixed media; collagist and mural painter. He studied architecture at Cambridge and London Universities and art at BATH ACADEMY OF ART under WILLIAM SCOTT and PETER POTWOROWSKI, 1949–51, working for a year as Potworowski's assistant. He has exhibited at the RWA, at the RA in 1973 and 1974, at the LG, and has held solo exhibitions in galleries including the Woodstock Gallery, 1966–9. He taught at Sydney Place, Bath, 1951–68. CF

GILBERT and GEORGE, (b. 1943 and 1942 respectively). Performance, conceptual and wall artists using video, photography, music and ephemera. Gilbert was born in Italy and studied at the Wolkenstein and Hallein schools of art, Austria. George, born in Totnes, studied at Dartington Hall College of Art and Oxford School of Art. They met as students at ST MARTIN'S SCHOOL OF ART where amongst their contemporaries were JOHN HILLIARD, VICTOR BURGIN, RICHARD LONG and HAMISH FULTON. They began to work together in 1968 and since then have exhibited at numerous London galleries, including Anthony d'Offay, and internationally. In 1986 they were awarded the TURNER PRIZE and there followed a major exhibition at the Hayward Gallery. Their collaboration started at a time when conceptual and body art were challenging the traditional aesthetic and moral views of the art object. Their early work was performance art: dressed identically in suits, they designated themselves 'sculpture' and so implied that no barrier existed between art and life. Their work progressively moved away from performance to incorporate a range of images from photographs etc., in which their everyday experience and mundane objects were presented as art, e.g. *Balls – the evening before the morning after*, 1975. During the 1970s and 1980s their work became more explicitly social and sexual, using strong colour in their photographic pieces. Recent work has included large hand-coloured photomontages and assemblages of postcards. Seeking a democratic art they describe their work as expressing modern visual ideas.

LIT: *Gilbert and George: The Complete Pictures*, Carter Ratcliff, London, 1986; *The Art of Gilbert and George*, Wolf Jahn, Thames and Hudson, 1989. CF

GILBERT, Stephen (b. 1910). Painter of figurative and non-figurative images; architectural designer and sculptor. He studied at the SLADE under TONKS, 1929–32, married the sculptor Jocelyn Chewett in 1935 and from 1938 to 1939 lived in Paris, subsequently painting in Dublin and returning to Paris in 1945. He joined the COBRA Group, 1948–51, and exhibited at the Salon des Surindépendants and the Salon des Réalités. In 1954 he began to make 3-dimensional constructions, joined the Groupe Espace and exhibited at the Salon de la Jeune Sculpture. He held his first solo exhibition at the Wertheim Gallery, London, in 1938 and he has subsequently exhibited in London and on the Continent. His work is represented in the TATE GALLERY. His early figurative painting was influenced by Cézanne and later evolved towards free abstraction. LIT: *Stephen Gilbert*, E. Jaguer, Bibliothèque de Cobra, Munksgaard, Copenhagen, 1950; *Stephen Gilbert*, catalogue, Galerie 1900–2000, Paris, 1987. CF

GILCHRIST, Philip Thomson, RBA (1865–1956). Painter of marines and landscapes in oils. He studied painting under TOM MOSTYN and exhibited at the RA, RBA, RSA and RHA as well as in the provinces. A member of the Liverpool and Manchester academies of art, his work is represented in several public collections. His finely painted works could be very intense in colour giving a strong sense of light and space, e.g. *The Boating Lake at Southport*. In quiet scenes such as *A Forgotten Lancashire Port* (Manchester City Art Gallery), the simple arrangement of motif and reflection establishes a sense of atmosphere and calm. CF

GILL, Arthur Eric Rowton, ARA (1882–1940). A stone carver, wood engraver, typographer and draughtsmen, Gill is celebrated as a sculptor. After studying decorative lettering at Chichester Technical and Art School (1897–9) he was apprenticed to the architect W.H. Caroë, 1899–1903, and studied lettering at the CENTRAL SCHOOL under EDWARD JOHNSTON, as well as masonry and stone-cutting. He began to make wood engravings in 1906, when embarked on his profession as a stone-cutter. He later made some engravings on zinc and copper, but he is best

known for his vivid and inventive wood engravings of religious subjects (*Crucifixion*, 1922) and erotic subjects (*Ibi dabo tibi* from *The Song of Songs*, 1925). Sometimes, the two themes were daringly combined, as in *Nuptials of God* (1922) or *Earth Receiving* (1926). His engravings were very precise, reflecting his admiration for medieval and Indian Art; they are bold, smooth, rhythmical and clearly defined; some are black lines on a white ground and others the reverse. Many were intended to be illustrations; Gill illustrated over 138 books and made over a thousand engravings. There are over a hundred works on paper in the TATE. He became a Roman Catholic in 1913, and in 1921 formed the Guild of St Joseph and St Dominic with a number of fellow artists who had gathered to live near him in Ditchling in Sussex since 1916; the Ditchling Community included DAVID JONES, PHILIP HAGREEN and his former teacher EDWARD JOHNSTON; a similar community later surrounded him at Capel-y-ffin in Wales
LIT: *Autobiography*, Eric Gill, London, 1940; *Eric Gill, Man of Flesh and Spirit*, Malcolm Yorke, London, 1981; *Eric Gill*, Fiona MacCarthy, London, 1989. AW

GILL, Colin, NEAC, IS (1892–1940). Painter of portraits, genre, historical and allegorical subjects; decorator. Trained at the SLADE SCHOOL OF ART, he won a ROME SCHOLARSHIP in decorative painting in 1913. From *c.* 1918 to 1920 he was an OFFICIAL WAR ARTIST. He exhibited with the NEAC, becoming a member in 1926, he also showed at the RA, in London galleries and internationally. Between 1922 and 1925 he was an instructor in painting at the RCA. His decorative work includes murals in the Houses of Parliament and the Bank of England. His painting for the BRITISH SCHOOL IN ROME, *Allegory*, reflects the influence of STANLEY SPENCER. His sharply delineated style combined realism of detail with a conceptual treatment of space and composition. Similar elements are found in his portraits.
LIT: Memorial exhibition catalogue, Canterbury College of Art, 1985. CF

GILL, Macdonald, FRIBA (1884–1947). Painter and architect; designer of posters and cartographer. Born in Brighton, the brother of the sculptor ERIC GILL, he was a student at Chichester School of Art and the CENTRAL SCHOOL OF ART, London. Between 1901 and 1903 he was assistant to Sir Charles Nicholson and he became

FRIBA in 1931. He exhibited as an architect at the RA from 1907 to 1923 and he was also a member of the FRIDAY CLUB, 1921, the Architecture Club, the AWG and the Society for the Protection of Ancient Buildings. He was designer for the Imperial War Graves Commission. As a painter he worked with ROGER FRY on the decoration for the Borough Polytechnic, (his *Punch and Judy* now being in the TATE GALLERY), and produced decorations for the House of Commons and Lincoln Cathedral.
LIT: 'Decorative Maps', Macdonald Gill, *Studio*, Vol.128, 1944, p.161. CF

GILLIES, Sir William, CBE, RA, RSA, RSW, SSA (1898–1973). Painter of landscapes and still-life in oils and watercolour. His studies, begun in 1916 at the EDINBURGH COLLEGE OF ART were interrupted by a period of military service; he returned to the College in 1919 and gained his Diploma in 1922. With other ex-students who graduated in the same year, he formed the 1922 Group, which held annual exhibitions for about ten years. In 1923 he was awarded a post-graduate scholarship, and in the following year a travelling scholarship enabled him to visit Paris, where he studied with André Lhote, and, later on, Italy. On his return to Scotland he taught first at Inverness and then at the Edinburgh College, where he was to become Head of the School of Painting, 1946, and Principal, 1960–6. He exhibited with the Society of Eight from 1932 to 1938. His first one-man show was at the French Institute in Edinburgh in 1948, and his first in London was at the Mercury Gallery in 1978, some years after his death. His work was close-toned and harmonious in restrained colour, and his compositional methods sensitively reflected his training in Cubism by Lhote. AW

GILMAN, Harold John Wilde, PLG (1876–1919). Painter of figures, interiors, landscapes and portraits in oils. In 1896 he studied at Hastings School of Art and from 1897 to 1901 at the SLADE SCHOOL. He spent a year in Spain 1902–3, in 1905 visited America, in 1911 visited Paris with CHARLES GINNER, and in 1912–13 went to Norway and Sweden. He exhibited at the Indépendants and the AAA in 1908, at the Carfax Gallery in 1913, the Goupil Gallery in 1914, as well as the Baillie and LEICESTER GALLERIES, the London Salon, NEAC and ROI. He was a founder member of the FITZROY STREET GROUP in 1907, the CUMBERLAND MARKET GROUP, and a founder member and first President of the LG in

1913. A close friend of Ginner and GORE, he taught at WESTMINSTER SCHOOL OF ART in 1915, and opened an art school with Ginner. In 1918 he was commissioned by the Canadian Government to paint *Halifax Harbour* for the War Memorial, Ottawa. Memorial exhibitions were held at the Leicester Galleries in 1919 and the TATE in 1955. Gilman's career was short but important in its distinctive response to Post-Impressionism. Early work, influenced by Velazquez, was restrained in colour and carefully crafted. Under the influence of SICKERT, *c.*1910, his painting developed a less unified surface, using a mosaic of opaque touches and a higher colour register, whilst his subjects centred around *intimiste* scenes and portraits. He developed the use of colour patches whilst retaining his commitment to drawing and modelling in planes, being influenced both by French and English art. After the Post-Impressionist exhibitions and his 1911 visit to Paris his painting showed the influence of Van Gogh in its impasto and bright colour. As a 'Neo-Realist' with Ginner, he advocated the return to the study of nature, and *c.*1914 his work, influenced by Ginner's, became flatter and restrained in colour. Later he established a re-interpretation of Post-Impressionist influences, combining a controlled, dry technique with surface construction, and use of contour with modelling and recession through colour. Late works, e.g. *Mrs Mounter at the Breakfast Table*, 1916–17 (TATE GALLERY), reveal his sensitive palette and humane regard for his subject.
LIT: *Harold Gilman. An Appreciation*, Wyndham Lewis and Louis F. Fergusson, Chatto & Windus, London, 1919; *Harold Gilman*, Arts Council catalogue, 1981–2; *The Camden Town Group*, Wendy Baron, Scolar Press, 1979. CF

Gimpel Fils was founded in South Molton Street by Peter and Charles Gimpel in 1946. It is now at 30 Davies Street. Traditionally, but not exclusively, they have encouraged painterly abstraction. Contemporary British, European and American artists represented include TERRY ATKINSON, CHARLES BEAUCHAMP, GWYTHER IRWIN, ALBERT IRVIN and LOUIS LE BROCQUY. AW

GINESI, Edna, LG, ARCA (b. 1902). Painter of landscapes, flowers and still-life in oils; stage designer (Camargo Ballet) and interior decorator. She studied at Leeds College of Art and the RCA 1920–4. She visited Holland, Belgium, France and Italy on a travelling scholarship and

in 1926 married Raymond Coxon. She exhibited in London galleries, having her first solo exhibition at ZWEMMERS GALLERY in 1932, and with the LG (member 1933). She also travelled and exhibited in America. Her earlier paintings used impasto strokes to suggest form and texture. Later work became looser in technique and created a semi-abstract design, e.g. *Everglades* (TATE GALLERY).
LIT: Retrospective exhibition catalogue, Bradford, 1956. CF

GINNER, Isaac Charles, CBE, ARA, RWS, LG, ROI (1878–1952). Painter of townscapes, landscapes and still-life in oils and watercolours. Born in Cannes, he studied art at the Académie Vitti under Gervais and Anglada y Camarosa, and at the Ecole des Beaux-Arts. In 1909 he went to Buenos Aires and in 1910 settled in London becoming a member of the FITZROY STREET GROUP after GORE had noticed his work in 1908. He became closely associated both with Gore and HAROLD GILMAN, with whom he started an art school. He collaborated with Gore, LEWIS and EPSTEIN on decorations for Mme Strindberg's *Cave of the Golden Calf*. A founder member of the CAMDEN TOWN GROUP, 1911, LG, 1913, and the CUMBERLAND MARKET GROUP, 1914, he exhibited at the AAA, Carfax & Co. Gallery and the Goupil Gallery as well as other London galleries and societies, the NEAC and the London Salon. Elected NEAC in 1920, ARA in 1942 and RWS in 1945, he was made CBE in 1950 and from 1939 to 1945 he was an OFFICIAL WAR ARTIST. His earliest work, influenced by Anglada y Camarosa, was thickly painted with large strokes of impasto, but he quickly absorbed the influence of Impressionism and Post-Impressionism, particularly that of Van Gogh whom he studied on a visit to Paris with Gilman in 1911. Paintings of 1910–11 show him using small strokes and blobs of colour and a strong expressive colour range. Gradually his work placed greater emphasis on overall surface texture and the delineation of form by lines. Regular thick strokes in strong colour harmonies cover the surface of works such as his London scenes, e.g. *Piccadilly Circus*, 1912 (TATE GALLERY). In 1914 he exhibited as a 'Neo-Realist' and published a manifesto advocating a return to the study of nature, the use of solid pigment and the role of Cézanne and the Post-Impressionists as realists. He also made eleven woodcuts. His painting became more concerned with accurately observed form and appearances recorded by an

even application of thickly applied small marks, e.g. *Emergency Water Storage Tank*, 1942, in which spatial recession is minimized by the close-toned and close-coloured surface.
LIT: *Neo-Realism*, Preface, Goupil Gallery catalogue, 1914; *Charles Ginner 1878–1952*, exhibition catalogue, Fine Art Society, 1985; *The Camden Town Group*, Wendy Baron, Scolar Press, 1979. CF

GINSBORG, Michael (b.1943). Painter of abstracts in acrylic and mixed media. He studied at the Ealing, CENTRAL and CHELSEA Schools of Art and has exhibited in London galleries, including the SERPENTINE and Benjamin Rhodes Galleries. He has taught widely and in 1984 became Director of MA Fine Art, Birmingham Polytechnic. He has won numerous awards. His paintings have used a variety of different media and scales, evolving from a use of grid-like lines to a complex and intuitive abstraction.
LIT: Catalogue, Benjamin Rhodes Gallery, 1989 CF

The Glasgow School; The Glasgow Boys. There was no common background other than that of working in and around Glasgow for the dozen or so artists who were known as a loose group by the first name cited but who preferred the second. Although they had no formal organization, common aim or style, they all recorded what they saw from observation and experience, they all avoided narrative content, they painted with vigorous brushwork and were open to the influence of the painterly realism developing in France and Holland during the 1880s. Picturesque scenes of urban and peasant life in Britain and France were frequent subjects. WILLIAM YORK MACGREGOR, JAMES GUTHRIE, JAMES PATERSON, E.A. WALTON, JOSEPH CRAWHALL and JOHN LAVERY were among the central figures of a circle which may be seen as having included as many as twenty artists. They enjoyed international recognition and success in Europe and America at the turn of the century, and laid the foundation for the development of the SCOTTISH COLOURISTS.
LIT: *The Glasgow Boys*, W. Buchanan, catalogue, Scottish Arts Council, 1969–71; *The Glasgow Boys*, Roger Billcliffe, John Murray, 1985. AW

Glasgow School of Art. Opened in 1844 in Ingram Street as Glasgow Government School of Design. After 1863 it became Glasgow School of Art until it moved to Sauchihall Street in 1869 where it was re-named School of Art and

Haldane Academy. In 1892 it reverted to being The Glasgow School of Art, and it transferred to the first half of the Mackintosh building in Renfew Street in 1899. Francis Newbery, who had been headmaster since 1885, was largely responsible for the School acquiring a very high reputation in Britain and abroad. A four-year Diploma course was introduced by him, female students were numerous in all departments, and the School was notable for courses in design, crafts and architecture as well as painting and sculpture. The sisters MARGARET and FRANCES MACDONALD, and their respective future husbands CHARLES RENNIE MACKINTOSH and Herbert McNair formed a group known as 'The Four', and had spectacular success in Vienna and Turin at this period, for their coordinated architectural and decorative schemes. Later students of distinction have included MUIRHEAD BONE, ROBERT COLQUHOUN, ROBERT MACBRYDE, JOAN EARDLEY, DOUGLAS PERCY BLISS, the film-maker Norman McLaren and the actor Robbie Coltrane. BRUCE MCLEAN (studied 1961–3) was appointed Slade Professor in Printmaking, 1996. AW

GLASS, William Mervyn, RSA, PSSA (1885–1965). Scottish painter of landscapes and coastal scenes in oils. He trained at Aberdeen School of Art, at the RSA Life Schools, Edinburgh, in Paris and Italy. He exhibited mainly in Scotland at the RSA and GI, as well as at the RA and in Liverpool. He was elected ARSA in 1934 and RSA in 1949 and was PSSA from 1930 to 1933. His broadly brushed scenes, mostly of Scotland, give an atmospheric and painterly account of his subjects, e.g. *A Rocky Shore* and *Ben Mure, Mull*. CF

GLEDSTANES, Elsie, RBA, PS, SWA (b. 1891). Painter of figures, landscapes and portraits in oils, tempera, watercolours and pastels. She studied at the SLADE SCHOOL, the BYAM SHAW SCHOOL OF ART and in Paris. She exhibited mainly at the RBA, the RA and the SWA, and was elected ARBA in 1923, RBA in 1929 and SWA in 1935. She also showed in London galleries including the Cooling Galleries, and was a member of the Ridley Art Club. Her work showed a clear delineation of form both in oils and tempera, e.g. *A Welsh Farm*, RA 1932, and *The Tea Party*. CF

GLEICHEN, Lady Helena, RBA (1873–1947). Painter of animals, landscapes and flowers in oils; sculptor. Daughter of Victor Gleichen and sister of Feodora Gleichen, she studied at Rollshoven,

WESTMINSTER and Calderon's School of Animal Painting and exhibited widely, showing mainly at the Goupil and Alpine Galleries. She also exhibited at the RA from 1901 to 1933, at the RBA (member 1910), the SWA, ROI, in the provinces and Scotland. Represented in many private collections, her work includes studies of horses, landscape from Britain and abroad and subjects such as *Turning the Plough*, RA 1904. CF

GLENAVY, Lady Beatrice, RHA (1883–1970). Painter of figures in oils; stained glass artist, illustrator and modeller. Née Elvery, she trained at Dublin School of Art and at the SLADE where she won the Taylor Scholarship three times, as well as bronze and silver medals. She exhibited mainly at the RHA (ARHA 1932, RHA 1934) and also showed at the RCA, SWA, and at the RA in 1933, 1938 and 1948. A teacher at Dublin Metropolitan School of Art, her exhibited works included subjects such as *The Intruder*, RA 1933, and *Country Life*, RA 1948. CF

GLUCK (Hannah Gluckstein) (1895–1976). She studied at ST JOHN'S WOOD SCHOOL OF ART and with ALFRED MUNNINGS. She painted portraits and flowers with an idiosyncratic, fashionable panache, exhibiting at the FINE ART SOCIETY.
LIT: *Gluck, her biography*, Diana Souhami, Pandora, 1988. AW

GOBLE, Anthony. A.R.Cam.A. (b. 1943). Painter of figures, portraits and landscapes in oils; poet and stage designer. Born in Wales, he attended Wrexham School of Art and Coleg Harlech and has exhibited regularly in Wales and in mixed exhibitions since 1970. Elected A.R.Cam.A. in 1977, his work is represented in the Welsh Arts Council Collection. Member, 1979, and Chairman, 1984, of AADW, in 1985 he became Director of Oriel Llandover. His expressive painting uses a palette knife technique.
LIT: *Anthony Goble. A Selection of Paintings 1980–1985*, catalogue, Viriamu Jones Gallery, University College, Cardiff, 1985. CF

GODWIN, Mary, LG (1887–1960). Painter of townscapes, figures and interiors in oils and watercolours. Born in Bristol, she studied at King's College under BYAM SHAW 1908–11, with SICKERT 1911–14, with GILMAN in 1915 and at the WESTMINSTER POLYTECHNIC. She exhibited widely in London, mainly at the NEAC and the Cooling Gallery, but also at the RA from 1913, at the LS and other London and provincial galleries. She was elected LG in 1914 and her warmly coloured works reflect the influence of Gilman in their palette. Her paintings combine representational views with an awareness of the role of colour and shape on the picture surface. CF

GOLDEN, Grace L., ARCA (b. 1904). Painter of historical and figure scenes and landscapes in oils and watercolours; black and white artist, wood engraver and poster designer. She studied with J.D. Revel at CHELSEA SCHOOL OF ART, with ROTHENSTEIN at the RCA and at the Regent Street Polytechnic. She exhibited at the RA from 1936 to 1940, also showing at the RBA, in London galleries including the LEICESTER, and in Liverpool. Two of her works, *Summer Evening, Embankment Gardens* and *Free Speech*, were purchased by the CHANTREY BEQUEST. Her subject pictures such as *Sir Henry Wood Conducting the London Symphony Orchestra in Queens Hall, 10th August 1940*, 1941, based on many watercolour and pencil studies, demonstrate her ability to handle complex detail and atmosphere in a painterly manner. CF

GOLDING, John (b. 1929). Painter of abstracts in acrylic; writer and art historian. Born in Hastings, Sussex, he spent his childhood in Mexico. Studying first at the University of Toronto, he took a Ph.D. at the COURTAULD INSTITUTE, London University 1957, where he taught Art History from 1959 to 1981. He exhibited at Gallery One in 1962, and has subsequently shown at the Rowan Gallery, London, in the provinces and abroad, being represented in many group exhibitions and public collections nationally and internationally. He has taught painting at the RCA since 1971, becoming Senior Tutor in 1981, and from 1978 to 1979 he was Slade Professor of Fine Art, University of Cambridge. In 1984 he became a Trustee of the TATE GALLERY. He has published many books on art and has organized and selected major exhibitions. He began as a figurative artist of roughly textured nudes and moved to abstraction, firstly dividing the canvas into a few simple geometric shapes and then painting bands or flares of colour, which he describes as the 'pleating of light'. His works reflect his interest in pure pigment and are built up by layers of acrylic paint and glazes.
LIT: Exhibition catalogue, Yale Centre for British Art, 1989; Golding's own publications; *Cubism: A History and an Analysis 1907–1914*, John Golding, Faber & Faber, London, 1959. CF

Goldsmiths' College. Founded in 1891 as the Technical and Recreative Institute of The Worshipful Company of Goldsmiths at New Cross in South East London, it became part of London University in 1904. The visual, literary and performing arts are taught, as well as behavioural and mathematical sciences, design and educational studies. The School of Art has provided the training of many distinguished artists since the 1890s. During the 1980s, a new wave of young British artists emerged from the college who possessed a number of characteristics in common: a desire to comment critically and often sardonically on aspects of contemporary life and society; a willingness to use a wide variety of media to express their ideas, and a vigorous policy of early self-promotion, in accord with that of many of their friends in the world of popular music. A common factor in their work is the stress on the concept, and often the establishment of a disturbingly bland, simple image, open to wide interpretation on the part of the viewer, sometimes achieved with complex technology but employing little of traditional artistic skills. DAMIEN HIRST mounted an influential three-part exhibition at the disused Port of London Authority in 1988, entitled 'Freeze'. It included work by Mat Collishaw, IAN DAVENPORT, Anya Gallacio, RICHARD and SIMON PATTERSON, MARK WALLINGER, FIONA RAE, Gavin Turk and GARY HULME among many others. This well-publicized and controversial exhibition drew widespread attention to artists and students from the college. AW

GOODALL, John Strickland, RI, RBA (b. 1908). Painter of Victorian and Edwardian beach and country scenes, landscapes and interiors in watercolours; illustrator. He studied under Sir Arthur Cope in 1923, John Watson Nicol and Harold Speed in 1924, and at the RA SCHOOLS 1925–9. He exhibited at the RA, RI, RBA, and in London galleries including the Christopher Wood Gallery. Working both as a painter and an illustrator, he has designed for the *Radio Times* and *The Bystander*, and is now well known for the illustrations for children's books published by Macmillan, e.g. *Victorians Abroad*, and *Above and Below Stairs*. His paintings range from landscapes of England, Portugal and France to period scenes painted in a fluid, easy style with great accuracy of detail and light toned colour. CF

GOODEN, Stephen Frederick, RA, RE, RMS (1892–1955). Engraver, etcher and illustrator.

Studied at the SLADE, then served in France 1915–18. His earlier figure compositions were very influenced by Italian renaissance engravings. AW

GOODSIR, Agnes Noyes, ARWA, SSN (1864–1939). Painter of portraits, genre, still-life and flowers. Born in Victoria, Australia, she studied at Bendigo, Australia, with Woodward, in Paris at the ACADÉMIE JULIAN and at COLAROSSI'S under J.P. Laurens, winning two silver medals. She exhibited in Australia, in Paris at the Salon de la Société des Artistes Français, where she won a silver medal in 1924, and in London at the RA, ROI, LS and the Cooling Galleries. She was elected ARWA in 1916 and was a member of the Société de Paris Moderne. Her portrait subjects included Ellen Terry. CF

GOPAL-CHOWDHURY, Paul (b. 1949). Painter of figures in oils, he trained at CAMBERWELL and the SLADE SCHOOL and has exhibited in London, recently at the Benjamin Rhodes Gallery, and in the provinces. He was Gregory Fellow, Leeds University, 1975–7, and Artist in Residence, Gonville and Caius College, Cambridge, 1983–4. His work has developed from empathetic nude studies to groups and pairs of figures painted in strong colour areas in limited space.
LIT: Exhibition catalogue, Kettle's Yard, Cambridge, 1984. CF

GORE, Frederick, RA (b. 1913). Painter of urban scenes, figures and landscapes in oils. Son of SPENCER GORE, he studied at the RUSKIN and WESTMINSTER Schools of Art and at the SLADE. He held his first solo exhibition in 1937 at the REDFERN GALLERY where he exhibited until 1962 and he has shown at the MAYOR GALLERY, regularly at the RA from 1945 (ARA 1965, RA 1973) and abroad. His work is represented in collections including Southampton Art Gallery. He has taught at WESTMINSTER, Epsom and CHELSEA Schools of Art and from 1951 to 1979 was Head of Painting at ST MARTIN'S. Chairman of the RA Exhibition Committee, 1976–87, his publications on art include *Abstract Art*, Methuen, 1956. His work has been influenced by Post-Impressionism, using bright structural colour and a painterly technique. Much recent work has depicted topographical subjects.
LIT: *Spencer Gore and Frederick Gore*, catalogue, Redfern Gallery, London, 1962; *Frederick Gore RA*, catalogue, Royal Academy of Art, London, 1989. CF

GORE, Spencer Frederick, NEAC, LG (1878–1914). Painter of landscapes, figures and theatre scenes in oils. Born in Epsom, he was educated at Harrow and the SLADE SCHOOL 1896–9, where he formed a friendship with HAROLD GILMAN and where contemporaries included WYNDHAM LEWIS and ALBERT RUTHERSTON. In 1902 he went to Madrid with Lewis and studied Goya; in 1904 he painted in Normandy with Rothenstein, visiting SICKERT in Dieppe. Through this meeting and Gore's description of the vitality of contemporary English art, Sickert decided to return to London. In 1905 Sickert lent Gore his house at Neuville and Gore visited the Gauguin exhibition in Paris. A friend of LUCIEN PISSARRO, he was a founder member of the FITZROY STREET GROUP, of the AAA in 1908, the CAMDEN TOWN GROUP in 1911 (of which he was the first President), and of the LONDON GROUP in 1913. He also exhibited at the NEAC, becoming a member in 1909. In 1912 his work was included in the second Post-Impressionist Exhibition and he was chief organizer and an exhibitor in the 'English Post-Impressionists, Cubists and Others' exhibition, Brighton. In 1913 he exhibited with Gilman at the Carfax Gallery where he continued to exhibit. He also showed in Paris and in 1912 organized the 'Cave of the Golden Calf' decorations. He described himself as a Neo-Impressionist and he was one of the most innovative and widely liked amongst his contemporaries. His early interests were in Goya, Whistler and in theatrical subjects. His close contact with Sickert in 1906 is reflected both in subject and style and by 1907 he had also absorbed much from Lucien and Camille Pissarro, using broken brushstrokes, colour analysis and, in some works, a pointilliste technique. Under the impact of the Post-Impressionist exhibitions and the work of Gauguin and Matisse, his own work began to use larger areas of colour painted in flatter patterns and in his later work at Letchworth and Richmond he evolved a personal, innovative style of formal shapes and bright colour.
LIT: Exhibition catalogue, Anthony d'Offay, 1983; *The Camden Town Group*, Wendy Baron, Scolar Press, 1979. CF

GOSSE, Laura Sylvia, RBA, RE, SWA (1881–1968). Painter of street scenes, interiors, still-life and figures in oils; engraver. She trained at ST JOHN'S WOOD SCHOOL OF ART, the RA SCHOOLS and under SICKERT. She exhibited at the AAA from 1909, the NEAC from 1911 and the RA from 1912. One of the first women members of the LG, her first solo exhibition was at the Carfax Gallery in 1916; thereafter she exhibited in leading London galleries. Represented in many public collections, she was elected RBA in 1929, RE in 1936 and SWA in 1935. She taught at Sickert's school in Rowlandson House, nursed him in Dieppe in 1920 and in 1934 instigated the Sickert Fund. Her work was influenced by him in subject and technique.
LIT: *Conversations with Sylvia: Sylvia Gosse, Painter 1881–1968*, Kathleen Fisher, London, 1975; exhibition catalogue, Michael Parkin Gallery, 1989. CF

GOTCH, Thomas Cooper, RBA, RI, RWA, PRBC, NEAC, RP (1854–1931). Painter of genre, allegorical figures, landscapes and portraits in oils, watercolours and pastels; etcher. He studied at HEATHERLEY'S in 1876, at the Ecole des Beaux-Arts, Antwerp, in 1877, with Samuel Lawrence in London, at the SLADE in 1879 and with J.P. Laurens in Paris. He travelled to Australia in 1884 and settled in Newlyn in 1887. A friend of STANHOPE FORBES, he was a founder member of the NEAC in 1886, and founder, 1887, and President, 1913–28, of the RBC. He exhibited widely in galleries including the RBA (member 1885), the RI (member 1912), at the RA from 1880 to 1931, in the provinces, Scotland and abroad. His work is represented in the TATE GALLERY. His early naturalistic painting was influenced by Bastien-Lepage but he later painted allegorical subjects, particularly after visiting Italy in 1891, often depicting children in an imaginative, symbolic style.
LIT: 'The Work of T.C. Gotch', A.L. Baldry, *Studio*, Vol.XIII, pp.73–82; *Painting in Newlyn 1880–1930*, exhibition catalogue, Barbican Art Gallery, London, 1985. CF

GOTLIB, Henryk, LG (1890–1966). Painter of figures, landscapes, animals and portraits in oils and watercolours; sculptor, theatrical designer and writer. He studied at the Academy of Fine Art, Cracow, in Munich, Amsterdam and Paris, and in 1939 he settled in London. A prominent member of the Polish avant-garde, he exhibited in Warsaw in 1918, Berlin in 1921 and Amsterdam in 1922. In 1941 he exhibited *Christ in Warsaw* at the Leger Gallery, London, and was elected LG. From 1942 he showed at leading galleries and he is represented in many public collections including the TATE GALLERY. From 1949 to 1950 he taught at the Cracow Academy of Fine Art. His earlier colourful and expressionistic work was

GOULD

influenced by Bonnard but after 1950 his work darkened and became harsher in its search for a truth that went beyond the colouristic.
LIT: Gotlib's own writing including *The Travels of a Painter*, 1947; retrospective exhibition catalogue, National Museum, Warsaw, 1980. CF

GOULD, Alec Carruthers, RBA, RWA (1870–1948). Painter of landscapes, rivers and marines in oils and watercolours. Born in Essex, the son of Francis Carruthers Gould, he exhibited in London from 1892, showing mainly at the RBA, the RA and Walker's Gallery and being elected RBA in 1903. He also exhibited in other London galleries, at the NEAC, LS, ROI, RI and in the provinces. His works are impressionistic in style with lively, broken brushmarks, e.g. *Richmond Bridge* (exhibited 1920). In some works he adopted a Whistlerian, atmospheric and fluid use of paint to express the light and colour harmony of a particular scene, e.g. *The Fairground*. CF

GOWING, Sir Lawrence Burnett, ARA, CBE (1918–1991). Painter of landscapes, figures and portraits in oils; writer. In 1936 he became a pupil of WILLIAM COLDSTREAM at FITZROY STREET and in 1938 he studied at the EUSTON ROAD SCHOOL and met Stephen Spender. Thereafter he painted regularly in the English countryside and abroad, travelling to Spain, France, Italy, USA and Russia. He exhibited from 1942 to 1955 at the LEICESTER GALLERIES, subsequently showing at the MARLBOROUGH and WADDINGTON Galleries. A retrospective exhibition was held at the SERPENTINE GALLERY in 1983, and his work is in many public collections including the TATE GALLERY. From 1944 to 1947 he taught at CAMBERWELL; he was Professor of Fine Art, University of Durham 1948–58; in 1959 he became Principal CHELSEA SCHOOL OF ART and from 1967 to 1975 Professor of Fine Art, Leeds University. In 1975 he became SLADE Professor of Fine Art. He was a Trustee (1953–64) and Keeper of the British Collection, Deputy Director of the Tate Gallery 1965–7, and a Trustee of the BM 1976–81. He served on many committees of the visual arts and was awarded his CBE in 1952 and a knighthood in 1982. His many books on art include *Vermeer*, Faber & Faber, 1952, and *Lucian Freud*, Thames & Hudson, 1982. His own painting began in an observant, finely painted style rooted in the Euston Road tradition. Later his technique broadened and his experience of being totally

and bodily involved with landscape in the 1940s instigated an investigation into the character of visual information in the 1960s; later he explored the possibilities of painting with the whole of his body, using himself as the subject and the vehicle for life-size figurative works.
LIT: Gowing's own writing; retrospective exhibition catalogue, Serpentine Gallery, 1983; interview in the *Artist* (UK), July 1983. CF

Grafton Group, see FRIDAY CLUB

GRAHAM, David, RBA, ARCA, PS (b. 1926). Painter of townscapes, landscapes, portraits and figures in oils. He trained at Hammersmith School of Art, ST MARTIN'S and the RCA 1948–51. He has exhibited at the RA, RP and the Paris Salon, and his solo exhibitions include those at the Guildhall and Mall galleries in 1971, and more recently at the Herbert Art Gallery and Museum, Coventry. His work is represented in public collections including the London Museum. He has taught at the Sir John Cass School of Art, London. He has made many trips to Israel to record the people, architecture and landscape in a series of paintings. His work is richly coloured, selective in detail and establishes the subject with a direct, vibrant handling of paint. CF

GRAHAM, George, RSW, RI, ROI, RBA (1881–1949). Painter of landscapes and symbolic subjects in oils and watercolours; wood engraver. He studied architecture in Leeds and attended Leeds School of Art before working at the London School of Art under BRANGWYN, WILLIAM NICHOLSON and J.M. Swan. He exhibited widely in galleries including the ROI (member 1918), the RI (member 1922), the RSW (member 1927), the GI and the FINE ART SOCIETY. Elected RBA in 1948, he showed at the RA from 1908 to 1947 and his work is represented in the Laing Art Gallery, Newcastle. Until the age of fifty, he concentrated on landscapes; he then produced a series of symbolic works on The Creation, using natural forms without figures which share some characteristics with the work of Blake.
LIT: *George Graham and his Creation Paintings*, R.H. Sauter, W.P. Griffith & Sons Ltd; *George Graham 1881–1949*, catalogue, Rye Art Gallery, 1978. CF

GRANT, Professor Duncan Alistair Antoine, RBA, RSA, FRCA (1925–1997). Painter in oils, lithographer and etcher of figures, portraits, townscapes and landscapes; illustrator. Born in

London, he was half-French, and retained his mother's house in Etaples (where he went to school) all his life. He studied at Birmingham College of Art 1941–3, under Fleetwood-Walker, and at the RCA 1947–51, under WEIGHT, SPEAR and BUHLER where he was also taught printmaking by EDWIN LA DELL and ROBERT AUSTIN. As a member of the New Editions group he exhibited at ZWEMMER'S in the 1950s and 1960s and he held regular solo exhibitions in London galleries and abroad. He showed at the RA, LG, RBA and AIA and is represented in collections including the V & A. He was appointed Head of Printmaking at the RCA in 1970 and Professor in 1984. His direct, observant work reflected his sense of structure and expressive line. LIT: 'Alistair Grant', G.S. Sandilands, *Studio*, April 1957, pp.112–15; *Alistair Grant. Etchings and Drypoints 1954–1958*, Austin/Desmond Contemporary Books, London, 1989. CF

GRANT, Duncan James Corrowr, LG (1885–1978). Painter of portraits, figures, still-life and landscapes in oils and collages; decorator, designer and theatrical designer. He studied at WESTMINSTER SCHOOL OF ART 1902–5, at Atelier La Palette, Paris, under J.E. Blanche (where he met WYNDHAM LEWIS), and at the SLADE SCHOOL 1908. He studied and copied widely in museums and in 1905 joined the FRIDAY CLUB. He made many visits to France throughout his life and worked regularly with VANESSA BELL in London, Sussex and the South of France. He exhibited at the United Arts Club in 1907 and showed at the NEAC from 1909, at the Friday Club from 1910, with the CAMDEN TOWN GROUP in 1911, at the second Post-Impressionist Exhibition in 1912, with the Grafton Group from 1913 and with the VORTICISTS in 1915. From 1919 to the 1950s he exhibited with the LG and from 1926 with the LAA. His first solo exhibition was in 1920 at the Carfax Gallery. There followed many national and international exhibitions and retrospective exhibitions including the TATE GALLERY, 1959. His work is represented in many public collections. From 1938 to 1939 he taught at the EUSTON ROAD SCHOOL and in 1937 he was awarded a Medal of Merit, Paris International Exhibition for Textile Design. He was elected Hon. Doctor of Letters of the RCA in 1970, and of the University of Sussex in 1972. He associated with FRY in decorations for the Borough Polytechnic in 1911, and thereafter completed many decorative commissions often in association with Vanessa Bell. His theatre and ballet designs included work for the producer Jacques Copeau and as a co-director of the OMEGA WORKSHOPS in 1913, he worked on a wide range of decorative activities, including textiles, pottery and carpets. His early paintings were realistic, revealing an interest in design and pattern. The influence of the Post-Impressionist exhibitions caused him to develop an innovatory style with rapid brushstrokes establishing a pattern of bright, clear colour. In *c.* 1912, the influence of Picasso is seen in his use of cross hatchings and an interest in African art, e.g. *The Tub* (Tate Gallery). Later work became more firmly modelled with solid forms and less broken strokes, giving a greater impression of depth. LIT: *Duncan Grant and his World*, Wildenstein Gallery, 1964; *Bloomsbury Portraits*, Richard Shone, Phaidon, 1976; *Duncan Grant*, Roger Fry, Hogarth Press, London, 1930; exhibition catalogue, Scottish National Gallery of Modern Art and MOMA, Oxford, 1975; *The Art of Duncan Grant*, Simon Watney, John Murray, 1990. CF

GRANT, Ian Macdonald, ARCA (b. 1904). Painter of landscapes and portraits in oils, watercolours and pastels. He trained at GLASGOW SCHOOL OF ART 1922–6, in Paris at COLAROSSI'S 1927, and at the RCA 1927–30. He exhibited in Scotland at the RSA and GI and in England at the RA and in Manchester. His work is represented in several public collections. He taught at Victoria School of Art, Southport in 1935, and from 1937 at MANCHESTER SCHOOL OF ART. His early work shows a classical, figurative style, e.g. *Figures by a Lake*, 1921, which won second prize in the PRIX DE ROME. Later paintings were more broadly painted, balancing observed form and stylization, e.g. *Self Portrait*, 1939, and *Cheshire Mill*, 1939, both in Manchester City Art Gallery. CF

GRANT, Keith (b. 1930). Painter of northern and tropical landscapes in oils, acrylic, watercolours and gouaches. Born in Liverpool, he attended the Willesden School of Art 1952–5, and the RCA 1955–8, and since 1959 has held many solo exhibitions in Britain (at ROLAND, BROWSE AND DELBANCO and Francis Kyle). He has shown in Ireland, France, Norway and Iceland and in many group exhibitions. His work is represented internationally in public collections and from 1982 he has been Head of Art, Roehampton Institute of Higher Education. His

commissions include mosaic murals (Newcastle upon Tyne subway), stage sets for Ingmar Bergman, and he has been the subject of several TV films. His association with the lands of the arctic circle began in 1960 and in 1980 he was commissioned by British Aerospace to record the launching of the Ariane rocket in French Guiana. In subsequent visits to Sarawak he painted the tropical forest and tribal people. His bold, observant paintings are records of unique peoples and elemental landscape which reflect his interest in the question of conservation.
LIT: Exhibition catalogue, Metropole Arts Centre, Folkestone, 1986; 'Landscape Painters: Keith Grant', Ian Simpson, *Artist* (UK), Vol.104, No.3, March 1989. CF

GRANVILLE (b. 1945). Painter of landscapes and figures. He studied textile design at Northwich College of Art 1962–5, and first exhibited paintings in 1967 in Liverpool. He has subsequently exhibited in London and the provinces, particularly at the Colin Jellicoe Gallery, Manchester. From early industrial landscapes and fantastic figure paintings, his work since 1983 has concentrated on Spanish landscape painted in a spontaneous, lively manner.
LIT: Retrospective exhibition catalogue, Bootle Art Gallery, 1978; *Figure 80*, exhibition catalogue, Colin Jellicoe Gallery, Manchester, 1980. CF

GRAY, Douglas Stannus, ROI, RP (1890–1959). Painter of portraits, landscapes, flowers and figures in oils. He trained at Clapham, Croydon and the RA SCHOOLS where he was influenced by SARGENT. In 1910 he visited Paris and in 1925 painted in the South of France. In 1920 he exhibited at the RA, subsequently showing there regularly as well as at the ROI, RP, the NEAC and in the provinces. He was a founder member of the London Portrait Society in 1928, and was elected ROI in 1926 and RP in 1933. His work is represented in public collections including the TATE GALLERY. Influenced by artists with a painterly technique, e.g. Velazquez and Sargent, his own work has an immediacy of brushstroke and handling of chiaroscuro particularly in subjects painted in dappled outside light.
LIT: Exhibition catalogues, Spink & Son, 1986; Nevill Keating Pictures, 1988. CF

GRAY, Joseph (1890–1962). Painter of landscapes, figures, flowers and architecture in oils; etcher and illustrator. He studied at South Shields School of Art and made sketching trips to Russia, Germany, Spain, France and Holland. During the First World War he served with the Black Watch and was appointed war artist for the *Graphic*. He exhibited in London galleries including the FINE ART SOCIETY, at the RSA and on the Continent and his work is represented in collections including the IMPERIAL WAR MUSEUM. CF

GRAY, Ronald, RWS, NEAC (1868–1951). Painter of landscapes and figures in oils and watercolours. Born in Chelsea, he studied at WESTMINSTER SCHOOL OF ART under FRED BROWN and in Paris at the ACADÉMIE JULIAN. He exhibited widely at the NEAC (member 1923) and RWS (member 1941), at the RA and in other societies and leading galleries, including the Goupil Gallery, London. He was a silver medal winner in Paris and in 1925 his portrait *My Mother* was purchased by the CHANTREY BEQUEST. His work is represented in public collections including the V & A. In 1908, 1909 and 1910 he worked in America. Influenced by WILSON STEER, his work ranges from lively, detailed portraiture to brief, lightly washed and spacious watercolours, e.g. the watercolours of Blakeney and High Ham (Collection of the RSW). CF

GREAVES, Derrick, ARCA (b. 1927). Painter of figures, landscapes, flowers, portraits and still-life in acrylic and collage; printmaker. He was apprenticed to a sign writer before studying at the RCA 1948–52, winning an Abbey Major Scholarship to study in Italy 1952–4. He has travelled in Russia, 1957, Italy, 1970, Israel, 1979 and Greece, 1981. His first solo exhibition was at the BEAUX ARTS GALLERY in 1953 and he subsequently exhibited regularly in London galleries including ZWEMMER'S, Monika Kinley and Fischer Fine Art, at the ICA in 1969 and 1971, and at the Whitechapel Gallery in 1973. He has exhibited internationally and his work was shown in the 1956 Venice Biennale and the 1964 Carnegie International Exhibition, Pittsburgh. His work is included in many public collections here and abroad. In 1957 he won a JOHN MOORES prize and in 1962 a Purchase Prize at the Belfast Open Painting Exhibition. He has taught at ST MARTIN'S SCHOOL OF ART, Maidstone College of Art and the RA SCHOOLS and in 1983 he became Head of Printmaking, Norwich College of Art. His early work was influenced by Van Gogh and Guttuso in its real-

ism and he was associated by critics with MIDDLEDITCH, BRATBY and JACK SMITH. In the 1960s he moved away from descriptive realism and evolved a style that balanced abstraction and figuration, combining elegant purity of line with the more random element of collage. He describes his slowly achieved work as 'an act of clarification, a process of elimination'.
LIT: Retrospective exhibition catalogue, Graves Art Gallery, Sheffield, 1980; and for Loughborough College of Art and Design, 1986; *The Artist* (UK), December 1990. CF

GREAVES, Walter (1846–1930). Painter in oils and watercolours and etcher of London scenes. The son of Charles Greaves, a Chelsea boat-builder and waterman, and brother of Henry Greaves, he trained as a shipwright and meanwhile started to draw and paint the river. In the early 1860s he met Whistler who became a close friend and with his brother he took Whistler on the river, acted as studio assistant and became Whistler's pupil. Their friendship lasted until the early 1880s. He exhibited mainly at the Goupil Gallery which held exhibitions of his work in 1911 and 1922, at the GROSVENOR GALLERY and in the provinces. His work is represented in collections including the TATE GALLERY, and recent exhibitions have been held at the Parkin Gallery in 1980 and 1984. Much of his life was spent in poverty and in 1919 a dinner was organized by WILLIAM NICHOLSON and WILLIAM ROTHENSTEIN to restore his reputation damaged by accusations that Whistler had painted some of his work. In 1922 his painting *Hammersmith Bridge on Boat Race Day*, *c*.1862, was purchased by the CHANTREY BEQUEST for the Tate Gallery and in the same year he was admitted to the Charterhouse as a Poor Brother where he remained until his death. His early work was painted in a naïve, primitive style but subsequent paintings shared many characteristics with those of Whistler.
LIT: *Walter Greaves. Pupil of Whistler*, Christian Brinton, Cottier & Co., New York, 1912; *Chelsea Reach*, Tom Pocock, Hodder & Stoughton, 1970. CF

GREEN, Alan (b. 1932). Born in London, he studied at Beckenham 1949–53, and the RCA 1955–8 following military service in Korea and Japan. In 1958 he won an RCA Major Travelling Scholarship to France and Italy. He was primarily a printmaker before he began to make large oil and acrylic compositions; he has won many inter-national print prizes, including Bradford (1974 and 1982), Fredrikstad (1978), Tokyo (1979) and Jywalskyla, Finland (1981). His first one-man exhibition was at the AIA in 1963; his second at Annely Juda in 1970, where he has exhibited ever since. His work has been shown world-wide in many one-man and group exhibitions, and is in many National Collections. He taught at Hornsey 1959–74, Leeds and Ravensbourne. His abstracts have simple rectangular formats, in which the density and texture of the paint estab-lish luminous relationships of colour.
LIT: 'Alan Green, possibilities for painting in 1980', *Aspects*, October 1981; *Alan Green: Recent Paintings and Drawings*, Juda Rowan Gallery, 1985. AW

GREEN, Anthony, RA, LG (b. 1939). Painter of figures and domestic scenes in oils. He trained at the SLADE SCHOOL 1956–60, and has exhibited at the Rowan Gallery since 1962 and at the RA since 1966, being elected RA in 1977. He has shown internationally in group exhibitions and his work is represented in public collections including the TATE GALLERY. His paintings con-centrate on detailed scenes of his domestic and intimate life painted in high colour with perspec-tival distortion often on a shaped support.
LIT: *A Green Part of the World*, A. Green, 1984. CF

GREEN, Roland, MBOU, FRSA, FZS (1896–1972). Painter of birds and wildlife in watercolours and oils; illustrator, etcher and writer. He studied at Rochester School of Art and Regent Street Polytechnic and exhibited mainly at the Ackermann Galleries in London and Norfolk. He was a Fellow and Vice-President of the RSPB and spent much time studying birds at Hickling Broad in Norfolk where he lived. He wrote and illustrated *How I Draw Birds* and *Wing Tips*. His paintings convey a strong sense of nat-uralistic settings and the natural movement of birds. CF

GREEN, William (b. 1934). Action painter. After a brief period in a drawing office, and then as an architect's pupil, he attended Sidcup (1952–4) and then (following three months imprisonment as a conscientious objector to military service) the RCA (1955–8). As a student, his poured and thrown bitumen abstracts were also ridden over with a bicycle and skidded on with plimsolls; they attracted the attention of Ken Russell, who then directed a film on him, *Making an Action*

Painting, in 1957. He taught 1963–5 at GOLDSMITHS', but after *c.*1980 did little painting for about a decade. His *Susan Hayward XIV* (1993) was shown at England & Co. in that year.

AW

GREENGRASS, Walter (1896–1970). Linocut artist and wood engraver. He studied at the GROSVENOR SCHOOL OF MODERN ART with CLAUDE FLIGHT. He later became an Assistant Keeper at the V & A. His prints evoke speed and movement (*Hurdlers*, 1932) using devices derived from Italian Futurism.

LIT: *Linocuts of the Machine Age: Claude Flight and the Grosvenor School*, Stephen Coppel, Scolar Press, 1995. AW

GREENHAM, Peter George, RA, RBA, RP, NEAC, CBE (b. 1909). Painter of portraits, landscapes, beach scenes, interiors and figures in oils; critic and writer on art. Brother of ROBERT DUCKWORTH GREENHAM, he studied at the BYAM SHAW SCHOOL under F. ERNEST JACKSON and exhibited regularly at the RA, becoming ARA in 1951 and RA in 1960. He held solo exhibitions at the NEW GRAFTON GALLERY from 1972. Three of his paintings have been purchased by the CHANTREY BEQUEST for the TATE GALLERY. He taught at the RA SCHOOLS from 1954 and was Keeper of the RA 1964–85. He was awarded a CBE in 1977. He was art critic of the *Scotsman*, and in 1969 published *Painters on Painting: Velazquez*. Best known for his portraits, his sitters have included Dr F.R. Leavis and Lord Hailsham. His painting, based on drawing and tonal values, initially used a restricted palette which broadened and lightened in later work. His technique creates form through many light touches of paint which reflect his thoughtful and delicate approach.

LIT: Retrospective exhibition catalogue, the RA, London, 1985; 'The Apollo Portrait: Peter Greenham RA', *Apollo* (UK), June 1987; 'Peter Greenham at 80', *Artist* (UK), November 1989. CF

GREENHAM, Robert Duckworth, RBA, ROI (1906–1976). Painter of beach scenes and seaside towns, portraits, landscapes and still-life in oils, watercolours, pastel and tempera; mural painter and wood-cut engraver. Brother of PETER GEORGE GREENHAM, he studied at the BYAM SHAW SCHOOL under VICAT COLE and F. ERNEST JACKSON, and at the RA SCHOOLS under SICKERT, WALTER RUSSELL, SIMS and RICKETTS, where he won the Landseer and Creswick Prizes, silver and

bronze medals. He exhibited mainly at the RBA, ROI, RA and NEAC and was elected RBA and ROI in 1931. He also showed in London galleries, the provinces and abroad. Before the late 1930s his work was more expressive in touch but after *c.*1938 the painted surface became calmer and the sense of overall design became more apparent and ordered. He painted many scenes of the English seaside resorts, depicting them in decisive areas of bright colour (*Cromer Beach with Bathing Huts and Figures*, 1964, exhibited at the RA in 1947).

LIT: *Beach Scenes 1930–70*, catalogue, The Maclean Gallery, London, 1981. CF

GREENWOOD, Ernest, RWS, ARCA (b. 1913). Painter of landscapes, townscapes, figures and portraits in oils, watercolours and gouache; mural painter, etcher and engraver. He studied at Gravesend School of Art and at the RCA under ROTHENSTEIN 1931–5, winning a scholarship to Rome and also travelling to Paris and Copenhagen. On his return from Rome he worked for a year under MALCOLM OSBORNE at the RCA School of Engraving. He exhibited at the RA, RI, RWS, RBA and NEAC and held his first London solo in 1951. He was elected RWS in 1972 and his work is represented in some public collections including the Harris Museum and Art Gallery, Preston. His romantic, lyrical landscapes reveal his concern for the fluctuations of light, texture and pattern and often have a Palmeresque atmosphere of mystery. CF

GREENWOOD, John Frederic RBA, RE (1885–1954). Wood engraver, etcher, designer and painter. He studied at Shipley and Bradford Schools of Art, and at the RCA 1908–11. He taught at Battersea, Bradford and Leeds . He treated conventional landscape and other subjects with great technical craftsmanship. AW

GREENWOOD, Sydney, ATD, RWA, FRSA (b. 1913). Painter of landscapes and coastal scenes in oils and watercolours; lithographer. He studied under C. Hanney at GOLDSMITHS' COLLEGE OF ART, Croydon School of Art and in France. He exhibited at the RA 1952–63, and also showed at the RWA and the Mall Galleries. His work is represented in private and public collections in the USA. He was Lecturer in Painting at MANCHESTER COLLEGE OF ART before becoming Head of Fine Art and Design and Vice-Principal of Southampton College of Art. His exhibited paintings and lithographs include English and

Welsh subjects such as *Itchen Ferry*, 1956, and *Valley in Wales*, 1952, both exhibited at the RA.

CF

GREIFFENHAGEN, Maurice William. RA, RP, NEAC (1862–1931). Painter of portraits and imaginative subjects in oils; decorative painter, illustrator and poster designer. He drew from the antique at the BM, studied anatomy at HEATHERLEY'S and attended the RA SCHOOLS from 1878, winning the Armitage Prize and other awards. He exhibited mainly at the RA 1884–1932 and was elected RA in 1922. He also showed at the NEAC (member 1886), at the RP (elected RP 1909), in London galleries, Scotland and abroad. His work is represented in public collections including the TATE GALLERY and the NPG, London. Between 1906 and 1929 he taught at GLASGOW SCHOOL OF ART. His book illustrations which include some Rider Haggard novels, refer closely to the text, portraying a precise moment in the narrative. His richly coloured paintings of imaginative subjects were influenced by Rossetti and the Venetians (*Women by a Lake*, Tate Gallery), and his portraits range from work influenced by Whistler to more dramatic compositions (*Mrs Greiffenhagen in Black*, 1905). LIT: 'Maurice Greiffenhagen and his Works', J.S. Little, *Studio*, Vol.IX, p.235.

CF

GRESLEY, Harold, BWS, NSA (1892–1967). Painter of landscapes and figures in watercolours and oils. Son of the landscape painter Frank Gresley, he studied at Derby School of Art 1912, Nottingham School of Art under Arthur Spooner and at the RCA. He exhibited at the RA, RI, RWS, at the Cooling Gallery and in Birmingham; he was elected NSA in 1936 and BWS in 1945. His work is represented in some public collections including Derby Art Gallery. He was assistant art master at Repton School and his naturalistic, traditional landscapes often depict the Derbyshire countryside.

CF

GRIGGS, Frederick Landseer Maur, RA, RE (1876–1938). Self-taught as an etcher, he joined C.R. Ashbee's Guild of Handicrafts in Campden in 1903. His topographical and landscape subjects were treated with a visionary intensity reflecting his enthusiasm for Samuel Palmer, and influencing many artists such as SUTHERLAND and PIPER. His *Carnagh* (1918) is a characteristic work.

LIT: *A Gothic Vision: F.L. Griggs and his work*, F.A. Comstock, Boston, Mass., 1966.

AW

GROSS, Imre Anthony Sandor, LG, ARE, RA CBE (1905–1984). Painter and etcher of contemporary life; illustrator and animated cartoon film maker. Born in London, he attended the SLADE SCHOOL, the CENTRAL SCHOOL under W.P. Robins, the ACADÉMIE JULIAN, Paris, under Pierre Laurens and the Ecole des Beaux-Arts, Paris, under C.A. Waltner. In 1924 he worked under Carlos Berger in Madrid and from 1924 to 1927 he travelled widely, forming a friendship with S.W. HAYTER. From 1927 he lived and worked in France, becoming a member of La Jeune Gravure Contemporaine in 1931. He worked in England from 1939, visited the USA in 1953 and from 1955 worked in France and England. He exhibited at the RA from 1924 (RA 1980), and showed in Paris from 1930. He held regular solo exhibitions in London galleries including the LEICESTER GALLERIES from 1934, and exhibited at the LG (member 1946). His work is included in many public collections including the TATE GALLERY. He taught at the Central School 1948–54, at the Slade 1954–76, and at Minneapolis School of Art, USA, 1965. From 1941 to 1945 he was an OFFICIAL WAR ARTIST and he was awarded his CBE in 1982. His film work includes *La Joie de Vivre*, 1932–4, and amongst his book illustrations are those for Cocteau's *Les Enfants Terribles*, 1937. In 1970 he published *Etching, Engraving and Intaglio Printing*. His early painting reflects the style of Van Gogh, Soutine and Dunoyer de Segonzac and his etchings were also influenced by Segonzac as well as by Joseph Hecht and Emile Laboureur. In later work his technique broadened and became more painterly and colourful. All his work is characterized by its liveliness and, particularly in etching, by diversity of line, wealth of detail and vivacious movement. LIT: Exhibition catalogue, Ashmolean Museum, Oxford, 1989; *The Prints of Anthony Gross*, Robin Herdman, Scolar Press, 1991; *Anthony Gross*, Jean-Pierre Gross, Scolar Press, 1992.

CF

The Grosvenor School of Modern Art. The School was established at 33 Warwick Square by IAN MACNAB in 1925. Students could enrol at any time, and stay as long as they wished. MacNab was Principal and Professor of Engraving and Watercolour; Design, Composition and Life Drawing were taught, as well as The Dance by Mrs MacNab. CLAUDE FLIGHT taught linocutting and FRANK RUTTER was a visiting lecturer. The School continued until

1940 and was amalgamated with HEATHERLEY'S when both schools reopened after the war. AW

Group X. WYNDHAM LEWIS organized an exhibition in March 1920 at Heal's Mansard Gallery of six painters formerly associated with VORTICISM (Lewis, DISMORR, ETCHELLS, HAMILTON, ROBERTS, WADSWORTH) and four other artists (Frank Dobson, EDWARD MCKNIGHT KAUFFER, John Turnbull and CHARLES GINNER). Lewis wrote the Foreword to the catalogue. The Group dissolved afterwards. AW

The Grubb Group was founded by EDWARD ANTHONY CRAIG who was its first President. It exhibited first in 1928 and amongst its members was CLAUDE FLIGHT who joined the Group briefly in that year. CF

GUEVARA, Alvaro, NEAC (1894–1951). Painter of portraits, figures and landscapes in oils. Born in Chile, he came to England in 1908 and studied at Bradford School of Art and the SLADE. He married Méraud Guinness and was associated with leading figures in Bloomsbury, with AUGUSTUS JOHN, SICKERT and Edith Sitwell. He worked at the OMEGA WORKSHOPS, returned to Chile from 1922 to 1926 and from 1930 lived mainly in France. He exhibited at the NEAC from 1915 (member 1920), at the RP and IS and held solo exhibitions in London, including the CHENIL GALLERY in 1917. Represented in the TATE GALLERY, his work was influenced by Post-Impressionism, by Cubism and the Fauves, and by Sickert in subject matter.
LIT: *Latin Among the Lions: Alvaro Guevara*, Diana Holman Hunt, Michael Joseph, 1974; *Alvaro Guevara*, catalogue, P&D Colnaghi & Co., London, 1974–5. CF

GUEVARA, Méraud (b. 1904). Painter of figurative and non-figurative work in oils, collage and paint on plaster. Born Méraud Guinness, she studied at the SLADE under TONKS from 1923, with Archipenko in New York in 1926, and with Picabia in France 1927–8. In 1929 she married ALVARO GUEVARA. She held her first solo exhibition in Paris in 1928, and subsequently showed in London galleries, including the O'Hana, in Paris and New York. Her smoothly painted work combines elements of Cubism and Surrealism with an archaic simplicity.
LIT: Catalogue for the Salander Galleries, New York, 1978; *Arts Magazine* (USA), Vol.53, pt.5, January 1979, p.5. CF

GUNN, Sir Herbert James, RA, PRP, NS (1893–1964). Painter of portraits, townscapes, landscapes, interiors and beach scenes in oils. Born in Glasgow, he attended GLASGOW SCHOOL OF ART, the RSA Schools, Edinburgh, and the ACADÉMIE JULIAN under J.P. Laurens. He exhibited widely, showing at the RA from 1923, the FINE ART SOCIETY, Colnaghi & Co. and in Scotland at the RSA and GI. He was elected ARA in 1953, RA in 1961 and PRP from 1953 to 1964. He also exhibited at the Paris Salon (where he won a Gold Medal in 1939), and in Venice and Pittsburgh. Best known as a portraitist, his work includes the State Portrait of HM The Queen, 1953/4, and the *Conversation Piece at the Royal Lodge, Windsor*, 1950 (NPG, London). His formal portraits were detailed and exactly painted whilst his other subjects used a looser, more varied technique. CF

GURSCHNER, Herbert (b. 1901). Painter of portraits, landscapes, figures and religious subjects in oils, watercolours and tempera; theatrical designer and maker of woodcuts. Born in Austria into a family of sculptors, he studied at the Kunstgewerbeschule, Innsbruck, at the Munich Academy under Franz von Stuck and as a private pupil with Egger Lienz. He travelled in Spain and Italy, exhibited at the Venice Biennale, 1930, and in 1932 settled in England. He held his first solo exhibition in London at the FINE ART SOCIETY, 1929, and subsequently exhibited in London galleries, on the continent and in the USA. His painting *The Annunciation* was purchased by Sir Joseph Duveen for the TATE GALLERY. Influenced by Hodler and Lienz, his paintings have a sense of solidity and directness, using stylized, simplified figures painted with a sculptural feeling for form.
LIT: 'Herbert Gurschner', Louis Golding, *Studio*, Vol.XCIV, p.33. CF

GUTHRIE, Sir James, PRSA, HRSW, HROI, HRMS, IS, NEAC, RP, RBA, LLD (1859–1930). Painter of landscapes, portraits and genre in oils and pastels. Born in Greenock, he painted with WALTON and CRAWHALL in 1879 and studied with John Pettie in London where he was also influenced by Bastien-Lepage and John Robertson Reid. He exhibited widely, mainly in Scotland, and was elected NEAC in 1889, RSW in 1890, RP in 1893, ARSA in 1892, RSA in 1895, PRSA from 1902 to 1919, HROI and HRSW in 1903, HRMS in 1904 and RBA in 1907. He was knighted in 1903. His work is rep-

resented in collections including Glasgow Art Gallery. A leader of the GLASGOW SCHOOL, his early realistic paintings evolved towards a greater naturalism and economy and from 1885 he painted many portraits.
LIT: *Sir James Guthrie PRSA, LLD*, Sir James L. Caw, Macmillan & Co., London, 1932; *The Glasgow Boys*, Roger Billcliffe, John Murray, 1985. CF

GUTHRIE, James Joshua (1874–1952). Painter, illustrator, printer, wood engraver and etcher; author and poet. Father of ROBIN GUTHRIE, he studied at HEATHERLEY'S and with the British Museum Student's Group and worked as an assistant to Reginald Hallward from 1897 to 1899. In 1899 he established the Pear Tree Press and became a significant figure in the development of wood engraving and private presses. He exhibited mainly at the Baillie Gallery and showed at the RA, RSA, IS and abroad. His work is represented in the V & A. He made many illustrations and his imaginative work shares some characteristics with that of Samuel Palmer.
LIT: *Last Bookplates*, James Guthrie, Pear Tree Press, Flansham, 1929; *James J. Guthrie and the Pear Tree Press*, University of California Library, Santa Barbara, 1968. CF

GUTHRIE, Robin Craig, RP, NEAC, SMP (1902–1971). Painter of portraits, landscapes and genre in oils; mural painter, illustrator and draughtsman. Son of JAMES GUTHRIE, he attended the SLADE SCHOOL 1918–22, under STEER, TONKS and RUSSELL where he won the Sir William Orpen Bursary and Scholarship. He exhibited at the NEAC from 1923 (member 1928), and in 1926 he showed with RODNEY BURN and STEPHEN BONE at the Goupil Gallery, where he continued to exhibit. He also showed at the RA, 1931–70, and at various London and provincial galleries. His work is represented in public collections including the TATE GALLERY. He was Director of the School of the Museum of Fine Art, Boston, USA, 1931–3, and Instructor at the RCA, 1950–2. His illustration work includes *All the Way to Alfriston* by Eleanor Farjeon, 1919, and his painting style was based on fine, observant draughtsmanship. CF

GWYNNE-JONES, Allan, RA, RP, NEAC, DSO, CBE (1892–1982). Painter of portraits, still-life, flowers and landscapes in oils; etcher and writer. After studying law, he attended the SLADE SCHOOL 1914 and 1919–22, and from 1926 to

1927 studied etching with MALCOLM OSBORNE. He exhibited at the NEAC, 1913–39, and at the FRIDAY CLUB, 1914–18, and held his first solo exhibition at the GROSVENOR GALLERY in 1923. He exhibited widely in London galleries and was elected NEAC in 1926 and RA in 1965. His work is represented in public collections including the TATE GALLERY. From 1923 to 1930 he was Professor of Painting at the RCA, and from 1930 to 1959 he taught at the Slade School. He was a Trustee of the Tate Gallery, 1939–46, and was created CBE in 1980. During the 1920s he produced landscape etchings which reflected his interest in Palmer and Linnell. His paintings are subtly coloured and sensitive and his still-life works have a Chardinesque restraint of technique and image. His later paintings use a looser handling with touches of colour and tone constructing forms in terms of light.
LIT: Gwynne-Jones's own writings including *Introduction to Still-Life*, Staples Press, 1954; retrospective exhibition catalogue, National Museum of Wales, 1982. CF

H

HAAGENSEN, Frederick Hans (1877–1943). An etcher, born in Grimsby of a shipping family of Norwegian origin. Self-taught, his subjects were primarily those of the sea and bleak northern landscapes, evoking a powerful, brooding Nordic romanticism.
LIT: *Haagensen's Etchings, Watercolours and Drawings*, Audrey Haagensen, Malden, 1970. AW

HACKER, Arthur, RA, RI, ROI, NEAC (1858–1919). Painter of genre, religious and imaginative subjects, townscapes and portraits in oils. He trained at the RA SCHOOLS and at the Atelier Léon Bonnat, Paris, 1880–1, where his contemporaries included STANHOPE FORBES. He travelled widely and exhibited at the RA (RA 1910), and in other societies and galleries in London and the provinces. A founder member of the NEAC, in 1892 his painting *The Annunciation* was bought by the CHANTREY BEQUEST. His early genre work was influenced by French realism but after the success of *By the Waters of Babylon*, 1888, he turned to subject pictures painted in a dramatic manner. Later in his life he painted London street scenes and rural subjects such as *Couch Burners* (exhibited at the RA in 1910).

LIT: *The Last Romantics*, catalogue, Barbican Art Gallery, London, 1989; *Studio*, Vol.56, 1912.
CF

HACKNEY, Alfred, RWS, ARE (b. 1926). Painter and illustrator in pen and ink and watercolour; printmaker. Brother of ARTHUR HACKNEY, he studied at Burslem, EDINBURGH and in France and Italy. He exhibits with the LONDON GROUP, and has work in numerous public and private collections.
AW

HACKNEY, Arthur, RWS, RE, ARCA (b. 1925). Painter of landscapes, flowers and figures in oils, watercolours and gouache. Brother of ALFRED HACKNEY, he attended Burslem School of Art and the RCA and has exhibited regularly at the RA from 1948, at the RE (ARE 1948, RE 1960), the RWS (ARWS 1950, RWS 1957, VPRWS 1973–6) and in the provinces. His work is represented in collections including the V & A. Head of Printmaking at West Surrey College of Art until 1985, his painting uses decorative stylized forms and has a strong sense of design, e.g. *Silver Birch, Jan. 1967* (Coll. Harris Museum & Art Gallery, Preston).
CF

HADDON, Arthur Trevor, RBA (1864–1941). Painter of genre, particularly Italian and Spanish subjects, and portraits in oils. He attended the SLADE SCHOOL under Legros, winning a scholarship in 1883 and a medal in life painting in 1885; he subsequently studied in Madrid 1886–7. In 1888–90 he worked with Herkomer at Bushey and from 1896 to 1897 he studied in Rome. He travelled in Venezuela in 1921 and between 1926 and 1930 visited Canada, the USA and Hawaii. He exhibited mainly at the RBA (member 1896), but he also held solo exhibitions in London galleries including the LEICESTER, and showed at the RA and in other societies. He painted descriptively detailed, picturesque scenes showing Italian and Spanish peasants in national dress using a warm, harmonic colour range.
LIT: See Haddon's own publications including *Southern Spain*.
CF

HADEN, Sir Francis Seymour, PRE (1818–1910). Self-taught, his principal career was in medicine. He worked closely for a period with his brother-in-law Whistler, and was a founder-member of the Society of Painter-Etchers (see ROYAL SOCIETY OF PAINTER-PRINTMAKERS).
AW

HAGEDORN, Karl, RBA, RSMA, NS, NEAC (1889–1969). Painter of landscapes, marines, figures, portraits and townscapes in oils and watercolours. Born in Berlin, he settled in England in 1905 and studied art at MANCHESTER and the SLADE and in Paris and from 1913 worked as a designer of cotton prints. He exhibited mainly at the FINE ART SOCIETY, the RBA (member 1935), the NEAC, the LS and in Liverpool. He showed at the RA from 1931 to 1961, at the RP, RI, Manchester and Paris. Represented in Manchester City Art Gallery, his work is strongly realized and painted.
CF

HAGGAR, Reginald George, RI, ARCA, FRSA (1905–1987). Painter of townscapes, particularly the Potteries, landscapes and coastal scenes in watercolours; writer, teacher and designer. He studied at Ipswich School of Art 1920–6, and the RCA 1926–9, and exhibited at Sadler's Gallery, London, in 1937 and 1944. He was elected RI in 1952, showed at the RA from 1938 to 1961, and exhibited at the RBA, RSA, RSW and in Manchester. Represented in Stoke-on-Trent Art Gallery, he was head of Stoke, 1934–41, and Burslem, 1941–5, Art Schools and published widely on ceramic history. Co-founder of the Society of Staffordshire Artists with GORDON FORSYTH in 1934, his work became broader in technique later in his career.
LIT: Retrospective exhibition catalogue, City Museum and Art Gallery, Stoke-on-Trent, 1980.
CF

HAGGER, Brian (b. 1935). Painter of urban scenes in oils. Born in Bury St Edmunds, he attended Ipswich School of Art 1952–6, and the RCA 1958–61, holding his first solo exhibition at the Bramante Galleries, London, in 1968. He has subsequently shown at the Thackeray Gallery and at the RA, and his paintings, often depicting the more faded areas of Fulham and Chelsea, use restrained colour and strong draughtsmanship to capture the atmosphere of a particular place.
LIT: *Paintings by Brian Hagger*, catalogue, Bramante Galleries, London, 1968; *Brian Hagger*, catalogue, Thackeray Gallery, London, 1974. CF

HAGREEN, Philip (1890–1988). Wood engraver, sculptor, typographer and painter. Instrumental in founding the SOCIETY OF WOOD ENGRAVERS, he was a friend of ERIC GILL and lived for over twenty-five years in the Community at Ditchling. His work was bold, simple and romantic (*The Wind*, 1921).
AW

HAIG, George Douglas (The Earl Haig), Professional MSSA (b.1918). Painter in oil and watercolour, he was educated at Stowe and Christchurch, Oxford, and studied art (after Military Service and imprisonment as a POW during the Second World War) at CAMBERWELL, 1945–7, under VICTOR PASMORE, and privately with PAUL MAZE. He exhibited at the REDFERN (*Red-haired Nude* was bought by the ARTS COUNCIL in 1955) with the LG and many times at the Scottish Gallery in Edinburgh. He lives in Melrose, and his work is represented in the collections of the Scottish National Gallery of Modern Art, his main oeuvre including the field of geometrical abstraction. AW

HAILE, Samuel (1909–1948). A Surrealist painter and ceramist. He attended evening classes at Clapham School of Art, then went to the RCA, 1931–5, where he was influenced by the organic forms of HENRY MOORE's work; he also studied pottery there under Staite Murray. He exhibited once at the NEAC. His characteristically Surrealist compositions 'Automobilistes', 1938, and 'Woman and Suspended Man', 1939, are respectively in the Southampton and Manchester City Art Galleries.
LIT: Exhibition Catalogue, *Sam Haile*, Birch and Conran, 1987. AW

HALL, Arthur Henderson, ARWS, RE, ARCA (b. 1906). Painter of landscapes and figures in oils and watercolours; lithographer, etcher and illustrator. He studied at Accrington and Coventry Schools of Art and at the RCA where he gained his Diploma in 1930. In 1931 he was awarded a PRIX DE ROME in engraving. He exhibited at the RA from 1930 to 1970 and showed at the RWS and LG. His work is represented in the Collection of the Trustees of the RWS. He was Head of Graphic Design, Kingston College of Art, and his work included English and Italian landscape subjects such as *Rainy Day, Henley*, 1948, and *Tuscan Landscape*, 1970 (both exhibited at the RA). CF

HALL, Christopher (b. 1930). Painter of townscapes and landscapes in oils. He studied at the SLADE SCHOOL and held his first solo exhibition at Arthur Jeffress Gallery in 1958. He has subsequently exhibited regularly in London galleries including the NEW GRAFTON GALLERY and has shown at the RA and LG. His work is represented in public collections including the London Museum; and he served for a period as Mayor of Newbury. His paintings, many of Italian as well as British subjects, combine realism and naïveté, capturing the appearance and atmosphere of each particular place. CF

HALL, Clifford Eric Martin, ROI, NS (1904–1973). Painter of figures, landscapes, portraits and street scenes in oils and acrylic; etcher. He studied at the Richmond and Putney schools of art, at the RA SCHOOLS under SIMS and SICKERT 1926–7, and in Paris under André Lhote 1928–9. He held his first solo exhibition at the BEAUX ARTS GALLERY in 1935 and subsequently showed in leading London galleries, at the RA from 1930 to 1958, and at the RP, ROI, NEAC, LG, RBA and the Paris Salon. His work is represented in public collections including the V & A and the IMPERIAL WAR MUSEUM. His early, restrained style was influenced by Sickert but later work depicted wrapped figures, often seen from the back, painted in large areas of strong colour, evoking a Surrealist atmosphere.
LIT: Catalogue, Belgrave Gallery, London, 1977. CF

HALL, Lady Edna Clarke (1879–1979). Painter in watercolours; etcher, lithographer and illustrator. Edna Waugh, as an 'infant prodigy' of sixteen, studied at the SLADE 1895–9 under TONKS, winning Second Prize for the Summer Composition of 1897 for her painting *The Rape of the Sabine Women*. Her sister Rosa and GWEN JOHN were fellow-students. She became a fine draughtsman, and although she had some lessons from Gwen John with oils, she did little or nothing in that medium. She exhibited with the FRIDAY CLUB and the NEAC. Her watercolours *A Girl*, 1924, *Justin Reading*, 1932, and some of her many romantically charged drawings illustrating *Wuthering Heights* (from which she also made etchings) are in the TATE GALLERY. Her approach was typically of loose and spontaneous watercolour, often reinforced with pen or pencil drawing. AW

HALL, Frederick, RBC, NEAC (1860–1948). Painter of landscapes and genre in oils; caricaturist. He studied at Lincoln School of Art 1879–81, and at Verlat's Academy, Antwerp, 1882–3. He settled in Newlyn *c.*1885–6; in the later 1880s he painted at Porlock, Somerset, and his association with Newlyn ended *c.*1897. After 1911 he lived near Newbury. He exhibited in London from 1883, showing mainly at the FINE ART SOCIETY and at the RA from 1887. He was elected NEAC in 1888 and won a gold medal at

the Paris Salon of 1912. Much of his Newlyn work is now lost, but his paintings ranged from *plein-air* studies to interior genre scenes such as *The Result of High Living*, 1892, as well as subtle, impressionistic landscapes painted in warm, glowing colour such as *In the Kitchen Garden*, 1887 (Barclays Bank plc.).

LIT: *Painting in Newlyn*, catalogue, Barbican Art Gallery, London, 1985; catalogue, Fry Gallery, London, 1975. CF

HALL, Oliver, RA, RWS, RE, IS (1869–1957). Painter of landscapes and architecture in oils and watercolours; etcher. Born in London, he studied at the RCA under Sparkes 1887–90, and attended evening classes at LAMBETH and WESTMINSTER schools of art. He also studied privately with the Liverpool artist D.A. Williamson and with W.L. Windus. He travelled widely in Spain, Italy and France and held his first solo exhibition at the Dowdeswell Gallery in 1898. He exhibited at the RA from 1890 (first as an etcher), and he showed widely in London galleries and societies and abroad. He was elected RE in 1895, IS in 1904, RWS in 1919 and RA in 1927, becoming a Senior Academician in 1945. In 1920 and 1936 his work was purchased by the CHANTREY BEQUEST. He painted widely in Yorkshire, often depicting moorland scenes, and in Spain. His work reflects his ability to suggest detail broadly. LIT: 'The Landscape Paintings and Watercolours of Oliver Hall', T. Martin Wood, *Studio*, Vol.XL, p.268. CF

HALL, Patrick (1906–1992). He studied at York and at Northampton. A painter in watercolour and gouache, an etcher and lithographer, his light, cheerful topographical views of European cities led to honours including being made Freeman of the City of York. AW

HALL, Patrick (b. 1935). From County Tipperary, he studied at CHELSEA 1958–9, and at the CENTRAL 1959–60. His first solo exhibition was in 1980, at the Lincoln Gallery, Dublin. He lived in Spain 1966–73, and his dark vision owes much to certain traditions of Spanish art. He returned to Dublin in 1974, and in 1982 was made a member of Aosdána by the Irish State. Themes in his work, as exemplified by *Mountain* (1994) have dwelt on male bodies, sexual encounters and, in that painting, the threat of AIDS. AW

HALLIDAY, Edward Irvine, PRBA, PRP, ARCA (b. 1902). Painter of portraits and classical sub-

jects in oils and watercolours; decorative painter. He studied at Liverpool School of Art 1921–3, at COLAROSSI'S in Paris 1923, and at the RCA 1923–5, winning a ROME SCHOLARSHIP in decorative painting from 1926 to 1929. He exhibited at the RA, in Liverpool and at the Paris Salon, winning a gold medal in 1953. He was elected RBA in 1942, RP in 1952, PRBA in 1956 and PRP in 1970. His work is represented in private and public collections. Painter of many well-known figures, his commissions included portraits of members of the Royal Family and his style concentrated on a precise realistic depiction of his sitters, e.g. *The Rt. Hon. Lord Denning*, 1962 (Lincoln's Inn). CF

HALLIDAY, Trevor (b. 1939). Painter in acrylic, oils and watercolours. He studied at Birmingham College of Art 1955–60, and at the RA SCHOOLS 1960–3. He held his first solo exhibition at the Ikon Gallery, Birmingham, in 1974, and he has subsequently exhibited at London and Birmingham galleries and at Nottingham University Gallery in 1980. He has shown regularly in group exhibitions, including the JOHN MOORES, at the LG 1964–71, and at the RA. From 1963 to 1968 he taught at Coventry College of Art; between 1968 and 1972 worked at Tabernacle Street Studios, London, and since 1964 has taught at Birmingham Polytechnic and as Visiting Lecturer at the RCA and RA SCHOOLS. In the 1970s he produced large-scale, vigorous abstract paintings in acrylic, at the end of the decade he also started to work on large-scale figurative works which used a personal range of imagery from a wide range of sources to depict mythological figures in a deliberately archaic, decorative style. LIT: *Studio International*, December 1973 and March 1974. CF

HAMBLING, Maggi (b. 1945). Painter of portraits, figures and a wide range of subjects in oils and watercolours. She studied with CEDRIC MORRIS in East Anglia, at CAMBERWELL and at the SLADE SCHOOL, and has exhibited in London galleries since 1967, including the NPG in 1983, the SERPENTINE in 1987, and in the provinces. Her work is represented in public collections including the TATE GALLERY. From 1980 to 1981 she was the first Artist in Residence at the National Gallery, London: Her portraits, such as those of Max Wall, are very popular. Her vibrant, colourful paintings express movement and light in energetic marks

and recent work has concentrated on the subject of sunrise.
LIT: Article in *Art Line*, No.5, March 1983; *Maggi Hambling, Paintings, Drawings and Watercolours*, Serpentine Gallery, 1987. CF

HAMILTON, Cuthbert (1885–1959). Painter of figurative and VORTICIST works in oils; designer of textiles and pottery. He studied at the SLADE SCHOOL where he was a contemporary of WYNDHAM LEWIS, and in 1912 he assisted Lewis with his decoration for the Cave of the Golden Calf. In 1913 he joined the OMEGA WORKSHOPS but left after Lewis's rift with FRY. He exhibited at the 2nd Post-Impressionist Exhibition, the 1913 Post-Impressionist and Futurist Exhibition at the Doré Galleries and in the Cubist Room of the 1913–14 Brighton Exhibition. He also showed with the LG and was a member of the REBEL ART CENTRE. A signatory of the Vorticist Manifesto, he contributed to *Blast* No.1 and to the GROUP X Exhibition of 1920, subsequently concentrating on work for the Yeoman Potteries which he had founded. Influenced by Wyndham Lewis, his work used energetic, radically distorted and simplified forms with jagged, mechanistic shapes and vigorous diagonals.
LIT: *Vorticism and Abstract Art in the First Machine Age*, Richard Cork, Gordon Fraser, London, 1976. CF

HAMILTON, James Whitelaw, RSA, RSW, NEAC, IS (1860–1932). Painter of landscapes and coastal scenes in oils and watercolours. He attended GLASGOW SCHOOL OF ART and painted with GUTHRIE, WALTON and CRAWHALL at Cockburnspath in Berwickshire. He studied in Paris under Dagnan-Bouveret and Aimé Morot, subsequently returning to Glasgow where he was associated with the Glasgow School. He exhibited mainly in Scotland at the GI, RSA and RSW, being elected RSW in 1895 and RSA in 1922. He also showed at the RA, NEAC (member 1887), RP, Barbizon House and in the provinces. He exhibited abroad and in 1897 won a gold medal at the Munich International Exhibition. His work is represented in collections in Britain and abroad. A founder member of the IS and member of the Munich Secession, he was a Governor of Glasgow School of Art, President of the Scottish Artists' Benevolent Association, Hon. Vice-President of the GI and member of the Royal Fine Art Commission for Scotland. Influenced by Walton and by French painting, his work

includes landscapes of the Berwickshire coast and of Westmorland.
LIT: 'The Paintings of James Whitelaw Hamilton', A. Stodart Walker, *Studio*, Vol.LX, p.9. CF

HAMILTON, Letitia Marion, RHA (1878/9–1964). Irish painter of landscapes and coastal views in oils and watercolours; enamel plaque artist. She studied at the Metropolitan School of Art, Dublin, under Sir WILLIAM ORPEN and at the CHELSEA POLYTECHNIC, London, under FRANK BRANGWYN. She travelled widely in Europe and exhibited mainly at the RHA, but she also showed in London galleries including the Goupil, and at the RA, 1922–35, and the Paris Salon, 1925–8. A founder member of the Dublin Painters, her work was influenced by PAUL HENRY and RODERIC O'CONOR, using a heavy impasto and a quick but broad impressionistic technique, e.g. *Rain at Kilkee* (exhibited at the RHA in 1948). CF

HAMILTON, Richard (b. 1922). Painter of figures, interiors and contemporary subjects including pop imagery in a wide range of media, collage and photographic processes; printmaker. He attended WESTMINSTER TECHNICAL COLLEGE under GERTLER and ST MARTIN'S SCHOOL OF ART under MENINSKY before working as a display assistant in a commercial studio. He studied at the RA SCHOOLS 1938–40 and 1945–6, and was a student at the SLADE SCHOOL 1948–51, studying etching with JOHN BUCKLAND WRIGHT. In 1951 he organized the exhibition 'Growth and Form' (ICA London), he was a member of the INDEPENDENT GROUP 1952–3, and in 1955 he organized the exhibition 'Man, Machine and Motion' (Newcastle upon Tyne). He exhibited in 1956 in the 'This is Tomorrow' exhibition (Whitechapel Gallery, London) which launched him as a pioneer of the Pop Art movement, and in 1963 he made his first trip to the USA with Duchamp where he was influenced by American artists including Warhol, Lichtenstein and Oldenburg. Between 1965 and 1966 he worked on the reconstruction of Duchamp's *Large Glass* and in 1966 organized the Duchamp exhibition at the TATE GALLERY. He held his first solo exhibition at GIMPEL FILS, London, in 1950 and he subsequently exhibited in London galleries, including Waddington Graphics, nationally and internationally. He has collaborated in exhibitions with Dieter Roth, 1976 and 1977, and with RITA DONAGH, 1983. His work is represented in many

public collections including the Tate Gallery, the Guggenheim Museum and MOMA, New York. He taught Design at the CENTRAL SCHOOL, 1952–3; was Lecturer in Basic Design at Durham University, 1956–8, where he instigated the 'Developing Process' course with VICTOR PASMORE and was lecturer in Interior Design at the RCA, 1957–61. His many awards include the joint 1st Prize at the JOHN MOORES in 1969. His early work was often concerned with the representation of movement and the use of a schematic perspective notation. Works such as the collage *Just What is it that Makes Today's Homes so Different, so Appealing*, 1956, encapsulated the major concerns of Pop Art. He has subsequently continued to use popular imagery as well as referring to the Fine Art tradition and to social and political issues such as the Maze prisoners. Often depicting the human figure and interiors, his work has a detached, ironic manner and a precise, virtuoso pictorial technique which combines different media, styles and degrees of illusion.
LIT: Catalogue, Tate Gallery, 1970; *Collected Works*, Richard Hamilton, 1982. CF

HAMNETT, Nina, LG (1890–1956). Painter of portraits, landscapes and urban scenes in oils; illustrator. She trained at the Pelham School of Art under SIR ARTHUR COPE, the London School of Art under Swan, LAMBERT and NICHOLSON, and lived for some time in Paris. Amongst her friends were Modigliani, SICKERT, AUGUSTUS JOHN, WYNDHAM LEWIS, Satie, Cocteau and Stravinsky. Associated with both GAUDIER BRZESKA and FRY, she was a founder member of the OMEGA WORKSHOPS and exhibited in the 'New Movement in Art' exhibition, 1917. She held her first solo exhibition at the Eldar Gallery, London, in 1918, and continued to exhibit in London galleries and at the AAA, FRIDAY CLUB, Grafton Group, LG (member 1917), NEAC and the Salon d'Automne, Paris. Her work is represented in some public collections including Southampton Art Gallery. From 1917 to 1918 she taught at the WESTMINSTER TECHNICAL INSTITUTE and her illustrations include Osbert Sitwell's *The People's Album of London Statues*, Duckworth, 1928. Influenced by French painting, Fry and Modigliani, her direct, strong painting reflects her interest in the structure of form and her desire to 'represent accurately the spirit of the age'.
LIT: *Nina Hamnett and her Circle*, catalogue, Michael Parkin Fine Art, London, 1986; *Laughing Torso*, Nina Hamnett, Constable, London, 1932; *Is She a Lady?*, Constable, 1955;

Nina Hamnett: Queen of Bloomsbury, Denise Hooker, Constable, 1986 CF

HANNAFORD, Charles E., RBA (1863–1955). Painter of landscapes and marines in watercolours. After being elected to the Institute of Civil Engineers in 1888 and working as an architect, he settled in Plymouth in 1897 and concentrated on painting, studying with STANHOPE FORBES in 1889, and in Paris. He exhibited mainly at the RBA (member 1916) and at Walker's Gallery, London, where he held solo exhibitions in 1910 and 1912. He also exhibited at the RA, RCA, RI and in Manchester; examples of his work were purchased for the Royal Collection. His painting is also represented in some public collections including Exeter Museum and Art Gallery. His watercolours reveal his interest in effects of light and sometimes use broken strokes of colour. CF

The Hanover Gallery. Between *c.*1948–71 the Hanover Gallery at 32a St George Street, Hanover Square, London, showed major British and Continental artists, concentrating on twentieth-century painting, drawing and sculpture. Amongst the exhibitions held there were GERALD WILDE and MICHAEL AYRTON in 1948, Tchelitchew and FRANCIS BACON in 1949, LUCIEN FREUD in 1950, RICHARD HAMILTON in 1964, Max Ernst in 1965 and PAOLOZZI in 1967. CF

HARDIE, James Watterson (b. 1938). Painter of figures, landscapes and townscapes in oils. He studied at GLASGOW SCHOOL OF ART 1955–9, winning the Keith Award and the Chalmers Bursary to study in Holland and France. He held his first solo exhibition at the Blythswood Gallery, Glasgow, 1961, and he has subsequently exhibited regularly in Scotland; his work is represented in public collections including the TATE GALLERY. Winner of the Torrance Award and prizewinner at the Arbroath Festival, he has been Lecturer in Drawing and Painting at Glasgow School of Art since 1980. His work selects and simplifies figurative elements, depicting them with lively strokes of colour in painterly areas which stress the canvas surface and move the composition towards abstraction. Recent paintings have taken subjects from Scotland and America. CF

HARDIE, Martin, CBE, RI, RSW, RE, SGA, (1875–1952). Etcher and watercolourist; museum curator. He studied under SIR FRANK SHORT,

and became Keeper of the Departments of Painting and Engraving at the V & A 1921–35. The revival of interest in Samuel Palmer owed much to his work at the museum, and he wrote many books on art, such as *Watercolour Painting in Britain*. His landscape etchings were calm and limpid, with little trace of human activity. AW

HARRIS, Alfred (b. 1930). Painter of a wide range of subjects in acrylic, mixed media and collage; printmaker and draughtsman. He attended Willesden School of Art 1947–52, and the RCA 1952–5, and held his first solo exhibition at the Ben Uri Gallery, London, in 1959. He subsequently exhibited regularly in London and Sweden and has shown in group exhibitions since 1951. His work is represented in public collections in Britain and Sweden, and he is Chairman of the Department of Art and Design, University of London Institute of Education. He presents his images without illusionistic perspective, often setting figurative details against more abstract passages of colour. Some paintings use a shaped support whilst others are divided into equal rectangular shapes by a painted grid.
LIT: *Alfred Harris: Ten Years in Retrospect*, catalogue, Bedford Way Gallery, London, 1979. CF

HARRIS, Lyndon Goodwin, RI, RSW, RWA (b. 1928). Painter of landscapes and architecture in oils and watercolours; etcher and stained glass designer. He attended Birmingham and the CENTRAL schools of art, the COURTAULD INSTITUTE, and the SLADE SCHOOL 1946–50, under SCHWABE and COLDSTREAM. He exhibited at the RA from 1942 to 1956, at the RWA, RSW, RI, RSA, RBA and NEAC, and was elected RWA in 1947, RSW in 1952 and RI in 1958. He also showed at the Paris Salon where he was awarded Hon. Mentions in 1948 and 1949 and a gold medal in 1956. His exhibited work includes English scenes such as *Old Houses and Church, Halesowen*, RA 1942, and *The Clees from Walton*, RA 1952. CF

HARRISON, Claude William, RP, ARCA (b. 1922). Painter of portraits, conversation pieces and imaginative figure subjects in oils and tempera. He studied at Preston School of Art 1939–41, Liverpool School of Art 1941–2, and the RCA 1947–50. He has exhibited regularly at the RA, the RP (member 1961) and in group exhibitions, and has held solo exhibitions in London, Northern England, Italy and the USA. His work is represented in public and private collections and

he is married to the artist AUDREY JOHNSON. His early works were painted on a small scale in great detail. In the 1950s he turned to tempera and his imaginative figure paintings represented contemporary and allegorical subjects. Many of these works now depict pierrots, maskers and clowns shown against bleak and deserted backgrounds.
LIT: *Portrait Painters' Handbook*, Claude William Harrison, 1968; *The Book of Tobit*, 1969. CF

HART, John (b. 1921). Painter of abstracts in oils, acrylic, watercolours, ink and collage; calligrapher. Born in Manchester, he attended Liverpool College of Art 1946–51, and worked in Cassis and Paris in 1958. He held his first solo exhibition at the BEAUX ARTS GALLERY, London, and has subsequently shown in London galleries including the Camden Arts Centre, the provinces and regularly in group exhibitions. His work is represented in public collections including Nottingham Castle Museum. A member of the Midland Group of Artists, he has taught at Liverpool and GOLDSMITHS' colleges of art. In 1965 his interests in painting and calligraphy combined in works confronting the problems of his own eyesight; he used written material: documents, braille, codes and numbers etc., as a visual source.
LIT: *Hart's Camden Exhibition*, Camden Arts Centre, 1975. CF

HARTRICK, Archibald Standish, RWS, NEAC, IS, OBE (1864–1950). Painter of figures and landscapes in watercolours and oils; draughtsman, lithographer and illustrator. He trained at the SLADE SCHOOL under Legros 1884–5, at the ACADÉMIE JULIAN, Paris, and with Cormon. He met Toulouse-Lautrec and Van Gogh, and in 1886 he met Gauguin at Pont-Aven. On his return to Britain he worked for the *Daily Graphic* and the *Pall Mall* magazine before settling in Gloucester with his wife LILY BLATHERWICK. He exhibited first at the Paris Salon and showed in London at the RA 1895–1907, at the NEAC (member 1893), the IS (member 1906), the RWS (member 1922), and widely in societies and galleries. His work is represented in public collections including the TATE GALLERY. A founder member of the SC, he taught at CAMBERWELL and the CENTRAL Schools of Art. Best known for the perception and freshness of his draughtsmanship, his work was influenced by French painting.
LIT: *A Painter's Pilgrimage through Fifty Years*, 1939; *Lithography as a Fine Art*, 1932: both by A.S. Hartrick. CF

HARVEY, Harold C. (1874–1941). Painter of landscapes, marines, figures and interiors in oils. Born in Penzance, he studied under NORMAN GARSTIN, and in Paris at the ACADÉMIE JULIAN under Constant and Laurens in 1890. He married the artist GERTRUDE HARVEY, née Bodinar, and settled in Newlyn, Cornwall. He exhibited at the RA 1898–1941, held several solo exhibitions in London galleries including the LEICESTER GALLERIES and also showed regularly at the Newlyn Art Gallery. His work is represented in public collections including the Birmingham Museum and Art Gallery. He was influenced first by STANHOPE FORBES and Garstin but from 1915 he adopted a flatter, more sharply focused style, often depicting figures in interiors in a manner which reflected the influence of DOD PROCTER. LIT: *Painting In Newlyn*, Barbican Art Gallery, London, 1985. CF

HARVEY, Marcus (b. 1963). Painter. He graduated from GOLDSMITHS' in 1986. He has been best known for large paintings of nude female torsos, sometimes derived from pornographic magazine photographs, executed in violently expressionist thick impasto acrylics; black outlines are (by contrast with the thick paint) flat and revealed with the removal of masking-tape. *Dudley, Like What You See? Then Call Me* (1996) is typical. His *Myra* (1995; a monochrome transcription of the notorious photograph of Myra Hyndley on a giant scale, using child's-hand shaped stencils) caused much controversy and was damaged when on exhibition in the 1997 'Sensation' exhibition at the RA. AW

HARVEY, Michael A., NDD, FRSA (b. 1921). Figurative painter in oils, watercolours and pastels; journalist and art critic. He studied at Wimbledon School of Art and has held solo exhibitions in London and exhibited with the Royal Society of Marine Artists. His work is represented in public private and corporate collections including Camden Council, East Sussex County Council and Johns Hopkins University, USA. Life Member of the International Association of Art (UNESCO), Chichester Art Society and Reigate Society of Artists, he is a Council Member of the SGA. In 1973 he was awarded the Linton Prize for painting. His work is instinctive, non-sensational, unobsessive surrealism, and recent subject matter concerns the sea or the seashore. CF

HASELDEN, Ron (b. 1944). Artist in installations using a wide range of materials; sculptor

and draughtsman. He studied at Gravesend School of Art in 1960, winning a scholarship to EDINBURGH COLLEGE OF ART in 1963. He has exhibited in London galleries including the ICA Gallery, in the provinces, Scotland and abroad and his work is represented in public collections including the ARTS COUNCIL Collection. A lecturer at Reading University Department of Fine Art, his awards include a Major Arts Council Bursary, 1978, 1st Prize in the Holborn Tube Station Competition, 1980, and an Edwin Austin Abbey Memorial Scholarship, 1988. His time-based works have been concerned with social issues and aspects of contemporary industrial history and recent installations and outdoor pieces have used light as a material. His drawings show ideas for projects in meticulously drawn structures of fine lines and coloured marks. LIT: Catalogue, Ikon Gallery, Birmingham, 1988; *Aspects*, No.25, Winter 1983/4. CF

HASLEHURST, Ernest William, RI, RBA, RWA, RBC (1866–1949). Painter of landscapes, townscapes and architecture; illustrator and poster designer. He trained at the SLADE SCHOOL under Legros and painted in England and Holland. He exhibited mainly at the RBA where he was elected a member in 1911; he also showed at the RI (member 1924), at the RA 1914–45, in Liverpool, Glasgow, and at the Ridley Art Club. His work is represented in some public collections including the V & A. He was a member of the Langham Sketching Club and President of the Midland Sketching Club. He illustrated the *Beautiful Britain* books and designed posters for British Rail. His work was noted for its full-toned, transparent colour and its fine composition. LIT: *Folkestone and Dover*, W. Jerrold, illustrated by Ernest Haslehurst, Blackie & Son Ltd, London, 1920. CF

HASTINGS, John, 15th Earl of Huntingdon (b. 1907). Painter of murals and easel paintings. He studied at the SLADE under TONKS, and, following travel in the South Pacific, had his first one-man show in San Francisco in 1931. He became a pupil and assistant of Diego Rivera and worked for him on the San Francisco Stock Exchange Lunch Club murals. In 1933 he painted murals for the Hall of Science at the Chicago World's Fair. He exhibited at the LEFEVRE gallery and later painted murals at Buscot Park for the socialist Lord Faringdon. AW

HAUGHTON, David (1924–1991). Painter of townscapes, landscapes and abstracts in oils;

printmaker. He trained at the SLADE SCHOOL and moved to Cornwall in 1947 where he painted in the town of St Just. He exhibited at the Crypt Gallery, St Ives, in 1948, with the St Ives Society of Artists and the PENWITH SOCIETY. He has held solo exhibitions in Cornwall, London and the provinces and shown in group exhibitions. He taught at the CENTRAL SCHOOL OF ART 1951–84. From the severe geometrical simplification of his early work his paintings became more complex in structure and texture. This development led to abstraction in which lively marks were set against grids, reminiscent of the natural and man-made elements in his townscapes.
LIT: Catalogues for Newlyn Art Gallery, 1979; Work of Art Gallery, London, 1983. CF

HAWKINS, Dennis, DFA, AIA (b. 1925). Painter of landscapes and abstracts in oils and mixed media; printmaker; relief and decorative artist; muralist. He studied at the RUSKIN SCHOOL under ALBERT RUTHERSTON 1947–9, and at the SLADE SCHOOL under COLDSTREAM 1949–52. He held his first solo exhibitions in Nottingham in 1955, and at the New Vision Centre and the AIA Gallery, London, in 1958. He has subsequently exhibited in London galleries including the ZWEMMER GALLERY and Philip Francis Gallery, exhibited with the LG and shown in group exhibitions in Britain and abroad since 1961. His work is represented in public collections including the V & A. Founder member and Chairman of the Printmakers' Council of Great Britain, he was art master at Repton School from 1952. His commissions include a crucifix for Repton School, 1979–80, and his work ranges from intense abstract prints to images based on seeing landscape from the air. CF

HAWKINS, Harold Frederick Weaver (b. 1893). Painter of portraits, figures and landscapes in oils and watercolours; etcher, engraver, aquatinter and linocut artist. He trained at CAMBERWELL and WESTMINSTER Schools of Art and at the RCA. He exhibited mainly at the Goupil Gallery, London, and at the RA in 1921 and 1923, at the NEAC, with the South London Group and in Liverpool. His exhibited works included some North African subjects such as *El Sokko Grande, Tangier*, and *A Moorish Market* (both exhibited at the RA in 1923). CF

HAWTHORNE, Elwin (b. 1905). Painter of urban scenes and still-life in oils. He worked for three years in SICKERT'S studio and exhibited

mainly at the LEFEVRE Gallery where he held a solo exhibition in 1938. A member of the East London Group, he was influenced by John Cooper. His work is represented in collections including Manchester City Art Gallery (*Church Near Blackheath*); his paintings use simplified, solid forms with clear delineation and sharp tonal contrasts. CF

HAY, James Hamilton (1874–1916). A painter and etcher, born in Birkenhead, he studied at St Ives under JULIUS OLSSON, and later with AUGUSTUS JOHN. He painted landscapes and townscapes 'free from topographical, historical or anecdotal interest'; his main concern being with broadly expressed effects of light. He moved to London in 1912 and was elected to the LONDON GROUP in 1915.
LIT: *James Hamilton Hay*, exhibition catalogue, Walker Art Gallery, Liverpool, 1973. AW

HAYES, Colin, RA (b. 1919). Painter of landscapes, marines, portraits and still-life in oils; writer on art. He was educated at Westminster School and Christchurch, Oxford, and studied art at BATH SCHOOL OF ART and the RUSKIN SCHOOL of Drawing 1946–7. He has travelled extensively and has exhibited at the RA since 1952, becoming ARA in 1963 and RA in 1971. His London exhibitions include shows at MARLBOROUGH FINE ART, Agnews and the NEW GRAFTON GALLERY, and his work is represented in public collections including that of the ARTS COUNCIL. He was Senior Tutor and Reader at the RCA 1949–84, and in 1960 he became Fellow, RCA. His publications on art include *Renoir*, 1961, *Stanley Spencer*, 1963, and *Rembrandt*, 1969. The subjects of his paintings reflect the width of his travel, ranging from views of Greece to Tibetan and Indian scenes. His work is painted in simplified shapes of strong, bright and contrasting colour which both represents the subject and emphasizes the surface of the canvas. CF

HAYMAN, Patrick (1915–1988). Painter of figures and landscapes in oils and watercolours; poet and illustrator. He began to paint in Dunedin, New Zealand, and subsequently worked in St Ives and London. A member of the PENWITH SOCIETY, he exhibited in St Ives in 1951, and later in London, the provinces and abroad. His work is represented in public collections including the TATE GALLERY. His simplified, powerful images evoke myths and mystery in strong colour.

LIT: Catalogue, Whitechapel Art Gallery, 1973; 'A Painter's Notes', *The Painter and Sculptor*, Vol.3, 1959–60. CF

HAYTER, Stanley William, CBE (1901–1988). Painter of abstracts in oils and gouache; engraver and etcher; writer. Son of the artist William Harry Hayter, he took a B.Sc. in Chemistry and Geology at King's College, London, and worked in Iran 1922–5, before going to the ACADÉMIE JULIAN, Paris. There he met Balthus and Calder and he studied copper engraving with Joseph Hecht. He lived in Paris from 1926 to 1939 and in 1927 was the founder and director of ATELIER 17. During these years he was influenced by the SURREALISTS and associated with Eluard, Miró, Arp and Tanguy. In 1934 he met Picasso who became a frequent visitor to the Atelier. In 1939 he moved to London and between 1940 and 1946 lived in the USA where he opened Atelier 17 in New York in 1941. Amongst the artists who worked with him there were Motherwell, Pollock and Rothko. Returning to Paris in 1950 he reopened the Atelier and in 1951 bought a house in Alba in the Ardèche. He exhibited with the Surrealists in Paris in 1933, in London (1936), and in New York; he held his first solo exhibitions in Brussels in 1927 and in London at the Claridge Gallery in 1929. He exhibited extensively both nationally and internationally, as a printmaker and as a painter, in solo and group exhibitions. His work is represented in numerous public collections and retrospective exhibitions have included those at the Whitechapel Gallery, 1957, Kobe, Japan, 1985, and the Ashmolean, Oxford, 1988. He taught in California, Chicago and New York and his many prizes and awards include the Liturgic Prize, Venice Biennale, 1958, and the Grand Prix de la Ville de Paris, 1972. He was awarded a CBE in 1967, became an Honorary RA in 1967 and in 1986 Commandeur, Légion d'Honneur. One of the most influential twentieth-century printmakers, he pioneered new processes which transformed the art of gravure, initiating simultaneous colour printing and a wider range of colours. His painting moved towards abstraction in the late 1920s and was influenced by Surrealism in its reconstruction of nature. His paintings show his concern with structure and movement expressed in mobile, rhythmic and graphic lines, which run across brilliantly coloured areas.
LIT: *New Ways of Gravure*, S.W. Hayter, 1949; *The Renaissance of Gravure*, S.W. Hayter, Clarendon Press, Oxford, 1988. CF

HAYWARD, Alfred Robert, ARWS, RP, NEAC, IS, ROI, RC (1875–1971). Painter of landscapes, portraits and figures in oils. He trained at SOUTH KENSINGTON and the SLADE SCHOOL 1895–7, where he formed a friendship with AUGUSTUS JOHN. He painted in Venice in 1923 and continued to travel throughout his life. He exhibited widely showing many works at the NEAC (from 1897), the RA, and the Goupil Gallery. An Honorary Life Member of NEAC in 1957, he was elected ROI in 1928 and RP in 1929. His work is represented in the TATE GALLERY, IMPERIAL WAR MUSEUM and other public collections. He was an OFFICIAL WAR ARTIST in 1918 and later often painted with STEER and helped ORPEN with commissions. His own work ranges from early lyrical landscapes to realistic war work and more impressionistic views of Venice.
LIT: Centenary exhibition catalogue, Belgrave Gallery, 1975. CF

HAYWARD, Arthur (b. 1889). Painter of portraits, figures and landscapes in oils. Born in Southport he attended Warrington School of Art and studied under STANHOPE FORBES. He exhibited at the RA, ROI, RSA, RWA, in the provinces and at the Paris Salon. He was Principal of St Ives School of Painting and a member of the St Ives Art Club. His clearly formed and coloured works range from bright studies of St Ives to stylized, strongly designed portraiture, e.g. *Self Portrait*, 1933 (National Portrait Gallery, London). CF

HAZELWOOD, David (b. 1932). Painter and collagist of abstracts in a wide range of materials including wood, cloth, hessian, music sheets and natural dyes. He is mainly self-taught as an artist and held his first solo exhibitions at the University of London in 1965 and 1967. He has subsequently shown in London galleries, in the provinces and in Germany principally at Galerie Redies, Düsseldorf. He has exhibited at the RA from 1977 and in many group shows, particularly with Anthony Dawson Fine Art, London. He is represented in public collections including the V & A. His lyrical and evocative abstract collages unify their various materials through subtle colour, balance and unity of composition.
LIT: *David Hazelwood: Collagen*, C. Vielhaber, Galerie Peerlings, Krefeld, 1993. CF

HEAD, Tim (b. 1946). Born in London, he studied at Newcastle University 1965–9, worked for Claes Oldenburg in New York in 1968, and stud-

ied sculpture at ST MARTIN'S 1969–70. His first one-man show, of mirrors and projected light, was at the Museum of Modern Art in Oxford in 1972. In 1987 he won first prize at the JOHN MOORES Exhibition, Liverpool. He now exhibits at Nicola Jacobs Gallery, and recent paintings in acrylic evoke micro-biological organisms in clear, flatly painted colours. AW

HEATH, Adrian (1920–1992). Painter of abstracts and semi-abstracts in oils and acrylic; collagist and constructivist. Born in Burma, he studied art under STANHOPE FORBES at Newlyn in 1938 and attended the SLADE SCHOOL in 1939 and 1945–7 under SCHWABE. As a POW he met and taught TERRY FROST and in 1949 and 1951 visited St Ives where he met BEN NICHOLSON. In the early 1950s he was associated with the MARTINS, PASMORE and ANTHONY HILL and arranged exhibitions in his studio for abstract artists. Influenced by Hambidge, Ghyka and D'Arcy Thompson, he published the essay *Abstract Art: Its Origins and Meaning*, Alec Tiranti, 1953, and between 1953 and 1954 made a series of constructions. He exhibited first at the Musée Carcassone, 1948, and from 1953 showed at the REDFERN GALLERY, London, as well as at other London galleries, in the provinces and abroad. His work has been shown in many group exhibitions and is in national and international public collections including the TATE GALLERY and the Hirschhorn Museum, Washington. He taught at BATH ACADEMY OF ART, 1955–76, and at the University of Reading, 1980–5. In 1969 he was Artist in Residence, University of Sussex, and Senior Fellow, Glamorgan Institute of Higher Education, 1977–80. He was Chairman of AIA 1955–64 and on the panel of the ARTS COUNCIL, 1964–7. His painting moved from abstraction to semi-abstraction and developed a style which retained memories of nature and combined the abstract with the experience of the motif. His drawings from nature and the figure became sources for painterly invention.
LIT: Exhibition catalogue, PALLANT HOUSE GALLERY, Chichester, 1981. CF

HEATH, Frank Gascoigne (1873–1936). Painter of landscapes, harbours, marines, figures and interiors in oils. Born in Purley, London, he studied art at SOUTH KENSINGTON, Croydon, WESTMINSTER, in Antwerp and at the HERKOMER SCHOOL in Bushey. He painted in Brittany and then studied under STANHOPE FORBES in Newlyn, Cornwall. He lived in Lamorna, Cornwall, and

exhibited in London at the RA, 1905–35. He also showed at the ROI, in the provinces and at the Paris Salon. His bright, lively scenes of Cornwall reflect the interest in *plein-air* effects and realism of the Newlyn artists.
LIT: *Painting in Newlyn 1880–1930*, Barbican Art Gallery, 1985. CF

Heatherley's. The Heatherley School of Fine Art originated in the Art School at Maddox Street, London, which was founded in 1845. In 1848 it moved to 79 Newman Street with James Matthew Leigh as Principal. Between 1860 and 1887 Thomas Heatherley was Principal and from that time the School took his name. In 1907 it moved to 75 Newman Street and in 1927 to George Street, acquiring additional studio space in the 1930s. Closed during the Second World War, it was amalgamated with the GROSVENOR SCHOOL OF MODERN ART in 1946 and re-opened at Warwick Square where it remained until 1977. The School was run on the French atelier system and was open to students without any formal entry requirements. It taught both men and women and served to prepare many students for entry to the RA SCHOOLS, placing a great importance on working from the model. Principals of the School included John Crompton, 1887–1907, Henry Massey from 1907 and IAIN MACNAB who was joint Principal with Massey from 1919 to 1925 and with Frederic Whiting from 1946 to 1953. Students of the School included Burne-Jones, WALTER CRANE, CLAUDE FLIGHT, SIR WILLIAM RUSSELL FLINT, CLAUDE ROGERS and DAME ETHEL WALKER. The Heatherley Sketch Club was open to past and present students of the School, and held monthly exhibitions, criticisms and lectures. CF

HEDGER, Ray (b. 1944). Engraver, film-maker and painter, he studied at Swindon and at the CENTRAL. His film based on Ted Hughes's *Crow* had much success. He worked in arts administration for Thamesdown and RAF Fairford 1983–8. His romantic wood engravings of landscape are characterized by strong texture and vigorous movement. AW

HEMPTON, Paul (b. 1946). Painter of landscape abstractions in oils and watercolours. He studied at GOLDSMITHS' COLLEGE OF ART 1964–8, at the RCA 1968–71, and had his first solo exhibition in 1972 at the University of Nottingham. He has exhibited in London galleries including the Ian Birksted Gallery, in the provinces and in group exhibitions. He has shown with the LG and at the

RA and is represented in public collections including the V & A. From 1971 to 1973 he was Fellow in Fine Art, Nottingham University, and he subsequently taught at Reading University and Wolverhampton Polytechnic. In 1982 he won a Gulbenkian Foundation Print Award. His work expresses the underlying forces of nature in a complex painted surface often using a marker or fixed point around which the work operates.
LIT: Exhibition catalogue, Wakefield Art Gallery and Museum, 1980. CF

HEMSWORTH, Gerard (b. 1945). Painter of figurative imagery in acrylic, often working with text. He studied at ST MARTIN'S SCHOOL OF ART 1963–7, and his London exhibitions include those at Nigel Greenwood in 1970 and the ICA in 1986. He has also shown in the provinces and abroad. His work, often in monochromatic or restricted colour, uses techniques influenced by film and photography to create large images from life, their meaning transformed through their juxtaposition.
LIT: Catalogue, ICA, 1986; *Nine Works*, Gerard Hemsworth, London, 1974. CF

HENDERSON, Elsie Marian, Baroness de Coudenhove (1880–1967). Born in Sussex, she studied at the South Kensington Schools (RCA) and at the SLADE, and worked in Paris 1908–9 and 1912. In 1924 she shared an exhibition at the LEICESTER GALLERIES with PAUL NASH and Frederick Whiting. In 1928 she married the French consul in Guernsey. She is best known for her drawings of animals, but also made sculpture. Her work is in many public collections including the Fitzwilliam Museum and the TATE GALLERY.
 AW

HENDERSON, Joseph Morris, MA, RSA, RSW (1864–1936). Painter of landscapes and coastal scenes in oils and watercolours. Born in Glasgow, the son of Joseph Henderson, he was educated at Glasgow University (where he gained his degree in 1885), and at GLASGOW SCHOOL OF ART. He exhibited mainly in Scotland at the GI, the RSA and the RSW, but he also showed at the RA and in the provinces. He was elected ARSA in 1928 and RSA in 1936. A member of the Glasgow Art Club, his work is represented in collections including the Glasgow Art Gallery. Influenced by his father, his naturalistic works include many studies of the sea and coast. CF

HENDERSON, Nigel (b. 1917). Photocollagist and collagist using a wide range of techniques and materials. He met Duchamp and Tanguy in Paris in the 1930s and after the war attended the SLADE SCHOOL 1945–9, and met PAOLOZZI, visiting him in Paris where he was introduced to Léger, Brancusi and Giacometti. From 1949 he lived in the East End and was active in the creation of the INDEPENDENT GROUP. With Paolozzi and the Smithsons he organized the 'Parallel of Life and Art' exhibition, ICA, 1953, and contributed to 'This is Tomorrow' at the Whitechapel Gallery in 1956. In 1955 he founded Hammer Prints Ltd with Paolozzi and held his first major solo exhibition at the ICA in 1961. He subsequently exhibited in London galleries including the SERPENTINE, 1983, and in the provinces. His work is represented in public collections including the TATE GALLERY. He has taught widely: from 1972 at Norwich School of Art. Aspects of his work influenced Paolozzi and HAMILTON and his photographic images use a variety of innovatory means to manipulate and transform the image, e.g. the series of heads and his own image, 1977–82.
LIT: Exhibition catalogues for Kettle's Yard, Cambridge, 1977; Norwich School of Art Gallery, 1982. CF

HENDERSON, William (b. 1941). A painter, he studied at Brighton and at the SLADE. His first one-man show was at the SERPENTINE GALLERY in 1975. *The Boxer* (1979) is in the TATE. His most characteristic abstracts contain vibrant bars and stripes of vivid colour, arranged in violent, dancing rhythms. AW

HENDRIE, Herbert, ARCA (1887–1946). Painter of landscapes and townscapes; designer of stained glass. Born in Manchester, he settled in London in 1910 and studied at the RCA under Lethaby. After war service he also studied at the SLADE SCHOOL under TONKS in 1919. He exhibited mainly at the RA, 1911–13, but also showed at the RSW, RSA, NEAC, in Liverpool and Glasgow, and at the GROSVENOR GALLERY, London. From 1923 he was Head of the Design School, Edinburgh. Many of his RA exhibits were designs for stained glass and these included a memorial window for St Peter Mancroft, Norwich, 1921, and a window for Brechin Cathedral, 1932. His paintings at the RA showed street scenes of Paris and views of France. CF

HENNELL, Thomas Barclay, RWS, NEAC (1903–1945). Painter of landscapes and figures in watercolours; writer, poet and illustrator. He

studied at Regent Street Polytechnic 1921–5, and from 1930 painted full-time. A friend of BAWDEN and RAVILIOUS, he worked for the RECORDING BRITAIN scheme in 1940, and from 1943 was an OFFICIAL WAR ARTIST in Iceland, France, Holland and the Far East where he was captured and killed. He exhibited at the NEAC (member 1943), at the RA and RWS (member 1943), and in 1944 his Icelandic pictures were exhibited at the National Gallery. His work is represented in public collections. He wrote and illustrated books on country subjects and his paintings reflect his knowledge in a swift calligraphic style full of movement.
LIT: Hennell's own publications including *Change in the Farm*, 1934; *Thomas Hennell. Countryman, Artist, Writer*, Michael Macleod, Cambridge University Press, 1988; memorial exhibition catalogue, Leicester Museum and Art Gallery, 1956. CF

HENRI, Adrian (b. 1932). Painter of landscapes and townscapes in oils, acrylic and mixed media; Liverpool poet and playwright. He studied Fine Art at Durham University and has exhibited regularly in Liverpool since 1958 as well as in London and the provinces. He has lectured at Manchester and Liverpool colleges of art and in 1972 became President, Liverpool Academy of Arts, having won the £2000 JOHN MOORES prize in that year. His paintings recreate remembered scenes, conveying naïve pleasure and enjoyment.
LIT: *Autobiography*, Jonathan Cape, 1971; catalogue, South Hill Park, Bracknell, 1986. CF

HENRY, Paul RHA (1876–1958). Painter of landscapes and coastal scenes (particularly of Ireland) and portraits in oils; draughtsman in charcoal and pencil; poster artist. Born in Belfast, he studied at Belfast School of Art, in Paris under J.P. Laurens at the ACADÉMIE JULIAN, and under Whistler. Married to the artist Grace Mitchell, from c.1912–20 he lived in Achill on the West Coast of Ireland and subsequently settled in Dublin. A founder member of the AAA and co-founder of the Dublin Painters with his wife, he exhibited in Belfast and regularly in Dublin, particularly at the Stephen's Green Gallery, showed at the RHA (ARHA 1926, RHA 1929), in London galleries, at the RA, in the provinces and abroad. His work is represented in the National Gallery of Ireland. He produced two autobiographical works: *An Irish Portrait*, Batsford, 1951, and *Further Reminiscences*, Blackstaff Press, 1978. Influenced by Millet,

Whistler and the Post-Impressionists, his work used flattened forms, harmonic colours and reflected his interest in pattern and design.
LIT: *Paul Henry 1876–1958*, catalogue, Trinity College, Dublin, and Ulster Museum, Belfast, 1973–4; *Paul Henry*, catalogue, The Oriel Gallery, Dublin, 1978. CF

HENRY, Sue (b. 1954). Painter of landscapes in acrylic. She studied at BATH ACADEMY OF ART, Winchester School of Art and Reading University. She has exhibited in solo and group exhibitions in London and the provinces since 1978 and shows at the Colin Jellicoe Gallery, Manchester. She teaches and paints in South Humberside and her representational work uses line and colour in a selective manner.
LIT: *Landscapes*, exhibition catalogue, Colin Jellicoe Gallery, Manchester, 1982. CF

HEPPLE, Robert Norman, RA, RP, NEAC (1908–1994). Painter of portraits, landscapes, flowers and figures in oils; engraver. Born in London, his father was the painter Robert Hepple and his uncle Wilson Hepple, the Northumberland animal painter. He was educated at Colfe's Grammar School, Blackheath, and studied art at GOLDSMITHS' COLLEGE, the RCA, and the RA SCHOOLS under SIR WALTER RUSSELL, winning a British Institute Scholarship in Engraving. He exhibited regularly at the RA from 1928 as well as at leading London galleries including Spink and Son Ltd. His work is represented in public and private collections in Britain and abroad. He was elected RP in 1948, NEAC in 1950, ARA in 1954 and RA in 1961, and from 1979 to 1983 he was PRP. During the war he was an OFFICIAL WAR ARTIST for the London Fire Service and his paintings are now in the IMPERIAL WAR MUSEUM. Best known as a portrait painter, his many distinguished sitters included members of the Royal Family and amongst these commissions are the portrait of HM The Queen, painted for the Royal Marines in 1965, and the portrait of HRH Prince Philip, painted for the Royal Air Force Staff College, 1964. His tonally controlled portraits presented his sitters with elegance and directness. In these and other subjects he combined a light, fluid touch with perceptive and subtle draughtsmanship and sensitive colour. CF

HEPWORTH, Dame Barbara (1903–1975). Born in Wakefield, Yorkshire, she studied at Leeds College of Art in 1921 and at the RCA 1921–4. In 1924–5 she lived in Italy, and mar-

ried fellow sculptor John Skeaping. In 1932 and 1933 she and BEN NICHOLSON (who then became her second husband) visited Picasso, Braque, Mondrian, Arp and Brancusi. She joined Abstraction-Création in 1933, was a member of UNIT ONE, and befriended Gabo when she and Nicholson moved to St Ives at the outbreak of the Second World War. During the early part of the war she concentrated on drawing, using some colour. In 1948 she exhibited paintings at REID & LEFEVRE, carried out with a mixture of pencil and oil paint, of surgical operations she had observed. Celebrated as a sculptor, she was nevertheless influential on the work of a number of painters, and, through her commitment to close contacts with contemporary European artists, she influenced the course of art in general in Britain.

LIT: *Barbara Hepworth*, exhibition catalogue, Tate Gallery, 1968; *Barbara Hepworth: A Pictorial Autobiography*, Adams & Mackay, 1970. AW

HERBERT, Albert (b. 1925). Painter of figures, including biblical subjects, in oils; etcher. He studied at ST MARTIN'S 1942–3, and Wimbledon 1947–9, and at the RCA, winning travelling scholarships to work in Spain, Paris and Rome from 1952 to 1954. He has exhibited at the RA since 1951, and with the LG, and has held solo exhibitions in London and provincial galleries and abroad. He has taught at St Martin's since 1964. After painting representational work he turned to abstracts in the 1960s but subsequently gave up painting for some years. He returned to making small-scale, painted figurative images influenced by children's art, depicting events with symbolic simplicity.

LIT: *Albert Herbert*, exhibition catalogue, England & Co., London, 1989. CF

Herkomer Art School. This was established at Bushey in Hertfordshire by Hubert von Herkomer in 1883, and continued until 1904. There were usually about thirty students in a year; married ladies or women over twenty-eight were not admitted, but students of both sexes attended segregated classes which had different lighting in order to provide a varied experience. The pose of the model was set in turn by the students; portraiture, landscape and composition were taught, in a detailed, realist approach. Many of the over 500 students (who included Algernon TALMAGE and William NICHOLSON) achieved professional distinction. AW

HERMAN, Josef, LG, OBE, RA (b. 1911). Painter of figures, particularly workers, in oils, watercolours, gouaches, pastels and pen and wash. Born in Warsaw into a Jewish family, he attended the Warsaw School of Art 1930–1, and in 1935–6 was a co-founder of the group called 'Phrygian Cap'. In 1938 he went to Brussels and became acquainted with the work of Permeke; in 1940 he moved to Britain, becoming a British citizen in 1948. He settled first in Glasgow where he knew JANKEL ADLER, then in London. In 1944 he visited South Wales, finding in the village and miners of Ystradgynlais a deep source of inspiration. He worked there until 1961 when he moved to Suffolk, returning to live in London in 1972. He travelled widely from the 1950s recording the working people of Europe and in 1968–9 he visited Mexico. He exhibited first in Warsaw, showed in Glasgow and Edinburgh in 1941–2, and in 1943 exhibited with LOWRY in London. From 1946 he exhibited regularly at ROLAND, BROWSE & DELBANCO. His work is in many public collections and retrospective exhibitions of his work include those at the Whitechapel Gallery in 1956, and Camden Arts Centre in 1980. His commissions included work for the Festival of Britain, 1951, and amongst his many awards was the Gold Medal, Royal National Eisteddfod, 1962. He received his OBE in 1981. He has formed an important collection of African sculpture. The subject of his painting is work and the interrelationship of man and nature expressed in monumental figures, often shown in twilight. His restricted palette of subtly glowing colours is applied from light to dark on the canvas, colours being overpainted with darker glazes.

LIT: Herman's own writings including his autobiography *Related Twilights*, London, 1975; retrospective exhibition catalogue, Camden Arts Centre, 1980. CF

HERMES, Gertrude Anna Bertha, RA, RE, LG, SWE (1901–1983). Painter, sculptor, wood engraver, printmaker and book illustrator. She attended Beckenham School of Art 1919–20, and between 1919 and 1921 became acquainted with the work of Rodin and Lehmbruck. From 1921 to 1925 she attended Leon Underwood's School of Painting and Sculpture where contemporaries included MOORE, COXON and PITCHFORTH. In 1922 she began wood engraving and in 1924 started to make carvings. In 1926 she married BLAIR HUGHES-STANTON and collaborated with

him in illustrations for *Pilgrim's Progress*, Cresset Press, 1926, and in murals for the World Fair, Paris, 1928. She subsequently received many commissions for wood engravings including work for Penguins Illustrated Classics and in 1931 received her first commission for a portrait sculpture. From 1940 to 1945 she worked in Canada and on her return to London began to make wood and lino block cuttings using colour. She exhibited regularly at the RA from 1934, becoming ARA in 1963 and RA in 1971, and showed in London and provincial galleries. In 1939 she represented Britain at the Venice International Exhibition and her work is represented in public collections including the TATE GALLERY. She taught at CAMBERWELL, WESTMINSTER, ST MARTIN'S and the CENTRAL schools of art and from 1966 taught wood and lino block printing at the RA SCHOOLS. Her many commissions included a mosaic floor for the Shakespeare Memorial Theatre, Stratford. She established herself as a leading wood engraver in the 1920s with work of great delicacy and complexity. Many of her subjects in sculpture and prints are animals and children and her work was influenced by Brancusi and GAUDIER BRZESKA. All her work is elegant and concentrated, expressing the essential rhythms and detail of the natural world with economy.
LIT: Catalogues for retrospective exhibitions at Whitechapel Gallery, 1967; RA, 1981; *Selborne: Wood Engravings*, Gertrude Hermes, Gregynog: Gwasg Gregynog, 1988. CF

HERON, Patrick, CBE (b. 1920). Painter of abstracts in oils and gouaches; textile designer, art critic and writer. Born in Leeds, he lived in Cornwall from 1925 to 1929, studied at the SLADE SCHOOL under SCHWABE 1937–9, and worked as an assistant to BERNARD LEACH at St Ives in 1944–5. In 1945 he moved to London, but continued to visit St Ives and returned to live in Cornwall at Zennor in 1956, taking over NICHOLSON'S studio in St Ives in 1958. He exhibited at the REDFERN Gallery, 1947–58, and at the WADDINGTON GALLERIES from 1960. He has shown extensively both nationally and internationally and retrospective exhibitions of his work include those at the Whitechapel Gallery in 1972 and the Barbican Art Gallery in 1985. His work is represented in numerous public collections including the TATE GALLERY and the V & A. He taught at the CENTRAL SCHOOL OF ART 1953–6, lectured in Australia in 1967 and 1973 and in

America in 1978. His prizes include the Grand Prize, JOHN MOORES Exhibiton 1959, and a silver medal in the VIII Bienal de São Paulo, 1965. A Trustee of the Tate Gallery from 1980 to 1987, he has been awarded Honorary Doctorates from the universities of Exeter, Kent and the RCA, London. He received his CBE in 1977. During the 1940s and 1950s he was art critic for a number of publications and he also designed for Cresta Silks. The main focus of his work is colour. His early painting was influenced by Braque and in the 1950s he turned to abstraction. By the 1970s this took the form of highly coloured shapes which gave an overpowering optical sensation and intense interaction of colour. In later work form and colour became more expansive and organic with greater reference to the natural world.
LIT: *The Shape of Colour*, Patrick Heron, London, 1973; *Patrick Heron*, ed. Vivian Knight, John Taylor/Lund Humphries, 1988. CF

HEWITT, Beatrice Pauline, RBA, ROI (b. 1907). Painter of landscapes, townscapes and portraits in oils. She studied at the SLADE SCHOOL and in Paris and exhibited mainly at the SWA, the ROI (member 1940), at the RA between 1927 and 1947 and at the RBA. She lived at St Ives until the late 1930s and was a member of the St Ives Art Gallery Hanging Committee. Her RA work ranges from Cornish scenes such as *Herring Packing, St Ives*, 1928, to paintings of Assisi and Kitzbühel in 1938 and in the 1940s views of London, e.g. *The Temple Gardens*, 1942. CF

HEWLETT, Francis, RWA (b. 1930). Painter of figures and landscapes in oils; sculptor in ceramics. He studied at the West of England College of Art 1948–52, at the SLADE SCHOOL, and at the Ecole des Beaux-Arts, Paris, and in 1955 he travelled in Italy. He held a solo exhibition at the NEW ART CENTRE, London, in 1964 and he has subsequently exhibited regularly in the West Country, at the Nicholas Treadwell Gallery, London, at the RA from 1978 and at the RWA. A member of the Newlyn Society of Artists, his work is represented in collections including Plymouth Art Gallery. He has taught at Falmouth School of Art since 1957 and in 1977 was the Gregynog Arts Fellow. His figurative work is based on careful observation.
LIT: *Francis Hewlett, Oymrodor Gregynog 1977*, catalogue, Welsh Arts Council, Cardiff, 1978. CF

HEYWORTH, Alfred, RWS, RBA, NEAC, ARCA (b. 1926). Painter of landscapes, figures and still-life in oils, watercolours and pastels; etcher. Born in Birmingham, he studied at Birmingham College of Art 1942–6, the RCA 1946–50, and La Grande Chaumière, Paris, 1950–1. He has exhibited at the RA since 1948 and his work is represented in several public collections. His watercolour paintings show his control of tone and draughtsmanship, e.g. *Low Tide, Chiswick Mall* (Coll. of the Trustees of the RWS). CF

HICKS, G.A.W. (Jerry), RWA (b. 1927). Painter of portraits, Mediterranean landscapes and figures in motion, including sporting subjects, in oils and pastels. He studied at the SLADE 1944–5 and 1948–50, under COLDSTREAM, FREUD and TOWNSEND, and during army service with WALTER BAYES at Lancaster. He works in Bristol and the South of France and has exhibited regularly at the RWA, shown in London and the provinces, at the RA, RBA and with his wife Anne Hicks. His many awards include a Silver Jubilee Award and RWA prizes. His figurative work includes portraits in landscape and it has been influenced by a range of artists including Rembrandt, Degas, SICKERT and Monet.
LIT: Catalogue for the Dorchester Gallery, Dorchester, 1990. CF

HIGSON, Jo (b. 1925). Painter of landscapes in oils. She studied at CAMBERWELL SCHOOL OF ART 1946–9, and in 1953 was awarded an Abbey Memorial Travelling Scholarship to Italy. She exhibited with the LG in 1949 and in 1954 married the poet Vernon Scannell. She resumed painting again in 1982, exhibiting at the RA and at the Brunel Gallery, Uxbridge, Middlesex, in 1988. In 1950 she taught at Leeds College of Art. Her work was influenced early by Cézanne and her recent work is based on the landscape of Dorset. CF

HILDER, Rowland, PRI, RSMA (1905–1993). Painter of landscapes and marines in watercolours, pen and ink and some oils; illustrator. Born in the USA, he studied at GOLDSMITHS' COLLEGE OF ART under E.J. Sullivan 1922–5, and exhibited at the RA 1926–47. He held his first solo exhibition at the FINE ART SOCIETY in 1939 and exhibited at the NEAC, RHA and at the RI where he became a member in 1935 and President in 1964. From 1986 he showed at Duncan Campbell, London. He taught at

Goldsmiths' and at Farnham School of Art and his illustration commissions included *Moby Dick*, Cape, 1926. He is best known for his landscapes of South East England (e.g. *The Shell Guide to Kent*, 1958) with webs of trees set against fields and downs depicted with a mastery of chiaroscuro and detail.
LIT: Exhibition catalogue, Woodlands Gallery, London, 1985; *Rowland Hilder's England*, Herbert Press, London, 1986; *Rowland Hilder. Painter of the English Landscape*, J. Lewis, 1988. CF

HILL, Anthony (b. 1930). Constructivist and painter of abstracts. He trained at ST MARTIN'S School of Art 1947–9, and at the CENTRAL SCHOOL 1949–51, meeting PASMORE and ADAMS. In the 1950s he was associated with the MARTINS and ADRIAN HEATH and was active in the constructivist group. He corresponded with Duchamp and Biederman and began making constructional reliefs in 1954, abandoning painting in 1956. In 1958 he met GILLIAN WISE with whom he later collaborated. He exhibited in 'Nine Abstract Artists', REDFERN GALLERY 1955, and subsequently showed in London galleries including the ICA and the Hayward. He taught at Regent Street Polytechnic, CHELSEA SCHOOL OF ART, and since 1972 has been Visiting Research Associate, Department of Mathematics, University of London. He has published on mathematics since 1963 and in 1971 was awarded a Leverhulme Research Fellowship. His reliefs are austere and refined, conditioned both by mathematical considerations and by aesthetic sensibility.
LIT: *Nine Abstract Artists*, Lawrence Alloway, London, 1954; retrospective exhibition catalogue, Hayward Gallery, 1983. CF

HILL, Derek (b. 1916). A portraitist, stage designer and writer. He studied in Munich, Paris and Vienna, and visited Russia, China and Japan in 1936. He began to paint after 1938, and held his first one-man show at the Nicholson Gallery in 1943. He contributed to *Penguin New Writing*, organized the Degas exhibition for the Edinburgh Festival in 1952 and has written books on Islamic art and architecture. He has designed for the ballet and the opera, and was Director of Art, the BRITISH SCHOOL AT ROME, 1953–5 and 1957–9. His work is in the TATE and other national collections; typical of his fresh, spontaneous painting is *Cliff Face, Tory Island*.
LIT: *Derek Hill: An Appreciation*, Grey Gowrie, Quartet Books, 1987. LP

HILL, Rowland Henry (1873–1952). Painter of landscapes and figure compositions in oils and watercolours and black-and-white media. Born in Halifax, he lived all his life in Yorkshire. He studied at Halifax School of Art, Bradford Technical College and HERKOMER'S SCHOOL in Bushey. He exhibited at the RA and at the Paris Salon; typical work included *A Yorkshire Moorland*. LP

HILLIARD, John (b. 1945). Artist in photography, installations and constructions. He trained at Lancaster College of Art and ST MARTIN'S SCHOOL OF ART and since 1970 has exhibited at the Lisson Gallery, London. He has exhibited in Europe and America and his work is represented in public collections including the TATE GALLERY. He has taught at CAMBERWELL and the SLADE and since the late 1960s he has explored reality and image making as conditioned by the photographic process.
LIT: Interviews in *Aspects*, Autumn 1978 and Summer 1980; exhibition catalogue for the ICA, 1984. CF

HILLIER, Tristram Paul, RA (1905–1983). Painter of landscapes, marines, architectural scenes and still-life in oils. Born in Peking, he was educated at Christ's College, Cambridge, attended the SLADE SCHOOL under TONKS 1926–7, and the WESTMINSTER SCHOOL OF ART under MENINSKY. In 1927 he travelled in France and attended COLAROSSI'S in Paris under Lhote. Throughout his life he travelled in Europe, living for periods in France and Italy and working with Masson at Tossa in 1935 and with WADSWORTH at Etretat in 1939. He exhibited first in Paris at Galerie Barreiro in 1929, and held his first London solo exhibition in 1931 at ALEX REID & LEFEVRE GALLERY. He was a member of UNIT ONE, 1933, and exhibited with NASH and Wadsworth in READ'S 'Art Now' exhibition at the MAYOR GALLERY. He subsequently exhibited in London at Tooth & Sons from 1946 to 1973. He was elected ARA in 1957 and RA in 1967 and his work is represented in many public collections including the TATE GALLERY. His early paintings reflected the influence of Matisse and Picasso but by the 1930s he had evolved a personal interpretation of Surrealism and Cubism which at the end of the decade was modified by his interest in fifteenth century Italian and Flemish painting. His work was meticulously painted with sable brushes to a smooth surface, presenting scenes of great stillness and calm where apparent clarity of detail evoked a surreal atmosphere.

LIT: *Leda and the Goose: An Autobiography*, Tristram Hillier, Longmans, 1954; *A Timeless Journey. Tristram Hillier RA*, exhibition catalogue, Bradford Art Galleries and Museum, 1983. CF

HILLS, Joan. She founded the Sensual Laboratory with her husband MARK BOYLE in 1966. Their collaborative works are exact reconstructions of the earth's surface, including any loose objects, and precisely depicting botanical and geological aspects of the ground area chosen at random, executed in resin, fibreglass and paint.
LIT: *Journey to the Centre of the Earth*, catalogue, Arts Council, 1969. LP

HILTON, Matthew (b. 1948). He studied photography and film at Bournemouth 1967–70, and worked with the Welfare State Theatre Company 1972–4. After a year in the West Yorkshire Fire service, he moved to Hull in 1985. Baltic voyages in 1989 and 1991 inspired colour linocuts and drypoints evoking the sea and life in boats. AW

HILTON, Roger, CBE (1911–1975). Born in Northwood, Middlesex, he studied at the SLADE SCHOOL 1929–31, and for some two-and-a-half years in Paris at the Académie Ranson under Bissière. He is best known for his abstract works in oils of the 1950s, many suggesting landscape, although after 1961, the female figure often appears. His first one-man show was at the Bloomsbury Gallery in 1936. In 1940 he joined the Commandos and was a prisoner of war 1942–5. He taught at Bryanston School after the war and at the CENTRAL SCHOOL 1954–6. He painted and exhibited his first abstract works in the early 1950s, and travelled to Holland with a Dutch member of the COBRA Group, Constant, after which he reduced his palette to the primaries and to black, white and earth colours, inspired by Mondrian. He won prizes at the JOHN MOORES EXHIBITION in 1959 and 1963, and showed at the Venice Biennale in 1964. He settled in St Ives in 1965 after having visited PATRICK HERON some nine years earlier and subsequently renting a studio for summer use. His abstracts of this period suggest floating figures or boats. He was bedridden for the last two-and-a-half years of his life, painting humorous and fantastic figurative works freely and rapidly in bright colours in gouache on paper.
LIT: Catalogue, Arts Council Exhibition, 1974. LP

HILTON, Rose (b. 1931). Painter of figures, landscapes and still-life in oils and pastels. She trained at Beckenham Art School and at the RCA 1954–7, winning an Abbey Scholarship to Rome; in 1959 she married ROGER HILTON. In 1984 and 1985 she studied for periods with CECIL COLLINS and she has exhibited in Cornwall at the Newlyn and PENWITH Societies. She has also shown at the RA and at the Michael Parkin Gallery, London, in 1988. Her harmonic work combines an informal figurative subject with an expressive use of shape and vibrant colour.
LIT: *Rose Hilton, Recent Paintings and Drawings*, catalogue, Newlyn Art Gallery, 1987. CF

HINCHCLIFFE, Richard George, P.R.Cam.A. (1868–1942). A portrait, landscape and figure painter, born in Manchester, who studied at Liverpool School of Art, the SLADE and the ACADÉMIE JULIAN, as well as in Munich. He exhibited widely from 1894 to 1940, and was President of the Liverpool Academy from 1931, and of the R.Cam.A. in 1939. LP

HIRST, Damien (b. 1965). A painter and artist in many different media. He studied art at Leeds, then at GOLDSMITHS'. His first one-man show was at the Old Court Gallery in Windsor in 1987; he then conceived and curated the exhibition 'Freeze' at the empty Port of London Authority Building in 1988, which brought many of his contemporaries to public notice. His paintings have included series of brightly coloured spots on a neutral field, and radiating lines of colour created by centrifugal force on circular canvases that have been spun. (*beautiful, kiss my fucking ass painting* 1996 is an example.) He is best known for displays of dead animals preserved in formaldehyde, calculated to provoke a disturbing frisson in the viewer, such as *Mother and Child Divided* (1993) consisting of four adjacent glass tanks containing half a cow and half a calf. He won the TURNER PRIZE in 1995. He has also made humorous promotional videos for pop groups such as Blur.
LIT: *I Want to Spend the Rest of My Life Everywhere, With Everyone, One to One, Always, Forever, Now*, Damien Hirst, Booth-Clibborn, 1997. AW

HIRST, Derek (b. 1931). A painter who studied at Doncaster and then the RCA. From 1953 he has worked for long periods in Spain. His first one-man show was in 1961 at the Drian Gallery; more recently he has exhibited with Angela Flowers. He was the first Artist in Residence at the University of Sussex, in 1966. The TATE holds examples of his series paintings, such as *Kyoto 1–6* (1972–3) and *Paradox I-V* (1975). AW

HITCHENS, John (b. 1940). Painter of landscapes and flower pieces, of a semi-figurative and abstract nature, principally using oils in vivid hues and warm/cool harmonies. Much of the canvas, usually horizontal, is often covered with broadly painted rhythms: a typical work is *Movement Through Blue*, 1988. The son of IVON HITCHENS, his first one-man show was at Marjorie Parr in 1964; today he often exhibits at the Montpelier Studio. LP

HITCHENS, Sydney Ivon, CBE (1893–1979). His mature work depicted landscapes, still-life and (very occasionally) figures, in a rich and subtly-coloured semi-abstract manner, although for a period in the 1930s he produced some totally non-figurative works. His usual medium was oils and he usually employed an elongated horizontal canvas format ('seascape') after *c*.1936. Born in London, he travelled to New Zealand, Australia and Ceylon in his late teens when recuperating from an illness. He studied at ST JOHN'S WOOD SCHOOL OF ART in 1911 and spent four years, with breaks, at the RA SCHOOLS 1912–19. He was a co-founder of the SEVEN AND FIVE SOCIETY in 1919. His style, during the 1920s was influenced by Braque, Bonnard and Matisse, of whom he had learned through FRY and BELL; in 1923 he visited France and painted landscapes (*La Roche Guyon* for example) in homage to one of his greatest influences, Cézanne. In 1925 he had his first one-man show at the MAYOR GALLERY, and became a member of the LONDON GROUP in 1931. After his London house was bombed in 1940 he moved to Midhurst, Sussex, and adopted the landscape of the Downs as his prime subject, often painting out-of-doors, using a white ground. His use of vibrant colour and loose brushwork gave his works a characteristic appearance, as, for example, in the many versions of *Terwick Mill*; he saw nature as a series of objects and spaces; he aimed for a transcendental, musical quality: 'My pictures are painted to be listened to'. He was a great painter of flowers, seeing them as presenting the same problems as landscape, whilst in his last phase he painted a number of pictures of the Sussex sea. He had a major retrospective in 1945 (Leeds), won an ARTS COUNCIL award for his 1951 work for the Festival of Britain, *Aquarian Nativity*, and exe-

cuted an important mural commission for the English Folk Song and Dance Society (Cecil Sharp House, 1952–4); his work was shown at the Venice Biennale in 1956.
LIT: *Ivon Hitchens*, Alan Bowness, Lund Humphries, 1973; *Ivon Hitchens*, Peter Khoroche, André Deutsch, 1990. LP

HOCKEY, James Morey, RBA, ROI (1904–1990). Painter in oils and watercolours; etcher and engraver. His subjects included portraits, still-lifes, landscapes and flowers. Born in London, he studied at GOLDSMITHS' COLLEGE 1922–7, and exhibited at the RA, RBA and ROI. He was Principal of the Farnham School of Art, later West Surrey College of Art & Design. His carefully-wrought works were executed from nature in light, clear colours. LP

HOCKNEY, David, RA (b. 1937). An outstandingly prolific painter, printmaker, illustrator, stage designer and photographer who has worked on a wide variety of subjects: figure compositions, portraits, still-life, landscapes and fantasies in most media. Born in Bradford, he studied at Bradford School of Art 1953–7, and at the RCA 1959–62. Contemporaries there were CAULFIELD, KITAJ and JONES; on graduating he won the gold medal. He has travelled widely, his first visit to New York being in 1961 (he has returned to the USA frequently and has lived there semi-permanently for long periods). His visit to Egypt in 1963 was of formative importance; he has since visited France, Spain, Morocco, Japan, China and many other countries. His first one-man show was at Kasmin's in 1963; he won first prize at the 1967 JOHN MOORES EXHIBITION and by 1970 a major retrospective was held at the Whitechapel. He has since exhibited widely nationally and internationally. He has always admired Picasso for his versatility and eclecticism, and consciously emulates these qualities, although his own style is very often neat, precise and self-consciously naive. His best known works are perhaps those dealing with his homosexuality. Those of the 1960s took inspiration from the poems of Walt Whitman, using words and coded messages on the surface. In California his work reflected his interest in problems of the representation of water, with pictures of men in swimming-pools and showers. His pool works of the 1960s (e.g. *A Bigger Splash*, 1967) were restated in the 1970s with his *Paper Pools* series, which used handmade paper dyed when still in the pulp stage. A fine draughtsman, his portraits are almost always

of friends. In the 1980s he began to execute photo-collages, and more recently has transmitted large composite drawings using a FAX machine.
LIT: *David Hockney by David Hockney*, Thames & Hudson, 1976; *David Hockney*, Marco Livingstone, Thames & Hudson, 1987. LP

HODGE, Francis Edwin, ROI, RI, RP (1883–1949). Painter of portraits, and landscapes; decorative artist. Born in Devon, he studied at Plymouth Art School, at WESTMINSTER SCHOOL OF ART at the SLADE SCHOOL, at JOHN and ORPEN'S 'CHELSEA ART SCHOOL', and in Paris. He travelled in France and Italy, exhibited at the RA and the NEAC, won medals in the Paris Salon, taught painting at a number of London art schools and Stained Glass at Belfast School of Art; he was assistant to Professor Moira at the RCA. He painted murals at the Old Bailey, and was official illustrator to the 4th Army in the First World War. He painted a sober and restrained portrait of HM King George VI in 1938. LP

HODGE, Jessie Mary Margaret (b. 1901). A painter and mural decorator, working mainly in tempera, she studied at the RA SCHOOLS, and exhibited regularly at the RA. Much of her work was on mythological themes (*The Land of Nod*, 1922; *Europa and the Bull*, 1933) or illustrating poetic and fanciful scenes from Shakespeare in a light, decorative and mildly erotic style. From c.1940 she painted everyday pastoral subjects as well, such as *Gathering Spring Blossoms*, 1944, and *Barnacle Geese*, 1947. LP

HODGKIN, C. Eliot (1905–1987). Painter of fruit and flowers, townscapes and murals; writer. He worked mainly in oils and tempera. Born in Purley, he studied at the BYAM SHAW SCHOOL and then at the RA SCHOOLS. His first one-man show was at the Picture Hire Gallery in 1936, and he exhibited at a number of London and New York galleries. He taught mural painting at the WESTMINSTER SCHOOL OF ART and wrote a number of books including *She Closed the Door*, 1931, and *A Pictorial Gospel*, 1949. He is perhaps best known for his egg tempera still-lifes, which have the quality of Victorian botanical illustrations: the CHANTREY BEQUEST bought *October* (1936) and *Undergrowth* (1941), both in the TATE GALLERY.
LIT: *Eliot Hodgkin, Painter and Collector*, catalogue, Introduction by Sir Brinsley Ford, Hazlitt, Gooden & Fox, 1990. LP

HODGKIN, Howard, CBE (b. 1932). Born in London, he was evacuated to the USA for a period as a child, and was trained at CAMBERWELL 1949–50, and BATH ACADEMY OF ART 1950–4. He taught at Charterhouse School, 1954–6, at the Bath Academy, 1956–66, and at CHELSEA SCHOOL OF ART, 1966–74. He was Artist-in-Residence at Brasenose College, Oxford, 1976–7. During the 1950s he painted mask-like faces (e.g. *Dancing*, 1959). Widely travelled in Europe and America, his visits to India have been of great importance to him; he draws on his great knowledge of Mughal Miniatures, which he collects, for the development of his semi-abstract, intensely coloured evocations of friends in their interiors, executed usually on board and often small in scale, often also integrating the painting of the frame with the picture itself. His usual method is to start from a memory, eliminating excess detail in order to concentrate the essence of his experience in a saturation of colour and pattern, sometimes overpainting a work for several years. He had a show of 'Forty Paintings 1973–84' at the Venice Biennale of 1984, which also inaugurated the renovated Whitechapel Gallery. In 1985 he won the TURNER PRIZE. He has been a Trustee of the TATE and National Galleries.
LIT: *Howard Hodgkin*, Michael Compton, Tate Gallery, 1982; *Howard Hodgkin, Forty Paintings 1973–84*, exhibition catalogue, Whitechapel Art Gallery, 1984. LP

HODGKINS, Frances (1870–1947). Her usual works were figure groups, portraits and still-life, and her favourite medium in her earlier career was watercolour, although from 1915 she began to paint in oils. A New Zealander by birth, she was first tutored by her father, an amateur painter of landscapes, then attended Dunedin School of Art 1895–6. Her *Maori Woman*, 1900, was bought by the National Gallery of New Zealand, and later in that year she travelled to Europe, visiting England, Holland, Morocco and France, where she was briefly a pupil of GARSTIN in Normandy and Brittany. In 1902 she began to teach watercolour at the ACADÉMIE COLAROSSI, and apart from a return visit to New Zealand in 1912, settled in Paris until 1914. From 1914 to 1919 she lived in St Ives, and from 1922 to 1926 taught in Manchester, also working as a designer for the CPA. She exhibited at the RA from 1903, with the LONDON GROUP, (her first solo exhibition was at the Claridge Gallery in 1928; she was elected to the SEVEN AND FIVE in 1929) and at the LEFEVRE from 1930. She represented Britain at

the 1940 Venice Biennale, and in 1944 the TATE first bought a picture. Her mature work was characterized by a fluid and poetic harmony of loosely integrated still-life and environmental elements, for example *Walls, Roofs and Flowers*, 1941. From 1932 she lived in Purbeck, and in 1942 she was granted a Civil List pension.
LIT: *Frances Hodgkins*, Myfanwy Evans, Penguin, 1948; *Modern English Painters*, John Rothenstein, Vol.1, Macdonald, 1984. LP

HODGSON, Clive (b. 1953). Painter of figures in oils, watercolours, tempera and mixed media. He studied at ST MARTIN'S SCHOOL OF ART 1971–2. and at the SLADE 1972–7, winning the Troughton, J. Milner Kite and Boise Scholarships. In 1977 he worked in Nice and he has exhibited at BROWSE AND DARBY, 1977–8, at the WHITECHAPEL OPEN, 1981–4 and most recently at the Anne Berthoud Gallery in 1988 and 1990. Represented in the ARTS COUNCIL Collection, his expressive compositions depict figures with an imaginative use of scale, colour and setting.
LIT: *In a City: George Blacklock and Clive Hodgson*, catalogue, Ikon Gallery, Birmingham, 1984. CF

HOGAN, Eileen, ARWS (b. 1946). Born in London, she is a painter in oils and watercolours, best known for her lyrical and yet geometrical compositions inspired by the parks of South London. She studied at CAMBERWELL SCHOOL OF ART 1964–7, at the RA SCHOOLS 1967–70, and at the RCA. She won a BRITISH COUNCIL Scholarship to Greece in 1971, and had her first one-man exhibition at the British Council in Athens in that year. She has taught at Camberwell since 1978, in the same year establishing the Burnt Wood Press and in 1983 the Camberwell Press. She was commissioned to paint HM The Queen presenting Colours to the Fleet at Portsmouth in 1986. LP

HOGARTH, Arthur Paul, OBE, RA (b. 1917). Painter and topographical draughtsman, born in Kendal, and best known for his work as an illustrator. He studied at MANCHESTER SCHOOL OF ART, at ST MARTIN'S, and then in Paris. He has taught at the RCA. He has collaborated with and illustrated works by Graham Greene, Brendan Behan and Robert Graves. LP

HOGGATT, William, RI, RBC, R.Cam.A. (1880–1961). Born in Lancaster, he studied art at

the ACADÉMIE JULIAN under J.P. Laurens, 1899–1901. He painted full-time from 1903, and in 1907 moved to the Isle of Man, where he became best known for his landscapes of the island. **LP**

HOLDEN, Cliff (b. 1919). Born in Manchester, he is a painter of figures and landscapes in oils, watercolours and tempera; printmaker and designer. He first studied agriculture and veterinary science, then, beginning to paint in 1943, he studied under DAVID BOMBERG. He was a founder member and President of the BOROUGH GROUP, 1946–51; he married the painter DOROTHY MEAD. He visited Scandinavia in 1956, and had his first one-man show in Stockholm; subsequently he has lived mostly in Sweden, retaining London contacts. He became a member of the LONDON GROUP in 1961. The TATE GALLERY owns his *Yellow Seated Nude*, 1947, and the ARTS COUNCIL collection includes *Seated Figure*, 1950. His work has the expressive vigour characteristic of pupils of Bomberg. **LP**

HOLIDAY, Gilbert Joseph (1879–1937). Painter of sporting compositions; illustrator. He studied at the RA SCHOOLS, and exhibited at the RA, RI, PS and the Sporting Gallery. He did illustrations for *The Tatler* and *The London Illustrated News*, and is best known for his lively polo paintings (*By the Stands at Hurlingham*, 1920). **LP**

HOLLAWAY, Antony Lynn, ARCA, ATD, FCSD, FRSA (b. 1928). Designer of stained glass and mosaic murals; sculptor and painter. He trained at Bournemouth College of Art 1948–53, and at the RCA 1953–7, where he was a Royal Scholar. In 1957 he started his own practice as a stained glass and mural designer. He has exhibited as a designer, sculptor and painter and his work is represented in public collections including Southampton Art Gallery (painting) and the ARTS COUNCIL Collection (stained glass). He has taught widely, held a number of consultancies and in 1989 was appointed Chairman of the Eastern Region Royal Society of Arts. His many commissions include windows for Manchester Cathedral. LIT: Article, *Stained Glass*, Autumn 1983. **CF**

HOLLOWAY, Edgar, RBA (b. 1914). Painter in oils and watercolours; illustrator and etcher. Born in Yorkshire, he was largely self-taught as a painter and etcher. His first one-man show was in 1931, after which he attended classes at the SLADE. He established his reputation with literary

portraits – Read, Spender, Eliot – and was a member of Eric Gill's entourage at Ditchling and at Capel-y-ffin. He recorded the 5th Batallion the Wiltshire Regiment as an etcher in 1940; he did not return to painting until the late 1970s, when he made architectural watercolour studies. He has exhibited at the RA, RI and RSA and at Chichester House.
LIT: *Edgar Holloway*, catalogue, The Robin Garton Gallery, 1979. **LP**

HOLMES, Sir Charles John (1868–1936). A landscape painter, etcher and art historian, born in Preston, Lancashire. He studied at Brasenose College, Oxford, and was self-taught as an artist. He became a member of the NEAC in 1905, and had his first one-man show at the Carfax Gallery in 1909. He was Editor of the *Burlington Magazine*, 1903–9, was Slade Professor at Oxford, 1904–10, Director of the NPG, 1909–16, of the National Gallery, 1916–28, and was the author of books on Constable, Hokusai, the National Gallery Collections and an autobiography. From the beginning interested in industrial scenes of the North of England, he also, stimulated by CHARLES RICKETTS, made some 85 etchings. Of three paintings in the TATE GALLERY *The Red Ruin*, Lucerne, 1907, is very typical of his mountain landscapes. **LP**

HOLROYD, Sir Charles, RE, HRMS (1861–1917). Painter of subject pictures, portraits and landscapes in oils and watercolours; etcher and sculptor. He studied at the SLADE under Legros, 1880–4, winning a travelling scholarship to Italy, 1889–91, where he returned from 1894 to 1897. A friend of WILLIAM STRANG, he exhibited mainly at the RE (member 1885), the IS, at the RA from 1885 to 1895 and in Liverpool. He also showed in London galleries, in the provinces and in Scotland. His work is represented in collections including the TATE GALLERY. A member of the ART WORKERS' GUILD in 1889, and Master in 1905, he was elected HRMS in 1912. He taught at the Slade under Legros, was first Keeper of the Tate Gallery, 1897–1906, and Director of the National Gallery, 1906–16. He was knighted in 1903. Best known as an etcher, he was influenced by Legros and Italian painting.
LIT: 'The Paintings and Etchings of Sir Charles Holroyd', A.L. Baldry, *Studio*, Vol.XXX, pp.283–92; 'Sir Charles Holroyd's Etchings', Campbell Dodgson, *Print Collectors Quarterly*, Oct.–Dec. 1923, pp.309–67. **CF**

HOLT, David (b. 1928). Painter of landscapes in oils and watercolours; collagist. Born at Saltwood, near Hythe, he studied at Canterbury, Hammersmith and the RA SCHOOLS 1945–54. In 1958 he won a Harkness Fellowship to the USA. He has exhibited in London, at the Arts Centre, Folkestone, in the provinces and abroad since 1957. His landscapes, often small in scale, include subjects, which have a surreal quality, taken from the area of the Ranges at Hythe.
LIT: *David Holt, Barry Kirk, Veronica Togneri*, exhibition catalogue, Arts Centre New Metropole, Folkestone, 1978. CF

HOLT, Eric (b. 1944). Born in Sutton, he studied at Epsom and Ewell 1959–62, and at Wimbledon School of Art for one term in 1962, then taking various kinds of employment whilst painting. His first one-man show was at the Maltzahn Gallery in 1972, and he has since exhibited regularly at the RA, the PICCADILLY GALLERY and elsewhere. Working in oils or in egg tempera, his highly-wrought figure compositions, often on moral themes (*Bishops and Politicians, Blind Leading the Blind*, 1987) have vivid characterization and distorted surreal perspective. LP

HOLT, Lilian (1898–1983). A painter of landscapes, figures and portraits in oils and in charcoal. She studied at Clarke's College, Putney, Putney School of Art 1913–14 and at the Regent Street Polytechnic. A founder member of the BOROUGH GROUP and the Borough Bottega, she travelled widely after the death of her second husband, DAVID BOMBERG, in Spain, Turkey, Mexico, Iceland and Morocco in search of primitive landscapes. She painted abstract works in Buckinghamshire, 1967–71. Typical of her strong, expressive works are *David Bomberg*, 1928, and *The Canyons of Chihuahua*, 1971. Her first solo exhibition was at the Woodstock Gallery in 1971. *The Tajo Ronda*, 1956, was bought by the TATE GALLERY in 1980, following a retrospective exhibition at the Ben Uri Gallery. LIT: Retrospective exhibition catalogue, Introduction by Richard Cork, Ben Uri Gallery, 1981; 'Conversation with Lilian Holt', Sue Arrowsmith, *Art Monthly*, No.44, March 1981. LP

HOLZHANDLER, Dora (b. 1928). Painter of figures and domestic subjects in oils, gouache and watercolours. Born in Paris, she studied at ST MARTIN'S SCHOOL OF ART, London, in 1943, and in Paris at the Sorbonne, La Grande Chaumière and L'Atelier St Jacques. In 1950 she settled in London, but has travelled extensively. She has held solo exhibitions in London galleries since 1960, including the Langton and RONA Galleries, in New York and the provinces, and has shown in international group exhibitions since 1949. Her work is represented in collections including the Nuffield Foundation. Brought up in the Eastern European Jewish culture, her paintings depict everyday life in an innocent style which employs variegated colour, decorative effects and pattern, sharing some characteristics with those of Chagall and of Emma Stern.
LIT: 'Dora Holzhandler', Sheldon Williams, *D'Arte Naive*, October 1975; *Dora Holzhandler*, catalogue, RONA Gallery, London, 1990. CF

HONE, Evie S. (1894–1955). Painter and stained-glass designer, born in Dublin, she studied under SICKERT at the WESTMINSTER SCHOOL OF ART, at the BYAM SHAW and the CENTRAL Schools. She also worked in Paris, 1920–31, principally as a pupil of Lhote and then Gleizes; she was there accompanied by her lifelong friend Mainie Jellett, also from Ireland and also a pupil of Sickert. She exhibited at the Indépendants and the Salon d'Automne, was a member of the SEVEN AND FIVE SOCIETY, 1926–31, and of Abstraction-Création from 1932. Her style reflected the influences of Cubism and of Georges Rouault. From 1933 she made stained glass, and was associated with the Dublin Glass Studio 'An Túr Gloine'. Among her commissions were windows for St Michael's Highgate, and Eton College Chapel. Her *Crucifixion* (stained glass), 1948, is in the TATE GALLERY. LP

HOOPER, George (b. 1910). He studied at the SLADE and RA SCHOOLS, and was awarded a ROME SCHOLARSHIP. He contributed to the RECORDING BRITAIN scheme in 1940. AW

HORNEL, Edward Atkinson (1864–1933). Born in Australia, but brought up in Scotland, he studied at the Trustees Academy, Edinburgh, 1881–3, and under Verlat in Antwerp in 1883. He became a leading member of the 'Glasgow School'. A friend of GEORGE HENRY, he visited Japan with him in 1893–4, also visiting the USA and Canada; he revisited Australia and saw Ceylon in 1907. He exhibited at the RA and the ROI; his pictures, using rich, jewel-like colour reflect his interest in oriental art, gained on his travels. *Autumn*, 1904, is in the TATE GALLERY.

LIT: *Edward Atkinson Hornel, 1864–1933*, exhibition catalogue, Fine Art Society, Glasgow, 1982; *The Life and Work of Edward Atkinson Hornel*, Bill Smith, Atelier, 1997.	LP

HORSFIELD, Nicholas (b. 1917). He studied at the RCA 1935–8 and his first one-man show was in Liverpool (his home town) at the Bluecoat Gallery in 1963. He makes charcoal, watercolour and oil sketches in front of the subject, and works the pictures up in the studio; French landscapes are often a source of inspiration. There is an expressive intensity in his work, which often approaches total abstraction. He worked for the ARTS COUNCIL in Manchester, 1948–56.	LP

HORTON, Percy Frederick (1897–1970). Born in Brighton, he was a painter of figures, portraits and landscapes, working in oils and pen and wash. He studied at Brighton School of Art 1914–16, the CENTRAL SCHOOL 1918–20, and the RCA 1922–5. He spent two of the War years in prison as a conscientious objector. He taught at Rugby School, 1920–2, the RCA, 1930–49, and was Master of Drawing at the RUSKIN SCHOOL, 1949–64, having been a visitor since 1933. He exhibited at the RA and the NEAC, and wrote some art criticism for the *Left Review*. Much of his work was inspired by his social conscience. The TATE GALLERY owns *The Invalid*, 1934. During the Second World War he joined the Home Guard, and made some portrait drawings for the WAAC; in 1947 he was invited to make portrait drawings of workers on a project to build the Youth Railway in Yugoslavia, with HOGARTH, Scarfe and Searle.
LIT: *Percy Horton: Artist and Absolvetist*, Janet Barnes, Sheffield City Art Galleries, 1982.	LP

HOSKING, Knighton (b. 1944). Born in Devon, he studied at Exeter College of Art 1959–63, and at the CENTRAL SCHOOL 1963–6. He won the Peter Stuyvesant Foundation Bursary and travelled to the USA in 1966; he has taught at MANCHESTER and Wolverhampton Colleges of Art. The ARTS COUNCIL own his *Earth Band*, 1974–5. His semi-abstract work is concerned with the ecology of nature.	LP

HOUÉDARD, Dom Sylvester (Pierre Thomas Paul, b. 1924). Poet and artist. A refugee from the Channel Islands in 1940, his education at Jesus College, Oxford (1942–9) was interrupted by military service 1944–7. Following travel in India and Ceylon, he entered the Benedictine Abbey of Prinknash in 1949. He studied at the University of Rome 1951–5, and was ordained in 1959. He has played a central and widely influential role nationally and internationally, in the movement of Concrete Poetry, the practitioners of which are fundamentally concerned with the visual appearance of the letter and the word; many painters and printmakers have responded to his enthusiasm.	AW

HOUSMAN, Clemence (1861–1955). Wood engraver and author. She studied at the LAMBETH SCHOOL OF ART at the same time as her brother LAURENCE HOUSMAN. She made some engravings after his designs (for example *The House of Joy*, 1895) and her Pre-Raphaelite-influenced style was distinguished for its outstanding technical brilliance.	AW

HOUSMAN, Laurence (1865–1959). Painter and illustrator, best known as a poet, playwright and novelist; brother of A.E. Housman. He studied at Lambeth School of Art in 1883, and at the RCA. He exhibited widely between 1894 and 1906, and showed at the NEAC. He illustrated works by Christina Rossetti and Shelley as well as many of his own stories. The TATE GALLERY owns *The White Doe*, c.1904, and *The Rat Catcher's Daughter*.	LP

HOUSTON, John, RSA (b. 1930). Born in Buckhaven, he studied at EDINBURGH COLLEGE OF ART and had his first one-man show at the 57 Gallery, Edinburgh. He is a figurative painter in oils and watercolours, favouring beach scenes with bathers, which evoke a strong atmospheric mood. He won the Guthrie Award in 1964 and the Cargill Prize in 1965 and regularly exhibits at the Mercury Gallery in London. He is married to ELIZABETH BLACKADDER and teaches at Edinburgh College of Art.	LP

HOUTHUESEN, Albert Antonius Johannes (1903–1979). Painter of genre, landscapes, seascapes, clowns and imaginative subjects in oils, using acrylics in the 1960s. He was born in Amsterdam and came to Britain in 1912; he was naturalized in 1922. He attended evening classes at ST MARTIN's School of Art 1917–23, and won a scholarship to the RCA in 1923, remaining there for four years. Contemporaries included MOORE, HEPWORTH, BURRA, RICHARDS and COLLINS. He eventually married fellow-student CATHERINE DEAN. His first one-man show was at

the Reid Gallery in 1961; he also exhibited at the NEAC and the RA. His *Maes Gwyn Stack Yard*, 1935 (TATE), was bought by the CHANTREY BEQUEST. He painted with strong brushstrokes and resonant colour; an imaginative fantasy on an operation (*A tout ... l'heure*, 1961) included collaged canvas elements. A BBC documentary on him *Walk to the Moon* was made in 1977.
LIT: *Albert Houthuesen: An Appreciation*, Introduction by John Rothenstein, Mercury Gallery, 1969. LP

HOW, Julia Beatrice (1867–1932). Born in Bideford, Devon, she painted figures, especially intimate studies of women and children, nudes, flowers and coastal scenes. She worked in oil and pastel. She studied at the HERKOMER SCHOOL in Bushey and in Paris. She remained in France most of her life, but also painted in Holland and Britain, exhibiting at the Salon and at the RA. Carrière, Bonnard and Vuillard influenced her luminous use of colour. Her *L'Infirmière c.*1914–18 (TATE) was bought by the CHANTREY BEQUEST. LP

HOWARD, Charles (1899–1978). Born in New Jersey, he took up painting in 1922 after study at the University of California, and travelled in France and Italy. From 1933 to 1940 he lived in London, exhibiting in the First International SURREALIST EXHIBITION in 1936 and associating with the group around *The London Bulletin*. Typical works include *Presage*, 1936, and *Dove*, 1939. He also painted abstracts. He returned to England in 1946 and in 1963 became a British citizen.
LIT: *English Art and Modernism, 1900–1939*, Charles Harrison, 1981. LP

HOWARD, Ken, RA, NEAC, ROI, RWS, RWA (b. 1932). Painter of landscapes, marines, town-scapes and interiors in oils. He studied at Hornsey College of Art 1949–53, and at the RCA 1955–8, winning a British Council Scholarship to Florence 1958–9. He held his first solo exhibition in 1955 and has subsequently exhibited regularly in London at the NEW GRAFTON GALLERY, in the provinces and abroad. He was elected NEAC in 1962, ROI in 1966, RWS in 1979, RWA in 1981 and ARA in 1983. His work is represented in public collections including the Sheffield Art Gallery and between 1973 and 1980 he worked with the British Army in Northern Ireland and abroad. His ordered, tonally controlled paintings in muted colour reveal his interest in the way light defines form.

LIT: Articles on his work, *Artist* (UK), April 1981 and June 1983; 'Aspects of Composition', Ken Howard, *Artist* (UK), May 1989; 'Painting the Figure', Ken Howard, *Artist* (UK), July 1989 CF

HOWARD-JONES, Ray (Mary Rose 1903–1996). Born in Lambourne, Berkshire, she studied at the SLADE SCHOOL 1921–4, and as a postgraduate in Arbroath. She painted landscapes and portraits, and executed mosaics for Thomson House, Cardiff, and Grang Church, Edinburgh. Her work is in many national and provincial collections, including those of Wales, of S. Australia, and of the cities of Glasgow and Aberdeen. AW

HOWSON, Peter (b. 1958). A Londoner, he moved to Scotland in 1962. He studied 1975–7 at GLASGOW SCHOOL OF ART, and returned there 1979–81 after serving in the infantry. His first solo exhibition was of wall murals at Feltham Community Association. He is best known for strong and disturbing paintings relating to his personal experiences or reflecting brutal male life in the city streets; he was sponsored by *The Times* to record the British peacekeeping force in Bosnia during the civil war in 1994.
LIT: *A Different Man: Peter Howson's Art, from Bosnia and Beyond*, Alan Jackson, Mainstream, 1997. AW

HOYLAND, Francis (b. 1930). Born in Birmingham, he studied at CAMBERWELL and the SLADE. He believes in the value of seeking inspiration from the Old Masters, and has had numerous commissions for religious paintings, including those on the Life of Christ for Southwark Cathedral. In such works, a controlled spontaneity is used, and a flattened pictorial space. LP

HOYLAND, John, RA (b. 1934). Born in Sheffield, he studied at Sheffield College of Art 1951–6, and the RA SCHOOLS 1956–60. He has travelled widely in Europe and both North and South America, and has been Artist in Residence at the Studio School in New York and at the University, Melbourne, Australia in 1979. Influenced by Hans Hofmann and other New York contacts, his work is abstract, with vibrant blocks of colour poured, splattered, brushed and applied with a palette-knife; he also makes screenprints, monotypes and etchings. His first one-man show was at the MARLBOROUGH GALLERY in 1964; he regularly exhibits at WADDINGTON'S, and he had a major exhibition at the Whitechapel in 1967. He has taught in New

York, at CHELSEA, ST MARTIN'S, the RA SCHOOLS and the SLADE.
LIT: *John Hoyland, Paintings 1967–79*, exhibition catalogue, Arts Council, 1979. LP

HOYTON, Edward Bouverie, FRSA (1900–1988). An etcher, engraver and watercolour artist, he studied at GOLDSMITHS' and won the PRIX DE ROME in 1926. He subsequently became Principal of the Penzance School of Art, and he married INEZ HOYTON. His work depicted West Country and Italian scenes, influenced by Turner and Samuel Palmer, as well as by his contemporary F.L. GRIGGS. AW

HOYTON, Inez Estella (1903–1983). Painter of landscapes and townscapes in oils and gouache. Born in Winchester, she studied at Leeds College of Art and lived in Penzance. She exhibited at the RA in 1948 and 1952, at the PENWITH SOCIETY, the Newlyn Art Gallery, in London and the provinces. A teacher at Penzance School of Art, her work included subjects such as *Spanish Street Scene* and *In a Wood Farm, Nether Stowey, Somerset*, RA 1948. CF

HUBBARD, Hesketh, PRBA, ROI (1892–1957). Born in London, he studied at HEATHERLEY'S, Croydon School of Art and CHELSEA POLYTECHNIC. A landscape and architectural painter in oils and watercolours and an etcher, he also designed furniture. He exhibited at the RA, the Paris Salon, the Cheltenham Group, the Society of Graver-Printers in Colour, the ROI and RBA. He also founded the Forest Press, publishing several books on aspects of printing. LP

HUBBARD, John (b. 1931). Born in Connecticut, he studied at Harvard University (BA 1953), and following military service (in Japan) at the Art Students League, New York, 1956–8, and later with Hans Hoffman in Provincetown. He travelled in Europe, 1958–60, staying some time in Rome, and in 1961 settled in Dorset. His first British one-man show was at the NEW ART CENTRE in 1961. He taught at CAMBERWELL, 1963–5, and has designed sets and costumes for several ballets (*Midsummer*, Royal Ballet, 1983) and was resident artist at the Poet's House, New Harmony, Indiana, in 1988. Apart from the Dorset coast, he has taken themes from visits to the Vaucluse in France and from Morocco and Greece; his abstracted landscapes in oil on canvas or paper express the quality of light and shadow; the garden is a recurring focus of his work.

LIT: *John Hubbard: The Breath of Nature 1981–85*, exhibition catalogue, Oxford, MOMA, 1985. LP

HUBERT, Edgar (b. 1906). Painter of abstracts in oils and gouache. Associated with GEOFFREY TIBBLE, RODRIGO MOYNIHAN and GRAHAM BELL and their experiments with 'Objective Abstraction', he exhibited abstracts at the LG in 1933 but was excluded from the 'Objective Abstractions' exhibition at ZWEMMER'S in 1934. He showed at the AIA in 1940, at the MAYOR GALLERY in 1948 and at the BRITISH COUNCIL Exhibition 'La Jeune Peinture en Grande Bretagne', Paris, in 1948. His work is represented in the British Council Collection. In his later work he limited colour to black and white and he evolved a personal, non-geometric abstraction.
LIT: *The Euston Road School*, Bruce Laughton, Scolar Press, 1986. CF

HUDSON, Anna Hope (Nan) (1869–1957). Painter of landscape, figure and architectural compositions. An American, she was of the circle around ETHEL SANDS. A member of the FITZROY STREET GROUP, a founder member of the LONDON GROUP in 1913, she also exhibited at the NEAC. Her *San Giorgio Maggiore, c.*1906, is characteristic of her work, painted in with a dry, broken square touch in a limited palette of subtly modulated colours. A similar picture was bought by SICKERT and shown ('to be seen and slowly rubbed in, week by week') to the other Fitzrovians.
LIT: *Miss Ethel Sands and Her Circle*, Wendy Baron, Peter Owen, 1977. LP

HUGHES, Malcolm (b. 1920). Born in Manchester, he studied at the Regional COLLEGE OF ART, MANCHESTER, and at the RCA. His geometrical abstract works are drawn, painted and sometimes constructed in relief. He exhibited widely in Britain after his first one-man show at the ICA in 1965, and his work is in many national collections including the TATE GALLERY and the ARTS COUNCIL. In 1969 he co-founded the SYSTEMS GROUP, which furthered the development of Constructivism in Britain, emphasizing the intellectual and logical processes of developing a work. LP

HUGHES, Patrick (b. 1939). Born in Birmingham, he qualified as a teacher and taught in State schools 1961–4. Following his first one-man show at the Portal Gallery in 1961, he exhibited at the HANOVER GALLERY and since

1970 with Angela Flowers. His images play with visual and verbal puns, painted in bright colours in hard-edged areas, often investing the representation of common objects with humour.
LIT: *Vicious Circles and Infinity*, Patrick Hughes and George Brecht, Doubleday, 1976. LP

HUGHES-STANTON, Blair (1902–1981). Painter and wood engraver, of figures, imaginative subjects and of semi-abstract compositions. He studied at the BYAM SHAW SCHOOL 1919–21, the RA SCHOOLS, and under LEON UNDERWOOD, who had a school in Hammersmith, 1921–4. The son of SIR HERBERT HUGHES-STANTON, he married fellow artist GERTRUDE HERMES in 1926 after illustrating T.E. Lawrence's *The Seven Pillars of Wisdom* and became best known as a designer, illustrator and producer of fine books, for the Golden Cockerel and Cresset presses, for the Gregynog Press, 1930–3, and for his own Gemini Press, 1933–6. He was seriously wounded as a POW during the Second World War.
LIT: *Blair Hughes-Stanton*, Penelope Hughes-Stanton, Private Libraries Association, 1990. LP

HUGHES-STANTON, Sir Herbert Edwin Pelham, RA, PRWS, ROI, RWA (1870–1937). Born in London, he was taught by his father William Hughes. A painter in oils and watercolours, he was a member of the Society of 25 Artists and exhibited at the RA, the GROSVENOR GALLERY, the New Gallery, the ROI and internationally. He worked much in France, in the Pas de Calais. He visited Japan in 1924. A prolific artist, his *Pastures Among the Dunes, Pas de Calais*, was bought by the CHANTREY BEQUEST in 1908; he was an OFFICIAL WAR ARTIST in the First World War, and was the father of BLAIR HUGHES-STANTON. LP

HUGONIN, James (b. 1950). Painter and printmaker. He studied at Winchester 1970–1, at West Surrey 1971–4, and at CHELSEA 1974–5. His first solo exhibition was at LI YUAN-CHIA's LYC gallery in Cumbria in 1978. His abstracts have consistently used a vertical and horizontal formal grid as a base for delicate and minutely varying articulations of colour in small touches or panels, creating subtle, luminous effects. AW

HULBERT, Thelma (1913–1995). Painter of landscapes, flowers and birds and the natural world in oils and watercolours. Born in Somerset, she studied at BATH SCHOOL OF ART and settled in London in 1934. In the mid- to late

1930s she was associated with the group of artists including PASMORE, COLDSTREAM and ROGERS and she became the organizing secretary for the EUSTON ROAD SCHOOL. She travelled widely after the war, in America, Africa and Europe. Her first solo exhibition was at Heffers Gallery, Cambridge in 1950, and she exhibited in London at the LEICESTER GALLERIES, with the LG in various group exhibitions. A retrospective exhibition of her work was held at the Whitechapel Art Gallery in 1962. Her work is represented in public collections including the ARTS COUNCIL Collection; it shows a personal, poetic vision of traditional subjects constructed in terms of light and space, often on a large scale.
LIT: Exhibition catalogue, Whitechapel Gallery, 1962. CF

HULL, James (1921–1990). A design consultant for many years, Hull exhibited abstract compositions in the 1950s, and again (at Adrienne Resnick's Gallery) shortly before his death. His first one-man show was at the Brook Street Gallery in 1949. He painted a mural, *The Story of Coal*, for the Festival of Britain, and took part in the 'This is Tomorrow' exhibition (ICA) in 1956. His earlier work was loosely geometric; his later work was more fluid and diffuse. AW

HUME, Gary (b. 1962). A painter and filmmaker, he studied at Liverpool Polytechnic and at GOLDSMITHS'. His first one-man show at Karsten Schubert was in 1989. His highly simplified, flattened subjects (for example *Begging For It*, 1994), executed with glossy household decorator's paint, approach non-figuration in their sophisticated surface design; earlier paintings based on the elevations of swing doors (*Dolphin Painting No.IV*, 1991) could be mistaken for abstracts. He was the British representative at the São Paulo Biennale in 1996. AW

HUNT, Cecil Arthur, RBA, VPRWS (1873–1965). Painter of landscapes, particularly mountains, and seascapes in watercolours, tempera; some in oils. He was educated at Winchester and Trinity College, Cambridge, and in 1919 took up painting full-time after ceasing his Bar practice. He exhibited widely in London galleries and societies, showing many works at the RWS where he was elected ARWS in 1919, RWS in 1925 and VPRWS from 1930 to 1933. He also exhibited extensively at the FINE ART SOCIETY. A retrospective exhibition was held at the RWS in 1966 and he is represented in collec-

tions including the V & A. His subjects, taken from Britain, the continent, USA and South Africa, were executed in strong, bright colour, often with scratched highlights. His mountain scenes were particularly atmospheric, e.g. *Thunder Weather in the Engadine*. CF

HUNT, Edgar (1876–1953). Painter of animals and birds in oils. Probably the son of Charles Hunt and the brother of WALTER HUNT, 1861–1941, he is believed to have worked in the Midlands where his work is very popular. His detailed, realistic and carefully finished paintings depicted farmyard scenes in an attractive manner. CF

HUNT, Walter (1861–1941). Painter of animals, particularly farm animals, in oils. Son of Charles Hunt and father of EDGAR HUNT, he studied with his father and exhibited at the RA from 1881, also showing at Tooth's Gallery, in Birmingham and in Liverpool. In 1885 his painting *The Dog in the Manger* was purchased by the CHANTREY BEQUEST and his work is represented in public collections in this country. His farmyard paintings give an attractive, idyllic view of rural life painted in a detailed manner with a warm palette, e.g. *Summer Idyll, Calves and Ducks by a Stream*, 1920. Some of his RA exhibits showed a greater interest in movement and incident, e.g. *Bolting the Otter*, RA 1894. CF

HUNT, George Leslie (1877–1931). Painter of landscapes, still-life and portraits in oils. One of the SCOTTISH COLOURISTS. His family moved from Scotland to California in 1890 and he initially worked as an illustrator in San Francisco. He visited Paris in 1904 and his first solo exhibition in San Francisco in 1906 was destroyed by the earthquake. He returned to Scotland in 1910, then moved to London and made frequent trips to France. He visited Italy in 1922 and 1923, the South of France in 1926 and 1929 and New York in 1929. He painted in Scotland where he was encouraged and exhibited by Alexander Reid. In 1923 and 1925 he exhibited with the other Scottish Colourists in London at the LEICESTER GALLERIES and in 1924 showed with them at the Galerie Barbazanges, Paris. He also exhibited at the RSA, GI, in the provinces and New York. His work is represented in collections including Glasgow Art Gallery and Museum and Dundee Art Gallery. He studied the working methods of Van Gogh, Gauguin and Cézanne and was influenced by the Fauves. His work has clarity and richness of colour and a free, assured handling.

LIT: *Introducing Leslie Hunter*, T.J. Honeyman, Faber & Faber, London, 1937. CF

HUNTER, John Young (1874–1955). Painter of portraits, genre, historical scenes and landscapes in oils. Born in Glasgow, son of the painter Colin Hunter, he studied at the RA SCHOOLS where he won two silver medals, and under SARGENT, Alma Tadema and Orchardson. He travelled widely and from 1913 lived in America. He exhibited regularly at the RA from 1895 and also showed at the RBA, RI, ROI, at the FINE ART SOCIETY, in the provinces and at the Paris Salon. In 1899 his painting *My Lady's Garden* was purchased by the CHANTREY BEQUEST. His subjects range from Biblical scenes such as *The Finding of Moses* to romantic subjects from many periods. His early work was influenced by the Pre-Raphaelites whilst later he turned mainly to portraiture. CF

HUNTER, Margaret (b. 1948). Painter of figures in oils, mixed media, acrylic and pastels. Born in Irvine, Scotland, she attended GLASGOW SCHOOL OF ART 1981–5, winning the Cargill Travel Award, and at the Hochschule der Kunst, Berlin, under Georg Baselitz, 1985–6. She has exhibited in Berlin since 1986, at the 369 Gallery, Edinburgh, at the Vanessa Devereux Gallery, London, since 1988, and in group exhibitions since 1985. In 1987 she was awarded a Scottish Arts Council Bursary. Influenced by Baselitz and primitive art, her expressionist paintings use strong colour and strongly worked surfaces for subjects that reflect contemporary issues.

LIT: *Margaret Hunter. Recent Paintings and Drawings*, catalogue, Vanessa Devereux Gallery, London, 1990. CF

HURDLE, Robert Henry, RWA (b. 1918). Painter of landscapes, townscapes and still-life in oils. He trained at Richmond School of Art 1935–7, and after the war at CAMBERWELL SCHOOL OF ART under COLDSTREAM. He exhibited at University College, Swansea, in 1969, and has since shown regularly in Bristol, at the RWA, and in the provinces. In London he exhibited with the LG from 1949 to 1965, and at the RA. He taught at the West of England College of Art and until 1980 at the Bristol Polytechnic. His recent painting depicts landscapes and buildings in simplified areas of high-toned colour enlivened with small touches of pigment to give a soft, sparkling surface. CF

HURRY, Leslie (1909–1978). Painter of landscapes, portraits, figures and abstracts in oils, acrylic, watercolours and ink; theatrical designer. He attended St John's Wood School of Art and the RA Schools 1927–31. He began to paint landscapes in 1932, exhibiting at the Wertheim Gallery in 1937 and working for Grace Sholto Douglas from 1940. He showed in London galleries including the Redfern and Mercury, in the provinces, and in Canada where he worked from 1966. He is represented in public collections including the Tate Gallery. In 1941 his theatrical work started with a commission from Helpmann to design for the ballet *Hamlet* (Sadler's Wells Company), and this success resulted in many commissions for the leading theatres of Britain and Canada. His work was recognized for its ability to reflect the atmosphere and meaning of the play or ballet in the sets and costumes. His concern with colour, texture and detail was reflected also in his painting which developed through English neo-romanticism to a personal interpretation of Surrealism and, later in his life, to abstraction. In all his work he would build up a rich complex surface with many layers of colour.
LIT: *Paintings and Drawings by Leslie Hurry*, Jack Lindsay, 1950; retrospective exhibition catalogue, The Minories, Colchester, 1987. CF

HUSSEY, The Very Rev. Walter (1909–1985). A collector and patron. When Vicar of St Matthew's, Northampton, he commissioned the Virgin and Child (1943–4) from Henry Moore, and a Crucifixion (1946) from Graham Sutherland for the church. Later, when Dean of Chichester Cathedral, he commissioned important works from Piper, Sutherland, Ceri Richards, Marc Chagall and others. He left most of his private collection of modern art to Chichester on condition it formed the nucleus of a gallery; Pallant House was established as a result. He left other works to Northampton City Museum.
LIT: *Patron of Art*, Walter Hussey, Weidenfeld & Nicholson, London, 1985. AW

HUTCHISON, Sir William Oliphant, HRA, PRSA, RP, Hon.LLD (1889–1970). Painter of portraits and landscapes in oils. Born in Kirkcaldy, he studied at Edinburgh College of Art 1909–12, and in Paris. He exhibited mainly in Scotland at the RSA (ARSA 1937, RSA 1943, Treasurer 1947–9, PRSA 1950) and the GI, and also showed at the RP (RP 1948, VPRP 1960),

the RA (HRA 1950), the RBA, IS, Barbizon House, in Liverpool and abroad. His work is represented in collections including the NPG, London. From 1933 to 1943 he was Director of Glasgow School of Art and from 1941 to 1943 President of Glasgow Art Club. He was knighted in 1953. His portraits include the State Portrait of Her Majesty the Queen in Thistle Robes, 1955.
LIT: National Galleries of Scotland, *Bulletin* No.2, 1977. CF

HUXLEY, Paul, RA (b. 1938). Painter of abstracts in acrylic. He studied at Harrow School of Art and at the RA Schools 1956–60. He has exhibited at the Rowan Gallery, London, since 1963, and at the Kornblee Gallery, New York, since 1967. He was elected ARA in 1987 and has shown in major group exhibitions and is represented in public collections including the Tate Gallery and MOMA, New York. He has taught widely: in 1974 he was Visiting Professor, Cooper Union, New York, and from 1986 he has been Professor of Painting at the RCA. A Trustee of the Tate Gallery 1975–82, amongst his awards and prizes have been a Harkness Fellowship 1965–7, and the Athena Arts Prize, London, 1985. He has been a member of the Arts Council Arts Panel. His restrained work has developed from simple organic shapes painted on a pale ground to the ordering of rectangular forms which show a progressive complexity of perspectival and spatial relationships.
LIT: Exhibition catalogue, Mayor Rowan Gallery, 1989. CF

HYATT, Derek (b. 1931). Born in Ilkley, he studied at Leeds 1948–52, and at the Royal College 1954–8, after National Service. He teaches at Leeds Polytechnic. His first one-man show was at the New Art Centre in 1960, and he has exhibited widely in Britain and abroad; he has pictures in many museum, university and corporate collections both here and in the USA. He is concerned with landscape, myth and history, in large abstracted works, often in bright, cool, sharp colours.
LIT: 'Landscape Painters', *The Artist*, Vol.104, February 1989; *Derek Hyatt*, Tim Barringer, Smith Settle, forthcoming. AW

HYMAN, Timothy (b. 1946). He studied at the Slade. His expressive, loosely painted figurative paintings deal with scenes of modern life. In 1981 he held his first one-man show at Blond

Fine Art; he has also written art criticism for the *London Magazine*.　AW

HYNES, Gladys (1888–1958). She studied at the London School of Art under FRANK BRANGWYN and then 1906–7 under STANHOPE FORBES and ELIZABETH FORBES at Newlyn. Her portraits and figure compositions were stylishly elegant and smoothly painted, and not without humour. She also carried out a number of sculptural commissions.　AW

I

ICA: Institute of Contemporary Arts. Begun in 1947 with a small office in Charlotte Street, the prime movers of the ICA were ROLAND PENROSE, HERBERT READ, Peter Watson, Peter (Eric) Gregory and Peter (Noel) Norton. The first exhibition organized, of Surrealist and abstract paintings and sculpture, was held in the basement of the Academy Cinema in Oxford Street in 1948; 'Forty Years of Modern Art': The second, which was much more ambitious, and which included Picasso's picture *Les Demoiselles d'Avignon* on loan from New York, was entitled 'Forty Thousand Years of Modern Art', in order to underline the inspiration from, and sense of continuity with, the prehistoric and tribal art which the organizers believed to be central to modernism. In 1950 the ICA moved to a first floor gallery in Dover Street, and ultimately, in 1968, to very large premises in Carlton House Terrace, the Mall, refurbished, as were the Dover Street headquarters, by the architect Jane Drew. Since its foundation, the ICA has held many major exhibitions of contemporary art, and has presented lectures, performances, conferences and regular film seasons primarly devoted to the visual arts. The policy of the Institute has always been one of concentrating on the exploration of novel developments in art rather than in holding retrospective or historical surveys..　AW

IHLEE, Rudolph, NEAC (1883–1968). Painter of landscapes, townscapes and figures in oils. After an engineering apprenticeship he studied at the SLADE SCHOOL 1906–10, where he was a contemporary of GERTLER and WADSWORTH and formed friendships with NEVINSON and LIGHTFOOT. From 1922 to 1940 he lived at Collioure, France. His first solo exhibition was at the Carfax Gallery in 1912 and he subsequently

exhibited at the LEICESTER, CHENIL and Goupil Galleries, at the FRIDAY CLUB, the NEAC (member 1919), and at the LG. Between 1931 and 1935 he held solo exhibitions in Perpignan and exhibited in Paris. He is represented in public collections including the V & A. He also worked in the applied arts and produced designs for textiles and ceramics. His work was influenced both by Cubism and Fauvism and his mature style reflects that of Derain. His subjects are painted in clear, strongly coloured forms and contrasting patterns of chiaroscuro.
LIT: Retrospective exhibition catalogue, Belgrave Gallery, London, 1978.　CF

IMMS, David (b. 1945). Painter of landscapes and figures in oils, watercolours and gouache; printmaker. He studied at Derby College of Art and the CENTRAL SCHOOL OF ART and has exhibited in London, most recently at the NEW GRAFTON GALLERY, and in the provinces. His work is based on the landscape, literature and history of Dorset and recent work has also been inspired by Avebury and Silbury Hill. His figures in landscape reflect the power and symbolism of ancient sites, of their art and archaeology.　CF

Imperial War Museum. The Museum, in Lambeth Road, London SE1, is concerned with the impact of war in the twentieth century. Its Department of Art holds the largest collection of war paintings and war posters in the country. Thanks to the enlightened patronage of the OFFICIAL WAR ARTISTS SCHEME in the First World War and the WAR ARTISTS ADVISORY COMMITTEE in the Second World War, many works are by the most distinguished artists Britain has produced. Special exhibitions are mounted in addition to the display of the permanent collection.　AW

INCE, Charles Percy, RI, RBA (1875–1952). Painter of landscapes and marines in watercolours and oils. Born in London, he attended King's College, and studied art under the landscape painter H.G. Moon. He exhibited widely in galleries and societies in London, showing many works at the RBA, the RI, and the Goupil Gallery as well as exhibiting at the RA between 1921 and 1930. He also exhibited at the ROI, RWS, the FINE ART SOCIETY and in the provinces. He was elected RBA in 1912 and RI in 1927. His drawings were published in journals including *Punch*, and *The Sketch*, and he painted scenes of the English countryside such as *Boats at Littlehampton*, RA 1929.

LIT: 'The Watercolours of Charles Ince', Jessica Stephens, *Studio*, Vol.XCIV, p.188. CF

INCE, Evelyn Grace, ARWS, RBA (*c.*1886–1941). Painter of flowers, landscapes and portraits in tempera, oils, watercolours and pastels; illustrator and teacher. Born in India, she studied art at the BYAM SHAW and VICAT COLE School of Art 1911–16, winning a scholarship in 1913. She exhibited at London galleries and in the provinces but showed most of her work at the RBA (member 1926) and at the RA between 1917 and 1941. She also showed at the NEAC, ROI, RP, RWS (where she was elected Associate in 1937) and at the International Exhibition of the Carnegie Institute, Pittsburgh. In 1934 her painting *Flower Piece* was bought by the CHANTREY BEQUEST. Many of her RA flower paintings were executed in tempera and her Chantrey Bequest picture shows an attractive simplicity of vision. CF

Independent Group of the ICA. First organized by Reyner Banham in 1952–3 in order to discuss technique and the way in which ideas from science and technology could be utilized by the arts. These ideas were reflected in the exhibition 'Parallel of Life and Art', 1953. The Group was reconvened in 1954–5 by Lawrence Alloway and John McHale in order to consider popular culture and it was from this forum that 'Pop Art' emerged, and exhibitions such as 'This is Tomorrow', 1956. Members of the Group included Banham, Alloway, RICHARD HAMILTON, PAOLOZZI, WILLIAM TURNBULL, Tony del Renzio, NIGEL HENDERSON, Peter and Alison Smithson and Colin St John Wilson. CF

INGHAM, Bryan (1936–1997). Painter of still-life and landscapes in oils and collage; etcher. He trained at ST MARTIN'S, the RCA, and the British Academy in Rome and exhibited in London, at Francis Graham-Dixon Gallery, as well as in the provinces and in Germany. He was a member of the PENWITH SOCIETY OF ARTS. His work is represented in public collections including the V & A. His cubistic style redefined the subject and moved it towards abstraction.
LIT: 'Drawings', *Ambit*, No.67, 1976. CF

INLANDER, Henry (1925–1983). Painter of landscapes and figures in oils and acrylic. Born in Vienna, he came to England in 1938 and studied at ST MARTIN'S SCHOOL OF ART 1939–41, CAMBERWELL SCHOOL OF ART 1945–6, and the SLADE SCHOOL 1949–52, under COLDSTREAM, ROGERS, PASMORE and GOWING, winning a ROME SCHOLARSHIP in 1952. He exhibited first in Rome in 1953, and from 1956 to 1965 at the LEICESTER GALLERIES, London. He subsequently exhibited at ROLAND, BROWSE AND DELBANCO and the NEW ART CENTRE, also showing at the RA, LG, abroad and in group exhibitions. His work is represented in public collections including the TATE GALLERY. In 1955–6 and 1971–6 he was Art Advisor to the BRITISH SCHOOL IN ROME, and from 1957 Visiting Lecturer at Camberwell School of Art. His awards include a Harkness Fellowship, 1960–2. For over thirty years he painted around the village of Anticoli Corrado in the Abruzzi and his work was influenced by Van Gogh, Gauguin and Utrillo. His paintings are rich yet economical, presenting a powerful psychological presence within an apparently simple form.
LIT: Exhibition catalogue, New Art Centre, 1984. CF

INNES, James Dickson, NEAC (1887–1914). Painter of landscapes, particularly mountains, and figures in oils and watercolours. Born in Llanelli, Wales, he studied at Carmarthen Art School 1904–5, and at the SLADE SCHOOL 1906–8, where he was influenced by STEER and met JOHN FOTHERGILL and DERWENT LEES. In 1908 he went to France with Fothergill and painted at Collioure, and in 1910 he lived in Paris close to MATTHEW SMITH with whom he visited Leo Stein's collection. From 1910 he established a close friendship with AUGUSTUS JOHN, painting with him in Wales, Ireland and Provence. In 1912 he travelled to the South of France with Lees and spent the winter of 1913–14 in North Africa with Trelawney Dayrell Reed. He exhibited with the NEAC from 1907 (member 1911), with the AAA in 1908, and with the CAMDEN TOWN GROUP from 1911. He held solo exhibitions at the CHENIL Galleries in 1911 and 1913 and memorial exhibitions were held at the TATE GALLERY, 1921–2, and Chenil Galleries, 1923. His work is represented in many public collections including the Tate. His early work showed the influence of Steer but his stay at Collioure, and the example of Post-Impressionism assimilated through contact with the Camden Town Group caused him to lighten his palette. He adopted John's technique of rapid painting on small wooden panels and combined broadly painted areas with dabs of intense colour. An admirer of Cotman and Turner, he retained aspects of their work whilst also reflect-

ing ideas from Post-Impressionism and from Japanese prints. His landscapes recorded the atmospheric change of light and colour and expressed his poetic, intense response to nature. LIT: *James Dickson Innes*, J. Fothergill and L. Browse, 1946; retrospective exhibition catalogue, Southampton Art Gallery, 1977. CF

INSHAW, David (b. 1943). Painter of figures and landscapes in oils; printmaker. He studied at the RA SCHOOLS and in Paris and has exhibited at WADDINGTON GALLERIES since 1975 and at the RA since 1976. His work is represented in public collections including the TATE GALLERY. In 1975 he was Fellow Commoner in Creative Art, Trinity College, Cambridge. Associated with the BROTHERHOOD OF RURALISTS from 1975 to 1983, his work shows intense, dream-like images painted with näiveté and realism of detail.
LIT: *David Inshaw*, Academy Editions, London, 1978; interview by John Kemp, *Artseen*, No.7, 1986. CF

IRONSIDE, Robin (1912–1965). Painter of figures and imaginative subjects in oils, watercolours and gouache; theatrical designer, writer on art. He studied at the COURTAULD INSTITUTE, and was self-taught as an artist. From 1937 to 1946 he was Assistant Keeper at the TATE GALLERY, leaving to devote himself to painting. He exhibited first in 1944 at the REDFERN GALLERY, London, and subsequently exhibited in London and at Durlacher Bros, New York. His work is represented in public collections including the Tate Gallery. He was Assistant Secretary, CAS, 1938–45, and from 1945 Secretary to the Massey Committee. In 1948 he designed the décor for *Der Rosenkavalier*, Covent Garden, and subsequently associated with his brother Christopher in theatrical and ballet designs, amongst them Ashton's revival of *Sylvia*, 1952. His publications include *The Pre-Raphaelites*, Phaidon, 1948. His paintings show complex, fantastic subjects painted with a Surrealist atmosphere in great detail, e.g. *Street Entertainer Playing Threatening Music to a Cinema Queue*.
LIT: Retrospective exhibition catalogue, NEW ART CENTRE, 1966. CF

IRVIN, Albert, LG (b. 1922). Painter of abstracts in acrylic and oils. He studied at GOLDSMITHS' COLLEGE OF ART 1946–50, and held his first solo exhibition in Edinburgh at Gallery 57 in 1960, and in London at the NEW ART CENTRE in 1961, where he continued to exhibit until 1976. He has

exhibited regularly in London galleries, the provinces, in Germany and in major group exhibitions. A member of the LG from 1965, he was invited to show at the RA in 1987. His work is represented in public and corporate collections. He has taught at Goldsmiths', 1962–74, and his prizes include an ARTS COUNCIL Award in 1968, enabling him to visit the USA. His acrylics, watercolours and prints are vigorous non-figurative compositions in vibrant colour with large and expressive brushstrokes crossing explosively splashed passages.
LIT: Exhibition catalogues, SERPENTINE GALLERY, 1989, and Ludwigshafen, July 1974; *The Experience of Painting*, exhibition catalogue, South Bank Centre and Laing Art Gallery, Newcastle, 1989. CF

IRVINE, Robert Scott, RSW, RSA (b. 1906). Painter of landscapes in watercolours. Born in Edinburgh, he attended EDINBURGH COLLEGE OF ART 1922–7, and exhibited mainly in Scotland at the RSA (RSA 1933), the RSW (RSW 1934) at the GI and the SSA, as well as in the provinces and abroad. His work is represented in several public collections. He painted on the West Coast of Scotland and in Edinburgh and his style has some similarities with that of JOHN NASH. CF

IRVING, Laurence Henry Forster, SMA (b. 1897). Painter of landscapes, marines and architecture in oils and watercolours; illustrator, stage and film designer. The son of H.B. Irving, he attended the BYAM SHAW and RA SCHOOLS and exhibited mainly at the FINE ART SOCIETY and at the RA between 1921 and 1935. He also showed at AGNEW'S, London, and at the GI. Between 1928 and 1929 he was Art Director to Douglas Fairbanks and he also illustrated books, including Masefield's *Philip the King* for Heinemann. He exhibited stage and film designs at the Fine Art Society as well as his paintings which showed British, Continental and Californian subjects. CF

IRWIN, Gwyther (b. 1931). Born in Cornwall, he was taught by ROGER HILTON at Bryanston 1946–50, and went to the CENTRAL SCHOOL 1951–4. His first one-man show was at the Gallery One in 1957, since when he has regularly shown at GIMPEL FILS. His work has been shown in many national and international exhibitions, including the Venice Biennale, 1964. He taught at BATH, Hornsey and CHELSEA during the 1960s, and was Head of Fine Art at Brighton Polytechnic, 1969–84. He has done some sculp-

ture (Rectangular Relief, BP House, 1965–8) and his earlier work was of delicately torn paper collages made from old posters, the compositions resembling ancient manuscripts. More recent work, although still abstract, is more brightly coloured, and painted in acrylics from studies made up of collage material.

LIT: Extracts from his journal in *The First Sixty*, Fenella Crichton, catalogue, Kettle's Yard, 1981; *Gwyther Irwin: A Retrospective*, catalogue introduction by Nick Wadley, Gimpel Fils, 1987.AW

ISHERWOOD, James Lawrence, FRSA, FIAL (b. 1917). Painter of portraits, figures, landscapes and flowers in oils and watercolours; pastelist and modeller. Born in Wigan, he studied at Wigan School of Art 1934–8 and 1947–53 and between 1975 and 1981 he travelled extensively. He has exhibited widely throughout Britain and abroad, often in private exhibitions and in Oxford and Cambridge Colleges. In 1980 he opened the Isherwood Gallery in Wigan. His work is represented in collections including Stoke City Art Gallery. He was elected FIAL in 1959. The subject of BBC and ITV programmes, his work is noted for its colourful, exuberant style and sometimes controversial subject matter.

LIT: Catalogue, Fontainbleau Coffee House, London, 1965; catalogue notes, retrospective exhibition, Memomatics Ltd, Wigan, 1970. CF

J

JACK, Richard, RA, RI, RP, ARCA (1866–1952). Painter of portraits, figures, landscapes and interiors in oils and watercolours; black and white artist. He won a National Scholarship to the RCA in 1886 and in 1888 a Travelling Scholarship to work in Paris at the ACADÉMIE JULIAN and COLAROSSI'S under Robert-Fleury and Bouguereau. From 1930 he worked in Canada. He exhibited widely with London societies showing regularly at the RA from 1893 and becoming RA in 1920, RP in 1899 and RI in 1917. He also showed abroad, winning medals at the Paris International Exhibition, 1900, and the Carnegie International Exhibition, Pittsburgh, 1914. In 1912 his painting *Rehearsal with Nikisch*, was purchased by the CHANTREY BEQUEST. His many portraits included those of George V and Queen Mary. His wide-ranging work demonstrates his ability to order complex

scenes, e.g. *The Return to the Front: Victoria Railway Station* (York City Art Gallery). CF

JACKLIN, Bill, RA (b. 1943). Painter of urban scenes, figures, interiors and abstracts in oils; printmaker. He studied graphics and painting at Walthamstow School of Art 1960–1 and 1962–4, and from 1964 to 1967 attended the RCA. In 1985 he moved to New York where he now lives. He has held solo exhibitions in London from 1970 and since 1980 has shown at MARLBOROUGH FINE ART in London and New York. His work has been included in many group shows and is represented in public and corporate collections including the TATE GALLERY and MOMA, New York. Between 1967 and 1975 he taught widely and in 1975 was awarded an ARTS COUNCIL Bursary and gave up teaching. His earlier work was abstract but in 1975 he turned to representational painting which is concerned with light and its changing character. Recent paintings of New York combine clear and soft focus, intense colour and documentary subject matter.

LIT: *Bill Jacklin, Urban Portraits*, exhibition catalogue, Marlborough Fine Art, London, 1988. CF

JACKSON, Albert Edward (1873–1952). Painter of figures and landscapes in oils and watercolours; illustrator. He trained at Camden School of Art under Francis Black and exhibited at the RA and the RBA. From 1893 to 1947 he worked as an illustrator for Amalgamated Press. His oil paintings such as *The Bridge*, 1919, show a romantic, lyrical interpretation of his subject. CF

JACKSON, Arthur (b. 1911). Painter of abstracts in oils; architect. A cousin of Barbara Hepworth, he studied at ST MARTIN'S SCHOOL OF ART 1929–32, and was a pupil of BEN NICHOLSON 1932–6. On trips to Paris he met Hélion and Hans Erni; in London he worked in the Mall studios with Nicholson, MOORE and Hepworth. A member of the SEVEN AND FIVE SOCIETY, he exhibited with them in 1935, at the LEFEVRE and LEICESTER Galleries and in group exhibitions of abstract art during the 1930s. He is represented in public collections including the TATE GALLERY. In 1939 he stopped painting and from 1938 studied architecture at Hull School of Architecture, completing his training in 1947 and subsequently working as an architect. His abstracts, showing simple shapes and their interaction, reflect the work of Nicholson and Hepworth. CF

JACKSON, Francis Ernest, ARA (1872–1945). Painter of portraits, figures and some flower, landscape and architectural subjects in oils; lithographer and poster designer. He studied in Paris at the ACADÉMIE JULIAN and the Ecole des Beaux-Arts under Bouguereau, Constant, Ferrier and Laurens. He exhibited mainly at the RA from 1907 to 1945 (becoming ARA in 1944), and at the NEAC, as well as London galleries and the provinces. In 1940 his portrait of Mrs Beasley, 1936–7, was purchased by the CHANTREY BEQUEST. He taught at the CENTRAL SCHOOL 1902–21, the RA SCHOOLS 1921–39 and was Principal of the BYAM SHAW SCHOOL 1926–40. A member of the SC, he designed for London Underground, worked for the Ministry of Information 1914–18, was co-founder of the Design and Industries Association in 1915, and Master of the AWG in 1928.
LIT: 'F. Ernest Jackson: Draughtsman and Lithographer', *Apollo* (UK), May 1987.　CF

JACKSON, Frederick William, RBA, NEAC (1859–1918). Painter of landscapes, marines and some still-life and figures in oils and watercolours. A student at Oldham School of Art, he painted with the 'Manchester School' of J. Anderson Hague in 1880. He then studied in Paris at the Ecole des Beaux-Arts under Lefèbvre and Boulanger and travelled in Europe. He exhibited widely, showing many works at the RA and in Manchester. A member of the NEAC in 1886, he showed there from 1886 to 1891 and in 1907 and 1910, and became RBA in 1894. He was also a member of the Staithes Group. His work is represented in public collections including Manchester City Art Gallery; it gives a painterly, impressionistic account of the subject, e.g. *The Kremlin, Moscow, under Snow*, RA 1914.　CF

JACKSON, Vanessa, MA, RCA (b. 1953). Painter of non-figurative works in oils; woodcut artist. She studied at ST MARTIN'S SCHOOL OF ART 1971–5, and at the RCA 1975–8, and has held solo exhibitions at the National Theatre in 1978, in London galleries including the AIR Gallery in 1981, and most recently at the Winchester Gallery, Hampshire, in 1990. She has shown widely in group exhibitions since 1974 and her work is represented in collections including Imperial College, London, and the Paul Getty Museum, USA. Head of Painting at Winchester College of Art since 1988, amongst her awards has been the Yaddo Fellowship, New York, 1985 and 1991. Her large abstract works have developed through self-imposed rules and limitations concerned with the potential of paint and colour and are also influenced by architecture of a human scale.
LIT: *Tabellae*, text by J. Laughlin, woodcuts by Vanessa Jackson, Grenfell Press, New York, 1986; exhibition catalogue, Winchester Gallery, 1990.　CF

JAMES, Edward (1907–1984). Patron and collector. Having a considerable fortune, James travelled and lived abroad for much of his life, but retained his family houses in Britain, including West Dean Park in West Sussex. His friendships in Paris with artists such as René Magritte, Salvador Dali and LEONORA CARRINGTON made him particularly interested in SURREALISM; he sponsored the magazine *Minotaure* between 1933 and 1939. He established the Edward James Foundation in about 1960, and in 1972 had West Dean converted into an important adult residential college for training in the arts and crafts; much of his collection was sold to provide funding for this project.
LIT: *Edward James*, John Lowe, 1991.

JAMES, Richard (b. 1937). Painter of abstracts in acrylic. Born in Yorkshire, he studied at Doncaster School of Art 1957–9, ST MARTIN'S SCHOOL OF ART 1959–60 and at the SLADE SCHOOL 1960–4, winning a ROME SCHOLARSHIP in Painting in 1964. He held a solo exhibition in 1971 at the School of Art Gallery, Norwich, and subsequently exhibited at the DLI Museum and Arts Centre, Durham, the Stockwell Depot, at the Acme Gallery, London, and with Ruth S. Schaffner, Santa Barbara, USA. His work has been included in group shows in Britain and America. He has taught widely and since 1968 has been a member of staff at Norwich and Wimbledon Schools of Art. In 1979 he was awarded an Austen Memorial Scholarship. His painting shows calligraphic, organic motifs painted in a fluent and expressive style.　CF

JAMIESON, Alexander, ROI, IS (1873–1937). Painter of landscapes, townscapes, flowers and some portraits in oils. Born in Glasgow, he studied at Haldane Academy, Glasgow, winning a scholarship to Paris in 1898 where he met many impressionist painters. Thereafter he made frequent visits to France and travelled to Spain in 1911. He held a solo exhibition at the Carfax Gallery in 1912 and subsequently exhibited in London, the provinces, at the ROI (member

1927), and at the RA. He also showed in Europe and is represented in public collections including the TATE GALLERY and the Louvre. He was married to the artist Gertrude Macdonald. Influenced by Manet and the Impressionists, he painted works in one sitting in rapid broken brushstrokes which could also be broad and expressive.
LIT: Article by J.B. Manson, *Studio*, 1910, pp.274–82. CF

JAPP, Darsie Napier, NEAC (1883–1973). Painter of figures and landscapes in oils. Educated at St John's College, Oxford, he worked for his father in his shipping office whilst attending evening classes at LAMBETH SCHOOL OF ART under CONNARD 1904–7. In 1908–9 he studied at the SLADE SCHOOL. He lived in France and Spain from 1926 to 1953; he then settled in England and later in life lived in Portugal. He exhibited at the NEAC from 1912 (member 1919), and is represented in several public collections including the IMPERIAL WAR MUSEUM (*The Royal Field Artillery in Macedonia*, 1919), Bradford Art Gallery (*Una Murciana*), and the TATE GALLERY (*Saddleback from Wallthwaite*). CF

JARAY, Tess (b. 1937). Painter of abstracts in acrylic and gouache; etcher; designer of decorative floors and murals. Born in Vienna, she studied at the SLADE SCHOOL 1957–60, winning an Abbey Minor Scholarship to study in Italy in 1960. In 1961 she worked in France on a French Government Scholarship and in 1979 visited Australia. She held her first London solo exhibition at the Grabowski Gallery in 1963, and subsequently exhibited at leading galleries including the Whitechapel in 1973, and the SERPENTINE in 1988. She has shown in Australia and extensively in group exhibitions and her work is represented in public collections including the TATE GALLERY. Her decorative commissions include a mural for the British Pavilion, Expo '67, Montreal, and floors for Victoria Station and Stoke Garden Festival. Since the 1960s she has worked with abstract geometric shapes influenced by architecture, in particular Islamic structures and decoration. Her work is flatly painted in soft colour and shows the repetition and transformation of shapes bound together in an invisible structural frame.
LIT: Catalogue, Serpentine Gallery, 1988; article in *Artscribe*, May/July 1984; catalogue of retrospective of graphic work, Ashmolean Museum, 1984. CF

JEGEDE, Emmanuel Taiwo (b. 1943). Painter, sculptor, printmaker, musician and poet. After studying sculpture in Nigeria, 1960–3, he continued his studies in Willesden (1964–8) and at the Hammersmith College of Art (1969–72). His first one-man show was at the Woodstock Gallery in 1968. He has since exhibited regularly and widely in this country and abroad, as well as teaching and lecturing. His paintings, such as *Path of Joy*, 1993, are crowded with references to Yoruba culture, history, religion and legend. AW

JELLICOE, Colin (b. 1942). Painter of figures and landscapes in oils, art gallery director. He studied at MANCHESTER COLLEGE OF ART and held his first solo exhibition in 1970 at Monks Hall Museum, Eccles. Retrospective exhibitions of his work have been held at Stockport Art Gallery in 1981, and the Colin Jellicoe Gallery, Manchester, in 1986 and 1990. He has exhibited in group exhibitions since 1964 and shown regularly at the Manchester Academy Exhibitions since 1970. He opened his first gallery in 1963, and in 1968 in partnership with Alan Behar opened his gallery in the city centre, Manchester. In the 1960s he painted landscapes of Platt Fields, Manchester, in painterly impasto, but later work concentrated on figures in interiors or landscape depicted with more clearly delineated forms. Influenced by the cinema and photography, his recent work shows sequences based on one subject, particularly single figures in a landscape, using a stippled technique.
LIT: 'Guy Lawson talks to Colin Jellicoe', *Art Line*, Vol.2, No.1, April 1984. CF

JENNINGS, Humphrey (1907–1950). Painter of landscapes, townscapes, Surrealist subjects, locomotives and a wide range of images in oils; collagist; documentary film maker, poet and theatrical designer. He read English at Pembroke College, Cambridge, 1926–9, designing theatrical sets and costumes there and for the London Opera Festival in 1929. In 1931 he went to Paris and from 1934 worked in London with the GPO Film Unit where he met Cavalcanti. A close friend of Eluard, Breton and ROLAND PENROSE, he was on the organizing committee of the International SURREALIST Exhibition, London, 1936, in which he also exhibited. He held a solo exhibition at the LONDON GALLERY in 1937 and a memorial exhibition was held at the ICA Galleries in 1957. He co-edited the *London Bulletin* with E.L.T. Mesens, and with Stuart Legg and David Gascoyne he was responsible for

the idea of 'Mass Observation', 1936. Throughout the War he produced documentary films including *The First Day* and *Fires Were Started*, and from 1943 to 1946 he directed eight other films. His painting was influenced by Surrealism and Cubism and in the 1930s sought a means of combining tradition and modernism in a style that would show 'a new solidity as firm as cubism, but fluid'. His later work was characterized by short, energetic lines flying from the forms as if to express their movement and inherent energy. He often returned to particular images: the plough, the horse and the locomotive, which reflected his concern with symbol, the industrial revolution and with a new iconography of modernism.
LIT: *Humphrey Jennings: Film Maker, Painter, Poet*, British Film Institute, 1982. CF

JOHN, Augustus Edwin, OM, RA (1878–1961). A painter of portraits and figure compositions; draughtsman. Born in Tenby, he attended the SLADE SCHOOL 1894–8, making an impressive debut as a student. Thereafter he visited Paris regularly; he exhibited with the NEAC in 1899, and in 1903 shared an exhibition with his sister GWEN JOHN at the Carfax Gallery. Nine months of travel in France and Italy in 1910, when he met and lived with gypsies, and visited museums, galleries and churches was of importance to his development. Friendly with INNES and DERWENT LEES, he worked and travelled with them in Wales, 1911–14, painting landscapes and groups of romantic figures, loosely executed in light, harmonious tones, with occasional passages of intense colour. These have an affinity with the Rose Period paintings of Picasso, whom he met and strongly admired, although after tentatively exploring stylistic mannerisms derived from his artistic contacts in Paris (he also admired Modigliani), his work remained relatively conventional in approach, although always executed with a virtuoso handling of paint and brilliantly assured draughtsmanship. His portraits were among his most popular and successful works (for example, Mme Suggia, G.B. Shaw, Dylan Thomas, W.B. Yeats). He was a war artist during the First World War for Lord Beaverbrook's Canadian War Memorials Fund and published *Chiaroscuro; Fragments of Autobiography* in 1952. President of the Society of Mural Painters, he was elected ARA in 1921, RA in 1928, but resigned (1938) over the Academy's rejection of the portrait of T.S. Eliot by WYNDHAM LEWIS, an artist on whom John had a strong personal rather

than artistic influence. He was re-elected in 1940.
LIT: *Augustus John*, Michael Holroyd, 2 vols, Heinemann, 1974, 1975. AW

JOHN, Edwin (b. 1905). Painter of landscapes, figures, flowers, townscapes and still-life in watercolours. The son of AUGUSTUS JOHN, he exhibited in London at the Connell Galleries in 1937 and at the BEAUX ARTS GALLERY in 1939 and 1951, showing watercolours of English and Continental subjects such as *View of St Rémy* and *Still-Life with Daffodils*. CF

JOHN, Gwendolen Mary (1876–1939). A painter in oils and watercolours, she was born in Haverfordwest, Wales, and attended the SLADE SCHOOL 1895–8, winning a prize for Figure Composition in her final year. She then studied for a year in Paris at Whistler's Académie Carmen, along with her Slade friends Ida Nettleship and Gwen Salmond. In 1899 she returned to London, and exhibited at the NEAC in 1900. In 1903 she shared an exhibition with her younger brother AUGUSTUS JOHN at the Carfax Gallery. In 1904 she moved back to Paris where she formed a liaison with Rodin, for whom she posed: she was the model for the 'Muse' of Rodin's MONUMENT TO WHISTLER. She became friendly with the poet Rilke, and, initially to be close to Rodin, she moved to Meudon in 1911, living there for the rest of her life, apart from visits to Paris, where she maintained a studio for many years, to Pléneuf near St Malo (every summer, 1915–21) and a couple of brief visits to England. She became a Roman Catholic in 1913, attending the chapel of the Dominican Convent of the Sisters of Charity of Meudon, for whom she painted a number of versions of portraits of their seventeenth-century founder, Mère Poussepin. Her work was much sought after by the American collector John Quinn, who was also her patron in other respects; she became friendly with Jacques Maritain, his wife Raissa and her sister Véra Oumançoff, to whom she gave many drawings. She had a retrospective exhibition at the New Chenil Galleries in 1926, but probably did little work, owing to ill-health, during the last six to ten years of her life. She also appears to have destroyed much work. She developed a remarkable technical approach, applying the paint with dry, chalky touches, usually in closely-related tones, whilst her subject-matter – interiors, nudes, self-portraits, portraits of nuns and young girls – was treated with extreme

refinement of handling, delicate purity of form and simplicity of composition.

LIT: *Gwen John*, Mary Taubman, Scolar Press, 1985; *Gwen John*, Susan Chitty, Hodder and Stoughton, 1981. AW

John Moores (Liverpool Exhibitions; Prizes). The first of the biennial exhibitions was held in 1957, sponsored by John Moores Esq. and the Liverpool Arts Committee. The organization of the Exhibition has varied from time to time (in 1959, for example, there was an invited French section) but normally it is open to all painters and sculptors working in the British Isles, subject to selection for the exhibition and for a number of substantial cash prizes and purchases. In some years certain artists have been invited, exempt from the Selection Committee but still eligible for prizes; again, a number have been invited *hors concours*. The aims of the Exhibition have always been firstly to give the people of Merseyside the opportunity of seeing the most vital contemporary painting and sculpture, and secondly to encourage young British artists. AW

JOHN, Vivien (b. 1915). She studied at the SLADE and the EUSTON ROAD SCHOOL. She further studied at the Regent Street Polytechnic after having served as a Red Cross nurse during the Second World War. Her first solo exhibition was at the Upper Grosvenor Galleries in 1981. AW

JOHNSON, Audrey (b. 1919). Painter of still-life and wild flowers in oils. She trained at Preston College of Art and the CENTRAL SCHOOL, London, and married the artist CLAUDE HARRISON in 1947. Between 1947 and 1949 she worked as a scenic artist for MGM Films and in 1949 settled in the Lake District. She has exhibited at the RA, and in two-man and group shows in London, Preston, Cumbria, the USA and Japan. A restorer, collector and writer on antique dolls and dolls' houses, she paints directly from life and her flower studies show her concern for botanical accuracy. CF

JOHNSON, Elaine (b. 1945). Painter of non-figurative works in acrylic. Born in Widnes, she studied at Liverpool College of Art 1963–4, Newcastle University 1965–70, winning the Hatton Scholarship, at CHELSEA SCHOOL OF ART 1970–1, and between 1971 and 1972 she held the John Brinkley Fellowship at Norwich School of Art. She held a solo exhibition at the Calouste Gulbenkian Gallery, Newcastle, in 1971, and she

has subsequently exhibited in the provinces and London galleries, including the AIR Gallery in 1980 where she exhibited her *Zoar* series. CF

JOHNSTON, Alan (b. 1945). Painter, sculptor and draughtsman. He studied at EDINBURGH and the RCA, and worked for a period in Düsseldorf. His minimalist abstract drawings have been carried out on paper, canvas and on the walls of galleries as installations. AW

JOHNSTONE, William, RSA, OBE (1897–1981). Painter of landscapes, abstracts and portraits in oils; teacher and writer on art. He studied with Tom Scott at EDINBURGH COLLEGE OF ART, the RSA Schools and in Paris with André Lhote, and held his first solo exhibitions in 1935 at the Wertheim Gallery, London, and the Scottish Gallery, Edinburgh. He subsequently exhibited in London, Scotland and the provinces. An influential art teacher, he was Principal of CAMBERWELL and the CENTRAL Schools of Art; he was awarded an OBE in 1954 and an Honorary Doctorate, Edinburgh University in 1980. A close friend of Hugh MacDiarmid, in the 1930s he painted Surrealist abstracts of powerfully coloured organic forms. From more representational work of the 1940s he moved toward greater abstraction, retaining subconscious reference to the landscape and his mastery of colour.

LIT: *Points in Time*, W. Johnstone (autobiography), 1980; *William Johnstone*, Douglas Hall, 1980. CF

JONES, Adrian (1845–1938). Painter in oils and sculptor of equestrian and military subjects, figures and portraits. He qualified as a veterinary surgeon in 1866 and served in the army as a veterinary officer until 1891. He studied art under C.B. Birsch and after 1891 he established a studio in Chelsea. A friend of SARGENT and Whistler, he exhibited between 1884 and 1935, showing mainly at the RA as well as at the ROI, LS, the GROSVENOR and Baillie Galleries, in Liverpool and at the GI. His work is represented in collections including the Walker Art Gallery, Liverpool. Patronized by the Royal Family, he was best known as a sculptor and amongst his many commissions are the Quadriga of Peace, 1912, Hyde Park Corner, and the Cavalry Memorial, 1924, Hyde Park. His paintings ranged from equestrian portraits of generals to portraits of racehorses.

LIT: *Memoirs of a Soldier Artist*, Capt. Adrian Jones, Stanley Paul & Co. Ltd, London, 1933,

Adrian Jones: His Life and Work, J.A. Cunningham, catalogue, The Sladmore Gallery, London, 1984. CF

JONES, Allen, RA (b. 1937). Painter of figures in oils and watercolours; sculptor and lithographer. He trained at Hornsey College of Art 1955–9 and 1960–1, and at the RCA 1959–60, with KITAJ, HOCKNEY and BOSHIER. From 1964 to 1965 he lived in New York. He held his first solo exhibition in 1963 at Tooth & Sons where he continued to exhibit until 1970, thereafter showing at the WADDINGTON GALLERIES. He has exhibited regularly abroad, in group exhibitions and at the RA since 1976, being elected ARA in 1981. Retrospective exhibitions have been held in 1978 at the ICA and in 1979 at the Walker Art Gallery, Liverpool, and he is represented in many public collections including the TATE GALLERY and MOMA, New York. He has taught at Hornsey and CHELSEA schools of art and at the Hochschule für Bildende Künste, Hamburg, the University of South Florida, the University of California at Irvine and Los Angeles, the Banff School of Fine Art, Alberta, and at the Hochschule für Künste, West Berlin. In 1966 he was awarded the Tamarind Lithography Fellowship, Los Angeles, and between 1969 and 1970 he designed sets and costumes for *Oh Calcutta*, London, and *Männer wir Kommen*, Cologne. His sculpture commissions include work for the International Garden Festival, Liverpool, 1984. Influenced by Abstract Expressionism and by Kitaj, his paintings combine figurative and abstract elements and employ different styles, contrasting flat shapes with highly modelled forms. Since the 1960s the subject of his work has been the preoccupations of contemporary society, in particular sexuality and fetishism. Ideas on the nature of male and female characteristics drawn from the theories of Jung and Nietzsche are economically expressed, often by isolated sexually potent fragments of female figures painted in hot colours.
LIT: Retrospective exhibition catalogue, Walker Art Gallery, Liverpool, 1979; Lawrence Gowing in *Art & Design*, June 1985; 'Allen Jones Sculptures', Victor Arwas, *Art & Design* (UK), Vol.3, Pt1–2, 1987. CF

JONES, Christopher (b. 1958). He studied at Newcastle upon Tyne University, then at CHELSEA. He spent some time living in Cumbria at this period. He was Fellow in Fine Art at Gloucester College of Art 1983–4, then travelled in Spain

with a Boise Scholarship for two months. His first one-man show was at the University of Nottingham in 1985, the year he moved from Merseyside to London. He uses complex collage techniques of dismembering and re-assembling his images, tearing, cutting and reversing fragments to make shaped canvases. AW

JONES, Colin (b. 1934). Constructivist. He studied at GOLDSMITHS' COLLEGE OF ART with KENNETH and MARY MARTIN and since 1962 has exhibited in constructivist group exhibitions in Britain and abroad. He has taught at Leicester Polytechnic since 1964 and his awards include ARTS COUNCIL Grants in 1970–2 and 1980. His geometric reliefs are precise and complex and recent work has concentrated on large scale architectural commissions. CF

JONES, David Michael, CH, CBE, SWE (1895–1974). Painter of landscapes, portraits, still-life, animals, imaginative subjects and inscriptions in watercolours; draughtsman, engraver, writer and poet. He studied at CAMBERWELL SCHOOL OF ART 1909–14, under HARTRICK who influenced his use of pencil, watercolour and bodycolour, and SAVAGE who introduced him to the work of the Pre-Raphaelites and the English illustrators. From 1915 to 1918 he served with the Royal Welch Fusiliers and in 1919–21 attended WESTMINSTER SCHOOL OF ART under BAYES and MENINSKY where he was influenced by Blake and El Greco. In 1921 he was received into the Catholic Church and he made his first visit to ERIC GILL in Ditchling. He subsequently moved to Ditchling, becoming a member of the Third Order of St Joseph and St Dominic and learning wood engraving from Desmond Chute. In 1924 he moved to North Wales with Gill and in 1925 painted at Caldy Island. He was elected SWE in 1927 and in 1929 he worked at Rock Hall, Northumberland, the home of Helen Sutherland, but a breakdown in 1932 prevented him from painting until 1936. A period working in London was followed by another breakdown in 1946–7. He first exhibited with Eric Gill at St George's Gallery in 1927, subsequently showing with the SEVEN AND FIVE SOCIETY from 1928 to 1933, at the Goupil Gallery in 1929 and at leading London galleries. His work was exhibited at the Venice Biennale in 1951, and at the TATE GALLERY 1954–5 and 1981. He is represented in many public collections including the Tate Gallery and he was created CBE in 1955 and CH in 1974. His wood engravings, influenced by Gill,

include illustrations for *The Chester Play of the Deluge*, 1927, and other publications for the Golden Cockerel Press, whilst his own writings include *In Parenthesis*, 1937, for which he was awarded the Hawthornden Prize, and *The Anathemata*, 1952. His art is essentially religious, expressing the spiritual character of landscape and figures. He evolved an idiosyncratic, elegant and complex visual language using areas of transparent watercolour and many fine lines to build up a wealth of detail and allusion. In his intricate 'subject' pictures he wove together mythological and Christian iconography in order to express his spiritual vision.
LIT: *The Paintings of David Jones*, Nicolete Gray, John Taylor/Lund Humphries, London, 1989; exhibition catalogue for the Southbank Centre, 1989. CF

JONES, Frederick Cecil, RSA, RBA (1891–1956). Painter of townscapes and landscapes in watercolours; etcher and illustrator. He was a student at Bradford College of Art 1905–16, and Leeds College of Art 1930–5, and he exhibited at the RA from 1931, the RWS and RBA, where he was elected a member in 1940. He also showed at Liverpool and the RSA, being elected a member in 1952. In 1937 his work *Chimney Stacks and Winding Ways, Whitby*, was purchased by the CHANTREY BEQUEST. He was an art master at Pudsey Grammar School and Deputy Principal of Pudsey School of Art. His townscapes are detailed and realistic and his panoramic view of Dewsbury (Bradford Art Gallery) captures the receding rows of houses and the smoking chimneys of the industrial landscape. CF

JONES, Harold, ARCA (b. 1904). Painter of figures and still-life in oils and watercolours; illustrator in ink and watercolours. He studied at GOLDSMITHS' COLLEGE OF ART, CAMBERWELL SCHOOL OF ART and at the RCA 1924–8, under SCHWABE and ROTHENSTEIN. He exhibited at the RA, NEAC, and in London galleries including the LEICESTER GALLERIES. His work is represented in public collections including the TATE GALLERY. From 1945 to 1958 he taught at CHELSEA SCHOOL OF ART and in 1980 he was awarded the Gold Medal of the Academia d'Italia. Introduced to illustration work by BARNETT FREEDMAN, he established his reputation with *This Year, Next Year*, Faber and Faber, 1937, and he subsequently wrote and illustrated books for children. His

paintings and illustrations are based on his clear draughtsmanship.
LIT: Exhibition catalogue, Sally Hunter Fine Art, London, 1988. CF

JONES, Patrick (b. 1948). Painter of abstracts in acrylic and pastel. He studied at Exeter, Cheltenham and Birmingham colleges of art, 1965–71, and from 1973 to 1975 was awarded the Hoftburger Scholarship to the Maryland Institute, Baltimore, USA. He has exhibited since 1971 and held solo exhibitions in London galleries including the Nicola Jacobs Gallery. In 1981 he was awarded the John Brinkley Fellowship in Painting, Norwich School of Art. His fluid, expressive abstracts are motivated by colour. CF

JONES, Peter, SMP (b. 1917). Painter of abstracts in acrylic, oils and emulsion; printmaker, draughtsman and maker of relief constructions in wood. Born in London, he studied at Richmond School of Art and held solo exhibitions in London galleries, including the REDFERN and Molton Galleries. He also showed at the RA and the RBA and his work is represented in public collections including the V & A. Influenced by his experience as a pilot and by his interest in engineering, his work explores the relationship between natural and manmade forms. In the 1970s his abstracts were composed of juxtaposed squares and in 1974 his series of figurative drawings of the Royal Free Hospital were exhibited at Camden Arts Centre. CF

JONES, Stanley (b. 1933). Lithographer. He studied at the SLADE (1954–6) under CERI RICHARDS and in 1956 won a scholarship to the Ecole des Beaux-Arts in Paris, where he specialized in stone and plate lithography. He also worked until 1958 at the Atelier Patris in Paris, printing work by HAYTER and others in addition to his own. The Hon. Robert Erskine then invited him to run the St. Mary's Studio in Plaistow for the CURWEN PRESS, which he has done ever since, working with many distinguished artists. *Sheelin* (1978) is in the TATE.

JONES, Trevor (b. 1945). Painter of abstracts in acrylic; printmaker. Born at Stourbridge, Worcestershire, he attended Stourbridge College of Art 1960–3, Birmingham College of Art 1963–5, and the RCA 1965–8. He held his first solo exhibition in 1969 at the NEW ART CENTRE where he continued to exhibit until 1987, subse-

176

quently showing with Angela Flowers at Flowers East in 1990. He has exhibited in group exhibitions since 1969 in Britain, Canada and the USA and his work is represented in collections including the Department of the Environment. He has taught at Birmingham Polytechnic, CAMBERWELL SCHOOL OF ART and at the LONDON INSTITUTE where he is Senior Lecturer in Fine Arts. His work is influenced by the observation of nature and his complex prints use rapid calligraphic marks.
LIT: Aldeburgh Festival Programme, June 1990.
CF

JOSEPH, Peter (b. 1929). Painter of abstracts in acrylic; environmental and installation artist. Self-taught as an artist, he held his first solo exhibition in London in 1966 at the Greenwich Theatre Gallery. He has subsequently shown regularly at the Lisson Gallery, London (and internationally), and his work is represented in collections including the TATE GALLERY. A prizewinner at John Players Exhibition, Nottingham 1968, between 1969 and 1972 he taught at Portsmouth College of Art. His painting is based on a central rectangle with a border or surround using two colours. Concerned with symmetry, light, proportion and scale, he paints in thin layers which produce a subtle, coloured surface.
LIT: Exhibition catalogue, Museum of Contemporary Art, Chicago, 1983.
CF

JOWETT, Percy Hague, RWS, NEAC, NS, ARCA, CBE (1882–1955). Painter of landscapes, interiors and flowers in oils and watercolours. He studied at Harrogate Technical Institute, Leeds School of Art and the RCA, winning the PRIX DE ROME. A friend of CLAUDE FLIGHT, with whom he painted regularly in France between 1926 and 1939, he was a founder member and Secretary of the SEVEN AND FIVE SOCIETY. He held four solo exhibitions at the St George's Gallery in the 1920s and exhibited at the NEAC (member 1929), at the RA from 1907 to 1926, at the RWS (ARWS 1936, RWS 1938) and in London and provincial galleries. His work is represented in the Laing Art Gallery, Newcastle. He was Head of CHELSEA POLYTECHNIC in 1927, Principal of the CENTRAL SCHOOL, 1929–35, and Principal of the RCA, 1935–47. His painting was characterized by its sense of light, pattern and colour.
LIT: Catalogue, exhibition of watercolours, Clarges Gallery, London, 1978; *Percy Hague Jowett*, catalogue, Parkin Gallery, London, 1983.
CF

K

KALKHOF, Peter (b. 1933). Born in Stassfurt in Germany, he studied painting 1952–5 in Brunswick after having begun his training in colour-chemistry. In 1956–7 he studied in Stuttgart, winning first prize in a portrait competition of the Stuttgart Academy. He was at the SLADE SCHOOL 1960–1, and at the Ecole des Beaux-Arts in Paris in 1962. Since 1963 he has lived and worked in Britain, apart from a period as Artist-in-Residence at Osnabrück in 1985. He has taught at Reading University (to begin with, lithography and etching) since 1964. His first one-man show was at the Galerie am Bohlweg, Brunswick, in 1962, and since 1970 he has shown regularly at Annely Juda and Juda Rowan. His work has featured in many national and international exhibitions: in group exhibitions such as 'British Painting '74' for example, or the selection of his major work from 1961 in the Landesmuseum, Oldenburg, 1988. His abstract paintings and floor pieces are intense and resonant in colour, often sprayed or smoothly graded, and expressive of his experience of light and space. His work is in the collections of the ARTS COUNCIL, of Reading Museum, of the Landesmuseum, Oldenburg, the European Parliament and the Koh Gallery, Tokyo. Travel, in every continent, has been of vital importance to him.
LIT: *Kalkhof, Farbe und Raum*, essays (with translations) by Roger Cook, Paul Kopecek and Peter Reindl, catalogue, Landesmuseum, Oldenburg, 1988.
AW

KAPP, Edmond Xavier (1890–1978). Painter of portraits, landscapes and abstracts in oil; lithographer and draughtsman. Whilst at university in Cambridge he published drawings and caricatures in *Granta* and the *Tatler*, continuing to earn his living in this way until the outbreak of the First World War, when he enlisted. In 1919, on demobilization, he rented a studio in St John's Wood, London, and studied at three art schools, including the SLADE SCHOOL. He was later to study in Vienna, Paris and Rome where he was influenced by the American painter, Maurice Sterne. He worked in Spain in 1926, and then in Antibes where he met, and later drew, Picasso. Although London based he made long trips to Geneva, Paris and the South of France. He exhibited in London and the provinces, France and the

177

USA. An important retrospective was held at the Whitechapel Gallery, London, in 1961. He took part in several major group exhibitions including 'British Art since Whistler', National Gallery, London, 1940. Commissions include ten colour lithographs of prominent legal figures for Butterworths in 1925, six of which were reproduced as stained glass windows in Yale Law School Library; twenty-five lithographs portraits of figures in the League of Nations, for the British Museum and the National Gallery, London, from 1933 to 1935; and a record of life in London's underground during the blitz entitled *Under London*, for the IMPERIAL WAR MUSEUM, 1940–1. He made twenty portrait drawings at the first UNESCO Congress. Kapp's work falls into two sections: his portraits and lithographs which capture the subjects' personalities in lively and bold, swiftly drawn line; and his fresh, colourful landscapes and abstracts, often painted in oils on paper. From 1960 he painted abstracts almost exclusively, the exceptions being occasional portraits.

LIT: *Edmond Kapp: a retrospective exhibition of paintings and drawings, 1911–1961*, Whitechapel Art Gallery, London, 1961. JK

KARLOWSKA, Stanislawa de, LG (1876–1952). Painter of townscapes, still-life and interiors in oil. She studied in Warsaw, Cracow and at the ACADÉMIE JULIAN, Paris. In 1897 she married ROBERT BEVAN and they settled in London, which became the main subject of her painting. She also painted in Poland, Brittany and the West Country. She exhibited with the WIAC from the early 1900s, the AAA from 1908, and was a founder member of the LG, exhibiting with them until she gave up painting in the last few years of her life. One-man shows included the Adams Gallery in 1935, and a memorial exhibition there in 1954. The Polish Library held a joint exhibition in honour of Bevan and Karlowska in 1968. Influenced by traditional Polish crafts she always retained a strong feeling for colour and pattern, which can be seen in her clear, simple, almost naïve London townscapes, and in her landscapes of Poland and Brittany.

LIT: *Robert Bevan and Stanislawa de Karlowska*, catalogue, Polish Library, 1968. JK

KASHDAN, John (b. 1917). Painter of figures and still-life in oils; printmaker. He studied at the RA SCHOOLS 1936–9, winning many awards, and in the 1940s he lived in Cambridge where he knew HENRY MOORE and Gustav Kahnweiler. He

held his first solo exhibition at the REDFERN GALLERY in 1945 and has subsequently exhibited in provincial and London galleries and in America. His work is represented in collections including the BM, London. Between 1951 and 1982 he taught at Guildford and Epsom Schools of Art. Influenced by Cubism, ADLER and Klee, his expressive figurative work reflects his humanist outlook. His monotype prints were admired by Adler, COLQUHOUN, MCBRYDE and MINTON.

LIT: *John Kashdan. Monotypes and Paintings 1940–1955*, exhibition catalogue, England & Co., London, 1989. CF

KAUFFER, Edward McKnight (1890–1954). Born in Montana, USA, he came to England in 1914 after a year's study in Paris. He exhibited as a painter until 1921, attending meetings of the CUMBERLAND MARKET GROUP, acting as Secretary to the LONDON GROUP, and participating in the GROUP X exhibition in 1920. He achieved public and professional success, however, as a graphic artist, as chief poster designer for the London Underground for over twenty-five years. His work familiarized a very wide public with the conventions of modern painting in a popular, decorative, but vigorous cubist style. He returned to the USA in 1940.

LIT: *E. McKnight Kauffer, A Designer and his Public*, Mark Haworth-Booth, London, 1979. AW

KAY, James, RSA, RSW (1858–1942). Painter of marines, landscapes and townscapes in oils and watercolours. Born on the Isle of Arran, he studied at GLASGOW SCHOOL OF ART and worked in Scotland, Holland and France. He exhibited mainly at the GI, the RSA (ARSA 1934, RSA 1939) and the RSW (member 1896). He also showed at Connell & Sons, where he exhibited in 1935, at the RA from 1889, in the provinces and at the Paris Salon from 1894. His work is represented in Glasgow Art Gallery. Awarded silver and gold medals from the Société des Amis des Arts and the Société des Artistes Français, Rouen, 1903, his work often depicted shipping, river and coastal scenes.

LIT: *Studio*, Vol.39, pp.258 and 260. CF

KEATES, John Gareth, LAA (b. 1915). Painter of landscapes, figures, underwater forms and abstracts in oils, watercolours and gouache. He studied at the Liverpool College of Art 1933–8, and after the Second World War at the CENTRAL SCHOOL. During the Second World War he

served in Burma, and was mentioned in dispatch-
es. On his return he taught at Guildford School
of Art whilst studying at the Central School. In
1948 he became a lecturer at Liverpool School of
Art (later Polytechnic), where he stayed until his
retirement in 1978. He has exhibited in London
and the provinces with the FREE PAINTERS AND
SCULPTORS GROUP, and held one-man shows at
the Atkinson Gallery, Southport, and Prestons
Gallery, Bolton. His work was strongly influ-
enced by meeting Teake Hansema and the
COBRA Group whilst travelling in France and
Italy during 1958, and by studying underwater
forms in S. Ireland. Keates's work developed in
stages through the early landscapes into a con-
centration on lyrical form and colour in the
1960s. During the 1970s he stopped painting to
care for his wife who was seriously ill. She died
in 1980. In 1981 he produced a series of draw-
ings of Southern China during a trip to Hong
Kong. Since then he has produced landscapes and
figure studies in oil, gouache and mixed media.
LIT: Catalogue, Prestons Art Gallery, Bolton,
1964; *John Keates: a retrospective*, Atkinson Art
Gallery, Southport. JK

KEATING, John (CEITINN, Sean), RHA,
Hon.RA, Hon.RSA (1889–1980). Painter of
landscapes and figures in oils and pastels; book
illustrator. He studied at the Dublin
Metropolitan School of Art, then lived on Aran,
off the west coast of Ireland for four years,
before returning to Dublin. He later worked in
London with Sir WILLIAM ORPEN, and settled per-
manently in Dublin again in 1916. He exhibited
at the RHA, RA, RSA, and his work is in many
public collections in Ireland, Britain and abroad.
At twenty he won the Dublin Scholarship in Art,
and was later awarded the Taylor Scholarship in
Painting and the Orpen Painting Prize. He illus-
trated *The Grey Goose of Kilnevin* by Patricia
Lynch, J.M. Dent, London, 1939. Characteristic
works include *Half Flood*, *Men of the South*, *On
the Run*, and *An Allegory*. JK

KELLY, Felix (1914–1994). Painter of land-
scapes and architectural portraits in oils and
gouache; book illustrator and stage designer.
With no formal training, Felix Kelly taught at
Auckland Art School, New Zealand, before com-
ing to London shortly before the Second World
War. He later travelled widely in Britain and the
USA with trips to Russia and Thailand. He exhib-
ited throughout the war at the LEFEVRE GALLERY,
London, whilst serving in the RAF. He had many

one-man shows in London and New York. Book
illustrations include *The Green Child* by Herbert
Read, Grey Walls Press, 1945, and a series of his-
torical books by Elizabeth Burton. Between 1952
and 1965 he designed many stage sets including
A Day by the Sea, by N.C. Hunter with Sir John
Gielgud, at the Haymarket, and *The Merchant of
Venice* at the Old Vic. His landscape paintings
were meticulous in execution, yet hold an air of
enigma: a real building was often set in an imag-
inary landscape, sometimes with a mysterious fig-
ure passing by. His paintings have a narrative
atmosphere and the precision of a photograph.
LIT: *Paintings by Felix Kelly*, Herbert Read,
Falcon Press, 1946. JK

KELLY, Francis (b. 1927). Painter and printmak-
er of figures and landscapes. Born in St Pauls,
Minnesota, he studied art at the Art Centre
School, Los Angeles, in 1948, and in Paris at the
Académie de la Grande Chaumière 1951–2. In
1953 he went to the University of Hawaii,
Honolulu, and then worked with John Paul Jones
at the University of California, Los Angeles.
Awarded a Fulbright Grant in 1955, he worked
at the CENTRAL SCHOOL of Art, London, and
studied conservation at the COURTAULD
INSTITUTE. He has held numerous solo exhibi-
tions internationally since 1952 and he shows at
the Colin Jellicoe Gallery, Manchester. His work
is represented in collections including the
Ashmolean Museum, Oxford. His work ranges
from landscape etchings to dramatically lit stud-
ies of the nude.
LIT: *Art Restoration*, Francis Kelly, 1971; *The
Studio and the Artist*, Francis Kelly, 1975; exhi-
bition catalogue, Editions Graphiques Gallery,
London, 1973. CF

KELLY, Sir Gerald Festus, PRS, RHA, HRSA,
KCVO (1879–1972). Painter of portraits and
some landscapes in oils, Sir Gerald Kelly was
educated at Eton and Trinity College,
Cambridge, before studying art in Paris, where
he lived for some years. He later visited Spain,
Burma, the USA, and South Africa, but London
became his permanent base. He exhibited widely
at the RA and other leading galleries from 1909.
Important one-man shows included the
LEICESTER GALLERIES in 1950, the RA Diploma
Gallery in 1957 (where he was only the fourth
RA member to be honoured with a retrospective
exhibition in his lifetime), and a memorial exhi-
bition at the FINE ART SOCIETY in 1975 (London)
and 1976 (Edinburgh). He became a member of

the Salon d'Automne, Paris, in 1904, a founder member of the Modern Portrait Painters Society in 1907, Associate RHA in 1908, founder member of the NPS in 1910, was elected RHA in 1914, and RA in 1930. He was a member of the Fine Art Commission 1938–43, Honorary Surveyor of Dulwich Art Gallery 1945, Knighted in 1945, President of the RA from 1946 until reaching the RA retirement age of seventy-five in 1954,and was invested Knight Commander of the Royal Victorian Order in 1955. He painted many well-known figures including his close friend Somerset Maugham (*The Jester*, 1911), and state portraits of King George VI and Queen Elizabeth (now the Queen Mother). Visible brushstrokes were eliminated from his portraits and his colour was restrained. Although an enthusiastic visitor to some of the Impressionists' studios in Paris, he regarded Velasquez and Ingres as the chief influences on his work. Somerset Maugham commented that Sir Gerald made every effort to bring out the character and spirit of his sitters. His landscapes were also nineteenth-century in feeling, those of Burma being the best known.

LIT: Preface by Somerset Maugham, exhibition catalogue, Leicester Galleries, 1950; *For the Love of Painting: the Life of Sir Gerald Kelly, KCVO, PRA*, Derek Hudson, Peter Davies, London, 1975. JK

KELLY, Robert George Talbot, RI, RBA, RBC (1861–1934). Landscape and genre painter in oils. Studied under his father the Dublin born artist Robert George Kelly, in Birkenhead. He originally exhibited as R.G. Kelly Jr., later inserting the family name Talbot to avoid confusion with his father. He travelled to North Africa in the 1880s establishing a studio in Cairo. He spoke Arabic and lived with the Bedouin for a time. In the summer of 1892 he travelled to Iceland. On his marriage in 1894 he returned to England, living again in Birkenhead, but from 1902 until 1914 he had studios in both London and Cairo. He went to Burma in 1903–4 at the request of the Burmese Government. After the First World War he resumed his travels, but now concentrated on Europe, especially France. In 1902 he published his first book *Egypt*, his second *Burma* followed in 1905. He exhibited at the RBA, RI, RA and had four one-man shows at the FINE ART SOCIETY, and three at the LEICESTER GALLERIES. He was elected RBA in 1892, RI in 1908, RBC in 1910, and served on the committee of each. He took great pains to express the

spirit of the desert – its oppressive heat, or the peace of the Nile. Meticulous in detail, yet full of feeling, his work was at the height of its popularity in the early years of this century.

LIT: *Paintings by Robert Talbot-Kelly*, catalogue, Williamson Art Gallery, Birkenhead, 1980; 'Current Art Notes', *The Connoisseur*, Vol.LXIX, p.183. JK

KEMP-WELCH, Lucy Elizabeth, RI, ROI, RBA, R.Cam.A. (1869–1958). Painter of animals, especially horses, landscapes and flowers in oils and watercolours. She studied at Bournemouth School of Art and the HERKOMER SCHOOL OF ART, Bushey. In the late 1920s she travelled around England with Lord John Sanger's Circus, exhibiting the resulting paintings in the Arlington Gallery, London. She exhibited annually in London shows, including the RA, which refused to elect her as a member because she was a woman. One-man shows included the FINE ART SOCIETY in 1905, Dudley Galleries in 1912, LEICESTER GALLERIES in 1914, and Arlington Galleries in 1934 and 1938. She was elected RBA in 1902. From 1907 to 1926 she took over Herkomer's School, running it on a smaller scale. She illustrated *Black Beauty* for J.M. Dent in 1915 and designed posters during the First World War. After the war she was commissioned to paint *Russley Park Remount Depot*, and in 1920 the Empress Club commissioned her to paint a panel at the Royal Exchange depicting women's war work. In 1922 she painted a picture the size of a postage stamp for the Queen's dolls' house. This was a great contrast to the huge, lively animal paintings she worked on outdoors. A tiny woman, with great stamina, she preferred work-horses to thoroughbreds, and portrayed them with tremendous spirit. In later years she became a recluse, but still exhibited one painting at the RA in 1949 at the age of eighty.

LIT: *The Life and Work of Lucy Kemp-Welch*, David Messum, Antique Collectors' Club, 1976; *In the Open Country*, Lucy Kemp-Welch, Hodder & Stoughton, 1905. JK

KENDALL, Richard (b. 1946). A painter and art historian. He studied at MANCHESTER, the CENTRAL SCHOOL and, for the history of art, at the COURTAULD INSTITUTE. He has taught at Stockport and at Manchester Polytechnic, and is now a freelance art historian. He travelled widely and painted in Europe 1974–6. While basing some of his own work on images drawn from the art of Degas, his work reflects direct experience

but sometimes includes images developed from newspaper photographs; nudes, prisoners and victims have been themes. He has also published extensively on Degas and on nineteenth-century French art, his books including *Dealing With Degas* (with Griselda Pollock), Pandora, 1992 and *Degas Landscapes*, Yale, 1993. AW

KENDRICK, Sydney Percy (1874–1955). Genre, landscape and portrait painter; sculptor. He studied in Paris and exhibited at the RA and in the provinces. He lived in London. His commissions included bronze portrait plaques for the Birchenough Bridge and for the Sir Otto Beit Bridge over the Zambesi, Zimbabwe. JK

KENNEDY, Cedric J. (1898–1968). Painter of landscapes and portraits in watercolours and oils. He studied at the London School of Art under RICHARD JACK, at Florence School of Art, and at the RA SCHOOLS under CHARLES SIMS, 1925–7. He exhibited mainly at Walker's Gallery between 1926 and 1942 and showed at the RA between 1926 and 1945, at the NEAC and the RP. His work is represented in the BM and the V & A. He taught at Rugby School, 1926–8, Cheltenham College, 1935–6, and Dean Close School, 1938–9 and 1945–62. He is best known as a *plein-air* watercolourist of landscape, often depicting the West Country and Wales, and was concerned with tonal values and visual reality.
LIT: Memorial exhibition catalogue, Cheltenham Art Gallery, 1969; *Watercolour Landscapes*, catalogue, Manning Gallery, London, 1973. CF

KENNEDY, William (1860–1918). Landscape and military painter in oils, watercolours and pastels. He studied at the ACADÉMIE JULIAN, Paris, along with other Scottish artists. After spending several years in Paris he returned to Scotland, taking a studio in Stirling in the 1880s. In the 1890s he moved to Berkshire. He exhibited at the Glasgow and Paisley Institutes and at leading London galleries. He was the President of the GLASGOW SCHOOL and a corresponding member of the Munich Secession. Many of Kennedy's French paintings are untraced but the surviving nocturne *Les Derniers Jours de la Tuilerie* shows Whistler's influence. A later nocturne *Stirling Station*, attracted attention at the Glasgow Institute with its unusual treatment of an everyday subject. Influenced by Bastien-Lepage's naturalistic techniques, Kennedy's landscapes were delicate in colour, careful in composition and detail, while

his military scenes were stronger in colour and bolder of execution.
LIT: *The Glasgow School of Painting*, David Martin, Bell & Sons, London, 1897/Harris, Edinburgh, 1976; *The Glasgow Boys: the Glasgow School of Painting, 1875–1895*, Roger Billcliffe, J. Murray in assoc. with Britoil, London, 1985. JK

KENNEY, John Theodore Eardley (1911–1972). Painter of sporting subjects in oils, watercolours and pen and ink. He studied at Leicester School of Art and worked as a commercial artist until 1952. He exhibited in London galleries, the provinces and America and in 1946 illustrated *There is an Honour Likewise* by Edward Bouskell-Wade. Influenced by MUNNINGS, his painting used a direct technique and reflected his interest in effects of light and colour. CF

KENNINGTON, Eric Henri, RA (1888–1960). Painter of portraits in oils and watercolours; draughtsman in pastel and crayon; sculptor. Son of T.B. Kennington, he studied at St Paul's Art School, LAMBETH SCHOOL OF ART and the City and Guilds School. After active service in France he served as a WAR ARTIST from 1917 to 1918, later travelling in Arabia in 1920 where he made portrait drawings for T.E. Lawrence's *Seven Pillars of Wisdom*, 1926. He exhibited mainly at the Goupil Gallery, where he held his first solo exhibition in 1916, at the LEICESTER and Alpine Club Galleries. He also showed at the RA from 1920 to 1961 (ARA 1951, RA 1959), the ROI, RP, IS and in the provinces. His work is represented in the TATE GALLERY. His sculpture commissions included the Battersea Memorial to the 24th Division. He is best known as a perceptive and revealing portraitist of soldiers, again becoming a war artist, 1940–5.
LIT: *British Artists at the Front. Eric Kennington*, C. Dodgson, Country Life Ltd, 1918; *Eric Kennington War Artist*, catalogue, Imperial War Museum, London, 1980. CF

KENNY, Michael, ARA (b. 1941). Born in Liverpool, and trained at Liverpool College of Art 1959–61, and at the SLADE SCHOOL 1961–4, he has been primarily a sculptor, but makes important reliefs and drawings of a painterly character as well as sculptural constructions in wood and metal that employ oil paint. Since 1966 he has taught at GOLDSMITHS' COLLEGE. His first one-man show was at the Bear Lane Gallery in Oxford in 1964; in 1978 he exhibited at

Annely Juda and today is represented by Juda Rowan. He won an award in the Littlewoods Sculptural Design Competition in 1964, and ARTS COUNCIL Major Awards in 1975, 1977 and 1980. His work has represented British art in many exhibitions abroad. Typically it establishes the spatial implications of the presence of a human figure, which is often only vestigially represented by marks or drawing in the context of an extensive setting.
LIT: 'The Crisis of Skill in Contemporary Painting and Sculpture', Michael Kenny, *Fine Art Letter*, Vol.5, February 1982; interview by Adrian Lewis in *Aspects*, No.19, Summer 1982; *Michael Kenny*, Peter Davies, Scolar Press, 1997.
AW

KENT, Leslie, RBA, RSMA (1890–1982). Marine painter in oil. Educated at Leeds University, he studied art under Fred Milner at St Ives 1918–20, but was a professional civil engineer 1910–45, painting in his spare time. He took up painting professionally on his retirement, exhibiting at the RA, RSA, ROI, NEAC, RBA, the Paris Salon and in the provinces. He had five one-man shows, and was elected RSMA in 1939 (Member of Council 1952–5), and RBA in 1940 (Member of Council 1943–67). JK

KERNOFF, Harry Aaron, RHA (1900–1974). Painted portraits, landscapes and murals in oils and watercolours; made woodcuts and lithographs. He studied at the Metropolitan School of Art, Dublin where he won the Taylor Scholarship in 1923. He exhibited at the RHA from 1926, held sixteen one-man shows in Dublin, 1926–58, and also exhibited in London and abroad. He is represented in public collections in Ireland, Britain, the USA and Canada. He was elected RHA in 1936. His work has an emphasis on form, expressed in careful composition with an excellence of technique. His clarity of vision was in direct reaction to the romantic and dreamy work of some of his contemporaries. His many portrait subjects included James Joyce, Brendan Behan, Sean O'Casey and W.B. Yeats. His bold and dramatic woodcuts present a confirmed city dweller's view of Dublin and the surrounding countryside.
LIT: *Woodcuts*, Harry Kernoff, Cahill, Dublin, 1942. (Limited edn.) JK

KERR-LAWSON, James (1865–1939). Painter of portraits, figures, landscape and architecture in oils, tempera and watercolours; muralist and lith-

ographer. He studied in Rome under Luigi Galli and in Paris under Lefèbvre and Boulanger. He worked in Spain, Florence, Scotland and London, in Canada and the USA, and exhibited first at the R. Canadian A. in 1882. He subsequently showed at the GI and RBA from 1890, at the RP, the IS and in London galleries, holding his first solo exhibition at the Dowdeswell Gallery in 1903. Founder member of the Society of Painters in Tempera in 1900, and of the SC in 1909, his work is represented in collections including the NPG, London. A friend of Whistler, LAVERY and HENRY, his work ranged from outdoor naturalism to portraits influenced by Whistler and more decorative murals of architecture.
LIT: Exhibition catalogue, Art Gallery of Windsor, Ontario, 1983. CF

KESSEL, Mary (b. 1910). She studied at Clapham School of Art and at the CENTRAL SCHOOL. She executed a mural for Westminster Hospital, and was an OFFICIAL WAR ARTIST, visiting Belsen and Berlin in 1945. Her resultant work is in the IMPERIAL WAR MUSEUM. Her first one-man show was at the LEICESTER GALLERIES in 1950. AW

KESTELMAN, Morris, LG, ARCA, RA (b. 1905). Painter of landscapes and figure compositions, and later of abstracts, in various media including oil, gouache, watercolour and pastel; also muralist, lithographer and theatre designer. He studied at the CENTRAL SCHOOL 1922–5, and the RCA 1926–9. In 1931 he made the first of many painting trips to France, and has also visited the USA several times, including in 1958, to serve on the jury for the Guggenheim International Prize. He exhibited in various group shows in the 1930s, in mural exhibitions at the New Burlington in 1950, and the V & A in 1960; in 'Jewish Artists in England', Whitechapel Gallery, 1956; in the 'London Group Jubilee', TATE GALLERY, 1964; in the '50th Anniversary Exhibition of Jewish Artists', Ben Uri Gallery, 1966; in the Print exhibition for a special folio, Tate Gallery, 1976 and in 'Jewish Art in England', Camden Arts Centre, 1986. He has had one-man shows in several London and provincial galleries, and has works in public collections including the ARTS COUNCIL and the V & A. He was Head of Fine Art at the Central School 1951–7; was elected a member of the LG in 1951 and won the Abbey Major Award in Painting in 1983. In the 1940s he designed stage sets for Sadlers Wells, and for the Old Vic. Commissions

include two murals for the V & A, 1946, and two large paintings for the Festival of Britain, 1951. A sense of boldness and clarity is found in both the earlier figurative works and the later abstracts, and a strong sense of form is complemented by the assertive use of colour. Kestleman attributes the clarity of his work to his study of nature and form.

LIT: Catalogue, Preface by Morris Kestelman, Morley Gallery, 1978; Catalogue Introduction by Mel Gooding, Sally Hunter Fine Arts, 1987. JK

KEY, Geoffrey (b. 1941). Painter of figures, animals and still-life in oils; sculptor. Born in Manchester, he attended MANCHESTER REGIONAL COLLEGE OF ART and as a post-graduate studied sculpture. He has exhibited in London, in the provinces including the Colin Jellicoe Gallery, Manchester, and abroad since 1966. In 1990 a retrospective exhibition of his work was held at the Salford Museum and Art Gallery. Winner of the first prize at the Manchester Academy in 1971, his work is represented in collections including Manchester City Art Gallery. His powerful paintings depict monumental forms in strong colour.

LIT: *Geoffrey Key*, exhibition catalogue, Salford Museum and Art Gallery, 1976; exhibition catalogue, Solomon Gallery, London, 1985. CF

KIDNER, Michael (b. 1917). Abstract artist working in oils, gouache and other media, including silk screen printing and computer plotting; sculptor. He studied History and Anthropology at Cambridge University 1936–9 and Landscape Architecture at Ohio State University 1940–1. In 1946 he started NDD at GOLDSMITHS' but left dissatisfied with the teaching. Whilst in Paris in 1953–5 he attended André Lhote's atelier. He has had one-man shows at Grabowski and other London galleries, in Paris, Poland and Sweden. He has exhibited at JOHN MOORES, Liverpool, 1963, 1965 (2nd prize) and 1967; with the SYSTEMS GROUP in London and Helsinki, 1969–72; in 'The Responsive Eye', Museum of Modern Art, New York, 1965; in 'Recent British Paintings', TATE GALLERY, 1967; 'British Painting '74', Hayward, 1974; 'British Painting 1952–77', RA; and 'Concepts in Construction 1910–80', USA and Canada, 1983–5. His works are represented in public collections including the Tate Gallery, Museum of Modern Art, New York, Poznan Museum, Poland, and the Amos Anderson Museum, Helsinki. He served in the Canadian army 1941–6; taught in Pitlochry

1947–50, at Leicester Polytechnic 1963–4, at the BATH ACADEMY 1964–80, and was Artist in Residence at Sussex University in 1967 and at the American University, Washington DC in 1968. His prizes include a Gulbenkian Purchase Award 1965, and Major Prize at the Arts Council of Northern Ireland Exhibition. Until 1964 he painted stripes in bright colours, e.g. *Orange and Violet* (Tate Gallery), 'trying to create dynamic colour relationships'. He later began notations of waves 'as a way of limiting a colourfield'.

LIT: *Elastic Membrane*, Michael Kidner, Circle Press, 1979; *Michael Kidner: Painting, Drawing, Sculpture, 1959–1984*, Arts Council, 1984. JK

KIFF, Ken, RA (b. 1935). Painter of imaginative figures and landscapes in oils and acrylic; also does drawings and woodcuts. He studied at Hornsey 1955–61. In 1981 he travelled to India, staying at The Artists' Camp, Kasauli. He exhibited frequently at Nicola Jacobs, London, and Edward Thorp, New York, and his one-man shows include: 'Ken Kiff 1965–85', ARTS COUNCIL; and 'New Work', Fischer Fine Arts, London, 1988. His group shows include: JOHN MOORES, Liverpool, 1974, 1980, 1982; 'British Painting', Neue Galerie, Aachen, 1981; 'New Work on Paper', Museum of Modern Art, New York, 1981; '4th Biennale', Sydney, 1982; and 'New Art', TATE GALLERY, 1983. He has taught at CHELSEA SCHOOL OF ART and at the RCA. He illustrated *Folk Tales of Great Britain*, by Michael Foss, Macmillan, 1977. Kiff uses glowing colours to create imaginary landscapes and fantastic creatures.

LIT: 'Shadows and Rainbows: Ken Kiff', Malcolm Miles, *Alba*, Spring 1989; *Ken Kiff 1965–85*, Arts Council (touring exhibition 1986) catalogue includes essays by Timothy Hyman and Martha Kapos. JK

KIKI, John (b. 1943). Painter of figures in acrylic and oils. Born in Cyprus, he studied at CAMBERWELL SCHOOL OF ART 1960–4, under AUERBACH, UGLOW, PATRICK SYMONS and PATRICK PROCTER, and at the RA SCHOOLS 1964–7. He exhibited in 1972 at the RA Student Gallery and has subsequently shown in London galleries, including the Thackeray, in the provinces and abroad. His work has been purchased by the CHANTREY BEQUEST and the National Museum of Wales. His vigorous painting uses flat, bold colour, with strong pattern, rhythm and outline.

LIT: *Icons of the Eighties*, catalogue, Norwich Gallery, Norfolk Institute of Art and Design, 1989. CF

KING

KING, Dorothy, RBA (b. 1907). Painter of nudes and landscapes in oils, watercolours and pastels. Lives in London but often paints in the New Forest. She has exhibited at the RA, RBA, NEAC, NS and GI and held a retrospective exhibition at South London Art Gallery in 1974. During the Second World War she worked with East End children, encouraging them to paint a mural. She was elected RBA in 1947; was Temporary Keeper at the RBA Galleries in 1959, and Keeper at the South London Art Gallery 1961–74. She originally worked in pastel, keeping a similar palette when she started to use oils. In 1967 she extended her subject range from nudes to include landscapes. Her current works are freely painted landscapes, often close to abstraction.
LIT: *Dorothy King: Retrospective*, South London Art Gallery, 1974. JK

KINGSBURY, Alan (b. 1960). Self-taught painter of figures, landscapes and architectural subjects in oil. Born in London and now living in Dumfries & Galloway, he has made several working visits to Venice. A group of his Venetian paintings were shown at the Park Walk Gallery, London, in 1989. Harmonious colours and rough brushwork produce a feeling of movement in many of his paintings; others have a more delicate surface and a calmer atmosphere.
LIT: *Venice: an exhibition by Alan Kingsbury*, catalogue by Jonathon Cooper, Park Walk Gallery, 1989. JK

KINLEY, Peter (1926–1988). Painter of near abstract landscapes and figures in oils; sculptor. Born in Vienna, he fled to England in 1938. In 1943 he joined the army and served in France, Holland and Germany until 1948. He studied at Düsseldorf Academy 1948–9, and returned to London to study at ST MARTIN'S SCHOOL OF ART 1949–53. He participated in many group shows including 'Six Young Contemporaries', GIMPEL FILS, London, 1951 and 1953; Pittsburgh International Exhibition, 1961; 'British Painting in the Sixties', Contemporary Arts Society; 'British Art Today', San Francisco Museum of Art; The Tokyo International Biennale, 1974; and 'British Art '74' at the Hayward. He had one-man shows at Arthur Tooth & Sons and Gimpel Fils, London, Paul Rosenberg & Co., New York, The Bluecoat Society of Arts, Liverpool, and a retrospective at the Museum of Modern Art, Oxford in 1982. Prizewinner at JOHN MOORES, Liverpool in 1969, his works are in the TATE GALLERY and ARTS COUNCIL collec-

tions, and in galleries in the USA, Australia and Brazil. He taught at St Martin's, Wimbledon and BATH. Influenced by de Staël, and a friend of HOWARD HODGKIN, Kinley paints simple stylized figures on brightly coloured grounds, in thick textured paint, using a palette knife.
LIT: *Peter Kinley: Paintings, 1956–82*, catalogue, Museum of Modern Art, Oxford, 1982; 'Peter Kinley', by Michael Pennie, in *Modern Painters*, Vol.1, No.4, Winter 1988–9, p.112–13. JK

KIRBY, J. Kynnersley, ROI, NEAC (*fl.* 1914–1939). A figure painter in oil, who studied at the SLADE SCHOOL. Born in Nottingham, he lived in London, and later Stansted, Essex. He exhibited at the RA, NEAC, ROI, and at the Rembrandt Gallery. His works are in permanent collections at Nottingham, Bristol and other provincial galleries. The paintings depict social life in a satirical vein.
LIT: *Artists & Sculptors of Nottingham and Nottinghamshire 1750–1950*, Henry C. Hall, Herbert Jones & Son, Nottingham, 1953. JK

KIRK, Eve (1900–1969). A landscape painter who studied at the SLADE SCHOOL and travelled to Italy, France and Greece. She exhibited at London galleries including Paterson, Arthur Tooth & Sons, the LEICESTER GALLERIES and REDFERN, in the 1930s and 1940s. She decorated the Catholic Church in Newtown, Montgomery, in the mid-1940s, and has one painting (*Avignon*) in the TATE GALLERY. She moved to Italy in 1955 and stopped painting. JK

KITAJ, R.B., RA (b. 1932). Painter of figures and portraits, of subjects based on politics, history, art and literature, in oils; pastelist and printmaker. Born in Cleveland, Ohio, he studied at the Cooper Union, New York 1950–1, and the Akademie der Bildenden Künste, Vienna (under Albert von Gütersloh and Fritz Wotruba), at the RUSKIN SCHOOL, Oxford, under Edgar Wind, 1957–9, and at the RCA 1960–2, where he formed a friendship with HOCKNEY and influenced many of the 'Pop' artists. He travelled extensively as a merchant seaman between 1948 and 1952, spent summers at Sant Felice de Quixols, Spain, from 1962, and lived for periods in America. He has held regular solo exhibitions at the MARLBOROUGH GALLERY in London and New York and has shown internationally in major museums and in group exhibitions. His work is represented in many public collections including the TATE GALLERY, MOMA, New York,

and the Art Institute of Chicago. In 1976 he organized the exhibition 'The Human Clay' at the Hayward Gallery, London, and he has taught at Ealing Technical College and CAMBERWELL SCHOOL OF ART 1961–3, at the University of California at Berkeley in 1967, at Los Angeles in 1970 and as Artist in Residence at Dartmouth College, New Hampshire in 1978. He has collaborated with Robert Creeley and with PAOLOZZI and his varied work has been influenced by, and refers to, a wide range of sources from Surrealism to the writings of Walter Benjamin and themes from nineteenth-century art. His paintings are complex in composition, juxtaposing different techniques, styles and sources, many depicting political and recent historical subjects. Later work has an autobiographical content, often on Jewish subjects.
LIT: *R.B. Kitaj*, Marco Livingstone, Phaidon, 1985; *First Diasporist*, R.B. Kitaj, Thames & Hudson, London, 1989; *The Prints of R.B. Kitaj*, Jane Kinsman, Scolar Press, 1994. CF

KITE, Joseph Milner (1864–1946). Painter of figures and landscapes in oils, many depicting French rural life. Born in Taunton, he trained at the Académie Saint-Luc, Antwerp, where he became a friend of RODERIC O'CONOR. From 1883 he studied at the ACADÉMIE JULIAN, Paris, under Laurens, Bouguereau and Robert-Fleury and he travelled widely before settling in Paris in 1889. A friend of LAVERY and JAMES WILSON MORRICE, he spent long periods in Brittany, particularly at Pont Aven, where he knew Gauguin and Bernard. He exhibited in England between 1886 and 1908, showing mainly at the RBSA, as well as at the RA, RBA, IS and in the provinces. Initially influenced by Bastien-Lepage, he continued to paint naturalistic, *plein-air* works throughout his life using a fluid, impressionistic technique and a bright palette.
LIT: Catalogue, Whitford & Hughes, London, 1985. CF

KLINGHOFFER, Clara Esther, NEAC (1900–1970). Painter of portraits and figures in oils; draughtsman and lithographer. Born near Lemberg, Poland, she studied in London at the John Cass Institute, at the CENTRAL SCHOOL, at the SLADE under TONKS and BROWN, 1919–21, and she worked at La Grande Chaumière in Paris in 1928. She lived in France, in Holland, and from 1939 in the USA. A friend of NINA HAMNETT, the EPSTEINS and the PISSARROS, her work was admired by FRY and SICKERT. She held a solo exhibition in 1920 at the Hampstead Art Gallery and subsequently exhibited widely in London galleries including the LEICESTER, Goupil and REDFERN, at the LG, NEAC, RA, in Holland, the USA and Mexico. Her work is represented in the TATE GALLERY. She was best known for her sensitive drawing, particularly of children.
LIT: 'Clara Klinghoffer', J.B. Manson, *Studio*, Vol.XCIV, p.410; *Clara Klinghoffer*, catalogue, Belgrave Gallery, London, 1976. CF

KNAPP, Stefan (1921–1996). Born in Poland, in 1939 he was a prisoner in Siberia, but reached England where he became a pilot in the RAF, serving from 1942 to 1945. After demobilization, he attended the SLADE SCHOOL 1947–50. He had the first of his many one-man shows at the LONDON GALLERY in 1947, and subsequently exhibited in major galleries all over the world, but principally in England, as he lived and worked in London. His work is in private collections and in National Museums in many countries; although he painted in oils and acrylics on canvas, he made a speciality of works in baked enamel on metal. He also sculpted. He executed many mural decorations in enamel, in and on major buildings all over the world. Well-known examples in London are on the façade of Terminal 2 at Heathrow Airport, and on the exterior of the Grabowski Gallery 2 in Kensington. His work was usually abstract or highly formalized using very bright colours, often but not always with sharply defined shapes on graded fields of colour. He received many awards, including a Churchill Fellowship, and was a Knight of the Cross Polonia Restituta.
LIT: He published an autobiography, *The Square Sun*, Museum Press, 1956; and was featured in *Life Magazine*, Vol.52, No.6, 1962. AW

KNEALE, Professor Bryan, RA (b. 1930). Painter in oils and gouache; sculptor in steel, metal and wood. He studied at Douglas School of Art under W.H. Whitehead, 1947, and at the RA SCHOOLS under RUSHBURY and CONNARD, 1948–52, winning the PRIX DE ROME 1949–51. He has exhibited since 1954 at the REDFERN GALLERY and from 1953 at the RA (ARA 1970, RA 1973) and has shown widely in group exhibitions in the UK and abroad. His work is represented in the TATE GALLERY. Professor of Sculpture at the RA Schools and Head of Sculpture at the RCA, he gave up painting to concentrate on sculpture in 1960. He is now Professor of Drawing at the RCA, the first to be so appointed.

LIT: *New Sculpture*, exhibition catalogue, Redfern Gallery, London, 1981; *Sculpture and Bone Drawings*, exhibition catalogue, RCA, London, 1986. CF

KNIGHT, Charles, ROI, RWS (1901–1990). A painter in oils and watercolours, particularly influenced by the Norwich School. He studied at Brighton Art School and at the RA SCHOOLS under CHARLES SIMS. He worked extensively for the RECORDING BRITAIN project. AW

KNIGHT, Edward Loxton, RBA (b. 1905). Painter of landscapes in oils, watercolours, gouache and pastel; poster and woodcut artist. He studied at Nottingham School of Art under Joseph Else, 1924–9, and exhibited between 1924 and 1939, mainly at the Brook Street Gallery and the RBA (member 1935). He also showed at the RA in the 1930s, the ROI, RI, in London and provincial galleries and abroad. His work is represented in collections including Nottingham Art Gallery. His exhibited work included landscapes such as *Lingering Snow*, RA 1936, and *From Arundel Park*, RA 1938. CF

KNIGHT, Harold, RA, ROI, RP, RWA, PNSA (1874–1961). Painter of portraits, interiors and genre in oils. Born in Nottingham, he studied at Nottingham School of Art under Wilson Foster *c.*1893, where he met Laura Johnson (LAURA KNIGHT) whom he married in 1903. He won a British Institute Scholarship to Paris where he worked at the ACADÉMIE JULIAN under Benjamin Constant and J.P. Laurens and he then settled at Staithes on the Yorkshire coast with the artists Fred Mayor and ARTHUR FRIEDENSON. Between 1905 and 1907, he spent some time living in Holland where he studied Dutch painting and was influenced in particular by Rembrandt, Vermeer and Hals. In Laren he also worked with the Canadian painter Wilder M. Darling. In 1907 he settled in Newlyn, Cornwall, where he stayed until 1918, subsequently settling in London. He exhibited at the RA from 1896 (ARA 1928 and RA 1937) and showed at the ROI (member 1906), the RP (member 1925), in London galleries including the LEICESTER GALLERIES, in other societies, in Scotland and the provinces. In 1938 his painting *A Student* was purchased by the CHANTREY BEQUEST for the TATE GALLERY. His early painting depicted interiors and genre scenes of peasants and rural subjects which share some characteristics with the work of Joseph Israels. After moving to Newlyn he continued with simi-

lar subjects but his palette brightened and in 1909 he began a series of women in interiors painted with strong tonal contrasts and clarity. After his move to London he received many portrait commissions.
LIT: *Painting in Newlyn*, catalogue, Barbican Art Gallery, London, 1985; 'The Art of Harold and Laura Knight', Norman Garstin, *Studio*, Vol.LVII, p.183. CF

KNIGHT, Dame Laura (née Johnson), RA, RWS, RE, RWA, PSWA, DBE (1877–1970). Painter of a wide range of subjects including landscapes, the circus, ballet, theatre, music-hall and gypsies. She was a WAR ARTIST during the Second World War. Media include oil, watercolour, pencil; also etchings and aquatints. She studied at Nottingham School of Art under Wilson Foster, with her future husband, HAROLD KNIGHT. They moved to Staithes, Yorkshire, making frequent visits to Holland, then to Cornwall, before settling in London in 1919. During the Second World War they lived in Malvern. She visited America (to serve on the jury of the International Exhibition at the Carnegie Institute, Pittsburgh) in 1922, and again in 1927. She was a regular exhibitor at the RA from 1903 when her first accepted painting was sold to Edward Stott. She exhibited at many London galleries, having a retrospective at the UPPER GROSVENOR in 1963. A major exhibition of her work was shown at the Nottingham Festival in 1970. She was elected ARWS in 1919, ARA in 1927, RWS in 1928, RE in 1932 and RA in 1936 (one of the first women RAs); she was created DBE in 1929. During the Second World War she was commissioned to paint munitions factories, airfields, and the Nuremberg Trials. Her meticulous accuracy was ideal for this work. She refused to confine herself to any one subject or medium, recording all she saw with great vigour.
LIT: *The Magic of a Line: the Autobiography of Laura Knight, DBE, RA*, Dame Laura Knight, William Kimber, 1965; *Dame Laura Knight*, Caroline Fox, Phaidon, 1988. JK

KNIGHTON-HAMMOND, Arthur Henry, RI, RSW, ROI, PS (1875–1970). Landscape painter in various media including oils, watercolours and pastels. Studied at Nottingham and WESTMINSTER art schools, in Paris and in Venice. He painted in Italy, France and the USA, living for many years in Southern France and Italy before returning to England and the West Country. He exhibited at London galleries including the RA, ROI, RBA,

NEAC, RSA, and the RHA, in the provinces and extensively abroad. His works are in many permanent collections. In 1920 he painted 30 oils of a chemical plant in Michigan. He was elected RI in 1933 and was a member of the PS of England, The Water-color Society of America and other societies.
LIT: *Artists and Sculptors of Nottingham & Nottinghamshire*, Henry C. Hall, Herbert Jones & Son, Nottingham, 1953; *A.H. Knight-Hammond*, Peter Norris, Lutterworth, 1993. JK

KNIGHTS, Winifred Margaret, NEAC (1899–1947). Decorative and landscape painter; draughtsman. Born in London, she studied at the SLADE under TONKS and BROWN, 1915–17 and 1918–20, winning the Slade Scholarship in 1919 and the ROME SCHOLARSHIP in Decorative Painting in 1920. She worked in Rome from 1920 to 1925 and married W.T. MONNINGTON there in 1924. She exhibited at the Imperial Gallery from 1927 to 1931 and was a member of the NEAC from 1929 to 1931. Represented in the TATE GALLERY (*Italian Landscape*, 1921), her commissioned work included *St Martin Dividing his Cloak*, for the Milner Memorial Chapel, Canterbury Cathedral. Her meticulous draughtsmanship influenced Monnington's work.
LIT: *Monnington 1902–1976*, exhibition catalogue, Royal Academy of Arts, London, 1977.
CF

KOKOSCHKA, Oskar, CBE (1886–1980). Painter of portraits, figures, landscapes, imaginative and symbolic subjects in oils and watercolours; draughtsman, lithographer, theatrical designer and writer. Born in Austria, he studied at the Kunstgewerbeschule, Vienna, from 1904 under Czeschka and Löffler. In 1907 he became an associate of the Wiener Werkstätte and in 1908 he met Adolf Loos who encouraged him to paint. He contributed to *Sturm* in Berlin in 1910 where he held his first solo exhibition at the Cassirer Gallery. In 1911 he met artists of the Blaue Reiter and in 1912 began his relationship with Alma Mahler. Wounded during the war, he taught in Dresden from 1919 to 1924, subsequently travelling extensively in Europe before settling in Vienna and Prague, leaving for London in 1938, where he was the President of the Free German League of Culture. He became a British citizen in 1947 but later lived in Switzerland. He held his first solo exhibition in London in 1928 at the LEICESTER GALLERIES and he exhibited in New York in 1938. He continued

to exhibit internationally and his work is represented in many public collections including the TATE GALLERY and MOMA, New York. He was awarded a CBE in 1959. He lectured at the Dresden Akademie der Kunst 1919–24, and in 1953 he founded the 'School for Seeing' at Salzburg. His literary activities ranged from criticism to drama and his theatrical designs included Furtwängler's production of *The Magic Flute* in 1954. Politically concerned, his paintings are based both on personal experience and on the expression of wider concerns through symbolic subjects. Influenced by Art Nouveau, Symbolism, Van Gogh and German Expressionism, he evolved a fluid, dynamic style using rich colour and rapid brushmarks which became more broken and energetic in his later work.
LIT: *My Life*, Oscar Kokoschka, London, 1974; exhibition catalogue, Tate Gallery, London, 1986; *Kokoschka and Scotland*, catalogue, Scottish National Gallery of Modern Art, Edinburgh, 1990.
CF

KONEKAMP, Frederick (1897–1977). Born in Germany, he studied Mathematics and Philosophy at Basle, Freiburg and Berlin, and lectured on these subjects until 1933 when he went into exile in Switzerland, and there began to paint. Moving to Britain he eventually settled, living as a recluse on Carn Ingli in Dyfed. His expressionist landscapes and seascapes were of the surrounding countryside. His *Low Tide at Newport*, 1953, is in the collection of the Pembrokeshire Museums, at the Castle, Haverfordwest.
AW

KORTRIGHT, Reginald Guy (b. 1877). Painter of landscapes in oils and watercolours; decorative painter. Born in Clifton, Gloucestershire, the son of Sir Cornelius Kortright, he studied in Toronto under Wylie Grier and at St Ives, Cornwall, under Louis Grier. Before the First World War he spent some time in Paris and also lived in Wales. He exhibited between 1901 and 1939, showing mainly at the RA and at the BEAUX ARTS GALLERY as well as in the provinces. During the war he served as a camouflage officer in Liverpool and subsequently settled in London, concentrating more on watercolour painting. His decorative, clear work included scenes of Spain and Corsica such as *The Heart of Corsica*, exhibited at the Walker Art Gallery, Liverpool, in 1933.
LIT: 'Guy Kortright', Jessica Walker Stephens, *Studio*, Vol.XCI, p.20; 'Mr Guy Kortright: his

Spanish painting', Jessica Walker Stephens, *Studio*, Vol.XCVI, p.281. CF

KOSSOFF, Leon, LG (b. 1926). Painter of figures, portraits, suburban scenes and landscapes in oils. Born in London of Russian-Jewish parents, he studied at ST MARTIN'S SCHOOL OF ART 1948–53, in the evenings at the Borough Polytechnic under BOMBERG 1950–2, and at the RCA 1953–6. He held solo exhibitions at the BEAUX ARTS GALLERY from 1957 to 1964, subsequently showing in London galleries (including Anthony d'Offay), and in America. He has exhibited internationally in group shows and his work is represented in collections including the TATE GALLERY. He taught at the Regent Street Polytechnic and CHELSEA SCHOOL OF ART 1959–64, and at St Martin's School of Art 1966–9. A friend of AUERBACH, his work was influenced by Bomberg in its expressionist style and it combines cool colours, thickly worked impasto and vigorous linear accents.
LIT: Exhibition catalogue, Whitechapel Gallery, 1972; *Leon Kossoff, Paintings from a Decade, 1970–80*, Museum of Modern Art, Oxford, 1981; catalogue, Anthony d'Offay, 1988. CF

KRAMER, Jacob, LG (1892–1962). Painter of figures and portraits in oils; draughtsman. Born in the Ukraine, he studied at Leeds School of Art in 1907, winning a Jewish Educational Aid Society grant to study at the SLADE SCHOOL in 1912 under McEVOY, TONKS and STEER. In 1915 he exhibited at the VORTICIST Exhibition, showed with the NEAC and held his first solo exhibition in Bradford. He subsequently exhibited in London and in the provinces and his work is represented in collections including the TATE GALLERY. A friend of EPSTEIN and GERTLER, and encouraged by Michael Sadler, he taught at Leeds and Bradford colleges of art and his paintings, many of Jewish subjects, use angular, simplified forms which take on a symbolic character.
LIT: *Jacob Kramer: A Memorial Volume*, compiled by Millie Kramer, Arnold, 1969; exhibition catalogue, Ben Uri Gallery, London, 1984. CF

KUHFELD, Peter, NEAC (b. 1952). Painter of landscapes, townscapes, portraits and interiors in oils. Born in Cheltenham, he trained at Leicester Polytechnic 1972–6, and at the RA SCHOOLS under PETER GREENHAM 1977–80, where he was awarded the David Murray Landscape Prize, 1978 and 1979, a Silver Medal for Drawing and the Dooley Prize for Anatomical Drawing.

Between 1980 and 1981, he also received the Elizabeth Greenshield Foundation Scholarship and the Richard Ford Scholarship to Spain. He held his first solo exhibition at the Highgate Gallery, London, in 1983 and he has subsequently exhibited in London galleries including the NEW GRAFTON GALLERY, at the RA from 1978, at the RWA, RP and in the provinces. From 1976 to 1978 he taught at Rugby School of Art and in 1978 was made a Freeman of the Worshipful Company of Painters and Stainers. His cool-toned, observant paintings combine detail with a broad technique, depicting form in terms of light and colour. CF

L

LA DELL, Edwin, ARA, RBA, ARCA (1914–1970). Painter of genre, landscape and architectural subjects in oils and watercolours; engraver and lithographer. Often using flat colours overlaid, his work conveys a strong sense of design as well as an interest in atmospheric effects. Already an etcher, La Dell took up lithography in 1933, and later produced series in this medium focusing on cities such as Oxford, Cambridge and Edinburgh. Born in Coventry, the son of an artist, La Dell studied art at Sheffield College of Art and later at the RCA under GILBERT SPENCER and BARNETT FREEDMAN. He showed extensively in London and the provinces, and exhibited at the RA from 1948. He travelled on the continent and worked in Italy. A tutor at the RCA from 1948, he was latterly Head of the Printmaking Department there. An illustrator of Wilkie Collins' *The Moonstone* in 1951, La Dell wrote and illustrated *Your Book of Landscape Drawing*, 1964. GS

LAMB, Charles Vincent, RHA, RUA (1893–1964). Painter of Irish peasant life and landscape in oils. Inspired by ORPEN, and in search of what he considered the 'national essence' of Ireland, Lamb often worked on large-scale figure compositions. Born at Portadown, the son of a painter and decorator, he attended the Technical School there, winning a gold medal for the best apprentice house painter in 1913. He studied life drawing at Belfast School of Art, and attended the Metropolitan School of Art, Dublin, 1917–20. First visiting Carraroe, Connemara, in 1921, the area became the lasting inspiration for his work. Working in Brittany in 1926 he found

rural themes comparable to those in Ireland. He exhibited at the RHA from 1922; in America and London. He provided the illustrations for M.O. Cadhain's book *Cre na Cille*, 1949. GS

LAMB, Henry, RA, LG (1883–1960). Primarily a portrait painter and draughtsman, Lamb also executed figure compositions, genre, street scenes, landscape and still-life. Painting in a thin precise manner, Lamb's handling tended to loosen after 1930. Born in Adelaide, Australia, the family resided in Manchester from 1896, where his father taught mathematics. Lamb studied medicine at Manchester 1901–4, before a trip to Italy with his father in 1904 determined him to become an artist. Studying at Manchester 1904–5, he formed a close friendship with FRANCIS DODD. Moving to London with Nina Forrest, Lamb enrolled in 1906 at the CHELSEA SCHOOL OF ART run by JOHN and ORPEN. Accompanying the John family to Paris in 1907, he enrolled at the Ecole de la Palette under J.E. Blanche 1907–8. Introduced to Lytton Strachey in 1908 and Lady Ottoline Morrell in 1909, Lamb painted his major portrait of the former in 1914. Working in Brittany *c*.1909/10, Lamb also visited Ireland in 1912–13, where he showed an interest in peasant subjects and primitivism influenced by Gauguin. Picasso's Blue and Rose period work was also influential at this time. Serving as a Medical Officer abroad 1916–18, Lamb was awarded the MC during the War. The result of national and local commissions, Lamb produced several important war pictures between 1919 and 1923. In close contact with STANLEY SPENCER after 1913, Lamb lived at Poole, Dorset, 1922–8, while always retaining a London studio. Resident at Coombe Bissett, Wiltshire from 1928, he painted his friend Evelyn Waugh in 1930. As an OFFICIAL WAR ARTIST 1940–4, Lamb made portraits of servicemen. He exhibited at the NEAC, AAA, and LG, and at the RA from 1921 (member 1949). He held his first one-man show at the Alpine Club Gallery in 1922 and was closely involved with the CAMDEN TOWN, London and BLOOMSBURY Groups. He was also an accomplished musician.
LIT: *Henry Lamb*, G.L. Kennedy, 1924; *Henry Lamb, the Artist and his Friends*, K. Clements, 1985. GS

LAMB, Lynton Harold, LG, SWE, ROI, FRSA (1907–1977). Painter and draughtsman in pen and ink and watercolour, of landscape and genre; wood engraver, glass engraver, lithographer and illustrator. Born in India, Lamb was educated at Kingswood School, Bath, before studying at the CENTRAL SCHOOL OF ART 1928–30, under WILLIAM ROBERTS and BERNARD MENINSKY. Later sharing a studio with VICTOR PASMORE, he was associated with the EUSTON ROAD SCHOOL. Exhibiting widely at the LEICESTER, REDFERN and Wildenstein Galleries, he held one-man exhibitions in 1936 and 1956. Elected a member of the LG in 1939, he showed at the RA from 1952. An advisor to the Oxford University Press from 1930, Lamb taught at the Central School in the department of Book Production, 1935–9. He also taught at the RUSKIN SCHOOL, Oxford, at the SLADE SCHOOL and at the RCA. The illustrator of numerous volumes, including an edition of *The Compleat Angler*, 1959, Lamb designed the binding of the Bible used at the Coronation Service in 1953. The author of several practical manuals on art, a designer of postage stamps, he lived latterly in Essex.
LIT: *The Purpose of Painting*, H. Lynton Lamb, 1936. GS

LAMBERT, Claire (b. 1936). Artist in a wide range of media: ceramics, drawings, watercolours, pastels and prints. From 1956 to 1975 she worked at the Atelier de Dour, Belgium, and in 1976 settled in Ipswich. She has held solo exhibitions since 1985 at the John Russell Gallery, Ipswich, and has shown widely in group exhibitions. Her work is represented in public and private collections including Ipswich Borough Council Collections. Much of her inventive work depicts the human figure with simplicity of line.
LIT: *Drawings and Prints 1971–1988*, exhibition catalogue, Christchurch Mansion, Ipswich, 1988. CF

The Lambeth School of Art was founded in 1854 by Canon Robert Gregory of St Mary's Church, Lambeth, in order that the young mechanics who worked in local industry should be taught to draw. Assisted by a grant from the Department of Science and Art, the School opened at the National School, Princes Road, initially running evening classes in basic drawing and design. In 1857 John Sparkes was appointed Head of the Lambeth School of Art and the School rapidly expanded: in 1860 the Prince of Wales lay the foundation stone of a new building at Miller Lane, later called St Oswald's Place. Sparkes was responsible for the close association that was formed between the School and the Doulton fac-

tory at Lambeth which began in 1863 and he also particularly promoted the teaching of modelling and sculpture at the Art School. From 1879 the Lambeth School worked in conjunction with the City and Guilds of London Technical Institute of Art (later called the South London Technical School of Art) at 122 and 124 Kennington Park Road where classes in modelling, design, life drawing, wood engraving, book illustration and house decoration were held. In 1908 this association was ended and the Lambeth School of Art continued teaching until 1916 under the Headship of Thomas McKeggie. It was then amalgamated with the WESTMINSTER TECHNICAL INSTITUTE, Vincent Square. The Lambeth Art School and the Technical Institute of Art were particularly noted for the teaching of sculpture and modelling and for the work carried out in association with Doultons. Amongst the teachers at Lambeth were Dalou, Hugh Stannus and William Silver Frith, and students included STANHOPE FORBES, LA THANGUE, SAMUEL MELTON FISHER, EDMUND BLAMPIED, CHARLES RICKETTS and CHARLES SHANNON. CF

LAMBOURN, George (1900–1977). Painter of figures and landscapes in oils, gouache, mixed media and glass painting. He studied at GOLDSMITHS' COLLEGE and at the RA SCHOOLS 1924–6, where he formed a friendship with EDWIN JOHN. He travelled in Spain and subsequently settled in Cornwall. He held solo exhibitions at the Matthiesen Gallery in 1936 and 1938, at St George's Gallery in 1956, and in the provinces. His work is represented in collections including the TATE GALLERY. Between 1942 and 1946 he organized the decoration of the allied armies canteens, theatres, etc. His painting was intuitive and direct and ranged from symbolic figures representing suffering to strongly painted Cornish landscapes and coastal subjects.
LIT: *George Lambourn 1900–1977*, catalogue, Newlyn Art Gallery, Penzance, 1982. CF

LAMBOURNE, Nigel, RBA, RE, ARCA (b. 1919). Draughtsman and painter of figures in a range of media; printmaker and illustrator. He studied at the CENTRAL SCHOOL OF ART, Regent Street Polytechnic and at the RCA under OSBORNE and AUSTIN. He exhibited in London galleries, at the RA, RBA (member 1947), RE and NEAC and his work is represented in collections including MOMA, New York. His strong, sensual draughtsmanship emphasizes the simplified shapes of the human form.

LIT: 'The Drawings of Nigel Lambourne', Albert Garrett, *Studio*, Vol.148, 1954, p.118. CF

LAMMING, Ken (b. 1924). Painter of landscapes, portraits, flowers and beach scenes in oils and pen and ink. He trained at Lincoln and Leicester Colleges of Art and held his first solo exhibition at Scunthorpe Art Gallery in 1965. He has subsequently exhibited in London, the provinces (particularly at the Colin Jellicoe Gallery, Manchester), and abroad. Represented in municipal and private collections here and abroad, he teaches in Humberside and his painting uses colour, form and technique to comment on and to respond to nature.
LIT: Exhibition catalogue, Rufford Craft Centre, Ollerton, Notts., 1982. CF

LAMPLOUGH, Augustus Osborne (1877–1930). Painter in watercolours, of Venetian architectural views and Oriental, especially North African, subjects. Born in Manchester, he studied at Chester School of Art and later taught perspective at Leeds School of Art 1898–9. Inspired by the painter R. TALBOT-KELLY, he travelled widely in the Middle East and North Africa, and from *c*.1905 specialized almost exclusively in delicately atmospheric Egyptian views – both studies of local life and of ancient remains. Enjoying Royal patronage, Lamplough exhibited widely in London, especially at the FINE ART SOCIETY, and in the provinces. Wintering in Egypt most years, Wales latterly became his home.
LIT: An author and illustrator of several volumes, his *Cairo and its Environs* appeared in 1909, together with his illustrations to Pierre Lotis' *Egypt*. GS

LANCASTER, Mark (b. 1938). Painter of abstracts and figurative subjects in a range of media. He studied at Newcastle University under HAMILTON 1961–5, and worked with Warhol in New York in 1964, settling there in 1972. He has exhibited regularly at the Rowan Gallery since 1965, in America and internationally in group exhibitions. Represented in collections including the TATE GALLERY, from 1968 to 1970 he was Artist-in-Residence at King's College, Cambridge. His work ranges from geometrical abstracts to variations on Warhol's image of Marilyn Monroe.
LIT: Exhibition catalogue, Walker Art Gallery, Liverpool, 1973; 'Andy Warhol Remembered', *Burlington Magazine*, March 1989. CF

LANCASTER, Percy, RI, RBA, R.Cam.A., RBC, ARE (1878–1950). Painter of landscapes, townscapes and figures in watercolours and oils; etcher. Apprenticed to an architect, he attended evening classes at Southport College of Art and sketched in the Lake District. A friend of PHILIP CONNARD, he produced cartoons for papers and journals; he worked on forging documents during the First World War and in 1920 he abandoned architecture for painting. He held a solo exhibition in 1940 at the Atkinson Gallery, Southport, and showed mainly at the RE (ARE 1912), the RBA (member 1914), the RI (member 1921), the R.Cam.A., at Walker's Art Gallery, London, and in Liverpool. Many of his works are now in the Atkinson Gallery, Southport. He is best known for his lively watercolours of the Lake District and of mountains.
LIT: Retrospective exhibition catalogue, Atkinson Art Gallery, Southport, 1981. CF

LANGLEY, Walter, RI, RBSA, RWA (1852–1922). Painter of genre in watercolours and oils. Born in Birmingham, he was apprenticed to a lithographer and studied at Birmingham School of Art and at the RCA in London. On returning to Birmingham he attended art classes at the RBSA and the Midlands Art Group and by 1879 he was associated with the Birmingham Art Circle. In 1881 he made a short trip to Brittany and after visiting Newlyn in 1880 he settled there in 1882. He exhibited in Birmingham and was elected ARBSA in 1881 and RBSA in 1884. He showed at the RA from 1892 to 1919, at the RI (member 1883), in London galleries and in the provinces. His work is represented in collections including Birmingham City Art Gallery. Best known as a watercolourist, he was dedicated to the depiction of the fisherfolk of Newlyn. His controlled technique captured subtle changes of colour and texture.
LIT: *Walter Langley,* catalogue, Royal Albert Museum, Exeter, and Birmingham Art Gallery, 1984; *Painting in Newlyn 1880–1930,* catalogue, Barbican Art Gallery, London, 1985. CF

LANYON, George Peter (1918–1964). Painter of landscape abstractions in oils, gouache and watercolours; constructivist, muralist and potter. Born in St Ives, Cornwall, he took lessons from BORLASE SMART in 1936, and attended the Penzance School of Art in 1937. He met ADRIAN STOKES in 1937 and in 1938 spent four months at the EUSTON ROAD SCHOOL. In 1939 he met NICHOLSON, HEPWORTH and Gabo and received tuition from Nicholson. In the 1940s and 1950s he visited Italy and America and held his first solo exhibition in London at the LEFEVRE GALLERY in 1949. He subsequently showed regularly in London galleries (including GIMPEL FILS), in America from 1953, in the provinces and internationally in group exhibitions. Member of the CRYPT GROUP 1946–7, founder member of the PENWITH SOCIETY 1949–50, and Member in 1953, and Chairman in 1960, of the Newlyn Society of Artists, his work is represented in public collections including the TATE GALLERY and the Carnegie Institute, Pittsburgh. He taught at BATH ACADEMY OF ART 1950–7, ran an art school with FROST and REDGRAVE at St Ives 1957–60, and between 1960 and 1964 taught at Falmouth, Bristol and at the San Antonio Art Institute, Texas. His mural work included commissions for the Universities of Liverpool in 1960, and Birmingham in 1963. Although abstract, his paintings are directly concerned with the experience of landscape, particularly of Cornwall. Influenced by Cubism and Constructivism through Nicholson and Gabo, *c.*1939 he turned to making constructions, returning to landscape painting after the war but continuing to make constructions as preparation for paintings. His work developed from built-up surfaces to a more fluid, direct technique and the experience of gliding in the 1960s enabled him to combine elements of land, sea and sky in his paintings.
LIT: Exhibition catalogue, Tate Gallery, 1968; *Peter Lanyon 1918–1964,* Andrew Lanyon, 1989; *Peter Lanyon,* A. Causey, 1971. CF

LARKINS, William Martin, ARE (1901–74). A painter and etcher of architectural subjects, he studied at GOLDSMITHS' and there introduced GRAHAM SUTHERLAND to the work of Samuel Palmer. His work vividly evoked the life of the modern city, as in *Bush House, London* (1927). He later became an art director at the advertising agency of J. Walter Thompson. AW

LATHAM, John (b. 1921). Multi-media artist whose work ranges from book reliefs and spray paintings to conceptual art. He studied at Regent Street Polytechnic 1946–7, and CHELSEA SCHOOL OF ART 1947–51, holding his first solo exhibition in 1948 at the Kingly Gallery, London. He has subsequently exhibited regularly in London galleries (including the Lisson Gallery), abroad and in group exhibitions since 1959. Represented in collections including the TATE GALLERY, he was a founder member of the Institute for the Study of

Mental Images in 1954, and with his wife Barbara Steveni of the Artists Placement Group in 1966. In 1954 he produced his first spray painting and he developed his 'event-structure' theory and later his 'Skoob Art' used books as material and subject. He has become increasingly concerned with social and theoretical issues and the development of an alternative framework for regarding art.

LIT: Exhibition catalogue, Lisson Gallery, 1987; *Time-Base and Determination in Events*, John Latham, catalogue, Tate Gallery, 1976.　　CF

LA THANGUE, Henry Herbert, RA, NEAC, ROI (1859–1929). Painter of rustic genre and landscapes in oils. Born in Croydon, he attended Dulwich College where his contemporaries included STANHOPE FORBES, and he studied art at the SOUTH KENSINGTON SCHOOLS, LAMBETH SCHOOL OF ART and the RA SCHOOLS from 1874. In 1880 he studied in Paris at the Ecole Nationale des Beaux-Arts under Jean-Leon Gérôme and spent the summers working with Stanhope Forbes on the Brittany Coast. On his return to England in 1884 he settled in Norfolk, later moving to Rye and in 1890 to Bosham, Sussex. In the early years of the twentieth century he travelled in Provence and Liguria. He exhibited at the RA from 1878 (ARA 1898 and RA 1913) and showed at the Paris Salon from 1881. Elected ROI, in 1883 and NEAC in 1886, he campaigned to change the NEAC to a more broadly-based institution. He exhibited in London galleries, holding his first solo exhibition at the LEICESTER GALLERIES in 1914. He also showed in Venice and Rome and in 1896 his painting *The Man with the Scythe*, was purchased by the CHANTREY BEQUEST for the TATE GALLERY. In Paris he was influenced by the *plein-air* naturalism of Bastien-Lepage, and working outside he developed a technique using square brushstrokes of bright, opaque colour. He continued to paint rustic genre pictures which later included Sussex farming scenes and Ligurian and Provencal subjects, but he also produced pure landscape. His later style emphasized his bright palette and developed a more decorative, rich mosaic of surface marks.

LIT: *A Painter's Harvest*, catalogue, Oldham Art Gallery, 1978; 'H.H. La Thangue and his Work', G. Thomson, *Studio*, Vol.IX, p.163.　　CF

LAVER, James, CBE, RE, FRSA, FRSI (1899–1975). Art critic and writer. Born in Liverpool and educated at Oxford, he was Assistant Keeper at the Victoria and Albert Museum in 1922, Keeper in 1927. He retired in 1959. He wrote on aspects of French painting, on fashion and costume, on Whistler and on BRODSKY (1935).　　AW

LAVERY, Sir John, RA, RSA, RHA, NPS, NS, IS, NEAC, PRP, HROI (1856–1941). Painter of portraits, interiors, townscapes and landscapes in oils. Born in Belfast, he attended evening classes at the Haldane Academy of Art *c.*1875, studied at HEATHERLEY'S Art School in 1879 and worked at the ACADÉMIE JULIAN under Robert-Fleury and Bouguereau and at the Atelier COLAROSSI in Paris from 1881. In 1883 he painted at Grez-sur-Loing with KENNEDY, MILLIE DOW, ROCHE and Frank O'Meara, and in 1885 he settled in Glasgow. In 1890 he visited Morocco where, in 1903, he established a second home, and in 1891 he visited Madrid and studied Velazquez. In 1896 he moved to London and continued to travel widely, regularly spending long periods in Tangier. He exhibited extensively, showing first at the GI in 1880, at the RSA in 1881 (RSA 1896), and at the Paris Salon in 1883. He exhibited at the RA from 1886 (RA 1921), and at the RBA and NEAC from 1887. In 1890 he showed with the Glasgow artists at the GROSVENOR GALLERY and in Munich, and his first solo exhibition (at the Goupil Gallery, 1891) was followed by regular exhibitions in London and abroad. In 1898 he was a co-founder with Whistler of the IS and was its Vice-President until 1908. His work is represented in many collections including the TATE GALLERY. An OFFICIAL WAR ARTIST in 1917, he was knighted in 1918. Influenced initially by the *plein-air* painting of French artists and by O'Meara and Stott of Oldham, his later work reflected his study of Velazquez and the influence of Whistler. His direct painting was fluid and technically assured, sharing some characteristics with that of SARGENT.

LIT: *The Life of a Painter*, Lavery's autobiography, Cassell & Co., 1940; *John Lavery: His Work*, Walter Shaw Sparrow, 1911; exhibition catalogue, Ulster Museum, Belfast and the FINE ART SOCIETY, 1984–5.　　CF

LAW, Bob (b. 1934). Painter of abstracts in oils and acrylic; sculptor. He began to paint in 1957 and between 1957 and 1960 he lived in St Ives. In 1961 he was awarded a French Government Scholarship to work in Aix-en-Provence and he held his first solo exhibition in 1962 at the Grabowski Gallery. He has subsequently exhibited in London galleries (including the Lisson

Gallery and the Karsten Schubert Gallery), and abroad. His work is represented in collections including the TATE GALLERY. Since 1959 he has produced series of paintings in which fields of colour, black or white are surrounded by a clearly defined border, the field being established by a number of rapidly applied coats.
LIT: Exhibition catalogues for MOMA, Oxford 1974; and Whitechapel Art Gallery, London, 1978. CF

LAWRENCE, Alfred Kingsley, RA, RP (1893–1975). Figure painter in oils, pastels and watercolours, Lawrence often favoured historical and allegorical subjects with literary or classical themes. Fashionable also as a portrait and mural painter, he occasionally painted landscapes. He was an admirer of Piero Della Francesca, aiming for grandeur through simplicity of structure. Born in Lewes, Sussex, the son of a solicitor, he studied at King Edward VII School of Art, Newcastle upon Tyne, before serving with the Northumberland Fusiliers during the First World War. Resuming his studies at the RCA under ROTHENSTEIN, Lawrence won a travelling scholarship in 1922, attended the BRITISH SCHOOL IN ROME, and won the PRIX DE ROME in 1923 with his *Allegory of Human Life*. Executing a mural, *The Altruists* for the International Exhibition at Wembley in 1924, Lawrence, in company with other Rome Scholars, decorated St Stephen's Hall, Palace of Westminster in 1927 (his subject being 'Queen Elizabeth commissions Sir Walter Raleigh to discover unknown lands AD 1584'). Painting murals for the new Bank of England in 1932, he also worked for the Church, painting a *Resurrection* for the Church of St James, Beckenham, Kent, in 1954. Exhibiting in London and abroad, he showed at the RA from 1929, was elected RA in 1938 and RP in 1947. A memorial exhibition was held at the Mall Galleries in 1976. He held a lifelong interest in the theatre.
LIT: 'What is Academic Art?', Alfred Kingsley Lawrence, *The Listener*, 1 February 1951. GS

LAWRENCE, Eileen (b. 1946). Painter of natural objects (often feathers, bird's eggs and twigs), in watercolours, handmade papers and oils. She studied at EDINBURGH COLLEGE OF ART 1963–8, and held her first solo exhibition in 1969 at the 57 Gallery, Edinburgh. She subsequently exhibited in Scotland, in London galleries (including Fischer Fine Art), and in the provinces. In 1972–3 she worked in Germany. She has exhib-

ited internationally in group shows and her work is represented in collections including the ARTS COUNCIL Collection. Influenced by Chinese and Egyptian art and by Taoist philosophy, her early work took the form of 'prayer sticks' horizontally decorated in watercolours with natural objects, calligraphic marks and bands of colour. After 1985 she employed a brighter palette and more complex compositions.
LIT: Exhibition catalogue, Artsite Gallery, Bath, 1986. CF

LAWSON, Frederick (1888–1968). Painter and etcher of landscape and architectural subjects. Usually working in watercolour directly from the motif in his native Yorkshire, his work is broadly handled and spontaneous. Born in Yeadon, Lawson studied at Dewsbury Technical College and Leeds School of Art. Although well-travelled on the continent, a visit to Wensleydale in 1910, and his subsequent permanent removal to Redmire, Yorkshire, proved this the locale for most of his subsequent inspiration. Exhibiting locally and at the RI and RA 1915–49, he illustrated several books by Dorothy U. Ratcliffe, such as *Lillilows*, 1931.
LIT: Memorial exhibition catalogue, appreciation by J.B. Priestley, Middlesborough Art Gallery, 1968. GS

LAWSON, Sonia, RA, ARWS (b. 1934). Painter of imaginative figure subjects, landscapes and figures in oils, watercolours, chalk and ink. She studied at Doncaster School of Art 1951–5, and at the RCA 1956–60, winning a travelling scholarship to France. She held her first solo exhibition at the ZWEMMER GALLERY, London, in 1960 and she has subsequently exhibited in London galleries, the provinces, in group exhibitions including the JOHN MOORES, with the LG and the Midland Group, and at the RA. She was elected ARA in 1982 and ARWS in 1984. Her work is represented in collections including the IMPERIAL WAR MUSEUM and amongst her awards was a Lorne Scholarship 1986–7. Tutor at the RA SCHOOLS and Visiting Tutor at the RCA, she was featured in two BBCTV films: *Private View*, 1960, and *25 Years of British Painting*, 1977. Her work is richly coloured, resonant and atmospheric and depicts such figures as Watteau, John Clare and Hilda of Whitby to create a personal mythology painted on a large scale in shallow space with perspective distortion.
LIT: Catalogue, Boundary Gallery, London, 1989. CF

LEACH, Bernard (1887–1979). Celebrated as a potter, Leach was born in Hong Kong; he first studied painting at the SLADE (1903) and later etching under BRANGWYN (1908). He worked in Japan for ten years from 1909, and exhibited etchings as well as ceramics in Peking (Beijing) 1916–18. He always continued to draw, and during the 1970s he made a number of lithographs. The TATE GALLERY holds a substantial number of his graphic works. AW

LEAPMAN, David (b. 1959). He studied painting at ST MARTIN'S, GOLDSMITHS' COLLEGE and at CHELSEA. His work has explored the conflicts and the harmonies between brilliant, often fluorescent hard-edged zones of textured paint and thin, pale meandering lines (in pearlescent pigment containing mica) crossing them, which hover on the brink of depicting disjointed images. The drawn elements may suggest signs, hieroglyphics, figures, animals or architectural elements; *Thin Skin* (1992) is characteristic. AW

LEAPMAN, Edwina (b. 1934). Painter of abstracts in acrylic. She studied at the SLADE and CENTRAL Schools of Art 1951–7, and exhibited at the NEW ART CENTRE, London, in 1974. She has subsequently shown at the Juda Rowan Gallery, abroad, and in group exhibitions since 1954. Her work is represented in public collections including the ARTS COUNCIL. Her paintings use stripes of varying tones of a single hue to create mood, suggest variation in depth and to evoke a sense of movement.
LIT: *The Experience of Painting*, exhibition catalogue, South Bank Centre and Laing Art Gallery, Newcastle, 1989. CF

LEAVER, Noel Harry, ARCA (1889–1951). Painter of landscapes, street scenes, still-life and flowers in watercolours. He studied at Burnley School of Art and at the RCA where he was influenced by MOIRA and Lethaby. He won a travelling scholarship to Italy in 1911 and in 1912 he returned to Italy and travelled to North Africa on the Owen Jones Studentship. He exhibited mainly in Burnley between 1919 and 1950, but he also showed at Frost and Reed's Gallery, London, in Bristol, and in America. His work is represented in several public collections. He established his reputation with paintings of the English Cathedrals, whilst in the 1920s and 1930s he produced many North African subjects. He was noted for his architectural draughtsmanship and for his use of blue, influenced by Fra Angelico and Botticelli.

LIT: Catalogue, Towneley Hall Art Gallery, Burnley, 1983. CF

LE BAS, Edward, RA, LG, NS, ARCA (1904–1966). Painter in oils of portraits, landscapes, still-life, flowers and genre. Richly coloured and with paint boldly applied, his work owed much to early twentieth-century French and English painting, especially the CAMDEN TOWN GROUP, of whose work he formed an extensive collection. Born in London and educated at Harrow, Le Bas took a degree in Architecture at Cambridge in 1924. Inspired by two months spent with the painter Hermann Paul at Meudon, Paris, in 1922, Le Bas studied painting at the RCA from 1924 under WILLIAM ROTHENSTEIN. Travelling widely, he worked in Majorca, France and Morocco. Holding his first one-man show at the LEFEVRE GALLERY in 1936, he was elected a member of the LG in 1942 and RA in 1953. Exhibiting at the RA from 1933, Le Bas's collection of French and English Modern paintings were exhibited in the Diploma Galleries in 1963. Resident in Chelsea from 1948, he was awarded the CBE in 1957. GS

LE BAS, Philip, RBA, NEAC, ATD (b. 1925). Painter in oils and muralist, Le Bas often paints architectural subjects conveying a nostalgic sense of place. Recent work however consists of a series of 'Icons' – portrait busts of modern celebrities. Born in Bordeaux, France, he moved to London in 1934. Having served in the RAF, he studied painting at Regent Street Polytechnic 1948–51, and at Brighton 1951–2. He exhibited in London (notably at the Portal Gallery), in France and the USA. A cousin of the late EDWARD LE BAS RA, he has lectured at King Alfred's College, Winchester. GS

LE BAS, Rachel Ann, RE, NEAC, AWG (b. 1923). Painter of genre and landscape, often favouring the atmospheric effects of the West Country; line engraver. The daughter of Captain R.S. Le Bas, she was educated at W. Heath School, Sevenoaks and at the City and Guilds of London Art School, under MIDDLETON TODD, from 1946. An exhibitor at the RA since 1945, she also shows with the NEAC, LG and RBA. A member of the Somerset Guild of Craftsmen, she lives in Somerset. GS

LE BROCQUY, Louis, RHA (b. 1916). Painter of the human figure and head in oils and watercolours; industrial and tapestry designer; illustrator. Working in a naturalist manner le Brocquy

developed a style in the 1940s influenced by contemporary Neo-Romanticism and Synthetic Cubism. Since, preoccupied with the notion of an inner reality of mind or spirit, he has worked on themes or series on the isolated human figure or head, set in an elemental void. With varying degrees of abstraction, le Brocquy often works with a thick impasto upon a carefully prepared monochrome ground. Born in Dublin, where he studied chemistry, he worked in the family oil business until 1938 when, deciding to become a painter, he left Ireland. Self-taught through travel to the National collections in London, Venice and Geneva (where he was much influenced by the tonal qualities of Spanish art), he settled at Menton, France. Returning to Ireland in 1940, he began to exhibit at the RHA. Moving to London in 1946, he staged the first of many exhibitions at GIMPEL FILS the following year. The Irish tinker-women who recur in his work in the late 1940s give way to increasingly isolated, universal personages. In 1958 he began a series of white pictures based on the human torso. Discovering in 1964 at the Musée de l'homme, Paris, the possibilities of the human head as a cult image, le Brocquy began a succession of 'ancestral heads', giving way in 1975 to a specific concern with the poet's head as 'an image of the human consciousness'. Having represented Ireland at the Venice Biennale, 1956, le Brocquy exhibits widely in America, Japan and on the Continent. Working now chiefly from France, he has taught at the CENTRAL SCHOOL OF ART 1947, and at the ROYAL COLLEGE (textile design) 1954. A Fellow of the Society of Industrial Artists in 1970, in 1975 he was made Chevalier de la Légion d'Honneur. Illustrated works by le Brocquy include Kinsella's translation of *The Tain*, 1969, and Joyce's *Dubliners*, 1986.
LIT:*Louis le Brocquy*, D. Walker, monograph, Dublin, 1981. GS

LE BRUN, Christopher, RA (b. 1951). A painter and printmaker. He studied at the SLADE 1970–4, and at CHELSEA 1974–5. His first solo exhibition was at Nigel Greenwood in 1980. His romantic, visionary works sometimes appear to verge on the abstract, but, evoking angels, spectral presences, figures from Greek Mythology or from Wagner are typified by his *Rider with Sea Motif,* 1990–1. The TATE holds a number of his works, including a group of seven untitled lithographs. AW

LECHMERE, Kate (1887–1976). A painter of cubist pictures, she was educated at Clifton College, Bristol, and at La Palette, Paris, as well as with SICKERT at the WESTMINSTER SCHOOL OF ART. A friend of WYNDHAM LEWIS whom she met in 1912, she painted with LAWRENCE ATKINSON in Normandy and in 1913 exhibited three works at the AAA Salon: *Study (Man)*, *Lady in Furs*, and *Buntem Vogel*. She provided financial backing for the REBEL ART CENTRE and for the publication of *Blast*.
LIT: 'Women under the Banner of Vorticism', *ICSAC Cahier* (Belgium), Nos.8–9, December 1988; *Vorticism and Abstract Art in the First Machine Age*, Richard Cork, Gordon Fraser, London, 1976. CF

LEE, Richard (b. 1923). Painter of landscapes and beach scenes, particularly of Normandy and Norfolk, of figures, interiors and still-life in oils, watercolours and gouache. He studied at CAMBERWELL SCHOOL OF ART 1947–50, and was awarded an Abbey Major Scholarship in 1951. He exhibited first at the Gallerie de Seine in 1958, and he has subsequently exhibited regularly in London at the NEW GRAFTON GALLERY, in other London galleries and in the provinces. He has shown with the LG, at the RA and in many mixed exhibitions and his work is represented in public collections including the ARTS COUNCIL Collection. He taught at Maidstone College of Art 1956–7, and Camberwell School of Art 1953–82, and his awards include the Tolly Cobbold 'Folio Award', 1985. Influenced by Cézanne, his poetic, sensitive paintings are in the Camberwell tradition of observation and painterly response. CF

LEE, Rupert (1887–1969). Painter and sculptor. Born in Bombay, he studied at the RA SCHOOLS and the SLADE. He was President of the LONDON GROUP 1926–1936, and Chairman of the 1936 International SURREALIST Exhibition in 1936. Although personally sympathetic to radical new developments in art, his still-life, landscape and portrait paintings were characteristic of the Post-Impressionism encouraged by ROGER FRY. AW

LEE, Sydney, RA, RWS, RE, NEAC, IS, RBA (1866–1949). Painter of landscapes and townscapes in oils, watercolours and sepia; etcher, aquatinter, mezzotinter and wood engraver. Born in Manchester, he studied at MANCHESTER SCHOOL OF ART, at COLAROSSI's in Paris, and he later worked extensively abroad. He exhibited widely in London, particularly at Colnaghi & Co., and at the NEAC from 1903 (member

LEE

1906), at the RBA (member 1904), the RA (RA 1930), and at the RWS (member 1945). He also showed abroad, winning gold medals in Munich and Milan, a bronze medal in Barcelona and Hon. Mentions at the Paris Salon and the Carnegie Institute. Two of his works were purchased by the CHANTREY BEQUEST for the TATE GALLERY: *Amongst the Dolomites*, 1924, and *The Top of the St Gotthard*, and he is represented in many other public collections including the Manchester City Art Gallery. His work is based on the certainty of his draughtsmanship and his feeling for surface texture and tone.
LIT:'The Woodcuts of Mr Sydney Lee', Malcolm Slaman, *Studio*, Vol.LXIII, p.19. CF

LEE, Terry (b. 1932). Born in Sheffield, he studied at Sheffield College of Art and then at the SLADE SCHOOL. He taught at CAMBERWELL and then at Sheffield College of Art, where he was Head of Painting until 1984. He had one-man shows at the NEW ART CENTRE from 1960 to 1965, at the Stone Gallery, Newcastle, in 1965, and with AGNEW'S in 1973, 1976 and 1978. He has frequently exhibited in Maastricht, and has participated in many mixed exhibitions, such as the JOHN MOORES in Liverpool (1957, 1959, 1961 and 1963; winning prizes in 1957 and 1963), and featured in national exhibitions such as the 1980 British Art Show, chosen by William Packer. His work is in a number of public collections in this country, including the Walker Art Gallery, the Graves Art Gallery, Sheffield, and those of Coventry, Hull and Oldham. His landscapes, of Yorkshire and Spain, some with still-lives on tables in the foreground, are broad and sweeping in their scope, often with stormy skies and brilliantly contrasted effects of light and shade.
LIT: He was discussed in Herbert Read's *Contemporary British Art*, 1964. AW

LEE-HANKEY, William, RWS, RI, ROI, RE, RBA, RMS (1869–1952). Painter of landscapes, coastal scenes, figures and portraits, in oils; etcher and illustrator. He studied at Chester School of Art under Walter Shroeder, at the RCA under John Sparkes, and in Paris. From 1904 onwards he lived for long periods at Etaples in France. He exhibited widely from 1893: in London galleries (including the LEICESTER GALLERIES), abroad and in many societies, being elected RBA and RMS in 1896, RI in 1898, ROI in 1908, RE in 1911 and RWS in 1936 (Vice-President 1947–50). President of the London Sketching Club 1902–4, and a member of the Society of 25 Artists, his

work is represented in collections in this country and abroad. His subjects range from studies of Breton peasants to fresh, direct marine views such as *The Mussel Gatherers*, exhibited at the ROI in 1934. He began etching in 1902, later working increasingly in drypoint.
LIT: *The Etched Works of W. Lee-Hankey RE from 1904–1920*, Martin Hardie, L.H. Lefevre & Son, London, 1921; 'An English Impressionist', Anthony J. Lester, *Antique Dealer and Collector's Guide*, Vol.42, Pt11, June 1989. CF

LEECH, William John, RHA (1881–1968). Irish painter of landscapes, townscapes, figures and portraits in oils and watercolours. He studied at the Metropolitan School of Art, Dublin, at the RHA Schools from 1899, under Walter Osborne, and at the ACADÉMIE JULIAN, Paris, under Ferrier, Royer, Boulanger and J.P. Laurens, c.1901–3. In 1903 he visited Concarneau, Brittany, with Sidney Thompson and he returned there every year until c.1908. After the war he continued to paint in Concarneau and Brittany. He exhibited at the RHA 1900–20, at the ROI 1907–11, at the RA from 1910 and at the Paris Salon. He held his first solo exhibition at the Goupil Gallery in 1912. His early work was influenced by Whistler and in France he adopted the vivid palette and looser technique of the Post-Impressionist painters and the Fauves.
LIT: *William John Leech RHA: His Life and Work*, Alan Denson, Kendal, 1969. CF

LEES, Derwent, NEAC (1884–1931). Painter in oils and watercolours of landscapes and figure compositions. Intimate with J.D. INNES and AUGUSTUS JOHN, his work – often small scale and on panel – shared with them a passionately romantic response to landscape. Lees' decorative sense and fluid, shorthand method of paint application owe much to their influence. Often portraying his wife Lyndra within a lyrical landscape, Lees was also a skilled portrait draughtsman. Born in Tasmania, he studied at Melbourne University and Paris before arriving in London in 1905. Entering the SLADE SCHOOL that year, he soon distinguished himself and served there under TONKS as a teacher of Drawing from 1908 to 1918. Travelling widely in Europe, his subjects include French, Spanish, Italian and Belgian localities. In 1912 he accompanied Innes to the South of France. He also worked in Dorset, in close contact with John. A member of the NEAC from 1911, he held a one-man show at the CHENIL GALLERY in 1914. Suffering mental illness

in 1918, Lees ceased to paint, and was thereafter confined to an institution. GS
LIT: *In Search of Derwent Lees*, Henry Lew, 1996.

Lefevre (Alex Reid and Lefevre). This gallery, at 30 Bruton Street, was founded in 1926. They exhibit nineteenth- and twentieth-century European painting and drawing, and are well known for their representation of L.S. LOWRY (for whom they pioneered support) and EDWARD BURRA. AW

LEGGE, Arthur J., RBA (1859–1942). Painter of landscapes and figures in watercolours and oils. Father of Phyllis May Legge, he exhibited mainly at the RBA (member 1892), at the RA, GI, RI and in Liverpool. Active from c.1886 to 1921, he was Head of West Ham School of Arts and Crafts. His exhibited works included subjects such as *The Haunt of the Kingfisher*, 1905, and *A Quiet Corner*, 1920, both exhibited at the RA. CF

The Leicester Galleries. Established in 1902, the Leicester (Ernest Brown and Phillips), directed by Oliver Brown, put on important exhibitions in Leicester Square of modern French and British painting from the time of JOHN LAVERY to that of MOORE, MEDLEY and GOWING. An important feature of their later calendar was the summer exhibition of 'Artists of Fame and Promise'. AW

LEIGH-PEMBERTON, John, ROI, NS (b. 1911). Painter of figures and other subjects in oils, tempera and gouache; illustrator. Educated at Eton, he studied art in London between 1928 and 1931, and exhibited between 1934 and 1948, showing at the RA from 1935 to 1948, the ROI (member 1936), the NEAC and R.Cam.A. His work is represented in collections including the IMPERIAL WAR MUSEUM. His illustration work includes books on natural history, many for children, and advertising series such as *Whitbread Craftsmen*, Whitbread & Co., London, 1948. Other commissions include a painted panel for USS *Uganda*. He retired in 1982. His exhibited paintings depicted subjects such as *The Window*, RA 1936, and *The Hospital Gate*, RA 1947. CF

LEIGHTON, Alfred Crocker, RBA (1901–1965). Painter of Canadian and English landscapes in watercolours and some oils, pastelist. He studied at Hastings School of Art and was encouraged by E. Leslie Badham to exhibit at the RBA where he became an associate in 1926 and a member in 1929. He was employed as a commercial artist by the Canadian Pacific Company, travelling to Canada in 1925 and 1927 where he exhibited both Canadian and English subjects. He showed at the RA, NEAC and at the Paris Salon, and in 1929 he settled in Canada where he exhibited regularly. He was Director of the Art Insitute of Calgary from 1929 and founder and first President of the Alberta Society of Artists. He worked outside, often using pen and ink with watercolour, and based his paintings on detailed drawing, sometimes using a 'Claude Glass' to establish tonal harmony. His later work shows a greater interest in skies.
LIT: Retrospective exhibition catalogue, Edmonton Art Gallery, Canada, 1981. CF

LEIGHTON, Clare Veronica Hope, RE (1901–1989). A wood engraver, painter, writer and designer of stained glass. She studied art at Brighton, the SLADE and the CENTRAL SCHOOL. Her subjects were drawn from contemporary rural and city life. She published *Wood Engravings of the 1930s* in 1936, and emigrated to the USA in 1939, where she became an American citizen.
LIT: *The Wood Engravings of Clare Leighton*, Patricia Jaffé, Cambridge, 1992. AW

LESSORE, Helen, RA, OBE (1907–1994). Painter of figures, portraits, interiors and gardens in oils. She studied at the SLADE SCHOOL under TONKS 1924–8, and married Frederick Lessore, founder of the BEAUX ARTS GALLERY, in 1934. From 1951 to 1965 she was the Director of the gallery and was awarded an OBE in 1958. An exhibitor at the RA from 1967, her work is represented in the TATE GALLERY and combines observed images with memories and experience using clear colour influenced by Italian Renaissance painting.
LIT: *A Partial Testament*, Helen Lessore, 1986; catalogue, Fine Art Society, London, 1987. CF

LESSORE, John (b. 1939). Painter of figures, portraits, interiors and landscapes in oils. Son of Helen Lessore, he studied at the SLADE SCHOOL 1957–61, winning a travelling scholarship to Italy. He held his first solo exhibition at the BEAUX ARTS GALLERY in 1965, and has subsequently exhibited in London, in the provinces, and at the RA since 1965. His work is represented in the TATE GALLERY (it featured in the exhibitions 'The Hard-Won Image',Tate 1984, and 'The Pursuit of the Real', Manchester City Art

Gallery 1990), and he has taught at Norwich School of Art since 1978. His paintings use a broadly brushed, direct technique which gives an atmosphere of expressive reality.

LIT: Catalogues for the WADDINGTON GALLERY, 1981; and the Sternberg Centre for Judaism, London, 1986. CF

LESSORE, Thérèse (1884–1945). Painter of figures and urban scenes, particularly music-halls and circuses, in oils. Daughter of Jules Lessore, she studied at the SLADE SCHOOL 1904–9, and exhibited first at the AAA in 1912. A founder member and regular exhibitor at the LG, she held her first solo exhibition at the Eldar Gallery in 1918. Married to SICKERT in 1926, her work adopted many of his methods.

LIT: *The Sickert Women and the Sickert Girls*, catalogue, Michael Parkin Fine Art, London, 1974. CF

LETT-HAINES, Arthur (1894–1978). Painter, sculptor and teacher. Studied at CHELSEA, Newlyn and in Paris at the Académie Colarossi. His first one-man show was at the Casa d'Arte Bragalia, Rome, in 1922; in 1937 he set up the East Anglian School of Painting and Drawing with CEDRIC MORRIS. Pupils included MAGGI HAMBLING and LUCIAN FREUD. In 1984 a retrospective exhibition was held at the REDFERN GALLERY. AW

LEVENE, Ben, RA (b. 1938). Painter of still-life and landscapes in oils. Born in London, he studied at the SLADE SCHOOL 1956–61, where he was awarded the Boise Scholarship. From 1961 to 1962 he lived in Spain and he held his first solo exhibition at the Thackeray Gallery, London, in 1973, where he continued to exhibit until 1981. He has subsequently shown in London galleries including the NEW ART CENTRE and BROWSE AND DARBY. He has shown regularly at the RA since 1965 (ARA 1975 and RA 1986), and with the LG as well as in America. His work has been purchased by the CHANTREY BEQUEST and he teaches at CAMBERWELL SCHOOL OF ART and at the RA SCHOOLS. His strongly coloured, representational paintings have a strong sense of rhythm and design, using slightly flattened, angular forms which impart an overall strength to the picture surface.

LIT: Article in *Artist* (UK), August 1984. CF

LEVERETT, David (b. 1938). Painter of abstracts in acrylic, resin, collage and mixed media. He studied at Nottingham College of Art 1957–61, and at the RA SCHOOLS 1961–4, working as a builder-designer and as a scenic design assistant before painting and teaching from 1965. He has held solo exhibitions at the REDFERN GALLERY, London, since 1965 and has shown regularly in mixed exhibitions and abroad. His work is represented in public collections including the TATE GALLERY and the V & A. He has taught widely in England and abroad and between 1971 and 1973 he was Visiting Artist at the RA Schools, the RCA and at Hornsey College of Art. Since 1971 he has been Visiting Lecturer at the SLADE SCHOOL. His work has gradually broken down the concept of a 'completed' image in order to preserve and to reveal the creative process in all its stages. Recent paintings in acrylic make specific reference to landscape in bold, strong areas of colour.

LIT: *Sacred Gardens*, catalogue, Jersey Arts Centre, St Helier, 1986. CF

LEVY, Emanuel (1900–1986). Painter of figures and portraits in oils; draughtsman. He studied at MANCHESTER SCHOOL OF ART under VALETTE (where his contemporaries included LOWRY and FITTON), and at ST MARTIN'S SCHOOL OF ART. He exhibited first in 1924 at the Manchester Art Federation and subsequently showed in London, at the RBA, NEAC, RA, in Manchester, Liverpool and abroad. His work is represented in public collections including Manchester City Art Gallery. Instructor in Drawing and Painting at Manchester University after Valette's retirement, he was for a time Art Critic for the *Manchester Evening News* and the *City News*. Influenced by Cubism and Surrealism, his powerfully observed works ranged from imaginative surrealistic scenes to psychologically penetrating portraits.

LIT: Memorial exhibition catalogue, Ben Uri Gallery, London, 1989. CF

LEWIS, Edward Morland, LG (1903–1943). Painter of landscapes and townscapes, particularly of seaside towns, in oils. Born in Carmarthen, he studied at ST JOHN'S WOOD SCHOOL OF ART, at the RA SCHOOLS, and as a pupil and assistant to SICKERT. He exhibited at the LG from 1929 (member 1931) and at the AAA from 1930 to 1934. In 1938 he held an exhibition at Picture Hire Limited, Brook Street, London, but exhibited little apart from this. His work is represented in public collections including the National Museum of Wales, Cardiff. He taught at CHELSEA COLLEGE OF ART and died on active service in

North Africa. His paintings were influenced by Sickert in their use of a warm-toned underpainting and application of colour, he also used photographs as a source for his compositions. LIT: Catalogue, Howard Roberts Gallery, Cardiff, 1962. CF

LEWIS, Neville, RP (b. 1895). Painter of portraits, figures and some landscapes in oils. Born in Cape Town, South Africa, he studied in England under STANHOPE FORBES in Newlyn in 1912, and from 1914 to 1916 at the SLADE SCHOOL, London, under TONKS, STEER, LEES and MCEVOY. Between 1918 and 1938 he established a studio in London and concentrated on portraiture. He spent some time working in South Africa, where he eventually settled, and from 1940 to 1945 he was the first South African OFFICIAL WAR ARTIST. He held his first London exhibition at the Carfax Gallery in 1920, subsequently exhibiting in London galleries, in Europe, the USA and South Africa. He showed at the RA from 1923 to 1962 and his work is represented in public collections including the TATE GALLERY. His vigorous, broad handling was influenced by AUGUSTUS JOHN.
LIT: *Studio Encounters*, Neville Lewis, Cape Town, 1963. CF

LEWIS, Percy Wyndham, LG (1882–1957). Painter in oils and draughtsman of figures, portraits, self-portraits, Vorticist, abstract and imaginative subjects; author and critic. Born on his father's yacht off Amherst, Nova Scotia, he studied at the SLADE SCHOOL 1898–1901, accompanied GORE to Madrid *c.*1902, and then studied art in Europe 1902–8, spending six months at the Akademie Heimann, Munich, and some time with AUGUSTUS JOHN. He settled in England in 1909 (meeting Ezra Pound), exhibiting at the AAA from 1911, with the CAMDEN TOWN GROUP and at the second Post-Impressionist Exhibition. In 1912 he collaborated on the decorations for the Cave of the Golden Calf and in the same year was influenced by the London exhibition of the Italian Futurists. In 1913 he was a founder member of the LG and he worked for the OMEGA WORKSHOPS, but quickly broke with FRY over the Ideal Home Exhibition commission and left with WADSWORTH, ETCHELLS and HAMILTON. He showed in Rutter's Post-Impressionist and Futurist Exhibition, led the Cubist Group at the Brighton Exhibition of 1913–14 and in 1914 founded the REBEL ART CENTRE and the VORTICIST Group. Editor of *Blast*, 1914–15, he

exhibited at the Vorticist exhibitions in London in 1915 and New York in 1917. After active service in France, he was an OFFICIAL WAR ARTIST between 1917 and 1918, and after the war he founded GROUP X, organizing a group exhibition in 1920 at the Mansard Gallery, London. He held his first solo exhibition at the Goupil Gallery in 1919 and he subsequently showed in leading London galleries including the LEICESTER GALLERIES. His work is represented in many public collections including the TATE GALLERY. His writing encompassed plays, fiction, autobiography, essays and art criticism and he edited the arts reviews *The Tyro*, 1921–2, and *The Enemy*, 1927–9. In 1952, he was awarded an Hon. Litt.D. by Leeds University. Influenced by Cubism and Futurism, his avant-garde painting used angular, clearly delineated forms and between 1913 and 1915 his innovative abstract work employed machine-like formations with strong diagonal axes. His later representational work continued to use hard, sculptural forms painted in sharp, idiosyncratic colour, and he also depicted imaginative semi-abstract compositions often inspired by literary themes.
LIT: See Lewis's own writing including *Wyndham Lewis the Artist*, Laidlaw & Laidlaw, 1939; catalogues for the Tate Gallery, 1956, and Manchester Art Gallery, 1980; *Wyndham Lewis*, W. Michel, Thames & Hudson, 1971. CF

LE WITT, Jan (1907–1991). Painter, designer and poet, he was born in Czestochowa, Poland, and following a period of travel throughout Europe in 1925–8, he visited the Bauhaus in 1931 and met Paul Klee. In 1933 he began a graphic design partnership in Warsaw with George Him, which was revived later when they were both in exile in Britain. In London from 1937, he married in 1939 and worked for the Ministry of Information, the GPO and the exiled Polish Government. He made friends with HENRY MOORE and HERBERT READ, and had his first one-man show at ZWEMMERS in 1947. He did work for the Festival of Britain and for John Cranko at Sadler's Wells, exhibited at the LEICESTER and GROSVENOR Galleries, was included in 'Eight British Artists' at the National Museum, Stockholm, in 1952, and showed in Rome, Milan and Paris. Typical of his calligraphic, Surrealist work was *Centaur*, 1952; later work was more abstract (*Solarium*, 1967). AW

Li Yuan-Chia (1929–1994). Calligrapher, painter, woodcarver, photographer and gallery

owner. Born in Kwangsi Province, South China, Li studied at the art school in Taipei, and privately with Li Chun-Son. In 1956 he exhibited the first abstracts seen in Taipei, and in 1957 formed the group *Tan Fan*, which still meets. He moved to Italy in 1962, and was a founder-member of the group *Punto*. His work is in many private and public collections, including the Galleria Nazionale d'Arte Moderna in Rome. In 1965 he arrived in London, exhibiting at the Lisson Gallery and in the 'All or Nothing' (1967) and 'Pavilions in the Park' exhibitions (1968). He settled in Cumbria in 1968, and founded the LYC Museum and Art Gallery, Bankside, a farmhouse which he bought from WINIFRED NICHOLSON. He included his own work in the exhibitions he organized there; it ranged from calligraphic abstracts to magnetic red and black discs with moveable parts. The gallery closed in 1982. His work was in 'The Other Story' at the Hayward Gallery in 1989, and in his last two years Li took up calligraphic carving of texts on wood, and devoted much effort to poetic and mysterious hand-coloured photography. AW

LIGHTFOOT, Maxwell Gordon (1886–1911). Painter of portraits, figures, still-life and flowers in oils. He studied at Chester School of Art and in 1905 attended evening classes at the Sandon Studios, Liverpool, under GERARD CHOWNE. He also studied at the SLADE SCHOOL under TONKS 1907–9, where he formed friendships with WADSWORTH, NEVINSON, GERTLER and SPENCER. He exhibited in 1907 in the Liverpool Autumn Exhibition, at the NEAC in 1910, and he was subsequently introduced to the FITZROY STREET CIRCLE by GORE, exhibiting in 1911 at the FRIDAY CLUB and at the first CAMDEN TOWN GROUP exhibition at the Carfax Gallery. Initially influenced by Chowne and MacNair, his later work used flatter areas of colour, simple forms and fine tonal gradations which gave his paintings a lyrical, more traditional appearance than those by contemporaries in the Camden Town Group.
LIT: Catalogue, Walker Art Gallery, Liverpool, 1972. CF

LILLY, Marjorie (b. 1891). Painter of figures, portraits and flowers in oils. Born in London, she was a student at the SLADE SCHOOL where she met CHRISTIANA CUTTER and later WENDELA BOREEL. In 1917 she met SICKERT; she held joint exhibitions with Boreel and Cutter in 1922, 1928, 1930 and 1939. She showed mainly at the Baillie Gallery as well as at the LG, NEAC, RA, LS, RBA

and ROI. She wrote *Sickert the Painter and his Circle*, Elek, London, 1971. Her sensitive painting was clearly influenced by Sickert. CF

LINDSAY, Alan, ARCA (b. 1918). Painter of landscapes and still-life; illustrator and graphic designer. Born in Ludlow, he studied at the Birmingham College of Arts and Crafts 1934–6, and at the RCA 1938–9 and 1946–8. He exhibited at the RA from 1949 to 1957, at the NEAC and in leading galleries. His landscapes showed English, Welsh and Irish scenes such as *Cerne Abbas, Dorset*, 1955, and *North Wales Village Crossroads*, 1957, both exhibited at the RA. CF

LION, Flora, ROI, RP, NPS (1876–1958). Painter of portraits, landscapes, genre and flowers in oils; lithographer. She attended ST JOHN'S WOOD SCHOOL OF ART in 1894, the RA SCHOOLS under SARGENT, SOLOMON J. SOLOMON, CLAUSEN and ARTHUR HACKER 1895–9, and the ACADÉMIE JULIAN, Paris, under J.P. Laurens 1899–1900. She exhibited widely, showing at the RA from 1900, in London societies and galleries, and abroad at the Paris Salon and in America. She was elected ROI in 1909, NPS in 1910 and RP in 1913 and her work is represented in public collections including the TATE GALLERY. She won silver (1921) and gold (1949) medals from the Société des Artistes Français and her elegant portraits included many well-known figures and members of the Royal Family. CF

LISTER, Edward d'Arcy, ARCA (b. 1911). Painter of landscapes, portraits, figures and still-life in oils, watercolours and gouache; colour print artist and mural decorator. He studied at Leeds College of Art 1928–33, and at the RCA under GILBERT SPENCER 1933–7. He exhibited at the RA between 1935 and 1962, in provincial galleries, and his work is represented in public collections including the V & A. A lecturer at Bournemouth and Poole Colleges of Art, his mural designs included work for the Percival Leigh Library, Leeds, and his paintings depicted observed scenes such as *The Nairn in Spate*, 1948, as well as aspects of contemporary life, e.g. *Saturday Night*, 1958 (Southampton Art Gallery). CF

LITTLE, George Leon (1862–1941). Painter of landscapes, marines and portraits in oils. He exhibited at the RBA from 1884, at the RA, NEAC, in Liverpool and at the Goupil Gallery. His work included evocative, atmospheric land-

scapes, some moonlight scenes and sensitive portraiture such as the painting of Sir Henry Rider Haggard at the National Portrait Gallery, London.　　　　　　　　　　　　　　CF

LIVENS, Horace Mann, IS, RBA (1862–1936). Painter of landscapes, townscapes, interiors, figures, flowers and poultry in oils, watercolours and pastels; etcher and illustrator. He studied under Walter Wallis at Croydon School of Art and from 1885 at the Antwerp Academy under Verlat, where he formed a friendship with Van Gogh and on his advice continued his studies in Paris, returning to London in 1890. He exhibited at the RA from 1890 to 1930, showed at the NEAC and RBA from 1894 (RBA 1895) and was a foundation associate and member (1907) of the IS where he exhibited from 1898 to 1925. He held his first solo exhibition at the Goupil Gallery in 1911 and exhibited in many galleries and societies and abroad. His work is represented in collections including the TATE GALLERY. Influenced by Van Gogh, Manet, Ribot and particularly Whistler, he used a dark ground, applying colour in fluid shapes. His poultry subjects reflect his interest in Japanese prints whilst his etchings reveal his mastery of dramatic tonal contrasts.
LIT: Catalogue, Belgrave Gallery, London, 1978; *The Drypoints of Horace Mann Livens*, Irving Grose, Belgrave Gallery, 1979.　　　　CF

LLEWELLYN, Sir William Samuel Henry, PRA, HROI, HRMS, HRE, HRSA, RI, RBA, RP, RWA, RBC, NEAC (1858–1941). Painter of portraits and landscapes in oils. He studied at the RCA under Poynter, 1879–80, and in Paris under Cormon, Lefèbvre and Ferrier. He exhibited widely, showing at the RA from 1884 to 1941 (ARA 1912, RA 1920, PRA 1928–38), in London and provincial galleries. A member of the Society of 25 Artists, he was elected NEAC in 1887, RBA in 1888, RP in 1891, ROI, in 1898, RI in 1918, HROI and RE in 1929 and HRMS in 1930. He was friendly with and influenced by LA THANGUE. Awarded the KCVO in 1918 and the GCVO in 1931, his work is represented in the TATE GALLERY (*Sailing at Blakeney* purchased through the CHANTREY BEQUEST in 1938). A Trustee of the National Gallery, 1933–40, his portraits included the State Portrait of Queen Mary, 1910.
LIT: 'The Portraits of Mr W. Llewellyn', M.H. Dixon, *The Lady's Realm*, 1906; *Studio*, Vol.39, pp.150 and 156.　　　　　　　　　CF

LODGE, George Edward (1860–1954). Painter of birds and animals in watercolours heightened with bodycolour, tempera and oils; engraver and illustrator. Brother of the bird photographer R.B. Lodge, he was a student at Lincoln College of Art and apprenticed to a wood engraver. He travelled widely and was a friend of Archibald Thorburn. He exhibited at the RA, the RBA and in London and provincial galleries from 1881 and he illustrated many books including the twelve volumes of *Birds of the British Isles* by David Bannerman, 1953–63. His work reveals his delicacy of touch, the accuracy of his realistic detail and his knowledge of bird and animal life.
LIT: *Memoirs of an Artist Naturalist*, George Edward Lodge, 1945; catalogue, Tryon and Moorland Gallery, 1984.　　　　　　CF

LOGSDAIL, William, RP, RBC, NEAC (1859–1944). Painter of architecture, subject paintings, portraiture, landscapes and flowers in oils. A friend of Frank Bramley, he studied at Lincoln School of Art under E.R. Taylor, the RCA and in Antwerp under Verlat. From 1880 to 1887 and 1892 to 1902 he lived in Venice and in 1883 he toured the Balkans, Egypt and the Holy Land. He exhibited mainly at the FINE ART SOCIETY, at the RA from 1877 to 1926 and at the RP (member 1913) as well as in other London and provincial galleries and in Scotland. Elected NEAC in 1886, in 1888 his painting *St Martin-in-the-Fields* was purchased by the CHANTREY BEQUEST for the TATE GALLERY. Up to 1902 he painted mainly realistic architectural subjects, he then turned more to portraiture until 1922–37 when he concentrated on paintings of Oxford and on flower studies.
LIT: Memorial exhibition catalogue, Usher Art Gallery, Lincoln, 1952.　　　　　　CF

London Artists' Association. Formed in 1925 by Samuel Courtauld and John Maynard Keynes at the instigation of ROGER FRY to guarantee a small income to the artist should he fail to earn a certain minimum from work contributed to the Association, and to organize exhibitions at the minimum cost to young artists. The financial guarantors had an option on all work produced by members, at prices agreed upon beforehand. The first exhibition was held at the LEICESTER GALLERIES in 1926, and subsequently others were held at the Cooling Galleries. IVON HITCHINS and PAUL NASH benefited from membership of the LAA, as did COLDSTREAM, MEDLEY, PASMORE and ROGERS, who had their first one-man or two-man

joint exhibitions under these auspices. The Association was dissolved at the end of 1933. LIT: Catalogue for the commemorative exhibition, Ferens Art Gallery, Hull, 1953, Preface by CLIVE BELL. AW

London Gallery. The Director, from 1937, was the Belgian poet E.L.T. Mesens, and he also edited the *London Bulletin* (1938–40) assisted by ROLAND PENROSE and HUMPHREY JENNINGS. The Gallery was the London headquarters of Surrealism, showing work by the leading European and American surrealists, although a major survey, 'Living Art in England' of January 1939, included non-Surrealist resident foreigners such as Mondrian and KOKOSCHKA. The Gallery closed during the Second World War, and reopened 1946-*c*.1950. AW

The London Group (1913-). A broadly-based exhibiting society, where all modern methods could find a platform, resulting from the amalgamation of the FITZROY STREET GROUP and the CAMDEN TOWN GROUP in November 1913. Epstein is credited with the name of the Group, which numbered over thirty (including sculptors), at the time of its first exhibition at the Goupil Gallery in March 1914. Initially there was some friction between the realists of the old guard and the formalists represented by LEWIS and his followers, NEVINSON, HAMILTON, WADSWORTH and ETCHELLS, who brought a change in emphasis contributing to the resignation of PISSARRO and SICKERT in 1914. In 1916 MARK GERTLER and MATTHEW SMITH exhibited with the Group, which had by then overcome its problems, and Sickert rejoined. After 1920 the Bloomsbury artists, VANESSA BELL, DUNCAN GRANT and BORIS ANREP, grouped around ROGER FRY, dominated the society. Other members representing the modern movement were BOMBERG, PAUL NASH, GAUDIER-BRZESKA and ROBERTS. GILMAN was the first President, and then from 1924 to 1928 the sculptor Frank Dobson; Bevan was Treasurer and MANSON Secretary. The second exhibition in 1915 included Epstein's plaster for *The Rock Drill*. The large retrospective in 1928 held at the New Burlington Galleries included Matthew Smith's *Woman with a Fan*, 1928, and at the 1930 show Nash's *Northern Adventure*, 1928, heralded Surrealism. The group has changed direction over the years, but its flexibility has assured its survival. It can be seen as the successful culmination of efforts to create an atmosphere where young progressive painters could flourish.

LIT: *London Group, 1914–64: Jubilee Exhibition*, D. Farr and A. Bowness, Tate, 1964; *The London Group 1913–1939*, Denys J. Wilcox, Scolar Press, 1995. DE

LONG, Richard (b. 1945). Conceptual and land artist, working with outside sculpture and inside wall and floor installations using natural materials, texts, maps and photographs. Born in Bristol, he studied at the West of England College of Art 1962-5, and at ST MARTIN'S SCHOOL OF ART 1966-8. He made his first landscape art work in 1967 and held his first solo exhibition in 1968 at the Konrad Fischer Gallery, Düsseldorf, where he continued to exhibit regularly. He has shown in Paris since 1969, in American galleries including the Guggenheim Museum, New York, in 1986, and in leading London galleries including the Whitechapel Gallery in 1972 and 1977, the Lisson Gallery 1973-9, and at Anthony d'Offay since 1979. His work was shown at the Venice Biennale of 1976 and has appeared internationally in mixed exhibitions since 1966. He is represented in many public collections including the TATE GALLERY and MOMA, NY. In 1988 he was awarded the Kunstpreis Aachen. His work is concerned with movement, time, ideas and the land and it often arises from walks through landscape during which he marks the earth or rearranges natural objects in basic, fundamental shapes. Concerned to work with nature rather than impose on it, his gallery work also uses natural materials gathered from his walks and presents the viewer with ideas and documents about the walk itself and the outside sculpture that has arisen from it. Both object and idea are given equal significance by the artist.

LIT: See Long's own publications including *Lines of Time*, Amsterdam, 1986; *Sixteen Works: Richard Long*, catalogue, Anthony d'Offay, London, 1984; *Richard Long*, R.H. Fuchs, Thames & Hudson, 1986. CF

LONGLEY, Stanislaus Soutten, RI, RBA (1894–1966). Painter of landscapes in watercolours; decorative figure painter and designer. He studied under G.P. Gaskell and H. Watson at the Regent Street Polytechnic and exhibited at the RA between 1925 and 1954, at the RBA (member 1925) and the RI (member 1932) as well as showing at the FINE ART SOCIETY and at the Paris Salon. His decorative figure subjects, many of period scenes, used flattened areas of colour, pattern and tone clearly delineated by fine lines, whilst his paintings included subjects

such as *Old Dutch Cottages, Mudeford*, 1946, and *The Old Boat House, Wareham*, 1954. CF

LOVEGROVE, James William, ARCA, RE (1922–1997). Etcher and watercolourist. Trained at Woolwich Polytechnic and then the RCA following active service during the Second World War. His etching *Bankside Coal Wharf* (1952) was selected as 'plate of the year' by the Print Collectors' Club. He spent much of the rest of his life at sea and on expeditions, becoming Director of the Mary Rose Trust; he did not return to full-time professional art until 1992. AW

LOVELESS, John (b. 1943). Painter of abstracts in acrylic. Born in Bristol, he studied architecture at the RWA School of Architecture, Bristol, 1961–3, and painting at the West of England College of Art 1963–5. He held a solo exhibition at the Arnolfini Gallery, Bristol, in 1967, and he continued to exhibit there, in London and in the provinces as well as in group shows. His work is represented in public collections including the Arnolfini Trust and Bristol University. He has worked as a Research Assistant in Graphics at the Audio Visual Aids Unit, University of Bristol. His early geometric work was concerned with the structural implications of the square and later in the 1960s with the relationship between chromatic variations within a simple geometric format. In the 1970s he began to use a diagonal, triangular organization of the canvas with less emphasis on the role of colour. CF

LOWE, Peter (b. 1938). Constructivist and draughtsman. Born in London, he made his first constructions in 1960 and from 1961 to 1962 worked in product design. In 1969 he was a founder member of the SYSTEMS Group and in 1973 he became a member of the Internationaler Arbeitskreis für Konstruktive Gestaltung. He has held solo exhibitions at the Gardner Centre, Sussex University, 1975, in London galleries and abroad, and he has shown internationally in group exhibitions since 1957. His geometric, refined work often uses a basic module.
LIT: *Working Information: 6 Artists*, limited edition of 230 copies, 1976; *Transformations on Paper*, exhibition catalogue, Galerija Suvremene Umjetnosti, Zagreb, 1979. CF

LOWINSKY, Thomas Edmond (1892–1947). Painter of portraits and figure compositions; book illustrator. Educated at Eton and Trinity College, Oxford, he studied art at the SLADE. He served with the Scots Guards during the First World War. His first one-man show was at the LEICESTER GALLERIES in 1926; he also became a member of the NEAC in that year. He illustrated books by Edith and Sacheverell Sitwell, and his meticulous paintings, such as *The Dawn of Venus* (1922, TATE GALLERY) were often in tempera on canvas. AW

LOWNDES, Alan (1921–1978). Born in Stockport, he left school at fourteen and, apart from night-school study following his military service (1939–45, in the Middle-East, then in Italy and Austria, where he managed to see as much as he could of Renaissance painting), he was largely self-taught as an artist. Before the war he was apprenticed to a painter and decorator; for a period after the war he designed textiles. He exhibited regularly from 1950 at the CRANE KALMAN Gallery in Manchester (and later in London), although his work was subsequently included in many group exhibitions in Britain, Germany and the USA. He lived for a while in Cornwall, 1950–68, and later in Gloucestershire. He used oil paint with a thick and expressive impasto, and his colour was usually rich and sombre. His subject-matter was drawn from everything he observed in his life in Stockport, St Ives and elsewhere, including portraits, interiors, street scenes and landscapes. His work is in many public collections for example the Art Galleries of Manchester, Plymouth and Liverpool.
LIT: He wrote a statement ('Notes') in the catalogue of his retrospective exhibition *Alan Lowndes*, Stockport Museum and Art Gallery, 1972. This also includes essays by John Willett and Keith Waterhouse (as does the almost identical catalogue for his 1972 exhibition at the Crane Kalman Gallery). AW

LOWRY, Lawrence Stephen, RA, RBA, LG, NS (1887–1976). Painter of industrial scenes, figures, seascapes and landscapes in oils. Born in Manchester, he worked as a clerk from 1903 and studied at private classes under Reginald Barber. From 1905 to 1915 he was an evening pupil at Manchester College of Art, working under ADOLPHE VALETTE, and from 1907 to 1915 he studied in private classes with William Fitz. He was employed as a clerk for the General Accident Fire and Life Assurance Company between 1907 and 1910 and in 1910 he joined the Pall Mall Property Company where he continued to work until his retirement in 1952. Between 1915 and 1925 he attended classes at Salford School of Art

under Bernard D. Taylor and in 1918 he was accepted for the life class at Manchester Academy of Fine Arts. He lived at home and nursed his mother through the last years of her life until her death in 1939. In 1948 he moved to Mottram-in-Longdendale, Cheshire. He exhibited first in 1919 in the Annual Exhibition of the Manchester Academy of Fine Art and in the 1920s he showed widely: at the Paris Salon, with the NEAC from 1927, in Dublin and Manchester. In 1930 he held a solo exhibition of drawings at the Round House, Manchester, and in 1939 there was a one-man exhibition of paintings at the REID & LEFEVRE GALLERY, London, where he subsequently held 15 solo exhibitions between 1945 and 1976. He exhibited at the RA from 1932 (RA 1962) and with the RBA from 1933 (member 1934) and he was elected a member of the MAFA in 1934 and LG in 1948. Retrospective exhibitions of his work include those at Manchester City Art Gallery, 1959, and at the RA, London, 1976, and his work is represented in many public collections including the TATE GALLERY and MOMA, New York. In 1953 he was appointed Official Artist at the Coronation, and he was awarded an Honorary D.Lit. by the Universities of Salford and Liverpool in 1975. His early work showed the influence of Valette and shared some of the characteristics of the CAMDEN TOWN SCHOOL. Influenced by Bernard Taylor to use a white ground, he organized his canvas in terms of tonal contrast, the white ground playing a more prominent role in his later work. Best known for his paintings of industrial towns peopled by many slight, dark-toned and simplified figures painted without shadows, his work (including his imaginary portraits) is often melancholy and sometimes humorous.
LIT: *The Life of L.S. Lowry*, Allen Andrews, London, 1977; *Lowry*, Julian Spalding, The South Bank Board and The Herbert Press Ltd, 1987. CF

LOXTON PEACOCK, Clarisse (b. 1926). Painter of still-life, figures, flowers, birds and animals in oils. Born in Hungary, she studied at the Regent Street Polytechnic, at CHELSEA, the CENTRAL and ST MARTIN's Schools of Art and has exhibited at the RA, RBA, LG, ROI, RI and in London galleries, most recently at Cadogan Contemporary. She has been awarded a silver medal at the Paris Salon and her work is represented in collections including MOMA, San Francisco, and St Edmund's Hall, Oxford.

Influenced by Braque and Morandi, all her work is strongly structured using simplified forms and, in recent paintings, vivid colour.
LIT: Catalogues for the Fox Galleries, London, 1978, and the Cadogan Contemporary Gallery, London, 1988. CF

LUARD, Lowes Dalbiac, RBA (1872–1944). Painter in oils, draughtsman in pastels, charcoal and chalk and etcher of animals (particularly horses) and figures; illustrator. He studied with Alexander Davis Cooper, at the SLADE under BROWN and TONKS and in Paris under Lucien Simon and René Ménard at La Grande Chaumière. He lived in Paris from 1904 to 1931 where he held his first solo exhibition in 1911 at the Galeries Georges Petit. He exhibited at the Goupil Gallery, London, in 1914 and subsequently showed in London galleries including the FINE ART SOCIETY, the RBA (member 1937) and at the RA between 1914 and 1943. His work is represented in the V & A. His publications include *The Horse. Its Action and Anatomy by an Artist*, Faber & Faber, 1935, and *Horses and Movement*, Cassell, 1921. Primarily concerned with the depiction of movement, his work concentrated first on the Percheron horses of Paris and later on racehorses and circus subjects.
LIT: Exhibition catalogue, Michael Parkin Fine Art Ltd, London, 1980; 'The Work of Lowes Dalbiac Luard', Sir Nicholas Lyell, The British Sporting Art Trust, *Essay No.20*, Spring 1989. CF

LUKE, John, RUA (1906–1975). Born in Belfast, he lived there for most of his life, after studying at the Belfast College of Art, 1923–27, and in London at the SLADE SCHOOL (1927–30) and the WESTMINSTER SCHOOL OF ART (1930–31). Encouraged in 1933 to work in tempera by his friend and patron John Hewitt, then Assistant at Belfast Art Gallery, he exhibited landscapes and still-lifes in that medium (painted in soft, bright unreal colour) widely in Ireland (the RHA for example), in England and elsewhere.
LIT: *John Luke (1906–1975)*, John Hewitt, Arts Councils of Ireland, 1978. AW

LUMB, Edna (1931–1992). A painter, she trained at Leeds 1948–53, and in 1951 visited France and Spain on a travelling scholarship. She recorded the sufferings of the Biafran people in 1969. Her first solo exhibition was at Bradford Industrial Museum in 1973, and although her main interest (as an 'onsite artist') was to make

dramatic records of industrial machinery (*Engine, Ellenroad Ring Mill*, 1975 is typical), she was commissioned to record the Upper Volta Drought Relief Programme in 1976.　　AW

LUMSDEN, Ernest Stephen RSE, RE (1883–1948). A portrait and genre painter and etcher. He studied art at Reading and in Paris. He travelled widely all over the world, and this is reflected in his wide range of atmospheric topographical and other subjects. He married MABEL ROYDS and later lived in Edinburgh. He wrote a classic, indispensable book on technique, *The Art of Etching*, London, 1925. The Burnaby Art Gallery, Vancouver, has an almost complete collection of his work.　　AW

M

MABBUTT, Mary (b. 1951). Painter of figures, interiors and portraits in oils and watercolours. She studied at Luton College of Art 1970–1, Loughborough College of Art 1971–4, and at the RA SCHOOLS 1975–8, winning the John Player Portrait Award in 1984. She has held solo exhibitions at the NEW GRAFTON GALLERY and the Paton Gallery, shown in group exhibitions and at the RA since 1976. She has taught at Cardiff, Falmouth and ST MARTIN'S Schools of Art. At times influenced by Klee, her painterly figurative work has a strongly personal style.
LIT: *Room at the Top*, catalogue, Nicola Jacobs Gallery, London, 1985.　　CF

McBEY, James (1883–1959). Painter of landscapes and portraits in watercolours and oils; etcher. From 1899 to 1910 he worked in a bank at Aberdeen and was self-taught as an artist. He travelled to Holland in 1910 before settling in London and he continued to travel extensively. From 1917 to 1919 he was an OFFICIAL WAR ARTIST in Egypt. He visited the USA in 1929 and 1930 and in 1932 settled in Morocco. He subsequently divided his time between Britain, the USA and Morocco. He exhibited widely in galleries including Colnaghi & Co., the GROSVENOR and the FINE ART SOCIETY, at the RA from 1912 to 1939, and in societies and galleries in London and the provinces. His work is represented in the IMPERIAL WAR MUSEUM, London. Influenced by Rembrandt and Whistler, he was best known as an etcher in the 1920s. He began to paint watercolours in 1912 in Morocco and he depicted sub-

jects with broad washes of pale colour and sharp pen lines.
LIT: *The Early Years of James McBey*, ed. N. Barker, OUP, 1977; *James McBey 1883–1959*, catalogue, Imperial War Museum, London, 1977.　　CF

MACBRYDE, Robert (1913–1966). Painter of still-life and figures in oils. Born in Maybole, Ayrshire, he studied at GLASGOW SCHOOL OF ART under HUGH ADAM CRAWFORD, IAN FLEMING and James Cowie, 1932–7, where he met ROBERT COLQUHOUN, forming a lifelong relationship. Between 1937 and 1939 he travelled to France and Italy with Colquhoun, returning to Ayrshire in 1939. He lived in Leeds and Edinburgh whilst Colquhoun was serving in the RAMC and in 1941 they settled in London, sharing a house with JOHN MINTON. In 1943 they met JANKEL ADLER and in 1947 made monotypes and lithographs at the Miller's Press, Lewes. In 1949 they travelled to Italy and from 1950 to 1954 lived at Dunmow, Essex. Macbryde subsequently lived in London with Colquhoun, also staying in Spain with him from 1958 until Colquhoun's death in 1962. In 1966 he moved to Dublin where he died. He held a solo exhibition at the LEFEVRE GALLERY in 1943, where he also showed in group exhibitions in 1942 and 1946, and he also exhibited at the REDFERN and CRANE KALMAN Galleries, in Manchester and Liverpool. His work is represented in collections including the Scottish National Gallery of Modern Art. In 1948 he was commissioned with Colquhoun to design for Massine's Ballet *Donald of the Burthens*, produced in 1951. His early work was influenced by English neoromanticism, particularly SUTHERLAND and PIPER, his painting later reflected the work of Adler in its bold colour and use of black lines and the influence of Braque and Gris.
LIT: *Robert Colquhoun and Robert Macbryde*, catalogue, The Mayor Gallery, London, 1977; *Colquhoun and Macbryde. A Retrospective*, catalogue, Glasgow Print Gallery, Glasgow, 1990.　　CF

McCALL, Charles James, ROI, NEAC, FRSA (1907–1989). Painter of figures in interiors, landscapes, townscapes and coastal subjects in oils and pastels. He studied at EDINBURGH COLLEGE OF ART under PEPLOE (Diploma 1935) and was awarded scholarships in 1936 and 1937, travelling extensively and working with Othon Friesz at the ACADÉMIE COLAROSSI, Paris. He exhibited at the RA from 1939 to 1969, at the RSA, ROI (member

1950) and NEAC (member 1957) and has shown in solo exhbitions in London galleries including the LEICESTER and Belgrave, in the provinces, the USA and Canada. Represented in Paisley Art Gallery, his broadly painted works reflect the influence of PEPLOE, Bonnard and Vuillard.
LIT: *Charles McCall*, catalogue, Belgrave Gallery, London, 1975; *Interior with Figure. The Life and Painting of Charles McCall*, Mitzi McCall, The Book Guild Ltd, Lewes, 1987. CF

McCANCE, William (1894–1970). Painter of figures, landscapes, portraits and non-figurative images in oils and watercolours; sculptor, typographer and critic. He studied at GLASGOW SCHOOL OF ART, winning the Haldane Travelling Scholarship, and worked as an illustrator for *Lloyds Magazine* and as art critic for the *Spectator*, 1923–6. A defender of modernity, particularly the work of EPSTEIN, he exhibited in group shows from 1928 and held solo exhibitions in provincial and London galleries including Foyles Art Gallery, 1961. His work is represented in Glasgow Art Gallery. From 1930 to 1933 he was Controller of Gregynog Press and from 1944 to 1959 Lecturer in Typography at Reading University. Influenced by Cubism and VORTICISM in 1919, his work continued to employ strong angular shapes and rhythms.
LIT: *William McCance 1894–1970*, catalogue, Dundee Art Gallery, 1975; *Printing at Gregynog*, catalogue, Welsh Arts Council, Cardiff, 1976. CF

McCANNELL, Ursula Vivian, WIAC (b. 1923). Painter of figures and portraits in oils, watercolours and tempera. The daughter of WILLIAM OTWAY MCCANNELL with whom she exhibited in 1934 at the Wertheim Gallery, she visited Spain in 1936 and between 1939 and 1942 studied at Farnham School of Art and from 1942 to 1944 at the RCA under TRISTRAM. In 1937 she was elected WIAC and she exhibited at the NEAC and SWA. She showed at the RA from 1940 and held regular solo exhibitions in London galleries including the Modern Art Gallery, GIMPEL FILS, ROLAND BROWSE & DELBANCO and the Thackeray Gallery. She is married to Peter REES ROBERTS and her work is represented in Manchester City Art Gallery. Influenced by English neo-romanticism, her work has also occasionally shared some characteristics with that of ADLER and COLQUHOUN.
LIT: Catalogue for the Ashgate Gallery, Farnham, 1962; *Three Generations*, catalogue, England & Co., London, 1989. CF

McCANNELL, William Otway, RSA, RBA, RWA, RMS, NS, RI, FRSA (1883–1969). Painter of figures and landscapes in oils, watercolours and tempera; illustrator. Father of URSULA MCCANNELL, he studied at Bournemouth School of Art from 1899 and at the RCA under MOIRA from 1904. He exhibited at the RA from 1915 to 1952, at the RBA from 1918 (member 1921), at the RI, RP and RWS. He was elected RMS in 1917 and he held solo exhibitions in London galleries including the Drian, Leger and New Vision Centre between 1946 and 1969. Represented in collections including the National Gallery of Ireland, his illustration work included *The Rubaiyat of Omar Khayyam*, Ward Lock & Co., 1953. He taught at Harrow and ST MARTIN'S Schools of Art and between 1928 and 1945 was Head of Farnham School of Art. In the 1920s and 1930s his romantic, idealized work was influenced by Bourdelle and BRANGWYN; later he produced symbolic subjects in a style influenced by Cubism and, in the 1960s, by Turner.
LIT: Retrospective exhibition notes, West Surrey College of Art, Farnham, 1972; *Three Generations*, catalogue, England & Co., London, 1989. CF

MacCOLL, Dugald Sutherland, NEAC, RSW (1859–1948). A watercolour painter of English and Continental topographical and architectural subjects treated in a loosely handled manner, MacColl also produced oils – notably a portrait of AUGUSTUS JOHN in 1907. Born in Glasgow, he attended University College London, Lincoln College, Oxford and the WESTMINSTER SCHOOL OF ART. Although a member of the NEAC from 1896, MacColl was as much a critic, art historian and poet, as a painter. From 1890 he wrote for the *Spectator* and other reviews championing French art, and lectured in Art History at the SLADE SCHOOL 1903–9. He was Keeper of the TATE 1906–11, and of the Wallace Collection 1911–24. He was the author of numerous studies including the *Life, Work and Setting of P.W. Steer*, 1945.
LIT: *Confessions of a Keeper*, D.S. MacColl, London, 1931. GS

McCOMB, Leonard, RA (b. 1930). Painter of landscapes, figures, still-life and flowers in watercolours and oils; sculptor. Born in Glasgow, he studied at MANCHESTER SCHOOL OF ART 1954–6, and the SLADE 1956–9. He has exhibited in London galleries including the SERPENTINE in 1983, the Gillian Jason Gallery in 1989, and at the RA since 1976 (ARA 1987), and has shown regu-

larly in group exhibitions. His work is represented in collections including the TATE GALLERY and the ARTS COUNCIL. Amongst his awards has been the Korn/Ferry Prize, 1988. His work combines the observation and experience of nature with a visionary quality. He is now Keeper of the RA.
LIT: *Artscribe* (UK), No.37, October 1982, pp.38–43; *Leonard McComb, Drawings, Paintings, Sculpture*, catalogue, Serpentine Gallery, Arts Council, London, 1983. CF

McCOMBS, John, NDD, ROI, FRSA, MAFA (b. 1943). Painter of landscapes in oils. Born in Manchester, he studied at ST MARTIN'S COLLEGE OF ART 1962–7, under KOSSOFF, REYNOLDS, DE FRANCIA and FREDERICK GORE and subsequently returned to the north to paint, settling at Saddleworth. He exhibits in London and at his gallery in Delph and his work is represented in collections including Manchester City Art Gallery. Amongst his awards was the David Murray Landscape Scholarship from the RA in 1966. His strong painting combines a painterly technique with the depiction of observed landscape.
LIT: 'Painting the Pennines', *Artist* (UK), Vol.98, pt.1, January 1983, p.34. CF

McCORMICK, Arthur David, RI, RBA, ROI (1860–1943). Landscape and figure painter in oils and watercolours; illustrator. McCormick commonly treated elaborate historical subjects in costume, often concentrating on domestic incident and maritime associations, as in *An Admiral's Wooing*, 1938. Born in Coleraine, Ireland, McCormick studied at the RCA. He exhibited in London, chiefly at the Alpine Club Gallery, the RA, RI and ROI from 1889. Accompanying Sir Martin Conway's expedition to the Himalayas, 1892–3, he subsequently published *An Artist in the Himalayas*, 1895, illustrated by his sketches. In 1895 he visited the Caucasus. An illustrator, especially of travel books, he also treated an edition of Southey's *Life of Nelson*, 1916. GS

McCROSSAN, Mary, NEAC, RBA (c.1865–1934). Painter of marines, landscapes and flowers in oils. She studied at Liverpool School of Art, at the Académie Délécluse in Paris, and with JULIUS OLSSON in St Ives, where she herself later taught. She exhibited widely in London, particularly at the BEAUX ARTS GALLERY and the RBA (member 1926), in the provinces and at the Paris Salon. Her impressionistic work was brightly coloured, sometimes adopting a more Post-Impressionist style with flatter areas of colour and outlined forms.

LIT: *British Impressionism*, L. Wortley, 1988. CF

MACDONALD, Frances (1873–1921). Painter in watercolour and pastels; illustrator; designer of metalwork, glass, enamel and textiles. From 1890 she attended GLASGOW SCHOOL OF ART under FRANCIS NEWBERY where she met James MacNair, whom she married in 1899, and CHARLES RENNIE MACKINTOSH, who married her sister MARGARET MACDONALD in 1900. She collaborated closely with MacNair and her sister from 1895, showing at the 5th Arts & Crafts Exhibition in London and in 1898 at the VIIIth Secession Exhibition, Vienna. She also exhibited at the LG, the Baillie Gallery and in Liverpool. Her work is represented in Glasgow Museum and Art Gallery. She taught at Glasgow School of Art in 1909–10. As one of 'The Four', she pioneered the elegant figurative forms and the decorative patterns of the Glasgow Art Nouveau style.
LIT: 'Some Glasgow Designers and their Work', Gleeson White, *Studio*, Vol.XI, pp.86 and 227; *Margaret Macdonald Mackintosh*, catalogue, Hunterian Art Gallery, Glasgow, 1983–1984. CF

MACDONALD, Margaret *see* MACKINTOSH, Margaret Macdonald

MACDONALD, Frances (b. 1914). Painter of landscapes, townscapes and portraits in oils and watercolours. Born in Cheshire, she studied at Wallasey School of Art 1930–4, under Gordon Macpherson, and at the RCA under ROTHENSTEIN and FREEDMAN, 1934–8. She held her first solo exhibition at Wildenstein's, London, in 1947, and subsequently showed at the Alfred Brod Gallery in 1961 and at the RA in 1962. Represented in the TATE GALLERY, her work included commissions as an OFFICIAL WAR ARTIST, 1940–6, work for the Pilgrim's Trust and the CURWEN PRESS. She married LEONARD APPELBEE. Her paintings include landscapes of Wales, England and the South of France. CF

McEVOY, Arthur Ambrose, NEAC, NPS, IS, ARA, RP, ARWS (1878–1927). A painter of domestic interiors and landscapes, McEvoy later gained a considerable reputation as a painter of society portraits, mainly of women, in oils or watercolours. An heir to the tradition established by Reynolds and Gainsborough, McEvoy's portraiture is characterized by a dashing painterly technique and sensitivity to the effects of delicate lighting. Born in Crudwell,

Wiltshire, the son of a maritime inventor, in 1879 the family moved to West Kensington. In his youth he was encouraged by Whistler, coincidentally a family friend. McEvoy attended the SLADE SCHOOL 1893–6, where he struck up an important friendship with AUGUSTUS JOHN. On leaving the Slade, McEvoy continued his own studies of the Old Masters, particularly Titian, Rubens and Gainsborough. After working in Dieppe with SICKERT, and at Chelsea, in 1906 McEvoy acquired the London riverside house in Grosvenor Road which became his life-long home. Exhibiting at the NEAC from 1900, the GROSVENOR, GRAFTON and LEICESTER Galleries, he held a one-man exhibition at the Carfax in 1907. For the year 1904 McEvoy lived near the house of his important early patron Sir C.K. Butler at Shrivenham. From about 1910 McEvoy's style developed increasing technical facility, and portraits replace the atmospheric interiors he had hitherto painted. The success of his 1914 NEAC exhibit *Madame*, helped determine his later career as a fashionable society portrait painter. Through his practice of glazing over an initial monochrome underpainting he was able to combine a rich painterly technique with the vivid elegance his sitters required. In 1911 McEvoy was a founder member of the National Portrait Society. In 1918 as an OFFICIAL WAR ARTIST in France, McEvoy was attached to the Royal Navy Division; despite one attempt at a war picture *Night Flying*, it was for official military portraiture that his services were mostly required. Visiting New York in 1920, he held an exhibition at the Duveen Gallery. McEvoy was elected ARA in 1924 and RP in 1925. Latterly he increasingly used watercolour.
LIT: *Ambrose McEvoy*, R.M.Y. Gleadowe, 1923; *Modern English Painters*, John Rothenstein, 1952. GS

McEVOY, Mary Spencer (1870–1940). Painter of interiors, flower pieces, still-lives and portraits in oils. Daughter of Colonel Edwards, she married the painter AMBROSE MCEVOY, to whom she had been introduced by AUGUSTUS JOHN, in 1901. Born at Freshford, Somerset, she attended the SLADE SCHOOL and exhibited at the NEAC 1900–6. Specializing in contemplative, quietly-lit interiors, her exhibiting waned during her years of marriage. However, after her husband's death in 1927, she again exhibited seriously, notably at the RA from 1928 to 1937. Her portraits, such as the Duchess of Leinster, were much influenced by her husband's style. GS

McFALL, Major Chambers Haldane Cooke (1860–1928). Painter, illustrator and author, McFall exhibited at the RA in 1923, and produced black and white illustrations in theme and style inspired by the eighteenth century. Inspired by Whistler, McFall had taken to art theorizing and criticism when a young Sandhurst cadet. Later publishing numerous works on French eighteenth-century painting, Whistler and Beardsley, he also wrote novels. GS

McFAYDEN, Jock (b. 1950). Painter of figures in oils; sculptor. He attended CHELSEA SCHOOL OF ART 1973–7, and held his first solo exhibition in 1978 at the Acme and New 57 Galleries, London. He has shown regularly in London galleries including Blond Fine Art and his work is represented in the ARTS COUNCIL Collection. In 1981 he was Artist in Residence at the National Gallery. Influenced by KITAJ, HOCKNEY and ALLEN JONES in the 1970s, his satiric, caricatural work depicts themes from London, Northern Ireland and America.
LIT: Catalogue, Northern Centre for Contemporary Art, Ceolfrith Press, Sunderland, 1986; catalogue, Scottish Gallery and Forum, Messenhallen, Hamburg, 1989. CF

MacGEORGE, William Stewart, RSA (1861–1931). An Edinburgh painter with strong Glasgow associations, MacGeorge painted landscapes, portrait and figure subjects. Interested in *plein-air* and the effects of sunlight, he frequently painted woodland settings populated by children or girls, comparable in treatment and subject to the work of A.E. HORNEL. He produced realist subjects with specifically Scottish associations. Born at Castle Douglas, Kirkcudbrightshire, MacGeorge studied at the Royal Institution Art School, Edinburgh, from 1880 and then at the Antwerp Academy under Verlat. Attending the RSA Life School, he won the Keith Prize in 1887. He travelled widely in Italy, and he lived mainly in Kirkcudbright and Edinburgh. Elected RSA in 1910, he exhibited regularly there and at the Glasgow Institute. GS

MACGREGOR, William York, RSA, RSW, NEAC, IS (1855–1923). He studied at GLASGOW and the SLADE. With JAMES PATERSON, whom he met in 1878, he founded the GLASGOW SCHOOL. He worked in England, France and South Africa. He painted landscapes, urban scenes, genre, still life and portraits with a vigorous, painterly realism, eschewing narrative content. AW

MACHIN, Geoffrey (b. 1937). Painter of non-figurative work in acrylic, mixed media, collage and screenprints. He studied at Chesterfield and CHELSEA Schools of Art and has held solo exhibitions at the Peterloo Gallery, Manchester, and the Ikon Gallery, Birmingham. His work is represented in the ARTS COUNCIL Collection. He has taught at Hereford College of Education and Dudley College of Technology; his work uses shaped, interlocking canvases and a relief structure to suggest space and volume.
LIT: *Constructed Paintings*, catalogue, Stoke-on-Trent Art Gallery, 1983. CF

MACKAY, Arthur Stewart, ROI (b. 1909). Painter of landscapes, coastal scenes and figures in oils; poster artist. Born in Dulwich, he studied at Regent Street Polytechnic and Hornsey School of Art and has exhibited at the ROI (member 1949), at the RA between 1931 and 1985, at the RBA and the Paris Salon. A former lecturer at Hammersmith College of Art, his work is represented in many private collections and includes English seaside scenes such as *Margate Pier*, RA 1975, and *The Seaside Hotel*, RA 1980. CF

McKEEVER, Ian (b. 1946). Painter of landscape abstractions in oils and with photography. He studied at Avery Hill College of Education; he was Artist-in-Residence at the Bridewell Studios, Liverpool, 1980–1, and at Nuremberg in 1981. He held his first solo exhibition in 1971 at Cardiff Arts Centre and he has subsequently exhibited in London galleries (including Nigel Greenwood), and abroad. His work uses a technique of painting over landscape photographs.
LIT: Exhibition catalogue, Kunstverein, Braunschweig, 1987. CF

McKENNA, Stephen (b. 1939). Born in London, he studied at the SLADE SCHOOL 1959–64. Following a period living in Bonn, 1971–8, he divides his time between London, Brussels and Co. Donegal in Ireland. His first one-man show was at the Galerie Olaff Hudtwalcker in Frankfurt, since when he has had many, in Germany, England, Scotland, Belgium, Ireland and the USA. He has similarly exhibited widely in group exhibitions in Europe and America. His work makes use of ambiguous perspectival and spatial effects.
LIT: *Stephen McKenna*, catalogue, ICA, 1985. CF

MACKENZIE, Alexander (b. 1923). Born in Liverpool, he studied at Liverpool College of Art 1946–50, after war service. He moved to Cornwall in 1950, and taught at Penzance, 1951–64, becoming Head of Department of Fine Art at Plymouth College of Art, 1964–8. He has lived in Saltash (1971–84) and Penzance. He exhibited at WADDINGTON'S in the 1950s and 1960s. His paintings, collages and reliefs frequently use passages of texture in gently rhythmical compositions of lines, bars and circular forms. AW

MACKENZIE, James Hamilton, ARSA, RSW, ARE (1875–1926). Painter of landscapes and architectural subjects in oils and watercolours; etcher and pastelist. Born in Glasgow, he studied at the GLASGOW SCHOOL OF ART winning the Haldane Travelling Scholarship to work in Paris and Florence. He exhibited mainly in Scotland at the GI, RSW (member 1910) and the RSA (ARSA 1923), but he also showed at the RE (ARE 1910), in Liverpool and Manchester, and at the Dowdeswell Gallery, London in 1911. Between 1923 and 1925 he was President of the Glasgow Arts Club. His work is represented in public collections including the Glasgow Art Gallery. During the First World War he worked in East Africa; his landscape subjects include the Western Isles of Scotland and scenes from abroad.
LIT: 'James Hamilton Mackenzie: Painter and Etcher', E.A. Taylor, *Studio*, Vol.78, 1920, p.148. CF

McKENZIE, Lucy (b. 1950). Painter of flowers, still-life, gardens, marines etc. in watercolours and oils on gesso; draughtswoman in coloured pencils and pastels; embroiderer and maker of assemblages in found and hand-painted objects. She trained at Bristol Polytechnic 1970–3, and at the RCA 1973–6, winning a Gloucestershire College of Art Fellowship in 1976–7. She has exhibited in London at Fischer Fine Art since 1979 and held her first exhibition in New York in 1986 at the Coe Keer Gallery. Her paintings are intensely realistic and detailed. CF

MACKIE, Charles Hodge, RSA, RSW, SSA (1862–1920). Landscape artist, portrait painter, watercolourist and wood engraver. He studied at the RSA SCHOOLS, and in Paris; he later met Sérusier and Gauguin in Brittany. His colour woodcuts were elaborately printed from as many as fourteen blocks. AW

MACKINNON, Sine (b. 1901). Painter of landscapes, townscapes, marines and still-life in oils and watercolours. Born in Northern Ireland, she studied at the SLADE SCHOOL under TONKS, 1918–20 and 1921–4, winning prizes in painting, drawing and anatomy and a scholarship. She married the artist Rupert Granville-Fordham and lived for many years in France, travelling also in Spain, Greece and Portugal. She held her first solo exhibition in London at the Goupil Gallery in 1928 and she exhibited widely in London galleries including the REDFERN and the LEFEVRE as well as showing at the NEAC, the LG and in Paris. Her work is represented in collections including the TATE GALLERY. Her exhibited subjects include scenes from France, Greece, Portugal and Ireland, e.g. *Provencal Landscape* (Tate Gallery). CF

MACKINTOSH, Charles Rennie, RIBA (1868–1928). Architect, designer and painter of flowers, landscapes, townscapes and symbolist subjects in watercolours. He attended evening classes at GLASGOW SCHOOL OF ART, winning a scholarship to Italy, France and Belgium in 1889. In Glasgow he met Herbert MacNair, MARGARET MACDONALD whom he married in 1900 and her sister Frances. Together, as 'The Four', they established the 'Glasgow Style'. As an architect with Honeyman and Keppie 1889–1913, his influential work included the GLASGOW SCHOOL OF ART, 1896. After his resignation from the firm in 1913 he concentrated on watercolour painting, working at Walberswick in 1914, in London from 1915 to 1923, and in France at Collioure and Port Vendres from 1923 to 1927. His work is represented in collections including the Collection of the Glasgow School of Art and the TATE GALLERY. His paintings combined a delicate, stylized and elegant line with an interest in pattern. LIT: *Mackintosh Watercolours*, Roger Billcliffe, 1978; *Charles Rennie Mackintosh and the Modern Movement*, Thomas Howarth, 1977. CF

MACKINTOSH, Margaret Macdonald, RSW (1865–1933). Painter of symbolist and figure subjects in watercolours; artist in gesso and embroidery; illustrator; textile, stained glass and metal designer. Born in Staffordshire, née Macdonald, she studied at the GLASGOW SCHOOL OF ART under NEWBERY and with her husband, CHARLES RENNIE MACKINTOSH, her sister Frances and her husband Herbert MacNair formed 'The Four', together establishing the 'Glasgow Style'. She exhibited mainly at the RSW (member 1898–1923) and in Europe: her work is represented in collections including Glasgow School of Art and Museum Art Gallery. Much of her work was made in collaboration with 'The Four' and in 1900 she turned increasingly to gesso work and embroidery. After 1909 she produced very little. Her imaginative paintings and designs, influenced by Toorop, Beardsley and nineteenth-century Japanese prints, used elongated, stylized figures and decorative patterns. LIT: Exhibition catalogue, Hunterian Art Gallery, Glasgow, 1984. CF

MACKLIN, Thomas Eyre, RBA (1867–1943). Painter of portraits, townscapes and landscapes in oils; illustrator, poster and magazine artist; sculptor. He studied at the RA SCHOOLS 1887–93, and lived for some time in France. He exhibited at the RA from 1889, at the Paris Salon and the RBA (member 1902). He maintained strong connections with Ulster and he is represented in collections including the Ulster Museum. His work ranged from the design of war memorials to strong, realistic scenes such as *Pollock Dock, 1934* (Collection of the Belfast Harbour Commissioners). CF

McLEAN, Bruce (b. 1944). Performance and installation artist; sculptor; painter in acrylics; printmaker and ceramicist. He studied at GLASGOW SCHOOL OF ART 1961–3, and ST MARTIN'S SCHOOL OF ART 1963–6, where he exhibited as a performance artist in 1965. He has subsequently shown in major London galleries (including Anthony d'Offay from 1981), and internationally. His work is represented in public collections including the TATE GALLERY. He has been awarded a Major Award and a Bursary from the ARTS COUNCIL, 1975 and 1978, a DAAD Fellowship in West Berlin, 1981, and the Mercédès Benz Prize and the 1st Prize in Painting at the JOHN MOORES EXHIBITION in 1985. Initially recognized as a performance artist and founder of the 'Pose Band' in 1971, his later work has concentrated more on paintings which, influenced by his performances, combine linear figures and features with gestural marks and abstract areas of colour. In 1996 he became Slade Professor of Fine Art. LIT: See his own publications including *Dream Works*, Knife Edge Press, London, 1985; exhibition catalogue, Edinburgh Festival, 1986; *Bruce McLean*, Mel Gooding, Phaidon, 1990. CF

McLEAN, John (b. 1939). Painter of abstracts in acrylics. He studied at St Andrews University 1957–62, and at the COURTAULD INSTITUTE OF ART, London, 1963–6. He held a solo exhibition in 1971 at the SERPENTINE GALLERY and he has subsequently exhibited at London galleries including the Nicola Jacobs and the Francis Graham-Dixon Galleries, and abroad. His work is represented in public collections including the TATE GALLERY. He has taught at CHELSEA SCHOOL OF ART, GOLDSMITHS' COLLEGE and UNIVERSITY COLLEGE, LONDON, and his painterly, colouristic abstracts use simple shapes on coloured grounds with contrasting weight and opacity of pigment. His work has been influenced by Morris Louis, Kenneth Noland and Jack Bush.
LIT: *Alba* (UK), No.6, Winter 1987. CF

MCLEAN, Talbert (1906–1992). Painter and cartoonist. Born in Dundee, he studied design at the School of Art between 1923 and 1927, but exhibited paintings in 1933, then moved to London with the painter Edwin Callaghan. Throughout the 1930s he published cartoons in *London Opinion* and *Lilliput*. During war service, he met WILLIAM SCOTT and began to paint seriously. In 1948 he was appointed art master at Arbroath High School, and later at the Arbroath Academy. His earlier, austere, abstracted landscapes and still-life paintings had an affinity with those of Scott; later, he executed more freely painted non-figurative works. His first one-man show was in 1973, the year he retired. A retrospective was held at the Talbot Rice Gallery in Edinburgh in 1992. AW

MACLEAN, Will, ARSA (b. 1941). Maker of assemblages and constructions in painted wood and mixed media combining found and made objects (many using imagery drawn from the sea and fishing); painter. Born in Inverness, he studied at Grays School of Art, Aberdeen, and Hospitalfield School of Art, Arbroath, 1961–5.. In 1966 he won the George Davidson Memorial Scholarship and a Scottish Educational Travelling Scholarship to the BRITISH SCHOOL IN ROME where he held his first solo exhibition in 1967. He showed in Edinburgh at the New 57 Gallery in 1968 and he has subsequently exhibited in Scottish and London galleries (including Runkel-Hue-Williams Ltd), and internationally. Elected ARSA in 1978, his work is represented in collections including the Scottish National Gallery of Modern Art, Edinburgh. He has lectured at

Duncan of Jordanstone College of Art, Dundee, since 1981. His constructions often have the character of a primitive shrine concerned with man's association with the sea. Recent work has also depicted subjects from modern America.
LIT: *Alba* (UK), No.9, 1988; exhibition catalogue, Runkel-Hue-Williams Ltd, London, 1990. CF

MCLEOD, Ian (b. 1939). Painter of figures, landscapes and still-life in oils and acrylic; printmaker, collagist and maker of boxed constructions; photographer. Born in Port Glasgow, he worked as a welder before attending EDINBURGH COLLEGE OF ART 1961–5, winning the Edward Grant Scholarship and a travelling scholarship. He held his first solo exhibition in 1970 at the New 57 Gallery, Edinburgh, and he has exhibited in Scotland, London and Manchester, showing there at the Colin Jellicoe Gallery where a retrospective exhibition of his work was held in 1987. A member of the SSA in 1968, and of the Glasgow League of Artists, his work is represented in collections in Britain and abroad. Since 1990 he has taught at Duncan of Jordanstone College of Art, Dundee. His realist work is mainly concerned with the figure.
LIT: *Scottish Realism*, exhibition catalogue, Scottish Arts Council, 1971. CF

MACMIADHACHAIN, Padraig (b. 1929). Painter of abstracts and semi-abstracts based on landscape in oils and gouache. Born in Downpatrick, Ireland, he studied at Belfast College of Art 1944–8, the National College of Art, Dublin, 1948–9, and at the Academy of Art, Krakow, Poland, in 1960–1. In 1957 he was awarded a travelling scholarship to Moscow and he has travelled extensively, exhibiting internationally since 1951. He has shown at the RA, RWA, RUA, in London galleries, most recently at the New Academy Gallery in 1990, and in the provinces, including the Hann Gallery, Bath, in 1990. His work is represented in collections including the Arts Council (Ireland). His painting, which shares some characteristics with the St Ives artists, is often inspired by magic markings and primitive religious objects from many countries. CF

McMILLAN, William, RA, FRBS, CVO (b. 1887). Sculptor and painter in watercolours, oils, pen and chalk. He studied at Grays School of Art, Aberdeen, and at the RCA, London, 1908–12,

under Lantéri. He exhibited mainly at the RA from 1917 to 1970 (ARA 1925, RA 1933) and also showed at the RSA, GI, ROI and in Liverpool. Elected ARBS in 1928 and FRBS in 1932, his portland stone statue *Birth of Venus* was purchased by the CHANTREY BEQUEST for the TATE GALLERY in 1931. From 1929 to 1940 he was Master of the RA Sculpture Schools. Best known as a sculptor of busts, memorials, medallions and statues, including the statue of George VI in The Mall, London, he also exhibited paintings that ranged from subjects such as *Gypsy Camp*, RA 1952, to interior scenes such as *Early Morning Tea in Hospital* and *Quiet Evening at the Club*, RA 1950. CF

MACNAB OF BARACHASTLAIN, Iain, PROI, RE, NS, SWE, FRSA (1890–1967). Painter, wood engraver, draughtsman and etcher of figures and landscapes; illustrator. He studied at GLASGOW SCHOOL OF ART 1917, and at HEATHERLEY'S 1918, and exhibited mainly at the RA between 1923 and 1960, at the RE (ARE 1923 and RE 1932), the ROI (ROI 1932 and PROI 1949–67), the RSA and the GI as well as in the provinces and in London galleries. His work is represented in collections including the V & A. A member of the English Society of Wood Engravers and the SOCIETY OF WOOD ENGRAVERS, he was also associated with the development of the Federation of British Artists. He was Joint Principal of Heatherley's from 1919 to 1925 and its Director of Art Studies from 1946 to 1953. Between 1925 and 1940 he was Founder and Principal of the GROSVENOR SCHOOL OF MODERN ART. Best known for his wood engravings, many of them autonomous prints, his work is characterized by its clarity of form and compositional strength.
LIT: *The Student's Book of Wood Engraving*, Iain Macnab, Pitman, London, 1938; *Wood Engravings and Drawings of Iain Macnab*, Albert Garrett, Midas Books, 1973. CF

MACNAMARA, Nicolette (b. 1911). Painter of landscapes, animals, birds and interiors in watercolours and oils. She has exhibited at the NEAC, at the RA in 1942 (*The Gramophone Room*), at Cooling & Sons Gallery and at the Storran Gallery where she held a solo exhibition in 1937. Represented in Manchester City Art Gallery, her work ranges from interiors such as *Juanita in the Morning* (Manchester) to subjects such as *Wild Duck Surprised* and *Fishing on the Lodden*, both exhibited at the Storran in 1937. CF

MACNEE, Robert Russell, GI, RSA (1880–1952). Painter of rural scenes in oils and watercolours. Born in Milngavie, Dunbartonshire, he studied at GLASGOW SCHOOL OF ART and exhibited mainly in Scotland at the GI and the RSA. He also showed at the RA from 1892, at the RHA and RSW, in Liverpool, Manchester and at the Paris Salon. Many of his works showed farming scenes with figures and domestic animals.
LIT: *Scottish Watercolours 1740–1940*, Julian Halsby, Batsford, 1986. CF

MACPHERSON, Alexander, VPRSW (d. 1970). Painter of landscapes and flowers in watercolours and oils. He worked in Glasgow and exhibited mainly in Scotland at the RSW (RSW 1932), the GI and the RSA. He also showed at the RA in 1934 and in Liverpool and his work is represented in collections including Bradford Art Gallery. He often painted the West Coast of Scotland and Arran and he combined pencil, ink and watercolours in his works.
LIT: *Scottish Watercolour 1740–1940*, Julian Halsby, Batsford, 1986. CF

MACPHERSON, Sophie (b. 1957). Born in London, she was trained at ST MARTIN'S and at CAMBERWELL. Her oils are mostly detailed studies of peeling paint and rusting ironwork on boats and old buildings. After ten years of exhibiting in group shows and executing commissions, her first one-man show was in 1989 at the Richmond Gallery. AW

MACTAGGART, Sir William, PRSA, PSSA, RA, HRSW, LLD, FRSE (1903–1981). Painter of landscapes, seascapes, still-life and flowers in oils. Born in Loanhead, Scotland, the grandson of William Mactaggart RSA, he trained at EDINBURGH COLLEGE OF ART, where he formed friendships with W.G. GILLIES and WILLIAM CROZIER. From 1923 he made regular trips to France and he exhibited first at the RSA in 1921. He held his first solo exhibition in Edinburgh at Aitken Dott & Son in 1929, and subsequently exhibited regularly in Scotland and internationally. His work is represented in public collections including the TATE GALLERY. A founder member of the 1922 Group and a member of the Society of Eight, he was elected SSA in 1922, PSSA in 1933, ARSA in 1937, RSA in 1948, PRSA in 1959, FRSE in 1967, ARA in 1968 and RA in 1973. In 1961 he was awarded a LLD, University of Edinburgh, in 1962 he was knighted and in

1968 he became a Chevalier de la Légion d'Honneur. His robust, richly textured work reflected the influence of Dunoyer de Segonzac, Rouault and Expressionism in general, and shared some characteristics with the painting of MATTHEW SMITH. His late work used intense, jewel-like colour and a heavier impasto.

LIT: *William Mactaggart*, H. Harvey Wood, Edinburgh University Press, 1974; the retrospective exhibition catalogue, Scottish National Gallery of Modern Art, Edinburgh, 1968. CF

MADDOX, Conroy (b. 1912). Painter of Surrealist subjects in oils, gouache, collage and photomontage. In the early 1930s he was a member of the Birmingham Group and in 1936 he refused to exhibit in the London International SURREALIST Exhibition. In 1937 he worked in Paris associating with the Surrealist painters there and in 1938 he joined the English Surrealist Group and exhibited at the Wertheim Gallery. The following year he showed at E.L.T. Mesens' London Gallery and he subsequently continued to contribute to Surrealist exhibitions internationally. He has held solo exhibitions abroad and in London galleries (including Blond Fine Art) and his work is represented in public collections including the TATE GALLERY. He contributed to the *London Bulletin* in 1939 and 1940, *Message from Nowhere*, edited by Mesens in 1945, to *Le Savoir Vivre* in 1946 and to the Chicago Surrealists' *Arsenal*, in 1970. In 1974 he published a book on Salvador Dali (Hamlyn). His work often refers to contemporary or historical events, investing them with a sense of mystery or unease. In 1947 he developed a semi-automatic technique called 'ecrémage'.

LIT: Retrospective exhibition catalogue, Camden Arts Centre, London, 1978; *Conroy Maddox: Surreal Enigmas*, Silvano Levy (ed.), Keele University Press, 1995. CF

MAHONEY, Charles, RA, NEAC, ARCA (1903–1968). Painter of figures, landscapes, biblical subjects and plants; draughtsman and mural painter. Born Cyril Mahoney, he studied at Beckenham School of Art under Percy Jowett and at the RCA under ROTHENSTEIN from 1922 to 1926. He exhibited at the NEAC from 1936 (member 1950) and at the RA from 1960 (ARA 1961 and RA elect in 1968). His work is represented in public collections including the TATE GALLERY. He taught painting at the RCA from 1928 to 1953, at the BYAM SHAW SCHOOL from 1954 to 1963 and at the RA SCHOOLS from 1961

to 1968. His mural painting included decorations (destroyed) for Morley College with RAVILIOUS and BAWDEN and the series of paintings in the Lady Chapel of Campion Hall, Oxford, 1941–52. His work combined observed detail with a sense of classical grace and unity. He produced many detailed, delicate drawings of plants and flowers.

LIT:*Charles Mahoney. A Tribute by Sir John Rothenstein*, memorial exhibition catalogue, Parkin Gallery and the Ashmolean Museum, Oxford, 1975; *Country Life* (UK), Vol.181, April 1987. CF

MAISTRE, Roy de, CBE (Leroy Leveson Laurent Joseph) (1894–1968). A notable early exponent of Post-Impressionist and Cubist influenced styles in Australia, de Maistre treated figure subjects, portraits, still-life, landscapes and religious themes in oil. Born at Bowral, New South Wales, Australia, the son of a horse-trainer, he studied at the RAS School, Sydney, under Dattilo Rubbo, and at the Sydney Art School under Julian Ashton. A period of music study at the Sydney Conservatorium fostered his preoccupation with musical colour analogies; he invented a colour disc with Roland Wakelin and a colour music scale with Adrian Verbruggen. After spending nine months in the army in 1916, de Maistre began to exhibit in Sydney in 1918. Travelling on a scholarship to Europe in 1923 heralded an international career, exhibiting at the Paris Salon in 1924, and at the Venice Biennale in 1926. Returning to Australia he held a one-man show at the Macquarie Gallery in 1926. Finally settling in Europe in 1930, he held his first one-man show in London at the BEAUX ARTS in 1930, and after a brief residence in France, London became his centre of operations. In 1934, with MARTIN BLOCH, he founded a painting school in London. Working with the British Red Cross (French Section) during the Second World War, he temporarily abandoned painting. After the War he exhibited widely, enjoying retrospectives at Leeds in 1943, Birmingham in 1946 and the Whitechapel in 1960. He was in close contact with such figures as Patrick White, JOHN ROTHENSTEIN and FRANCIS BACON. Working on *The Stations of the Cross* for Westminster Cathedral, he exhibited at the RA 1941–67, often showing still-lives and religious subjects. Influenced by Cézanne and Cubism, his work was formally inventive, representing subjects in abstracted geometrical forms and in strong colour. GS

MAITLAND, Paul Fordyce, NEAC (1869–1909). Painter of townscapes in oils, mainly of Chelsea Embankment and Kensington Gardens. He studied at the RCA, where he later taught, and under Théodore Roussel. He exhibited with the London Impressionists in 1889 and also showed in London galleries, with the NEAC (member 1888), the RBA, in Glasgow and abroad. His work is represented in public collections including the TATE GALLERY. A friend of SICKERT who admired his work, between 1893 and 1908 he was Art Examiner to the Board of Education. Influenced by Roussel and Whistler, his atmospheric, small-scale works were painted from nature.
LIT: Preface by Sickert, exhibition catalogue, Leicester Galleries, London, 1928; *Studio*, Vol.96, 1928, p.134. CF

MAJOR, Theodore (b. 1908). Painter of northern townscapes (particularly of Wigan), figures, biblical subjects, still-life and flowers in oils. Born in Wigan, he studied at Wigan, Liverpool and Southport Schools of Art. He exhibited at the Manchester Academy, with the Manchester Group, in London and in provincial galleries. His work is represented in public collections including Manchester City Art Gallery and the Atkinson Museum and Gallery, Southport. Influenced by his environment, his work shares some characteristics with LOWRY's in its depiction of place, but his technique is more expressionist with a greater use of impasto and his vision has an intense, symbolic character.
LIT: *A Northern School*, Peter Davies, Redcliffe Press, Bristol, 1989. CF

MAKINSON, Professor Trevor Owen (b. 1926). Painter of portraits and landscapes in a range of media. Born in Southport, he attended Hereford School of Art and the SLADE under SCHWABE. He has held solo exhibitions at the Hereford Art Gallery between 1944 and 1955 and has shown at the RA between 1944 and 1952, at the RBA, RSA, RP, RI and SSA. Represented in collections including Glasgow Art Gallery, he teaches at GLASGOW SCHOOL OF ART. His exhibited work has included subjects such as *March in Herefordshire*, RA 1944. CF

MALCOLM, Ellen, RSA (b. 1923). Painter of interiors, gardens and landscapes in oils. She studied at Grays School of Art 1940–4, under Robert Sivell and D.M. SUTHERLAND and was elected ARSA in 1968 and RSA in 1976. Her work is represented in collections including Perth City Art Gallery and she is married to the artist Gordon S. Cameron. CF

MALENOIR, Mary (b. 1940). Born in Surrey, she studied at Kingston School of Art 1957–61, the RA SCHOOLS 1961–4, and was ROME SCHOLAR in Engraving 1965–7. She worked in HAYTER'S ATELIER 17 in 1967, and is now a Fellow of the Royal Society of Painter-Etchers and Engravers, and a member of the Printmaker's Council. A painter in oils and watercolours as well as etcher, her work is highly abstracted, with fragmentary images evocative of the circus, the night, the foliage and furnishings of gardens and other themes, sometimes derived from literature, such as Rimbaud's *Illuminations*. She regularly exhibits at the RA, the New Ashgate Gallery and elsewhere nationally and internationally; she has won many awards for painting and printmaking. She is married to MICHAEL FAIRCLOUGH. The Ashmolean, Oxford, the Graves Art Gallery, Sheffield and many other public collections possess examples of her work. AW

MALET, Guy Seymour Warre, RBA, SWE (1900–1973). Painter and wood engraver of landscapes. Born in Southsea, he started work in an insurance office before attending the London School of Art under Frank Eastman 1924–6. Between 1926 and 1927 he studied at the Regent Street Polytechnic and in 1927 he became a student at the GROSVENOR SCHOOL of Modern Art under IAIN MACNAB who persuaded him to start wood engraving. During the 1930s he worked for some time on Sark in the Channel Islands and he exhibited at the RA from 1931, at the RBA (member 1935) and at the SWE (member 1947). He also showed at the NEAC, the REDFERN and Brook Street Galleries, in the provinces and abroad. His work is represented in collections including the V & A. All his sensitive and powerful woodcuts were autonomous prints.
LIT: *A History of British Wood Engraving*, Albert Garrett, Midas Books, 1978. CF

MALTHOUSE, Eric, ARWA (b. 1914). Painter of figurative and abstract works in oils and gouache; draughtsman, lithographer and mural painter. Born in Birmingham, he studied at Birmingham College of Art 1931–7, and exhibited at the RBA in 1931, at the AIA and the International SURREALIST Exhibition in 1937 and with the LG in 1954. In 1959 a retrospective exhibition was held

at the National Museum of Wales and he subsequently exhibited in London, holding his first solo exhibition there in 1965 at the New Vision Centre. He has shown in the provinces and in Wales and his work is represented in collections including the National Museum of Wales. He taught at Cardiff College of Art from 1944 and in 1957 he formed the 56 Group with DAVID TINKER and MICHAEL EDMONDS. His figurative work was concerned with line and form; later more abstract paintings became freer with colour playing a more independent role.

LIT: Retrospective exhibition catalogue, National Museum of Wales, Cardiff, 1959. CF

Manchester School of Art (Regional College of Art, Manchester; Manchester Polytechnic). Founded in 1838 as a School of Design, it was renamed in 1853 a School of Art, for which a Gothic Revival building (Architect G.T. Redmayne) was put up in 1880-1 in Grosvenor Square (All Saints). This is still used by the Faculty of Art and Design, which now has other premises including the eight storey Chatham Building (1966). ADOLPHE VALETTE taught there in the earlier part of this century, and eminent former students include WILLIAM RATCLIFFE, JAMES FITTON, L.S. LOWRY, ERIC NEWTON, CHARLES CUNDALL and MATTHEW SMITH. An important Principal was John Holmes, who visited the Bauhaus, and who introduced what was probably the first Basic Design Course in this country (1940). Subjects now taught range from Architecture to Film Studies, but Fine Art retains a central, important place in the establishment.

LIT: *A Hundred Years and More*, D. Jeremiah, Manchester Polytechnic, 1980. AW

MANN, Cathleen, RP, ROI, NS, WIAC, SWA (1896-1959). Painter of portraits, flowers, landscapes and figures in oils and watercolours. The daughter of HARRINGTON MANN, she studied at the SLADE SCHOOL and in Paris and exhibited widely in London, showing at the RA between 1924 and 1959, at the RP (member 1931), at the SWA (member 1932), the ROI (member 1935) and the NEAC as well as leading London galleries including the Goupil, LEFEVRE and LEICESTER Galleries. Her work is represented in public collections including Glasgow Art Gallery. Best known as a portraitist, her work was influenced by MATTHEW SMITH, whose portrait she exhibited at the RA in 1956.

LIT: Retrospective exhibition catalogue, O'Hana Gallery, London, 1960. CF

MANN, Harrington, RP, RE, NEAC, NPS, IS (1864-1937). Painter of portraits and figures in oils. Father of CATHLEEN MANN, he was born in Glasgow and studied at the SLADE SCHOOL under Legros, where he won a travelling scholarship, and in Paris under Boulanger and Lefèbvre. During the 1880s he painted in Yorkshire fishing villages (including Staithes) and from 1890 to 1900 he lived in Glasgow and began to specialize in portraiture. In 1900 he settled in London and later lived and worked in New York. He exhibited at the RA from 1885 to 1937, at the IS from 1898 and widely in societies and galleries including the LEICESTER GALLERIES and abroad. Elected RE from 1885 to 1891 and RP in 1900, he was a founder member of the Society of Eight in 1912, and of the NPS in 1911. His work is represented in public collections including the TATE GALLERY. His portraits combined realism with a painterly technique influenced by Sargent. He painted many portraits of children and his formal portraiture included members of the Royal Family.

LIT: 'The Paintings of Mr Harrington Mann', *English Illustrated Magazine*, No.46, p.337, London, 1907. CF

MANSON, James Bolivar, NEAC, LG (1879-1945). Painter of landscapes, portraits, flowers and still-life in oils; writer. He studied at HEATHERLEY'S, Lambeth School of Art and at the ACADÉMIE JULIAN, Paris, under Laurens. In 1910 he met LUCIEN PISSARRO and through him became associated with the FITZROY STREET GROUP. In 1911 he was a founder member and Secretary of the CAMDEN TOWN GROUP and of the LONDON GROUP in 1913. In 1920 he was a founder member of the Monarro Group, exhibiting with them in 1920 and 1921. He also exhibited at the AAA, the NEAC from 1915 (member 1927), at the RA, and in London galleries, particularly the LEICESTER GALLERIES where he had his first solo exhibition in 1923. He also exhibited in Paris. Between 1917 and 1930 he was Assistant Keeper, TATE GALLERY, and from 1930 to 1938 Director of the Tate where he established the collection of Impressionist and Modern paintings. He also published books on art. He remained a close friend of Pissarro and with him represented the more traditional wing of the Camden Town Group in contrast with those of more radical Post-Impressionist tendencies. His painting shows the influence of Impressionism in colour, brushstroke and subject, although later canvases showed a greater freedom and variation.

LIT: *James Bolivar Manson*, D. Buckman, Maltzahn Gallery, London, 1973; *The Camden Town Group*, Wendy Baron, Scolar Press, 1979.
CF

MARA, Professor Timothy Nicholas (1948–1997). A printmaker, born in Dublin, he moved to England in 1955. He studied art at Epsom and Ewell, Wolverhampton and the RCA. His first one-man show was at the Birmingham Arts Laboratory in 1974; his elaborate screen-prints, such as *Portrait of Astrid* (1973), then showed the influences of RICHARD HAMILTON and the films of Fellini. He was Head of Printmaking from 1980 at CHELSEA, then, from 1990, Professor of Printmaking at the RCA. His later prints, such as *Two Bar Electric Fire 1* (1995–6) were often on canvas, and required as many as sixty colours, with some highlighting in oils by hand. He regularly exhibited at Flowers East gallery.
AW

Marlborough Fine Art. Six to eight exhibitions of contemporary art are mounted per year at 6 Albermarle Street, although the gallery also deals in some Old Masters and Impressionists. Founded in 1946, they are agents for many of the most celebrated British artists, including AUERBACH, BACON, KITAJ, PASMORE and REGO. They are also agents for the estates of KOKOSCHKA and SUTHERLAND.
AW

MARSHALL, Rita (b. 1946). Painter of abstracts in acrylic. She studied at Birmingham College of Art 1962–4, and at ST MARTIN'S SCHOOL OF ART 1964–7. From 1969 to 1973 she was an assistant to BRIDGET RILEY and in 1974 her work was included in the 'British Art '74' exhibition at the Hayward Gallery, London. Her paintings are concerned with the way forms enliven space and how they can be read in a number of different ways.
CF

MARTIN, Barry (b. 1943). Painter of abstracts in acrylic, oils and collages; sculptor. He studied at GOLDSMITHS' COLLEGE OF ART and ST MARTIN'S SCHOOL OF ART. He has exhibited in London, in the provinces and abroad and in many group exhibitions; his work is represented in public and private collections. He has taught widely and was founder and Editor of *One* magazine. His strongly coloured work, often produced in series, has taken a number of forms in exploring questions of time, space, light and movement.

LIT: *Light and Movement. Paintings and Sculpture*, Barry Martin, Hilstone Press, 1984.
CF

MARTIN, Francis Patrick (1883–1966). Painter of figures and landscapes in oils and water-colours. He studied at the GLASGOW SCHOOL OF ART and exhibited mainly in Scotland at the RSA, GI, in Aberdeen and Paisley as well as in Liverpool. His work is represented in public collections including the Glasgow Art Gallery. His figure paintings combine realistic scenes with slightly idealized figures modelled with light impasto highlights that follow and describe form, for example *Bathers*.
CF

MARTIN, Jason (b. 1970). He studied at CHELSEA and at GOLDSMITHS'. A painter who makes very large non-figurative monochrome works executed with a single careful brushstroke, using a specially designed brush for each panel. *Merlin* (1996) oil on aluminium, 244 × 244cm, is characteristic. In 1995 he won the Sohen Ryu Tea Ceremony Foundation Scholarship in Kamakura, Japan.
AW

MARTIN, Kenneth, LG, ARCA, OBE (1905–1984). Abstract painter in oils; constructivist, printmaker. He studied at Sheffield School of Art 1927–9, and at the RCA 1929–32. In 1930 he married Mary Balmsford. After a period of painting figurative works he produced abstract paintings in 1948–9 and in the early 1950s was associated with the constructivist group that included PASMORE, HILL, ADAMS, HEATH and his wife MARY MARTIN. They were influenced by the writings of Biederman; in 1951 Martin contributed to *Broadsheet* No.1 and subsequently continued to publish widely on constructivist theory and his art. He exhibited in London with Mary Martin in 1960 at the ICA, and thereafter showed in major London galleries, including the WADDINGTON GALLERIES, in the provinces and abroad. His work was represented in numerous group exhibitions and is in public collections all over the world, including the TATE GALLERY. From 1946 to 1967 he was a visiting teacher at GOLDSMITHS' COLLEGE OF ART. He received public commissions and won many awards, receiving his OBE in 1971. He regarded constructivist work as kinetic and was an innovator in abstract three-dimensional constructions. From 1951 he started to make mobiles, e.g. the Screw Mobiles, a form which involved concepts of time, movement and space. Through this work he developed

his ideas on scale, fundamental form and the correspondences between abstract constructions and natural forces. In the 1960s he became interested in the role of chance and, influenced by Le Witt and Klee, started drawings based on the chance selection of numbers in order to determine the placement of lines on a chosen grid. In 1969 he began his *Chance and Order* paintings. All his work is characterized by 'the building, by simple events, of an expressive whole'.

LIT: Exhibition catalogues for his shows at the Tate Gallery, 1975, and the SERPENTINE GALLERY, 1985. CF

MARTIN, Mary Adela, LG, ARCA (1907–1969). Painter of abstracts; constructivist and printmaker. She studied at GOLDSMITHS' SCHOOL OF ART 1925–9, and the RCA 1929–32. In 1930 she married KENNETH MARTIN and in the early 1950s was a member of the constructivist group that included PASMORE, HILL, ADAMS, HEATH and KENNETH MARTIN. She exhibited with the LG from 1932, becoming a member in 1956, and showed with Kenneth Martin in 1954, thereafter exhibiting regularly in London, the provinces and abroad. Her work is represented in many public collections. In 1969 she was joint first prizewinner at the JOHN MOORES EXHIBITION and her commissioned works include reliefs for the SS *Oriana*, 1960; wall constructions for the Congress Building, International Union of Architects, 1961, and for the University of Stirling, 1969. Her earliest paintings were influenced by Post-Impressionism; in the 1940s her work moved towards abstraction in selecting and distilling elements from landscape. In 1950 she painted abstract works and subsequently, influenced by constructivist theories, pioneered the form of geometric abstract reliefs, e.g. *Columbarium*, 1951. Her work was based on simple geometric units and concerned with movement, change, and the complex permutations through which a single unit could be taken. A similar concern is apparent in her drawings. Whereas her early paintings were strongly coloured, her reliefs used only restricted colour or black and white and sometimes employed reflective or mirrored surfaces.

LIT: *Mary Martin*, Tate Gallery, London, 1984; *Mary Martin and Kenneth Martin*, Arts Council, 1970–1. CF

MARTIN, William Alison, LAA (*c*.1878–1936). Painter of figures and landscapes in oils, mural painter; etcher and lithographer. He studied at Liverpool School of Art, winning a gold medal for drawing and a travelling scholarship to work in Paris (under Bouguereau and Ferrier) and to study in Italy. He exhibited at the RA from 1902, also at the R.Cam.A., the Walker Art Gallery, Liverpool, the LS, GI, and at the Baillie Gallery where he had his first solo exhibition in 1907. His work was purchased by the Pacific Steam Navigation Co. and was illustrated in *The Studio*. Some of his figure paintings reflect the influence of Bouguereau, e.g. *The Pearl Gatherers*, showing idealized female nudes in a landscape setting. Architectural and landscape etchings were more objective in style and intent. CF

MARX, Enid Crystal Dorothy, RDI (b. 1902). A wood engraver, fabric designer and writer. She studied art at the CENTRAL and the RCA. Although perhaps better known for her work in textiles (she designed furnishings for the wartime Utility Scheme of the Board of Trade, and was appointed a Royal Designer for Industry in 1942), she designed London Underground posters (1957) and postage stamps (for the accession of HM Queen Elizabeth II, in 1953, and for Christmas 1976). Her bold and brilliantly patterned colour linocuts used transparent water-based inks to create accidental effects. *Budgerigars* (1972) is in the TATE. She was an influential teacher and lecturer. AW

MASOERO, Jeanne (b. 1937). Painter of abstracts in acrylic, oils and gouache. She studied at GOLDSMITHS' COLLEGE and the SLADE SCHOOL, winning a travelling scholarship to Rome. She has exhibited at the Angela Flowers Gallery from 1971 as well as in other galleries and in group shows. In early work paint was poured on to her canvases; more recent paintings show discs, roads and horizons painted in small coloured specks.

LIT: Catalogue, Gardner Centre Gallery, 1981. CF

MASON, Arnold Henry, RA, RP (1885–1963). Painter of portraits and landscapes in oils. He attended the Macclesfield School of Art, the RCA, the SLADE SCHOOL and studied in Paris and Rome. He exhibited mainly at the RA from 1919 (becoming RA in 1951), as well as at the NEAC, the RP (becoming RP in 1935), and at London galleries. He also showed in the provinces and his work is represented in public collections. His portraits, often of head and shoulders, present a realistic, firmly modelled account of his subject. His

painting technique could be broad, working in large areas of light and shadow, particularly in his paintings of Provence, but many portraits show a more detailed approach, although still retaining a freshness of brushmark and a sense of life.　CF

MASON, Robert (b. 1946). Painter of figures in mixed media. He studied sculpture at Hornsey College of Art 1965–8, and worked at the BRITISH SCHOOL IN ROME 1968–70, holding his first solo exhibitions in 1970 in Italy and Hamburg. He has exhibited regularly in London galleries, particularly the Anne Berthoud Gallery, and in the USA. Represented in the ARTS COUNCIL Collection, his sombre, dramatic, highly abstracted work, illuminated by strong flashes of colour, was earlier concerned with the subject of death. Recent paintings have depicted figures including workers on the Broadgate development in London.

LIT: Exhibition catalogue, Yale Center for British Art, New Haven, USA, 1986; *Broadgate Paintings and Drawings 1989–1990*, Rosehaugh Stanhope Developments plc., London, 1990. CF

MATTHEWS, H. Philip (1916–1984). Painter of portraits, landscapes and still-life in oils. He studied at Maidenhead School of Art and at the EUSTON ROAD SCHOOL. Between 1939 and 1940 he was one of the first private students taken by COLDSTREAM at 8 Fitzroy Street where he also met GRAHAM BELL and PASMORE. He exhibited at the RA, NEAC, LG, and the LEICESTER GALLERIES, and he showed with the Euston Road School painters in 1948 at Wakefield Art Gallery. From 1946 to 1981 he taught at CAMBERWELL SCHOOL OF ART, becoming Head of Fine Art in 1964. His work is represented in many public collections. His painting style was based on the observant realism of Euston Road and the technique taught by Coldstream. His landscapes and figures show the underlying structure of forms in blocked areas of colour, e.g. *Landscape, Dorney, Berks*, RA 1979.　CF

MAXWELL, John, RSA, SSA (1905–1962). Painter of figures, landscapes, murals and portraits in oils and watercolours. He studied at EDINBURGH COLLEGE OF ART, winning a travelling scholarship to France, Spain and Italy. He exhibited at the RSA from 1937, becoming RSA in 1949, and his work is represented in public collections. Between 1928 and 1961 he taught at Edinburgh College of Art. His paintings reflect the influence of Chagall in form and content.

LIT: Exhibition catalogue, Scottish National Gallery of Modern Art, 1963; *John Maxwell*, David McClure, Edinburgh University Press, 1976.　CF

MAYER, Michael (b. 1932). Painter of abstracts in acrylic. He studied at Exeter College of Art 1955–8, and has exhibited at the GIMPEL FILS GALLERY and in group exhibitions in London. His work is represented in public collections. Between 1961 and 1964 he taught at Bideford School of Art and from 1965 at Exeter College of Art. His paintings establish a pattern or grid of small geometric shapes which are spatially ambiguous and modulated by changes of light and colour.　CF

Mayor Gallery. Founded in Sackville Street by Fred Hoyland Mayor and Douglas Cooper in 1925, it moved into striking new premises in Cork Street designed by Brian O'Rorke and Arundell Clarke in 1933. In the October of that year the exhibition 'Art Now' was held, to coincide with the publication of HERBERT READ's book of that title. It was also the venue of the first and only exhibition of UNIT ONE (April 1934). The gallery is run today by James Mayor.　AW

MAZE, Paul Lucien (1887–1979). Painter of figures and a wide range of subjects in oils, watercolours and pastels. Born in Le Havre, he knew Dufy and Braque as a young man and after serving in the 1914–1918 War he turned to painting. Working in Paris he met Derain, Segonzac and Bonnard. Later he settled in England. He exhibited first in France; his first London solo exhibition was at the Independent Gallery in 1925. Thereafter he exhibited regularly at a number of major London galleries, in Paris and in America. His work is represented in public collections including the TATE GALLERY. His fluid, colourful work celebrates movement and life and has its stylistic roots in Impressionism and the work of Bonnard and Vuillard.

LIT: *Paul Maze: The Lost Impressionist*, Anne Singer, London, 1983; exhibition catalogue, Marlborough Fine Art, London, 1967.　CF

MEAD, Dorothy, LG (1928–1975). Painter of figures and still-life in oils. She studied with BOMBERG from 1945 to 1951 and at the SLADE SCHOOL from 1956 to 1959. She exhibited with other Bomberg students at the Archer Gallery in 1947 and 1948 and at the Everyman in 1947.

She showed with HOLDEN (to whom she was married), CREFFIELD and RICHMOND in Sweden in 1953 and subsequently in a number of group exhibitions in Britain. She was a founder member of the BOROUGH GROUP and President of the LG. Her forceful painting style reflects Bomberg's expressionistic response to form. CF

MEDALLA, David (b. 1942). Painter, kinetic, performance and happenings artist; sculptor. Born in Manila, the Philippines, he studied at Columbia University, USA 1954–6, and has exhibited widely in London, the USA and in Manila. His work is represented in collections including the National Museum of the Philippines and he has taught in London art schools including CHELSEA SCHOOL OF ART. He has worked in collaboration with JOHN DUGGER and he was Founder-Secretary of the Artists Liberation Front, 1971–4, and Co-founder of Artists for Democracy, 1974. In the 1960s he turned from painting and kinetic art to participaton and performance work. Informed by Marxism, Leninism and Maoism, his art is based on a wide range of cultural and ethnic sources. LIT: Interview in *Art & Artists* (UK), Vol.7, pt.10, January 1973, p.26; 'Impromptus: David Medalla', Guy Brett, *Art in America* (USA), Vol.77, pt.11, November 1989, p.156. CF

MEDLEY, Robert, RA, LG, CBE (1905–1994). Painter of figures, still-life, landscapes and abstracts in oils and acrylic; theatrical designer. From 1921 to 1923 he attended the BYAM SHAW SCHOOL and between 1923 and 1925 the RCA and the SLADE SCHOOL under TONKS and STEER. From 1926 to 1928 he studied in Paris at the Académie Moderne under Jean Marchand. In London he knew ROGER FRY, DUNCAN GRANT and members of the Bloomsbury Group; in 1929 he met artists of the Diaghilev Ballet through his friendship with Rupert Doone, with whom he associated in designs for the Group Theatre, 1932–8, and which included productions of work by Auden and Eliot. Between 1940 and 1945 his war service took him to the Middle East and in 1969 he travelled to Persia. He became a member of the LG and the LAA in 1930 and had his first solo exhibition in 1931 at the Cooling Gallery. He exhibited regularly in London galleries and in group exhibitions, including the London SURREALIST Exhibition in 1937. His painting is represented in numerous public collections including the TATE GALLERY. He taught at the Slade School, Stage Design

Department, 1951–8 and 1968–9. From 1958 to 1965 he was Head of Fine Art, CAMBERWELL SCHOOL OF ART, and in 1968 he became Chairman of the Faculty of Painting, BRITISH SCHOOL IN ROME. He was awarded a CBE in 1982 and became RA in 1986. His painting passed through a number of developments from Surrealist tendencies to the search for form and structure in the 1940s. Later work was increasingly intuitive, using visual appearances as a starting point rather than a constant point of reference. After a period of geometric abstraction he returned to figurative work employing a free, intuitive style and lyrical colour. LIT: *Drawn from Life*, Robert Medley, Faber & Faber, 1983; retrospective exhibition catalogue, Whitechapel Art Gallery, 1963. CF

MEDNIKOFF, Rueben (1906–1975). A painter and linocut artist who studied at ST MARTIN'S School of Art (1920). He worked with and later married DR. GRACE PAILTHORPE, who concentrated on psychological art research. He exhibited in the International SURREALIST Exhibition in 1936. His work had affinities with that of André Masson (see his *Untitled Drawing*, 1936, TATE GALLERY). AW

MEE, Henry (b. 1955). Painter of portraits and of figures from the life model in oils. He studied at the University of Leeds Department of Fine Art, 1975–9, under GOWING, and has received many commissions including the portrait of HRH the Prince of Wales as Patron of the London Press Club, 1982. Between 1986 and 1990 he worked on a series of portraits of celebrities, and his assured work has been influenced by Goya, Velazquez, Manet, SICKERT and the EUSTON ROAD SCHOOL. LIT: *British Eminencies*, exhibition catalogue, Sotheby's and the Hop Exchange, London, May–June 1990. CF

MEESON, Dora, ROI, WIAC (d. 1955/6). Painter of landscapes, flowers, portraits and figures in oils, tempera and watercolours. Born in Melbourne, Australia, she studied at Melbourne National Gallery, at the SLADE SCHOOL, London, under TONKS, and at the ACADÉMIE JULIAN, Paris, under Laurens and Constant. She exhibited mainly at the ROI (becoming a member in 1920), as well as at the LS, RA, SWA, RP, RI, in the provinces and at the Paris Salon where she gained an Honourable Mention in 1923. She was a member of the Society of Painters in Tempera

and Mural Decorators and her work is represented in public collections including the Australian National Gallery. She was married to the artist GEORGE COATES. Her work ranges from charcoal portrait drawings to colourful scenes from France.　　　　　　　　　　　　　　　　CF

MELHUISH, George William Seymour (b. 1916). Painter of landscapes, portraits, buildings and abstracts in oils. Born in Bristol, he was self-taught, studying in London and Paris. He exhibited at the RWS in 1935, at the RA in 1943 and 1944, at the ROI, in solo exhibitions in Paris and in London galleries, including the Irving in 1951 and the O'Hana in 1953. Represented in Bristol Art Gallery, he has also published books on philosophy including *The Paradoxical Universe*, 1959. His painting uses an expressionist technique and bold, primary colours.
LIT: *George Melhuish*, Richard Hutton, Bristol Writer's and Artist's Association, Bristol, *c*.1945.　　　　　　　　　　　　　　　　　　　　　　CF

MELLAND, Sylvia, RE (b. 1929). Painter in oils and etcher of still-life, townscapes, portraits and abstracts. She studied at MANCHESTER COLLEGE OF ART the BYAM SHAW SCHOOL, the EUSTON ROAD SCHOOL and the CENTRAL SCHOOL. She exhibited at the RA from 1944 to 1977, has held solo exhibitions at the Wertheim and Jackson's Galleries and has shown abroad. Represented in collections including Leeds Art Gallery, her work depicts subjects such as *Still-life with Leeks*, RA 1946, and *Athens Outlook*, RA 1963.　　CF

MELLIS, Margaret (b. 1914). Painter and constructivist. She studied at EDINBURGH COLLEGE OF ART under PEPLOE, 1929–33, in Paris under Lhote, in Spain and Italy 1933–5, held a Fellowship at Edinburgh College of Art 1935–7, and worked at the EUSTON ROAD SCHOOL in 1938. In 1938 she married ADRIAN STOKES and from 1939 to 1946 lived in St Ives. In 1948 she married Francis Davison. Closely associated with the St Ives artists, she held a solo exhibition at the AIA in 1958 and has subsequently exhibited in London galleries including the WADDINGTON and the Hamilton, in Scotland and the provinces. Represented in the TATE GALLERY, her work includes constructions made in the 1940s influenced by NICHOLSON and Gabo, figurative and abstract paintings, colour structures, reliefs in colour and driftwood reliefs. All her work is characterized by its simplicity of form and strong colour.

LIT: *St Ives 1939–1964*, catalogue, Tate Gallery, London, 1985; retrospective exhibition catalogue, Redfern Gallery, London, 1987.　　CF

MELLOR, Tom, OBE (1914–1994). Architect and painter. Trained at Liverpool School of Architecture and at the School of Civic Design there. Tom Mellor practised as an architect, was Director of Furnishing Fabrics at David Whitehead Ltd (commissioning work from PIPER and MOORE), and taught at Liverpool University until his retirement at the age of 53. He regularly exhibited Surrealist paintings indebted to the work of de Chirico and Ernst, with strong architectural motifs, at the RA.　　　　　　　AW

MELVILLE, Arthur, ARSA, RSW, RWS, RP (1855–1904). Painter of figures, landscapes and genre in watercolours and oils. Born in Angus, he studied at the RSA Schools, with James Campbell Noble and from 1878 to 1880 at the ACADÉMIE JULIAN, Paris. He travelled to Egypt, India and Persia before returning to Scotland in 1882 where he formed a friendship with GUTHRIE and was associated with the GLASGOW SCHOOL. He settled in London in 1889 and made frequent journeys to Morocco, Spain and Italy. He exhibited mainly at the RSA (ARSA 1886), the RWS (ARWS 1888, RWS 1899), and in Liverpool and he was elected RP in 1899. Represented in collections including the National Gallery of Scotland, his work was influenced by Bastien-Lepage and *plein-air* painting and intensified by the light and colour of the Middle East. His experimental, impressionistic and fluid painting, particularly in watercolour, was a strong influence on the Glasgow School.
LIT: *Arthur Melville*, A.E. Mackay, F. Lewis, Leigh-on-Sea, 1951; *Arthur Melville*, catalogue, Dundee Art Gallery, 1977 and touring.　　CF

MELVILLE, John (1902–1986). Painter of figures, portraits and still-life in oils and watercolours. Self-taught as an artist, he was attracted to SURREALISM in the early 1930s. A member of the Birmingham Group in the 1930s, he joined the Surrealist Group in 1938 and was a contributor to the *London Bulletin* in 1939, and to *Arson* in 1942. He exhibited first in London at the Wertheim Gallery in 1932, and continued to exhibit in London and the provinces. His painting is represented in a number of public collections. His works often showed transformed figures and a dream-like, unexpected conjunction of images. During the 1940s he painted portraits

and still-life but returned to surrealism in later works.
LIT: Memorial exhibition catalogue, Gothick Dream Fine Art, London, 1987. CF

MENINSKY, Bernard, NEAC, LG (1891–1950). Painter of figures, portraits and landscapes in oils, watercolours and gouache; draughtsman, theatrical designer and illustrator. He was born into a Jewish family in the Ukraine and studied at Liverpool School of Art winning the King's Medal and a scholarship to study at the ACADÉMIE JULIAN, Paris, 1910–11. Between 1912 and 1913 he studied at the SLADE SCHOOL under TONKS and BROWN. He exhibited with the LG from 1913 (member 1919),and the NEAC from 1914 (member 1923). In 1919 he had his first solo exhibition of drawings at the Goupil Gallery and in 1930 an exhibition of his oils was held at St George's Gallery. He regularly exhibited his drawings and watercolours and his work is represented in public collections including the TATE GALLERY. An influential teacher of drawing, he first taught at Gordon Craig's theatre school, Florence, and at the CENTRAL SCHOOL. In 1920 he succeeded SICKERT as teacher of life drawing at the WESTMINSTER SCHOOL OF ART. From 1940 to 1945 he taught at Oxford School of Art, and from 1945 he was Instructor in Drawing, Central School of Art. During the First World War he painted London scenes for the Ministry of Information. He took his own life in 1950. His paintings of monumental figures and lyrical landscape reflect the influence of Masaccio, Samuel Palmer and Picasso's neo-classicism; they are painted with a broad, rich handling and resonant colour and they show his mastery of selective line. Whilst his drawings are naturalistic his paintings achieve an alliance of romantic mood and classical form.
LIT: Memorial exhibition catalogue, Arts Council, 1951; *Mother and Child. 28 Drawings by Bernard Meninsky*, text by Jan Gordon, John Lane, 1920; 'Bernard Meninsky', Cora J. Gordon, *Studio*, Vol.132, 1946, p.13. CF

MENNIE, John George, ARMS, DA (1911–1983). Painter in oils and watercolours; engraver and printmaker. Born in Aberdeen, he attended Grays School of Art, Aberdeen, and WESTMINSTER SCHOOL OF ART, London, under GERTLER and BLAIR HUGHES STANTON. He exhibited at the RA, RP, and RMS, and in solo exhibitions at the Medici Society. His work is represented in public collections including the

IMPERIAL WAR MUSEUM. He taught life drawing and painting for the ILEA for many years and exhibited at the RA as an engraver. His war drawings, watercolours and prints record his experience as a POW of the Japanese from 1942 to 1945. They include work in pen and ink, linocuts and woodcuts, and range from representational drawing to more simplified, decorative compositions. CF

MENPES, Mortimer L., RI, RBA, RE, NEAC, ROI (1860–1938). Painter of figures, portraits, genre and landscapes in oils and watercolours; etcher and draughtsman. He came to England from Australia in 1879 and met Whistler in 1880 becoming his student and studio assistant. In 1886 he joined the Society of British Artists in 1888, following a visit to Japan, broke his association with Whistler. He returned to Japan in 1896 and continued to travel extensively, producing paintings and illustrating books on his travels. He exhibited at the NEAC, 1886–8, and became RBA in 1885 and ROI in 1899. He exhibited regularly in London galleries, including the Dowdeswell Galleries and the FINE ART SOCIETY, and later in his life at the RA. In 1900 he was a WAR ARTIST in South Africa and he was founder of the Menpes Press. His early painting style was influenced by Whistler in subject, technique and use of sketch-like scale and style. Later paintings became more precise and linear.
LIT: *Whistler as I Knew Him*, Mortimer L. Menpes, London, 1904; 'A Personal View of Japanese Art', Mortimer L. Menpes, *The Magazine of Art*, Vol.11, 1888. CF

MESSELL, Oliver, CBE (1904–1978). Theatrical designer; painter of portraits and flowers in oils, tempera and chalk; decorative artist and designer of interiors and houses. He studied at the SLADE SCHOOL under TONKS 1922–4, and was apprenticed to JOHN WELLS in 1925. An exhibition of masks made by him at Claridge Gallery brought him to the attention of Cochran and Diaghilev. Thereafter he worked as a theatrical and film designer for the Cochran revues (e.g. *Helen*, 1932), for Tyrone Guthrie at the Old Vic, for opera and ballet (e.g. *Sleeping Beauty*, Royal Opera House, Covent Garden, 1946). He painted portraits throughout his life and they were first exhibited at the LEICESTER GALLERIES in 1938. He received numerous awards for his designs and for his decorative commissions. In 1955 he became a Fellow of University College, London, and was awarded the CBE in 1958. His

decorations were recognized for their taste and sense of period. His paintings were spontaneous and lively.
LIT: Exhibition catalogue, Theatre Museum, V & A, London, 1983. CF

METHUEN, Lord Paul Ayshford, RA, RWS, RBA, NEAC, PRWA (1886–1974). Painter of landscapes, architecture and figures in oils, watercolours, pastels and pen and wash. He studied at the RUSKIN SCHOOL of Drawing, with SICKERT in London in 1927 and with SIR CHARLES HOLMES. His first solo exhibition was at the Warren Galleries in 1928 and he subsequently exhibited widely, particularly at the LEICESTER GALLERIES, at Colnaghi & Co., and at the RA. He became RBA and PRWA in 1939, NEAC in 1943, RWS in 1952 and RA in 1959. His work is represented in public collections including the TATE GALLERY. As President and Chairman of the Bath Society of Artists he met Clifford and Rosemary ELLIS and established the BATH ACADEMY OF ART at Corsham Court. A Trustee of the Tate and National Galleries and the IMPERIAL WAR MUSEUM, he was also a member of the National Fine Art Commission from 1952 to 1959. His work ranges from lively pen and wash drawings of architecture to landscape paintings and sketches grounded in the tradition of Constable.
LIT: 'Lord Methuen ARA', Mary Sorrell, *Studio*, December 1951; *Corsham, a Celebration*, catalogue, Michael Parkin Gallery, 1989. CF

MICHAELEDES, Michael (b. 1927). He studied art and architecture in Italy and England. In 1954 he won the 'Philadelphios' poetry prize in Athens. His first one-man show was at the LEICESTER GALLERIES in 1959; since 1972, he has shown regularly at Annely Juda. He represented Greece at the 1976 Venice Biennale, and has often shown in Italy. His work is in numerous public and corporate collections. His unprimed canvases are stretched over shaped formers.
LIT: See William Packer, *Financial Times*, 29 July 1976. AW

MICHIE, Alastair, RWA, ARBS (b. 1921). Painter, graphic artist and sculptor. Eldest son of ANNE REDPATH he was born in France and was educated there and in Scotland. He first studied architecture at Edinburgh, and after a successful career as a graphic artist, began to exhibit his painting and sculpture at the RA, RSA and elsewhere. He had many one-man shows at RICHARD DEMARCO, and was invited to travel in South America, holding a series of major exhibitions in Brazil in 1972. His carefully structured and strongly coloured work is in many public and private collections. AW

MICHIE, David Alan Redpath, RSA, PSSA (b. 1928). Painter of figures, flowers and townscapes in oils and watercolours. Son of ANNE REDPATH, he studied at EDINBURGH COLLEGE OF ART and in Italy. He has exhibited regularly at galleries including the Mercury Gallery, and he became RSA in 1972 and PSSA from 1961 to 1963. His work is included in many public collections. In 1982 he became Head of Drawing and Painting, Edinburgh College of Art, and he has won many awards. His attractive paintings show a selective, delicate celebration of his varied subject matter. CF

MIDDLEDITCH, Edward, RA, ARCA (1923–1987). Painter of landscapes, flowers and townscapes in oils. After war service (awarded MC) he studied art at Regent Street Polytechnic in 1948, and at the RCA under SPEAR and MINTON 1948–52, where his contemporaries included MALCOLM HUGHES, JACK SMITH and DERRICK GREAVES. In 1956 he visited Spain and returned to work there in 1957 and 1960. He exhibited first in the RA in 1949 and in group exhibitions including the 'YOUNG CONTEMPORARIES Exhibition', RBA Galleries, 1952. In 1954 he held his first solo exhibition at the BEAUX ARTS GALLERY where he continued to exhibit until 1965. He then exhibited mainly at the RA, becoming ARA in 1968 and RA in 1973. His work has been represented in many exhibitions, including the 1956 Venice Biennale, and is in many public collections. He taught at the Regent Street Polytechnic, Cambridge and ST MARTIN'S Schools of Art and from 1964 to 1984 was Head of Fine Art, Norwich School of Art. Between 1984 and 1986 he was Keeper of the Royal Academy. He won many awards including a Gulbenkian Foundation Scholarship in 1962. In his early work he was associated with realists such as BRATBY and Greaves and his paintings were sombre and restricted in colour, e.g. *Sheffield Weir I*, 1954 (Manchester City Art Gallery). His real subject, however, was not social realism but nature, particularly flowers and water shown with a direct, vigorous perception, often on a large scale. In the 1960s he experimented by showing different viewpoints on the same canvas and more recent work

included drawn studies of Suffolk cornfields. All his painting is distinguished by a rich surface, intuitive touch and strong drawing.
LIT: Exhibition catalogue, South Bank Centre, 1987–8. CF

MIDDLETON, Colin, RHA, MBE (1910–1983). Painter of a wide range of subjects in oils. He attended evening classes at Belfast College of Art under Newton Penrose and in 1928 was influenced by the Van Gogh exhibition in London at the LEICESTER GALLERIES. In 1931 he visited Belgium and studied Ensor. He exhibited with the Ulster Unit in 1934, and held his first solo exhibition at the Museum and Art Gallery Stranmillis in 1941. Thereafter he exhibited regularly in Dublin and London, becoming RHA in 1970. His work is represented in many public collections. From 1961 to 1970 he was Head of Art, Friends School, Lisburn, in 1969 he was awarded the MBE, and in 1972 an Honorary MA, Queen's University, Belfast. His varied work reflects a range of influences and encompasses Surrealist subjects, expressionistic landscape and geometric abstraction.
LIT: *Colin Middleton*, J. Hewitt, Arts Council, 1975; exhibition catalogue, Christie's, London, 1985. CF

MILLAIS, H. Raoul (b. 1901). Painter in oils and draughtsman of animals and sporting subjects. The grandson of J.E. Millais and the son of JOHN GUILLE MILLAIS, he studied at the BYAM SHAW School, the RA SCHOOLS in 1921, and with FRANK CALDERON. He travelled widely and has exhibited mainly at the FINE ART SOCIETY, London. His many commissions include work for HM King George VI and Sir Winston Churchill. Represented in the National Museum of Racing, Saratoga, his work includes racing, hunting and big game subjects and equestrian portraits.
LIT: *Millais. Three Generations in Nature, Art and Sport*, J.N.P. Watson, The Sportsman's Press, London, 1988. CF

MILLAIS, John Guille, FZS (1865–1931). Painter and draughtsman of animals and birds; sculptor and author. The son of J.E. Millais, he served in the army and travelled extensively on hunting expeditions throughout the world. A friend of GEORGE LODGE and ARCHIBALD THORBURN, he showed mainly at the FINE ART SOCIETY, where he exhibited in 1910 and 1921. He wrote and illustrated many books, including

The Wildfowler in Scotland, Longmans, 1901, and his work was often in half-tone washes.
LIT: *Millais. Three Generations in Nature, Art and Sport*, J.N.P. Watson, The Sportsman's Press, London, 1988. CF

MILLAR, Jack Ernest, RBA, ARCA (b. 1922). Painter of flowers, landscapes and interiors in oils. He studied at Clapham Art School, ST MARTIN'S SCHOOL OF ART and at the RCA under MOYNIHAN 1948–50. In 1950 he won the Andrew Lloyd Scholarship for landscape painting. He has exhibited at the RA since 1948, the LG and RBA, becoming RBA in 1954. He has held solo exhibitions at numerous galleries (including Duncan Campbell Fine Art, London), and he has won many prizes; his work has been purchased by public and private collections. From 1964 he was a visiting lecturer at the RA SCHOOLS; from 1966 to 1973 Head of Fine Art, Walthamstow School of Art, and from 1973 to 1986 Head of Fine Art, Kingston Polytechnic. His paintings, often showing flowers set against interiors and windows, are rich in colour and painterly in handling. CF

MILLER, Alan (b. 1942). Painter of abstracts and figurative work in acrylics, oils and collages. He studied at BATH ACADEMY OF ART 1959–63, and at the SLADE SCHOOL 1963–5. He has exhibited at the SERPENTINE GALLERY, 1971, at the Ikon Gallery, Birmingham, and his work has been represented in group exhibitions and public collections. He was a prize winner at the JOHN MOORES 1974 exhibition. His painterly work has developed from acrylic abstracts which suggested constructions and objects, to figurative paintings in oils. CF

MILLER, Clive Beverley (b. 1938). Painter in oils; mural painter and musician. He studied at Sidcup School of Art in 1955, Bromley College of Art in 1956 and the RCA 1960–4, winning the Rome and Abbey Scholarships. He has exhibited at the RA since 1975 and his work is represented in collections including the Welsh Arts Council. CF

MILLER, James, RSA, RSW (1893–1987). Painter of architecture and figures in watercolours and oils. He studied at GLASGOW SCHOOL OF ART and exhibited at the RSW, becoming a member in 1934, the RSA, becoming ARSA in 1943, and the GI. He was drawing master of Hillhead High School from 1919 and he travelled and painted regularly in Mediterranean countries. His colourful watercolours captured

figures and architecture with an assured technique.
LIT: Retrospective exhibition catalogue, Scottish Gallery, Edinburgh, 1987. CF

MILLER, John, RSA, PRSW, SSA (b. 1911). Painter of landscapes and still-life in oils and watercolours. He studied at GLASGOW SCHOOL OF ART under W.O. Hutchison and at Hospitalfield Arbroath with James Cowie in 1938. He exhibited in London at the RA and in Scotland at the RSA, RSW, SSA and GI, becoming RSW in 1952, PRSW from 1970 to 1972 and RSA in 1966. His exhibited work includes subjects such as *Summer Evening: Firth of Clyde*, 1968, *The Nunnery and Village, Iona*, 1968, and *Roses and Fruit*, 1967. CF

MILNE, John Maclauchan, RSA (1885–1957). Painter of landscapes and coastal scenes in oils and watercolours. Son of Joseph Milne, he studied with his father who influenced his early painting. Between 1919 and 1932 he made regular visits to France and in 1924 met PEPLOE, CADELL and DUNCAN GRANT. He exhibited at the RSA from 1912 to 1954, at the GI, in London and New York, and his work is in public collections. He became RSA in 1937 and in 1956 he was Warden of Hospitalfield, Arbroath. His work was influenced by Cézanne and he employed an energetic, vital handling and strong colour in both his French and Scottish subjects.
LIT: Centenary exhibition catalogue, Dundee Art Gallery and Museum, 1985. CF

MILNE, Malcolm, NEAC, MAFA (1887–1954). Painter of flowers, landscapes and still-life in oils and watercolours. Brother of Hilda Milne, he attended the SLADE SCHOOL under TONKS 1908–11, and WESTMINSTER SCHOOL OF ART under SICKERT. He travelled regularly in Europe from 1907. He exhibited at the NEAC from 1912 becoming a member in 1919, held his first solo exhibition in 1937 at the Galleries of Picture Hire Ltd, and continued to exhibit in London galleries and at the RA. In 1928 he became MAFA and his work is represented in public collections including the TATE GALLERY. Best known as a flower painter (e.g. *The Hundred Flowers*, Manchester City Art Gallery), his style shows the influence of Sickert and Gilman.
LIT: Retrospective exhibition catalogue, Ashmolean Museum, Oxford, 1966. CF

MILNES-SMITH, John (b. 1912). Painter of non-figurative images in oils, gouache and collages. He trained as an architect at the AA, London, 1934–8, and has exhibited since 1951, showing with the LG since 1952 and holding his first solo exhibition at the New Vision Centre in 1959. He has subsequently exhibited at the Drian Galleries since 1963 and at the RA from 1982. His work is represented in collections including the INSTITUTE OF CONTEMPORARY ARTS. In the 1950s his work reflected the influence of Manessier and GEAR and later the impact of Abstract Expressionism. His work uses warm colour, intuitive shape and varied texture.
LIT: *Reflections of the Fifties*, catalogue, England & Co., London, 1988; retrospective exhibition catalogue, Austin/Desmond Fine Art, London, 1989. CF

MILOW, Keith (b. 1945). Painter, construction and installation artist working in a variety of media. He studied at CAMBERWELL SCHOOL OF ART 1962–7, and the RCA 1967–8. In 1968 he worked on experimental projects with the Royal Court Theatre. He exhibited in 1968 at the Axiom Gallery, and subsequently at Nigel Greenwood Inc. Ltd, London. He has shown in the provinces and abroad and his work is in many public collections including the TATE GALLERY. He has taught since 1974 at the RCA and his many awards include the Gregory Fellowship, University of Leeds, 1970, and a Harkness Fellowship to work in New York, 1972–4. His work, often in series, is concerned with the transformation and reconstruction of images, e.g. the Latin Cross series, and with the relationship between abstraction, reality and symbol.
LIT: Interview, *Studio International*, London, March 1972; *British Art Now*, catalogue, Guggenheim Museum, New York, 1979. CF

MILROY, Lisa (b. 1959). Born in Vancouver, she studied at Banff, at the Sorbonne, at ST MARTIN'S and GOLDSMITHS'. Her first solo exhibition was at Nicola Jacobs in 1984 and at the Cartier Foundation in Paris. She won first Prize at the JOHN MOORES LIVERPOOL EXHIBITION in 1989. Her paintings and drawings are composed of ordered grids of images of common object-types, typically women's shoes, Greek vases, shirts, dresses or lightbulbs, sometimes hardly varied across the canvas, sometimes with the differences emphasized. AW

MINTON, John, RBA, LG (1917–1957). Painter of figures, townscapes and landscapes in oils and watercolours; book illustrator, graphic artist and theatrical designer. He attended St John's Wood School of Art under P.F. Millard and Kenneth Martin 1935–8, and then travelled and worked in France with Michael Ayrton and Michael Middleton, studying at Colarossi's and visiting Provence. In 1941 he collaborated with Ayrton on designs for Gielgud's *Macbeth*; from 1943 to 1946 he shared a studio with Colquhoun and Macbryde and from 1946 to 1952 with Keith Vaughan. In 1947 he visited Corsica and during the 1950s travelled in the West Indies, Morocco and Spain. He held his first solo exhibition in 1945 and thereafter exhibited regularly in London galleries, the RA, RBA and the LG, becoming a member in 1949 and RBA in 1950. He exhibited in New York from 1948 and his work is represented in many public collections including the Tate Gallery. From 1947 he produced numerous book illustrations, e.g. *Time was Away*, 1948, also posters, advertisements, murals and textile designs. He taught illustration at Camberwell School of Art 1943–6, drawing at the Central School of Art 1946–8, and painting at the RCA 1948–56. He took his own life in 1957. A lyrical artist, he was most successful in smaller works. His paintings reflect the influence of his contemporaries (including Craxton and Sutherland), the English romanticism of Palmer and aspects of French painting, particularly Picasso, Chirico, and Tchelichew. His earlier work was stylized and linear, e.g. *Porthleven, Cornwall*, 1945. In the 1950s the scale of his work increased and he employed a wide range of subject matter, e.g. *The Death of James Dean*, 1957 (Tate Gallery).
LIT: *Dance Till the Stars Come Down: A Biography of John Minton*, Frances Spalding, John Curtis, 1991; catalogue, Reading and Sheffield Art Galleries, 1974–5. CF

MITCHELL, Denis (b. 1912). Sculptor, painter and craftsman. He settled in St Ives in the 1930s and from 1949 to 1959 was chief assistant to Barbara Hepworth. He exhibited at St Ives and from 1961 in London and provincial galleries. His work is represented in public collections including the Tate Gallery. He was a founder member, 1949, and Chairman, 1955–7, of the Penwith Society. He turned from realistic painting to sculpture in 1949 producing abstract works which from 1959 were cast in bronze.

LIT: Interview, *Art Monthly*, July/August 1981; *Painting the Warmth of the Sun. St Ives Artists 1939–1975*, Tom Cross, Lutterworth Press, 1984. CF

MOFFATT, Alexander (b. 1943). Painter of portraits and figures in oils. He studied in Edinburgh and has exhibited in Scotland in solo and group exhibitions. From 1968 to 1978 he was Director of New 57 Gallery, Edinburgh, and in 1979 he began teaching at Glasgow School of Art. His precise, unblinking portrayal of figures and society are influenced by Beckmann, Kitaj and by his own social awareness.
LIT: *A View of the Portrait*, catalogue, Scottish National Portrait Gallery, 1973. CF

MOIRA, Gerald Edward, PROI, VPRWS, RWA, NPS (1867–1959). Painter of figures and landscapes in oils, watercolours and pastels; decorator, muralist, lithographer and illustrator. He studied at the RA Schools 1887–9, and in Paris. He exhibited widely: at the RA from 1891; the RWS, ROI, in London galleries and societies and in the provinces. His work is represented in several public collections including the Tate Gallery. He was elected NPS in 1911, RWA in 1919, RWS in 1932, PROI in 1945 and VPRWS in 1953. From 1900 he was Professor of Mural and Decorative Painting at the RCA, and between 1924 and 1932 Principal of Edinburgh College of Art. Acknowledged as a decorator he collaborated with Lynn Jenkins and his best known work includes murals for the Central Criminal Court, London. His paintings have a decorative style with bright, lively colour and clear delineation of form, e.g. *The Blue Carpet*, 1917.
LIT: *The Art of Gerald Moira*, Harold Watkins, 1922; 'The Paintings and Bas-Relief Decoration of Gerald Moira', *Studio*, Vol.12, p.223. CF

MONNINGTON, Sir Walter Thomas, PRA (1902–1976). Painter of figures, portraits and landscapes in oils and tempera; muralist and decorator. He studied at the Slade School 1918–1923, under Fred Brown, Walter Westley Russell, Steer and Tonks. In 1922 he won a scholarship in decorative painting and worked in Rome until 1926 where he painted *Allegory*, 1924–1926 (Tate Gallery). In 1924 he married the artist Winifred Knights. He exhibited mainly at the RA from 1931, becoming ARA that year, RA in 1938 and PRA in 1966. His work is represented in many public collections.

He taught at the RCA, the RA SCHOOLS, CAMBERWELL SCHOOL OF ART and he was Chairman of the Faculty of Painting, Slade School of Art 1949–67. He was an OFFICIAL WAR ARTIST with the RAF in the Second World War. He was Chairman, 1948–1967, and member of the Executive Committee, 1945–1972, of the BRITISH SCHOOL IN ROME, Trustee of the BM and NPG, President of the Artists' General Benevolent Institution and Vice President of the Foundlings Hospital. He was knighted in 1967. He executed many decorative commissions including a mural in St Stephen's Hall, Westminster 1925–27. His figurative style reflected the influence of the Italian quattrocento and particularly Piero della Francesca in its clarity and classical simplicity. As a war artist he was primarily concerned with the analysis of aerial views. At the end of the 1940s he radically altered his artistic aims, producing geometric, abstract work (based on his interest in mathematics and nuclear physics) both in paintings and decorative schemes, e.g. the ceiling for the conference hall, New Council House, Bristol, 1956. LIT: The memorial exhibition catalogue, RA, 1977. CF

MOODY, Victor Hume, RBSA, ARCA, FRSA (1896–1990). Painter of figures, portraits and landscapes in oils. He trained at Battersea Polytechnic and at the RCA under ROTHENSTEIN and exhibited mainly at the Goupil Gallery, London, and at the RA between 1931 and 1956. He also showed at the RSA and the RBSA and his work is represented in collections including the Harris Museum, Preston. Between 1936 and 1962 he was Head of Malvern School of Art and his exhibited subjects range from the portrait of George Bernard Shaw, 1938, to biblical and mythological scenes such as *The Judgement of Paris*, RA 1937, and scenes such as *Crossing the Brook* (Harris Museum, Preston). CF

MOON, Alan George Tennant, ARCA, FRSA (b. 1914). Painter in oils and watercolours; draughtsman in chalk and black and white. Born in Penarth, Glamorganshire, he attended Cardiff School of Art 1929–33, and the RCA 1933–7 under ROTHENSTEIN and GILBERT SPENCER. He exhibited at the RA between 1936 and 1939 and at leading galleries, including the LEICESTER GALLERIES. He was elected ARCA in 1936 and FRSA in 1949. His work is represented in public collections in Wales. He taught at LEICESTER COLLEGE OF ART 1946–9, was Principal of

Gravesend School of Art 1949–57, and subsequently Principal of Carlisle College of Art. He exhibited portrait studies at the RA in pencil, chalk, sanguine and wash. CF

MOON, Jeremy (1934–1974). Painter of abstracts in acrylic. He studied at the CENTRAL SCHOOL OF ART in 1961 but was mainly self-taught. He exhibited at the Rowan Gallery 1963–78 as well as in major group exhibitions. His work is represented in the TATE GALLERY and other public collections. He taught at ST MARTIN'S and CHELSEA Schools of Art. His clear, flat, geometric abstraction is concerned with colour and often investigates a grid structure. LIT: *Jeremy Moon*, catalogue, SERPENTINE GALLERY, 1976, and the interview in *One*, April 1974. CF

MOON, Michael, RA (b. 1937). Painter of abstracts in acrylic and mixed media; printmaker. He studied at CHELSEA SCHOOL OF ART and the RCA 1962–3, and has exhibited at the WADDINGTON GALLERIES and in group exhibitions. His work is represented in public collections including the TATE GALLERY. He has taught at the SLADE SCHOOL and in 1980 won first prize, JOHN MOORES LIVERPOOL EXHIBITION. His work has evolved from 'strip' paintings to object paintings and richly textured and coloured prints. LIT: *Michael Moon*, Judy Marle, Tate Gallery, 1976. CF

MOORE, Sir Henry, CH, OM (1898–1986). Celebrated as a sculptor, but was strongly influenced in his formative years by painters such as Giotto, Masaccio, Blake, Turner and Picasso, as well as the painter/sculptor Michelangelo. He was notable throughout his career for his output of graphic art (drawings, watercolours, etchings, lithographs), not necessarily closely related to the development of individual works in sculpture. These, unusually for a sculptor, often used colour and often established a complete pictorial setting for figures or for imaginary sculptural objects, in a manner recalling the work of De Chirico or Max Ernst. (He exhibited in the International SURREALIST Exhibition in 1936.) During the Second World War, as an OFFICIAL WAR ARTIST, he made a series of drawings of people sheltering in the London Underground, as well as studies of miners at the coalface. He frequently used watercolour over wax crayon employed as a resist. LIT: *Henry Moore, Sculpture and Drawings*, D. Sylvester, H. Read and A. Bowness, 3 Vols, Lund

Humphries, London, 1948–64; *Henry Moore, Graphics in the Making*, Pat Gilmour, Tate Gallery, 1975. AW

MORGAN, Glyn (b. 1926). Painter of figures, landscapes and still-life in oils; collagist and draughtsman. He studied at Cardiff School of Art under CERI RICHARDS, 1942–4, at CAMBERWELL SCHOOL OF ART in 1947, and with CEDRIC MORRIS. He worked in Crete in 1968 and Greece in 1972, and has held solo exhibitions since 1969 in galleries including the Gilbert-Parr Gallery, London. Represented in collections including the Welsh Arts Council, his work is frequently based on Greek myths and has been influenced by Bonnard, Dufy, Braque, Ceri Richards and Cedric Morris. LIT: Retrospective exhibition catalogue, The Minories, Colchester, 1981. CF

MORGAN, Howard (b. 1949). Born in North Wales, he trained at the Fine Art Department of Newcastle upon Tyne University 1969–73. He has painted landscapes, religious paintings, mural decorations and jazz musicians, but his main activity is as a portrait painter (RP 1986) working in a broad, Sargent-like manner. AW

MORLEY, Harry, ARA, VPRWS, RP, RE, RBA, (1881–1943). Painter of figures and landscapes in tempera, oils and watercolours; etcher and illustrator. He studied architecture at the RCA, winning a travelling scholarship to Italy where he decided to paint. In 1908 he attended the ACADÉMIE JULIAN, Paris, and then settled in London. He exhibited mainly at the RA, RWS, RE, RBA and at the BEAUX ARTS GALLERY. He was elected RBA in 1924, RE and RWS in 1931, ARA and RP in 1936 and VPRWS 1937–41. His work is represented in public collections including the TATE GALLERY. He taught at ST MARTIN'S SCHOOL OF ART and in 1940 was an OFFICIAL WAR ARTIST. His work shows technical mastery in a wide range of media and reflects the influence of Italian art and Cézanne. His watercolours are rapid and direct in contrast to his carefully finished studio works. LIT: His articles in *The Artist*, September 1936 to February 1937, and the catalogue for Julian Hartnoll's Gallery, 1982. CF

MORLEY, Henry, (1869–1937). Painter of landscapes in oils; etcher and pastelist. He studied at Nottingham School of Art and the ACADÉMIE JULIAN, Paris. He exhibited mainly in Scotland at the GI and RSA and he also showed in London

and the provinces, Munich, Berlin and Vienna. His work is represented in public collections in this country and in Munich and Berlin. He was a member of the Glasgow Arts Club and lived for some years in St Ninians, Stirlingshire. His landscapes show scenes of traditional country life, e.g. *Hauling Timber, Stirlingshire*, 1936–7 (Nottingham Castle Museum). CF

MORLEY, John (b. 1942). Born in Beckenham, he studied at Beckenham, Ravensbourne and at the ROYAL ACADEMY SCHOOLS 1963–6. In 1965–6 he held the David Murray Landscape Scholarship, and between 1974 and 1976 won awards from the ARTS COUNCIL. He has exhibited regularly at the Royal Academy since 1962. He has exhibited with the BROTHERHOOD OF RURALISTS, and in 1982 a BBC/TV film *A Week in the Country* was devoted to his work, which has concentrated on carefully-worked English, French and Spanish landscapes, architecture and still-life. AW

MORLEY, Malcolm (b. 1931). Painter of figurative images in oils, acrylic and watercolours. Born in London, he began to study art whilst in prison, later attending CAMBERWELL SCHOOL OF ART 1952–3, and the RCA 1954–7. In 1958 he settled in the USA and held his first solo exhibition in New York at the Kornblee Gallery, 1964. He has shown regularly in New York and abroad and widely in group exhibitions since 1955, exhibiting with the Superrealists in the late 1960s. In 1983 a major exhibition of his work toured Europe and the USA. Represented in collections including MOMA, New York, he has taught in Ohio and New York and in 1984 was awarded the TURNER PRIZE. In America he was initially influenced by Barnett Newman then in the 1960s he depicted figurative images, mainly of ships, using postcards and travel literature as a source for realistic, visually photographic paintings worked through a grid technique. Later work became less realistic in its illusionism and more concerned with texture. In the 1970s he made three dimensional paintings and 'social sculpture' whilst recent figurative work of landscapes and figures uses a rhythmic, gestural technique, painterly abstraction and rich colour. LIT: Exhibition catalogue, The Whitechapel Art Gallery, London, 1983; *Arts in Virginia* USA, Vol.26, pt.3, 1986, pp.2–13. CF

MORRIS, Sir Cedric Lockwood, Bt. (1889–1982). Painter of portraits, still-life, flow-

ers, birds and landscapes, in oils and water-colours. He studied in Paris 1920–6 and exhibited with the AAA, LONDON GROUP and SEVEN AND FIVE SOCIETY and at Tooths. He travelled widely, and lived in Cornwall and London before settling in East Anglia with LETT-HAINES with whom, in 1937, he opened the East Anglian School of Painting. He co-founded the Colchester Art Society and was President of South Wales Art Society. There are examples of his work in many national collections. His style reflects a close observation of people and nature, using strong colour and bold design. His enthusiasm for gardening and flowers is represented by *Iris Seedlings*, 1943 (TATE GALLERY).
LIT: *Cedric Morris*, catalogue, Tate Gallery, 1984. DE

MORRIS, Mali (b. 1945). Painter of abstracts in acrylic. She studied at Newcastle University 1963–8, winning the Hatton Scholarship, and at the University of Reading 1968–70. She has worked in Canada, the USA, Cyprus and Norway, and held her first solo exhibition at the Ikon Gallery, Birmingham, in 1979. She has subsequently shown in London galleries including the Nicola Jacobs and Francis Graham-Dixon Galleries and is represented in the Welsh Arts Council Collection. Influenced by Frankenthaler and Noland in the 1970s, she has developed a directly painted abstraction that achieves harmony through intuitive form and colour.
LIT: Catalogues for the Nicola Jacob Gallery, London 1980, and the Bede Gallery, Jarrow, 1988. CF

MORRISON, Kenneth Maciver, LG (1868–1936). A painter of landscapes, still-lifes, flowers and portraits, he studied at ACADEMIE JULIAN, working in France for some eighteen years after an early career as a portrait painter exhibiting in the RA. He was there influenced by Whistler and Carrière and then by Cézanne and other Post-Impressionists. His career after his return to England in 1920 was helped by the support of ROGER FRY. AW

MORROCCO, Alberto (b. 1917). Painter of portraits, figures, landscapes and still-life in oils and watercolours. He studied under James Cowie at Gray's Art School, Aberdeen, 1932–8, and won the Guthrie Award in 1942. Head of Painting, Duncan of Jordanstone College, Dundee, 1950–82, he was elected to the RSA in 1962 and to the GI in 1977. He has travelled frequently in

Europe and North Africa since the 1930s. He exhibits mainly in Scotland and at the Thackeray Gallery, London. Included in his commissions is a portrait of HM The Queen Mother for Dundee University. His style has gone through periods of experimentation with abstraction but is mainly figurative and based on closely observed studies from nature executed in warm Mediterranean colours.
LIT: *Alberto Morrocco*, Edinburgh Festival Exhibition catalogue, 1987. DE

MORTON, Alastair (1910–1963). Born in Carlisle, he studied at Edinburgh University and at Bailliol College, Oxford, and in 1932 became Art Director of Edinburgh Weavers, within the family business, Morton Sundour. He launched 'Constructivist Fabrics' in 1937, using designs by BEN NICHOLSON and BARBARA HEPWORTH among others; the large-scale abstract textile patterns he commissioned became celebrated in the 1950s. He exhibited his own abstract oil paintings between 1936 and 1962 at the LEFEVRE GALLERY, and his work is represented in the TATE. AW

MOSS, Marlow (Marjorie Sewell Moss) (1890–1958). An abstract painter and sculptor, she was born in Richmond, Surrey, and attended the ST JOHN'S WOOD SCHOOL OF ART and the SLADE. In 1927 she visited Paris, and in 1929 met the Dutch painter Piet Mondrian. She studied under Léger and Ozenfant, and painted non-figurative compositions of parallel lines and constructed relief panels; she was a founder-member of Abstraction-Création. She lived in France until 1940, and, having earlier spent some time in Lamorna, from 1941 she lived and worked for the rest of her life in Penzance.
LIT: *Marlow Moss, 1890–1958*, exhibition catalogue, Gimpel Fils, 1975. AW

MOSTYN, Thomas Edwin, ROI, RWA, R.Cam.A. (1864–1930). Painter of genre, landscapes, figures and portraits in oils. The son of Edwin Mostyn, he studied at MANCHESTER and from 1893 with HERKOMER at Bushey. He exhibited at the RA from 1891 to 1928 and showed widely in galleries, particularly at the FINE ART SOCIETY and Cooling & Sons, London, where a major exhibition of his work was held in 1933. He is represented in Manchester City Art Gallery. His earlier RA exhibits depicted contemporary genre but his later work became more romantic and poetic. He was known for his paintings of religious subjects and, in the 1920s, as a portraitist. His later painting used a

heavy impasto, palette knife technique and bold colour.
LIT: *Stand to your Work. Hubert Herkomer and his Students*, catalogue, Watford Museum, Watford Borough Council, 1983; *Antique Collector* UK, Vol.60, pt.11, November 1989, p.134. CF

MOYES, Jim, (b. 1937). Painter of abstracts in oils and collages. After taking a B.Sc. at Dundee in Electrical Engineering, he studied art at Regent Street Polytechnic and CHELSEA SCHOOL OF ART 1962–66. He has exhibited in London and provincial galleries and taught at Newcastle University and BATH ACADEMY OF ART, Corsham. His work explores the relationship between sound and light and methods of establishing values between tones and colours. CF

MOYNIHAN, Rodrigo, RA, LG, CBE (b. 1910). Painter of abstracts, portraits, still-life, landscapes and figures in oils, gouache, watercolours and pen and wash. Born in Tenerife, he was brought to England in 1918 and lived in New Jersey, USA, from 1924 to 1928. He then returned to Europe and studied in Rome and at the Accademia Rosso, Florence. From 1928 to 1931 he attended the SLADE School and in 1931 visited Madrid where he was influenced by Ribera. He exhibited with the LG from 1932 (member 1933), and between 1933 and 1936 led the Objective Abstraction Group, which included GEOFFREY TIBBLE and GRAHAM BELL, exhibiting with them at the ZWEMMER GALLERY in 1934. Between 1937 and 1940 he was associated with the painters of the EUSTON ROAD SCHOOL and in 1940 he held his first solo exhibition at the REDFERN GALLERY. An OFFICIAL WAR ARTIST in 1943, in 1957 he resigned from the RA and the RCA and subsequently worked in France and in New York. He has exhibited in London galleries including the Redfern from 1940 to 1961, the LEICESTER GALLERIES, at the RA from 1940 (ARA 1944, RA 1954–7, re-elected 1979) and in New York galleries including Karsten Schubert. His work is represented in the TATE GALLERY. Between 1948 and 1957 he was Professor of Painting at the RCA and he was awarded a CBE in 1953. From 1964 to 1968 he was joint editor of *Art & Literature* and in 1970 became a Fellow of University College, London. He married ELINOR BELLINGHAM SMITH in 1931 and Anne Dunn in 1960. His abstract work of the 1930s was influenced by late Monet, Cézanne and Turner, but he then turned to realistic, tonal and figurative images until 1956/7 when he started to paint both abstracts and landscapes which reflected his interest in Chinese painting and the work of Newman and Kelly. In the 1970s he began a series of perceptive portraits and still-life painted in an economic style, a rich but subdued palette and with great refinement of presentation.
LIT: Retrospective exhibition catalogue, Royal Academy of Arts, London, 1978; *Rodrigo Moynihan*, John Ashbery and Richard Shone, Thames & Hudson, London, 1988. CF

MUIRHEAD, David Thomson, ARA, ARWS, NPS, NEAC, RBA (1867–1930). Painter of landscapes, buildings and figures in oils and watercolours. Brother of John Muirhead (1865–1927), he studied at the RSA Schools and at the WESTMINSTER SCHOOL OF ART under FREDERICK BROWN. He settled in London in 1894 and exhibited at the RA from 1895 to 1931 (ARA 1928), at the NEAC from 1896 (member 1900) and widely in societies, particularly the RWS (ARWS 1924), the RSA, RHA and GI, as well as in London galleries including the CHENIL and Rembrandt Galleries. He was a founder member of the NPS and member of the Society of 25 Artists. Represented in the TATE GALLERY, his harmonious work included scenes of the Thames and Essex and richly coloured figure studies.
LIT: *Studio*, Vol.57, 1913, pp.97–106; *English Landscapes by David Muirhead*, catalogue, Colnaghi & Co., London, 1928. CF

MUNCASTER, Claude Grahame, PRWS, ROI, RBA, PSMA (1903–1974). Painter of marine subjects, particularly deck scenes on sailing ships, landscapes and townscapes in oils and watercolours; etcher; writer and lecturer. The son of OLIVER HALL, he exhibited as Grahame Hall until 1945 and was self-taught as an artist. He made several voyages on sailing ships and served in the RNVR in the Second World War. He exhibited at the RA from 1923 to 1969, showed extensively at the FINE ART SOCIETY where his first London solo was held in 1926, and extensively in societies, being elected ARWS in 1931, RWS 1936, PRWS 1951–60, SMA 1939, PSMA 1958, and ROI in 1948. Represented in collections including the TATE GALLERY, his publications include *Landscape and Marine Painting*, Pitman & Sons, 1958, and in 1946–7 he was commissioned by George VI for watercolours of the royal residences. Whilst his early work was meticulously detailed, later paintings became freer in technique but were still based on accuracy of observation.

LIT: *The Wind in the Oak*, Martin Muncaster, Robin Garton, London, 1978; catalogue for the Alpine Club Gallery, London, 1982. CF

MUNDY, Henry (b. 1919). Painter of non-figurative work in oils, acrylics, gouache and mixed media. He studied at Laird School of Art, Birkenhead, 1933–7 and at CAMBERWELL SCHOOL OF ARTS AND CRAFTS 1946–50. He won the William Frew prize, Pittsburgh, first prize in the third JOHN MOORES LIVERPOOL EXHIBITION in 1961, the Abbey Award and an ARTS COUNCIL of Great Britain grant in 1975. He taught at BATH ACADEMY OF ART and ST MARTIN'S SCHOOL OF ART. He has exhibited mainly at the HANOVER GALLERY and the Stone Gallery, Newcastle upon Tyne, and his work is represented in several collections in England, including the TATE GALLERY and the ARTS COUNCIL, as well as in Australia, Canada and the USA. His early lyrical style, which was concerned with discoid and amorphous shapes suspended in white space, has now been replaced by the exploration of variations of the grid principle, as in *Texture Drop Change*, 1971.
LIT: Exhibition catalogue, Stone Gallery, 1961.
DE

MUNNINGS, Sir Alfred James, KCVO, PRA (1878–1959). Painter of landscapes, figures and animals in oils and watercolours. He attended evening classes at Norwich Art School while apprenticed to a lithographer, 1893–8, and won a medal for poster design in 1899. He studied in Paris, 1903, was WAR ARTIST for the Canadian Government in 1918, and travelled extensively in England, Europe and the USA. From 1899 he exhibited mainly at the RA, becoming RA in 1925, and member of the RWS in 1929. Knighted in 1944, he was PRA from 1944 to 1949. He publicly voiced his disapproval of modern art. His admiration for Stubbs and the influence of British Impressionism combine in work such as *Arrival at Epsom Downs for Derby Week*, 1920, (Birmingham). Famous between the wars for large commissioned paintings of racehorses, including one for Queen Mary, he was primarily a painter of English country life.
LIT: Munnings' own works *An Artist's Life*, 1950, *The Second Burst*, 1951, *The Finish*, 1952; *Sir Alfred Munnings, 1878–1959*, S. Booth, 1986.
DE

MURFIN, Michael (b. 1954). Born in St Neots, he attended the Polytechnics of Leicester, Trent

and Birmingham, from 1972 to 1977. His first one-man show was at the Huntingdon Public Library in 1978. He has since exhibited regularly at the PICCADILLY GALLERY. He has participated in a number of 'Artist in School' schemes, as well as many group exhibitions. His precisely executed paintings (in acrylics), are often of figure compositions on themes to do with work, but with dream-like overtones. AW

MURPHY, John (b. 1945). Painter of work combining figurative and non-figurative images in oils. Born in St Albans, he studied at Luton School of Art 1962–4, and CHELSEA SCHOOL OF ART 1964–8. He has held solo exhibitions at the SERPENTINE GALLERY in 1971 and 1984, and at the Whitechapel in 1988, and exhibits in London at the Lisson Gallery, in the provinces and abroad. His work is represented in collections including the TATE GALLERY and it has developed from colour field painting through conceptual installations to recent images which combine a figurative image, abstract field painting and text, often in the form of a fragment of a poem which plays an active part in establishing the mood of the painting.
LIT: Catalogue, Whitechapel Art Gallery, London, and Arnolfini Gallery, Bristol, 1988; *Artscribe International* UK, No.69, May 1988, pp.55–7. CF

MURPHY, Myles (b. 1927). Painter of figures and portraits in oils. He studied at the SLADE SCHOOL 1951–5. In 1955 he won the Abbey Travelling Scholarship and in 1973 the Lorue Award. In 1974 he was awarded first prize at the Ninth JOHN MOORES LIVERPOOL EXHIBITION with *Figure Against a Yellow Foreground*. He taught at the Slade 1958–9, at CHELSEA ART SCHOOL 1960–74, and was Principal of Wimbledon School of Art 1981–8. His work has been included in exhibitions at the TATE GALLERY and with the ARTS COUNCIL. His figurative style often depicts single nude figures in a setting of spatial ambiguity.
LIT: 'A Prize Hermaphrodite for the Institutionalized Avant Garde', *Connoisseur*, September 1974. DE

MURRAY, Charles (1894–1954). Painter, etcher and wood engraver of landscapes, figure compositions and still-life. He studied at GLASGOW SCHOOL OF ART, and won the PRIX DE ROME for etching in 1922. He turned to landscapes and religious subjects during the later 1930s. His

work was often characterized by an intense and dramatic exaggeration of the forms and rhythms of a composition. A retrospective was held at Temple Newsam House, Leeds in 1955.
LIT: *Charles Murray, 1894–1954*, Sir John Rothenstein, London, 1977. AW

MUSZYNSKI, Leszek, RBA (b. 1923). Born in Poland, during the Second World War he escaped to Scotland, served in the armed forces and was wounded at the battle of Breda. In 1964–9 he attended EDINBURGH COLLEGE OF ART, and later moved to England, where he taught at Farnham School of Art, eventually becoming Head of the Painting School. He has exhibited widely at the RSA, the RA, the RBA, in the USA and in Poland, where a retrospective travelled in 1989. A painter in oils of figure compositions, landscapes and portraits, a pastellist and occasionally printmaker, he has worked much in Mexico and Ibiza; favourite themes are of the Spanish peasantry, executed in intense, glowing colour.
LIT: *Leszek Muszynski*, catalogue, London, Poznan, Warsaw, Krakow, 1989.

MYER, Hyam, LG (b. 1904). A painter of figures, landscapes and still-life, he studied at the SLADE under TONKS, and in Paris and Italy. His simplified and refined figures have affinities with those of Marie Laurencin. AW

MYNOTT, Derek, NEAC, RBA, DFA (b. 1926). Painter of landscapes, still-life and townscapes in oils and watercolours; printmaker. He studied at High Wycombe School of Art in 1939, and at the SLADE 1946–50, under SCHWABE and COLDSTREAM, holding his first solo exhibition at the RBA Galleries in 1953 (member 1952). He has shown in London, at the RA since 1972, in Paris and the USA. Winner of the de Laszlo Medal in 1974, his work is represented in the TATE GALLERY. His poetic, formally selective paintings often depict London parks, gardens and river scenes.
LIT: Catalogue for the Mall Galleries, London, 1975. CF

N

NALECZ, Halima (b. 1917). Painter of flowers in oils and gouache. Born in Poland, she studied in Paris and travelled extensively. She helped launch New Vision Centre in 1953. She exhibits widely, principally at the Drain Galleries, London, which she founded in 1957 and directs. Her exotic, colourful floral fantasies are in thick impasto.
LIT: See the catalogues of her exhibitions at the Drain Galleries. DE

NAPPER, John (b. 1916). He studied at Dundee School of Art 1930–3, at the RA SCHOOLS 1933–4, and under GERALD KELLY 1936–8. He was an OFFICIAL WAR ARTIST in Ceylon, 1943–4. His first one-man show was at the LEICESTER GALLERIES in 1949. He has taught at ST MARTIN'S, 1949–57, at the University of Southern Illinois, 1968–9, and lived in Paris 1957–68. His figurative painting, derived from his surroundings, is carefully-wrought and simplified in character. He is well known for his portraits of royalty and of celebrities. AW

NASH, John Northcote, CBE, RA (1893–1977). Painter, wood engraver and illustrator. His best known works are landscapes of the quintessentially English scene, but he also did still-life, comic illustrations and war paintings, working both in oil and watercolour. Educated at Wellington, he had no formal art training but was encouraged by his brother PAUL NASH. In 1913 they shared an exhibition at the Dorien Leigh Galleries. He was on active service in France, 1916–18, and an OFFICIAL WAR ARTIST in 1918 (*Oppy Wood, Evening*, 1917, 1919; *Over The Top, The 1st Artists Rifles at Marcoing*, 1918–19). His first one-man show was at Goupil's in 1921; he exhibited at the RA (ARA 1940, RA 1951) and taught at the RUSKIN SCHOOL, 1922–7, and at the ROYAL COLLEGE, 1934–40 and 1945–57. In 1940 he was again briefly an Official War Artist, attached to the Admiralty, but gave up painting to join the Royal Marines. He lived most of his life in Buckinghamshire, but he and his wife Christine moved to Essex in 1944 and became deeply attached to the Stour Valley, which provided him with an unending source of inspiration for his carefully painted, usually clear-coloured, light-toned landscapes. In 1967 the RA held a major retrospective of his work.
LIT: *John Nash*, Sir John Rothenstein, Macdonald, 1983; *John Nash, The Delighted Eye*, Allen Freer, Scolar Press, 1993. LP

NASH, Paul (1889–1946). He is best known for his landscapes in oil, watercolour, gouache, pen

and ink and pencil; also a photographer. After St Paul's School, encouraged by Selwyn Image and the poet Gordon Bottomley, he studied briefly at CHELSEA POLYTECHNIC, at an LCC technical school and then at the SLADE SCHOOL 1910–11. His first one-man exhibition was at the Carfax Gallery in 1912, where he showed work inspired by Palmer and the Pre-Raphaelites. He did some work for ROGER FRY'S OMEGA WORKSHOPS, and in 1914 married Margaret Odeh after joining the Artists' Rifles. He saw active service at Ypres but was injured in an accident shortly before most of his fellow officers were killed. After convalescence and an exhibition of his watercolours from France, he returned to the Front as an OFFICIAL WAR ARTIST. 'I am a messenger who will bring back word from the men who are fighting to those who want the war to go on for ever' he wrote to his wife: 'Feeble, inarticulate will be my message, but it will have a bitter truth and may it burn their lousy souls'. He began to use oils for the first time, carefully converting studies made on the battlefields, e.g. *The Menin Road*, 1919 (Imperial War Museum). After the war he designed theatre sets for a short while; in 1922 he visited Paris, and in the later 1920s painted interiors with affinities with the Italian 'Metaphysical' school. From *c.*1929 he began taking photographs relating to his paintings, and from 1930 wrote some art criticism. He travelled to the USA in 1931. A visit to Avebury in 1933 inspired him with the primitive emotional power of prehistoric megaliths in landscape. In that year he also organized UNIT ONE (which united both abstract and Surrealist tendencies, as did his own work at the time) with MOORE, HEPWORTH, NICHOLSON, BURRA and WADSWORTH; in 1936 he was an organizer of the International SURREALIST Exhibition in London, also exhibiting with the Surrealists in 1937 and 1938; among his contributions were *Found Objects*. His work evoked the magic spirit of landscape, poetic, often disturbing and sometimes bleakly pessimistic. He painted some semi-abstract fantasies during the 1930s. During the Second World War he was again an Official War Artist, recording the war in the air, expressing the anthropomorphism of these 'alarmingly beautiful monsters': examples are *Bomber in a Wood*, 1940, and *Totes Meer*, 1940–1 (TATE). In his last months he painted a number of intensely coloured sunflower paintings.
LIT: *Outline: An Autobiography*, Paul Nash, Faber, 1949; *Paul Nash*, Andrew Causey, OUP, 1980. LP

NASH, Thomas Saunders (1891–1968). Painter of figure compositions, religious subjects, landscapes and portraits in oils, often on strawboard. He studied at the SLADE SCHOOL 1909–12, where he met STANLEY SPENCER and became influenced by him. In 1912–13 he attended the Government Art Classes in Reading, living at Pangbourne. He exhibited at the RA, the NEAC and at the REDFERN GALLERY. His *Crucifixion*, 1928, and *Hop Pickers*, 1929, were bought by the CONTEMPORARY ART SOCIETY.
LIT: *Tom Nash*, catalogue, Reading Museum and Art Gallery, 1979. LP

NASH, Tom (b. 1931). Born in Wales, he studied at Swansea College of Art 1950–4, and whilst working in the slate quarries his painting moved from the naturalistic to the abstract, often developing such paintings from written information in sketchbooks rather than from drawings. He worked in Paris and in Provence in 1963 after winning a travelling scholarship; an Associate of the Royal Cambrian Academy he has had many solo exhibitions; his work is in the ARTS COUNCIL and other national collections. He now lives in Dyfed. LP

National Art Training School, see ROYAL COLLEGE OF ART

NAVIASKY, Philip (b. 1894). Painter in watercolour, pastel and oil of landscapes and portraits. He studied at the Leeds School of Art and the RCA. He exhibited widely in the period 1914–40 and had a one-man show at the Harris Museum and Art Gallery, Preston in 1932–3. He also exhibited at the ROI, RSA and the RA. He is best known for his portraits in oil of women and children, and for his atmospheric landscape paintings and sketches of the Yorkshire Moors.
LIT: *Philip Naviasky*, catalogue, Harris Museum and Art Gallery, Preston, 1932–3. LP

NEVINSON, Christopher Richard Wynne (1889–1946). Painter of landscapes, urban and industrial subjects, war scenes, figure studies and flower paintings; an accomplished etcher and lithographer who worked in a variety of styles. He attended ST JOHN'S WOOD SCHOOL OF ART 1907–8, the SLADE SCHOOL 1908–12 and the ACADÉMIE JULIAN, Paris, 1912–13, where he shared a studio with Modigliani, worked at the Cercle Russe and made friends with Severini. Interested in Cubism and Futurism, he was one of the first English artists to be deeply influenced

by new developments in Europe at that time; his work was included in the 'Post-Impressionists and Futurists' exhibition at the Doré Gallery in 1913, and he organized a banquet for the Futurist leader Marinetti in London in that year. A founder member of the LONDON GROUP, and active in the REBEL ART CENTRE, he wrote, with Marinetti, 'Vital English Art: A Futurist Manifesto', published in the *Observer* in 1914; he also contributed to the second issue of *Blast*. In 1915 he joined the RAMC, and was made an OFFICIAL WAR ARTIST in 1917; he was the first artist to draw from the air. He tried to sum up the anonymity of the individual in *Column on the March*, 1915, the destructiveness of war in *The Road From Arras to Bapaume*, 1918, and its horror in *Paths of Glory*, which was censored and earned him a reprimand from the War Office. His prints, with their bold contrasts and jagged forms marked a complete break with the Whistler tradition. In 1919 and 1920 he visited New York, and his emotional response inspired work such as *The Soul of A Soulless City*, 1920. He was elected to the NEAC in 1929, the RBA in 1932 and as ARA in 1939. His later landscape and flower pieces were gentler and less radical in design than his work before 1925.
LIT: Retrospective exhibition catalogue, Kettle's Yard, Cambridge, 1988–9. LP

New English Art Club (1886-). Founded by former Academicians such as SARGENT, STEER, LAVERY and BROWN, as well as CLAUSEN and STANHOPE-FORBES, as a reaction against the restrictive and parochial attitude of the RA. Members of the GLASGOW SCHOOL also joined in 1887. The NEAC was considered to be the modern wing of British art up to the turn of the century, although admiration was for Whistler, Legros and Manet rather than the more radical French Impressionists. There were about fifty members at the time of the inaugural exhibition in April 1886 at the MARLBOROUGH GALLERY. In 1887 an important amendment to the constitution allowed the previous year's exhibitors as well as members to elect the selection jury. The NEWLYN and Glasgow Schools dominated the Club until 1889 when their position was challenged by the London Impressionists led by SICKERT, who joined in 1888 and whose work outraged some members. Sickert's criticism of the Newlyners led to their resignation in 1890 and the Glaswegians in 1891. Sickert quit in 1897 but returned in 1906. The SLADE infiltrated the ranks in the 1890s with younger men such

as RUSSELL, ROTHENSTEIN, JOHN, GILMAN, GORE and PISSARRO. There was increasing polarization between the conservative wing of anglicized Impressionism, as practised by Clausen, and younger painters (susceptible to Post-Impressionist influences) such as BEVAN, GINNER and MANSON who were never invited to exhibit. Steer remained faithful, but the more reactionary faction returned to the RA in 1910 and the more progressive formed the Camden Hill Group. The NEAC, which was the first of many independent exhibiting societies, contributed to the introduction of French studio practices of life drawing and modified *plein-air* techniques in more advanced London art schools, and is still in existence. DE

New Grafton Gallery was founded in 1968 and is now situated at 49 Church Road, Barnes, London. The Director is David Wolfers and the Gallery exhibits mainly figurative English painting and drawing by living artists and English painting from 1900 to 1940, it also has a permanent Portrait Centre. Artists who have exhibited with the Gallery include TOM COATES, FRED DUBERY, MARY FEDDEN, PETER GREENHAM, JOHN NASH, RUSKIN SPEAR, KEITH VAUGHAN and CAREL WEIGHT. CF

NEWBERY, Francis H. (1855–1946). Painter of genre scenes and a distinguished teacher. Born in Devon, he studied at Bridport Art School, the SOUTH KENSINGTON SCHOOL OF ART and the RCA. He married fellow artist Jessie Rowat. He exhibited widely, especially at the RA, RBA, RSA and RSW; his work, influenced by realism and impressionism, is in many collections. He was made Director of the GLASGOW SCHOOL OF ART in 1885, and during his period there the great building by C.R. MACKINTOSH, one of his favourite pupils, was designed and constructed. He later retired from Glasgow to Corfe. LP

NEWLAND, Paul (b. 1946). He studied at the SLADE SCHOOL 1964–8, and won a French Government Scholarship.. He lived in Rome, 1975–6, and often revisits Italy. His first one-man show was at the University of Sussex in 1974–5. He shows at the RA, with the LONDON GROUP and at the NEW GRAFTON GALLERY. His range of work includes landscapes, portraits, figure compositions and nudes, in watercolours and oils. His landscapes and interiors are usually drawn from English and Italian country locations. LP

The **Newlyn School**. From *c*.1885–1895 the Newlyn School represented a clear reflection of late nineteenth-century French painting in British art. Painters were attracted to Newlyn during the 1880s by the spirit of friendship amongst the artists, many of whom had trained in Paris and Antwerp and worked in artists' colonies in France, and by the climate and environment in Newlyn itself. The first artists to settle there in 1882 were WALTER LANGLEY and Edwin Harris, followed by STANHOPE FORBES in 1884 and others including FRED HALL, Frank Bramley, THOMAS COOPER GOTCH, HENRY SCOTT TUKE, A. CHEVALLIER TAYLER, Elizabeth Armstrong, NORMAN GARSTIN and FRANK WRIGHT BOURDILLON. Many of the artists were associated with the NEAC, but the RA became their main exhibiting forum and it was the success of Forbes' *A Fish Sale on a Cornish Beach*, RA 1885 (Plymouth Museum and Art Gallery), that established Newlyn in the public eye. By the end of the decade the title 'Newlyn School' was in use and the first articles devoted to Newlyn painting were published in the *Art Journal* of 1889 by Alice Meynell. The painters were committed to *plein-air* painting and to subjects depicting the lives of ordinary people painted with realism and authenticity. Influenced by the Barbizon painters and particularly by Bastien-Lepage, they portrayed the life of the Newlyn area in interior and exterior scenes using local models. Initially they used the square brush technique, a method most prominent in the work of LA THANGUE which blurred outlines and enabled the artist to suggest the shimmer of atmosphere and light surrounding forms. By the end of the 1880s, however, most of the Newlyn artists had adopted a smoother style. With their growing success at the RA, the departure of some of the artists and the opening of the Pasmore Edwards Gallery in 1895 which became the base for the Newlyn Society of Artists, the character of painting in Newlyn altered and the unity of purpose that had existed was no longer so evident. A new generation of artists, including LAMORNA BIRCH, HAROLD and LAURA KNIGHT, ALFRED MUNNINGS and HAROLD and GERTRUDE HARVEY depicted a wider range of subjects with a brighter palette and the school of painting established by Stanhope and ELIZABETH FORBES also introduced new artists to the area including DOD and ERNEST PROCTER.
LIT: 'A Newlyn Perspective', Stanhope Forbes, *The Cornish Magazine*, Vol.I, 1898; *Painting in Newlyn 1880–1930*, catalogue by Caroline Fox and Francis Greenacre, Barbican Art Gallery, London, 1985. CF

NEWMAN, Avis (b. 1946). A painter, her first solo exhibition was at the Ikon Gallery, Birmingham. Her informal, spare, chaotic marks in various media suggest human figures; together with tiny, disturbing images and symbols, they have some of the character of prehistoric rock and cave paintings. *Figure who no-one is* (1983–4) is a five-part polyptych exhibited in 1984 at the SERPENTINE. AW

NEWSOME, Victor (b. 1935). Painter and sculptor, he was born in Leeds and studied at Leeds College of Art 1953–5 and 1957–60, after having completed his National Service. He was ROME SCHOLAR in Painting 1960–2, where he began working in three dimensions. His first one-man show (of sculpture) was at the Grabowski Gallery in 1966; he received a Peter Stuyvesant travel bursary in that year, visiting America, and an ARTS COUNCIL Sabbatical Award in 1967. He has taught both painting and sculpture at Leicester, Hull, Brighton, CAMBERWELL, GOLDSMITHS' and other Schools of Art. Many of his paintings of the 1970s were of bathrooms (in oils, tempera or acrylic), using complex architectural measured drawing techniques to establish an ambiguity of light, shadow and space with water, reflections and the evocation of figures.
LIT: *Victor Newsome*, exhibition catalogue, Marlborough Fine Art, 1987. LP

NEWTON, Algernon C., RA (1880–1968). Born in London, he studied at Clare College, Cambridge, then at Calderon's School of Animal Painting, at the SLADE and at the London School of Art. His first one-man show was at the LEICESTER GALLERIES in 1931. He was best known for his topographical city scenes of London (often at twilight) in oils. His *Surrey Canal, Camberwell*, 1935, was purchased by the CHANTREY BEQUEST. LP

NEWTON, Eric (1893–1965). Art critic and author. Educated at Manchester University, he was trained for a period as a craftsman in mosaics for a Manchester firm, and eventually became art critic of the *Manchester Guardian*, Slade Professor at Oxford, 1959–60, and Lecturer in Art History at the CENTRAL SCHOOL from 1963 until his death. He published books on CHRISTOPHER WOOD (1938) and STANLEY SPENCER (1947). AW

NICHOLLS, Bertram, PRBA, ROI (1883–1974). Painter of landscapes in oil and

watercolour. He studied at the SLADE 1901–4, and in Spain, Italy and France. He exhibited at the NEAC in 1905, at the Manchester Academy of Arts from 1914 (President 1921–31) and at the RA, RBA (PRBA 1931), ROI and RSA. He had his first one-man show at Barbizon House in 1924 and exhibited regularly at the FINE ARTS SOCIETY. He was President of the Society of Sussex Painters. He lived in Steyning, Sussex from 1912. His *Drying the Sails* of 1920 and *Steyning Church* of 1921 are typical works. (TATE GALLERY.) LP

NICHOLSON, Ben, OM (1894–1982). Born at Denham, Buckinghamshire, the son of WILLIAM NICHOLSON, he studied at the SLADE SCHOOL 1910–11, and travelled widely in Europe and the United States 1912–18. He married Winifred Roberts (WINIFRED NICHOLSON) and they lived (1920–31) in London and Cumberland, spending winters in Castagnola, Switzerland. His first one-man show was at the Adelphi Gallery in 1921, and he visited Paris in that year, seeing paintings by Picasso and Braque. During a visit to Cornwall in 1928 with CHRISTOPHER WOOD, the Nicholsons met ALFRED WALLIS, and bought work from him. Nicholson was a member of the SEVEN AND FIVE SOCIETY, and, until he and Nash (a friend from his year at the Slade) moved apart, he was active in UNIT ONE. In 1932 he visited Paris with BARBARA HEPWORTH (who became his second wife in 1934) and met Picasso, Braque, Brancusi and Arp. On subsequent visits to Paris in 1933 and 1934 they met Mondrian and Moholy-Nagy. Jean Hélion encouraged him to join Abstraction-Création in 1933. His *Au Chat Botté*, 1932, reflects his contact with Braque, and his White Reliefs of 1933–8, which were carved, suggest the influence of both Hepworth and Mondrian; he also acknowledged his debt to Miró. In 1937 he was an editor of *Circle*, and from 1939 to 1958 lived in Cornwall. In 1951 he was commissioned to paint a mural for the Festival of Britain; in 1954 had a retrospective exhibition at the Venice Biennale, in 1955 at the TATE (another was held in 1969), and was subsequently awarded many international prizes. His earlier figurative work absorbed naive approaches to drawing and composition; he later moved regularly between abstraction and figuration, always in cool, harmonious colours, subtle textures and typically in precisely shaped interpenetrating and interlocking shapes. He married a third time and in 1958 moved to Ticino in Switzerland.

LIT: *Ben Nicholson, Paintings, Reliefs, Drawings*, Introduction by Herbert Read, Lund Humphries, 1948; *Ben Nicholson*, retrospective exhibition catalogue, Tate Gallery, 1969; *Ben Nicholson*, Norbert Lynton, London, 1993. LP

NICHOLSON, Kate (b. 1929). Born in Cumberland, the daughter of BEN NICHOLSON and WINIFRED NICHOLSON. She studied at BATH ACADEMY OF ART 1949–54. She regularly worked with her mother on visits to Greece and had her first one-man exhibition at WADDINGTON'S in 1959. She works and exhibits in the places associated with her life: Cornwall and Cumbria. LP

NICHOLSON, Rachel (b. 1934). Born in London, the daughter of BEN NICHOLSON and BARBARA HEPWORTH. She paints mainly landscapes and still-lifes in acrylic on board, simplifying shapes and using fresh colour. Her first one-man show was in 1979 at the Field Gallery, Nottingham, and she has exhibited regularly at the Montpelier Studio, in St Ives and elsewhere. LP

NICHOLSON, Sir William Newzam Prior, NPS, IS (1872–1949). Painter in oils, well known for still-lifes, he executed a wide range of works, including portraits, flower pieces, landscapes and animals; woodcuts, poster designs and stage sets. Born at Newark-on-Trent, he studied under Herkomer 1888–9, and in Paris at the ACADÉMIE JULIAN 1889–90. There he met JAMES PRYDE, and married his sister Mabel; with Pryde he enjoyed great fame, designing posters and graphic works together as 'The Beggarstaff Brothers', 1893–9, introducing a witty and striking mode using simplified silhouetted forms in few colours. He had colour woodcuts published by Heinemann from 1896 to 1900 (e.g. *The Alphabet* and *Queen Victoria*, 1897). He travelled widely in Europe and also visited New York in 1901–2. He designed the first sets for *Peter Pan* in 1904. His first one-man show was at the Patterson Gallery in 1906. From 1903 his greatest reputation was as a portraitist (he was a founder member of the NPS in 1911), and his assured, essentially Whistlerian style of close-toned colour gave way to the use of brighter colours during the 1920s. LIT: *William Nicholson*, Lillian Browse, Rupert Hart-Davies, 1956; *William Nicholson, Paintings, Drawings and Prints*, catalogue, Arts Council, 1980. LP

NICHOLSON, Winifred (1893–1981). Born in Oxford, she is perhaps best known for her flower

paintings, but she also executed many landscapes, and during the 1930s some abstracts. She studied at the BYAM SHAW SCHOOL OF ART and exhibited at the RA as early as 1914. Travel and study in Paris, Lugano and India, was important to her. She married BEN NICHOLSON in 1920, subsequently exhibiting with him, at the Paterson Gallery in 1933, with the SEVEN AND FIVE SOCIETY, at the LEICESTER, LEFEVRE and CRANE KALMAN Galleries. Flower pieces before a window, with landscape elements from Cumberland, Cornwall and the South of France were characteristic of the 1920s, and abstracts using an elipse shape were executed during the 1930s; she considered colour to be all important, aiming for a clear vibrancy of hue. She was on friendly terms with Hélion, Mondrian and Hartung. In 1931 she separated from Ben Nicholson, and lived until 1938 in Paris; subsequently she lived in Cumberland. She sometimes used the surname 'Dacre'. Her work is in the TATE GALLERY, and in many other national and international collections.
LIT: *Unknown Colour: Paintings, Letters and Writings by Winifred Nicholson*, Winifred Nicholson, Faber, 1987; *Winifred Nicholson*, Judith Collins, retrospective exhibition catalogue, Tate Gallery, 1987. LP

NISBET, Noel Laura (1887–1956). Painter in oils and watercolours of landscapes, figures and flower pieces. She also worked in black-and-white and as an illustrator. Born in Harrow, the daughter of the author and painter Hume Nisbet, she married the artist Harry Bush. She studied at SOUTH KENSINGTON, winning gold medals and the Princess of Wales Scholarship. She exhibited at the RA from 1914, at the ROI and the RI. She became well known for her illustrations, for example of *Russian Fairy Tales*.
LIT: *The Last Romantics*, ed. John Christian, Lund Humphries, 1989. LP

NIXON, Job, RWS, RE, NEAC (1891–1938). A watercolourist and etcher, he studied at Burslem, the RCA, and after the First World War, at the SLADE. He won the PRIX DE ROME for engraving in 1920, and from 1924 taught at the RCA under MALCOLM OSBORNE. He depicted many scenes in France and Italy. AW

NUTTALL, Jeff (b. 1933). Painter, poet, performer and ceramist. His paintings and drawings have often explored erotic themes, usually with a strong element of the grotesque. He has also been active as a performance artist, as well as teaching at Leeds Polytechnic. He has exhibited at Angela Flowers Gallery. LP

O

O'CASEY, Breon (b. 1928). Painter, sculptor and jeweller. He studied for three years at the ANGLO-FRENCH ART CENTRE and was assistant to BARBARA HEPWORTH (1959–62) as well as to DENIS MITCHELL in St Ives. His first one-man show of paintings was at Somerville College, Oxford, in 1954. He has regularly exhibited with the PENWITH SOCIETY. His paintings have some characteristics of the ST IVES SCHOOL, being small abstracts, often on irregularly shaped pieces of wood, executed in warm earth colours; simple, 'primitive' and eloquent in outline. AW

O'CONNOR, John, RE, RWS, ARCA (b. 1913). Painter of landscapes in oils and watercolours; wood engraver, lithographer, writer and illustrator. He studied at Leicester College of Art 1930–33, and at the RCA under RAVILIOUS, JOHN NASH, R.S. AUSTIN and TRISTRAM. He exhibited mainly at ZWEMMER Gallery and from 1970 at the NEW GRAFTON GALLERY, as well as at the RA from 1955. His work is represented in the TATE GALLERY and other public collections. He taught widely and from 1948–64 was Principal, Colchester School of Art. He wrote and illustrated books and in 1960 designed murals for Basildon New Town. His landscape subjects seek the timeless aspects of the country and his watercolours are spontaneously and rapidly executed outside.
LIT: See his own books *Landscape Painting*, Studio Vista, 1968, and *A Pattern of People*, Hutchinson, 1961. CF

O'CONOR, Roderic Anthony (1860–1940). Painter in oils of landscapes, figures, portraits, interiors and still-life subjects; etcher. Strongly Francophile, especially influenced by Gauguin and the Pont-Aven circle, O'Conor was an important British exponent of Post-Impressionism. Always experimental and stylistically eclectic, O'Conor's work was often characterized by strong colour and richly applied impasto. Born at Milton, Co. Roscommon, Ireland, in 1865 his family moved to Dublin. After attending Ampleforth College, Yorkshire, 1873–8, O'Conor studied at the Metropolitan

School of Art, Dublin, 1879–81 and 1882–3, and at the RHA, Dublin, 1881–2. Successful in Ireland, he furthered his studies in Antwerp, 1883–4, before moving to Paris to study under Carolus-Duran, c.1887. Settling in Paris, this became his centre of operations. Although probably visiting the region earlier, O'Conor worked in Brittany regularly from 1891 to 1904. Often at Pont-Aven, he formed important friendships with Séguin, Amiet, Filiger, FORBES-ROBERTSON and Gauguin during the 1890s. Gauguin proposed that O'Conor should accompany him to the South Seas in September 1894. Van Gogh, whose work O'Conor knew from 1890, was an important stylistic influence. Travelling to London in 1891, O'Conor again visited Ireland on the death of his father in 1893 – an event which left the painter financially secure. From 1904 O'Conor again settled in Paris, visiting Italy in 1910, and travelling to Spain in 1912, 1934 and 1935. His work before the First World War often consisted of 'Intimiste' interiors and still-life. In the summer of 1913 he painted at Cassis. In 1933 he married and moved from Paris to Nueil-sur-Layon. Although holding only one one-man show (Galerie Bonaparte, Paris, 1937), O'Conor exhibited widely on the Continent. First showing at the Paris Salon in 1888, he exhibited with the Salon des Indépendants and regularly at the Salon d'Automne from its inauguration in 1903. Exhibiting at le Barc de Boutteville, he also showed in Brussels. Having exhibited early on at the RHA and NEAC, O'Conor maintained his British and Irish connections, exhibiting at the Guildhall exhibition of Irish painters of 1904 and with the AAA. Among his English contacts in Paris were CLIVE BELL, ROGER FRY and MATTHEW SMITH, whom he met in 1919.
LIT: Retrospective exhibition catalogue, compiled by R. Johnston, The Barbican Art Gallery, 1985. GS

O'DONNELL, Hugh, (b. 1950). Painter of abstracts and semi-abstracts in oils, acrylic on collage and mixed media. He studied at CAMBERWELL, Falmouth and Birmingham Schools of Art and in Japan 1974–76. He has taught widely and exhibited in London galleries, including MARLBOROUGH FINE ART, and in Tokyo. His boldly coloured and brushed work, sometimes on shaped supports, reflects his interest in Japanese art. Recent work has become organic and full of movement with references to the natural world.
LIT: The catalogue for Marlborough Fine Art, 1985. CF

Official War Artists; War Artists Advisory Committee; WAAC. The Official War Artists' Commission was brought into being by C.F.G. Masterman, a Liberal politician who became Director of Propaganda in September 1914. In 1916, MUIRHEAD BONE was employed to make drawings at the Front, and Masterman set up a committee which made further appointments. Starting in December 1916, Bone's drawings were published in reproduction, as were those of DODD, LAVERY, NASH, KENNINGTON and NEVINSON. Some artists were seconded from active service; various means were used to make others commissioned officers or to put them into uniform attached to the Intelligence Department, the Department of Information or as War Correspondents. The average stay at the Front for an artist was one month. All work was censored; no dead bodies, either Allied or German, were allowed to be depicted. Apart from that, artists could draw whatever they chose, and were free to exhibit their work as they wished; pictures were not necessarily acquired and copyright was only reserved for the duration of the war. Many of the artists pulled no punches in their depiction of waste and devastation; there was little or no aggressive or nationalistic work produced. Although a fairly small band of artists was chosen on an improvised basis, the Official War Artists Scheme encouraged some of the finest British art of the first half of this century.

The War Artists' Advisory Committee, with the brief to 'draw up a list of artists qualified to record the war at home and abroad' was set up in 1939 by Lord Macmillan, the Minister of Information, at the suggestion of Sir Kenneth (later Lord) CLARK. Committee members included Muirhead Bone, P.H. JOWETT and RANDOLPH SCHWABE. Artists were more systematically mobilized and briefed (some 800 names were considered) than in the First World War. Each Service was to have attached to it the artists it requested, but the Committee had a say in their selection, the direction of their work and advised on the use and destination of the pictures. Some artists were put on salaries for periods, some were given specific commissions, and in some cases work was bought from artists who approached the committee with work already done. As in the First World War, the choice of artists was remarkably felicitous, and whilst fewer works expressed the bitterness and horror of war, a great wealth of images, distinguished for their sober humanity, poetic vision and occasional humour were produced by artists

237

such as Nash, COLDSTREAM, GROSS, BAWDEN, RAVILIOUS, PIPER, MOORE, SUTHERLAND and many others.
LIT: *Artists at War, 1914–18*, catalogue, Robert Cumming, Kettle's Yard, Cambridge, 1974; *The War Artists*, Meirion and Susan Harries, Michael Joseph, IWM and the Tate, 1983. AW

OFILI, Chris (b.1968). From Manchester, he studied art at CHELSEA and the RCA. A prizewinner at the 1991 Whitworth YOUNG CONTEMPORARIES, his elaborately patterned, intensely coloured semi-abstracts and figurative subjects have included collaged photographs (often of black celebrities) and other materials such as the dried elephant dung he brought back from travel on a British Council Scholarship (1993) to Zimbabwe (for example, *Popcorn Tits*, 1996). In 1995 he had a one-man show at Gavin Brown's Enterprise, New York; his work figured prominently in 'The British Art Show 4' (South Bank Centre, 1996) and at 'Sensation' (RA, 1997). AW

OLIVER, Kenneth Herbert, ARCA, RWS, RE, RWA (b. 1923). Painter of landscapes, interiors and figures in watercolours; etcher and engraver. He trained at Norwich School of Art 1939–42, and at the RCA 1947–50, under R.S. AUSTIN. He has exhibited at the RA from 1949 and also shown his work at the RWS, RE, and the RWA, in the provinces and abroad. His work is represented in the Cheltenham Museum and Art Gallery, the RWA Collection and in private collections. He was Head of Printmaking, Gloucestershire College of Arts and Technology, until 1987, and is a member of the Cheltenham Group of Artists. His work records natural rhythms and detail in a selective and sensitive manner. CF

OLIVIER, Herbert Arnould, RI, RP, RE, RBC, RBA (1861–1952). Painter of portraits, figures and landscapes in oils and watercolours. He studied art at the RA SCHOOLS, winning the Creswick Prize in 1883. He exhibited extensively at leading societies and galleries including the RA, RP, RBA, RI and the FINE ART SOCIETY. He also showed abroad and was a silver medallist at the Paris Salon. He was elected RBA in 1887, RP in 1894 and RI in 1929. His work is represented in several public collections including the TATE GALLERY and the IMPERIAL WAR MUSEUM. He was Honorary Secretary of St John's Wood Art Club and in 1917 was made an OFFICIAL WAR ARTIST. His portrait style was lively and direct, giving a posed but relaxed account of his sitter, e.g. *Dame Freya Stark*, 1923 (National Portrait Gallery). CF

OLSSON, Julius, RA, RBA, RWA, NEAC, HRMS, PROI, (1864–1942). Painter of seascapes and landscapes in oils. He had no formal training but painted in London and abroad. He exhibited at the RA from 1890, becoming RA in 1920, and showed widely in leading societies and galleries in London and the provinces. He also exhibited abroad and was a gold medallist at the Paris Salon. He was elected RBA in 1890, NEAC in 1891, ROI in 1897, PROI in 1919 and HRMS in 1926. His work is represented in public collections including the TATE GALLERY. He lived in St Ives from 1896/7–1915 where he was a member of the St Ives Arts Club and amongst the artists that he taught and encouraged were JOHN PARK and BORLASE SMART. He served twice on the international jury of the Carnegie Institute, Pittsburgh. His best known works are seascapes, often of rough seas and also of moonlit scenes, painted in an impressionistic style.
LIT: 'Painter of Seascapes', A.G. Folliott Stokes, *Studio*, Vol.XLVIII, p.274. CF

OLVER, Kate Elizabeth, SWA (d. 1960). Painter of figures and portraits in oils and watercolours; illustrator. She trained at the RA SCHOOLS and exhibited mainly at the RA 1910–46, as well as at the SWA, becoming a member in 1935, the RP, in Scotland, Liverpool and at the Paris Salon. Her figures are realistically and delicately observed, e.g. *The Gypsy Dancer*. CF

O'MALLEY, Tony (b. 1913). Born in Callan, Co. Kilkenny, he worked in the Munster and Leinster Bank from 1933 until 1958, apart from military service for a year, 1940–1. During much of this time he suffered from periods of ill-health. In 1960 he moved to Cornwall, settling in Seal Cottage in St Ives in 1969, although he has now returned to Ireland. From 1977 onwards he regularly visited the Bahamas. His first one-man show was in 1961 in St Ives, and his first in London was at the Marjorie Parr Gallery in 1966. Since then he has taken part in many one-man and group exhibitions, and the ARTS COUNCILS of Ireland, of Northern Ireland and of Great Britain have toured his work nationally. In 1981 he was awarded the Douglas Hyde Gold Medal, and in 1989 elected honorary member of the Royal Hibernian Academy. His work is in many public collections, including those of the Arts Council of Ireland, the

Ulster Museum Belfast and the CAS. His oil paintings, watercolours and gouaches are abstracted from his experience of the radiant colour and light of the landscapes and seascapes where he lives.
LIT: Radio Telifes Eirann documentary film, *Places Apart*, 1982 *Tony O'Malley*, edited by Brian Lynch, Scolar Press, 1996. AW

Omega Workshops (1913–1919). Set up in London in 1913 by ROGER FRY, with VANESSA BELL and DUNCAN GRANT, as an artists' cooperative to provide an income for impoverished artists with similar interests. The Omega Workshops were officially opened on 13 July 1913 at 33 Fitzroy Square, Bloomsbury. Fry was the organizer and Grant's imagination dominated the designs. ETCHELLS and WYNDHAM-LEWIS were founder members and up to twenty artists such as GAUDIER-BRZESKA, PAUL NASH, BOMBERG, ROBERTS and GERTLER were at times involved. Artists worked a maximum of three-and-a-half days a week and all work was sold anonymously. An emblem was adopted, and there was a wide range of products from bead necklaces to textiles and painted furniture. Omega exhibited mainly at Fitzroy Square and also in joint exhibitions in London and took private commissions for interior decoration. A Daily Mail Ideal Homes Exhibition commission resulted in a rift with Lewis. The group was scattered by 1916; Bell and Grant having moved to Charleston ultimately caused more friction as they undertook independent commissions. Omega survived the war precariously: success at exhibitions diminished, financial worries increased, and tensions were exacerbated by complicated personal relationships. In June 1919 the workshop closed selling all its stock at halfprice. Omega's concerns were not with craftsmanship but with surface decoration and designs based on the principles of mass, line, form and colour. Ultimately it succeeded in creating work for aspiring artists and maintaining a link with mainstream European decorative trends.
LIT: *Omega and After*, Isabelle Anscombe, London, 1989. DE

O'NEILL, Daniel, (b. 1920). Painter of figures and landscapes in oils. Born in Belfast, he attended some classes at Belfast College of Art but is mainly self-taught as a painter. He has exhibited in galleries in London, Belfast and Dublin, including the WADDINGTON GALLERIES, and shown his work in America and Sweden. His

heavily painted, simplified forms with strongly painted highlights show some influence of Vlaminck in technique.
LIT: Catalogue, Arthur Tooth & Sons, 1952. CF

OPPENHEIMER, Charles, RSA, RSW (1875–1961). Painter of landscapes in oils and watercolours. Born in Manchester, he studied at the MANCHESTER SCHOOL OF ART under R.H.A. Willis and WALTER CRANE and worked in Italy. He exhibited at the RA from 1906 to 1952, and showed in Scotland at the RSW (member 1912), the RSA (ARSA 1927, RSA 1935), and the GI, as well as in the provinces and at the FINE ART SOCIETY. His work is represented in Manchester City Art Gallery and his landscapes include scenes from Switzerland and Italy, but many depict Scotland (particularly Kirkcudbright, where he lived, and Galloway). CF

OPPENHEIMER, Joseph, RP, IS (1876–1966). Painter of portraits, landscapes, townscapes and flowers in oils, watercolours, gouache and pastels. Born in Würzburg, Bavaria, he studied in Munich under Fehr, Raab and Hoecker and after travelling to Rome and the Middle East he settled in London in 1896. He travelled widely and between the wars lived in Berlin, becoming a member of the Berlin and Munich Secession. After 1949 he divided his time between Montreal and London. He exhibited at the RA from 1904 to 1953, in London galleries and internationally, winning gold medals in Munich and Barcelona and two honourable mentions at the Carnegie Institute, Pittsburgh. His work is represented in the NPG, London, and retrospective exhibitions have been held in Canada and at the Städtische Galerie, Würzburg, 1987. His work developed from a warm, richly-coloured impressionistic style to more expressionist paintings using a brighter palette.
LIT: *Joseph Oppenheimer*, exhibition catalogue, David Bathurst/St James's Art Group, London, 1990. CF

ORGAN, Bryan (b. 1935). Painter of portraits and a range of subjects in acrylic, oils, gouaches and watercolours. He trained at Loughborough College of Art 1952–5, and at the RA SCHOOLS 1955–9, winning the David Murray Travelling Scholarship in 1957, 1958 and 1959. He has exhibited at the RA and at London galleries including the REDFERN, 1967–75, and in the provinces. His work has been shown in exhibitions in Darmstadt, Köln, São Paulo, Brazil, and

New York, and it is represented in many public and private collections including the NPG. From 1959 to 1965 he taught at Loughborough College of Art and since 1965 has painted full-time. Best known as a portraitist, particularly of members of the Royal Family, his work gives a directly presented, economically arranged account of his sitter.
LIT: Interview, *Arts Review*, 17 July 1981. CF

ORGAN, Robert, DFA, RWA, (b. 1933). Painter of landscapes, interiors and figures in oils; architect. He trained at the West of England College of Art and the SLADE: he has exhibited at BROWSE AND DARBY, London, since 1984, and in the provinces. He has taught at Falmouth School of Art and the Architectural Association, London, and in 1987 was appointed Artist in Residence, Exeter Museum. His paintings are thickly painted, strongly realized responses to natural form. CF

ORMROD, Frank. Painter of landscapes in watercolours. He lived in London in 1922, at Dunsmoor, nr. Wendover, Bucks, in 1931, and later at Stanford Dingley, Berkshire. He exhibited at the RA between 1922 and 1938, 1941 and 1968, and at the NEAC. His exhibited work included landscapes of France, Scotland, Gloucestershire and Berkshire such as *Berkshire Village, Early Spring*, RA 1968. CF

OROVIDA, see PISSARRO, OROVIDA CAMILLE

ORPEN, Sir William Newenham Montague, RA, RHA, RWS, RI, NEAC (1878–1931). As a portrait painter of success comparable to that of Sargent, Orpen also painted genre, interiors, nudes, landscapes and allegories in oils, tempera and watercolours. With a strong feeling for the effects of light, he painted with swifter application, in a style which broadened in the 1900s. Of Anglo-Irish descent, he was born at Stillorgan, Co. Dublin, Ireland, the son of a lawyer. He studied at the Dublin Metropolitan School of Art 1890–7. Travelling to London he attended the SLADE SCHOOL 1897–9 where, a contemporary of JOHN, MCEVOY and LEWIS, his powers as a draughtsman singled him out as a prodigy. In 1899 he won the Slade Composition Prize for his work *The Play Scene from Hamlet*. Painting intimate interiors, genre and conversation-pieces comparable with those of MCEVOY and ROTHENSTEIN, Orpen gained a youthful success with his picture *The Mirror*, 1900. In the Autumn of 1903 he and John opened the CHELSEA ART

SCHOOL, where Orpen lectured on anatomy. Often in Ireland, Orpen also taught part-time at the Dublin School of Art, 1902–14, and became an important figure among Irish painters and collectors, forming friendships with Sean Keating, Hugh Lane and George Moore. He worked sometimes on large compositions such as *The Holy Well* (exh. 1916) in which he sought to embody the Irish spirit. Joining the army in 1916, Orpen was selected as an OFFICIAL WAR ARTIST which caused a break with Sean Keating. His pictures of the Somme battlefields were exhibited at AGNEW'S in 1918, and the large controversial composition *To the Unknown British Soldier in France* was exhibited in 1923. He attended the 1919 Peace Conference in order to portray the delegates. A founder member of the National Portrait Society in 1911, Orpen increasingly devoted himself to portraiture, maintaining studios in both Paris and London in the 1920s. Knighted in 1918, Orpen had exhibited at the NEAC from 1899, the RA from 1908, and was instrumental in the formation of the CHENIL GALLERY in 1906. A memorial exhibition was held at the Knoedler Gallery, New York in 1932.
LIT: *Orpen, Mirror to an Age*, B. Arnold, 1981; *An Onlooker in France 1917–19*, W. Orpen 1921; *Stories of Old Ireland and Myself*, W. Orpen, 1924. GS

ORR, Christopher, RA. (b. 1943). An etcher, lithographer and draughtsman, he studied at Ravensbourne 1959–63, Hornsey 1963–4 and at the RCA 1964–7. His first solo exhibition was at the SERPENTINE in 1971, and a BBCTV *Arena* film, *The Swish of the Curtain* was made about him in 1980. His figurative compositions are innocently humourous fantasies. AW

OSBORNE, Sir Malcolm, CBE, RA, PRE, RBC (1880–1963). An etcher and engraver, he studied at the RCA under SIR FRANK SHORT. His 1934 portrait of Sir Frank as President of the RE is considered a masterpiece of its kind, for technical brilliance, empathy and penetrating observation. He was head of the Engraving School at the RCA for many years. AW

OULTON, Thérèse (b. 1953). A painter, she was trained at ST MARTIN'S 1975–9 and the RCA 1980–3. Her first solo exhibition was at GIMPEL FILS in 1984. She has since exhibited widely all over the world. Her non-figurative paintings are built up of minute brushstrokes, but have an organic structure analogous to cel-

lular organizations of matter, even when obliquely evoking strange landscapes or apocalyptic struggles. It is evident from her titles that she is inspired by music, poetry (that of Hilda Doolittle for example) and alchemy. A number of her works are in the TATE, including *Smokescreen* (1989). AW

OVENDEN, Graham (b. 1943). Born at Alresford, Hampshire, Ovenden studied at the ROYAL COLLEGE OF ART 1965–8; he first exhibited at the PICCADILLY GALLERY in 1970, and has shown there at intervals ever since; most of his exhibitions have been in Britain. He was a founder member of the BROTHERHOOD OF RURALISTS, of which he has been a leading figure as organizer and contributor to exhibitions. He paints, usually in oil, makes prints, writes poetry, illustrates books and has published studies of early photography. His work which includes portraiture, figure compositions (very often of young girls) and landscape is very carefully wrought, smoothly painted and harmonious in colour.
LIT: He has been the subject of several broadcasts and films, such as *Summer with the Ruralists*, BBC TV, 1978, and *Bats in the Belfry*, ITV, 1987. AW

P

PAILTHORPE, Dr Grace (1883–1971). Self-taught as a painter and linocut artist, she was trained in medicine and after a distinguished career as a surgeon during the First World War, then as a GP and District MO in Australia, returned to England in 1922. her pioneering research into the psychology of delinquency gave way to the study of that of art following her meeting with RUEBEN MEDNIKOFF, whom she eventually married. She exhibited in the First International SURREALIST Exhibition, where her work was praised by André Breton. She spent the Second World War in Canada, returning to the UK in 1946. AW

PALIN, William Mainwaring, VPRBA (1862–1947). Painter of portraits, genre and landscapes in oils and watercolours; decorator. He was apprenticed to Josiah Wedgewood & Sons before winning a National Art Training Scholarship to the RCA. He also studied in Paris under Boulanger and Lefèbvre. He exhibited at the RA from 1889 and at the RBA, becoming a

member in 1905, Honorary Secretary 1911–13 and Vice President in 1914. He also showed at the ROI, RP, LS, Liverpool and abroad. He obtained an Honorable Mention at the Paris Salon, 1894, and his work *Orphans* was bought by the French Government. His decorative commissions included work at MacEwen Hall, Edinburgh University, and St Clement's Church, Bradford. His painting ranges from *An Idyll – Twilight*, exhibited at the RA in 1897, to sharply coloured genre scenes such as *A Summer Afternoon*, 1902, exhibited at the Paris Salon and the RA in 1904. CF

Pallant House Gallery. First opened in 1982 in an eighteenth-century house in Chichester, it is administered by a Trust set up to receive the WALTER HUSSEY bequest to the District Council of over 120 works of art. With further acquisitions, in particular the Kearley and Lucas bequests, there are today about 1,000 items, forming an important permanent collection of twentieth century British art, along with an art history library. Works are regularly loaned to other museums and galleries on a temporary basis, and there are four special exhibitions held per year on twentieth-century British and other European fine and appplied art. There is also a regular programme of lectures and other events. AW

PAOLOZZI, Sir Eduardo, RA, CBE (b. 1924). Sculptor, printmaker, artist in collages, gouaches and watercolours; writer. Born in Edinburgh, he studied at EDINBURGH COLLEGE OF ART 1942, and the SLADE SCHOOL, London, 1943–7. From 1947 to 1950 he worked in Paris, meeting Giacometti and studying the work of Miró, Klee, the Surrealists and Dadaists. His first solo exhibition was a show of drawings at the MAYOR GALLERY in 1947. His interest in popular culture was stimulated by his contact with Dubuffet in France, and he was a leading figure in the INDEPENDENT GROUP at the ICA in the 1950s. Thereafter he exhibited at leading London galleries including the HANOVER GALLERY, the TATE GALLERY 1971, and the SERPENTINE GALLERY 1987. He has exhibited regularly abroad and in major group exhibitions including 'Aspects of British Art Today', Tokyo 1982. His work was also shown in the 1952 Venice Biennale. The many public collections holding his work include the Tate Gallery and MOMA, New York. He has taught at the CENTRAL SCHOOL OF ART 1949–55, ST MARTIN'S SCHOOL 1955–8, and from 1968 at the RCA. He

was Visiting Professor, Hochschule Für Bildende Künste, Hamburg 1960–2, Professor of Ceramics, Fachhochschule, Köln 1977–82, Professor at the International Summer Academy, Salzburg 1981–2, and since 1981 Professor of Sculpture, Akademie der Bildenden Künste, Munich. He became RA in 1979, CBE in 1968 and in 1986 Her Majesty's Sculptor in Ordinary for Scotland. His environmental sculpture commissions include *Three Fountains*, Hamburg, 1953. His early sculpture used a collage technique: incorporating mechanical objects into the cast surface of semi-abstract, robotic figures. Later work has become more architectural and abstract, using machine-made components assembled by technicians. His writings, collages and prints explore the creation of a personal language influenced by the writing of Wittgenstein and his own interest in modern technology.
LIT: See his own writings, e.g. *Metaphysical Translations*, London, 1960; *Eduardo Paolozzi*, Diane Kirkpatrick, London, 1970. CF

PARK, John Anthony, ROI, RBA (1880–1962). Painter of coastal scenes and landscapes in oils. Born in Preston, he first studied at St Ives with JULIUS OLSSON in 1899. In 1905 he worked in Paris at the Atelier COLAROSSI and also studied the work of the Impressionists. In 1923 he returned to St Ives. He exhibited mainly at the RA from 1905, at the ROI, RBA, in the provinces and with the St Ives Society of Artists. He also showed abroad and gained an Honorable Mention 1923, a bronze and a gold medal 1924 and 1932, at the Paris Salon. He was elected ROI in 1923 and RBA in 1932. His work is represented in public collections including the TATE GALLERY. His paintings have a free, lively Post-Impressionist style with exuberant colour.
LIT: The catalogue for John Park, Penwith Gallery, St Ives, 1983. CF

PARKER, Agnes Miller, RE (1895–1980). A wood engraver and painter, she was trained at GLASGOW SCHOOL OF ART 1914–19, where she met and married WILLIAM MCCANCE. In 1926 she worked with GERTRUDE HERMES and BLAIR HUGHES-STANTON, with whom her work developed close affinities, especially in her virtuosity in rendering effects of light. She did much work for the Gregynog Press. AW

PARSONS, Beatrice E., (1870–1955). Painter of gardens, figures and portraits in watercolours. She studied at the RA SCHOOLS where she won a silver medal, and exhibited mainly at the Dowdeswell Gallery, at the RA from 1889 and in Liverpool. She held 13 solo exhibitions in London; her work was reproduced by leading publishers and is represented in public collections including the V & A. Between 1921 and 1929 she painted at Blickling Hall, Norfolk, each summer and many of her works show the gardens there. Her paintings are richly detailed, reflecting the pleasure of gardens in full bloom. Her portraits are delicate and observant. CF

PASMORE, Edwin John Victor, CH, CBE, RA, LG (1908–98). Painter of figures, landscapes, still-life and abstracts in oils, constructivist, theoretician and teacher. He attended evening classes at the CENTRAL SCHOOL under A.S. HARTRICK 1927–31, and in 1932 joined the LAA which sponsored his first exhibition at the Cooling Gallery 1933, and through which he met COLDSTREAM and ROGERS. He exhibited at the LG from 1930, becoming a member in 1934, and at the Objective Abstraction Exhibition, ZWEMMER Gallery 1934. In 1937 he was a founder with Coldstream and Rogers of the EUSTON ROAD SCHOOL and in 1940 married Wendy Lloyd Blood. In the late 1940s he turned to abstraction and in 1950 visited St Ives and was encouraged by NICHOLSON. In the early 1950s he was associated with the constructivist group that included HILL, ADAMS, HEATH and the MARTINS, organized exhibitions of abstract art with them at the AIA Gallery, REDFERN GALLERY and GIMPEL FILS, and, influenced by Biederman, started to construct reliefs. In 1955 he was appointed Consulting Architectural Designer, Peterlee Development Corporation and his large scale commissions included a pavilion for Peterlee. In 1966 he moved to Malta and returned to painting. He has exhibited regularly in leading London galleries, including the Redfern 1940–55, the MARLBOROUGH GALLERY from 1961, and retrospective exhibitions were held at the TATE GALLERY in 1965 and 1980. His work has been represented in numerous exhibitions including the 1960 Venice Biennale and is in many public collections including the Tate Gallery and MOMA, New York. He taught at CAMBERWELL SCHOOL OF ART 1943–9, and at the Central School 1949–54. From 1954–61 he was Master of Painting, Department of Fine Art, Durham University, and started the abstract foundation course 'The Developing Process'. A Trustee of the Tate Gallery 1963–6, his many awards and honours include a CBE 1959, and in 1981 Companion of Honour. His early painting was

influenced by Fauvism but this gave way to the realist Euston Road style influenced by SICKERT and Degas. In the 1940s he worked on a series of Thames and London scenes which sprang from a study of Whistler and Turner and which heralded his abstract work. This evolved from paintings of spiral forms to constructed reliefs. His later painting combines abstraction with references to natural forms. All his work reflects his interest in Japanese art.

LIT: *Catalogue Raisonné* by Alan Bowness and Luigi Lambertini, 1980; Tate Gallery exhibition catalogue, 1980. CF

PASMORE, Wendy, LG, WIAC (b. 1915). Abstract painter (née Blood), who studied at Chelmsford School of Art 1933–4. She married VICTOR PASMORE in 1940 and was a member of the WIAC from 1955 and the LG in 1956, becoming a member in 1958. She taught at Sunderland College of Art 1955–8, and at Leeds College of Art after 1958. Her work is represented in several public collections including the TATE GALLERY, ARTS COUNCIL and Leeds Education Committee. LMN

PATERSON, Emily Murray, RSW, SWA (1855–1934). Painter in oils and watercolours of landscapes, flowers, still-life and marine subjects. Born and educated in Edinburgh and connected with the GLASGOW SCHOOL, she later studied in London and Paris and worked extensively elsewhere in Europe. She exhibited widely including Barbizon House, the Glasgow Institute, RA, RSA, Royal Society of Painters in Watercolours and the SOCIETY OF WOMEN ARTISTS. Her work is found in many British and overseas public collections. Examples of her work include *The Green Ship, Venice*, 1913, *A Bouquet*, 1927 and *Roses*, 1930. LMN

PATERSON, G.W. Lennox, VRD, ARE, RSA (b. 1915). Portrait painter in oils; wood engraver and illustrator of poetry. He studied at GLASGOW SCHOOL OF ART and became Instructor in Graphic Art and Deputy Director there for many years. He exhibited at the RSA, RE, and GI and at the Society of Artist Printmakers. In 1946 he received the Guthrie award and was elected ARE in 1947. His illustrations include Robert Burns's *Poetical Works*, 1958, and his own books, *Scraperboard*, 1960, and *Making a Lino Cut*, 1963. LMN

PATERSON, James, RSA, PRSW, RWS, NEAC (1854–1932). Landscape, portrait and self-por-

trait painter who worked in oils and watercolours and was a keen photographer. He studied at GLASGOW SCHOOL OF ART and took classes in watercolour given by A.D. Robertson. He sent work during 1874–5 to Edinburgh and Glasgow exhibitions and to the Glasgow Arts Club in support of application for membership. In 1876–9 he studied in Paris under Jacquessen de la Chevreuse and between 1879 and 1883 in the atelier of Jean-Paul Laurens. He was also influenced by Puvis de Chavannes and Bastien-Lepage. He travelled widely on the Continent but was back in Scotland in 1878. In 1888 he was much involved in *The Scottish Arts Review*, the literary organ of the Glasgow School. At this time he had two works in the first NEW ENGLISH ART CLUB exhibition. During 1890 he exhibited with the Glasgow Boys at the GROSVENOR GALLERY, London, and in Munich, gaining a 2nd Class Gold Medal. His work, more restrained in colour and handling than that of his friends, is represented in British and overseas collections. He was elected a member of the RSW in 1885, ARSA in 1896, SSA in 1899, RWS in 1908, RSA in 1910, and was elected President of the RSW in 1922 and secretary of the RSA in 1924. Paterson finally settled in Edinburgh in 1906.

LIT: *The Paterson Family: One Hundred Years of Scottish Painting 1877–1977*, catalogue, The Belgrave Gallery, London, 1977; *The Glasgow Boys*, exhibition catalogue, Scottish Arts Council, 1969, 1971. LMN

PATERSON, Mary Viola (1899–1981). Painter, lithographer and colour printer who worked in oils, pastels and watercolours. In the early 1930s she had success with a technique she developed of printing in watercolour from woodcut blocks she called 'wood-types'. Her training began in London at the SLADE SCHOOL under TONKS and during 1919–21 she attended the GLASGOW SCHOOL OF ART under MAURICE GREIFFENHAGEN. Following this she studied in Paris at the Académie de la Grande Chaumière under Lucien Simon Besnard and at the Académie Lhote. She travelled extensively around the Mediterranean, and exhibited successfully in Scotland and London during 1920–40, at the RA, RSA, SSA, and the GI. Her work was seen often at the Society of Printmakers and is represented in the City of Edinburgh Art Centre. LMN

PATRICK, James McIntosh, RSA (b. 1907). Born in Dundee, he studied at GLASGOW SCHOOL OF ART and at first established himself as an

etcher. Primarily a landscape painter concerned with the agricultural year of the countryside around Dundee.

LIT: *James McIntosh Patrick*, exhibition catalogue, Introduction by Roger Billcliffe, FINE ART SOCIETY, 1987. AW

PATTERSON, Richard (b. 1963). The elder brother of SIMON PATTERSON, he studied at GOLDSMITHS' and he first came to public notice in HIRST's 'Freeze' exhibition in 1988. *Motorcrosser II* (1995) is a characteristic painting which originated as a painted toyshop model, a photograph of which was enlarged and copied to make a powerful, rather menacing painting. Other, mural-scale work has echoes of Rauschenberg, Rosenquist and RICHARD HAMILTON (*Culture Station #3-With Fur Hat*, 1997). AW

PATTERSON, Simon (b. 1967). He studied at Hertfordshire and GOLDSMITHS'. His first one-man show was at the Third Eye in Glasgow in 1989, although he was included in HIRST's 'Freeze' exhibition in 1988. A conceptual and installation artist in diverse media, he is concerned with the ambiguity of word-associations and information systems. *The Great Bear* (1992), for example, is a graphic version of the London Underground map with the names of celebrities substituted for those of the stations. AW

PEACOCK, Brian (b. 1934). He studied at Bromley College of Art, 1956–8, and at the RCA, 1958–61. He won the ROME PRIZE in 1960, and on his return from Italy taught at MANCHESTER SCHOOL OF ART, then at Sheffield Polytechnic, where he became Head of Painting. He retired in 1988. His first solo exhibition was at the PICCADILLY GALLERY in 1963, and he has since exhibited there and at the Church Street Gallery, Stow-on-the-Wold. His oil paintings, which evoke the work of Seurat, are carefully-composed, methodical compositions in which light plays an important part; recently many deal with coastal scenes and with the façades of cafés and shops in the Charente. AW

PEACOCK, Ralph (1868–1946). Illustrator and painter of portraits, genre and landscapes in oils. He studied at Lambeth School of Art in 1882, at the RA SCHOOLS in 1887 and at ST JOHN'S WOOD SCHOOL OF ART where he was eventually to teach. While at the RA Schools he won the Creswick Prize and a gold medal; he exhibited at the RA from 1888 to 1934 and won medals in Vienna and

Paris. The CHANTREY BEQUEST purchased *Ethel* in 1898 and his work is represented in several public collections including the TATE. LMN

PEAKE, Mervyn (1911–1968). Painter and theatrical designer who studied at the Croydon School of Art and the RA SCHOOLS where he won the Arthur Hacker Prize. He exhibited between 1931 and 1939 and worked with a group of painters on Sark during 1933–5. On his return to England he taught life drawing at WESTMINSTER SCHOOL OF ART until 1938 and in 1939 his first illustrated book *Captain Slaughterboard* (a humorous fantasy for children) was published. During war service he worked on his epic cycle of *Titus* novels but in 1943 he was invalided out of the forces and was able to concentrate fully on writing, illustrating and painting. He visited Germany in 1946 to record the devastation for *Leader* magazine and made drawings at Belsen which profoundly affected his later work. In 1946–9 he returned to Sark with his family and wrote *Gormenghast*. He taught drawing at the CENTRAL SCHOOL OF ARTS AND CRAFTS 1950–60. From 1955 he suffered from Parkinson's disease. In his own drawings he freely adapted his graphic style in response to the imaginative demands of his texts. He was able to interpret fantasy and was a successful illustrator of Lewis Carroll. His designs were whimsical and humorous but he also had a strong instinct for the macabre and grotesque.

LIT: *Mervyn Peake*, John Batchelor, Duckworth, 1974. LMN

PEARCE, Charles Maresco, LG, NEAC (1874–1964). Painter and collector. Educated at Christ Church, Oxford, articled to the architect Sir Ernest George, then studied at CHELSEA SCHOOL OF ART and in Paris under Jacques-Emile Blanche. His first one-man show was at the Carfax Gallery in 1910. His substantial collection included works by Gauguin, Bonnard, Maillol, DUNCAN GRANT, KEITH BAYNES and SICKERT. His own subjects were architectural, (for example *Piccadilly Circus* and *Café Royal*) and many were influenced by the work of SICKERT. AW

PEARCE, John (b. 1942). A painter in oils and watercolours of *plein-air* landscapes and urban subjects, as well as portraits. He was born and still lives in London, having studied painting and stained glass at Hornsey College of Art 1960–3. He was a prizewinner at the GLC Spirit of London Exhibition in 1980, and his portrait of

Barry Hall was included in the John Player Award Exhibition at the NPG in 1982. His studies of London houses and gardens are of a Pre-Raphaelite intensity and detail. AW

PEARCE, Walter Bryan (b. 1929). Born in St Ives, he began painting in 1953, and studied at the St Ives School of Painting under LEONARD FULLER, 1954–7. His first one-man show was at the Newlyn Gallery in 1959; he has exhibited at the JOHN MOORES LIVERPOOL EXHIBITION in 1963, at the New Art Centre, 1966, 1968 and 1973, and elsewhere; a retrospective was held at the Museum of Modern Art in Oxford in 1975. His fresh and clear paintings are all executed in the same technique – outline drawing in one colour, filled in with flat, fairly smooth areas of other colours, ignoring light and shade variations. His subject-matter is taken from his surroundings.
LIT: *The Path of the Son*, Ruth Jones, Sheviock Gallery Publications, 1976. AW

PEARS, Charles, ROI, RSMA (1873–1958). An OFFICIAL WAR ARTIST 1914–18 and again 1940–45, he worked almost exclusively on naval subjects. His six lithographs *Transport by Sea* during the First World War were for 'Britain's Efforts and Ideals' (TATE GALLERY). AW

PEARSALL, Phyllis (1906–1996). Painter, writer and the founder in 1936 of the Geographers' A–Z Map Company, having originated the A–Z Map of London. She used oil on canvas and board, watercolours and pen and ink. Educated at Roedean, Fécamp and at the Sorbonne in 1923, she was encouraged by JAMES MCBEY to paint, working in Spain, France and Belgium. She had many one-woman exhibitions in London, the provinces and abroad, and carried out many special commissions. During the Second World War she worked for the Ministry of Information, and recorded the work of the ATS, the WRNS, the WAAF, the Land Army and workers in munitions fac- tories. Her paintings were light and atmospheric; her lively and spirited drawings and watercolours had some natural affinity with those of her brother ANTHONY GROSS.
LIT: *Fleet Street, Tite Street, Queer Street*, Phyllis Pearsall, privately published, 1983; *Women At War, Drawn and Overheard*, Phyllis Pearsall, Ashgate Editions, Scolar Press, 1990. LMN

PEARSON, David (b. 1937). Painter; maker of prints and three-dimensional tableaux. Born in

London, he studied at ST MARTIN'S and the RA SCHOOLS and has held solo exhibitions at the Bede Gallery, Jarrow, and at the University of Liverpool. Represented in the ARTS COUNCIL Collection, his work has included subjects based on the paintings of Van Gogh, whilst recent paintings use a patterned, abstracted style retaining references to figurative images.
LIT: Catalogue, Senate House Exhibition Hall, University of Liverpool, 1989. CF

PEARSON, Harry John, RBA (1872–1933). Portrait painter, mainly of children. He became a member of the RBA in 1915 and President of the Langham Sketch Club. He exhibited at the RBA, ROI, and RWA. LMN

PELL, Robert Leslie, RBA, FRSA (b. 1928). Painter in oils and polymer. Born in Northampton, he studied at the Northampton School of Art and at CAMBERWELL SCHOOL OF ART, London. He has exhibited at the RBA and at the LEICESTER and PICCADILLY Galleries and his work is represented in collections including Northampton Art Gallery. He is Head of the School of Art, North Oxfordshire Technical College and School of Art, Banbury. CF

PENDER, Jack (b. 1918). Painter of works based on his Cornish environment combining figurative and non-figurative elements. Born in Mousehole, Cornwall, where he still works, he studied at Penzance School of Art 1938–9, Athens School of Art 1945–6, Exeter School of Art 1946–9, and the West of England College of Art, Bristol, 1949–50. He held a solo exhibition in 1963 at the Arnolfini Gallery, Bristol, and has exhibited regularly in the West Country, holding his first London solo exhibition at the Belgrave Gallery in 1990. A member of the Newlyn Society and the PENWITH SOCIETY OF ARTISTS, his work is represented in collections including Plymouth Art Gallery.
LIT: *Jack Pender, On My Knees*, exhibition catalogue, Orion Galleries, Newlyn, Cornwall, 1979; *Jack Pender*, exhibition catalogue, Belgrave Gallery, London, 1990. CF

PENN, William Charles, RP, ROI, R.Cam.A. (1877–1968). Portrait, genre and figure painter educated in London. He studied at the RA SCHOOLS and in Paris at the ACADÉMIE JULIAN, and the Ecole des Beaux-Arts. Examples of his work are *Fruits of Solitude* and *An Unconventional Portrait*, exhibited at the RA in 1927. He exhibited at the RA from 1902 and

with other principal societies and his work is represented in public collections. LMN

PENROSE, Sir Roland Algernon (1900–1984). Painter and writer on art who also made collages and objects; poet and collector. He studied at Queens' College, Cambridge, and in Paris. He introduced Surrealism to the general public by organizing the International SURREALIST Exhibition in London in 1936. He exhibited in Paris (his first one-man show), London and New York. In 1938 he collaborated on the publication of *The London Bulletin*, a mouthpiece for Surrealism, which continued until 1940. A friend and biographer of Picasso he was also friendly with and influenced in his art by Max Ernst and Joan Miró, on whom he published a book. He was married to Lee Miller, the photographer, and was a camouflage instructor during the Second World War. He was founder,1947, and President, 1969–76, of the ICA and was a benefactor of the TATE. In 1980 the ARTS COUNCIL mounted a retrospective of his work.
LIT: *Scrapbook 1980–81*, Roland Penrose, Thames & Hudson, 1981. LMN

Penwith Society. The Penwith Society of Arts in Cornwall was formed in 1949 in St Ives as a tribute to BORLASE SMART. It was intended to unite abstract and traditional artists and craftsmen after the split that had appeared in the St Ives Society of Artists. The President was HERBERT READ, the Chairman LEONARD FULLER, and active members included BARBARA HEPWORTH, BEN NICHOLSON and PETER LANYON and an exhibition gallery was established at the St Ives Public Hall, Fore Street. The issue of modern and traditional artists, however, continued to be divisive and led to a number of resignations including those of Peter Lanyon, SVEN BERLIN and BRYAN WYNTER. The Society organized three exhibitions of work annually and continued to flourish in the 1950s, receiving support from the ARTS COUNCIL and moving from the Fore Street Gallery to premises in Academy Place. Many of the younger St Ives artists exhibited there and in the 1960s the Society began an expansion scheme to include a complex of exhibition galleries and workshops and by the 1970s it had established extensive facilities. After the death of Hepworth and of the Chairman Marcus Brumwell, Arts Council support was withdrawn and the Society has since operated through the Penwith Society of Artists.
LIT: *Painting the Warmth of the Sun*, Tom Cross, Lutterworth Press, 1984. CF

PEPLOE, Denis Frederic Neal, RSA (b. 1914). Son of S.J. PEPLOE and a painter in oils, he studied at EDINBURGH COLLEGE OF ART 1931–6, and in Paris at the Académie André Lhote in 1937. He exhibited at the RSA and the GI and was elected ARSA in 1956 and RSA in 1966. He was on the staff of the Edinburgh College of Art from 1954, retired in 1979, and was made Governor in 1982. His work is represented in collections including Glasgow, Kircaldy, Perth, Edinburgh and the ARTS COUNCIL. He exhibited between 1938 and 1988, many times at the Scottish Gallery, Edinburgh. LMN

PEPLOE, Samuel John, RSA, NPS (1871–1935). Oil painter of still-life, landscapes, flowers and figure subjects which displayed remarkable freedom and richness of colour. Peploe developed close links with French painters, and his technique was conditioned by the colour and bold handling practised by many of his fellow Scottish artists of the same period. This background attracted him to Fauvism whose influence is apparent in such paintings as his *Boats at Royan*, 1910 (Edinburgh. NGS). He studied art under Charles Hodder at the Trustees School, Edinburgh, in the RSA life classes from 1892 to 1902 and in Paris at the ACADÉMIE JULIAN and Atelier COLAROSSI. From 1901 he exhibited at the RSA. He was elected ARSA in 1918 and RSA in 1927. He held his first one-man show at Aitken Dott, Edinburgh, in 1903, and in 1911 was a founder member of the NPS. A close friend of J.D. FERGUSSON, he worked in Paris from 1910 to 1913 and the South of France in 1928. His work is represented in many public collections.
LIT: *Peploe: An Intimate Memoir of an Artist and of his Work*, Stanley Cursiter, London, 1947. LMN

PETHERBRIDGE, Deanna (b. 1939). A painter, sculptor and draughtsman, born in South Africa, and although widely travelled in Italy, Greece, the Middle East, Africa and India, was based in England after study at the University of Witwatersrand 1956–60. Her first solo exhibition was at Angela Flowers Gallery in 1973. Her paintings, reliefs, sculptures and drawings are abstract, based on mathematical and architectural projections.
LIT: *Deanna Petherbridge: Drawings, 1968–82*, exhibition catalogue, Introduction by Timothy Clifford and Bryan Robertson, Manchester City Art Galleries, 1982. AW

PHILIPSON, Sir Robert James, RSA, RSW (Robin, 1916–1992). Painter in oils and water-colours who studied at EDINBURGH COLLEGE OF ART 1936–40. He taught at the College from 1947 and became Head of the School of Drawing and Painting, 1960–82. In 1969 he was elected Secretary of the RSA, and in 1973, President; he was a member of the Royal Fine Art Commission for Scotland from 1965 to 1980. He was also a member of the Council for the Edinburgh Festival Society and a Fellow of the Royal Society of Arts. His work was strongly coloured, abstracted and violent in execution, often on such themes as cock-fighting, the 1914–18 War and the Crucifixion. He exhibited in London and New York ('Seven Scottish Painters', IBM Gallery, 1965) and had a retrospective at the Edinburgh College of Art in 1989.
LIT: *Robin Philipson*, Maurice Lindsay, Edinburgh, 1976. LMN

PHILLIPS, Peter (b. 1939). Artist whose work ranges from oils on canvas to multi-image com-positions with photo-realist or collage elements with paint. He studied at Birmingham College of Art 1955–9, and at the RCA 1959–62. He taught at Coventry College of Art 1962–3, and later was guest professor at the Hochschule für Bildende Kunst, Hamburg. He designed for the Shakespeare Exhibition, 1959–62, at Stratford-upon-Avon, and in 1964 received a Harkness Fellowship. Since then he has lived and worked abroad; friendly with ALLEN JONES, his first one-man show was at the Kornblee Gallery in New York. During 1970–9 he travelled throughout the USA, Africa, the Far East and Australia. He collaborated in 'Hybrid Enterprises' with Gerald Laing. He has exhibited widely: at the YOUNG CONTEMPORARIES (1959–62), JOHN MOORES LIVERPOOL EXHIBITIONS, and was in 'British Art Today', which toured America in 1962. His work, which evokes popular culture, often has no depth, perspective or illusionistic space (e.g. *Automobila*, 1972–3, diptych, acrylic).
LIT: *Retrovision: Peter Phillips: Paintings 1960–1982*, Marco Livingstone, Walker Art Gallery, Liverpool, 1982. LMN

PHILLIPS, Tom, RA (b. 1937). Painter, graphic artist and musician who transforms traditional media, and for whom the fusion of words and imagery are of central importance. Educated at St Catherine's College, Oxford, and CAMBERWELL SCHOOL OF ART, he exhibited with the YOUNG CONTEMPORARIES in 1964, and his first one-man show was at the AIA Gallery in 1965. He has since exhibited nationally and internationally. He is concerned with creating unity from a wide range of ideas, deriving from observation, read-ing and reflection; what he has called 'the collage in the head'. One of his primary sources is the photographically based coloured reproduction; another, the literary text. He develops specific human and social themes by submitting the source image to elaborate processes of transfor-mation. Major works include *Benches*, 1970–1 (TATE), and *A Treatise on Colour Harmony*, 1975, which had its origin in a visit to South Africa. From 1966 he has often used texts derived from a Victorian novel *A Human Document* by W.H. Mallock, 1892, creating a 'treated Book' entitled *A Humument*, and many by-products including an opera, *Irma*, in 1973. Many musical performances have included one at the Bordeaux Festival, others in York, Rome and at the Purcell Room (with John Tilbury). He was a prizewinner at the 1969 JOHN MOORES LIVERPOOL EXHIBITION, showed in the 'Multiples' exhibition at the Whitechapel in 1970, and has more recently turned to television as a medium, as in *Dante's Inferno*, 1990, which he translated and published in 1983.
LIT: *Tom Phillips*, Editions Alecto, 1973; *Tom Phillips, Works-Texts to 1974*, Hansjorg Mayer, 1975. LMN

PHILPOT, Glyn Warren, RA, ROI, RP, NPS, IS (1884–1937). Portrait, figure and still-life painter in oils and watercolours; sculptor. He began, as a portrait painter, confining his palette to the buffs and blacks of the Spanish masters, but gradually more colour crept into his work until his later pictures tended towards decorative abstraction. He studied at Lambeth School of Art from 1900 and at the ACADÉMIE JULIAN, Paris, under Laurens, in 1905, and was at first greatly influ-enced by CHARLES RICKETTS. He exhibited at the RA from 1904 and had his first one-man show in 1910 at the Baillie Gallery. He was elected ARA in 1915 and RA in 1923 and became a member of the IS in 1913 and foundation member of the NPS in 1911. In 1913 he won the gold medal at the Carnegie Institute, Pittsburgh, and the fol-lowing year joined the army. In 1918 he painted four portraits of admirals for the IMPERIAL WAR MUSEUM. He worked occasionally in Spain and France and travelled in Italy. He painted a mural in St Stephen's Hall, Westminster, in 1927: In the early 1930s he lightened and sharpened his style, influenced by fashionable French painting.

A Young Breton was purchased by the CHANTREY BEQUEST in 1917 and *Mrs Gerard Simpson* in 1937. His work is represented in many public collections.
LIT: *Glyn Philpot, 1884–1937*, A.C. Sewter, Batsford, 1951; *Glyn Philpot, 1884–1937: Edwardian Aesthete to Thirties Modernist*, Robin Gibson, NPG, 1985.						LMN

PHIPPS, Howard (b. 1954). Studied painting and printmaking at Gloucestershire College of Art 1971–5, and at Brighton. He has published some books of wood engravings, such as *Interiors* (Whittington Press 1985) and *Further Interiors* (Whittington Press, 1992). His pastoral landscapes are at once strongly decorative and evocative of light and space.						AW

Piccadilly Gallery. Founded in 1953, and situated at 16 Cork Street, the Gallery has usually shown the work of romantic or imaginative British figurative painters, including ANN and GRAHAM ARNOLD, GRAHAM OVENDEN and TERRY LEE.						AW

PICKARD, Louise, NEAC, WIAC (1865–1928). Painter of landscapes, portraits and still-life in oils. She initially studied at an art school run by Herkomer's sister 1895–8, and then at the SLADE 1898–1900 (her studies included sculpture under O. Waldemann). She studied further in Paris and exhibited at the NEAC from 1909 (becoming a member in 1923), at the IS from 1911 and at the RA from 1917. In 1924 she exhibited with GINNER and ETHEL WALKER at the Goupil Gallery and was one of the group living and working in Chelsea who STEER had dubbed the 'Cheyne Walkers'. Her chief patron was Cyril Butler and *Still-life by a Window*, 1916, was bought by the CHANTREY BEQUEST. In 1928 a memorial exhibition was held at the Alpine Club Gallery and her work is represented in many public collections.						LMN

PICKING, John, NDD, D.A.Edin., ATD (b. 1939). Painter and lecturer, member of Manchester Academy and Senior Lecturer in Fine Art, MANCHESTER POLYTECHNIC. He studied at Wigan School of Art 1956–60 and won the Governors medal and a scholarship to Paris. He had a postgraduate scholarship at EDINBURGH SCHOOL OF ART 1960–3, a scholarship to Spain 1963–4, and he worked at GOLDSMITHS' COLLEGE 1965–6. He has exhibited regularly with the Scottish Gallery, Edinburgh, the Colin Jellicoe

Gallery, Manchester, and abroad at the Galleria Robinia, Palermo. His work is represented in permanent collections including Salford University and the Edinburgh Corporation. He has occasionally painted in Sicily, being interested in peasant communities, and he has also visited Lapland and Armenia.						LMN

PILKINGTON, Margaret, OBE, RE, (1891–1974). A wood engraver and painter in watercolours, she studied at the SLADE and at the CENTRAL SCHOOL. She worked with the SWE from its inception, becoming Hon. Secretary 1924, and Chairman 1952–67. She was Director of the Whitworth Art Gallery, Manchester from 1935, where she was responsible for building an important collection of prints. Her work was bold and decorative in its contrast of black and white.						AW

PIPER, Edward (1938–1990). Painter of nudes, flowers, interiors, landscapes and cityscapes in watercolours, acrylic and ink; photographer and graphic designer. Son of JOHN PIPER, he studied at BATH ACADEMY OF ART under HOWARD HODGKIN, 1956–7, and at the SLADE under CERI RICHARDS, 1957–61. His first solo exhibition was at the Marjorie Parr Gallery in 1975 and he showed in London and provincial galleries, most recently at the Catto Gallery, London. In the 1960s he painted hard-edged Pop Art, but later concentrated on life drawing and the depiction of scenes in vibrant colour and sharp, detached linear accents which reflect the influence of his father's work.
LIT: Catalogue, The Catto Gallery, London, 1989; *Edward Piper*, Sylvia Clayton, David and Charles, 1991.						CF

PIPER, John, LG, CH (1903–1992). Painter of architecture, landscapes, flowers and abstracts in oils, watercolours and gouache; draughtsman, collagist, printmaker; stained glass, textile and theatrical designer; illustrator, maker of reliefs, photographer and writer. Born in Epsom, he worked as an articled clerk, 1921–6, before studying under Coxon at Richmond School of Art in 1926, and at the RCA 1927–9, where he studied painting under MORRIS KESTELMAN and stained glass under Francis Spear. In 1927 he met Braque and HENRY MOORE and in 1929 married Eileen Holding. He exhibited at the LG from 1931, wrote criticism for the *New Statesman* and *The Listener* from 1933, and in 1934 began to make abstract constructions, becoming a mem-

ber, and subsequently secretary of the SEVEN AND FIVE SOCIETY. In 1934 he met Myfanwy Evans, whom he married in 1937, and worked with her on the magazine *Axis*. A friend of IVON HITCHENS, John Betjeman, PAUL NASH, ERIC RAVILIOUS and FRANCES HODGKINS, in 1940 he worked on the RECORDING BRITAIN scheme and painted scenes of war damaged churches for the WAAC, becoming an OFFICIAL WAR ARTIST in 1944. His commissions in the 1940s included a series of works of Renishaw Hall for Sir Osbert Sitwell and of Windsor Castle for HM The Queen. He continued to work widely on commissions and increasingly on stained glass design including windows for Coventry Cathedral, 1957–61, and Liverpool Metropolitan Cathedral, 1963–7. He exhibited extensively, holding solo exhibitions from *c*.1933 in many leading London galleries and his work is represented widely in public collections including the TATE GALLERY. His stage designs were commissioned for many major productions, e.g. Benjamin Britten's operas *Albert Herring*, 1947, and *Death in Venice*, 1973, and amongst his publications is *British Romantic Artists*, Collins, 1942. A Trustee of the Tate Gallery, 1946–61 and 1968–74, and a member of the Royal Fine Art Commission, 1960–77, he was awarded the Companion of Honour in 1972. Initially a landscape artist, he turned to abstraction in 1934 but by 1936 had returned to figurative painting, in particular topographical subjects. He developed a romantic idiosyncratic style which combined a range of rich, strongly contrasted passages of colour, rapidly drawn sharp lines and varied textures. In later works the detail is more abbreviated and the colour emotional and intense.
LIT: Retrospective exhibition catalogue, Tate Gallery, London, 1983; *Piper's Places*, Richard Ingrams and John Piper, Chatto & Windus, London, 1983; *John Piper. The Complete Graphic Works*, Orde Levinson, Faber & Faber, 1987. CF

PIRIE, Sir George, PRSA, HRA (1863–1946). Painter of birds, animals, figures and farmyard scenes who studied art in Glasgow and in Paris under Boulanger and Lefèbvre at the ACADÉMIE JULIAN. He exhibited at the RSA from 1887, the RA from 1888 and visited Texas in 1891. He served in the RAMC and was elected ARSA in 1913, RSA in 1923, PRSA in 1933–4, HRA in 1933 and was knighted in 1937. His work is represented in several public collections and an example of his work is *Mother Duck*, one of a large

number of paintings of ducks, which was purchased by the CHANTREY BEQUEST in 1940. LMN

PISSARRO, Lucien, NEAC (1863–1944). Landscape painter in oils and watercolours; wood engraver, designer and printer of books. A consistent style developed from the lasting influences of Impressionism (from his father Camille) and Neo-impressionism (from Seurat and Signac). His preoccupation with unity of design and delicate use of colour and tone was reflected in his books where he often printed texts in muted greens and greys rather than black. He studied art under his father and, for wood-engraving, under Lepère. Lucien exhibited at the last Impressionist Exhibition in 1886. In 1883–4 he was in London and working for music publishers but he returned to France and began work in Paris for Manzi Joyant, a firm of lithographers with whom he learnt the techniques of colour reproduction whilst continuing to paint. He emigrated to England intending to make his career as an illustrator and settled in London in 1890, becoming a naturalized Briton in 1916. He was strongly influenced by CHARLES RICKETTS who introduced him to the world of book illustration, typography and binding and who along with CHARLES SHANNON asked him to contribute to their woodcut illustrated journal *The Dial*. He had moved to Epping in 1893 and founded the Eragny Press (named after his father's final home), publishing thirty-five books between 1894 and 1914. The press was successful and he designed his own type called 'Brook' after his new Hammersmith home. He exhibited with the NEAC from 1904, becoming a member in 1906; he was a founder member of the CAMDEN TOWN GROUP in 1911 and of the Monarro Group in 1919. His first one-man show was held in 1913 at Carfax & Co. and he exhibited at the RA from 1934. A centenary exhibition was mounted by the ARTS COUNCIL in 1963, and his work is found in many public collections.
LIT: *Lucien Pissarro, Un Coeur Simple*, W.S. Meadmore, Constable, 1962; *Notes on the Eragny Press*, Lucien Pissarro, ed. Alan Fern, CUP, 1957. LMN

PISSARRO, Orovida Camille, RBA, WIAC (1893–1968): ('OROVIDA'). Painter and etcher of animal and figure subjects and a panel decorator. She studied art under her father LUCIEN PISSARRO and exhibited at the RA, the NEAC, the WIAC and the RBA. She had several one-man shows at home and abroad. Devotion to Oriental

Art was reflected in her prints and stylized painting of tigers and horses which she even mounted in the Chinese manner with strips of figured silk. When her sight began to fail she turned from etching to oil painting and towards domestic scenes and animals. A memorial exhibition of her work was held at the Ashmolean Museum in 1969 and an exhibition, 'Orovida Pissarro and her Ancestors – Lucien and Camille', was held at the Grafton Gallery in 1977. Her work is represented in a number of public collections including the Ashmolean Museum. LMN

PITCHFORTH, Roland Vivian, RA, RWS, LG, ARCA (1895–1982). Painter of landscapes, seascapes and architectural subjects in oils and watercolours; etcher and wood engraver. His work represented the traditionally English feeling for the countryside, the deep-rooted understanding that was first interpreted in paint by Constable. Born in Yorkshire he studied at Wakefield School of Art 1912–14. He attended Leeds College of Art 1914–15 and 1919–20, serving in between (1915–19) in the Artillery. During 1921–5 he was at the RCA under ROTHENSTEIN and UNDERWOOD and held his first one-man show in 1928 at the London Artists Association, becoming a member of the LG in 1929. He became an OFFICIAL WAR ARTIST with the Admiralty 1940–5, exhibited at the RA from 1941 and was elected ARA in 1942 and RA in 1953. During 1945 he visited Ceylon and Burma and worked in South Africa from 1945 to 1948, exhibiting in Cape Town, Durban and Johannesburg. His teaching appointments included instructor of life drawing and painting at CAMBERWELL in 1926, at ST MARTIN'S in 1930 and at Clapham School of Art 1926–39. He also taught at the RCA from 1937 to 1939 and on his return to England in 1948 he took up an appointment at CHELSEA POLYTECHNIC. Examples of his work are *Floods*, 1935, and *Night Transport*, 1939–40 (CHANTREY BEQUEST); he is represented in the museums of Manchester, Leeds and Wakefield.
LIT: 'R. Vivian Pitchforth, RA, RWS', Adrian Bury, *Old Watercolour Society*, Vol.43, 1967. LMN

PLATT, John Edgar, ARCA (1886–1967). Painter, colour woodcut artist and stained glass designer. He studied at the RCA 1905–8. He exhibited at the RA from 1913 and in both the NEAC and IS from 1917; also with the Arts & Crafts Society. He won the gold medal at the

International Print Makers Exhibition in 1922 and became President of the Society of Graver Printers in Colour from 1939 to 1953. He was an OFFICIAL WAR ARTIST 1939–45; as a teacher he became Principal at Leicester School of Art and Crafts 1923–9 and later Principal of Blackheath School of Art. His work is represented in many public collections. He published *Colour Woodcuts* in 1938. LMN

PLATT, Stella, BWS (b. 1913). Painter of industrial scenes in oils, watercolours and pastels. Born in Bolton, she studied at the Bolton School of Art and exhibited at the RSA, RBA, RI, ROI, SGA, SWA and the Paris Salon. A member of Manchester Academy of Fine Arts and of the Lancashire Group of Artists, her work is in many permanent collections in Lancashire. LMN

PLUMB, John (b. 1927). Painter of abstracts in acrylic, oils and gouache. He studied at the CENTRAL SCHOOL OF ART and held his first solo exhibitions in London at the New Vision Centre Gallery and Gallery One in 1957. He has subsequently exhibited in London galleries (including the Marlborough New London Gallery and the Axiom Gallery), in the provinces, abroad and in group exhibitions since 1960. His work is represented in public collections including the TATE GALLERY and from 1974 he was Senior Lecturer in Painting at the Central School of Art. His earlier work developed from geometric shapes of strong colour to canvases dominated by areas of a single hue. Later paintings used series of coloured marks on unpainted canvas and explored the combination of order and chance within the work.
LIT: Articles in *Studio International*, August 1966 and June 1973. CF

PLUMMER, Brian (b. 1934). A painter of carefully orchestrated abstracts in fresh colours, he studied at Hornsey and the RA SCHOOLS. His first one-man show was at the Manor House Gallery, Ilkley, in 1969. He has exhibited widely in this country and abroad, and has work in the collection of the Abbott Hall Gallery, Kendall. AW

POLLOCK, Fred (b. 1937). Painter of abstracts in acrylic and oils. Born in Glasgow he studied at GLASGOW SCHOOL OF ART 1955–9, and in 1959 worked in St Ives. He held his first solo exhibition at the New Charing Cross Gallery, Glasgow, in 1963, exhibited at the Garage Gallery, London, in 1974, and showed in the Stockwell

Depot Annual Exhibitions from 1975 to 1979. He has exhibited in group exhibitions including the SERPENTINE Summer Show in 1982, and his work is represented in public collections including the ARTS COUNCIL Collection. He has taught at Brighton Polytechnic, 1974–5, and at Canterbury School of Art in 1979. Influenced by American Abstract Expressionism in 1958, by the St Ives painters and by de Staël, his work is fluid and expressive, conveying the movement of forms in wide-ranging colour.

LIT: Catalogue, Poole Arts Centre, 1980. CF

POLUNIN, Vladimir (1880–1957). Painter and theatrical designer. Born in Moscow, he studied at St Petersburg, Munich and Paris before settling in London. He exhibited in Paris, Moscow and in London galleries (including REID & LEFEVRE Ltd), and his work is represented in collections including the V & A. He taught stage design at the SLADE SCHOOL and in 1914 he collaborated with Boris Anisfeld in designs for Nijinsky's ballets. He was commissioned by Sir Thomas Beecham for a drop curtain for *The Magic Flute*, 1914, and for scenery and costumes for Verdi's *Otello*, 1916. From 1918 he worked for Diaghilev's Russian Ballet both producing designs and painting scenes from the original designs by artists such as Bakst, Picasso and Matisse. His own painting included still-life and figure subjects.

LIT: *The Continental Method of Scene Painting* Vladimir Polunin, C.W. Beaumont, London, 1927; *Studio*, Vol.67, p.1101. CF

POOLE, Monica, RE (b.1921). A wood engraver, who studied with JOHN FARLEIGH (about whom she wrote *The Wood Engravings of John Farleigh*, 1985) at the CENTRAL SCHOOL. Her subjects are treated either starkly (*Broken Shells*, 1973) or more gently, as in her landscapes.

LIT: *Monica Poole-Wood Engraver*, George Mackley, Biddenden, 1984.

PORTER, Frederick James, LG (1883–1944). Painter of landscapes, townscapes and still-life in oils. Born in Auckland, New Zealand, he studied in Auckland, Melbourne and at the ACADÉMIE JULIAN, Paris, under Laurens. He settled in London where he was associated with DUNCAN GRANT and VANESSA BELL and he was a founder member of the LAA in 1925. He exhibited at the LG from 1916, becoming a member in 1921 and Vice-President from 1925 to 1935. In 1916 he held a solo exhibition in his studio at 8 Fitzroy Street; he showed in London galleries (including the LEICESTER GALLERIES), and in 1945 a memorial exhibition was held at the LEFEVRE GALLERY. His work is represented in public collections including the TATE GALLERY. From 1924 to 1944 he taught at the CENTRAL SCHOOL OF ART and his strongly constructed paintings reflect the influence of Cézanne and the Post-Impressionists, e.g. *Snow Scene*, (COURTAULD INSTITUTE GALLERIES, Fry Bequest). CF

PORTWAY, Douglas (b. 1922). Painter of non-figurative and figurative images in oils, gouache and watercolours. Born in Johannesburg, he studied at Witwatersrand Technical School of Art 1943–4, and held his first solo exhibition in South Africa in 1945. He visited the USA in 1952 and left South Africa in 1957, later living in Ibiza, St Ives and France. He has exhibited in London at the Drian Galleries, 1959–68, and from 1970 at the Marjorie Parr and Gilbert-Parr Galleries. Represented internationally in collections including the TATE GALLERY, his instinctive work has been influenced by the Expressionists, by the Mexican painter Tamayo and by Far Eastern art.

LIT: *Douglas Portway*, George Butcher, 20th Century Masters, London, 1963; *Douglas Portway. A Painter's Life*, J.P. Hodin, Springwood Books, 1983. CF

POTTER, Mary, LG (1900–1981). Painter of landscapes, seascapes, still-life, interiors and portraits in oils and watercolours. She studied at Beckenham School of Art in 1916, at the SLADE SCHOOL under TONKS and STEER 1918–20, and she travelled widely. After her marriage to Stephen Potter in 1927, she lived in Chiswick and later in Aldeburgh, forming a close friendship with Benjamin Britten. She exhibited with the SEVEN AND FIVE SOCIETY in 1922 and 1923, at the NEAC from 1920 and with the LG from 1927 and held her first solo exhibition at the Bloomsbury Gallery in 1931. She subsequently showed in London galleries including Tooth's, the LEICESTER GALLERIES and the NEW ART CENTRE. Her work was exhibited at the TATE GALLERY in 1980, at the SERPENTINE GALLERY in 1981, and also in the provinces. A prizewinner at the JOHN MOORES EXHIBITION in 1981, her work is represented in public collections including the Tate Gallery. Influenced by Klee and by Oriental painting, her work combined commitment to subject, light and atmosphere with growing abstraction. She used light, pale-toned colour and thin paint to depict ethereal, light-suffused forms.

LIT: *Oriel 31*, catalogue, Davies Memorial Gallery, Welshpool, 1989; 'Mary Potter', article in *The Green Book*, Vol.3., No.3, 1989. CF

POTWOROWSKI, Peter (1898–1962). Painter of landscapes, nudes, interiors and seated figures; stage designer and teacher. Born in Warsaw, he first studied architecture, then turned to painting and attended the Academy of Fine Arts in Cracow. He moved to Paris in 1924, where he remained for seven years, studying under Léger for a few months. He first visited London in 1928, and made friends with STANLEY HAYTER as well as exhibiting some pictures at Claridge's; he also travelled, before the outbreak of the Second World War, to Holland, Italy and Germany and back to Poland, where he had his first one-man shows (in Warsaw and Lvov, 1938–9). He then moved to Sweden, 1940–3, and subsequently joined the Polish Military Reserve in Scotland. He soon moved to London, where he became friendly with ADLER and also began to write novels. In 1946–7 he had his first London one-man show at the REDFERN; afterwards he showed for many years at GIMPEL FILS. He lived two years in Wookey Hole in Somerset, and entered his so-called 'green' period of landscapes saturated in that colour. He later worked regularly in Cornwall also. His painting set great store on freshness and spontaneity, and the evocation of place. He taught at BATH ACADEMY OF ART, Corsham Court (1949–58) being friendly with HEATH and Armitage and, he himself thought, closest in his artistic approach to LANYON. In 1958 he returned to Poland and became a Professor at Poznan and Gdansk. During his fifteen years in England he had considerable influence on his friends and pupils.
LIT: *Peter Potworowski, 1989–1962*, exhibition catalogue, London University, Institute of Education, 1984. AW

POWELL, John A., ARCA (b. 1911). Painter of landscapes and figures in oils and watercolours; etcher. He studied at Nottingham College of Art 1932–5, and at the RCA under GILBERT SPENCER 1935–9. He exhibited at the NEAC, LG, ROI, RBA, SMA, and at the RA between 1939 and 1949. He also showed in the provinces, particularly at Nottingham Museum and Art Gallery. For a time Principal of Portsmouth College of Art, his delicate and precise work (pointilliste in handling) ranged from subjects such as *Child at Breakfast* (Manchester Education Committee) to *March Snow*, RA 1949. CF

POWER, Cyril Edward, RIBA (1872–1951). Architect, painter, etcher and linocut artist. He first worked as an architect, then as a lecturer at University College, London; he published *A History of English Medieval Architecture* (3 vols) in 1916. He flew with the RFC during the First World War, and in 1923 studied at HEATHERLEY'S; he then helped MACNAB to start the GROSVENOR SCHOOL OF MODERN ART. There CLAUDE FLIGHT introduced him to linocuts. *Speed Trial* (*c*.1932) of Sir Malcolm Campbell's record-breaking car *Bluebird* is one of his best-known expressions of speed and movement. AW

POYNTER, Sir Edward John, Bart., PRA, RWS, RE, HRBA, HRMS, HROI, RP, HRSA (1836–1919). Painter of figures and portraits in oils; illustrator, designer and medallist. He worked in Italy in 1853, where he met and was influenced by Frederick Leighton. He studied with Leigh and W.C.T. Dobson in London, at the RA SCHOOLS and with Gleyre in Paris, 1856–9, where he met Whistler. After visiting Antwerp he settled in London in 1860. He exhibited mainly at the RA from 1861–1919 (ARA 1869, RA 1876, PRA 1896–1918) and at the FINE ART SOCIETY, and widely in other galleries and societies. His work is represented in collections including the TATE GALLERY. He was appointed SLADE Professor from 1871 to 1875, Principal of the National Art Training School, South Kensington, until 1881 and from 1894 to 1906 Director of the National Gallery. Knighted in 1896, he was made Baronet in 1902. His paintings include Greek and Roman subjects which share some characteristics with the work of Alma Tadema.
LIT: *The Drawings of Sir E.J. Poynter*, M. Bell, George Newnes, 1905; *Victorian Olympus*, William Gaunt, J. Cape, London, 1952. CF

PRIEST, Margaret (b. 1944). Painter and draughtsman of architectural and landscape subjects in oils, mixed media and pencil. She studied at Maidstone College of Art and the RCA before settling in Toronto, Canada, in 1976. She exhibited first in 1970, subsequently showing in London galleries (including the Albemarle Gallery) and in Canada. Her work is represented in collections including the TATE GALLERY and since 1983 she has taught at Guelph University. Her precise, meticulous works depict unpeopled modern architecture and landscape in realistic detail, conveying a sense of bleakness and austerity.
LIT: Catalogue, Albemarle Gallery, London, 1989. CF

PRIESTMAN, Bertram, RA, ROI, NEAC, IS, RBA (1868–1951). Painter of landscapes, seascapes, cattle and portraits in oils. Born in Bradford, he was a pupil of Edward More and travelled in Italy, Egypt and Palestine before attending the SLADE SCHOOL. He subsequently worked in the studio of WILLIAM LLEWELLYN and often painted in France and Holland. He exhibited at the RA from 1889–1951 (RA 1923) and showed widely in London societies and galleries, in the provinces and abroad, winning an Hon. Mention in the Paris Salon in 1900, a gold medal at the Munich International Exhibition in 1901, a bronze medal in Barcelona in 1911, and an Hon. Mention in Pittsburgh in 1912. A member of the Society of 25 Artists, his work is represented in public collections including the Leeds and Manchester Art Galleries. He influenced EDWARD SEAGO. His freely painted, atmospheric works capture light and reflections in a manner that was influenced both by Constable and by French painting.
LIT: Catalogues for the retrospective exhibition, Bradford City Art Gallery, 1981, and the Twentieth Century Gallery, London, 1985. CF

PRINGLE, John Quinton (1864–1926). He attended evening classes at GLASGOW SCHOOL OF ART, 1886–95, when apprenticed to an optician. Until 1922 he ran his own business and painted in his spare time. His oils and watercolours, painted in a style influenced by Bastien-Lepage and the GLASGOW BOYS (*Muslin Street, Bridgeton*, 1893, now belonging to the City of Edinburgh), developed towards neo-impressionism, using small clear touches of colour for the depiction of the urban landscape of Glasgow.
LIT: *John Quinton Pringle, 1864–1926*, exhibition catalogue, Scottish Arts Council, 1981. AW

PROCKTOR, Patrick, RA (b. 1936). Painter of townscapes, landscapes, figures, portraits and interiors in watercolours and oils; printmaker and theatrical designer. After studying Russian and serving in the Royal Navy, he attended the SLADE SCHOOL 1958–62, where he was taught by KEITH VAUGHAN, and took a variety of jobs including Russian interpreter for the British Council and art broadcaster for the BBC Russian Service. In 1962 he travelled to Italy and Greece and continued to travel extensively, visiting America in 1965 with HOCKNEY, NORMAN STEVENS and COLIN SELF and subsequently travelling to North Africa, India, Nepal, China, Egypt and Greece. He has exhibited at the REDFERN

GALLERY since 1963, has shown nationally and internationally and exhibited regularly in group exhibitions since 1957. His work is represented in public collections including the TATE GALLERY and MOMA, New York. He also taught at CAMBERWELL SCHOOL OF ART, Maidstone College of Art and from 1965 to 1972 at the RCA. In the 1960s he produced set and costume designs for the theatre and ballet including *Twelfth Night*, 1968, and *Total Eclipse*, 1969, for the Royal Court Theatre. In 1983 he was commissioned by the IMPERIAL WAR MUSEUM to paint the army in Belize and in 1985 he was asked by the British Council to record the Queen's visit to Portugal. His early paintings were strongly coloured and heavily painted but in the late 1960s the pigment became thinner and translucent, leading him to concentrate on watercolour painting. The success of the *Invitation to a Voyage* series of prints, 1969, began a succession of aquatints based on the watercolour records of his travels. His paintings use limpid washes, clean lines and fresh colour to depict the essential elegance of landscapes and townscapes in a simplified but representational style.
LIT: *Patrick Procktor*, Patrick Kinmonth, Cavallino/Venezia, 1985; *Patrick Procktor: Prints 1959–1985*, Birmingham Museum and Art Gallery, 1985. CF

PROCTER, Dod, RA, NEAC (1892–1972). Painter of portraits, figures and landscapes in oils. Born in London née Shaw, she studied under STANHOPE FORBES in Newlyn, Cornwall, 1907–10, before attending the Atelier COLAROSSI, Paris, and studying French painting, particularly Cézanne, Renoir and Seurat. She returned to Newlyn in 1911 and in 1912 married ERNEST PROCTER. In 1920 they worked together in Burma on decorations for the Kokine Palace, Rangoon, and she also travelled widely after his death in 1935. She exhibited with the IS in 1918, at the RA from 1922 and in London galleries including the LEICESTER GALLERIES from 1913. Elected NEAC in 1929 and RA in 1942, her work is represented in public collections including the TATE GALLERY. In the 1920s she began to concentrate on portraits, many of women and children, depicting her figures in powerfully-modelled, sculptural forms which showed the influence of Picasso (*Morning*, 1926, Tate Gallery). In the 1930s her style softened and became more painterly; she found many subjects in Africa and the West Indies.
LIT: *Painting in Newlyn*, Barbican Art Gallery, 1985; 'A Memoir', Noel Welch, *Cornish Review*,

No.22, Winter 1972; *Dod Procter RA 1892–1972*, exhibition catalogue, Laing Art Gallery, New- castle, and Newlyn Orion Gallery, Penzance, 1990. CF

PROCTER, Ernest, ARA, NEAC, IS (1886–1935). Painter of landscapes, portraits and allegorical subjects; decorative painter and designer. He studied with STANHOPE FORBES in Newlyn, Cornwall, 1907–10, and at the Atelier COLAROSSI, Paris, 1910. In 1912 he married Dod Shaw (DOD PROCTER) and settled in Newlyn, working with her at the Kokine Palace, Rangoon, Burma, in 1920. He exhibited at the IS from 1916 (member 1925), at the RA from 1921 (ARA 1932), he was elected NEAC in 1929 and showed in London galleries including the LEICESTER GALLERIES. His work is represented in public collections including the TATE GALLERY. From 1934 to 1935 he was Director of Design and Craft, GLASGOW SCHOOL OF ART. His wide-ranging work included decorative church painting and the invention of a new art form (painted and illuminated works) called 'Diaphenicons'. His painting reflected his interest in design and his allegorical subjects show the influence of early Italian painting and Oriental art.
LIT: *Painting in Newlyn*, Barbican Art Gallery, 1985. CF

PROUT, Millicent Margaret Fisher, ARA, RWS, ROI, RWA, NEAC, WIAC, SWA (1875–1963). Painter of landscapes, figures, flowers and animals in oils and watercolours. Daughter of MARK FISHER, RA, she studied with her father and at the SLADE SCHOOL under FRED BROWN 1894–7, marrying John Prout in 1908. She exhibited at the NEAC from 1906 (member 1925), at the RA from 1921 to 1964 (ARA 1948) and widely in London galleries and societies. Elected SWA in 1935, ROI in 1936 and RWS in 1945, she was a silver medallist at the Paris Salon in 1957. She taught at Hammersmith School of Arts and Crafts before 1914. Her painting was influenced by her father who had studied with Sisley and the Impressionists and she used an impressionistic technique with fresh, light colour. Her watercolours were sometimes enhanced with chinese white and charcoal drawing.
LIT: *Mark Fisher and Margaret Fisher Prout, Father and Daughter*, Vincent Lines, 1966. CF

PRYDE, James Ferrier, IS (1866–1941). Painter of architecture, interiors and figures in oils and watercolours; poster and theatrical designer.

Born in Edinburgh, he studied at the RSA Schools 1886–7, and at the ACADÉMIE JULIAN, Paris, under Bouguereau. In 1890 he settled in London and between 1894 and 1896 collaborated with his brother-in-law WILLIAM NICHOLSON designing innovative posters under the name of 'The Beggarstaff Brothers' which showed the influence of French posters and Japanese prints. He exhibited in London galleries and societies, holding two solo exhibitions during his life: at the Baillie Gallery in 1911, and the LEICESTER GALLERIES in 1933. His work is represented in public collections including the TATE GALLERY. His interest in the theatre influenced all his work and in 1930 he designed scenery for Paul Robeson's *Othello*. His earlier painting concentrated on dramatic portraits and figures, but *c*.1905 he turned to architectural subjects, depicting buildings, ruins and interiors in theatrical light and with an impression of great scale in a manner influenced by Piranesi and Velazquez, by memories of Edinburgh and by Venetian painting, particularly that of Guardi.
LIT: *James Pryde*, Derek Hudson, Constable, 1949. CF

Q

QUICK, Bob (b. 1939). Painter of abstracts in vitreous enamel on steel plate. He studied at Croydon and Brighton Colleges of Art and exhibited first in 1969 at 'Pavilions in the Park'. He subsequently showed at the Grabowski Gallery and in group exhibitions including 'British Painting '74', TATE GALLERY. His work is represented in collections including the ARTS COUNCIL of Wales. His paintings use bright primary colours, black and white in sharply defined, simple shapes distilled from popular imagery. CF

R

RAE, Fiona (b. 1963). Born in Hong Kong, she studied at Croydon and GOLDSMITHS'. Her work was included in HIRST's 'Freeze' exhibition in 1988. A painter of vivid and disturbing abstracts that include geometrically delineated and intensely coloured circles apparently floating in agitated spaces of violently dislocated passages of dark rhythmical marks and patches (*Untitled: Sky Shout*, 1997). AW

RAMSAY, Alex (b. 1947). Painter of figurative and non-figurative work in oils. He studied at CHELSEA SCHOOL OF ART, graduating in 1969, and he has exhibited in numerous group exhibitions. His first London solo exhibition was held at the Creaser Gallery in 1990. His recent work depicts simplified images of figures, birds, trees, boats, etc. floating against a bright surface. His sensual, colourful work is based on subjects concerning human relationships and particular places.
LIT: Catalogue for the Creaser Gallery, London, 1990. CF

RAMSAY, Lady Patricia, RWS, RWA, NEAC (1886–1974). Painter of landscapes, flowers, still-life and seascapes in oils. Daughter of the Duke and Duchess of Connaught and Strathearn, she was a pupil of A.S. HARTRICK and exhibited mainly at the Goupil Gallery, where she held a solo exhibition in 1928, and at the NEAC, becoming a member in 1931. She also showed at other London galleries including the LEFEVRE Gallery, in various societies and at the RA. Her work is represented in public collections including Manchester City Art Gallery. Her active, bright paintings show scenes from Ceylon, Bermuda and France as well as England. CF

RATCLIFFE, William Whitehead, LG (1870–1955). Painter of landscapes, townscapes and interiors in oils. He studied Design at MANCHESTER SCHOOL OF ART under WALTER CRANE and subsequently worked as a wallpaper designer, moving to Letchworth in 1906. In 1908 he met GILMAN who persuaded him to take up painting and in 1910 he studied part-time at the SLADE SCHOOL, attended meetings at Fitzroy Street, 1910–11, and in 1913 he painted in Sweden and in Dieppe. A member of the CAMDEN TOWN GROUP and a founder member of the LG, he exhibited with the Camden Town Group and at the AAA from 1911 and with the LG until 1926. He held his first solo exhibition at ROLAND, BROWSE AND DELBANCO in 1946 and also showed at the Chicago Art Institute and in Boston. His work is represented in public collections including the TATE GALLERY. Influenced by Gilman, GORE and LUCIEN PISSARRO, he used light, soft colour applied in short brushstrokes with thick paint. By 1913 his technique had become smoother and thinner, the colour stronger and the forms more clearly delineated.
LIT: Catalogue, Letchworth Museum and Art Gallery, 1982. CF

RAVERAT, Gwendolen Mary, RE (1885–1957). Wood engraver, lithographer, illustrator and art critic. She trained at the SLADE (1908)and at the Sorbonne, where she met and married Jacques Pierre Raverat. From 1920 to 1925, when her husband died, she lived in Vence. A founder-member of the SWE, she later (1938) worked for ROBERT GIBBINGS's Penguin Illustrated Classics. She was art critic for *Time and Tide* for many years. Her earlier work was visionary (*Creation of Light*, 1912) and her later wood engravings depicted more everyday occupations (*Jeu de Boules, Vence*, 1925).
LIT: *Wood Engravings of Gwen Raverat* Reynolds Stone, Cambridge, 1989. AW

RAVILIOUS, Eric William, SWE (1903–1942). Painter of landscapes, interiors and war subjects in watercolours; muralist, engraver, lithographer; illustrator and designer. He studied at Eastbourne School of Art 1919–22, and at the RCA under PAUL NASH, 1922–5, where fellow students included BAWDEN and BLISS. He won a travelling scholarship to Italy and on his return worked on wood engravings, becoming a member of the SOCIETY OF WOOD ENGRAVERS in 1925. Between 1928 and 1930 he painted murals at Morley College, London, with Bawden. In 1930 he married Tirzah Garwood and between 1929 and 1935 he lived at Great Bardfield, Essex, where Bawden also lived. As an OFFICIAL WAR ARTIST he served with the Royal Marines and the RAF and went missing, presumed killed, on an air-sea rescue mission in Iceland. He exhibited first in 1926 and held solo exhibitions at ZWEMMER'S in 1933 and 1936 and at Tooth's in 1939. His work is represented in public collections including the TATE GALLERY and the IMPERIAL WAR MUSEUM. He taught at Eastbourne School of Art and was Instructor in Design at the RCA between 1929 and 1938. As an engraver he was influenced by Bewick, combining freedom of expression with a precise technique; his commissions included work for the Golden Cockerel Press and the Nonesuch Press (Gilbert White's *Natural History of Selborne*, 1937). Between 1936 and 1940 he also worked for Wedgewood, producing designs for pottery and china. His watercolour paintings and his designs reveal his mastery of elegant, linear composition and patterning. In depicting empty landscapes, interiors and war scenes he used restrained colour and expressive, taut lines.
LIT: *The England of Eric Ravilious*, Freda Constable, Scolar Press, 1982; *Eric Ravilious:*

Memoir of an Artist, Helen Binyon, Lutterworth Press, 1983. CF

RAWLINSON, William Thomas, ATD, FRSA (b. 1912). Wood engraver and painter. Born in Liverpool, he studied at Liverpool College of Art 1929–35 (winning a Scholarship in Design in 1931, and a Senior City Art Travelling Scholarship in 1932), in France, Italy, Austria and Germany. He exhibited at the Paris Salon, winning a Gold Medal in 1935, and at the RA, the Royal Society of Wood Engravers from 1938 (member 1972), at the RCA and in Liverpool. He was an OFFICIAL WAR ARTIST for the RAF between 1943 and 1946 and he taught widely in schools and colleges. His work is represented in public collections including the IMPERIAL WAR MUSEUM. An admirer of Dürer, and Holbein, his own work demonstrates his ability to express form and volume.
LIT: *British Wood Engravings of the 20th Century*, Albert Garrett, Scolar Press, 1980; *A History of British Wood Engraving*, Albert Garrett, Midas Books, 1978. CF

RAWSTHORNE, Isabel (1912–1992). Artist and model. Born Isabel Nicholas, she studied at Liverpool School of Art and at the RA SCHOOLS. She posed for several spectacular portraits by JACOB EPSTEIN, and had a child, Jackie, by him in 1934. In that year she had an exhibition at Arnold Haskell's Valenza Gallery. She moved to Paris aged 22 to study at La Grande Chaumière and was portrayed by Derain, Picasso and Giacometti (examples are in the Sainsbury Centre, UEA). She was later the subject of a whole series by FRANCIS BACON. She married Sefton Delmer in 1934, and travelled with him in Spain, Poland and France. During the Second World War she designed propaganda leaflets and forged documents at Bletchley Park. She divorced in 1946 and married Constant Lambert in 1947 (collaborating on the sets for *Tiresias*). Following Lambert's death (1951) she married Alan Rawsthorne (d. 1971); she designed the sets for his ballets *Blood Wedding* and *Madame Chrysanthème* and for the opera *Elektra*. Her last exhibition was at the October Gallery, London, in 1986. AW

READ, Sir Herbert (1893–1968). Poet and critic. Born at Kirkbymoorside in Yorkshire, he studied at Leeds University until the outbreak of the First World War. He won the DSO and MC in the trenches, and after a spell at the Treasury was an Assistant Keeper at the V & A, 1922–31. He was

Professor of Fine Art at Edinburgh University, 1931–3, and Editor of the *Burlington Magazine* from 1935–9. There followed many academic appointments and honours, and he became President of the Society for Education through Art, of the ICA and of the British Society of Aesthetics. He was a Trustee of the TATE GALLERY from 1965. His distinction as a poet grew parallel to his influence as a writer on art; he was the leading advocate of abstract and Surrealist painting in Britain during the 1930s, with books such as *The Meaning of Art*, 1931, *Art Now*, 1933, and *Education Through Art*, 1943 (all published by Faber & Faber). As HENRY MOORE said in 1968, 'His work helped to change the whole situation of art in this country'.
LIT: *Herbert Read, A Memorial Symposium*, Ed. Robin Skelton, Methuen, 1970. AW

REASON, Cyril (b. 1931). Painter of figures in oils and acrylic; pastelist and etcher. He studied at St Albans School of Art and at the RCA 1951–4, winning a travelling scholarship to Spain and France in 1954. He exhibited at the BEAUX ARTS GALLERY in 1958, 1960 and 1962, in other London galleries and the provinces, and he has shown in group exhibitions since 1961. His work is represented in collections including the V & A and he has taught at Brighton Polytechnic since 1963. He taught at the RCA between 1966 and 1972 and from 1972 to 1979 he was Director of Art at Morley College, London. Much of his work is based on literary subjects, particularly Shakespeare and the Bible, and his concentrated, simplified presentation of figures in strong tonal contrasts conveys a sense of drama and immediacy.
LIT: Catalogue, Nottingham University Art Gallery, 1983. CF

REAY, John (b. 1947). Painter of coastal scenes in oils. He studied at Brighton and Norwich Schools of Art 1969–73, and settled on the East Coast at Lowestoft in 1974. He held his first solo exhibition at the Alwyn Gallery in 1978 and he has subsequently exhibited in galleries including the PICCADILLY, the Bohun Gallery, Henley, and the Phoenix Gallery, Lavenham. His paintings depict coastal scenes with figures, concentrating on transient effects of light and colour.
LIT: Exhibition catalogue, the Bohun Gallery, Henley-on-Thames, 1982. CF

The Rebel Art Centre. Founded by WYNDHAM LEWIS in the spring of 1914 after his break with

FRY and the OMEGA WORKSHOPS, it was intended to provide a centre for painting and applied art in which artists and craftsmen could work, find support and receive instruction. The prospectus stated that it would be based on 'principles underlying the movements in painting known as Cubist, Futurist and Expressionist' and that it would promote these ideas through discussion, lectures and gatherings. The Centre was established at 38 Great Ormond Street and at its opening in April 1914 its founder members included Lewis, ETCHELLS, CUTHBERT HAMILTON, NEVINSON and WADSWORTH, whilst financial backing was provided by KATE LECHMERE. These members were joined by others including HELEN SAUNDERS, JESSICA DISMORR and LAWRENCE ATKINSON. The Centre was supported by GAUDIER-BRZESKA and Ezra Pound and artists such as ROBERTS and BOMBERG were associated with its members. The Centre itself was decorated by members with Futurist-Cubist designs but the only group exhibition of Rebel Centre work was at the AAA Salon in June 1914. After disagreements between Lewis and T.E. Hulme, Lechmere withdrew her financial support and the Centre was closed in July 1914.

LIT: Prospectus for the Rebel Art Centre and the Art School, Rebel Art Centre, London, 1914; *Vorticism and Abstract Art in the First Machine Age*, Richard Cork, Gordon Fraser, London, 1976. CF

Recording Britain. The project 'Recording the Changing Face of Britain' was proposed in 1939 in the expectation of large-scale destruction during the war, and the experience of the pre-war ravages caused at 'the sinister hands of improvers and despoilers'. The Pilgrim Trust granted £6000, a fund administered by P.H. JOWETT (Principal of the RCA), SIR KENNETH CLARK (Director of the NG) and W. RUSSELL FLINT (representing the RA). They chose the artists, agreed the subjects (beginning with the coastal counties which they anticipated would soon either become restricted areas or the first battlefields) and held summer exhibitions of the pictures produced. Thirty-two English and four Welsh counties were studied and a similar scheme was devised for Scotland. Ninety-seven artists took part and 1,549 works were produced. Among those who participated were WALTER BAYES, WILFRED FAIRCLOUGH, A.S. HARTRICK, KENNETH ROWNTREE, JOHN PIPER, GRAHAM BELL, Louisa Puller, MICHAEL ROTHENSTEIN and RUSKIN SPEAR. In 1943 the responsibility for the whole collec-

tion was transferred to the V & A, which added some pictures to its collection, and offered others on loan to regional institutions. Four volumes of reproductions of the pictures, with notes, were published by the OUP with the Pilgrim Trust, 1946–9, and have recently (1990) been reprinted by David & Charles. AW

Redfern Gallery. Founded in 1923, it moved to Cork Street in 1936, and has had a considerable influence on the reputation of a number of artists. In 1938, the then Director, Rex Nan Kivell, organized a major retrospective of the work of his late friend CHRISTOPHER WOOD at the New Burlington Galleries, and sponsored a book on him by ERIC NEWTON. After the war, an important painter whose work was first shown (1952) and subsequently regularly exhibited was ALAN REYNOLDS. AW

REDPATH, Anne, OBE, RSA, ARA, ARWS, ROI, RBA, RWA (1895–1965). She was born in Galashiels, and entered the EDINBURGH COLLEGE OF ART (1913–19), and Moray House College of Education. She qualified as an art teacher before she was awarded the Diploma of Art and a Post-Graduate year. In 1919 she was awarded a travelling scholarship and visited Brussels, Bruges, Paris, Florence and Siena. In 1920 she married an architect, James Beattie Michie, and settled first of all in northern France for five years, and then on the Riviera, where she lived for a further ten years. During that time she did relatively little painting. She returned to Scotland to live in Hawick in 1934. When she began to exhibit regularly, she was elected to an increasing number of distinguished societies as her career developed. Her first one-man show was held in Edinburgh in 1947, and she revisited France in the following years; despite periods of serious illness in 1955 and 1959, she subsequently travelled in Spain and Portugal. She painted intensely-coloured landscapes and still-lives principally, to some degree in the tradition of the Scottish Colourists. LIT: *Anne Redpath: A Memorial Exhibition*, Arts Council, 1965–6; *Anne Redpath, 1895–1965, Her Life and Work*, Patrick Bourne, Bourne Fine Art, 1989. AW

REDPATH, Barbara (b. 1924). Painter in oils and watercolours. Born in London, she studied at EDINBURGH COLLEGE OF ART under W.G. GILLIES and has exhibited at the RSA, SSA, SSWA, GI, in London and France. Her work is represented in collections including the

Department of Fine Art, University of Glasgow.
CF

REES, Sir Richard Lodowick Edward Montague,
Bt. (1900–1970). Painter in oils and watercolours.
Born in Oxford, the son of Sir J.D. Rees, he stud-
ied watercolours with Fred Lawson in 1936, and
attended ST JOHN'S WOOD School of Art in 1937
and then CAMBERWELL SCHOOL OF ART 1945–6,
under COLDSTREAM, ROGERS, GOWING and
PASMORE. A friend of George Orwell, he exhibited
at the RA in 1949, 1953 and 1954, and showed at
the RSA, SSA and LG. His exhibited work includ-
ed subjects such as *King's Road*, RA 1953, and *In
the Mantle Mirror*, RA 1954.
CF

REES-ROBERTS, Lucien, MA, RIBA (b. 1952).
Painter of portraits and landscapes in oils. He
studied architecture at Cambridge 1972–5, and
worked as an architect in Britain and New York
until 1986 when he concentrated on painting. He
has worked in Italy and Spain and exhibited in
London, the provinces and New York. His por-
traits employ a technique of 'cut out' oil paint-
ings constructed from pieces of wood; he has
been influenced by a range of artists including
Matisse, Severini and HOCKNEY.
LIT: *Three Generations*, exhibition catalogue,
England & Co., London, 1989.
CF

REES-ROBERTS, Peter W., ARCA (b. 1923).
Painter of figures and portraits in oils and tem-
pera; mural painter. He studied at Wimbledon
School of Art 1939–41, at the RCA 1941–4, and
in 1945 married URSULA MCCANNELL, settling in
Farnham. He exhibited at the NEAC, the RBA,
and the RA and has shown in London and
provincial galleries and abroad. His many mural
commissions include Guildford Hospital, 1981.
He taught at Farnham and Brighton Schools of
Art and worked as a freelance national press
artist. His earlier work was influenced by
STANLEY SPENCER, Diego Rivera and English neo-
romanticism, whilst after 1948 his work reflects
the influence of Picasso, becoming simpler and
brighter in colour.
LIT: *Three Generations*, exhibition catalogue,
England & Co., London, 1989.
CF

REEVES, Philip Thomas Langford, ARCA, RE,
RSW, SSA, RSA (b. 1931). Painter, printmaker
and collagist. Born in Cheltenham, he studied at
Cheltenham School of Art 1947–9, and at the
RCA 1951–4. He has held solo exhibitions in
Scotland, recently at the Glasgow Art Gallery and

Museum in 1990, and has shown in many group
exhibitions. Elected RSW in 1959, SSA in 1965,
ARSA in 1971 and RSA in 1976, his work is rep-
resented in collections including the Scottish
National Gallery of Modern Art. He has taught at
GLASGOW SCHOOL OF ART since 1954 and in 1970
was appointed Senior Lecturer in Printmaking.
Founder member of the first Printmaker's
Workshop in Scotland, Edinburgh in 1967, and
of the Glasgow Print Studio in 1972, amongst his
awards has been the Cargill Award in 1976. Well
known as a printmaker in the 1960s, he has
worked in collage from 1970. His landscape-
based work has become more abstract but contin-
ues to be based on forms of the landscape in the
north and north-west of Scotland.
LIT: Retrospective exhibition catalogue of etch-
ings, Printmaker's Workshop Gallery,
Edinburgh, 1980; catalogue for Glasgow Art
Gallery and Museum, 1990.
CF

REGO, Paula (b. 1935). Painter of figures and
animals in oils, acrylic and collage. Born in
Lisbon, she trained at the SLADE SCHOOL 1952–6
and between 1957 and 1963 lived in Portugal
with her husband VICTOR WILLING. From 1963
to 1975 she divided her time between London
and Portugal and in 1976 settled in London. She
exhibited first in Lisbon in 1965 and held her
first London show in 1981 at the AIR Gallery.
She has continued to exhibit here, particularly at
the Edward Totah Gallery, London, and abroad.
In 1983 she became Visiting Lecturer at the Slade
School. Her compositions of fantastic figures and
hybrid animals, often inspired by stories, express
psychological tensions and emotional states.
Influenced by Dubuffet in 1959, she has moved
from brightly coloured, packed compositions to
disturbing, large-scale figures of children in
muted colours, strongly modelled in monumental
forms.
LIT: Catalogue, SERPENTINE GALLERY, 1988; arti-
cle in *Art in America*, July 1987.
CF

Reid & Lefevre, see LEFEVRE

REINGANUM, Victor (1907–1995). Painter and
illustrator. He was trained at HEATHERLEY'S and in
Paris at the ACADÉMIE JULIAN. He also studied
with Fernand Léger. In 1926 he formed the
Pandemonium Group with Nicolas Bentley, and
with them exhibited regularly at the BEAUX ARTS
GALLERY. As an illustrator he became responsible
for the style of the *Radio Times* during the 1930s
and 1940s. He called his most abstract paintings

RICHARDS

Diagrams, but these carefully wrought works evoked disturbing, organic objects; many were included in anthologies of latter-day Surrealism. A retrospective was held at the Oriel Gallery, Theatr Clwyd, Mold, in 1993. AW

REMFRY, David, RWS (b. 1942). Born in Sussex, he studied at Hull College of Art 1959–64. His principal medium has been watercolour, and his first important one-man show was at the NEW GRAFTON GALLERY in 1973. Since then he has shown regularly at the Mercury Gallery, as well as exhibiting elsewhere in Britain, in Holland and the USA. His work is in a number of public collections in this country and abroad. His technique is loose and fluid, in the depiction, for example, of women in extravagant attitudes and in theatrically disturbing compositions, as well as in fresh and spontaneous portraits. AW

REMINGTON, Mary, ROI, NEAC, NS, ARCA (b. 1910). Painter of landscapes, coastal scenes, still-life and portraits in oils. She studied at Redhill School of Art under William Todd-Brown, at the RCA under ROTHENSTEIN and at the Académie de la Grande Chaumière in Paris. She has exhibited at the RA from 1939 to 1978, at the Royal Society of Marine Artists, the NEAC (member 1954), the ROI (member 1962) and the NS (member 1970). Her work is represented in public collections including Brighton Museum and Art Gallery. CF

REYNOLDS, Alan (b. 1926). Born in Newmarket. In Germany in 1946, he first saw the work of Paul Klee, whose writings also influenced him profoundly. He studied at Woolwich Polytechnic 1948–52, and then at the ROYAL COLLEGE 1952–3. He taught at the CENTRAL SCHOOL 1954–61 and ST MARTIN'S from 1961. He first exhibited with the LONDON GROUP in 1950, and from 1952 to 1974 had many one-man shows at the REDFERN GALLERY. Since then he has exhibited in many national and international exhibitions all over the world, and similarly his work is in numerous public collections in many countries (for example the TATE GALLERY, The Museum of Modern Art, New York, the National Gallery of Canada, Ottawa, the National Galleries of New South Wales, Adelaide and Melbourne, etc). For many years he was best known for landscape paintings in oil and gouache of considerable romantic intensity, in which plant and tree forms were treated almost as botanical studies whilst tightly integrated with the earth

and sky. His work has passed through different phases, however, and between 1958 and 1966 he painted abstracts in oil and watercolour; in 1969 he constructed his first painted wooden reliefs, and between 1975 and 1978 he made further constructional reliefs, orthogonal in form, and free standing painted structures. More recently he has developed white modular reliefs and constructions of an austere, rectilinear, formal character, concerned with ratio and proportion.
LIT: *Alan Reynolds*, J.P. Hodin, The Redfern Artists Series, London, 1962; Reynolds's *Notebook* is quoted in the brochure for his March-April 1986 exhibition at Juda Rowan, which has been his London gallery since 1978. AW

RHOADES, Geoffrey H. (1898–1980). Painter of landscapes and figures in oils and watercolours; book illustrator and stage designer. He studied at Clapham Art School in 1916, and at the SLADE SCHOOL under TONKS, 1919–23. At this time he also met BARNETT FREEDMAN, HOUTHUESEN, PERCY HORTON and JAMES LAVER. He exhibited at the RA, NEAC and the ROI, also at London galleries (including the Goupil Gallery), and in the provinces. His work is represented in public collections including the TATE GALLERY and the V & A. From 1930 to 1945 he taught at Bishop's Stortford College and from 1953 to 1972 at the RUSKIN SCHOOL OF DRAWING, Oxford. His paintings, many of mythological subjects, were built up with touches of paint to achieve a rich, textured surface with flickering marks of light and shade.
LIT: *Geoffrey Rhoades*, catalogue, Sally Hunter Fine Art, 1987. CF

RICE, Anne Estelle (1877–1959). Painter of landscapes, coastal scenes, figures and portraits in oils. She studied at the Philadelphia Academy of Fine Art, USA, worked in Paris from 1906 to 1911 where she was associated with J.D. FERGUSSON and PEPLOE, and settled in England in 1911. She exhibited at the Paris Salon, from 1911 at the Baillie Gallery, London, at other leading galleries including the LEICESTER, and also abroad. She contributed to *Rhythm* from 1911 and married the critic O. Raymond Drey. A friend of Katherine Mansfield, her painting was fauvist in style with warm colours and a strong, expressive technique.
LIT: Exhibition catalogue, Fosse Gallery, Stow-on-the-Wold, 1986. CF

RICHARDS, Albert (1919–1945). Painter of figures and landscapes in oils and watercolours. He

259

studied at Wallasey School of Art 1935–9, winning a scholarship to the RCA. After starting at the RCA in January 1940 he was called up for national service in April. He served with the Royal Engineers, trained as a paratrooper in 1943 and in 1944 became an OFFICIAL WAR ARTIST, the WAAC having first purchased his work in 1941. His painting is represented in public collections including the IMPERIAL WAR MUSEUM and the TATE GALLERY. Much of his work reflected his experience as a paratrooper and it has stylistic affinities to the work of CHRISTOPER WOOD and PAUL NASH. He was killed near the river Maas.

LIT: *The Rose of Death: Paintings and Drawings by Captain Albert Richards*, catalogue, Imperial War Museum, 1978. CF

RICHARDS, Ceri Geraldus, LG, CBE (1903–1971). Painter of figurative works in oils; draughtsman, relief and collage artist; illustrator and theatrical designer. He studied at Swansea School of Art 1921–4, and at the RCA 1924–7, under SCHWABE who encouraged him to study Cubism, Kandinsky, Picasso and Mondrian. His first solo exhibition was in 1930 (Glynn Vivian Gallery, Swansea), and in 1933 he exhibited with the OBJECTIVE ABSTRACTION GROUP in London. Through JULIAN TREVELYAN he met Arp, and he formed friendships with MOORE and McWilliam; in 1936 he exhibited in the International SURREALIST Exhibition, London. He first exhibited relief constructions in 1937 and also that year became a member of the LG. After the war he was influenced by the Matisse and Picasso exhibition at the V & A. His first London solo exhibition was in 1942 at the Leger Gallery, and he subsequently exhibited regularly in London galleries including the REDFERN and MARLBOROUGH, in the provinces and in group shows nationally and internationally. His work is represented in public collections including the TATE GALLERY. From 1937 to 1939 he taught at CHELSEA SCHOOL OF ART, from 1940 to 1944 he was Head of Painting, Cardiff School of Art; he then taught at CHELSEA POLYTECHNIC, 1947–55, at the SLADE SCHOOL, 1955–8, and at the RCA, 1958–60. A Trustee of the Tate Gallery, he won many awards, receiving his CBE in 1960. His early reliefs and collages show the influence of Cubism and Surrealism. His paintings were often based on music and poetry, particularly that of Dylan Thomas and Debussy. e.g. the *Cathédrale Engloutie* series. His style combined figurative elements with more abstract passages and his later paintings showed greater

simplicity of form and colour whilst still fully expressing his poetic, complex imagination.

LIT: Retrospective exhibition catalogue, the Tate Gallery, 1981; *Modern English Painters*, John Rothenstein, 1974; *The Graphic Work of Ceri Richards*, Roberto Sanesi, Milan, 1973. CF

RICHARDS, Frances (b. 1903). Painter of figures and flowers in tempera, watercolours and cryla; illustrator, engraver and embroiderer. She attended Burslem School of Art 1919–24, and the RCA 1924–7. In 1929 she married CERI RICHARDS. She exhibited at the REDFERN GALLERY, 1945–54, and subsequently at London galleries including the LEICESTER, in Wales and the provinces. She showed with the LG, in group exhibitions, and her work is represented in public collections including the V & A and the TATE GALLERY. She was Head of the Design Department, CAMBERWELL SCHOOL OF ART, 1928–39, and taught at CHELSEA SCHOOL OF ART, 1947–59. Her imaginative paintings of elongated, symbolic figures, mainly of women and children, reflect her interest in Blake, early Italian art and in poetry. Her flower paintings are simple and economical.

LIT: Catalogue, Campbell and Franks Fine Arts, London, 1980. CF

RICHARDS, Frank, RBA (*fl.c.*1890–1925). Painter of landscapes and figures in watercolours and oils. He exhibited at the RBA (becoming a member in 1921), at the RA, ROI and the Dowdeswell Gallery as well as in the provinces. He lived for five years at Newlyn and also in Hampshire but many of his works depict the East Coast around Lowestoft. His painting ranges from detailed figure studies in watercolours, e.g. *The Old Fisherman*, 1890, to more simplified oil paintings, e.g. *On the Beach*, 1891. CF

RICHARDS, Paul (b. 1949). He attended Maidstone and ST MARTIN'S Schools of Art. His work includes portraiture, nudes and figures in oils and acrylics and performance art. In 1972 he was co-founder of the performance group 'Nice Style', and in 1979 creator with BRUCE McCLEAN of *The Masterwork*, with music by Michael Nyman. Film and video work includes *The Kiss* for Channel 4, and participation in *The Arts for Television*, (1987/8), which toured in Europe and the USA. He teaches at the SLADE SCHOOL. His oils are painted with violently broad and free brushstrokes.

LIT: 'Paul Richards', Chris Titterington, *Aspects*, October 1982. AW

RICHARDSON-JONES, Keith (b. 1925). Abstract artist working with paintings and structures. He studied at Northampton School of Art and the RA SCHOOLS 1950–2. He has exhibited in London and the provinces, is represented in public collections, and has taught at Newport College of Art. In 1967 he won first prize, Midland Group's National Open Competition. His restrained, minimalist work explores ideas through series, e.g. works on the tensions generated by arithmetic and geometric progressions. LIT: Article in *Constructivist Forum*, February 1989. CF

RICHMOND, Leonard, RBA, RI, ROI, PS (d. 1965). Painter of landscapes and figures in oils and watercolours; pastelist, writer and lecturer. He studied at Taunton School of Art and CHELSEA POLYTECHNIC and exhibited widely in leading London galleries and societies including the RBA (becoming a member in 1914), the ROI (member 1918), the RA, the FINE ART SOCIETY and the Cooling Gallery. He exhibited abroad winning awards at San Francisco in 1915, Chicago in 1928, and a silver medal at the Paris Salon in 1947. In 1918 he was commissioned by the Canadian Government to work in France and he lectured in Canada, 1925–6, America, 1928–9, and published several books on technique. His warmly coloured works achieve a depth of effect in oils and pastels. LIT: See his own books including *The Technique of Watercolour Painting*, L. Richmond and J. Littlejohns, London, 1927; 'Leonard Richmond RBA, ROI Landscape Painter', W.H. Chesson, *Studio*, Vol.LXXXI, p.96. CF

RICHTER, Herbert Davis, RI, RSW, ROI, RBA (1874–1955). Born in Brighton, he studied at BATH SCHOOL OF ART, at Lambeth and at the London School of Art under FRANK BRANGWYN. He painted architectural subjects, interiors and figure compositions in a bold, vigorous, airy manner in oils, watercolours and pastels. He published a number of books on technique – *Flower Painting in Oil and Watercolour* for example – and is represented in many public collections. AW

RICKETTS, Charles De Sousy, RA (1866–1931). Painter of figures in oils and watercolours; sculptor, theatrical designer, illustrator, collector and writer. He attended the South London Technical Art School where he met CHARLES SHANNON in 1882. He exhibited mainly at the RA (becoming RA in 1928), and in other societies, London galleries, and the provinces. His work is represented in many public collections. With Shannon he edited *The Dial*, 1889–97, and founded the Vale Press, 1896–1904. His book design and illustration included work for Oscar Wilde and from 1906 he produced many theatrical designs. He was appointed Advisor to the National Gallery of Canada, 1924–31, and his art collection, formed with Shannon, was bequeathed to the Fitzwilliam Museum, Cambridge. His painting was influenced by Symbolism, Moreau, Delacroix and by Daumier. Many of his subjects were tragic or dramatic, e.g. *Don Juan and Faust*. LIT: *Charles Ricketts*, J.G.P. Delaney, Clarendon Press, 1990; *Self Portrait*, ed. Cecil Lewis, Peter Davies, London, 1939. CF

RIELLY, James (b. 1956). A painter, born in Wales, who received his MA in Belfast in 1981. He was MOMART Fellow at the TATE GALLERY, Liverpool, in 1995, and in 1997 had a one-person show at the Musée des Beaux-Arts in Nantes. His work is playfully sinister, depicting (in grainy, pale colours) equivocal, snapshot-like glimpses of adults and children, in disconcerting attitudes or with disturbing attributes. His *Random Acts of Kindness* (1996) is a group of forty such small canvases. AW

RILEY, Bridget, ARCA, CBE (b. 1931). Painter of Op art in oils, acrylic and gouache; printmaker. She studied at GOLDSMITHS' COLLEGE OF ART under Sam Rabin, 1949–52, and at the RCA 1852–5, where contemporaries included DICK SMITH, PETER BLAKE, JOE TILSON and JOHN BRATBY. In 1959 she attended THUBRON'S summer school under MAURICE DE SAUSMAREZ. She has travelled extensively in Britain, Europe, India and the Far East, making an important visit to Egypt in 1981. Since 1961 she has worked partly in Vaucluse, France. She exhibited at Gallery 1, London, in 1962 and 1963, and from 1969 at the Rowan Gallery. From 1965 she has shown regularly in America and internationally, and in 1970–1 there was a major European travelling retrospective of her work. Retrospectives in this country include the Hayward Gallery in 1971, and the Whitworth Art Gallery in 1973. Her work is represented in numerous public collections including the TATE GALLERY and MOMA, New York. From 1959–1961 she taught at Loughborough College of Art, in 1960 at Hornsey College of Art and from 1962 to 1964 at Croydon College of Art. Her many awards

include the Grand Prize for Painting, Venice Biennale 1968, and a CBE in 1972. A Trustee of the Tate Gallery since 1981, her work has included decorations for the Royal Liverpool Hospital, 1983, and designs for *Colour Moves*, Ballet Rambert, 1983. A pioneer of Op art, she limited her painting to black and white in the early 1960s, covering the canvas with simple forms that underwent modulations in order to give a sense of movement and space. She gradually introduced tonal variations and, in 1966, colour. Using groups of colours, she concentrated on a form which would liberate fugitive colour with the minimum of distraction, e.g. stripes of colour. After her Egyptian visit she executed a series inspired by the unblended earth colours of the tomb paintings. Her later work became warmer, the formal elements more variable and the control of fugitive colour more apparent. The anonymous handling of paint by assistants allows the true subject of the work (perception and the sensation of seeing), to remain unhindered by extraneous allusions.
LIT: *Bridget Riley*, Maurice de Sausmarez, Studio Vista, London, 1970; exhibition catalogue by Robert Kudielka, the BRITISH COUNCIL, 1978; *Working with Colour*, catalogue, ARTS COUNCIL, 1984. CF

RILEY, Harold (b. 1934). A painter of urban and industrial scenes, of northern landscapes and of portraits, he was early encouraged by L.S. LOWRY and attended the SLADE SCHOOL. A number of his paintings, vigorous in contrast of tones and handling of paint, are in the collection of the City Art Gallery of his native Salford.
LIT: *Harold Riley*, exhibition catalogue, Salford Museum and Art Gallery, 1969. AW

RILEY, Harry Arthur, RI (b. 1895). Painter of landscapes, figures and marines in oils and watercolours; commercial artist, cartoonist and lecturer. He studied at Bolt Court under WALTER BAYES, 1910–15, and at ST MARTIN'S SCHOOL OF ART. He exhibited at the RI (becoming a member in 1931), the RBA, the ROI and at the Arlington Gallery. Between 1931 and 1963 he exhibited at the RA with subjects such as *The Harbour*, 1959, and *Porto Venere*, 1963. CF

RIZVI, Jacqueline, RWS, NEAC (b. 1944). Painter of a wide range of subjects in watercolours. She studied at CHELSEA SCHOOL OF ART 1962–6, and has exhibited at the RA and NEAC since 1978. at London galleries including the

NEW GRAFTON GALLERY and the Upstairs Gallery; at the RA, in the provinces and abroad. She was elected NEAC in 1982 and RWS in 1986. Her painterly yet delicate watercolours range from still-life to portraiture and gardens. CF

ROBERTS, John Vivian, ARWS, RE, ARCA (b. 1923). Painter of figures and portraits in acrylic, watercolours and gouache; etcher and illustrator. He studied at Cardiff School of Art and the RCA, has exhibited regularly, particularly in Wales, and is represented in public collections. From 1972 to 1983 he was Principal Lecturer, Department of Graphic Design, Liverpool Polytechnic, and is a member of Liverpool Academy of Arts. Many of his subjects are taken from the circus.
LIT: Retrospective exhibition catalogue, Newport Museum and Art Gallery, 1986. CF

ROBERTS, Lancelot, R.Cam.A., PS (d. 1950). Painter of portraits and figures in oils. He exhibited mainly at the R.Cam.A. as well as at the RA, in Birmingham, Liverpool and Manchester. His work is represented in public collections including Manchester City Art Gallery (*A Lancashire Lass*, 1929). CF

ROBERTS, William Patrick, LG, RA (1895–1980). Painter of figures and portraits in oils and watercolours. In 1909 he was apprenticed to the advertising firm Sir Joseph Causton Ltd and attended evening classes at ST MARTIN'S SCHOOL OF ART. In 1910 he won a scholarship to the SLADE SCHOOL where contemporaries included BOMBERG, WADSWORTH, NEVINSON, GERTLER, SPENCER and PAUL NASH. In 1913 he travelled in France and Italy, was influenced by Cubism and joined the OMEGA WORKSHOPS as an assistant. In 1914 he exhibited with the Grafton Group and left the Omega when WYNDHAM LEWIS asked him to join Wadsworth, ETCHELLS and HAMILTON who, with Lewis, had broken with FRY. He was a signatory of the VORTICIST Manifesto and his work appeared in *Blast*. In 1915 he exhibited with the LG and also showed abstract vorticist works in the Vorticist Exhibition at the Doré Galleries. In 1916 he joined the Royal Field Artillery and was appointed an OFFICIAL WAR ARTIST from 1917 to 1918. In 1920 he took part in the GROUP X exhibition and in 1923 had his first solo exhibition at the CHENIL GALLERIES. In 1927 he joined the LAA which sponsored his exhibitions at the Cooling Galleries in 1929 and 1931. Thereafter he exhibited at leading London galleries including the LEFEVRE and the

LEICESTER, and from 1948 at the RA, becoming ARA in 1958 and RA in 1966. His work is represented in many public collections including the TATE GALLERY. From 1925 to 1960 he taught at the CENTRAL SCHOOL OF ART. He was the author of many pamphlets and publications on his work. In 1961 he received a Gulbenkian Foundation Award for outstanding services to British painting. His early work developed a personal cubistic style and after producing paintings influenced by the mechanistic designs of the vorticists he returned to his main interest: the depiction of figures in a stylized, schematic manner with clear forms and strong colours. In later work the extreme angularity of forms softened to rounder shapes and his RA works became elaborate, many figured designs, e.g. *Trooping the Colour*, 1958-9. His work was prepared sequentially through sketches and drawings and transformed contemporary scenes into paintings of monumentality and permanence.

LIT: See his own publications, e.g. *Paintings and Drawings 1909-1964*, 1964; retrospective exhibition catalogue, Tate Gallery, 1965; *Vorticism and Abstract Art in the First Machine Age*, Richard Cork, Gordon Fraser, London, 1976. CF

ROBERTSON, Carol (b. 1955). She studied at Cardiff 1974-78, and at CHELSEA 1980-1. She won a Boise Scholarship to travel in Europe and (1993) an Abbey Award to the BRITISH SCHOOL AT ROME. Her first solo exhibition was at the Brewhouse Gallery, Somerset in 1981. Her rhythmical geometric abstracts use glazes, polished or matt textures to transform or to define colour; *A Poet's House* (1996) is characteristic. AW

ROBERTSON, Eric Harald Macbeth (1887-1941). A painter, he first studied architecture, then painting and drawing, at EDINBURGH. After exhibiting with a circle of friends from 1913, he formed the Edinburgh Group, which included J.R. BARCLAY, W.O. HUTCHINSON and D.M. SUTHERLAND. He married Cecile Walton, the daughter of E.A. Walton, becoming a Quaker. In 1917-18 he served with the Friends Ambulance Unit, and executed some oils and pastels of war subjects. His Pre-Raphaelite-influenced romantic figure compositions often included highly erotic nudes; these and his irregular private life were considered scandalous by many. His marriage and professional career failed, and in 1923 he moved to Liverpool, where he created the unsuccessful Electrical Arts Company to design neon advertising signs. AW

ROBINS, William Palmer, RWS, RE, NS (1882-1959). Landscape painter and etcher. First studied architecture at Kings College, London, then art at ST MARTIN's, GOLDSMITHS' and the RCA. He later taught at St. Martin's and the CENTRAL SCHOOL. A member of the SENEFELDER CLUB, he also made lithographs. His favourite etching subjects were flat landscapes with trees, often working directly from nature onto the plate, although he made some later London scenes. AW

ROBINSON, Frederic Cayley, ARA, RBA, ROI, RWS, NEAC (1862-1927). Painter of figures in oils, tempera and watercolours; decorator, theatrical designer and illustrator. He trained at ST JOHN's WOOD ART SCHOOL and the RA SCHOOLS; from 1890 to 1892 at the ACADÉMIE JULIAN, and in Florence 1898-1902. From 1902 to 1906 he worked in Paris. He exhibited at the RBA and ROI from 1888 (becoming a member in 1889 and 1906 respectively), at the RA from 1895 (becoming ARA in 1921), and in London galleries and in the provinces. He was also elected NEAC in 1912 and RWS in 1919. His work is represented in public collections including the TATE GALLERY. Between 1914 and 1924 he was Professor of Figure Composition and Decoration at GLASGOW SCHOOL OF ART. His theatrical design includes Maeterlinck's *Blue Bird*, 1909. His painting style was influenced by the early Italians, Burne-Jones and in particular by Puvis de Chavannes in its simplified forms and restricted tones.

LIT: Exhibition catalogue, Fine Art Society, 1977; article, Mary Anne Stevens, *Connoisseur*, September 1977. CF

ROBOZ, Zsuzsi (b. 1930). Painter and draughtsman of figures and portraits; lithographer. She studied at the RA SCHOOLS and in Florence with Annigoni 1955-7. She has exhibited in London galleries including Quinton Green Fine Art, at the RA since 1981 and in Paris and New York. Her work is represented in the TATE GALLERY and other public collections. Many of her firmly drawn subjects are from the theatre and ballet.

LIT: *Chichester 10, Portraits of a Decade*, Davis-Poynter, 1975; *British Ballet Today*, Davis-Poynter, 1980. CF

ROCHE, Alexander Ignatius, RSA, RP, NEAC (1861-1921). Painter of landscapes, portraits and genre in oils. He studied at GLASGOW SCHOOL OF ART, at the ACADÉMIE JULIAN, Paris,

under Boulanger and Lefèbvre and at the Ecole des Beaux-Arts under Gérôme. In the early 1880s he painted at Grès-sur-Loing with KENNEDY, LAVERY and MILLIE DOW, and in 1885 with W.Y. Macgregor in Glasgow. In the 1890s he visited Italy and America. He exhibited at the GI from 1885, at the RSA (becoming a member in 1900), at the RA, NEAC, and with the GLASGOW BOYS at the GROSVENOR GALLERY in 1889 and 1890. He was awarded a gold medal in Munich in 1891, and Dresden in 1897, and an Honorable Mention at the Paris Salon in 1892. His naturalistic painting style was influenced by William Stott and the artists working at Grès. He painted many portraits later in his career.

LIT: *The Glasgow Boys*, Roger Billcliffe, John Murray, 1985; *Studio*, Vol.37, 1906. CF

ROCHE, Laurence, DA, NDD, GRA (b. 1944). Painter of landscapes and industrial subjects in acrylics. He was a student at Swansea College of Art 1961–5, EDINBURGH COLLEGE OF ART 1965–9, and Moray House College of Education 1969–70. He has held numerous solo exhibitions and shown in group exhibitions, including the GRA. His work is represented in private and corporate collections in this country and abroad. Artist in Residence to Allied Steel and Wire PLC, his work has appeared in GRA publications including *To the Seaside*, David & Charles, 1990. His landscapes express through light, atmosphere and intense colour an ethereal and evocative mood. CF

ROGERS, Claude Maurice, PLG, NEAC, OBE (1907–1979). Painter of figures, portraits and landscapes in oils. He trained at the SLADE SCHOOL 1925–8, winning a Slade Scholarship, and where his contemporaries included COLDSTREAM, MOYNIHAN and TOWNSEND. He visited Paris in 1927 and 1937, Aix-en-Provence 1939 and Italy in 1951. He exhibited at the LG in 1930 (becoming a member in 1938 and President 1952–65), and at the LAA in 1933. In 1940 he exhibited at the LEICESTER GALLERIES and he continued to show there until 1960, later exhibiting at Fischer Fine Art. His work was shown in many group exhibitions and is included in public collections including the TATE GALLERY. In 1937 he was a founder member of the EUSTON ROAD SCHOOL with PASMORE and Coldstream. He taught at CAMBERWELL SCHOOL OF ART, the Slade School, 1948–63, and from 1963 to 1972 was Professor of Fine Art, University of Reading, and was created Professor Emeritus on his retirement.

He was a member of the Arts Panel, ARTS COUNCIL OF GREAT BRITAIN, 1955–63, and member of NCDAD and Chairman of the Fine Arts Panel, 1961–8. In 1951 he won an Arts Council Festival of Britain Prize and in 1959 was created OBE. He was married to the artist ELSIE FEW. His earlier Euston Road School paintings relied less on rigid measurement than on his search for shape and visual response to colour. His work became increasingly powerful in terms of the solidity of colour and organization and it is characterized by honesty of vision and the reality of observed shapes even in seemingly intractable subject matter, e.g. *Stubble Burning*, 1959–72, and his paintings from aircraft windows.

LIT: Retrospective exhibition catalogue, Whitechapel Art Gallery, 1973; *The Euston Road School*, Bruce Laughton, Scolar Press, 1985; *The Affectionate Eye: The Life of Claude Rogers*, Jenny Pery, Sansom & Co., 1995. CF

Roland, Browse & Delbanco. Founded in 1945 by Henry Roland, Lillian Browse and Dr Delbanco, the gallery in Cork Street showed figurative painting tending towards the expressionist; among the artists who established themselves there were BERNARD DUNSTAN, HENRYK GOTLIB, ZYSLAV RUSZKOWSKI, JOSEF HERMAN, KEITH GRANT, PRUNELLA CLOUGH, BRIAN SELWAY, PHILLIP SUTTON and ANTHONY WHISHAW. After 1977 the gallery re-opened as Browse & Darby.

LIT: *Behind the Façade: Recollections of an Art Dealer*, Henry Roland, Weidenfeld & Nicolson, 1991. AW

Rome Prize, Prix de Rome, see BRITISH SCHOOL AT ROME.

ROOKE, Noel, ARE, NS, SWE (1881–1953). Wood engraver, illustrator, painter and teacher. He studied at the SLADE and at the CENTRAL SCHOOL, where he later taught book illustration (1905) and wood engraving (1912). He was appointed Head of the School of Book Production in 1914. He had a tremendous influence as a teacher of wood engraving to several generations of important artists.

LIT: *Noel Rooke, 1881–1953*, exhibition catalogue Christ Church Picture Gallery, Oxford, 1984. AW

ROSE, Sir Francis Cyril, Bt. (1909–1979). Painter of portraits, figures and landscapes in oils and a range of media; designer and illustrator. Born in England, between 1925 and 1929 he

travelled in France, Italy, Austria and North Africa and between 1926 and 1936 he studied with Sert and Francis Picabia. In France he associated with Cocteau, Christian Bérard and Picasso and in 1929 he designed for the Diaghilev Company and painted in Brittany with CHRISTOPHER WOOD. In 1931 he met Gertrude Stein who continued to support his work. He travelled widely, later settling in Paris and then London. He exhibited first in Paris with Dali in 1930 and subsequently held regular exhibitions in London, Paris and New York. A retrospective exhibition was held at the South London Art Gallery in 1966 and his work is represented in the BM. His technically inventive work often created unusual surfaces and presented mysterious, surrealistic images with incisive lines and colour.
LIT: *Saying Life*, autobiography, Cassell, London, 1961; retrospective exhibition catalogue, England & Co., London, 1988. CF

ROSENBERG, Isaac (1890–1918). Born in Bristol, he was brought up in Whitechapel. During an apprenticeship in photo-engraving, he took evening classes in painting at Birkbeck College. He studied at the SLADE 1911–13, having won prizes, and visited South Africa before returning to England in 1915. Despite ill-health, he joined the army and was at the Front from 1916 until he was killed. A poet of distinction (he published two volumes of verse in his brief life: *Night and Day*, 1912, and *Youth*, 1915, and was considered by Sassoon to have 'mastery of his material' in his war poems), he exhibited little. His work was perhaps closest to that of his friend GERTLER.
LIT: *Isaac Rosenberg: The Half-Used Life*, Jean Liddiard, Gollancz, 1975; *Journey to the Trenches: The Life of Isaac Rosenberg*, Joseph Cohen, Robson, 1975. AW

ROSENBLOOM, Paul (b. 1949). Painter of abstracts in oils. He studied at the Polytechnics of Lanchester, Leeds and Birmingham and from 1972 to 1973 was Fellow in Painting, Gloucestershire College of Art. In 1979 he worked in Australia where he was influenced by the light and landscape. He exhibited at Durham University in 1977 and has since exhibited in London galleries (including Nicola Jacobs), and in group shows. His work is influenced by Oriental painting and abstract landscape motifs. CF

ROSOMAN, Leonard, RA, OBE (b. 1913). Painter of landscapes, townscapes, portraits and animals in oils; illustrator, mural and exhibition designer. He studied at Durham University, the RA SCHOOLS and the CENTRAL SCHOOL under MENINSKY, 1937–8. He has travelled widely and painted in the USA in 1966. He held his first solo exhibition at St George's Gallery in 1946 and has subsequently showed at ROLAND, BROWSE AND DELBANCO, the FINE ART SOCIETY and in New York. He has exhibited at the RA since 1959 (becoming ARA in 1960 and RA in 1970), and his work is represented in public collections including the TATE GALLERY and the IMPERIAL WAR MUSEUM. He taught at CAMBERWELL SCHOOL OF ART, 1947–8, EDINBURGH COLLEGE OF ART, 1948–56, and from 1956 at the RCA. As an OFFICIAL WAR ARTIST he worked with the British Pacific Fleet in 1945 and he was awarded an OBE in 1981. Whilst his earlier work reflects aspects of English neo-romanticism, later paintings present a personal, unexpected view of the subject using perspectival distortion and proportional ambiguities.
LIT: *A War Retrospective, 1939–1945*, Imperial War Museum, 1989; 'Leonard Rosoman', Bernard Denvir, *Studio*, Vol.135, 1948, p.144; 'The Portrait as Painting', Leonard Rosoman, *Artist* (UK), April 1989. CF

ROSSITER, Anthony, RWA, MSIAD (b. 1926). Painter of landscapes, interiors and still-life in oils, gouache and watercolours, pen and ink and mixed media; writer. He studied at CHELSEA POLYTECHNIC 1947–51, and in 1962 won a travel award to the USA where he stayed with Robert Frost. His first solo exhibition in London was in 1970, and he has shown at the RA, in London galleries and in the provinces since 1954. His work is represented in public collections including the V & A. Between 1960 and 1983 he taught at Bristol Polytechnic and he was the winner of the ARTS COUNCIL Award for Creative Prose in 1966 and 1970. His expressive work is in the tradition of English neo- romanticism and shows his interest in the contrast between natural and man-made objects.
LIT: See his autobiography *The Pendulum*, Gollancz, 1966. CF

ROTHENSTEIN, Michael, RA (1908–1993). Painter of figurative and abstract subjects in oils, watercolours, collage and mixed media; maker of assemblages, printmaker and writer on art. The younger son of WILLIAM ROTHENSTEIN, he studied at CHELSEA SCHOOL OF ART in 1923, and at the CENTRAL SCHOOL 1924–7, under

MENINSKY and HARTRICK. In 1957 he worked with HAYTER at ATELIER 17. He held a solo exhibition at the Warren Gallery in 1930 and thereafter showed regularly in London galleries (including Angela Flowers), in the provinces and abroad. He showed at the RA from 1932, becoming ARA in 1977 and RA in 1984, and he is represented in public collections including the TATE GALLERY. He worked for the RECORDING BRITAIN scheme 1940–3 and lectured extensively, and his publications include *Relief Printing*, 1970. He was greatly influenced by Hayter and in the 1960s produced many mixed media prints using abstract symbols. His direct, dramatic painting in powerful colour, ranged from the intense depiction of everyday scenes to the portrayal of certain symbolic images such as the cockerel.

LIT: Retrospective exhibition catalogue, Stoke on Trent Museum and Art Gallery, 1989.　　CF

ROTHENSTEIN, Sir William, NEAC, RP (1872–1945). Painter, draughtsman and lithographer of portraits, figures, landscapes and architectural subjects; mural painter. Born in Bradford to a Jewish family with Unitarian leanings, Rothenstein studied at the SLADE SCHOOL 1888–9, and at the ACADÉMIE JULIAN, Paris, 1889–93. Eclectic technically and stylistically, important French influences were early established – Degas, Toulouse-Lautrec; Puvis de Chavannes. A trip to Spain and Morocco in 1893 heralded an equally important Spanish predilection in the 1890s: he exhibited *Zuloaga on a Torero* in 1895. Encouraged by Sargent, Rothenstein wrote an influential book on Goya in 1899. Turning to domestic interiors in the early 1900s, he consciously sought to introduce 'English' associations. Making portraiture a speciality (he published lithographic series from 1893) it is estimated that by 1926 he had treated some 800 portrait subjects. Much travelled in Italy in 1906, India in 1910, the USA in 1912 (where he held a one-man exhibition at the Art Institute of Chicago), in 1912 Rothenstein settled at Far Oakridge in Gloucestershire, an area of inspiration for his later landscapes. A member of the FITZROY STREET GROUP in 1907, he worked as an OFFICIAL WAR ARTIST in France from 1917 to 1919 and from 1939 to 1941 executed a large series of RAF portraits. He painted a mural in the Palace of Westminster, 1926–8. While his marriage in 1899 made links with an older Pre-Raphaelite generation – notably W.M. Rossetti – Rothenstein forged contacts with an ever widening circle of his younger contemporaries in a spirit of benevolent patronage. He exhibited in Paris from 1891, at the NEAC from 1893, and subsequently often at the RP, Carfax, CHENIL, Goupil and LEICESTER Galleries. Professor at Sheffield University, 1917–26, he was Principal of the RCA, 1920–35, a Trustee of the TATE, 1927–33, and was knighted in 1931.

LIT: Among his many writings, *Men and Memories*, Faber & Faber, 1931–9; *William Rothenstein*, Robert Speight, Eyre & Spottiswoode, 1962.　　GS

ROTHMER, Dorothy (b. 1926). Painter of industrial landscapes in oils and mixed media. She studied at Santa Monica City College, California, and in Manchester. She held solo exhibitions in 1968 and 1972 at the Colin Jellicoe Gallery, Manchester, where she has continued to exhibit regularly, and in London and provincial galleries including the Salford Art Gallery in 1983. She has shown widely in group exhibitions and at Manchester Academy of Fine Arts and her work is represented in collections including Salford Art Gallery. Her work is strongly designed and coloured.　　CF

ROUSSEL, Theodore Casimir, RBA, ARE, NEAC (1847–1926). Painter in oils, watercolours and pastels and etcher of portraits, landscapes and genre. Born in Brittany, he was educated in Paris and spent two years in Rome before serving in the Franco-Prussian War. He then settled in London and concentrated on art. In Chelsea he knew Maitland and in 1885 he met Whistler and started to make etchings under his direction *c.*1887–8. He exhibited at the French Gallery in London in 1881–2 and at the NEAC from 1887 (member 1887). He showed mainly at the CHENIL GALLERY and Cooling & Sons, but also at a range of societies, being elected RBA in 1887 and ARE in 1921. His work is represented in collections including the TATE GALLERY. Interested in the theory of colour, both in painting and printmaking, he began to experiment with colour-etchings *c.*1895 and developed new techniques giving a wide range of colour and a new production process. Influenced by Whistler, particularly in his etchings, his tonal paintings used a fluid technique.

LIT: *Theodore Roussel*, Frank Rutter, The Connoisseur Ltd, 1926 (limited edition of 350 copies); 'Theodore Roussel's Chelsea', M.D. Hausberg, *Print Review* USA, No.20, 1985, pp.54–65.　　CF

ROWNTREE, Kenneth, ARWS (1915–1997). Painter of landscapes, architectural subjects, figures, still-life and semi-abstracts in oils, watercolours and acrylic; collagist. He studied at the RUSKIN SCHOOL OF ART 1930–4, and at the SLADE SCHOOL under SCHWABE, 1934–5. His first solo exhibition was at the LEICESTER GALLERIES in 1946, and he subsequently exhibited at London galleries including the ZWEMMER Gallery and the NEW ART CENTRE. He showed at the RA, NEAC, AIA and RSW and his work is represented in public collections including the TATE GALLERY and the V & A. Between 1949 and 1958 he taught at the RCA and the Ruskin School and in 1959 he became Professor of Fine Art, University of Newcastle. In 1959 he was awarded a Ford Foundation Grant to the USA and he was a member of the Summerson Council Fine Art Panel. His work ranged from landscapes which revealed his interest in structure and pattern (*Cornish Landscape*, Tate Gallery) to semi-abstract collages.
LIT: Exhibition catalogues, Laing Art Gallery, 1977; *Paintings and Drawings by Kenneth Rowntree*, Hexham Abbey Festival, 1987. CF

Royal Academy of Arts. The Royal Academy was founded by King George III in 1768, with Sir Joshua Reynolds as its first President. It was housed at first in Pall Mall, then at Somerset House, then in the National Gallery, and moved to its present building, Burlington House, Piccadilly, in 1867. An independent, self-supporting institution, its members (painters, engravers, sculptors and architects) are today designated Senior Academicians and Academicians. The category of Associate was abolished in 1991 and all the then Associates became full Academicians. Members, whose numbers are limited to eighty, serve in rotation on the Council, and elect their President annually. There are also Honorary Academicians and (non-artists) Hon. Fellows. Each Academician deposits a work with the Academy on admission, and these form a permanent collection supplemented by other acquisitions, some of which (such as a relief by Michelangelo) are of the highest importance. An unbroken series of Summer Exhibitions has been held since 1769, to which anyone may submit works; a Selection Committee decides which are to be accepted for hanging. In the winter, the galleries usually accommodate major thematic exhibitions. The revenue from admission charges to these events pays for the running of the ROYAL ACADEMY

SCHOOLS. For nearly one hundred years after the 1880s, there was considerable mutual hostility between Academicians and those artists who considered the Academy to be a bulwark of reaction and mediocrity in art; in recent years, however, a determined policy of electing the best artists willing to become members has transformed the institution into one of considerable vitality.
LIT: *The History of the Royal Academy*, Sidney Hutchison, RA, 1968. AW

Royal Academy Schools. The Instrument of Foundation of the Royal Academy of Arts (1768) provided for setting up Schools of Design, with Professors of Architecture, Painting, Sculpture, Anatomy and Perspective and Geometry; today there is also a Professor of Chemistry, and the Schools are housed behind the Galleries in Piccadilly. The Schools enjoyed a high reputation until the time of the Pre-Raphaelites (after which there was open hostility from many quarters), but are once again highly regarded. Painting, sculpture and printmaking are taught. Today they only admit postgraduates. The Academy awards a Diploma, and a number of prizes and scholarships. AW

Royal College of Art. In 1837 funds were provided by the Government to set up a 'School of Design' in Somerset House in the Strand. After moving first to Marlborough House and then to Brompton Park House, and being succeeded in 1851 by Henry Cole's College of Applied Art, in 1864 it was established in its first purpose-built home on the site adjoining the Brompton Oratory which was also to include the Victoria and Albert Museum. Several times re-named, as the School of Practical Art at South Kensington and as the National Art Training School, it was given its present name in 1896. It was then allowed to grant its own Diploma, and was divided into four schools, the Heads of which were given the title of Professor after 1901. The Headmaster was entitled Principal after 1902. Painting gained great emphasis with the appointment of WILLIAM ROTHENSTEIN as Principal in 1920. The College was evacuated to Ambleside from 1940 to 1945. Today it is mainly housed in a purpose-designed new building by H.T. Cadbury-Brown (1962) in Kensington Gore and now has University status as a postgraduate institution and is headed (since 1967) by a Rector. The many distinguished artists who trained at the RCA included ERIC RAVILIOUS, EDWARD BAWDEN, HENRY MOORE, BARBARA HEPWORTH, R.B. KITAJ and DAVID HOCKNEY.

LIT: *The Royal College of Art: One Hundred and Fifty Years of Art and Design*, Christopher Frayling, Barrie & Jenkins, 1987.　　AW

Royal Institute of Painters in Watercolours. Formed in 1831 as 'New Society of Painters in Watercolours', its forerunner having been the 'Old Society'; the eight founder members wished to provide exhibition space to encourage 'the outsider'. In 1883 purpose-built galleries were opened in Piccadilly (it was damaged in the Second World War), and Queen Victoria conferred the Royal title the following year. Membership is limited to 100, but an annual exhibition is held, open to non-members, at Carlton House.　　AW

Royal Society of British Artists. Founded in 1823 by artists dissatisfied with the Academy, who wished to distance themselves from the Schools and from the National Collection, then under the same roof. It was incorporated by Royal Charter in 1847 and constituted a Royal Society in 1887. This was in part owing to an adroit presentation by Whistler, the then President, of an Address and a number of etchings to Queen Victoria on the occasion of her Jubilee, and brought the status of the RBA close to that of the Academy. Membership is limited to 200; Associate Membership is by invitation. An annual exhibition is held, to which the work of non-members is admitted. They formerly held exhibitions at their celebrated galleries at 6½ Suffolk Street.　　AW

Royal Society of Painter-Printmakers. Founded by Seymour Haden as the Society of Painter-Etchers in 1880, the first exhibition was held the following year. The Crown granted the title 'Royal' in 1888. In 1898 the words 'and Engravers' were added to the title, and in 1992 the Society was given its present name. The first members included Legros, Herkomer and Tissot; distinguished members in the twentieth century have included SIR FRANK SHORT (President 1910–38), WALTER SICKERT, DAME LAURA KNIGHT, GRAHAM SUTHERLAND and ANTHONY GROSS. The Society is based at Bankside Gallery, where its annual exhibition, as well as a full programme of other exhibitions, is held; there is also an important archive. Diploma works are held in the Ashmolean Museum, Oxford.　　AW

Royal Watercolour Society. Formed by W.F. Wells and his friends in 1804 as a 'Society Associated for the Purposes of Establishing an Annual Exhibition of Painters in Watercolours',

their first exhibition was held in 1805. Many illustrious artists such as Turner, Linnell, Palmer, Cox and Copley became members. The first woman Associate Member was Anne Byrne, in 1806. After three changes, in 1881 the Society was called by its present name. Today there are 50 members and 30 associate members. RUSSELL FLINT, PATRICK PROCKTOR, DAVID REMFRY and WILLIAM BOWYER have been among the many well-known twentieth-century members. Elections and two exhibitions are held annually. From 1980 the Society has been based at BANKSIDE GALLERY, where there is an important archive. Paintings in the Diploma Collection are held in the British Museum.

LIT: *The Business of Watercolour: a Guide to the Archives of the Royal Watercolour Society*, Simon Fenwick and Greg Smith, Ashgate, 1997.　　AW

ROYDS, Mabel Allington (1874–1941). Painter and wood engraver, she won a scholarship to the RA SCHOOLS in 1889, but entered the SLADE, and later studied in Paris, where she worked with SICKERT, and acted as an assistant on his paintings. She taught in Toronto, Canada, and at EDINBURGH, and in 1913 married the etcher E.S. LUMSDEN. With him she travelled widely in India, which stimulated much work. She painted a ceiling for the Episcopal Church in Hamilton, Lanarkshire. Her colour woodcuts have an eastern panache and drama of composition and execution (*Dead Tulips*, 1934).　　AW

ROYLE, David (b. 1947). Painter of figurative and non-figurative images in oils and acrylic; printmaker. He studied at the CENTRAL SCHOOL 1966–9, and has held solo exhibitions at Winchester School of Art, 1969, where he taught, at the New 57 Gallery, Edinburgh in 1975, and the Woodlands Gallery, London in 1984. Represented in the ARTS COUNCIL Collection, his commissions have included ceiling paintings as well as etchings and a painting for the Albany Hotel, Birmingham. His earlier abstract paintings included work on shaped canvases, whilst more recent painting combines figurative images with an abstracted, decorative surface.

LIT: Exhibition catalogue, the Woodlands Gallery, London, 1984.　　CF

ROYLE, Stanley, RBA, ARWA (1888–1961). Painter of landscapes, seascapes and some portraits in oils, watercolours and pastels. He studied at Sheffield Technical School of Art and from 1931 to 1945 lived in Nova Scotia. He exhibited

at the RA from 1913 to 1950, at the RBA (ARBA 1919, RBA 1921) at the ROI, RI, in Scotland and the provinces. He showed at the Paris Salon, winning a silver (1951) and gold (1955) medal; he was a member of the Royal Canadian Academy (1942) and of the Sheffield Society of Artists. His work is represented in Sheffield City Art Gallery. In 1937 he was appointed the Director of the Art Gallery and College of Art, Mount Allison University, New Brunswick, later returning to England. His impressionistic paintings often depicted snow scenes.
LIT: *Stanley Royle*, catalogue, Worthing Art Gallery, 1953; memorial exhibition catalogue, Graves Art Gallery, Sheffield, 1962. CF

RUMNEY, Ralph (b. 1934). Painter of non-figurative imagery in oils and mixed media; artist in collage, sculpture, reliefs, prints and photography. He studied briefly at Halifax School of Art and worked in Paris and Italy, 1952–5. He has been associated with the Movimento Nucleare and Il Movimento Internazionale per un Bauhaus Imaginista, and was a founder member of Situationist International, 1957. He has worked and exhibited widely in Britain and Europe and is represented in collections including the TATE GALLERY. His work covers a wide range of styles and media which relate to reality in varied ways.
LIT: *Ralph Rumney. Constats 1950–1988*, catalogue, England & Co., London, 1989; Interview in *Art Monthly* (UK), No.127, June 1989, p.3. CF

RUSHBURY, Sir Henry George, RA, RE, NEAC, VPRWS, CBE, KCVO (1889–1968). Painter of architectural subjects in watercolours; draughtsman, etcher, illustrator and poster artist. He studied stained glass design and mural decoration at Birmingham College of Art 1903–9, and after working as an assistant to Henry Payne he went to London in 1912 and studied at the SLADE SCHOOL under TONKS in 1919. From 1920 he made regular foreign tours and he exhibited widely, principally at the NEAC, RA, RWS, Connell & Sons Gallery and at the GROSVENOR GALLERY where he held his first solo exhibition in 1921. He was elected NEAC in 1917, RE in 1922, RWS in 1926, RA in 1936 and he was VPRWS from 1945 to 1947. In 1931 the CHANTREY BEQUEST purchased *St Pauls*, and he is represented in many public collections. He was an OFFICIAL WAR ARTIST in 1918 and 1939, a Visitor in Engraving at the RCA in 1942, and at the BRITISH SCHOOL IN ROME in 1948; from 1949 to 1964 he was Keeper of the RA. Influenced by

MUIRHEAD BONE, his preferred media were pencil and drypoint; his work was clear and decisive, giving both the appearance and atmosphere of each particular subject.
LIT: Centenary exhibition catalogue, Birmingham Museum and Art Gallery, 1989. CF

Ruskin School, Oxford. John Ruskin founded the School when he was made SLADE Professor; his endowment of £5000 provided for a Drawing Master (the first was Alexander Macdonald) and was at first intended to enable undergraduates to study or to copy the drawings, engravings and photographs (eventually around 2000) that he provided. Students of either sex over the age of sixteen were admitted, and a rather eccentric curriculum, beginning with map drawing and ornamental design, progressed to the study of landscape and architecture in the second year, and to drawing from animals and the figure in the third year. Pass Certificates were awarded. Macdonald was succeeded by SYDNEY CARLINE in 1922, who found none of the equipment conventionally necessary for the teaching of art. He bought the easels, donkeys and model's throne from the life-drawing studio in the Cornmarket which had been established by ALBERT RUTHERSTON and JOHN NASH, but found that the University rule that no undergraduate should be allowed to draw from the nude, and that no model should pose in the nude in a University building to be a severe embarrassment, only solved by clandestine life drawing arrangements. Lectures were given on composition and on colour. Rutherston and Nash were engaged as visitors, as were Vera Poole, RICHARD CARLINE, GILBERT (and occasionally STANLEY) SPENCER. Evelyn Waugh was a pupil at that time. PERCY HORTON was an influential Master after the Second World War; his pupils included John Updike and R.B. KITAJ. The Ruskin School is now fully integrated into the University. AW

RUSSELL, Bruce (b. 1946). Painter of abstracts in oils, acrylic and mixed media. He studied at CHELSEA SCHOOL OF ART 1964–9, and from 1969 to 1970 held a Fellowship in Painting at Gloucestershire College of Art. His first solo was at the Hoya Gallery in 1976 and he has subsequently shown in London galleries including the Ian Birksted and the Benjamin Rhodes, at the RA from 1978 and in the provinces. Represented in the ARTS COUNCIL Collection, he teaches at ST MARTIN'S School of Art and his awards include

an Arts Council Major Award in 1978. His painterly, energetic abstraction is concerned with contrasts and paradoxes and retains some reference to the visual world.
LIT: 'Bruce Russell: Playing to the Audience', Ian Simpson, *Artist* UK, Vol.97, pt.10, October 1982, pp.22–5. CF

RUSSELL, Caroline (b. 1962). She studied at the RUSKIN SCHOOL and GOLDSMITHS'. Her first solo exhibition was at Anthony Reynolds Gallery in 1988. She is a prolific creator of multi-media installations, employing large numbers of new, carefully ordered common objects; for example *Display 9* (1988) incorporates wall-mounted offset litho prints from photocopies of polystyrene loose-fill packing as a setting for twelve chrome racks bearing one hundred and forty-four disposable cloths hung from the same number of plastic hooks. AW

RUSSELL, Sir Walter Westley, RA, RWS, NEAC, NPS, IS (1867–1949). Painter, illustrator and etcher of portraits, interiors and landscapes in oils and watercolours. An unassuming personality, Russell's work is quietly reflective in character, assimilating diverse influences from Constable, French Impressionism and WILSON STEER. Born in Epping, Russell studied under FRED BROWN at the WESTMINSTER SCHOOL OF ART. He taught at the SLADE SCHOOL, 1895–1927, before becoming Keeper of the RA 1927–42. From 1916 to 1919 he served with the Camouflage Corps. Influenced by the FITZROY STREET GROUP in 1907, by 1910 he severed his links, preferring the conservatism of the NEAC of which he had been a member since 1895. Supporting the RWS he often exhibited portraits at the RA. He was knighted in 1935. GS

RUSZKOWSKI, Zdzislaw (1907–1991). Painter of landscapes, portraits, figures and still-life in oils; sculptor. Son of Waclaw Ruszkowski, he studied at Cracow Academy 1924–9, and in France 1935–40, where he met MATTHEW SMITH. He settled in London in 1944, subsequently making many summer trips in England (including Newlyn) and abroad. He exhibited first in Warsaw and Paris and then held solo exhibitions in London galleries including ROLAND, BROWSE AND DELBANCO, 1948–55, the LEICESTER GALLERIES, 1960–5, and more recently at the Gillian Jason and Jablonski Galleries. He showed at the LG, at the RA from 1957 to 1982, and his work is represented in

collections including Leeds City Art Gallery. A major patron was the Scarborough hotelier Tom Laughton, brother of the actor Charles. Initially influenced by Van Gogh, Cézanne and Bonnard, he developed an individualistic, lyrical style which he described as 'form integrated with feeling'. His work used simplified shape and pattern and, particularly in his late painting, vibrant, glowing colour.
LIT: *Ruszkowski. Life and Work*, J.P. Hodin, Cory, Adams and Mackay, 1966; *Ruszkowski: Catalogue Raisonné of his Paintings*, Michael Simonow, Mechanick Exercises, London, 1987. CF

RUTHERFORD, Harry (1903–1985). Painter of urban scenes, figures, landscapes and portraits in oils. He studied at MANCHESTER SCHOOL OF ART under SICKERT and under ERNEST and DOD PROCTER at Newlyn. He exhibited mainly at the RA between 1930 and 1969, also showing at the RBA, NEAC, in Liverpool, Manchester and the Paris Salon. His work is represented in several public collections including Manchester City Art Gallery. He managed the Sickert School in Manchester, taught at Manchester College of Art from 1952 and between 1960 and 1969 was President, Manchester Academy of Fine Arts. His earlier works showed the influence of the Procters, e.g. *Penzance* (Manchester City Art Gallery), later paintings became more open in form and atmospheric, e.g. *Folkestone*, RA 1964. CF

RUTHERSTON, Albert Daniel, RWS, NEAC (1881–1953). Beginning his career as a painter of interiors, portraits and landscapes in oils, Rutherston abandoned the medium in 1912, concentrating on decorative figural designs (often in watercolour on silk), watercolour landscapes, book illustration and stage design. Returning to oils in the late 1930s, he painted portraits and nudes. Born in Bradford, younger brother of WILLIAM ROTHENSTEIN, he attended the SLADE SCHOOL 1898–1902. A holiday in Normandy with ORPEN, JOHN and CONDER in 1899 was followed by regular visits to France. In 1910 he commenced his experiments with watercolour. Changing his name to Rutherston, during the war he was posted to Egypt and Palestine, 1916–19. Teaching at CAMBERWELL, he later became RUSKIN Master of Drawing, Oxford, 1929–49. Involved with the CURWEN PRESS from 1919, he made an important contribution to book illustration during the 1920s.

Designing costumes, posters and pottery, Rutherston always stressed the need for union between 'Fine' and 'Applied' art. He exhibited at the NEAC from 1900, and at the Carfax and LEICESTER Galleries.
LIT: *Albert Rutherston*, Max Rutherston, 1988.
GS

RUTTER, Frank (1876–1937). Born in London and educated at Cambridge, he lived for periods in Paris, and became an enthusiast for French art. Back in London, he set up a fund in 1906 to buy Impressionist pictures for the National Gallery. He became art critic of the *Sunday Times* in 1908 and in the same year organizer of the ALLIED ARTISTS ASSOCIATION, in emulation of the Société des Indépendants in Paris, in that subscribers could exhibit without submitting their work to a jury. It enjoyed the support of SICKERT and PISSARRO; the exhibition in 1911 in the Royal Albert Hall included work by Kandinsky, the third time Rutter introduced that artist's work to the British public. In 1913 he organized the 'Post Impressionist and Futurist Exhibition' at the Doré Galleries. He became Director of the City Art Gallery of Leeds, 1912–17, and founded the Leeds Art Collection Fund. He took an active part in the activities of the Leeds Arts Club, encouraging the discussion of abstraction, and contributing to the climate in which HERBERT READ (with whom he collaborated, 1916–20, on the journal *Art and Letters*), HENRY MOORE and BARBARA HEPWORTH were to develop.
LIT: *Since I was Twenty-Five*, Frank Rutter, Constable, 1927.
AW

RYAN, Adrian (b. 1920). Painter of landscapes, still-life and flowers in oils and watercolours. He studied at the Architectural Association 1938–9, and at the SLADE SCHOOL 1939–40 under SCHWABE, BROOKER and CHARLTON. He lived in Mousehole, Cornwall, from 1945 to 1951 and 1959 to 1965, in London from 1951 to 1959, and since 1965 he has worked in Suffolk, London, France and Wales. He has exhibited at the REDFERN GALLERY since 1943 and has also shown in other London galleries, in the provinces and abroad. He has exhibited with the LG, in the third CRYPT Exhibition, St Ives, 1948, and at the RA since 1949. His work is represented in public collections including the TATE GALLERY. Between 1948 and 1983 he taught at GOLDSMITHS' COLLEGE OF ART. His painting style is energetic and lively using expressive strokes and touches of strong, exuberant colour.

LIT: *St Ives 1939–1964*, exhibition catalogue, Tate Gallery, London 1985.
CF

RYLAND, Adolfine Mary, WIAC (1903–1983). Printmaker, particularly of linocuts and wood engravings; sculptor, painter and designer. She studied at HEATHERLEY'S 1920–4, and at the GROSVENOR SCHOOL OF MODERN ART in 1925, under McNAB and FLIGHT where she developed her interest in printmaking and sculpture. During the 1930s she worked for the LCC and designed low reliefs for several buildings including ST MARTIN'S SCHOOL OF ART. She exhibited in London galleries including the Ward and Albany Galleries in 1931, and the Wertheim and Bloomsbury Galleries. She showed at the WIAC from 1927 (member 1936–54) and in 1940 her relief *Isaac Blesses Jacob* was purchased by the CHANTREY BEQUEST for the TATE GALLERY. Influenced both in technique and style by Claude Flight, her work used modernistic forms and designs. She signed some of her work 'Koncelik', her mother's maiden name.
LIT: *Printmakers of the 20s and 30s and Adolfine Ryland*, catalogue, Michael Parkin Gallery, London, 1987.
CF

S

Saatchi Gallery. Situated at 98A Boundary Road, this contemporary art museum was brilliantly converted from a former motor repair factory by the architect Max Gordon to make a spectacular 30,000 square foot space for the collection of Charles Saatchi. The gallery opened in 1985 for changing displays of works from Mr Saatchi's collection of some 1000 paintings, sculptures and installations by artists of the last twenty-five years or so. As much of this changing and evolving collection is in store or on temporary loan elsewhere, the exhibitions of recent art by European and American artists represent a selection from the whole at any one time. The gallery also hosts occasional guest exhibitions, and organizes lecture programmes. The focus of the collection on young British artists began about 1989, and Charles Saatchi's acquisitions, commissions and patronage have radically affected the development of contemporary British art.
LIT: *Shark Infested Waters*, Sarah Kent, Zwemmer, 1994; *Sensation: Young British Artists From the Saatchi Collection*, exhibition catalogue, RA, 1997.
AW

St Ives School. The St Ives School describes a loosely structured group of artists who worked in St Ives, mainly instigated by the arrival of BEN NICHOLSON, BARBARA HEPWORTH and Naum Gabo to work in St Ives in 1939. St Ives had attracted many artists prior to that date: the St Ives Arts Club had been formed in 1888, the St Ives Society of Artists in 1927, and artists such as BORLASE SMART, LEONARD FULLER and JOHN PARK had settled there whilst ALFRED WALLIS had begun to paint there c.1923–5. From the late 1930s, however, St Ives gained an international perspective and an avant-garde character. Although Gabo left for America in 1946, younger artists were drawn to work at St Ives, these included JOHN WELLS, W. BARNS-GRAHAM, BRYAN WINTER, PETER LANYON, TERRY FROST, PATRICK HERON and ROGER HILTON, and others such as VICTOR PASMORE and ADRIAN HEATH visited St Ives and established links with Nicholson and the other artists. The St Ives Society of Artists, the CRYPT GROUP and the PENWITH SOCIETY together provided a significant exhibiting forum. Nicholson left St Ives in 1958, but Hepworth remained until her death in 1975 and younger artists continued to settle in St Ives to work. Stylistically, the St Ives School is associated with non-formal abstraction, conditioned by landscape and seascape which is colouristic, painterly and vital in character. The TATE GALLERY has established a gallery there.
LIT:*Painting the Warmth of the Sun. St Ives Artists 1939–1975*, Tom Cross, Lutterworth Press, 1984; *St Ives 1939–1964*, exhibition catalogue, Tate Gallery, London, 1985. CF

St John's Wood School of Art was founded in 1878 by A.A. Calderon and situated at 29 Elm Tree Road, NW8. Initially intended to train students for entry to the RA SCHOOLS, it subsequently widened its teaching in order to train artists as fully as possible in painting, composition, anatomy, perspective, wall painting and commercial art. With a courtyard as well as studios the School also ran animal and outdoor classes. An independent institution, there were no restrictions on the course of studies that students followed and it was open to both men and women. Highly successful in preparing students for the RA Schools, between 1880 and 1903 over 300 students from St John's Wood were admitted; its association with the RA was strengthened in the 1930s when SIR WILLIAM LLEWELLYN PRA became the School's Patron. The School's Principals included Charles Q. Orchardson, B.E. Ward, P.F. Millard and Ernest Perry and amongst its students were LEWIS BAUMER, REX VICAT COLE, HERBERT DRAPER, SYLVIA GOSSE, JOHN MINTON and ETHELBERT WHITE. CF

Saint Martin's School of Art. Opened in 1854, originating as a parochial venture of the vicar of St Martin's-in-the-Fields, the Rev. M. Mackenzie, an advocate of industrial education. The School became independent in 1859, recognized by London County Council in 1894, and in 1913–14 moved from its first Castle Street, Long Acre site to its present one in Charing Cross Road. The present building was designed by E.P. Wheeler in 1938, and there are now a number of annexes. The college has an international reputation for work by the staff and students of its Departments of Fine Art (Painting, Printmaking and Sculpture) and Design (including Graphics, Film and Video and Fashion). Today it is part, with the CENTRAL SCHOOL, of the London Institute. AW

SALAMAN, Michael (b. 1911). Painter of landscapes, figures and portraits in oils. He studied at the SLADE SCHOOL and the RUSKIN SCHOOL OF ART 1928–31 where he met BARNETT FREEDMAN. Between 1933 and 1939 he lived in France and worked at the Académie Ranson and La Grande Chaumière. He has exhibited in London galleries, at the RA and LG, and his work is represented in public collections. He has taught at CAMBERWELL, CHELSEA and the RA SCHOOLS. His work ranges from landscape to imaginative figure subjects many to do with loneliness. CF

SALISBURY, Frank Owen, RI, ROI, RP, RBA (1874–1962). Painter of ceremonial pageants, portraits of political and aristocratic notables; of allegories and murals; stained glass designer. Salisbury's early exhibits often favoured childhood subjects. Working with speed and facility, with a vivid decorative sense, his art often had an essentially public purpose. Born at Harpenden, he studied for three years under his elder brother, a stained glass designer, before entering the RA SCHOOLS in 1892. Winning the Landseer Scholarship enabled him to visit Italy in 1896, where his taste for grand themes was established. The example of G.F. Watts, working simultaneously in portraiture and allegory, inspired his chosen direction. Much employed by British Royalty, he created work for the Empire, as well as travelling to the USA and Italy where, in 1934, he painted a portrait of Mussolini. He first exhibited at the RA in 1899 and often subsequently at the RP and RBA.

LIT: See his autobiography *Sarum Chase*, 1953.
GS

SANDERS, Christopher Cavania, RA, RP, ARCA (b. 1905). Painter of landscapes and portraits in oils; illustrator. He trained at Wakefield School of Art 1922–4, Leeds School of Art 1924–6, and at the RCA 1926–9. He held a number of solo exhibitions in London, New York and in the provinces, and exhibited at the RA from 1933 to 1968 (being elected ARA in 1953 and RA in 1961). He also showed at the NEAC, the RP (becoming a member in 1968), the Paris Salon (where he won a gold medal in 1955), and in Vancouver. A member of the RA Council and of the Selection and Hanging Committee, his work was influenced by Impressionism and English landscape painting. He painted in sunlight with a restricted palette of colours, combining texture and rhythm with detailed landscape observation. CF

SANDS, Ethel, LG (1873–1962). Painter of figures, interiors, still-life and flowerpieces in oils. Sands' work was influenced alike by French and English painting, her handling and colour often vigorous and strong. Born at Rhode Island, USA, her family settled permanently in England in 1879. She studied painting at Eugène Carrière's Atelier, Paris, 1896–1901. Dividing her life between France and England, she exhibited both there and in London. Meeting SICKERT in 1906, she was invited to join the FITZROY STREET GROUP in 1907. She was a founder member of the LONDON GROUP in 1913. An important artistic hostess of her time, she commissioned decorations from BELL and GRANT for her French house, and from SICKERT and BORIS ANREP for her Chelsea residence. She served as a nurse in France in both wars.
LIT: *Miss Ethel Sands and her Circle*, Wendy Baron, Peter Owen, 1977. GS

SAUNDERS, David (b. 1936). Systematic artist in paintings and sculpture. He studied at ST MARTIN'S SCHOOL OF ART and the RA SCHOOLS, 1956–62, and from 1965 to 1968 lived in Wales. He began his first systematic work in 1967–8 and was a co-founder of the SYSTEMS GROUP in 1969. From 1972 to 1973 he worked in Amsterdam. He held his first solo at the Greenwich Theatre Gallery in 1969 and has subsequently shown in London, the provinces and abroad. Represented in the ARTS COUNCIL Collection, his work examines ideas of repetition, transformation and

series, discovering the 'system' through an intuitive and methodical approach.
LIT: *Working Information. Six Artists*, limited edition of 230, 1976; catalogue for the Academy Gallery, Liverpool, 1980. CF

SAUNDERS, Helen (1885–1963). Painter, often in strongly coloured gouache, of VORTICIST compositions, who later reverted to a more representational style, treating still-life subjects. Born in Croydon, she studied at the CENTRAL SCHOOL and the SLADE SCHOOL 1906–7. Exhibiting with the FRIDAY CLUB in 1912, and the ALLIED ARTISTS' ASSOCIATION 1912–13, in spring 1914 she joined Lewis's REBEL ART CENTRE and contributed to the Whitechapel 'Twentieth Century Art' exhibition of June that year. She was a signatory to the VORTICIST Manifesto (*Blast* 1); she published designs *Atlantic City* and the *Island of Laputa* in *Blast* 2. In 1915 she helped Lewis decorate the 'Vorticist Room' at the Restaurant de la Tour Eiffel. In 1917 she participated in the New York Vorticist Exhibition. A friend of JESSICA DISMORR, she shared her involvement with the Suffragette Movement. GS

SAVILLE, Jenny (b. 1970). She studied at GLASGOW SCHOOL OF ART. Her large paintings have typically been close-up depictions in a photographic manner of grossly fat nude women, stressing their individuality, their fleshiness and their ambiguous role as sexual objects. In *Plan* (1995) a woman's body is shown covered with contour lines, perhaps suggesting marks painted on the skin ready for cosmetic surgery. AW

SCHOFIELD, Kershaw (*c.*1875–1941). Painter of landscapes, seascapes and flowers in oils and watercolours. He exhibited at the RA between 1900 and 1938 and showed in Birmingham, Manchester, Liverpool and Yorkshire. Manager of a photographic business in Bradford and member of the Bradford Arts Club, his work is represented in Bradford Art Gallery. He painted in the Dales and in Holland using subdued colour and compositions with low horizons, placing emphasis on the skies. CF

School of Design, see ROYAL COLLEGE OF ART

SCHWABE, Randolph, RWS, NEAC, LG (1885–1948). Painter, etcher and illustrator of figures and architectural subjects, with an interest in theatrical and historic costume, his work had a strongly graphic sense wherein the importance of

draughtsmanship was always stressed. The son of a Manchester cotton merchant of German ancestry, at fourteen Schwabe attended the RCA, transferring in 1900 to the SLADE SCHOOL. In 1906 he travelled to Paris to study at ACADÉMIE JULIAN. From 1914 to 1918 he was an OFFICIAL WAR ARTIST. A member of the LG from 1915 and the NEAC from 1917, Schwabe held teaching posts at Clerkenwell WESTMINSTER and the RCA. From 1930 he was Slade Professor, successor to TONKS. He illustrated several books including Francis M. Kelly's *Historic Costume*, 1925, and is discussed in the *Contemporary British Artists* series – *Draughtsmen*, 1924. GS

SCHWITTERS, Kurt (1887–1948). Born in Hanover, he is celebrated as a Dadaist who established his reputation in Germany after 1918 with his poetry, collages made of scraps of printed material (modified with paint) and for the 'Merzbau' constructions with which he transformed his domestic interiors. He arrived in Britain in 1940, and following a period of internment lived first in London and then, from 1945, in Ambleside. There he painted a number of conventional portraits and landscapes as well as his delicate and fantastic collages, which now used English printed material (sometimes from popular strip-cartoons). His last 'Merzbau' was in a barn; it was moved in 1965 to the Hatton Gallery, Newcastle. He received his British passport the day before he died.
LIT: *Kurt Schwitters*, Werner Schmalenbach, Thames & Hudson, 1967; *Kurt Schwitters*, John Elderfield, London, 1985; *Kurt Schwitters in Exile: The Late Work, 1937–48*, exhibition catalogue, Marlborough Fine Art, 1981. AW

SCOTT, Ian (b. 1940). Sculptor and painter of landscapes. Born on North Ronaldsay, Orkney, where he now works, he trained at Gray's School of Art, Aberdeen, under Leo A. Clegg. He has exhibited in solo and group exhibitions since 1962 and his work is represented in collections including that of the Scottish Arts Council. His sculpture arises from the analysis of specific natural forms, and his paintings, often small in scale, reflect his interest in the geological construction of landscape.
LIT: Retrospective exhibition catalogue, Pier Arts Centre, Stromness, Orkney, 1983. CF

SCOTT, Sir Peter Markham, CH, CBE, DSC and Bar, FRS, RA (1909–1990). Naturalist and painter of wild fowl and portraits in oils and

watercolours; illustrator. Son of Capt. R.F. Scott and the sculptor Kathleen Scott, he was educated at Oundle School and Trinity College, Cambridge, and studied art at Munich State Academy and the RA SCHOOLS. He exhibited from 1933 at London galleries, principally Ackermann & Son Ltd, and at the RA. He was the Director and founder of the Wild Fowl Trust, Slimbridge, Gloucester, and served on the committees of many ornithological and yachting associations. His illustration work included *The Snow Goose* by Paul Gallicoe and amongst his own publications were *Portrait Drawings*, 1949, and *A Thousand Geese* (with James Fisher), 1953. His precisely observed paintings reflected his wide knowledge of the natural world. He is best known for his paintings of wild fowl, often flying against atmospheric skies and landscape.
LIT: *Portrait Drawings by Peter Scott*, Preface by Lord Kennet of the Dene, Country Life Ltd, London, 1949. CF

SCOTT, William George, LG, CBE (1913–1989). Painter of still-life and abstracts in oils. Born in Greenock, his family returned to Northern Ireland in 1924 and he attended Belfast College of Art 1928–31, and the RA SCHOOLS 1931–5 where he studied both sculpture and painting. In 1936 he worked in Cornwall and between 1937 and 1939 he lived and worked in France at Pont-Aven and St Tropez. From 1939 he worked in Dublin, London and Somerset and in 1946 visited Cornwall, meeting NICHOLSON, LANYON, FROST and WYNTER. He continued to return to France and in 1953 and 1959 went to America where he met Pollock, de Kooning, Rothko and Kline. He exhibited at the Leger Galleries from 1942, at the HANOVER GALLERY and from 1974 at GIMPEL FILS, London. He has shown nationally and internationally and in 1958 a retrospective exhibition of his work was held at the Venice Biennale. His work is represented in many public collections including the TATE GALLERY and the Centre Pompidou, Paris. He taught painting at the BATH ACADEMY OF ART, 1946–56, at the Hamburg Academy in 1965, and from 1963 to 1964 he was Ford Foundation Artist in Residence in Berlin. His awards include a first prize at the JOHN MOORES EXHIBITION of 1959, and in 1966 he received his CBE. Concerned with still-life and ideas of 'primitive realism', his work reflects the influence of Cézanne, Chardin and Nicholson in its deliberately presented, symbolic simplification. Influenced by American painting, he produced larger abstract works between 1952 and 1954 but returned to

still-life later in the decade. Later abstracts, 1958–62, used evocative shapes which reflected still-life and the nude; they became increasingly refined and economical. More recent work combines the still-life subject with harmonious, vibrant colour and the purity of the abstract paintings.
LIT: *William Scott: Paintings*, Alan Bowness and others, Lund Humphries, London, 1964; retrospective exhibition catalogue, Tate Gallery, 1972. CF

The Scottish Colourists. The Scottish Colourists were F.C.B. CADELL 1883–1937, J.D. FERGUSSON 1874–1961, LESLIE HUNTER 1877–1961, and S.J. PEPLOE 1871–1935. The background for their style lay initially in the colour and vigorous brushwork of the GLASGOW SCHOOL, many of whom had worked in France. The four Colourists all painted in France between 1900 and 1914 and it was the influence of French painting, the work of the Fauves and Matisse which formed the basis of their highly-coloured, abbreviated style with its painterly, fluid handling. Their work was well-received in Scotland where they were promoted in particular by Alexander Reid and Aitken Dott, and in Paris where in 1924 they exhibited at the Galerie Barbazanges as 'Les Peintres de l'Ecosse Moderne'. In England they exhibited as a group in the 1920s, showing at the LEICESTER GALLERIES in 1923 and 1925 and also showing at REID AND LEFEVRE, but their main influence was in Scotland.
LIT: *The Scottish Colourists*, Roger Billcliffe, John Murray, London, 1989; *Three Scottish Colourists*, T.J. Honeyman, T. Nelson, London and Edinburgh, 1950. CF

SCULLY, Sean (b. 1945). Painter of abstracts in oils and acrylics. He studied at Croydon College of Art, Newcastle University and at Harvard University, USA. He has lived in New York and London since 1975 and has exhibited at the Rowan Gallery, London, since 1973. He has also shown regularly in America, in national and international group exhibitions, and his work is represented in public collections including the TATE GALLERY. He has taught in England and the USA and his awards include a Guggenheim Fellowship in 1983. His work has developed from complex grids to densely constructed paintings of stripes and panels in rich, often earthy colours.
LIT: Retrospective exhibition catalogue, Whitechapel Art Gallery, 1989. CF

SEABROOKE, Elliott, LG (1886–1950). Painter of landscapes, marines and still-life in oils and watercolours. Son of Robert Elliott and Harriet Seabrooke, he attended the SLADE SCHOOL under TONKS, 1906–11, and worked first in the Lake District and Epping Forest, later painting in Holland, France, Italy and Essex. He held his first solo exhibition in 1912 at the Carfax Gallery, and subsequently exhibited in London galleries, at the NEAC, 1909–20, and at the LG from 1919 (becoming a member in 1920, President 1943–8 and Vice-president 1949–50). His work is represented in several public collections including the TATE GALLERY. From 1914 to 1918 he was an OFFICIAL WAR ARTIST. Influenced by Cézanne in the Post-Impressionist Exhibition of 1910, and later by Seurat, he adopted a pointilliste technique, uniting the canvas both by the pattern of broken marks and by a strong pictorial structure.
LIT: *Elliott Seabrooke Memorial Exhibition*, catalogue, Arts Council of Great Britain, 1952. CF

SEABY, Professor Allen William (1867–1953). Colour woodcut artist, wood engraver and painter, he studied at Reading University and later became Professor of Fine Art there 1920–33. He specialized in animals and birds, and was the author of several books, including *Drawing For Art Students*, 1921.

SEAGO, Edward Brian, RWS, RBA (1910–1974). Painter of varied subjects, especially landscapes in oils and watercolours; illustrator. Characterized by spontaneity and a fluid facility of handling, Seago's concern with light and atmosphere is indebted to French nineteenth-century and English Romantic landscape. Living in Norfolk, he worked much in East Anglia and abroad, painting in Spain, Morocco, Italy, France, Greece and Antarctica. The son of a Norwich coal merchant, Seago received instruction from BERTRAM PRIESTMAN, and studied at the Royal Drawing Society. However, he was largely self-taught and at eighteen joined Bevin's Travelling Show and toured with the circus. Interest in the travelling life inspired several illustrated books in the 1930s. His first one-man show was held at the Sporting Gallery in 1933. He worked with the poet John Masefield on several illustrational projects between 1937 and 1942. Serving with the Royal Engineers, 1939–44, he often painted in Italy, exhibiting his war work in 1946. Work created during the Duke of Edinburgh's World Tour was shown in

275

1957. Amongst his many published writings are *Caravan*, 1937, and *A Canvas to Cover*, 1947. LIT: *Edward Seago*, Jean Goodman, Collins, 1978. GS

SEDDON, Dr Richard Harding, FMA, FRSA, ARCA (b. 1915). Painter in oils and watercolours. Born in Sheffield, he attended Reading University and studied art at the RCA 1936–9, under Paul and John NASH, RAVILIOUS, BAWDEN and AUSTIN. He exhibited at the RA, RBA, RIBA, NEAC and AIA and also showed in London galleries including the LEICESTER and REDFERN. His work is represented in public collections including the IMPERIAL WAR MUSEUM and the V & A. He taught at Reading University in 1944, and Birmingham University in 1947, and served on many committees for the Fine Arts. He was Director of Sheffield City Art Gallery and his writing on art includes *The Technical Methods of Paul Nash*, for the Memorial Volume, Lund Humphries, 1949. His work ranges from war drawings made in France, 1939–40, to his RA exhibits of 1952: *Hastings Pier*, 1947, and *Botanical Gardens*. LIT: *A Hand Uplifted: A Fragment of an Autobiography*, Richard Seddon, Frederick Muller Ltd, 1963. CF

SEDGLEY, Peter (b. 1930). Op and kinetic artist using acrylic, projected light, sound and installations. He first trained as an architect at Brixton Technical College and worked as an architectural assistant 1947–59. In 1961 he got to know the work of BRIDGET RILEY; in 1960–2 he started a Co-operative of Design and Construction Technicians and in 1963 he began to paint. He first exhibited in London and New York in 1965 and has subsequently exhibited regularly in London galleries (including the REDFERN), in the provinces, America and Germany. His work is represented internationally in public collections including the TATE GALLERY. In 1968 he was founder of the Art Information Registry and of Space Provision, Artistic, Cultural and Educational. His work investigates colour relationships: from his early hard-edged concentric forms he developed 'target paintings' and in 1967 began to use lights with these works. These ideas gave rise to his 'video-rotors': painted rotating discs which were subjected to variations of ultra-violet and stroboscopic light. In more recent work he has concentrated on light itself and has incorporated sound with the images.

LIT: Catalogue, Ikon Gallery, Birmingham, 1973; *Peter Sedgley: Paintings, Projects, Installations 1963–1980*, Kelpra Studios, London, 1980. CF

SEGAL, Arthur (1875–1944). Painter in oils of portraits and landscapes. Born in Romania, he studied in Berlin and Munich, exhibited with the Berliner Secession, and during the First World War showed cubist-influenced, abstracted still-lifes and figure compositions with graded strips of tone and colour (*Pietà*, 1918) at the Cabaret Voltaire in Zürich with the Dadaists. He moved back to Germany after the war. He was a member of the *Novembergruppe*, taught briefly at the Bauhaus, then emigrated: first to Mallorca (1933) then to England in 1936, where he eventually set up the Arthur Segal School of Painting. His *Bornholm Harbour* (1928) is in the TATE. LIT: *A. Segal, 1875–1944*, exhibition catalogue, Berlin, Cologne, Tel-Aviv, 1987. AW

SELF, Colin (b. 1941). Painter, printmaker, collagist, draughtsman and sculptor. He studied at Norwich School of Art and at the SLADE, travelling to the USA and Canada in 1962 and 1965. Since the 1960s he has worked in Scotland and Germany as well as in Norfolk, where he lives. He held his first solo at the PICCADILLY GALLERY in 1965, subsequently showing in Paris, Hamburg and Cologne and in London galleries. More recently he has exhibited at the ICA, London, in 1986. His awards include a drawing prize at the 1968 Paris Biennale and his work is represented in collections including the ARTS COUNCIL and MOMA, New York. He has taught at Norwich School of Art. His work covers a wide range of media and intentions, including landscape, ceramics and paintings based on photography, and has been influenced by a range of artists, particularly Turner, Crome and the Norwich School as well as by Picasso. LIT: *Colin Self's Colin Selfs*, exhibition catalogue, ICA Gallery, London, 1986. CF

The Senefelder Club. An exhibiting club for lithographers. Founder members were A.S. HARTRICK, ERNEST JACKSON, Joseph Pennell (the first President) and J. KERR LAWSON. They first met formally in 1908 to discuss their intention of raising lithography to the same standards as etching in the eyes of collectors; keeping to limited editions was a main objective. Liaison with directors and curators of museums was established at the beginning. A Chelsea studio was set up in

1910 and exhibitions were mounted from the same year. In the later 1950s the Club renamed itself The Senefelder Group. AW

SENIOR, Bryan (b. 1935). Painter of urban scenes, landscapes, still-life and figures in oils and acrylic. Born in Bolton, he read French and Spanish at Cambridge before studying at CHELSEA SCHOOL OF ART. He exhibited first at the Heffer Gallery, Cambridge, and has subsequently shown in London galleries, including the Temple Gallery and CRANE KALMAN, and has also exhibited in Italy, America and Ireland. An exhibitor in many group shows, his awards include a GLC Spirit of London Prize. His earlier paintings used broad areas of conceptualized colour and accents of dark tone that moved his subjects towards semi-abstraction. Later work is more detailed and realistic, giving a direct, monumental interpretation of everyday scenes, e.g. *Fishstall, Kilburn*, 1987. CF

SENIOR, Mark (1862–1927). Painter of landscapes, seascapes, genre and portraits in oils and watercolours. He trained at Wakefield School of Art and the SLADE SCHOOL where he formed a friendship with STEER. Amongst his friends were CLAUSEN, BRANGWYN, Whistler and ORPEN and he made frequent trips to the continent. From the 1890s he spent each summer painting at Runswick Bay, Yorkshire, and in 1906 he painted with Steer at Walberswick. He exhibited principally at the RA from 1892 to 1924 but much of his work was painted for private patrons. His early painting was influenced by Clausen whilst later work reflected the techniques of Steer, Whistler, Boudin and the Impressionists. He used pure colour and was noted for his masterly use of blue. His technique combined impasto touches with longer sweeps of more fluid paint.
LIT: Catalogue, Elizabethan Gallery, Wakefield, 1983. CF

Serpentine Gallery. Administered by the ARTS COUNCIL, it is situated in a former tea-room of 1908. Regular exhibitions are mounted of the work of young and experimental British and foreign contemporary artists. AW

SETCH, Terry (b. 1936). Painter of semi-abstracts and figurative works in oils and encaustic. He studied at Sutton and Cheam School of Art 1950–4, and at the SLADE SCHOOL 1956–60. He held a solo exhibition in 1967 at the Grabowski Gallery, London, and has subsequent-ly exhibited at leading galleries (including Nigel Greenwood), in the provinces and widely in group exhibitions. His work is represented in public collections including the TATE GALLERY. He has taught at Leicester College of Art, 1960–4, at Cardiff College of Art since 1964; in 1983 he was Artist in Residence, Victorian College of Art, Melbourne, and in 1984 he was elected to the Faculty of Painting, BRITISH SCHOOL IN ROME. A member of the 56 Group in Wales from 1966 to 1978, and of the Association of Artists and Designers in Wales in 1975, he has been a prizewinner at the JOHN MOORES in 1972 and 1985. His work has addressed ideas about popular taste, concerns such as pollution and aspects of particular communities and their lives. Recent paintings have used an encaustic technique and metallic pigment to give texture and flashes of jewel-like colour to the surface. CF

Seven and Five Society (1919–1935). Formed as an alternative to the LONDON GROUP, which was then dominated by Bloomsbury artists, with the aim of encouraging individual members to develop freely in their own way. The most enduring of the founder members, who at that time painted lyrical semi-naive landscapes and still-lifes, was IVON HITCHENS. The catalogue of the first exhibition at Walker's Art Galleries in April 1920 contained a brief manifesto which laid out the Society's modest aims. Its name referred to the original intention of having a nucleus of seven painters and five sculptors. Initial timidity and conservatism gave way during the 1920s to a more progressive attitude, largely due to new members such as BEN NICHOLSON, who joined in 1924 and who was elected Chairman in 1926. His influence reformed the Society and made it the only significant group in the 1920s as they moved towards abstraction. Between 1926 and 1930 the Society added to its membership JESSICA DISMORR, WINIFRED NICHOLSON, CHRISTOPHER WOOD, CEDRIC MORRIS, DAVID JONES and FRANCES HODGKINS. Works by the naive painter ALFRED WALLIS were included in the 1929 exhibition. The Society's most dynamic era began in 1931 with four exhibitions at the LEICESTER GALLERIES. It ended on a high note in 1935 with its last show at ZWEMMERS, described as the first all-abstract exhibition in England. It was dominated by the work of HEPWORTH, HENRY MOORE and Nicholson, whose first all-white relief was shown. PIPER and PENROSE also exhibited. The Seven and Five provided a forum for new ideas

during the 1930s which encouraged the development of a confident English avant-garde. DE

SHACKLETON, William, NEAC (1872–1933). Painter of figures, landscapes, imaginative subjects and portraits in oils. He won a scholarship to the RCA in 1893, winning a British Institute Scholarship to study at the ACADÉMIE JULIAN, Paris, and in Italy. He exhibited at the NEAC from 1901 (becoming a member in 1909), at the RA between 1895 and 1919, and held solo exhibitions at the Goupil Gallery in 1910, the LEICESTER GALLERIES in 1922, and Barbizon House in 1927. He exhibited widely in other galleries and societies and his work is represented in the TATE GALLERY. Influenced by Leonardo and Giorgione as well as by Turner and Watts (whom he knew), his paintings were symbolic, poetic and warmly coloured.
LIT: *The Last Romantics*, exhibition catalogue, Barbican Art Gallery, London, 1989. CF

SHAKESPEARE, Percy (1906–1943). He studied at Dudley Art School and later studied and then taught at Birmingham School of Art. His carefully organized, flatly painted compositions in oils, in which great attention was paid to the outline silhouette of each individual figure, were exhibited at the RA between 1934 and his death in an air-raid. Characteristic of his work is *The Bird House, Dudley Zoo, c.*1939. AW

SHANKS, William Somerville, RSA, RSW (1864–1951). Painter of portraits, landscapes, still-life and interiors in oils and watercolours. He attended evening classes at GLASGOW SCHOOL OF ART and studied in Paris with J.P. Laurens and Constant. He exhibited many works in Scotland at the RSA (where he was made a member in 1933), at the RSW (becoming a member in 1925), and at the GI. He also showed in London at the RA between 1914 and 1936 and in Manchester and Liverpool. He taught at Glasgow School of Art, 1910–39, and in 1922 was awarded a silver medal from the Société des Artistes Français. His bold pictures showed a painterly technique and in portraiture an observant use of detail, e.g. his portrait of Dame Clara Butt. CF

SHANNON, Charles Hazelwood, RA, NPS, ARE (1863–1937). Painter of figures, genre and portraits in oils; illustrator and lithographer. He was a student at the City and Guilds Technical Art School, Lambeth, 1881–5, under Charles Roberts, where he met CHARLES RICKETTS, his

lifelong companion. He took up lithography in 1888 and began to exhibit as a painter in the 1880s, holding his first solo exhibition at the LEICESTER GALLERIES in 1907. He exhibited widely in societies and London galleries (including Colnaghi & Co.), and held an important exhibition at Barbizon House in 1928. He showed at the RA between 1912 and 1930, being elected ARA in 1911 and RA in 1920. In 1916 the CHANTREY BEQUEST purchased *The Lady with the Amethyst* and his work is represented in public collections including the Ashmolean, Oxford. He was co-founder with Ricketts of *The Dial*, 1889–97, and of The Vale Press, 1896–1904, and together they formed an important art collection. A founder member of the International Society, and later its Vice-president, he was a gold medalist at the Munich International Exhibition in 1897. His paintings were dramatic and rich in effect, showing the influence of Titian, Watts and Puvis de Chavannes.
LIT: *At the Sign of the Dial*, Keith Spencer and others, catalogue, Lincoln, 1987–8. CF

SHANNON, Sir James Jebusa, RA, RBA, ROI, NEAC, PRP (1862–1923). Painter of portraits and figures in oils. Born in New York of Irish parents, he came to London in 1878 and studied at the RCA, winning silver and gold medals as a student. He exhibited at the RA from 1881 and was elected ARA in 1897 and RA in 1909. He became RBA in 1888, ROI in 1889, RP in 1891 and PRP from 1910 to 1923. A founder member of the NEAC in 1886, he was elected to the committee in 1887 and resigned from the club in 1892. Two of his paintings, *The Flower Girl* and *Phil May*, were purchased by the CHANTREY BEQUEST in 1901 and 1923, and he was awarded medals for portraiture in Paris, Berlin and Vienna. His early technique was influenced by the square brushstrokes of LA THANGUE and his spirited portraiture was in the tradition of English painting established by Reynolds and Gainsborough. CF

SHARP, Dorothea, RBA, ROI (1874–1955). Painter of landscapes and seaside figure compositions. She studied at the Regent Street Polytechnic and in Paris, later living in London, Blewbury and in St Ives, where many of her lively, impressionist pictures were painted. (*The Yellow Balloon*, 1937, Manchester City Art Gallery is an example.) AW

SHAW, John Byam Liston, RI, ROI, ARWS (1872–1919). Painter in oils, watercolours and

pastels; Shaw was also a tapestry and stained glass designer, a mural painter, stage designer, portrait painter, illustrator and cartoonist. Influenced by D.G. Rossetti, he elaborated poetic themes with a richness of colour and detail. Often imbued with a strongly narrative sense, he treated contemporary as well as literary and poetic subjects. Born in Madras, Shaw came to England in 1878. In 1887 he entered the ST JOHN'S WOOD ART SCHOOL, transferring in 1890 to the RA SCHOOLS. He exhibited at the RA from 1893, and in the early 1900s held four important one-man exhibitions at Dowdeswell's. From 1904 he taught at King's College, London, and in 1910 was one of the founders, with VICAT COLE, of the BYAM SHAW SCHOOL OF ART. Amongst his many illustrated books was *Ballads and Lyrics of Love* (ed. J. Sidgwick), 1908.
LIT: *The Art and Life of Byam Shaw*, R.V. Cole, 1932. GS

SHEPHERD, David, FRSA, OBE (b. 1931). Painter of a wide range of subjects, particularly African wildlife, in oils. He studied art under Robin Goodwin, 1950–3, first working as an aviation artist. He has exhibited at the RA, RP, nationally and internationally, and his awards include an Honorary Degree from the Pratt Institute, New York, and the Order of the Golden Ark in 1973. In 1979 he became Member of Honour, World Wildlife Fund, and OBE. His observant work is both realistic and dramatic.
LIT: See his autobiography *The Man who Loves Giants*, 1976; *David Shepherd, The Man and His Paintings*, monograph by C. Littlewood and D. Shepherd, 1985. CF

SHEPPARD, Faith Tresider, RGI, HC (b. 1920). Painter of landscapes and marines in oils. Born in London, she studied with her mother, Nancy Huntley, and at the RA, BYAM SHAW and CHELSEA Schools of Art. She has exhibited at the RA from 1940 to 1945, at the ROI, RBA, SMA, RGI, and in London and provincial galleries. She has won gold (1978) and silver (1975) medals at the Paris Salon and her work is represented in collections here and abroad. Her impressionistic paintings include scenes from Wales, France and Hertfordshire. CF

SHERINGHAM, George, PS, RDI (1884–1937). Painter of landscapes, flowers and interiors in oils and watercolours; theatrical designer, room decorator; poster and fan artist, book illustrator and textile designer. He studied at the SLADE SCHOOL 1899–1901, and in Paris 1904–6, where he held his first solo exhibition in 1905. He subsequently exhibited in London galleries and societies including the RA, in the provinces and abroad. His work is represented in public collections including the TATE GALLERY and the Nottingham Castle Museum. Between 1924 and 1932 he designed many theatrical productions, particularly for Sir Nigel Playfair at the Lyric Theatre, Hammersmith, and in 1925 he received a Grand Prix for Theatrical Design and Architectural Decorations in Paris. His work showed the influence of oriental painting in its use of pattern and shape. Later in his life he began an analysis of the rhythmic character of oriental art.
LIT: *Pen and Pencil Drawing*, George Sheringham, 1922; memorial exhibition catalogue, RBA Galleries, 1945. CF

SHERLOCK, Marjorie, SGA, WIAC (1897–1973). Painter of landscapes in oils; etcher. She studied at the SLADE SCHOOL, WESTMINSTER SCHOOL OF ART under SICKERT in 1916, the RCA under Osborne in 1928, and at the Académie Lhote, Paris, in 1938. She exhibited at the RA from 1916, at the NEAC, LS, SGA and at the Goupil Gallery. She was a close friend of OROVIDA PISSARRO. Her etching was precise and linear, carefully building form and tone from hatched lines, and a similar measured approach informed her ordered landscapes. CF

SHORT, Sir Francis Job (Frank), RA, RI, PRE (1857–1945). Painter, engraver and lithographer, his influence as a teacher and as Director, then Professor, of the Engraving School at the RCA (1891–1924) was enormous. Trained initially as an engineer, he studied art at South Kensington (see RCA) and WESTMINSTER. He was Master of the Art Workers Guild, and was Treasurer of the RA, 1919–32. He started the revival of interest in mezzotint and aquatint. He made many etchings after Turner and others; his original work was of technically brilliant, understated and peaceful landscapes. AW

SICKERT, Bernard, NEAC (c.1863–1932). Painter of landscapes, figures, coastal scenes and interiors in oils; pastelist. Son of Oswald Sickert and brother of W.R. SICKERT, he was born in Munich and came to England in 1868. He started to paint in 1885 and exhibited mainly at the NEAC, becoming a member in 1888. He also showed with the London Impressionist Group in

SICKERT

1889, in London galleries, exhibiting with W.R. Sickert at the Dutch Gallery in 1895, at the RA, RBA, ROI, LS, in the provinces and in Scotland. He often worked with W.R. Sickert in Dieppe and he knew Whistler, publishing an account of his life in 1908, and his broad atmospheric painting reflects the influence of both these artists. CF

SICKERT, Walter Richard, RA, PRBA, NEAC, ARE (1860–1942). Painter and etcher of diverse subjects. Famed for his urban and domestic interiors, especially of theatres and of Camden Town, he was influenced by the modern life subjects of Degas and the low tonality of Whistler. He had an abiding interest in popular culture, making the music-hall a special theme, and later in his career he adapted nineteenth-century engravings or modern photographs as his source. In the 1900s adopting a thicker, more mosaic-like application of paint, Sickert habitually organized compositions by mean of a squared grid. Born in Munich, the son of O.A. Sickert, a German/Danish painter who had studied under Couture, the family moved to England in 1868. Studying at King's College, London, Sickert spent three years on the stage, 1877–81. In 1881 he enrolled for a year's course at the SLADE SCHOOL under Legros. Striking up a close association with Whistler he worked as the latter's studio assistant. In Paris in 1883 he first met Degas, whose work profoundly influenced his development. From 1885 to 1922 Sickert lived part of virtually every year in Dieppe, being resident there permanently from 1899 to 1905 and 1919 to 1922. In 1895 he visited Venice and worked there regularly from 1900 to 1904. Settling in Fitzroy Street, London, Sickert became renowned among younger painters for his authority and knowledge of French painting. Sickert was thus the impetus behind the formation of many important artistic associations: the FITZROY STREET GROUP, 1907; the AAA, 1908; the CAMDEN TOWN GROUP, 1911; and the LONDON GROUP, 1913. An organizer of the London Impressionists exhibition in 1889, he was elected a member of the NEAC and Society of British Artists in the 1880s. Exhibiting widely in London, he showed in Paris and Brussels (Les XX, 1887). A writer of art criticism, he taught at several private schools from 1893 to 1923, and at WESTMINSTER SCHOOL OF ART, 1908–12 and 1915–18. Working in Brighton and Bath, he left London in 1934 for Thanet, finally settling at Bathampton where he died. He was married for the third time in 1926.

LIT: Sickert, W. Baron, Phaidon, 1973; Walter Sickert, Richard Stone, Phaidon, 1989. GS

SIMCOCK, Jack (b. 1929). Painter of landscapes in oils; poet. Born in Biddulph, Staffordshire, the son of a coal-miner, he has exhibited in London at the RA and the PICCADILLY GALLERY since 1957, in the provinces and abroad. His work is represented in public collections including the Walker Art Gallery, Liverpool. Many of his paintings are of Mow Cop on the Staffordshire/Cheshire border where he lives. He depicts unpeopled, isolated cottages and landscape with a direct and uncompromising vision, often from a low viewpoint. LIT: See his autobiography Simcock, Mow Cop, 1975. CF

SIMMONDS, William George, RWA, FRSA (1876–1968). Sculptor and painter. Born in Istanbul, he studied at the RCA under WALTER CRANE, 1893–9, and at the RA SCHOOLS 1899–1904. Between 1906 and 1910 he worked under E.A. Abbey and in 1912 married Eveline Peart. He worked as a precision draughtsman on tank and aircraft design from 1914 to 1918 and in 1919 settled in the Cotswolds. A friend of WILLIAM ROTHENSTEIN the Cockerells and Arnold Dolmetsch, he exhibited at the RA from 1903 to 1909 and at the Arts and Crafts Exhibition Society. Elected RWA in 1951, retrospectives of his work were held in Painswick in 1966 and Cheltenham in 1968, and he is represented in the TATE GALLERY. His early subject pictures were influenced by Walter Crane whilst his carving reflected his interest in Japanese art. LIT: William and Eve Simmonds, exhibition catalogue, Cheltenham Museum and Art Gallery, 1980. CF

SIMPSON, Charles Walter, RI, ROI, RBA (1885–1971). Painter of birds, animals, landscapes, seascapes, figures and portraits in oils, watercolours and tempera; illustrator and author. Largely self-taught, he studied for a short period with LUCY KEMP-WELCH at Bushey and painted with MUNNINGS in Norfolk. In 1905 he settled in Cornwall, taking lessons from J. Noble Barlow and establishing a studio in Newlyn; in 1910 he visited Paris and attended the ACADÉMIE JULIAN. In 1916/17 he moved to St Ives and ran a painting school with his wife Ruth Simpson and in 1924 he settled in London, returning to Cornwall in 1931. His first solo exhibition was at the Graphic Gallery, London, in 1910, and he

280

exhibited in leading galleries (at the RA from 1906), and widely in other societies and abroad. He was elected RI and RBA in 1914 and ROI in 1923 and his work is represented in public collections including the Laing Art Gallery, Newcastle (*The Herring Season*, 1924). Many of his early paintings were large-scale farming and animal scenes and from 1924 he was known for his hunting and equestrian subjects. On his return to Cornwall he concentrated on landscapes and Cornish scenes for the RA. His work reveals his mastery of light and reflections and his direct, open painting technique.
LIT: See his own books including *Animal and Bird Painting*, Batsford 1939; 'A Painter of Birds: C.W. Simpson', W.G. Constable, *Studio*, Vol.LXXXI, p.91. CF

SIMPSON, Ian, ARCA (b. 1933). Painter of townscapes and landscapes in oils and acrylic; writer and teacher. He studied at Sunderland College of Art and at the RCA under MOYNIHAN and WEIGHT, 1955–8. His painting is represented in public collections including Glasgow Art Gallery. Principal of ST MARTIN'S SCHOOL OF ART since 1972, he has written and presented BBC TV series on drawing and painting. His firmly constructed work uses interlocking shapes and cool-toned colour.
LIT: See his own publications including *Painters Progress*, Allen Lane; article, *Artist* (UK), July 1988. CF

SIMS, Charles, RA, RWS, ROI, RSW (1873–1928). Painter of portraits, figures, landscapes and imaginative semi-abstracts in oils, tempera and watercolours; mural painter. He attended the RCA in 1890, the ACADÉMIE JULIAN under Constant and Lefèbvre in 1891, and the RA SCHOOLS 1892–5, where he won the Landseer Scholarship. He exhibited at the RA from 1893 and held his first solo exhibition at the LEICESTER GALLERIES in 1906. He subsequently exhibited widely, showing many works at the RA, the Leicester Galleries, the RWS and Barbizon House. He also won gold medals at Amsterdam and Pittsburgh. He was elected ROI in 1904, RWS in 1914, RA in 1916 and RSW in 1926 and two of his paintings were purchased by the CHANTREY BEQUEST in 1908 and 1913. In 1918 he was a WAR ARTIST in France and between 1920 and 1926 he was Keeper of the RA Schools. He took his own life in 1928. His work ranges from early outdoor figure scenes painted with a light, fluent touch (*Butterflies*, RA 1904)

to formal portraits and paintings where he adopted a symbolist or primitive style (*The Seven Sacrements*, 1917). In 1926 he began a semi-abstract series of *Spirituals*.
LIT: See his own book *Picture Making: Technique and Inspiration*, Seely Service, London, 1934; 'The Paintings of Mr Charles Sims', *Studio*, Vol.XLI, p.89. CF

SINCLAIR, Beryl Maude, ARCA (b. 1901). Painter of landscapes, townscapes and some flowers in oils; etcher and potter. Born in Bath, she attended BATH SCHOOL OF ART winning a scholarship to the RCA where she was awarded her diploma in 1925. She exhibited regularly at the RA between 1931 and 1963 and also showed work at the NEAC, SWA, LG, RWA, in London galleries and with the Bath Society of Artists. Her pottery was exhibited at the Whitechapel Art Gallery, London, and her etching work includes a series of architectural views of Bath. She lived in London and in Amersham, Bucks, and this is reflected in her choice of subjects such as *February in Rotten Row*, 1937, and *Autumn in Buckinghamshire*, 1961. CF

Situation. The title of an exhibition held at the RBA Galleries in September 1960. BERNARD and HAROLD COHEN, JOHN HOYLAND, ROBYN DENNY and RICHARD SMITH were among the twenty artists who participated in the exhibition, which was designed to demonstrate the importance of painting large-scale works which would, in the current American fashion, occupy the whole field of vision of the spectator.
LIT: *The Sixties Art Scene in London*, David Mellor, Phaidon, 1993. AW

Situationists. Founded in Italy in 1957, the group included Italian and French artists, and a breakaway group of former COBRA artists led by Asger Jorn. They wished to break down the divisions between individual art-forms and to set up 'situations' involving 'creatively lived moments in specific urban settings'. The ancestry of their approach descended from the international Surrealist movement, and was strongly motivated by social and political concern. A magazine was published, and the annual conference held in London in 1960 was considered to be one of the most successful, but the English section, never very powerful, was excluded after 1967. A legacy of their activities may be seen in the work of GILBERT AND GEORGE, VICTOR BURGIN or BRUCE MCLEAN.

LIT: *An Endless Adventure...an Endless Passion...an Endless Banquet*, Iwona Blazwick, ICA Verso, 1989. AW

SKIÖLD, Birgit (1923–1982). Painter and printmaker. Born in Stockholm, she settled in London in 1948, and studied at the ANGLO-FRENCH ART CENTRE, then (1952–5) at the Regent Street Polytechnic. She subsequently studied at the Académie de la Grande Chaumière in Paris before returning to London and in 1958 opening the first Print Workshop in this country. Many distinguished artists worked in this studio, and it inspired the setting up of many more. She taught printmaking part-time at Bradford College of Art from 1963, where she was instrumental, with her husband Peter Bird (the then Director of Bradford City Art Gallery), in preparing for the establishment of the Bradford International Print Biennale (1968). She was also a founder-member of the Printmakers Council, and Chairman 1972–4. She frequently visited Japan, where she exhibited, lectured and researched for a book on handmade paper. Her later etchings and lithographs were delicate, intuitive, calligraphic abstracts, many evoking clear rippling water. She also painted in acrylics from the late 1970s, and exhibited photographs. Three *livres d'artiste* with her prints relating to poems by James Kirkup were published.
LIT: *Birgit Skiöld, Paintings, drawings, prints, photographs*, exhibition catalogue, Galerie Aronowitsch, Stockholm, 1982. AW

SLADE, Roy (b. 1933). Painter of seascapes, coastal subjects and abstracts in acrylic and oils; printmaker. He studied at Cardiff College of Art 1949–54; he exhibited in Cardiff in 1958 and in London at the NEW ART CENTRE in 1960. He has subsequently exhibited in London, the provinces and the USA where he became an American citizen in 1975. His work is represented in public and corporate collections including the ARTS COUNCIL Collection. He taught at Leeds College of Art and from 1970 to 1977 he was Dean of the Corcoran School of Art, Washington, USA. From 1972 to 1977 he was President of Cranbrook Academy of Art and Director of the Corcoran Gallery of Art. Between 1984 and 1985 he was Chairman, Commission of Art in Public Places for the State of Michigan. His early work recorded views of the Welsh, Devon and Yorkshire coastline whilst later paintings abstracted elements from various locations in order to make paintings 'analogous to nature'. CF

Slade School of Fine Art. Founded at University College, London, in 1871, as a result of Felix Slade's Endowments, and still in the same Gower Street building. The first Professor was Sir Edward Poynter: he and his successors, Legros, BROWN, TONKS, SCHWABE and COLDSTREAM taught a formidable list of students who have been central to the development of British art; the French academic tradition of drawing from the nude was a strong influence until recently. Painting, sculpture, printmaking, stage design and film studies are the main activities today.
LIT: *The Slade, 1871–1971*, Bruce Laughton, RA, 1971. AW

SMART, R. Borlase, ROI, RBA, RWA, RBC, SGA (1881–1947). Painter of seascapes and landscapes in oils. He studied with F.J. Snell in 1896, at Plymouth College of Art under Shelley in 1897, and at the RCA. In 1913 he worked under OLSSON at St Ives and from 1914 to 1917 he made a series of charcoal and wash studies of the trenches and Northern France. In 1917 he met LEONARD FULLER and settled in St Ives where he played a central role in the St Ives Society of Artists, encouraging the younger members, and in 1934 teaching PETER LANYON. In 1949 the PENWITH SOCIETY was formed as a tribute to him. Elected RBA in 1919, ROI in 1922 and RBC in 1928, he also exhibited at the RA and in London galleries. Represented in collections including Plymouth Art Gallery, his work was concerned with the observation of form and movement using a bold, direct technique and strong, pure colour.
LIT: *The Technique of Seascape Painting*, Borlase Smart, Pitman & Sons, London, 1934; *Borlase Smart. The Man and his Work*, catalogue, Penwith Gallery, St Ives, 1981. CF

SMELLIE, John (d. 1925). Painter of Scottish scenes in watercolours. He lived in Glasgow and exhibited in Scotland from 1909 showing at the GI, RSA and RSW. In watercolours such as *Tarbert*, 1916, he builds up a delicately realized image using touches of colour and wash over pencil. CF

SMITH, Ian McKenzie, DA, RSA, RSW, FRSA, FSS, FMA, FSA (b. 1935). Painter of abstracts in oils and watercolours. He attended Gray's School of Art 1953–8, and Hospitalfield College 1958–9. He has held solo exhibitions in Scotland since 1959, and his work is represented in public collections including the RSA, Edinburgh. Director of the Aberdeen Art Gallery since 1968,

his work has been influenced by Kenso Okada and uses a restricted colour range and immediate brushwork.
LIT: Exhibition catalogue, Fruit Market Gallery, Edinburgh, 1982. CF

SMITH, Jack, ARCA (b. 1928). Painter of figurative and abstract works in oils. He trained at Sheffield College of Art 1944–6, ST MARTIN'S SCHOOL OF ART 1948–50, under PITCHFORTH, and at the RCA 1950–3 where he was encouraged by MINTON and shared a house with Fullard and GREAVES. He held his first solo exhibition in 1952 at the BEAUX ARTS GALLERY where he exhibited until 1958. He has shown in New York, in London galleries (including the Whitechapel, 1959), in the provinces and internationally in group exhibitions, showing with BRATBY and Greaves at the 1956 Venice Biennale. His work is represented in collections including the TATE GALLERY. He has taught widely in art schools including CHELSEA SCHOOL and his awards include the first prize in the JOHN MOORES EXHIBITION of 1957. His early expressive figurative work depicted interiors and figures and during the 1960s he turned to abstraction. Using a vocabulary of particular forms, often placed on a white ground, he is concerned with light and the use of a visual language that conveys experience and sensation. His abstracts are sharply defined and strongly coloured.
LIT: *Jack Smith Paintings and Drawings 1949–76*, Sunderland Arts Centre, Ceolfrith Press, 1977. CF

SMITH, Sir Matthew Arnold Bracy, LG, CBE (1879–1959). Painter of nudes, flowers, still-life and landscapes in oils. Born in Halifax, he worked in Manchester before enrolling at the Art Department of the Manchester School of Technology in 1901. He attended the SLADE SCHOOL from 1905 and in 1907 met Gwendolin Salmond, whom he later married, at a summer painting school at Whitby. From 1908 to 1914 he worked mainly in France, painting at Pont-Aven, in Paris, where he attended the Atelier Matisse for a short period, at Dieppe, Etaples and at Gréz-sur-Loing. From 1914 he lived in London and after demobilization in 1919 he returned to France, visiting Paris (where he met and was influenced by RODERIC O'CONOR), and Gréz. In 1920 and 1921 he painted in Cornwall and subsequently spent much of his time in France, beginning a series of nudes of VERA CUNINGHAM in Paris in 1923 and visiting Italy

with her in 1927. In 1929 he settled in Paris and continued to visit England and travel in France, often visiting Cagnes-sur-Mer and Aix-en-Provence where he took a studio in 1937. In 1940 he returned to London. He first exhibited at the Salon des Indépendants in Paris in 1911 and 1912–13. He subsequently showed regularly at the LG from 1916 (member 1920) and held his first London solo at the MAYOR GALLERY in 1926. He later exhibited at the REID AND LEFEVRE Gallery and regularly at Arthur Tooth & Sons from 1929. His work was exhibited at the Venice Biennales of 1938 and 1950, a retrospective exhibition was held at the TATE GALLERY in 1953, and a memorial exhibition at the RA in 1960. His work is represented in many public collections including the Tate Gallery. He was awarded a CBE in 1949 and knighted in 1954. Initially influenced by fauvist painting, in the 1920s he evolved a richly intuitive and painterly style using glowing, but more naturalistic colour which still, however, reflected the work of French painters. Recognized by FRY in 1926, his painting has been admired by many artists, including AUGUSTUS JOHN, FRANK AUERBACH and FRANCIS BACON. He painted thickly and fluently, sometimes using his fingers, and the combination of sensual form and colour, particularly in his nudes, is reminiscent of Delacroix.
LIT: *Matthew Smith*, Sir Philip Hendy, Penguin, 1944; *Matthew Smith*, Francis Halliday and John Russell, Allen & Unwin, 1962; exhibition catalogue, Barbican Gallery, London, 1983. CF

SMITH, Percy John Delf (1882–1948). A painter, etcher, calligrapher and book designer, who studied at CAMBERWELL and the CENTRAL SCHOOL. He worked in the USA in 1927, and in Palestine in 1932. Deeply affected by the First World War, his *Twelve Drypoints of the War* (1916–18) and *The Dance of Death* (1918–19) are among the most sombre images created by an artist of the period. (*Death Awed*, for example, depicts the standing figure of Death on a devastated battlefield, empty but for a pair of boots still containing the stumps of leg bones.) He wrote *Quality in Life* (1919), an artist's philosophy. AW

SMITH, Richard, CBE (b. 1931). Painter of abstracts in oils and acrylic. He attended Luton School of Art 1948–50, St Albans School of Art 1952–4, and the RCA 1954–7, serving with the RAF in Hong Kong from 1950 to 1952. From 1957 he made frequent visits to America and in 1976 he settled in New York. He held his first

solo exhibition in New York in 1961 at the Green Gallery and he exhibited in London in the following year at the ICA. He has subsequently shown regularly in London galleries including the Kasmin Gallery, the Whitechapel in 1966, the TATE GALLERY in 1975, and from 1980 at the Knoedler Gallery. He has exhibited regularly abroad and internationally in group exhibitions since 1954. His work is represented in public collections both here and abroad including the Tate Gallery and the Hirschhorn Museum, Washington. He has taught in England at Hammersmith College of Art, 1957–8, and at ST MARTIN'S SCHOOL OF ART, 1961–3, and has been Artist in Residence (in the USA) at the Universities of Virginia in 1967, California at Irvine in 1968, and at Davis in 1976. His awards include the Robert C. Scull Prize, Venice Biennale 1966, and the Grand Prix at the Bienal São Paulo in 1967. He was awarded a CBE in 1972. His early abstract work was influenced by advertising, commercial products and the work of American artists, using simple forms and sharp colour. In the 1960s he produced three-dimensional constructions and shaped paintings concerned with sequence and he later developed a series of shaped, hanging or suspended canvases that reflected his interest in environment, texture and more restrained colour.
LIT: *Art and Artists* (UK), June 1970; exhibition catalogue, Tate Gallery, 1975. CF

SNOW, Peter, ARA (b. 1927). Born in London, he studied painting and stage design at the SLADE SCHOOL 1948–53, following military service. He had a one-man show at the BEAUX ARTS in 1958, the year in which he designed *Waiting for Godot* for Peter Hall. He had already designed the settings of *Love's Labour's Lost*, *The Beggar's Opera*, *The Dinner Engagement*, *Variations on a Theme of Purcell* (Ballet) and *The Buccaneer*, and has since then had a multi-faceted career, regularly exhibiting paintings as well as working on major theatre productions around the world: He has taught at the Slade since 1957; formed the Electric Theatre Company; illustrated three books following travel with a Churchill Fellowship to the USA and Mexico in 1967–9, and has published short stories and a novel (*Artist Unknown*). His paintings have included many on nightlife themes and scenes of the London street.
LIT: A statement by the artist appeared in the catalogue to his Albermarle Gallery exhibition in 1988. AW

Society of Painters in Tempera. Following an exhibition at Leighton House in 1901, the Society was formed by J.E. SOUTHALL Holman Hunt, G.F. WATT, WALTER CRANE, Mary Sargant-Florence and J.D. BATTEN. Characteristic works ranged from late Pre-Raphaelite works such as Batten's *Pandora* (1913, Reading University) to more realistic pictures like Southall's *Corporation Street, Birmingham, in March 1914* (Birmingham Museum and Art Gallery). AW

Society of Scottish Artists. Founded in 1891, it mounts annual exhibitions in the Royal Scottish Academy in Edinburgh. There is 'professional' and ordinary membership, but non-members may also submit work to the selection committee of the Society. AW

Society of Women Artists. The Society of Female Artists was formed *c.*1855 for the encouragement of women painters and sculptors and it held its first exhibition in 1857 at The Gallery, Oxford Street, in which 149 exhibititors showed their work. In 1858, 28 of these artists with 12 others became the founding members of the Society. In 1873 the name was changed to the Society of Lady Artists; in 1878 associate membership was introduced. In 1899 the name was changed to the Society of Women Artists. An exhibiting forum with annual exhibitions in London galleries, it settled at 6a Suffolk Street where it remained, apart from four years, from 1896–1922. From 1923 to 1969 the Society exhibited at the Royal Institute Galleries until the Galleries closed. Under the patronage of the Royal Family and with increasing membership the Society had always attracted leading artists such as Rosa Bonheur, LADY ELIZABETH BUTLER and DAME LAURA KNIGHT who was President from 1932 to 1967. In 1971 the Society moved to the Mall Galleries and in 1980 Princess Michael of Kent consented to be Patron. In 1987 the Society moved again to the Westminster Gallery where it continues to exhibit under its present President BARBARA TATE. Past members of the Society have included artists such as DAME ETHEL WALKER, ETHEL GABAIN, ANNE REDPATH, CATHLEEN MANN and DOROTHEA SHARP. CF

Society of Wood Engravers. Primarily an artist's exhibiting society of some seventy members, who are invited or elected to membership on merit. It was founded in 1920 by ROBERT GIBBINGS, LUCIEN PISSARRO, GWEN RAVERAT, ERIC GILL and

others. Subscribers receive a newsletter, and the annual exhibition of relief printmaking, primarily wood engravings, is selected from an open entry with no privileges for the members. It tours some half-dozen galleries between September and June each year.

LIT: *Engravers Two: A Handbook compiled for the Society of Wood Engravers*, Simon Brett, Silent Books, 1992. AW

SOMERVILLE, Stuart Scott, (1908–1983). Painter of flowers, landscapes, figures and interiors in oils, watercolours, gouache and pastel. He studied with his father, the landscapist Charles Somerville, and exhibited at the RA from 1925 to 1961, at the ROI and in London galleries, including the Claridge Gallery in 1930, and the BEAUX ARTS GALLERY c.1936. Between 1934 and 1935 he travelled in East Africa recording the British Museum expedition in the equatorial mountain region. His work ranges from finished flower paintings to brush drawings of great verve and economy. Some African watercolours use a rapid, calligraphic style reminiscent of oriental art and he often used vivid colour.

LIT: *Mountains of the Moon*, exhibition catalogue, Stephen Somerville Ltd, London, 1990. CF

SONNABEND, Yolanda (b. 1935). Painter of portraits, interiors and figures in oils; theatrical designer. She studied at the SLADE SCHOOL, working under ROBERT MEDLEY, and winning the Boise Travelling Scholarship in 1960. She has held solo exhibitions in London galleries, including the Whitechapel in 1975, and has shown internationally in group exhibitions. Her work is represented in collections including the V & A and the NPG. Her designs include those for Kenneth MacMillan's ballets and her canvases use a painterly, expressive technique.

LIT: Exhibition catalogue, Serpentine Gallery, London, 1986. CF

SORRELL, Alan, RWS, ARCA (1904–1974). Painter of landscapes, architecture, figures, archaeological and historical reconstructions in watercolours, gouache and oils; lithographer, illustrator and muralist. He studied at Southend School of Art and the RCA 1924–7; as a ROME SCHOLAR 1928–31, he became interested in Roman history and later travelled extensively. In 1947 he married the artist Elizabeth Tanner (ELIZABETH SORRELL), and he exhibited mainly at Walker's Gallery, London, at the RWS (member

1942) and at the RA between 1931 and 1948. His drawings of archaeological excavations in Leicester in 1936, led to further commissions and from 1950 he was increasingly concerned with this work. His paintings had an imaginative and detailed style, often employing a high viewpoint so as to include a wealth of incident.

LIT: Exhibition catalogue, National Museum of Wales, 1980. CF

SORRELL, Elizabeth, RWS, ARCA (1916–1991). Painter of gardens, landscapes, flowers, dolls etc. in watercolours; designer. Born in Yorkshire, née Tanner, she studied at Eastbourne School of Art 1934–8, and at the RCA 1938–42, where she concentrated on mural painting under TRISTRAM and was encouraged by PAUL NASH. She has exhibited at the RA since 1948, the NEAC, the RWS (member 1966), at the NEW GRAFTON GALLERY, London, in the provinces and abroad. In 1975 a retrospective exhibition of her work with that of her husband, ALAN SORRELL, was held at Chelmsford Art Gallery, and her work is represented in collections including the TATE GALLERY. Interested in medieval art, her own watercolours are detailed, rich in decorative effect and finely drawn.

LIT: Retrospective exhibition catalogue, Chelmsford Art Gallery, 1975. CF

SOUTHALL, Derek (b. 1930). Painter of abstracts and landscapes in acrylic and alkyd. Born in Coventry, he studied from 1947 at Coventry College of Art, CAMBERWELL SCHOOL OF ART and GOLDSMITHS' COLLEGE, working under EURICH and BLOCH. In 1954 he attended the Hochschule für Bildende Kunst, Berlin, under Joenisch and Schmidt-Rottluff. He held his first solo exhibition at the Drian Galleries in 1962, and he has subsequently shown in London galleries (including Nicola Jacobs), in the provinces and abroad. His work is represented in collections including the TATE GALLERY. Artist in Residence at the Universities of South Carolina and Yale, 1972–5, from 1980 to 1983 he was Senior Research Fellow at Cardiff University. His early abstract painting used shaped and unstretched canvases and he turned to figurative landscapes in 1977. His dramatic vision reflects his early admiration for Palmer, PAUL NASH, Blake and late Turner as well as German art, and he uses powerful colour and forms to evoke an intense and emotional landscape image.

LIT: *Artscribe*, Vol.52, 1985; exhibition catalogue, Artists Gallery, Bath, 1985. CF

SOUTHALL, Joseph Edward, RWS, NEAC, RBSA (1861–1944). Painter of literary figure subjects, genre, landscapes and portraits; engraver. After apprenticeship to an architect, he took up painting, visiting Italy in 1883 where he became interested in tempera. He attended Birmingham School of Art where he met Arthur Gaskin and he was encouraged by Ruskin, W.B. Richmond and Burne-Jones. He exhibited at the RA, 1895–42, at the RBSA (member 1902), the RWS (member 1925) and the NEAC (member 1926) as well as in London galleries, in the provinces and abroad. His work is represented in collections including the TATE GALLERY. A founder member of the Society of Painters in Tempera in 1901, and of the Birmingham Group of Artist-Craftsmen, he was Professor of Painting at the RBSA in 1933 (President 1939). His decorative, golden-toned work abandoned shadows and used flat areas of colour.
LIT: Catalogue by George Breeze, Birmingham City Museum and Art Gallery, 1980. CF

SPEAR, Ruskin, RA. PLG, ARCA, CBE (1911–1990). Painter of portraits, figures and townscapes, particularly of Hammersmith, in oils. Born in Hammersmith, he attended the School of Art there, winning a scholarship to the RCA in 1930, where he studied under ROTHENSTEIN, GILBERT SPENCER and CHARLES MAHONEY. Whilst at the RCA he worked as an assistant to EGERTON COOPER. He first exhibited at the RA in 1932 (ARA 1944 and RA 1954) where he has continued to exhibit regularly. He has shown at the LG (member 1942 and PLG 1949–50) and he held his first solo exhibition at the LEICESTER GALLERIES in 1951. In 1957 he exhibited with WEIGHT, HOGARTH and GREAVES in Moscow, and in 1980 a retrospective exhibition was held at the RA, London. His work is represented in many public collections including the TATE GALLERY and the NPG, London. Between 1940 and 1945 he was commissioned by the WAAC to paint in England and he took part in the RECORDING BRITAIN scheme. From 1941 to 1950 he taught at Croydon, ST MARTIN'S and Hammersmith Schools of Art, subsequently teaching at the RCA. His commissions include an altarpiece for the RAF Church, St Clement Danes, 1958, and murals for the liner *Canberra*, 1959. He was awarded a CBE in 1979. Initially influenced by SICKERT and the CAMDEN TOWN painters, and in portraiture by the EUSTON ROAD SCHOOL, his work is concerned with subject, observation, an element of narrative and a sense of satire and humour. Some works use improvisatory, partially concluded forms which give a sense of life and movement to his figures and portraits. All his work has a strong sense of location and identity.
LIT: *Ruskin Spear*, Mervyn Levy, Weidenfeld & Nicolson, 1985; exhibition catalogue, RA, London, 1980. CF

SPEED, Harold, RP (1872–1957). Painter of portraits, landscapes, interiors and historical subjects in oils and watercolours. He studied at South Kensington and at the RA SCHOOLS 1890–1, winning a gold medal and a travelling scholarship to Italy. He exhibited at the RA from 1893, at the RP (member 1896) and widely in galleries and societies in Britain and abroad. He held his first solo exhibition at the LEICESTER GALLERIES in 1907 and his work is represented in collections including the TATE GALLERY. Master of the ART WORKERS' GUILD in 1916, and member of the Société Nationale des Beaux-Arts, Paris, in 1931, he was best known as a portraitist whose sitters included King Edward VII in 1905. His work also ranged from frescoes to bright, clear landscapes.
LIT: *The Science and Practice of Oil Painting*, Harold Speed, 1924; *Studio*, Vol.XV, December 1898. CF

SPENCE, John (b. 1944). Painter of landscapes, townscapes and interiors in oils, pastels and varnish. He studied at Nottingham College of Art 1962–7, and at the SLADE SCHOOL 1967–9, and has exhibited in solo and group shows since 1970. His work is represented in collections including the ARTS COUNCIL Collection and his small-scale paintings depict his surroundings with an atmosphere of mystery and romance. CF

SPENCELAYH, Charles, HRBSA, RMS, VPBWS (1865–1958). Painter of genre, portraits and interiors in oils and watercolours; miniaturist and etcher. He studied at the National Art Training School, South Kensington (RCA) in 1885, and exhibited at the RA from 1892 to 1958. He also showed at the RMS (founder member 1896), at the ROI, the BSA and BWS and held solo exhibitions in Manchester, Sunderland and London. His work is represented in collections including Nottingham Museum and Art Gallery. He first achieved success as a miniaturist but he is best known for his meticulously detailed genre portraits. In works that

reflect his admiration for Frith he accurately depicted characters and their environment, often with a nostalgic narrative content.
LIT: *Charles Spencelayh and his Paintings*, Aubrey Noakes, Jupiter, London, 1978. CF

SPENCER, Gilbert, RA, RWS, NEAC, IS (1892–1979). Painter of landscapes, portraits, figures and religious subjects in oils and watercolours; muralist and illustrator. Born in Cookham, Berkshire, the younger brother of STANLEY SPENCER, he studied woodcarving at CAMBERWELL SCHOOL OF ART in 1911, and at Thurloe Place in 1912. Encouraged by Stanley Spencer to paint, he was a student at the SLADE SCHOOL under TONKS, 1913–15 and 1919, enlisting in the RAMC in 1915. After meeting Lady Ottoline Morrell he lived at Garsington until 1926, meeting LAMB, Strachey, GERTLER and Yeats. He exhibited at the NEAC from 1915 (member 1920–8 and 1934–53) and held his first solo exhibition in 1923 at the Goupil Gallery where he exhibited until 1932. He showed regularly at the LEICESTER GALLERIES, exhibited at the RA from 1932 (ARA 1950 and RA 1959–69 and 1971) and was elected RWS in 1949. His painting *A Cotswold Farm*, 1930–1, was purchased by the CHANTREY BEQUEST for the TATE GALLERY and his work is represented in public collections. An OFFICIAL WAR ARTIST 1940–3, he was Professor of Painting at the RCA, 1932–48, and Head of Painting at GLASGOW SCHOOL OF ART, 1948–50, and at CAMBERWELL SCHOOL OF ART, 1950–7. Between 1934 and 1936 he painted murals at Holywell Manor, Oxford, and his illustrations include books by T.F. Powys. Initially influenced by Stanley Spencer, his painting was based on his draughtsmanship. Interested in the countryside, particularly domesticated farm scenes and farm machinery, he painted landscape on the spot and his work transforms realistic scenes through selected detail, rhythm, muted colour and shape into a stylized idyllic vision.
LIT: *Memoirs of a Painter*, Gilbert Spencer, Chatto & Windus, 1974; exhibition catalogue, Fine Art Society, London, 1974. CF

SPENCER, Jean (b. 1942). Maker of non-figurative, systematic, constructive work. She studied at BATH ACADEMY OF ART and the University of Sussex and has exhibited in London, the provinces and internationally since 1964. A member of the SYSTEMS group and of 'Arbeitskreis', since 1983 she has been co-organizer of 'Exhibiting Space', London. From 1968 to 1988 she taught at Bulmershe College, Reading, and since 1988 has been Tutor to Students and Secretary to the School at the SLADE SCHOOL OF ART, London. Her recent work, mostly in oil on linen, explores colour as an ordered array.
LIT: Exhibition catalogue, 'britisch-systematisch', Stiftung für Konstruktive und Konkrete Kunst, Zürich, 1990. CF

SPENCER, Sir Stanley, RA, NEAC, ARCA, CBE (1891–1959). Painter of religious subjects, figures, landscapes and portraits; muralist. Born in Cookham, Berkshire, where he spent much of his life, he was the older brother of GILBERT SPENCER and he attended the SLADE SCHOOL under TONKS, 1908–12 and 1923, where he concentrated on drawing. His contemporaries there included NEVINSON, ROBERTS, BOMBERG, GERTLER, WADSWORTH and PAUL NASH and he formed particular friendships with LIGHTFOOT and IHLEE. In 1912 he exhibited in the second Post-Impressionist Exhibition and in 1913 he met Edward Marsh who, with Rupert Brooke, supported his work. Between 1915 and 1918 he served in the RAMC and in 1918 he was commissioned for an official war picture: *Travoys with Wounded Soldiers* (IMPERIAL WAR MUSEUM). A member of the NEAC, 1919–27, his first solo exhibition was at the Goupil Gallery in 1927, where he exhibited *The Resurrection, Cookham*, 1924–6 (TATE GALLERY). Between 1927 and 1932 he worked on the decorations for the Sandham Memorial Chapel, Burghclere, and he subsequently exhibited at the Venice Biennale in 1932 and 1938, and at the Tooth and Leger Galleries in London. Elected ARA in 1932 (resigned 1935) he was re-elected RA in 1950. Retrospective exhibitions of his work were held at Temple Newsam, Leeds, in 1947, and the Tate Gallery in 1955. His work is represented internationally in public collections. From the 1930s he worked on a series of paintings for his Church House scheme and in 1940 he was commissioned by the WAAC to paint shipbuilding subjects at Port Glasgow. *The Resurrection, Port Glasgow* (Tate Gallery) was one of nine pictures of the Resurrection painted between 1945 and 1950. He received his CBE in 1950 and was knighted in 1958. His painting gives a personal, visionary interpretation of secular and religious subjects, often depicting biblical scenes in the contemporary environment of Cookham. Influenced by early Italian painting and the work of contemporaries, including Gertler, Roberts and Nash, he used distortions of scale, perspective and anato-

my, heightened realistic detail, cool, earthy colour and rhythmical forms to produce work of great imaginative intensity. In the 1920s and 1930s he painted urban, domestic subjects, often with an erotic content. His sharply defined work was based on drawn preparation and painted in a methodical manner which rarely altered or over-painted images.
LIT: *Stanley Spencer Resurrection Pictures*, Faber & Faber, 1951; *Stanley Spencer's correspondences and reminiscences*, Paul Elek, London, 1979; exhibition catalogue, RA, London, 1980. CF

SPENCER PRYSE, Gerald (1882–1956). Lithographer. He studied in London and Paris, and was an early member of the SENEFELDER CLUB. During the First World War he was a dispatch rider in Flanders, and was twice wounded; however he published a large number of powerful lithographs of the war, some of which were used as propaganda posters. He later designed many posters, including publicity material for the Labour Party, which he supported. AW

SPENDER, John Humphrey, SMP, ARIBA, RSIA (b. 1910). Painter of landscapes and still-life in oils, watercolours and gouache; photographer, muralist and designer. He studied architecture at the Architectural Association under Howard Robertson, 1929–34, and from 1935 to 1941 and 1946 to 1956 worked as a documentary photographer and photo-journalist for the *Daily Mirror* and *Picture Post*. Official photograher for the 'Mass Observation' scheme and for the War Office, he exhibited at the RA, at the REDFERN and LEICESTER Galleries, in the provinces and abroad. From 1956 to 1976 he was Tutor in the Textile Department of the RCA and he has won four Industrial Design awards. His work includes murals for the Festival of Britain and the P&O Line, photographs of urban life, and paintings ranging from stylized still-life (*Still Life by a Window*, Southampton Art Gallery) to surrealistic images such as *Atomic Flower*, 1939/40.
LIT: *Lensman: Photographs 1932–1952. Humphrey Spender*, Chatto & Windus, London, 1987; 'Humphrey Spender', Bernard Denvir, *Studio*, Vol.136, 1948, p.79. CF

SPENDER, Matthew (b. 1945). Painter of figures in oils and gouache, sculptor of wooden reliefs and masks. Eldest son of Stephen and Natasha Spender, he was educated at Westminster and New College, Oxford, where he read Modern History. In 1967 he married the painter Maro

Gorky and in 1968 settled in Tuscany. He held his first solo exhibition in 1971 in Italy, where he has exhibited regularly, and in London in 1981 at the Space Gallery, subsequently showing at Gallery 24 in 1986, and at the Berkeley Square Gallery in 1988 and 1989. His work shows large, monumental figures enclosed in shallow space painted in warm, conceptual colour. CF

SPURRIER, Steven, RA, ROI, RBA, NS, PS (1878–1961). Painter of figures, circus and theatre scenes in oils and watercolours; illustrator, poster and stage designer. Whilst an apprentice silversmith he attended evening classes at HEATHERLEY'S School and in 1900 he began work as a freelance illustrator for magazines including *Black and White*. In the early 1900s he produced fashion drawing and costume design and in the war he worked on dazzle camouflage. He subsequently worked as an artist for publications including the *Illustrated London News* and *Harper's Bazaar*. He exhibited at the RA from 1906 (ARA 1943 and RA 1952) and showed mainly at the ROI (member 1912) and the RBA (member 1934) as well as other societies and galleries. In 1940 his work *Yellow Wash Stand* was purchased by the CHANTREY BEQUEST. His early painting depicted family and friends and in the 1930s he was introduced to circus subjects by LAURA KNIGHT. Between the wars circus and theatre subjects predominated in his work which like his illustrations, reflects his interest in people and events.
LIT: See his own publications including *Illustration in Wash and Line*, 1933; and *Black and White: A Manual of Illustration*, George Rowney & Co., London, 1909. CF

STEEL, George Hammond (1900–1960). A painter, he studied at Sheffield and Birmingham Schools of Art. His first one-man show was at the Graves Art Gallery, Sheffield in 1941. His richly textured landscapes and abstracts were often inspired by Cornwall. AW

STEELE, Jeffrey (b. 1931). Painter of abstracts in oils. He studied between 1948 and 1960 at Cardiff and Newport Colleges of Art and the Ecole des Beaux-Arts, Paris, holding his first solo exhibition at the ICA, London, in 1961, and subsequently exhibiting internationally. His work is represented in collections including the V & A. Co-founder of the SYSTEMS GROUP, 1969–76, his work has developed from strictly programmed painting influenced by Op art to work based on complex, compound systems influenced by Lohse.

LIT: Catalogue, Lucy Wilton Gallery, London, 1974. CF

STEER, Philip Wilson, NEAC, OM (1860–1942). Painter of landscapes, coastal scenes, figures and portraits in oils and watercolours. He studied at Gloucester School of Art 1878–80, under John Kemp; at the South Kensington Drawing School 1880–1; at the ACADÉMIE JULIAN, Paris, 1882–3, under Bouguereau, and at the Ecole des Beaux-Arts under Alexandre Cabanel, 1883–4. On a return to London in 1883 he visited the exhibition of Impressionist paintings at the Dowdeswell Gallery, and in the summer of 1884 he painted at Cowes, Walberswick and Etaples. He continued to alternate between England and France until 1895, thereafter painting mainly in the English countryside. He exhibited first in 1883 at the RA, showed at the Paris Salon and the GROSVENOR GALLERIES in 1884, and from 1885 to 1887 showed at the RBA. A founder member of the NEAC in 1886, he was associated with the most innovative wing of the club where he exhibited regularly until 1920. In 1889 he exhibited with the London Impressionist Group at the Goupil Gallery and he showed with Les XX in Brussels in 1889 and 1891. In 1894 he held his first solo exhibition at the Goupil Gallery, where he also exhibited in 1909 and 1924. In 1929 a major retrospective exhibition was held at the TATE GALLERY and in the 1930s he exhibited at Barbizon House, London. His work is represented in many public collections including the Tate Gallery and the Fitzwilliam Museum, Cambridge. He taught at the SLADE SCHOOL from 1893 to 1930 and he was awarded the Order of Merit in 1931. Initially influenced by Whistler, from the mid 1880s his painting reflected the work of Manet, Degas and the Impressionists, particularly of Monet. In beach and figure subjects such as *Knucklebones*, 1888/9, he used bright colour applied in short, broken strokes giving a poetic, rich effect. His innovatory style was recognized by contemporaries, including LUCIEN PISSARO. In the mid 1890s his painting changed, showing the influence of Turner and Constable and becoming broader in technique; in figure subjects he turned more to eighteenth-century French painting for inspiration. Later in life he increasingly used watercolours, using washes of colour to suggest form and light.
LIT: *Life Work and Setting of Philip Wilson Steer*, monograph, D.S. MacColl, 1945; *Philip Wilson*

Steer, monograph, Bruce Laughton, OUP, 1971. CF

STEPHENSON, Ian, RA (b. 1934). Painter of abstracts in oils and enamel. He studied under LAWRENCE GOWING at the University of Durham, Newcastle upon Tyne, 1951–6, winning a Hatton Scholarship in his final year. He held his first solo exhibition in London in 1958 at the New Vision Centre, and subsequently showed at the NEW ART CENTRE, the Hayward Gallery in 1977, and the RA in 1985. Elected RA in 1986, he has exhibited internationally in group shows since 1964 and his work is represented in collections including the TATE GALLERY. Between 1956 and 1958 he worked on 'The Developing Process' course with PASMORE and HAMILTON at Newcastle University where he was Director of Foundation studies from 1966 to 1970. In 1970 he was appointed Principal Lecturer in Painting at CHELSEA SCHOOL OF ART. He has served on numerous committees associated with the Fine Arts and has won many awards. His early work was influenced by Cubism and in the mid 1960s he worked on large sectional canvases which combined chance and determination in their technique. Later paintings became more minimal in content and his work is distinguished by its stippled technique, the surface being covered with thousands of dots of colour.
LIT: *Studio International*, November 1968; exhibition catalogue, Hayward Gallery, 1977. CF

STEPHENSON, John Cecil (1889–1965). Painter of abstracts and figurative work in tempera, oils and gouache; muralist; gold and silversmith. He studied at Leeds School of Art 1908–14, the RCA 1914–18, and the SLADE SCHOOL in 1918 under TONKS, where contemporaries included BEN NICHOLSON. Initially influenced by SICKERT, in the 1930s he was in contact with MOORE, Nicholson and HEPWORTH and in 1933 he began to paint abstracts. Between 1934 and 1939 he exhibited with the SEVEN AND FIVE SOCIETY, the Constructivists and at the AIA. Painting in a semi-figurative style during the war, he returned to abstraction in 1950 and held a solo exhibition at the Drian Galleries in 1960. His work is represented in the TATE GALLERY. His early abstracts, many in tempera, were uncompromisingly geometric whilst later work became freer and in the 1960s he used impasto and a palette knife.
LIT: Exhibition catalogue, Camden Arts Centre, 1975. CF

STEVENS, Norman, ARA, ARCA (1937–1988). Painter of landscapes and architecture in oils, watercolours and gouache; etcher. He studied at Bradford College of Art where contemporaries included DAVID HOCKNEY, and at the RCA where he worked under CERI RICHARDS. He visited the USA in 1965 and 1969 and held his first solo exhibition at the Mercury Gallery, London, in 1965. In 1974–5 he was Gregory Fellow at the University of Leeds. He subsequently exhibited at leading galleries, including the REDFERN, at the RA (ARA 1983) and internationally. His work is represented in collections including the TATE GALLERY. He taught at Maidstone and Hornsey Colleges of Art and in 1987 was Artist in Residence at Wimbledon School of Art. His work is characterized by its clearly defined style and the selectivity of its composition. In the 1960s and 1970s his paintings depicted details of clapboard houses, blinds, verandahs etc. and later work, both in paintings and etchings, encompassed landscapes and gardens all represented with a great sense of stillness and attention to light.
LIT: Exhibition catalogues for the Maltzahn Gallery, 1974, and the Redfern Gallery, 1989. CF

STOKES, Adrian Durham (1902–1972). Painter, poet and writer on art, born in London, he was educated at Magdalen College, Oxford, 1920–3, afterwards travelling in Italy and becoming well-known subsequently for his books, e.g. *The Stones of Rimini*, 1934 and *Colour and Form*, 1937. He began painting in 1936 and studied at the EUSTON ROAD SCHOOL in 1937; he began to exhibit in 1938, at REID & LEFEVRE, and in Cornwall was friendly with BEN NICHOLSON and BARBARA HEPWORTH. His first one-man show was in 1951 at the Leger Gallery. He was a Trustee of the National Gallery in 1960, and he continued to write prolifically until his death; his Cézannish paintings were low in key, close-toned and elusive in their focus; his still-lifes had 'a kind of luminosity which seems to derive from the inside of objects' (Patrick Heron).
LIT: The artist's many writings, and the catalogue *Adrian Stokes, 1902–1972*, SERPENTINE GALLERY, 1982. LP

STOTT, Edward, ARA, NEAC (1859–1918). Painter of genre and landscapes in oils and watercolours. He studied in Manchester and in Paris where he worked under Carolus Duran and at the Ecole des Beaux-Arts under Cabanel,

1882–4, where he was a contemporary of WILSON STEER. In 1889 he settled at Amberley in Sussex. He exhibited at the RA from 1883 to 1918, was a founder member of the NEAC in 1886, and showed in London societies and galleries, including the New Gallery, in the provinces and at the Paris Salon. Represented in the TATE GALLERY, his work was initially influenced by Millet and Bastien-Lepage. Later his paintings became more poetic, depicting Sussex rural life and biblical subjects. He painted in layers of small brush-strokes which, in his later works, give a *pointilliste* effect.
LIT: *Studio*, Vol.6, 1896, pp.70–83, and Vol.55, 1921, pp.3–10; *William Stott of Oldham and Edward Stott*, exhibition catalogue, FINE ART SOCIETY, London, 1976. CF

STRAIN, Euphans Hilary, SMA (1884–1960). Painter of portraits and marines in oils and watercolours. Born in Alloway, Ayrshire, she was educated in Baden, Germany, and studied at GLASGOW SCHOOL OF ART (diploma 1923), winning the Director's Prize in 1922, and with W.L. Wyllie. She was married to the artist HAROLD WYLLIE and she exhibited at the GI, RSA, SMA, RP, R.Cam.A., at the RA in 1925 (*Portrait of Miss Helen Lindsay*), in Liverpool and at the Paris Salon. Her work is represented in collections including the Royal Institute of Civil Engineers. CF

STRANG, Ian, RE (1886–1952). Etcher, draughtsman, illustrator and painter of architecture, landscapes and figures in oils and watercolours. The son of William Strang, he studied at the SLADE under BROWN and TONKS, 1902–6, and at the ACADÉMIE JULIAN under J.P. Laurens. He then spent some years travelling in France, Belgium, Italy, Sicily and Spain. He held his first solo exhibition at the Goupil Gallery in 1914 and also held solos at the CHENIL, LEICESTER and LEFEVRE Galleries. He exhibited at the NEAC from 1919, the RE (ARE 1925, RE 1930) and at the RA between 1923 and 1951. His work is represented in collections including the TATE GALLERY. A member of the Faculty of Engraving at the BRITISH SCHOOL IN ROME, he published *The Students' Book of Etching*, 1938. Well known as an etcher, his early work used dry-point to produce tonal, pictorial effects whilst his later prints used a pure etching technique.
LIT: *Etchings and Dry-points by Ian Strang*, P.G. Konody, 1920; memorial exhibition catalogue, the Leicester Galleries, London, 1952. CF

STUBBING, Newton Haydn (Tony) (1921–1983). Painter of figurative and non-figurative images in oils and a range of media; sculptor, theatre designer and mural painter. He worked in Iceland, 1941–3, where he was influenced by Kjarval and he later attended evening classes at CAMBERWELL SCHOOL OF ART. From 1947 to 1948 he painted in Spain and in 1949 he was a Charter Member of the School of Altamira and worked under Laurenz Artigas. He held solo exhibitions widely in Europe from 1943 and in the USA, and he is represented in collections including the TATE GALLERY. Best known for his hand-print paintings influenced by cave art and early cultures, he abandoned the technique in 1968, subsequently producing sculpture, and painting with brushes.
LIT: *Rituals. N.H. (Tony) Stubbing*, catalogue, England & Co., London, 1990. CF

STUDD, Arthur Haythorne (1863–1919). Landscape and figure painter. He was at the SLADE under Legros, and then at the ACADÉMIE JULIAN with WILLIAM ROTHENSTEIN. He met Gauguin, who influenced him (he later worked in Samoa and Tahiti; see *Pacific Island Subject*, 1898, TATE); he was close to Whistler in the 1890s in London and Dieppe, and Studd's beach and seascapes are indebted to his work. He was a collector and left important works by Whistler to the nation. AW

STURGESS-LIEF, Christopher (b. 1937). Painter of non-figurative work in oils, relief maker. Self-taught as a painter, he held his first solo exhibition at Gallery One in 1962. He subsequently exhibited at Rye Art Gallery in 1969, and more recently with the Belgrave Gallery, London. Represented in numerous private collections in Europe, Britain and the USA, his early reliefs showed the influence of Dubuffet. His poetic paintings reflect his interest in Oriental art and calligraphy.
LIT: Exhibition catalogue, Gallery One, London, 1962. CF

SUDDABY, Rowland (1912–1972). His usual works were in oil on canvas, panel or paper, watercolour, gouache or mixed media. He painted a wide range of subjects, including landscapes, still-lifes, flower pieces, nudes and portraits. Born in Yorkshire, he studied at the Sheffield College of Art 1926–30. His first one-man show was at the Wertheim Gallery in 1925; he subsequently showed at the REDFERN and at the Leger Gallery from 1943 to 1967. He worked on the RECORDING BRITAIN project, and was Curator of Gainsborough's Sudbury house for some years. His paintings and illustrations show sharp contrast of tone, linear rhythms and textures and fresh colour. Examples are in the V & A, the ARTS COUNCIL and many regional collections. LP

SUFF, David, (b. 1955). A painter in watercolours, gouache and coloured pencils; etcher. Born in Exeter, he studied Fine Art at Leeds University 1973–7 and at the RCA 1978–81. His first one-man show was at the Parkinson Gallery, University of Leeds, in 1978; he has regularly exhibited at the RA and at the PICCADILLY GALLERY. In 1980 he won the Anstruther Award for drawing. He is best known for his delicately coloured paintings of formal and domestic gardens, flowers and pools. LP

SUMMERS, Gerald (1886–1969). Painter in oils and watercolours; etcher. Principally a landscape painter, he also treated architectural, interior and portrait subjects (notably *David Bomberg c.1909*). Latterly favouring watercolour and etching, he was influenced by NEAC painting and nineteenth-century watercolours, often seeking the picturesque qualities in a subject. Born in Stalybridge, he attended the SLADE SCHOOL 1905–9. From 1907 he exhibited at the NEAC and travelled extensively on the Continent. Friendly with J.D. INNES and DERWENT LEES, he worked with the latter in Dorset in 1914. He was also friendly with JOHN and LAMB. From 1923 he lived permanently in Dorset. He held a one-man exhibition at W.B. Patterson's, 5 Old Bond Street, in 1930. A carpenter, he also published verse (*Railway Rhymes*, 1960, and *Random Rhymes*, 1963). GS

Surrealism. A movement concerned with the arts and with politics founded in Paris in 1924 which was slowly assimilated by the British avant-garde. The work of NASH, MOORE, WADSWORTH and BURRA demonstrated an early awareness of Surrealism, which eventually became best-known in England for its various visual rather than literary forms. In June 1936 the controversial International Surrealist Exhibition opened at the New Burlington Galleries. Impetus for the exhibition came from ROLAND PENROSE and the poet David Gascoyne who, with HERBERT READ and the Parisian Surrealists, André Breton, Paul Eluard, Georges Hugnet and Man Ray, along with the Belgian E.L.T. Mesens, formed the organizing committee. The 390 exhibits included

paintings, collages, 'found' and primitive objects, and photographs from fourteen countries. Among the English contributions were Nash's *Harbour and Room*, 1932–6 (TATE), and Burra's *Revolver Dream*, 1931. Gascoyne, in 1935, and Read, in 1936, published studies of the movement. Included among the twenty-two members of the English Surrealist Group whose names appeared in the Fourth International Surrealist Bulletin were HUMPHREY JENNINGS, Moore, MERLYN EVANS, Len Lye, JULIAN TREVELYAN, Nash and Ruthven Todd. The *London Bulletin* of the LONDON GALLERY (1938–40), edited by Mesens, became the official voice of the English Surrealists, and several predominantly Surrealist exhibitions were organized (Guggenheim Jeune, ZWEMMERS, MAYOR and the London Gallery). Surrealism set out to transform the world by revolutionizing the creative act, and to dispose of the contradictions between the conscious and the unconscious. British painters explored the liberating effects on the imagination of the wide range of figurative aspects of the movement such as dream imagery and the juxtaposition of unrelated objects, and developed an individual form of Surrealism finding its images in the natural world. The English Group was more social than revolutionary, and support for Communism (advocated by many) was difficult to sustain as polarization between artistic freedom and the Party line increased.

LIT: *Surrealism in Britain in the Thirties*, exhibition catalogue, Leeds City Art Gallery, 1986; *Surrealism in England, 1936 and After*, exhibition catalogue, Canterbury College of Art, 1986.

DE

SUTHERLAND, David McBeth, RSA (1883–1973). Painter, muralist and teacher. He was born in Scotland and studied at the Royal Institution School of Art in Edinburgh, and in 1911 was awarded a Carnegie travelling scholarship to Paris and then to Spain. He taught at EDINBURGH COLLEGE OF ART, and from 1933 to 1948 was Head of Gray's School of Art, Aberdeen. He was an OFFICIAL WAR ARTIST during the Second World War.

AW

SUTHERLAND, Graham Vivian, OM (1903–1980). Painter in oils, watercolours and gouache; etcher; designer. He was born in London and, after a period as an engineering apprentice, was trained at GOLDSMITHS' COLLEGE 1921–6, specializing in etching and engraving, and was influenced by F.L. GRIGGS and the revival of interest in Samuel Palmer. His first one-man exhibition was in 1925, and he was elected to the RE. In 1926 he was converted to Roman Catholicism. Following the collapse of the print market in 1929, he designed for posters, china, glass and fabrics, began painting and taught at CHELSEA SCHOOL OF ART. In 1934 he and his wife Kathleen first visited the West Country and Pembrokeshire (they returned annually thereafter until 1939), finding in the landscape a primitive drama and a source of inspiration for anthropomorphic natural forms, e.g. *Red Monolith*, 1937. He exhibited in the International SURREALIST Exhibition in 1936, and was most impressed with the work of Picasso, and particularly by *Guernica* when he saw it in London in 1938. From 1940 to 1945 he was an OFFICIAL WAR ARTIST and drew evocative scenes of bomb damage to buildings, as well as mining and quarrying in Wales and Cornwall. His first religious commission was in 1944, a painting for St Matthew's Church, Northampton: Sutherland chose to paint a *Crucifixion*. In 1950–1 he painted the ORIGINS OF THE LAND for the Festival of Britain, and in 1952 designed the huge tapestry of *Christ the Redeemer Enthroned in Glory in the Tetramorph* for the new Coventry Cathedral. His portrait of Somerset Maugham in 1949 (TATE) showed his gift for characterization; another major portrait commission, that of Sir Winston Churchill in 1954 was destroyed. He lived for much of the year from 1955 near Menton in France. His colour tended to be sharp and acid, and his use of paint dry in texture; his handling of form owed much to the harsher images of metamorphosis by Picasso.

LIT: *Graham Sutherland*, John Hayes, Phaidon, 1980; *Graham Sutherland*, exhibition catalogue, Tate Gallery, 1982.

LP

SUTTON, Keith George (1924–1991). Painter and critic. Born in Dulwich and educated at Rutlish School, Merton, he attended Wimbledon School of Art, then, after wartime service in the Navy, he went to the SLADE 1948–52. Friendly with MICHAEL ANDREWS, EUAN UGLOW, VIC WILLING, PAULA REGO and BERNARD COHEN, his first one-man show was of landscapes and still-lifes at the Galerie de Seine (Belgravia) in 1958. By 1962 he was painting hard-edged collages with flat and textured passages, influenced by the American painter Thomas Erma. During this period he was also teaching and began to contribute art criticism regularly to *Art News and Review* (1955–7), *The New Statesman* (1960),

The Listener (1961–2) and *The Times*. He published a book on Picasso (Hamlyn, 1962) and was editor of the art pages of *London Life* (1965–7). He taught until about 1970, at CORSHAM COURT and then Stourbridge, doing little painting after that until 1980, when he produced his last complex and colourful works. AW

SUTTON, Linda (b. 1947). Painter of fantastic compositions striving for a universality and cosmic significance. She uses brilliant colour in her translation of literary and autobiographical themes to explore symbols of the past and present in a personal mythology (a series was based on *The Tempest* for example, which included television sets and soap powders among the Shakespearian characters). Trained at Southend, Winchester and the RCA, her first solo exhibition was at the Galerij de Zwarte Panter in Antwerp. LP

SUTTON, Philip, RA (b. 1928). Born in Poole, Dorset, he studied at the SLADE SCHOOL 1949–53, after national service. In 1953 he travelled to Spain, France and Italy on scholarships, and later that year began to show his work at ROLAND, BROWSE AND DELBANCO, where he held his first one-man show in 1956, exhibiting there biennially for thirty years. He taught at the Slade, 1954–6, and in 1956 was a member of the LONDON GROUP; in 1963–5 he lived in Fiji; in 1977 he was elected ARA (RA 1989). He has worked in London, Cornwall, Australia, New Zealand, Ireland and Israel; he currently lives in Manorbier, Pembrokeshire. He has exhibited widely nationally and internationally, and has won many awards; the TATE GALLERY and the ARTS COUNCIL own several works and he is represented in many museums throughout the world. An outstandingly prolific artist, his figurative painterly work is notable for the remarkable virtuosity of his use of colour, exploring the radiance of light, his subject-matter being usually taken from his immediate environment: portraits, landscapes, animals, flowers, fruit. He has made many prints, and has done much painted pottery. LP

SWANWICK, Elizabeth (Betty), RA (1915–1989). A pencil and watercolour painter of imaginative fantasies, many based on biblical imagery. She studied, and later taught, at GOLDSMITHS', making friends with DENTON WELCH, and she wrote and illustrated three books: *The Cross Purposes*, 1945, *Hoodwinked*, 1957, and *Beauty and the Burglar*, 1958. LP

SYKES, John Gutteridge (1866–1941). Painter of landscapes and marine views, predominantly in watercolour. He studied at Sheffield School of Art, exhibited at the RA and RI, and lived from *c.*1903 in the artistic community in Newlyn, Cornwall. LP

SYMONS, Mark (1887–1935). Painter in oils of landscapes and figure compositions. He studied at the SLADE SCHOOL 1905–9, and following a religious crisis began to paint regularly after 1924. He exhibited at the RA from 1927, at the NEAC and in the provinces. His imaginative compositions were peopled with figures inspired by his religious belief and by his mystical and romantic fantasies.
LIT: Catalogue for exhibition at Reading Museum and Art Gallery, 1979. LP

SYMONS, Patrick (1925–1993). Born in Bromley, he studied at CAMBERWELL 1946–50. His first one-man show was at the NEW ARTS CENTRE in 1960; he taught at Camberwell, St Albans and CHELSEA Schools of Art. His precisely observed landscapes and figures were composed with a sense of underlying geometrical order, and space was evoked within the integrity of the flat picture surface. The ARTS COUNCIL own his *Study for a Cellist Practising*, a drawing of 1969. LP

Systems. A group formed by JEFFREY STEELE, MICHAEL KIDNER and MALCOLM HUGHES in 1969. Influenced by KENNETH and MARY MARTIN, by Max Bill and Richard Lohse, they developed canvases and constructions organized in arrangements free from painterly 'accident', subjective sensation or emotion, exhibiting regular constants and variables. The relationship between chance, disruption and anarchy on the one hand, and rules, laws and order on the other was, however, considered to be of vital importance in establishing an understanding of the forces unlocked by the complexities of pictorial elements conforming to a system.
LIT: *Systems*, catalogue, Whitechapel Art Gallery, 1972. AW

T

TALMAGE, Algernon Mayow, RA, ROI, RWA, ARE (1871–1939). Born in Fifield, he studied at the Herkomer School, Bushey, and in St Ives. He started the Cornish School of Landscape, Figure

and Sea Painting with OLSSON in St Ives, where he lived until he returned to London in 1907. His first one-man exhibition was at the Goupil Gallery in 1909. He was an OFFICIAL WAR ARTIST during the First World War, and made many etchings from 1927. His landscapes were in a restrained and sober Impressionist manner, and he painted simple and direct portraits. LP

TANDY, John (1905–1982). Painter and wood engraver. He first studied at the Architectural Association, then at LEON UNDERWOOD's School, at the GROSVENOR and in Paris. His clear, bold black-and-white abstracts, of geometric and organic shapes combined were exhibited as early as 1928 in his first one-man show at the Cottars Studio Gallery. AW

TANNER, Robin, RE (1904–1988). An etcher of pastoral subjects, he studied at GOLDSMITHS' under STANLEY ANDERSON. His elaborately worked plates were testimonies of hundreds of hours of work in the detailed evocation of botanical life, stones, textures and light effects. AW

TARR, James C. (b. 1905). Born in Wales, he paints in oil and watercolour. He studied at Cheltenham School of Art 1922–5 and at the RCA 1925–9. He has exhibited at the RA and elsewhere, and was Principal, successively, of Lydney, 1936–8, High Wycombe, 1938–46, and Cardiff, 1946–70, Schools and Colleges of Art. His rural landscapes are carefully and rhythmically composed in harmonious colours. LP

TATE, Barbara, PSWA, RMS, FSBA, ASAF (HC), FRSA (b. 1927). Painter in oils of portraits, genre, still-life, flowers and miniatures of these subjects. She trained at Ealing School of Art 1940–5, under LIGHTFOOT, Bayley and NICHOLLS, at Wigan School of Art 1945–6, and with PETER COKER 1957–8. She has exhibited at the RA, RP, ROI, RBA, NEAC, RMS, SWA, RI, in London galleries including the CHENIL, and abroad. Elected PSWA in 1986, her awards include a gold medal at the Paris Salon in 1969, and the Prix Marie Puisoye in 1971. Her detailed, academic work is represented in collections in the UK and in Europe. She married the artist JAMES TATE. CF

The Tate Gallery. Opened in 1897, it has housed the national collection of British art from the sixteenth century onwards, and modern British and foreign art from about 1875 to the present day. It possesses an important library and archive which is rich in material relating to modern British painting and printmaking. There are now Tate Galleries in Liverpool and St Ives, which exhibit works from the permanent collection, and mount or curate temporary exhibitions. AW

TAYLER, Albert Chevallier, RA, RBC, NEAC, RBA, ROI (1862–1925). Painter of genre, portraits and religious subjects in oils. He studied at the SLADE from 1879 and in Paris with J.P. Laurens (1881–2) and with Carolus Duran. He painted regularly at Newlyn, Cornwall, from 1884 to 1895, travelling to Venice in 1887 and Boulogne in 1890. In 1895 he settled in London. He exhibited at the RA from 1884 to 1925 (ARA 1904, RA 1910) and was elected NEAC in 1886, ROI in 1890 and RBA in 1908. He also showed in London galleries and at the Paris Salon (medal 1891). Represented in Birmingham Art Gallery, his painting was initially in the Newlyn tradition of genre; later he concentrated more on religious (specifically Roman Catholic) subjects and portraits.
LIT: *Painting in Newlyn 1880–1930*, catalogue, Barbican Art Gallery, London, 1985. CF

TAYLOR, Eric (b. 1909). A painter, printmaker and sculptor, born in London. He studied at the RCA 1932–5, under ROTHENSTEIN, and has exhibited widely in Britain and abroad. He taught at CAMBERWELL, 1936–9, the CENTRAL SCHOOL, 1946–8, and at Leeds College of Art (Principal 1956–69), becoming Assistant Director of the Polytechnic, 1969–71. His main activity has tended towards lithography. LP

TAYLOR, Leonard Campbell, RA (1874–1969). A painter of genre scenes, interiors, still-lifes and landscapes in oils. He studied at the RUSKIN SCHOOL, Oxford, the ST JOHN'S WOOD SCHOOL OF ART and, in 1905, at the RA SCHOOLS. He exhibited at the RA from 1899, at the Paris Salon and elsewhere. A visit to China and Japan resulted in oriental landscapes and interiors; his tranquil, highly detailed studio scenes were very popular in reproduction. LP

TAYLOR, Walter (1860–1943). Born in Leeds, he trained first as an architect then with FRED BROWN in 1897, at the RCA in 1898 and in Paris. He met and worked with SICKERT in Dieppe, and also worked in Italy. His first one-man show was at the Grafton Gallery in 1911. Primarily a land-

scape painter in watercolours, a collector of work by Sickert and GILMAN and a member (elected 1914) of the LONDON GROUP, he also painted architectural subjects. A memorial exhibition of his work was held in 1944 at the LEICESTER GALLERIES. AW

TEGETMEIER, Denis (1895–1987). Illustrator and painter in oils and watercolours. Born in Hampstead, he was apprenticed to an advertising agency in 1912, and after war service he studied at the CENTRAL SCHOOL OF ART 1919–22, meeting ERIC GILL and DAVID JONES. He visited Gill's Ditchling community in 1923 and from 1924–7 worked as a freelance cartoonist. In 1928 he moved to Pigotts, High Wycombe, and joined Gill's circle and in 1930 married Gill's daughter Petra. He worked at Pigotts until 1962, from 1941 to 1960 in partnership with Lawrence Cribb, and in 1962 settled in Wiltshire. His many book illustrations include *Sentimental Journey* by Sterne, Limited Editions Club, 1936, and works by Gill including *Unholy Trinity*, J.M. Dent & Sons, 1938. His line drawings were witty and imaginative and from 1962 he produced paintings in oil on gesso and some watercolours.
LIT: *Teg: An Exhibition of Work by Denis Tegetmeier*, catalogue, Studio One Gallery, Oxford, 1977. CF

TENNANT, Stephen (1906–1986). He studied at the SLADE SCHOOL, and also was briefly a ballet dancer. His first one-man exhibition was at the REDFERN GALLERY, and his last, in 1976, was at Anthony d'Offay.
LIT: *Serious Pleasures: The Life of Stephen Tennant*, Philip Hoare, Hamish Hamilton, 1990. AW

THOMAS, Keith (b. 1946). Born in Birmingham, he paints in acrylic on canvas and paper. He trained at Birmingham College of Art 1965–8, and at CHELSEA 1968–9. Examples of his highly rhythmical, gestural and linear work, often abstracted from animals, are *Snake*, 1977, and *Crawler*, 1978, owned by the ARTS COUNCIL. LP

THOMAS, Margaret (b. 1916). Born in London, she studied at Sidcup School of Art, at the SLADE 1936–8, and at the RA SCHOOLS 1938–9. She paints portraits, interiors and still-lifes in oil, realistically sensitive to light, atmosphere and colour. *The Chintz Tablecloth*, 1948, is in the ARTS COUNCIL COLLECTION. She has exhibited

regularly at the RA, and as a member of the RBA and NEAC. Her first solo exhibition was at the LEICESTER GALLERIES in 1949; she has more recently shown at Sally Hunter Fine Art in 1988. LP

THOMSON, Alex (b. 1942). Painter of non-figurative works in acrylic. Born in Glasgow, he studied at GLASGOW SCHOOL OF ART 1960–4, and at the SLADE 1966–8, subsequently holding a Fellowship at Norwich School of Art for a year. He has exhibited in group shows since 1965, including the JOHN MOORES EXHIBITION in 1965, at the ICA in 1969 and the SERPENTINE in 1974. His work is represented in the ARTS COUNCIL Collection and he teaches at Winchester School of Art. CF

THOMSON, Alexander P., RSW (d. 1962). Painter of landscapes and architecture in watercolours. He worked in Glasgow for many years and exhibited mainly in Scotland from 1906 at the RSW (member 1922), the RSA and the GI. He also showed at Liverpool and at the RA where between 1909 and 1933 he exhibited subjects such as *John Knox's House, Edinburgh*, 1913, and *The Bridge, Aberfeldy, Perthshire*, 1924. He painted views of the Highlands, often working on a large scale, using textured paper. CF

THOMSON, Alfred Reginald, RA, RP (1894–1979). Painter of portraits and murals; illustrator. He expressed a strong interest in character, and enjoyed caricature. Crowd scenes, genre and composite, commemorative portraiture were a speciality; he painted both Houses of Parliament in session. Born at Bangalore, India, the son of a civil servant, on residing in England he entered Margate School for the Deaf and Dumb. Encouraged by C.M.Q. Orchardson, he attended the John Hassell School for Commercial Art, Kensington, subsequently working in advertising and poster design. After the war he established a reputation as a figure and portrait painter, treating official and informal subjects alike, in a lively, accomplished manner. He exhibited at the RP, and from 1920 at the RA (elected a member in 1945). Commissions for murals came from public and private sources; those at the Science Museum and Duncannon Hotel being London examples. OFFICIAL WAR ARTIST to the RAF (1940–44), he was awarded the Olympiad Gold Medal for his treatment of sporting themes in 1948. GS

THOMSON, George, NEAC (1860–1939). Painter of architecture, interiors, figures, flowers, townscapes and landscapes in oils and watercolours; art critic. He studied at the RA SCHOOLS and exhibited at the RA from 1886. He showed mainly at the NEAC (member 1891), and at the LEICESTER and Goupil galleries. His work is represented in public collections including the TATE GALLERY. Between 1895 and 1914 he taught at the SLADE SCHOOL. His research into the technique of the early Italian painters influenced his own technique whilst his style reflects his admiration for Monet and Spanish painting. CF

THORBURN, Archibald (1860–1935). Painter of birds, animals and flowers in watercolours; illustrator. Son of Robert Thorburn, friend of George Lodge and of Joseph Wolf (from whom he received some tuition), he exhibited at the RA from 1880 to 1900, subsequently concentrating more on illustration. His first work was published in 1883 in *Familiar Wild Birds* by W.F. Swaysland and between 1885 and 1898 he produced watercolours for Lord Lilford's *Coloured Figures of the Birds of the British Islands*. He wrote and illustrated his own books on birds and in 1927 he was elected Vice-President of the RSPB. His watercolours are fresh and detailed.
LIT: *Archibald Thorburn Landscapes: The Major Natural History Paintings*, John Southern, Hamilton, 1981; *Thorburn's Birds*, ed. J. Fisher, Mermaid, 1982. CF

THORNTON, Alfred Henry Robinson, LG, NEAC (1863–1939). Primarily a landscape painter. Educated at Harrow and Trinity College, Cambridge, he studied art at the SLADE (1888–9) after a year in the Foreign Office, and followed this with two years at WESTMINSTER SCHOOL OF ART. He then taught there (1893–4) as an assistant to SICKERT. He travelled widely in Europe, and met Gauguin in Brittany. Typical of his Post-Impressionist works are *Sunday Morning* (1938, Manchester City Art Gallery) and *St. German* (1929, TATE GALLERY).
LIT: *The Diary of an Art Student of the Nineties*, Alfred Thornton, London, 1938.

THORNTON, Valerie, RE (1931–1991). Etcher and draughtsman of architecture; painter of architecture, still-life and landscape in oils. She studied at the BYAM SHAW SCHOOL in 1949, at the Regent Street Polytechnic 1950–3, and with HAYTER at ATELIER 17, Paris, in 1954. She exhibited at the Walker's Galleries in 1957 and 1959,

held a solo at The Minories in 1960 and subsequently exhibited in London and provincial galleries and in the USA where she worked in 1963–4 and in 1970. She exhibited at the RA from 1965 and was elected ARE in 1968 and RE in 1970. A founder member of the Printmaker's Council in 1965, she became a member of the Faculty of Engraving at the BRITISH SCHOOL IN ROME in 1974. Her work is represented in the V & A and BM. Influenced and encouraged by WINIFRED NICHOLSON, Rosemary Rutherford and her husband MICHAEL CHASE, her experimental printmaking created a richly textured surface to represent the masonry of old buildings.
LIT: Retrospective exhibition catalogue, The Minories, Colchester, 1974; interview in *Arts Review* (UK), Vol.34, pt.7, 26 March 1982, p.151. CF

THUBRON, Harry, OBE (1915–1985). Artist in collage and constructions; painter and art educationalist. He attended Sunderland School of Art 1933–8, and the RCA 1938–40, and exhibited in London from 1964, at the LG from 1980, in the provinces, abroad and in group exhibitions. He was Head of Fine Art at the Sunderland, 1950–4, Leeds, 1955–64, Lancaster, 1964–5, and Leicester, 1966–8, Colleges of Art, and held posts in America, Spain and Jamaica. He worked with PASMORE on the 'Developing Process' and instigated many innovatory art courses and schemes. In 1978 he was awarded an OBE. His abstract work uses both found and manufactured objects and from 1968 was influenced by the environment of Southern Spain where he found 'objects shaped by the elements and man's daily activity'.
LIT: Exhibition catalogue, SERPENTINE GALLERY, 1976; interview in *Art Line*, No.10, December 1983. CF

TIBBLE, Geoffrey Arthur, LG (1909–1952). Painter of figures, interiors, landscapes and abstracts in oils. He studied at the SLADE SCHOOL under TONKS, where his contemporaries were COLDSTREAM, CARR, TOWNSEND and BELLINGHAM-SMITH. In 1934 he exhibited abstract works at the Objective Abstraction Exhibition, ZWEMMER Gallery, and between 1933 and 1935 represented, with Moynihan, BELL and HUBERT, the most radical of the objective abstractionists. In 1937 he returned to figurative painting, having his first solo exhibition at Tooths Gallery in 1946, and subsequently exhibiting at leading London galleries (including

the LEICESTER and LEFEVRE), at the LG (member 1944), at the NEAC and in group exhibitions. His work is represented in public collections including the TATE GALLERY. All his work is characterized by his expressive use of paint. His figurative work, often of women in interiors, was initially influenced by Degas but later also reflected his interest in Japanese colour prints in its arrangement of colour areas.
LIT: Retrospective exhibition catalogue, City of Manchester Art Gallery, 1958. CF

TILLYER, William (b. 1938). Born in Middlesborough, he attended Middlesborough College of Art (1956–9) and the SLADE (1960–62). He had his first one-man show at Middlesborough Art Gallery in 1962, and was awarded a French Government Scholarship in that year, working 1962–3 at HAYTER'S ATELIER 17 in Paris. He taught 1963–4 at CHELSEA School of Art, until 1970 at the CENTRAL, and then, until 1972, at the BATH ACADEMY OF ART, Corsham Court. He visited New York in 1974, and was Visiting Professor at Brown University, Rhode Island, 1975–6. He was Artist in Residence at Melbourne University, Australia, 1981–2. In 1980 he made his home in Yorkshire where he continues to live and work. During the 1970s his painted reliefs, etchings and sculptural works were based on a mesh grid, but more recent works combine large, fluid and gestural brushstrokes with rectangular areas and sometimes hard-edged relief passages, evoking the experience of landscape. He has also made ceramics.
LIT: 'William Tillyer: Living in Arcadia'. Introduction by David Cohen to exhibition catalogue, Bernard Jacobson Gallery, 1991. AW

TILSON, Joe, ARCA, RA (b. 1928). Artist in wood reliefs and constructions; printmaker. Initially trained as a carpenter, he studied art at ST MARTIN'S SCHOOL OF ART 1949–52, and at the RCA 1952–5, winning the ROME PRIZE in 1955. Between 1955 and 1957 he worked in Italy and Spain, returning to London in 1958, and from 1970 he has worked in Tuscany and Wiltshire. He exhibited at the Marlborough New London Gallery from 1962 to 1970, and at the WADDINGTON GALLERIES from 1971. His work has been shown widely abroad and retrospective exhibitions have included those at the TATE GALLERY in 1978, and the Art Museum, Liubliana, Yugoslavia, in 1987. His work is represented in public collections nationally and internationally. He has taught at St Martin's

School of Art, the University of Durham, the SLADE SCHOOL, in New York in 1966 and in Hamburg in 1971–2. His many awards include the Gold Medal at the San Marino Biennale in 1963, and the Grand Prix d'Honneur, Biennale de la Gravure, Liubliana, in 1985. In the 1960s his work was influenced by Pop imagery, using technological processes, a range of media and making references to contemporary events. Later he turned to more universal themes through an interest in the elements and Greek mythology and his technique became more subjective, reflecting a greater involvement with his materials. His work reveals his interest in emblematic images, rituals and games and is clearly structured, often using words and language.
LIT: *Contemporary Artists: Tilson*, Michael Compton, Milan, 1982; *Joe Tilson, Recent Works*, catalogue, Waddington Galleries, 1988. CF

TINDLE, David, RA (b. 1932). Painter of landscapes, interiors, still-life, figures and portraits, in tempera, oils and watercolours. He studied at Coventry School of Art 1945–7, and has exhibited in London galleries including the PICCADILLY, 1954–83, and Fischer Fine Art. He has shown at the RA (becoming ARA in 1973 and RA in 1979), abroad, in the provinces and in many group exhibitions. His work is represented in public collections including the TATE GALLERY and the ARTS COUNCIL Collections. Between 1959 and 1974 he taught at Hornsey College of Art and from 1972 to 1983 at the RCA. In 1986 he became RUSKIN Master at Oxford University. He was elected Associate of the RCA in 1973, Fellow in 1981 and Honorary Fellow in 1984. In 1962 he was awarded the Critic's Prize. His recent finely painted work of unpeopled interiors and landscapes record a sense of stillness, memory and the passage of time.
LIT: Exhibition catalogue, Fischer Fine Art, 1985; *Apollo*, June 1968; 'The Artist in Conversation: David Tindle on Tempera Painting', *Artist* (UK), October 1988. CF

TISDALL, Hans, SMP (b. 1910). Painter of abstracts in oils and gouache; mural painter, mosaic and tapestry designer. Born in Munich, he studied there at the Academy of Fine Art in 1928, and in 1929 was apprenticed to Moisey Kogan and lived in Paris and Ascona. In 1930 he settled in London and between 1931 and 1935 he designed fabrics and book jackets. From 1935 he worked on mural painting, mosaic and tapestry design and published books in association

with Oliver Hill, including *Balbus – A Picture Book of Building*, Cresset Press, 1944. He was married to Isabel Gallegos who ran the Edinburgh Weavers, for whom he worked from 1956. He held his first solo at the Leger Gallery in 1947 and subsequently exhibited regularly in London galleries and abroad. His work is represented in the TATE GALLERY. From 1947 until the 1980s he taught at the CENTRAL SCHOOL OF ART. Whilst his early work depicted still-life subjects, from the 1960s it moved to abstraction informed by nature, simplifying and refining shape and colour. His later work uses simple, minimal shapes and saturated, glowing colour.
LIT: Retrospective exhibition catalogue, Albermarle Gallery, London, 1990. CF

TITCHELL, John, ARA (b. 1926). Painter of landscapes and marines in watercolours and oils. He studied at Sidcup School of Art 1940–4, and at the RCA 1948–51, exhibiting regularly at the RA and in the provinces. His first London solo exhibition was in 1989 in the Friend's Room at the RA. His small-scaled works are painted in a pointilliste technique with high-keyed colour and they show the changing light and colour of the coast and country around his home in Kent.
LIT: *Apollo*, October 1988. CF

TODD, Arthur Ralph Middleton, RA, RWS, RP, RE, NEAC (1891–1966). Painter of portraits, figures, flowers and landscapes in oils and watercolours; etcher and engraver. Son of Ralph Todd, he studied with STANHOPE FORBES, at the CENTRAL SCHOOL, at the SLADE SCHOOL under TONKS, 1920–1, and abroad. He exhibited widely but mainly at the RA from 1918. He was elected RE in 1930, RWS in 1937, NEAC and RA in 1945 and RP in 1958 and his work is represented in public collections including the TATE GALLERY and the V & A. From 1936 to 1939 he was Head of Drawing and Painting, Leicester School of Art, from 1946 to 1949 Tutor at the RA SCHOOLS, and from 1950 to 1956 Tutor, City and Guilds School, Kennington. His wide-ranging subject matter includes sensitive portraits such as *Sub-Officer Henry E. Shaw, BEM* (Manchester City Art Gallery). CF

TOLLEY, Sheila, ARWA (b. 1939). Painter in oils and watercolours. She studied at Bournemouth and Poole College of Art 1972–4 under Edward Darcy Lister and has exhibited at the RA since 1978 and at the RWA since 1976. Her exhibited subjects include *Walsall, Monday*

Morning, RA 1981, and *Staffordshire Colliery, Winter*, RA 1983. She often uses watercolour and collage for her abstracted landscapes, forming harmonious cubist compositions. CF

TONKS, Henry, NEAC (1862–1937). Painter in oils, pastels and watercolours of figures, interiors, portraits and landscapes; he also practised caricature. Assimilating influences from the Rococco, from English illustration of the 1860s and Degas alike, Tonks favoured themes of elegant ladyhood in softly-lit interiors, his conversation pieces characterized by mild sentiment. Son of a Solihull foundry owner, in 1880 Tonks began medical studies in Brighton, entering the London Hospital in 1881. Inspired by a trip to Germany in 1886, and in particular by the Dresden Gallery, on attaining his Fellowship from the Royal College of Surgeons in 1888, Tonks took art classes at WESTMINSTER SCHOOL OF ART under FRED BROWN. In 1892 he became Demonstrator in Anatomy at the London Medical School. Brown (on being elected SLADE Professor the same year) offered Tonks the post of his assistant. Thus began a lengthy Slade association during which Tonks gained a formidable reputation as a teacher of figure drawing, an opponent of ROGER FRY, as well as an encourager of female students. On Brown's retirement in 1917, Tonks became Slade Professor, 1918–30. He travelled widely, to Honfleur (with D.S. MacCOLLIN 1904), Northern Russia in 1919, Europe and Scandinavia in 1928. Betteshanger, Kent, became a favoured summer retreat in Tonks's later years. Returning to medicine, 1914–16, and recording plastic surgery, in 1918 he became an OFFICIAL WAR ARTIST. Exhibiting from 1891, chiefly at the NEAC he held a one-man exhibition at the Carfax Gallery in 1905.
LIT: His autobiographical 'Notes from Wander Years', *Art Work*, Vo.15, No.17, Winter 1929; *Life of Henry Tonks*, Joseph Hone, Heinemann, 1939. GS

TONKS, Dr Myles Denison Boswell, RI, RBA, PS, MRCS, LRCP (1890–1960). Painter of landscapes in oils and watercolours. He went to the Medway School of Art under HENRY TONKS and studied in London museums and galleries. He exhibited with London societies including RI (becoming a member in 1938), the RBA (becoming a member in 1940), the RA and at the FINE ART SOCIETY. His observed, controlled watercolours were also exhibited in the provinces.

LIT: 'The Artist on Tour. The French Alps', Myles Tonks, *Studio*, Vol.104, p.152.　　CF

TOPOLSKI, Feliks (1907–1989). Painter of figures, portraits, townscapes and the contemporary scene in oils; draughtsman, muralist, theatrical designer and illustrator. Born in Warsaw, he studied at the Academy of Art, Warsaw, 1925–30, and in Italy and Paris in 1938. He settled in England in 1935 and became a British citizen in 1947. From 1940 to 1945 he was an official Polish war artist. He has exhibited in London and provincial galleries and extensively abroad and his work is represented in many public collections including the TATE GALLERY and the V & A. He has produced BBCTV films and many publications and his decoration and mural commissions include *Cavalcade of Commonwealth*, Festival of Britain, 1951, *The Coronation of Elizabeth II*, Buckingham Palace, 1958–60, and since 1975 the mural environment *Memoir of the Century*. His immediately recognizable calligraphic style expresses movement and energy in a virtuoso technique. In his drawings, movement and form are expressed in a web of rapid lines.
LIT: *Feliks Topolski: Fourteen Letters*, autobiography, Faber and Faber, 1988.　　CF

TOWN, Norman Basil (1915–1987). A painter in watercolour and gouache, he studied at the RCA 1946–9, following work (as an Objector) in a Bomb Disposal Unit and down the mines; this was the subject of his early work. Friendship with KEITH VAUGHAN influenced his style and subject-matter, which included figure compositions and landscapes, many tending towards romantic abstraction in warm colours and strong textures. His first solo exhibition was at the Haworth Gallery, Wakefield, in 1949; he had a joint exhibition with John Christoforou at GIMPEL FILS in 1953 and also showed at the University of Surrey in 1980; he exhibited in mixed exhibitions in London at the Leger Galleries, at the RBA, the Whitechapel and elsewhere. He was Head of Graphic Design at Wimbledon College of Art until retirement, having rarely exhibited after 1956.　　AW

TOWNSEND, William, LG (1909–1973). Painter of landscapes and townscapes in oils. He studied at the SLADE SCHOOL under TONKS and STEER, 1926–30, and visited Italy, France and the Middle East, 1929–30. In 1931 he exhibited with the LG (becoming a member in 1951), and at the Bloomsbury Gallery; thereafter he showed regularly in London and Canadian galleries, in group exhibitions and his work is represented in public collections in Britain and Canada. He taught at CAMBERWELL SCHOOL OF ART, 1946–9, and from 1949 at the Slade School, becoming Professor in 1968. His association with Canada, and particularly with the Banff School of Fine Art, where he was made Head of Painting in 1966, began in 1951. In 1964–5 he selected work for the Canadian Biennial Exhibition and in 1970 was the co-author and editor of *Canadian Art Today*. In 1968 he was elected Fellow of University College, London. His early painting sought an objective, controlled style directly related to the reality of the subject. Later Canadian subjects moved towards abstraction and reflected his interest in classical Japanese painting.
LIT: *The Townsend Journals*, TATE GALLERY, 1976; retrospective exhibition catalogue, Tate Gallery, 1976.　　CF

TOYNBEE, Lawrence (b. 1922). Painter of landscapes, of contemporary sports subjects in oils; muralist. He studied at the RUSKIN SCHOOL of Drawing and exhibited at London galleries including the LEICESTER GALLERIES, 1961–9, and the FINE ART SOCIETY. His work is represented in public collections including the NPG. He taught at the Ruskin School, Oxford School of Art, Bradford College of Art, and was Director of the Morley Arts Centre and Gallery, 1969–72. His painting style is impressionistic using warm, golden-toned colour.　　CF

TREMLETT, David (b. 1945). Artist working in object-sculptures, coloured wall drawings, installations, pastels, graphite and line drawings. He studied at Falmouth, Birmingham and the RCA and has exhibited widely in London galleries (including the Serpentine in 1989), abroad and in group exhibitions. Examples of his work are in public collections including the TATE GALLERY. His extensive travel forms the basis for his work which refines his experiences into abstract details, often incorporating language.
LIT: See the artist's books, including *Ruins*, Amsterdam, 1987.　　CF

TREVELYAN, Julian Otto, RA, LG (1910–1988). Painter of industrial landscapes, marines, figures, animals and townscapes in oils, gouaches and mixed media; etcher. The nephew of G.M. Trevelyan, he studied English at Cambridge where through his friendship with HUMPHREY JENNINGS he began to look at French

painting, particularly the work of Masson. In 1931 he studied at ATELIER 17, Paris, with S.W. HAYTER, in 1935 he established his studio at Hammersmith, London, and he continued to travel widely. In 1937 and 1938 he was involved with Harrisson's 'Mass Observation' which influenced his choice of industrial landscape subjects. During the war he worked as a camouflage officer. In 1932 he exhibited at the Bloomsbury Gallery and later at London galleries including the LEFEVRE, ZWEMMER and the TATE. In 1936 his work was included in the London International SURREALIST Exhibition and subsequently in many group shows in Britain and abroad. Public collections containing his work include the Tate Gallery and MOMA, New York. He was active in the AIA, a member of the English Surrealist Group, 1937–8, and of the LG, 1948–63. He taught at CHELSEA SCHOOL OF ART, 1950–60, and from 1955 to 1963 was Tutor in Etching at the RCA. He was married twice: to Ursula (Mommens) Darwin in 1934 and to MARY FEDDEN in 1951. He published a number of important etching suites and three books. Initially his work displayed a wide range of styles from figurative realism to Surrealist subjects. After the war his admiration for Bonnard produced a looser painting technique but this later changed to a linear style with heavy outlines and firm, flat areas of strong colour.
LIT: See the artist's own books including *Indigo Days*, MacGibbon & Kee, 1958; retrospective exhibition catalogue, Waterman's Arts Centre, 1986. CF

TRISTRAM, Professor Ernest William, RSA, ARCA, D.Litt. (Oxon) (1882–1952). Painter, copyist and reconstructor of medieval paintings. He studied under William Lethaby at the RCA, 1900–4, who influenced him in his interest in medieval wall paintings. He exhibited at the RA in 1912 and 1942, was Professor of Design at the RCA from 1926 and was awarded a D.Litt. from Oxford in 1931. Examples of his work are in collections including the V & A. He published widely including *English Medieval Painting*, 1927, (with Professor Tancred Borenius).
LIT: *Copies of English Medieval Mural Paintings by E.W. Tristram*, catalogue, Leeds City Art Gallery, 1933. CF

TRYON, Wyndham, NEAC, LG (1883–1942). Painter of landscapes and abstracts in oils and watercolours. Educated at Charterhouse, he studied at the SLADE SCHOOL 1906–11, and in

1911 and 1914 visited Spain with DARSIE JAPP. He continued to travel in Spain and in 1929–30 he lived in the South of France. He exhibited mainly at the NEAC and was elected a member in 1920. His first solo exhibition was at the XXI Gallery in 1921 and he also showed at the Carfax and BEAUX ARTS Galleries and at the GI. He was elected a member of the LG in 1925. CF

TUCKER, James Walker, ARCA, ARWA, FRSA (1898–1972). Painter of landscapes and figures in oils and tempera. He studied at Armstrong College, Newcastle upon Tyne, under R.G. Hatton, 1914–22, and at the RCA where he was a student and studio assistant of ROTHENSTEIN. In 1927 he won a travelling scholarship and from 1928 to 1968 exhibited regularly at the RA. He also showed in London at the NEAC, RBA and the Cooling Gallery, and held a series of exhibitions in Cheltenham and Gloucester. From 1931 to 1963 he was Head of Gloucester School of Art. His clearly formed paintings combine observed and stylized form, e.g. *Hiking*, RA 1936.
LIT: Exhibition catalogue, Cheltenham Art Gallery and Museum, 1979. CF

TUKE, Henry Scott, RA, RWS, NEAC, RBA (1858–1929). Painter of figures, particularly the male nude in the open air, portraits and marines in oils, watercolours and pastels. He studied at the SLADE from 1875, in Florence from 1880 to 1881, where he was influenced by ARTHUR LEMON, and in Paris with J.P. Laurens 1881–3, where he met SARGENT and Bastien-Lepage. He worked in Newlyn in 1883 and 1884 and in 1885 settled in Falmouth. He exhibited at the RA from 1879 to 1928 and widely in London galleries, being elected NEAC in 1886, RBA in 1888, ARA in 1900, ARWS in 1904, RWS in 1911 and RA in 1914. His work is represented in collections including the TATE GALLERY. His early work was influenced by Bastien-Lepage but later he depicted bright sunlight in a more fluid, impressionistic manner, studying the effects of light on water and the nude.
LIT: *Henry Scott Tuke. Under Canvas*, David Wainwright and Catherine Dinn, Sarema Press, London, 1989. CF

TUNNARD, John, ARA, LG (1900–1971). Painter of abstracts, landscapes and marines in gouaches and oils; textile designer. Son of J.C. Tunnard, he studied design at the RCA 1919–23, and worked as a textile designer 1923–9. In 1926 he married Mary Robertson

and in 1929 he started to paint, visiting Cornwall in 1930–2 and moving there in 1933. He exhibited first in 1931 at the RA (becoming ARA in 1967), and at the LG where he exhibited regularly and became a member in 1934. His first solo exhibition was at the REDFERN GALLERY, London, in 1933, and he continued to exhibit in London galleries including the Guggenheim Jeune and McRoberts & Tunnard Ltd. His work was included in various Surrealist exhibitions in the later 1930s and thereafter in many shows of contemporary British art and in the 1940s his work began to appear in New York. He also exhibited in Europe and his work is included in public collections. He taught design at the CENTRAL SCHOOL, London, and from 1948 at the Penzance School of Art. His interest in jazz and in natural history was reflected in his work which early in his career was romantic Cornish landscape executed in a vigorous, rhythmic manner. During the 1930s his work was influenced by abstraction, constructivism and surrealism, and in particular the example of Miró. He used imaginative forms set in an illusory space, e.g. *Fulcrum*, 1939, and from the 1940s these forms reflected an interest in technology and, in the 1960s, the exploration of space. His work combined modernity, technological forms and the forms of the natural world.
LIT: Retrospective exhibition catalogue, RA, 1977; *John Tunnard*, Alan Peat and Brian A Whitton, Scolar Press, 1997. CF

TUNNICLIFFE, Charles Frederick, RA, RE, ARCA, OBE (1901–1979). Painter of birds and animals in watercolours; draughtsman, woodengraver, etcher and illustrator. He studied at Macclesfield and MANCHESTER art schools, winning a Royal Exhibition Scholarship to the RCA 1921–5. He then returned to Cheshire, moving to Anglesey in 1947. He exhibited at the RA, first as an engraver, then as a painter, becoming ARA in 1944 and RA in 1954. His work also appeared at the RE, in London and provincial galleries and abroad, and is represented in public collections. Over 40 years he illustrated more than 80 full-length books including Henry Williamson's *Tarka the Otter*, published his own books and produced a variety of commercial work. He drew many postmortem, measured studies of birds which were exhibited at the RA in 1974. He was the Vice-President of the RSPB and their Gold Medal winner, and he received an OBE in 1978. His paintings are accurate,

detailed and lifelike, balancing scrupulous observation, veracity of colour and an overall sense of design.
LIT: See his own books including *Birds of the Estuary*, Penguin, 1952, and *Shorelands Summer Diary*, Collins 1952; *A Country Artist. Charles Tunnicliffe*, Ian Niall, Gollancz, 1980; 'Charles Tunnicliffe ARA', Sidney Rogerson, *Studio*, Vol.129, 1945, p.155. CF

TURNBULL, William (b. 1922). Abstract painter in oils and acrylic and sculptor in a variety of media. Born in Dundee, he worked as an illustrator before attending the SLADE SCHOOL 1946–8. He lived in Paris from 1948 to 1950, meeting Giacometti and Brancusi, and he has travelled extensively since, making his first trip to America in 1957. He held his first solo exhibitions at the HANOVER GALLERY, showing sculpture in 1950 and painting in 1952. Thereafter he exhibited at London galleries (including the WADDINGTON from 1967), and abroad. His work appeared in the Venice Biennale of 1952 and 1957 and the Carnegie International, Pittsburgh, of 1958 and 1961. The many public collections holding his work include the TATE GALLERY and the Hirshhorn Museum, Washington. He was a founder member of the INDEPENDENT GROUP at the ICA. From 1952 to 1961 he was instructor in experimental design, and from 1964 to 1972 instructor in sculpture at the CENTRAL SCHOOL OF ART. He is married to the sculptor Kim Lim. In earlier sculpture he worked with pieces made up of repeating units, whilst recent work has been of simple, symbolic bronze shapes reminiscent of ancient art. In 1957 his painting was influenced by Rothko and Still and thereafter his work was concerned with colour fields, painted in a lively technique with thin applications of pigment. All his work is characterized by the economy and integrity of the image.
LIT: Retrospective exhibition catalogue, Tate Gallery, 1973; article in *Studio International* (London), July/August, 1973. CF

TURNER DURRANT, Roy, NDD, FRSA, FFPS, NEAC (b. 1925). Painter of abstracts and semi-figurative work in oils, gouache and watercolours; poet. He served with the Suffolk Regiment 1944–7 and then studied at CAMBERWELL SCHOOL OF ART 1948–52. He has held many solo exhibitions in London and the provinces and he shows in London at the Belgrave Gallery. He has exhibited at the RA, the LG, and the NEAC (member 1985) and he is a

member of the Cambridge Society of Painters and of the AIA. His work is represented in public collections including the IMPERIAL WAR MUSEUM. In the 1940s and 1950s he was influenced by English neo-romanticism whilst his later work included more abstract painting as well as semi-figurative studies.

LIT: Catalogue for the Belgrave Gallery, 1991.
CF

The Turner Prize. An annual cash prize competition organized by The Patrons of New Art, and usually sponsored by TV Channel 4; nominations are invited from the public, and four British artists under the age of 50 are chosen by a selection panel in April for a finalists' exhibition at the TATE GALLERY.
AW

TYRWHITT, Ursula (1878–1966). She studied at the SLADE 1893–4, becoming friendly with GWEN JOHN. She moved with her to Paris to work at the Atelier Colarossi, and also studied in Rome, at the BRITISH SCHOOL, before returning to the Slade, 1911–12. A member of the NEAC she painted interiors, still-life and flower compositions.
AW

TYSON, Ian (b. 1933). Painter, printmaker and sculptor. He attended Birkenhead School of Art and the RA SCHOOLS and held his first solo at the Ashgate Gallery, Farnham, in 1961. He has exhibited in London galleries, including the CURWEN, and abroad, and his work is represented in the TATE GALLERY. His awards include a Welsh Arts Council Prize in 1964, and from 1979 to 1980 he held the Brinkley Fellowship, Norwich School of Art. In 1970 he founded the Tetrad Press and his artist's books include *Seal of Approval/Ian Tyson*, Tower Block Books, London, 1989. His work combines formal and informal elements and reflects his interest in structure, text and music.

LIT: Interview, *Art Monthly* (UK), No.22, December 1988 – January 1989, pp.36–8. CF

TYZACK, Michael (b.1933). Painter of abstracts in acrylic. He studied at Sheffield College of Art 1950–2, and the SLADE 1952–6, winning a French Government Scholarship in 1956–7. In 1971 he settled in the USA. His first solo exhibition was at the Axiom Gallery, in 1966, where he subsequently showed in 1968 and 1970, and he has exhibited internationally, including at the Frances Aronson Gallery, Atlanta, USA, in 1978. His work is represented in the TATE GALLERY. A

prizewinner at the JOHN MOORES in 1965 and the recipient of a Welsh Arts Council Commission Award in 1969, he was Visiting Artist at the University of Iowa in 1971 and was appointed Professor of Fine Art, College of Charleston, Iowa, in 1976. His painting has used hard-edged geometric shapes on shaped canvases, abstract rippling shapes and the combination of hard-edged geometric forms with freer areas of vibrant colour.

LIT: *Perceptions*, Indianapolis Museum of Art, Vol.3, 1983–1984, pp.32–9. CF

U

UGLOW, Euan, LG (b. 1932). Painter of nudes, landscapes, still-life and figures in oils. He trained at CAMBERWELL SCHOOL OF ART 1948–51, winning a State Scholarship to the SLADE SCHOOL in 1951. In 1952 he was awarded a Spanish State Scholarship to work in Segovia and in 1953 the PRIX DE ROME, working in France, Holland and Belgium, as well as in Italy. In 1954 he continued at the Slade as a postgraduate and later travelled widely: to Morocco in 1963, Turkey in 1968, Italy in 1972–4 and 1976, India in 1984 and Cyprus in 1985. In 1987 he was invited to teach at the Hangzhou Fine Art Academy in China. He first exhibited with the LG in 1951 (becoming a member in 1960), and his first solo exhibition was in 1961 at the BEAUX ARTS GALLERY. He has since exhibited at London galleries, most recently at BROWSE AND DARBY, and retrospective exhibitions have been held at the Whitechapel Gallery in 1974 and 1989. His work has been represented in many group exhibitions and in public collections including the TATE GALLERY. He has taught at the Slade School and Camberwell School of Art since 1961. His awards include the Edwin Austin Premier Scholarship in 1970, and first prize in Painting, JOHN MOORES LIVERPOOL EXHIBITION, in 1972. His slowly achieved paintings are grounded in the EUSTON ROAD SCHOOL tradition of observing and recording reality. He paints by a process of analysis and constant referral to the subject and its daily changes, using measuring marks as a checking system (e.g. *Zagi*, 1981–2). All his work shares an intensity of perception and more recent paintings reveal his interest in compositional geometry, the growing role of colour and careful attention given to the surface.

LIT: Retrospective exhibition catalogues, Whitechapel Art Gallery, 1974 and 1989. CF

UHLMAN, Fred, LG, RBA (b. 1901). Painter of landscapes, townscapes and marines in oils. Born in Stuttgart, he studied law and from 1927 to 1933 practised as a lawyer. In 1933 he was a refugee in Paris and he taught himself to paint. Recognized by the critic Wertheim he held solo exhibitions in Paris in 1936, 1937 and 1938, and showed at the Salon d'Automne and the Salon des Indépendants. He settled in England where his work was admired by WYNDHAM LEWIS and exhibited at leading London galleries including the ZWEMMER, REDFERN, LEFEVRE and BROWSE AND DELBANCO, as well as in the provinces. His work is represented in public collections in Britain and abroad. He was elected LG in 1943 and was a member of the Royal Academy of Wales. His delicately handled paintings combine naiveté with an accomplished technique and intensity of imagery, characteristics which reflect his own admiration for such diverse artists as Caspar David Friedrich and Renoir.
LIT: See his own publications including his autobiography *The Making of an Englishman*, Gollancz, 1960; *Captivity. Twenty-four Drawings by Fred Uhlman*, R. Mortimer, London, 1946. CF

UNDERHILL, Tony (1923–1978). Painter of figures and landscapes in oils. Born in Sydney, Australia, he studied with William Dobell and moved to London in 1948, often, however, working abroad. He exhibited in Australia from 1947 and from 1948 in Europe, showing at leading London galleries and internationally. His work is represented in public collections here and abroad. He was Head of post-graduate painting at Birmingham Polytechnic. His bold technique modelled forms in broadly brushed, vibrant marks which moved figuration towards the abstract. CF

UNDERWOOD, Keith Alfred (b. 1934). Realist painter in oils and watercolours; sculptor and restorer. He studied art at Newport College of Art 1953–9, under Tom Rathmell and Hubert Dalwood, and at the West of England College of Art 1960–1. From 1957 to 1958 he was awarded a Leverhulme Research Award to work in France. He has exhibited at the Mall Galleries, with the Welsh Arts Council, in Chepstow and in a number of group exhibitions in this country and abroad, including British 'Art for Moscow'. His work is represented in public and private collections. His wide-ranging interests are centred on the town and community of Chepstow. CF

UNDERWOOD, George Claude Leon (1890–1975). Sculptor; painter in oils and watercolours; wood engraver and etcher; writer and illustrator. He studied at Regent Street Polytechnic 1907–10, at the RCA 1910–13, and at the SLADE 1919–20. He travelled extensively and was particularly influenced by visits to Altamira, 1925, Mexico, 1928, and West Africa, 1945. He held his first solo at the CHENIL GALLERY in 1921, and exhibited regularly in London galleries and at the NEAC. A founder member of the SEVEN AND FIVE SOCIETY, his work is represented in the TATE GALLERY. From 1921 to 1938 he taught at his own school, the Brook Green School, and in 1931 he founded the magazine *The Island*. His painting was influenced by primitive art and it reflects his belief in figuration, spiritual content, direct expression and a modernistic style.
LIT: *Art for Heaven's Sake*, Leon Underwood, Faber & Faber, 1934; *Leon Underwood*, Christopher Neve, Thames & Hudson, London, 1974. CF

Unit One. Eleven individuals formed Unit One in 1933. They were ARMSTRONG, MOORE, HEPWORTH, Bigge, BURRA, HILLIER, NASH, NICHOLSON, WADSWORTH, and the architects Wells Coates and Colin Lucas. For their one travelling exhibition, Herbert READ wrote the Introduction to a book *Unit One*, 1934, setting out the aims of the group to be the expression of a 'truly contemporary spirit' motivated by 'a new awareness of the real purpose or function of the arts'. It was in part an attempt to unite SURREALIST and abstract tendencies.
LIT: *Unit One*, exhibition catalogue, Portsmouth Museum, 1978. AW

UNWIN, Francis Sydney, NEAC (1885–1925). Draughtsman, lithographer and etcher. He attended Winchester School of Art, then the SLADE 1902–5. He travelled widely in Europe and the Near East; the consumption, of which he died, took him to Switzerland for convalescence, where he was inspired to make the Maloja Set of mountain scenes. AW

URQUHART, Murray McNeel Caird, RBA, MA (1880–1972). Painter of landscapes, portraits, figures and animals in oils and watercolours;

muralist. He studied at EDINBURGH SCHOOL OF ART, the SLADE SCHOOL, WESTMINSTER SCHOOL OF ART with SICKERT; at Frank Calderon's Animal School and at the ACADÉMIE JULIAN, Paris, under J.P. Laurens. He exhibited widely, mainly at the RBA (member 1914), the RA, and the LEFEVRE and Walker's Galleries. His painting style was impressionistic both in figures and landscapes and his watercolours used thin washes of colour over pencil drawing. CF

V

VALETTE, Adolphe (1876–1942). Painter of townscapes, portraits, landscapes and still-life in oils and watercolours. Born in St Etienne, he studied at art schools in St Etienne and Bordeaux before winning a travelling scholarship. In 1904 he attended a painting course at Birkbeck Institute, London, and by 1905 settled in Manchester, making regular visits back to France. He exhibited first in Liverpool in 1909 and 1910, and in Manchester as a founder member of the Society of Modern Artists from 1912. He continued to exhibit with the society until 1928 when he returned to France. He held solo exhibitions at Finnigan's Showrooms, Manchester, in 1918 and 1920, showed in London galleries and in France. His work is included in public collections, particularly the Manchester City Art Gallery. From 1906 to 1920 he taught at MANCHESTER SCHOOL OF ART, where pupils included L.S. LOWRY. He portrayed scenes of the industrial city, studying its subtle light and atmospheric effects in vertical strokes of colour, as well as more lyrical landscapes. His work was influenced by the Impressionists, Degas and Forain.
LIT: Retrospective exhibition catalogue, Manchester City Art Gallery, 1976. CF

VAUGHAN, John Keith, CBE (1912–1977). Painter of figures and landscapes in oils and gouache. Born in Sussex, he was self-taught as an artist and from 1931 to 1938 worked for the advertising agency Lintas, painting in his spare time. During the war his work was bought by the WAAC and he met, and was influenced by, SUTHERLAND, as well as MINTON, CRAXTON and COLQUHOUN. In 1946 he shared a house with Minton who introduced him to Duncan Macdonald at LEFEVRE Gallery and to William Johnstone. He travelled extensively throughout his life. His first solo exhibition was at the REID & LEFEVRE GALLERY in 1944, where he continued to exhibit until 1952, thereafter showing at leading London galleries, in the provinces and abroad. Retrospective exhibitions include those at the Whitechapel in 1962, and the University of York in 1970. He was represented in many group exhibitions and is in many public collections including the TATE GALLERY. He taught at CAMBERWELL, 1946–8, the CENTRAL SCHOOL, 1948–57, and the SLADE SCHOOL from 1959. In 1959 he was Resident Painter, State University of Iowa. He served on the ARTS COUNCIL Advisory Panel, became an Honorary Fellow of the RCA in 1964, and CBE in 1965. Commissions include murals for the Festival of Britain, 1951, and a series of lithographs for *Une Saison en Enfer*. The main subject of his work was the male nude in landscape. Early influences were those of Cézanne and the English neo-romantics. Later work achieved an integration of figurative subject and liberated colour and form, reflecting his admiration for de Staël and Matisse.
LIT: *Journals and Drawings 1939–65*, John Keith Vaughan, London, 1966; *Keith Vaughan*, Malcolm Yorke, Constable, 1990. CF

VAUGHAN, Michael (b. 1938). Painter of abstracts in a variety of media. He studied at Bradford College of Art 1956–60, at the RA SCHOOLS 1960–3, and was awarded a Painting Fellowship at MANCHESTER COLLEGE OF ART 1963–4. He has exhibited in London and abroad and is represented in public collections including the ARTS COUNCIL. He has taught at Manchester and Hornsey colleges of art. His work uses clearly articulated simple shapes which imply space and perspective.
LIT: Article in *Ambit*, No.84, 1980. CF

VAUX, Marc (b. 1932). Painter of abstracts in acrylic, and of relief paintings. He trained at Swindon School of Art and the SLADE SCHOOL. He first exhibited in 1963 at the Grabowski Gallery, London, and has subsequently exhibited widely in London galleries, in the provinces, abroad and in group exhibitions. His work is represented in public collections including the TATE GALLERY. He has taught at BATH ACADEMY OF ART and Hornsey College of Art, 1962–72, and at the CENTRAL SCHOOL OF ART, 1973–89. His economical, ordered work is concerned with the effect of light on colour.
LIT: *Marc Vaux: From Pigment to Light*, CICA, New York, 1990. CF

VELLACOTT, Elizabeth (b. 1905). Painter of figures, landscapes and portraits in oils on wooden panels; theatrical designer. She trained at the RCA and worked as a textile designer from 1929. She held her first solo exhibition at the Minories, Colchester, in 1968, and subsequently exhibited at the NEW ART CENTRE. Her work is represented in some public collections and she was a founder member of the Cambridge Society of Painters and Sculptors. Her clearly coloured, delicate works are slowly achieved by small strokes of paint and influenced by decorative art.
LIT: Catalogue, Kettle's Yard, Cambridge, 1981.
CF

VERNEY, Sir John, RBA (b. 1913). Painter in oils and watercolours; draughtsman, illustrator, furniture decorator and writer. He studied at the RUSKIN SCHOOL OF ART, the AA and at CHELSEA POLYTECHNIC and documented his war service in the autobiographical books Going to the Wars and A Dinner of Herbs (both published by Collins). He settled in Farnham, Surrey, in 1945 where he was the founder of the Farnham Trust and exhibited at the Ashgate Gallery from 1962. He has also shown in London galleries including the REDFERN and LEICESTER and regularly at the LG. His book illustrations, mainly in pen and ink, share some stylistic characteristics with EDWARD ARDIZZONE'S work, and his painting ranges from topographical subjects to abstracts.
LIT: Looking Back on Farnham, Ashgate Gallery, Farnham, 1974.
CF

VERPILLEUX, Emile Antoine, RBA (1888–1964). Born in London of Belgian parents, he was a painter, engraver and illustrator. He studied in England, France, Belgium and Holland; his powerful and strongly coloured woodcuts were primarily of architectural subjects (York, 1920 for example) although he also made portraits and landscapes.
AW

VEZELAY, Paule, LG, SIAD (1892–1984). Painter of abstracts in oils; sculptor; collagist and textile designer. Born Marjorie Watson-Williams, she studied at Bristol School of Art 1909–12, the SLADE, the London School of Art under George Belcher and John Hassell and at CHELSEA POLYTECHNIC 1912–14. She visited Paris in 1920 where she held her first solo exhibition, and in 1926 she settled in Paris, changing her name to Paule Vézelay. Closely associated with the School of Paris, she lived with André Masson from 1929 to 1932 and established a long friendship with Jean Arp and Sophie Tauber-Arp. In 1934 she joined the Abstraction-Création Group and in 1935 created her first Lines in Space, exhibited in Paris in 1937. From 1939 she lived in England and was a member of the AIA from 1944 to 1947. In 1953 she became a member of Group Espace and in 1954 she organized a British branch. She exhibited regularly in London and Paris and in 1983 a retrospective was held at the TATE GALLERY. Represented in collections including the Tate Gallery, her pioneering abstraction was characterized by its simplicity of form, balance and purity.
LIT: Retrospective exhibition catalogue, Tate Gallery, London, 1983; Paule Vézelay. Master of Line, catalogue, England & Co., London, 1988.
CF

VIRTUE, John (b. 1947). Born in Accrington, Lancashire, he studied at the SLADE 1965–9, and was influenced by FRANK AUERBACH. Working as a postman in and around Green Haworth, a Pennine village, he made hundreds of drawings on his rounds, which he mounted in boards to form a mosaic of powerful impressions of the landscape. His first one-man exhibition was at the Lisson Gallery in 1985, but he has won national prizes and awards since the 1960s. His work is in major public collections including the V & A Museum.
LIT: John Virtue: Green Haworth, 1978–1988, exhibition catalogue, Introduction by Richard Cork, Lisson Gallery, 1988.
AW

Vorticism, Vorticists (1914–1915). A dynamic movement towards modernism which grew out of Wyndham-Lewis's short-lived REBEL ARTS CENTRE founded after a rift with ROGER FRY and OMEGA in Spring 1914. The term Vorticism was coined by the poet Ezra Pound early in 1914 to describe a whirling force of and for new ideas. In June 1914 Lewis edited a blatant, satirical and typographically innovative publication, Blast, which launched the movement with manifestos and illustrations and wittily attacked the British Establishment. Lewis described the Great English Vortex as the 'great silent place' at the heart of a whirlpool. Among the signatories of this document were the sculptor GAUDIER-BRZESKA, WILLIAM ROBERTS and Lewis's greatest ally, WADSWORTH. A second issue of Blast appeared in 1915 and the first and only Vorticist Exhibition in which ETCHELLS, NEVINSON and BOMBERG participated, was at the Doré Galleries in June 1915. Epstein was also associated with the group but

did not sign the manifesto or exhibit. Expressionism, Cubism and Futurism were all contributing inspirations to Vorticism. However, Lewis sought a unique synthesis of Futurist dynamism and Cubist static monumentality to form a distinct and radical faction in British art, celebrating and reflecting the rigours of the machine and a love of order as opposed to the flux of nature. These principles were upheld in the philosophy of T.E. Hulme and visually in paintings such as Lewis's *The Crowd*, 1914–15 (TATE), which uses angular, aggressive shapes rigidly controlled by sharp contours and strident colours. Vorticism's development was curtailed by the outbreak of the First World War.

LIT: *Vorticism and Abstract Art in the First Machine Age*, Richard Cork, 2 vols, Gordon Fraser, London, 1976; *Vorticism and Its Allies*, Arts Council exhibition catalogue, Hayward Gallery, 1974. DE

VULLIAMY, Edward (1876–1962). Painter of landscapes in watercolours. He read Classics and Modern Languages at King's College, Cambridge, where he later lectured. He painted in his spare time and exhibited at Walker's Gallery, London, the NEAC and other London galleries. He was Honorary Keeper of Pictures at the Fitzwilliam Museum, Cambridge. His controlled watercolours have clearly drawn forms and show a realistic spatial organization, e.g. *Lock at Upwear* (Bradford Art Gallery). CF

W

WAAC, see OFFICIAL WAR ARTISTS

WADE, Arthur Edward (b. 1895). Painter in oils and watercolours who exhibited at the RCA, with the South Wales Art Society and the Swansea and Newport Art Society. His work is represented in the National Museum of Wales and the Newport Museum and Art Gallery. He lived in Cardiff and from 1947 was Chairman of the South Wales Art Society. CF

Waddington Gallery. Founded in Cork Street in 1966 by Leslie Waddington, it specializes in classic modern art, and has represented such artists as PETER BLAKE, PATRICK CAULFIELD, PATRICK HERON and ALLEN JONES. Waddington Graphics publishes limited edition prints by contemporary artists, and Theo Waddington, brother of Leslie,

opened his own gallery in 1993, specializing in modern British and foreign artists. AW

WADSWORTH, Edward Alexander, ARA, NEAC, LG (1889–1949). Painter of marines, marine still-life, landscapes and abstracts in tempera; draughtsman, muralist and wood engraver. He studied machine draughtsmanship in Munich before attending Bradford Art School and the SLADE SCHOOL 1909–12, where contemporaries included GERTLER, ALLINSON and NEVINSON. From 1921 he made regular visits to France and in 1923 travelled in Italy. He exhibited first with the NEAC in 1911, becoming a member in 1921, and the FRIDAY CLUB, 1912–13. In 1913 his work appeared in the second Post-Impressionist Exhibition and he joined the OMEGA WORKSHOPS. When Wyndham-Lewis broke from the Omega, Wadsworth followed him and subsequently showed in the Post-Impressionist and Futurist Exhibition, Doré Galleries. In 1914 he was a founder member of the LG, exhibited with the AAA, joined the REBEL ART CENTRE and signed the VORTICIST Manifesto. He exhibited with the Vorticists in 1915 and held his first solo exhibition of drawings and woodcuts in 1919 at the Adelphi Gallery. In 1920 he exhibited with GROUP X, in 1932 became a member of Abstraction-Création and in 1933 joined UNIT ONE. He exhibited widely and his work is represented in public collections including the TATE GALLERY. He was elected ARA in 1944. From 1917 to 1918 he worked on dazzle camouflage for battleships. His early paintings were structured and cubistic, influenced by Cézanne, whilst his Vorticist work often used woodcuts to express an intricate and angular imagery. After the war he turned to more representational work in tempera, including north country landscapes, harbour scenes and marine still-life, which reflected the influence of de Chirico and Picasso in their surrealistic atmosphere. His work moved through periods of abstraction and representation but was always concerned with clarity and structure.

LIT: Exhibition catalogue, Camden Arts Centre, 1990; memorial exhibition catalogue, Tate Gallery, 1951; *Edward Wadsworth. A Painter's Life*, Barbara Wadsworth, Michael Russell Publishing Ltd, 1989; *A Genius of Industrial England; Edward Wadsworth 1889–1949*, Jeremy Lewison (ed.), The Arkwright Arts Trust, 1990. CF

WAIN, Louis William (1860–1939). Painter and illustrator of cats in watercolours, pen and ink

and pencil. He trained at the West London School of Art 1877–80, where he taught as an assistant master, 1881–2. His cat drawings were first published in 1884 by *Illustrated London News* and they brought him wide recognition. In 1901 the first *Louis Wain Annual* appeared and was published regularly until 1913. In 1902 he started his association with the publisher Raphael Tuck and in 1907–10 he worked in New York producing two strip cartoons. He also worked in animated film. Initially realistic, in the 1890s he developed scenes showing humanized cats. His stylized but observant work, influenced by Phil May and Randolph Caldecott, used clear forms and strong colour. During a period of mental illness, his images of cats were transformed into remarkable crystalline patterns.
LIT: *Louis Wain's Cats*, Michael Parkin, Thames and Hudson, 1983; exhibition catalogue, Chris Beetles Ltd, 1989. CF

WAINWRIGHT, Albert (1898–1943). A painter, illustrator and stage designer, who was at school with HENRY MOORE and studied at Leeds College of Art 1914–17. He was art master at Bridlington School at the time of his death. AW

WAKEFIELD, Larry (b. 1925). Painter of abstracts and figurative subjects in acrylic and oils. He trained at Cheltenham College of Art, the Royal West of England Academy, Bristol, and Manchester University and he has exhibited widely since 1965 in London and provincial galleries (including Southampton Art Gallery in 1979, and the Colin Jellicoe Gallery, Manchester), as well as abroad. His work is represented in collections including Southampton Art Gallery. His painting combines the geometric with the organic, shares characteristics with that of Dine and Rivers, and uses airbrush and paint.
LIT: *Art Line International*, Vol.3, No.1, 1986. CF

WAKEFORD, Edward Felix, ARA, RBA (1914–1973). Painter of townscapes, landscapes, figures and a wide range of subjects in oils. He attended CHELSEA SCHOOL OF ART and the RCA and exhibited in London galleries and group exhibitions, including the JOHN MOORES 1964 and 1966. He was elected ARA in 1968 and is represented in public collections including the TATE GALLERY. He taught at Chelsea, 1946–64, and the West of England College of Art, 1964–6. His strong, expressive and economical style

approached each subject with freshness and simplicity of vision.
LIT: *A Prize for Art*, autobiography, Macmillan, 1961. CF

WALCOT, William, RBA, RE (1874–1943). Architect, etcher and watercolourist of architectural subjects. Born in Odessa of an English father and a Russian mother, he travelled widely as a child, then studied architecture in St Petersburg and Paris before practising architecture for five years in Moscow. In London he was sponsored by the FINE ART SOCIETY to visit Venice and Rome; the resulting work was exhibited in the gallery in 1909. His drypoints represented scenes in contemporary cities and imaginary ones set in classical antiquity. AW

WALES, Geoffrey, RE, SWE (1912–1990). A wood engraver, he studied at Thanet and the RCA. His compositions combined an admiration for the tradition of Blake and Palmer with a wholly modern sense of design and pattern. Some abstracts derive their textures and patterns from natural forms. AW

WALKER, Dame Ethel, ARA, RBA, RP, NEAC, SMP, SWA, LG, CBE (1861–1951). Painter of portraits, figures, still-life and landscapes in oils; draughtsman and sculptor. Born in Edinburgh, she studied at the Ridley School of Art, Putney School of Art, WESTMINSTER SCHOOL OF ART and the SLADE SCHOOL under Professor BROWN. In London she also attended evening classes with SICKERT. She exhibited at the RA and the NEAC from 1898, becoming ARA in 1940 and NEAC in 1900, later becoming an Honorary Life Member of the NEAC and serving on the selecting committee until 1947. She also exhibited at the RBA and RP and her work is represented in many public collections including the TATE GALLERY. A member of the Society of Mural Painters, her commissions included decorative works. She was awarded a CBE in 1938 and DBE in 1943. Her early work of interiors showed the influence of Brown in its sombre tones, and as a student she was also influenced by STEER, Velazquez and Manet. Best known for her portraits, from 1900 her painting reflected the influence of the Impressionists in its vitality of touch and colour both in the portraiture and in landscapes and seascapes (many painted near Robin Hood's Bay). In later more decorative works she evoked the vision of a golden age, uniting landscape and figures in a graceful, rhythmic style that was

founded on her sure draughtsmanship and sense of line, e.g. *Nausicaa*, 1920 (Tate Gallery). LIT: Memorial exhibition catalogue, Arts Council, 1952. CF

WALKER, John (b. 1939). Painter of abstracts in oils; printmaker. He studied at Birmingham College of Art 1955–60, and at the Académie de la Grande Chaumière, Paris, 1961–3. He has worked in London, New York and Melbourne, Australia. His first solo exhibition was at the Axiom Gallery in 1967, and he has since exhibited with Nigel Greenwood and regularly abroad. His work has appeared in many national and international group exhibitions; it was included in the Paris and Venice Biennales in 1969 and 1972, and it is in many public collections including the TATE GALLERY, the Guggenheim Museum, New York, and the National Gallery of Art, Washington. He has taught widely in Britain, America and Australia and his numerous awards include first prize, JOHN MOORES in 1976, and a Guggenheim Fellowship in 1981. His work investigates the nature of non-representational art, the illusion of space within an abstract idiom and the isolation of particular shapes. His paintings are strong physical presences and often produced in series with densely worked surfaces and expressive brushmarks.
LIT: Exhibition catalogues for the Hayward Gallery, London, 1985, and the Phillips Collections, Washington, 1982. CF

WALKER, Richard, ATD, NDD, UA, SGFA (b. 1925). Painter of portraits, landscapes and imaginative subjects in oils and a wide range of media; printmaker and illustrator. He trained at Croydon School of Art, the SLADE SCHOOL and the University of London; he has held solo exhibitions, has shown with the RP, RBA and ROI, and has exhibited in Paris and Germany. He is represented in collections including the Museum of London. His wide-ranging work seeks an expressive and individualistic response to his subject. CF

WALLACE, Harold Frank, BA, FZS, FRGS (1881–1962). Painter of sporting subjects and landscapes in watercolours; black and white artist. He was educated at Eton and Christchurch, Oxford, and exhibited at the RSW, RI and the Sporting and Greatorex galleries.
LIT: His own publications including *The Big Game of Central and Western China*, 1913, and *Hunting Winds*, 1949. CF

WALLACE, Robin, RA, RBA, ARBC (b. 1897). Painter of landscapes and marines in oils and watercolours; etcher. He studied at the BYAM SHAW AND VICAT COLE School of Art and exhibited widely in London, mainly showing at Barbizon House from 1930. He also exhibited at the RA and in the provinces. A member of the Lake Artists Society, many of his works show the district near Morecambe Bay in a clear but painterly technique based on nineteenth-century landscape tradition. CF

WALLINGER, Mark (b. 1959). A painter, sculptor, photographer and installation artist. He studied at CHELSEA and GOLDSMITHS' and he was included in the 'New Contemporaries' exhibition at the ICA in 1981. *Capital* (1990), a series of portraits of artists posing as homeless people standing before the doors of banking houses, deliberately subverted portraits of the wealthy. His criticism of contemporary life is expressed in *Race, Class, Sex* (1992) for example; he portrayed four racehorses in an utterly conventional style, to draw attention to racing, betting and breeding as supreme models of capitalist behaviour. An ironic act in the spirit of Marcel Duchamp was to buy a racehorse and designate it *A Real Work of Art* (1993). AW

WALLIS, Alfred (1855–1942). A self-taught artist who was born in Devonport, and who spent twenty-five years as a fisherman before he became a second-hand dealer and ice-cream seller in St Ives between 1890 and 1912. He began to paint when he was seventy years old, and in 1928 his work attracted the attention of CHRISTOPHER WOOD and BEN NICHOLSON, who modified their approach to colour and composition in the spirit of his painting. His pictures of boats, harbours and seascapes are assured in their control of warm, earthy colours and cool, fresh greys and blues; he applied his paint with a lively feeling for texture to small pieces of material, often oddly shaped fragments of board and cardboard. He composed houses and shipping on these surfaces with an uninhibited disregard of conventional perspective.
LIT: *Alfred Wallis, Primitive*, Sven Berlin, Nicholson & Watson, 1949; *Alfred Wallis: Cornish Primitive Painter*, Macdonald, 1967. AW

WALTERS, Evan (1893–1951). Born in Mynyddbach, West Glamorgan, he studied at Swansea College of Art 1910–13, and spent three years in the USA (1916–19). After exhibiting

work at the Glynn Vivian Gallery in Swansea, he moved to London, holding his first London one-man show at the Warren Gallery in 1927. He returned to live in Llangyfelach, his childhood village, in 1939, and remained there for the rest of his life. His early work, sombre and vigorously painted portraits and scenes of the mining world (*A Welsh Miner*, 1926–30) changed as he developed an approach based on the effect of double vision, a subject on which he published theoretical articles in *The Artist* in 1940. His later work was more highly coloured, for example *Cockle Woman* of 1935, which is painted in horizontal brushstrokes, and which has duplicated images beyond the centre of focus on the woman's face. He left over 400 canvases to the Glynn Vivian Art Gallery and Museum, Swansea.
AW

WALTON, Allan (1892–1948). A painter and designer, he studied at the SLADE, at the Académie de la Grande Chaumière in Paris, and at the WESTMINSTER SCHOOL OF ART where he came under the influence of SICKERT. His first one-man show was at Tooth's Gallery in 1933. His urban and landscape views are painterly and strong in colour.
AW

WALTON, Edward Arthur, RSA, PRSW, RP, NPS, HRWS, HRI, NEAC (1860–1922). Painter of landscapes, figures and portraits in oils, watercolours and pastels. He studied in Düsseldorf 1876–7, and at the GLASGOW SCHOOL OF ART. A friend of CRAWHALL and GUTHRIE, he painted with them at Roseneath and Brig O'Turk and with Guthrie at Cockburnspath. From 1894 to 1904 he lived in London where he knew Whistler. In 1904 he settled in Edinburgh. He exhibited at the NEAC from 1887 to 1893, at the RA from 1883 to 1922, at the GI, RSA (ARSA 1889, RSA 1905), the RSW (PRSW 1915–22) and with other members of the Glasgow School at the GROSVENOR GALLERY, London, and abroad. He is represented in collections including Glasgow Art Gallery. His early rural subjects were influenced by Bastien-Lepage but his later painting concentrated more on figures and portraits and reflected the influence of Whistler.
LIT: *E.A. Walton 1860–1922*, catalogue, Bourne Fine Art, Edinburgh, 1981; *The Glasgow Boys*, Roger Billcliffe, John Murray, 1985. CF

WARBURTON, Joan (1920–1996). A painter, best known for studies of flowers and plants. After visiting the studio of Oswald Poreau when at

Finishing School in Belgium, she attended the East Anglian School at Dedham 1937–40, and exhibited regularly after war service in the WRNS at the RA, the LEICESTER GALLERIES and the WOMEN'S INTERNATIONAL. She cited CEDRIC MORRIS, ARTHUR LETT-HAINES and ALLAN WALTON as the strongest influences on her development. From 1975 she exhibited at the Michael Parkin Gallery and then at Sally Hunter Fine Art. AW

WARD, John Stanton, RA, RWS, VPRP, NEAC, ARCA, CBE (b. 1917). Painter of portraits and a wide range of subjects in watercolours, oils and pen and ink; draughtsman and illustrator. After attending Hereford Art School he gained a scholarship to the RCA in 1936 where his teachers included GILBERT SPENCER, BARNETT FREEDMAN and PERCY HORTON. He completed his training after the war, winning a travelling scholarship and then working on *Vogue*, where he formed a friendship with Norman Parkinson. He has travelled widely and he held his first solo exhibition at Wildenstein's in 1954, subsequently exhibiting at leading London galleries and regularly at the Maas Gallery. He was elected ARA in 1956 and RA in 1965, his work is represented in many public and private collections and his commissions include work for members of the Royal Family. A member of the Executive Committee of the National Art-Collections Fund, he was awarded a CBE in 1985. His elegant, fluent style is based on his accomplished draughtsmanship.
LIT: Retrospective exhibition catalogue, Canterbury Museum and Art Gallery, 1987; article in *The Artist*, January, 1988. CF

WARDEN, William, RBA, LAA (b. 1908). Painter of landscapes in oils and watercolours, draughtsman. He studied at Liverpool School of Art 1924–30, under GEORGE MARPLES and W.C. PENN, and in Sussex under GEORGE GRAHAM. He exhibited at the RA from 1940 to 1978, and at the NEAC, RBA (member 1963), in Liverpool and the provinces. A member of Liverpool Academy of Arts in 1936 and the Society of Sussex Painters in 1938, his work is represented in some public collections including the IMPERIAL WAR MUSEUM. His landscapes depicted British and French subjects such as *Winter Light – Greenwich*, 1965, and *Snow at Liverpool Top Lock*, 1978, both exhibited at the RA. CF

WARDLE, Arthur, PS, RI, RBC (1864–1949). Painter of domestic and wild animals, birds, plants, figures and sporting scenes in oils, water-

colours and pastels. Having studied art privately, he exhibited at the RA from 1880 to 1938, held his first solo exhibition at the FINE ART SOCIETY in 1931 and showed widely in London, the provinces and Scotland. Elected PS in 1911 and RI in 1922, his painting *Fate* was purchased by the CHANTREY BEQUEST for the TATE GALLERY in 1904. He was particularly noted for his paintings of big cats, but his work ranged from studies of domestic pets to out-of-doors naturalistic scenes.
LIT: 'Mr Arthur Wardle's Paintings and Drawings of Animal Life', *Studio*, Vol.LII, p.196; 'Mr Arthur Wardle's Pastel Paintings', *Studio*, Vol.LXVIII, p.3. CF

WATERS, Billie (1896–1979). Painter of flowers, animals, birds, still-life, decorative panels and some abstract compositions in oils and tempera. She studied at the Harvey and Proctor School, Newlyn, 1926–30, at HEATHERLEY'S and under MACNAB at the GROSVENOR SCHOOL OF ART. She exhibited at the RA from 1928 to 1944, in London galleries (including the LEICESTER GALLERIES), in societies and clubs including the NEAC, SWA and ROI. Her subjects range from decorative animal studies such as *The Black and White Monkey*, 1935, to fine geometrical abstract compositions in oils and pencil. CF

WATSON, George Spencer, RA, ROI, RP (1869–1934). Painter of portraits, figures, nudes, imaginative subjects, riding subjects and landscapes. He trained at ST JOHN'S WOOD SCHOOL OF ART where he met RALPH PEACOCK and BYAM SHAW and at the RA SCHOOLS from 1889, winning a silver medal and the Landseer Scholarship. He exhibited at the RA from 1891 (RA 1932) and showed in many societies including the RP and ROI. He held his first solo exhibition in 1920 at the Hampstead Gallery, London, and showed in other London galleries, in Scotland and in the provinces. In 1935 his painting *A Lady in Black*, 1922, was bought by the CHANTREY BEQUEST for the TATE GALLERY. His work is varied in style; many of his precisely painted portraits were dramatically simple in presentation whilst some early subject pictures were influenced by Watts and reflect an interest in the decorative effect of patterned materials.
LIT: Exhibition catalogue, Dorset County Museum and Southampton Art Gallery, 1981/2. CF

WATSON, Harry, RWS, ROI, RWA (1871–1936). Painter of landscapes, figures and portraits in oils and watercolours. He trained at Scarborough School of Art 1884–8, and at the RCA where he won a travelling scholarship to Rome. He also attended Lambeth School of Art. He exhibited at the RA from 1896 to 1936, in London galleries including the Goupil Gallery; in societies, in the provinces and in Scotland. He was elected RWS in 1920, RWA in 1927 and ROI in 1932. In 1913 his painting *Across the River* was purchased by the CHANTREY BEQUEST for the TATE GALLERY. From 1913 he taught Life Drawing at Regent Street Polytechnic and his work, often depicting figures in landscape, was noted for its sureness of touch, fluency and freshness.
LIT: *Figure Drawing*, Harry Watson, 1930. CF

WATT, George Fiddes, RSA, RP (1873–1960). Painter of portraits in oils. Born in Aberdeen, he studied at Grays School of Art and at the RSA Schools, Edinburgh. He exhibited at the RSA (RSA 1924) and at the RA from 1906 to 1930. Elected RP in 1914, his portrait *The Artist's Mother*, 1910, was bought by the CHANTREY BEQUEST in 1930. Influenced by Robert Brough, his portraits included well-known figures such as *The Rt. Hon. H.H. Asquith, MP, Prime Minister*. CF

WEBB, Joseph, ARE (1908–1962). An etcher of architectural subjects, also a portrait painter and muralist, he studied at Chiswick School of Art and then at Hospitalfield, Arbroath. His first one-man show was at Colnaghi's in 1933. His real and imaginary medieval buildings are rendered with a visionary intensity of light and mood, as in *Shepherd's Haven*, 1929. AW

WEBB, Kenneth, NDD, ATD, ARWA, NS, ARUA (b. 1927). Painter of landscapes in oils, acrylic, gouache and wax emulsion. He studied at Gloucester College of Art 1948–52, and at University College, Swansea, from 1953. He held his first solo exhibition in Dublin where he has exhibited at the Ritchie Hendriks Gallery and he has shown in London and abroad. Elected FRSA in 1952, ARWA in 1956 and NS in 1962, his commissions include a mural at Bangor Abbey, 1960, and he is represented in the ARTS COUNCIL Collection. His landscapes use glazes of colour and wax emulsion to give a wide range of colour and texture. CF

WEIGHT, Carel Victor Morlais, RA, LG, RWA, RBA, CBE (1908–1997). Painter of portraits, figures and townscapes, often with religious or lit-

erary subjects. Born in London, he studied at Hammersmith School of Art 1926–9, where he met RUSKIN SPEAR, and at GOLDSMITHS' COLLEGE 1929–32, under GARDINER, MANSBRIDGE and BATEMAN. He formed a friendship with KOKOSCHKA and exhibited at the RA from 1931, becoming ARA in 1955, RA in 1965 and a Trustee from 1975 to 1984. He held his first solo exhibition in 1933 at the Cooling Gallery and subsequently exhibited in London galleries (including the ZWEMMER GALLERY and the NEW GRAFTON GALLERY), and in the provinces. Elected RBA in 1934, LG in 1950 and RWA in 1954, his work is represented in public collections including the TATE GALLERY and the V & A. Between 1945 and 1946 he was an OFFICIAL WAR ARTIST. He was Tutor, 1947–57, and then Professor, 1957–73, of Painting at the RCA where he was made Professor Emeritus in 1973 and a Senior Fellow in 1983. Awarded a CBE in 1962 and an Honorary Doctorate from Edinburgh University in 1982, his commissions included murals for the Festival of Britain in 1951, and for Manchester Cathedral in 1963 (*Christ and the People*). His paintings often presented an apparently realistic suburban setting in which unexpected human dramas were enacted. Subjects were depicted in strong colour, idiosyncratic perspective and small, open brushmarks, and the integration of figures, setting, light and atmosphere produced a strong emotional content, sometimes humorous, sometimes menacing. Influenced by Munch and sharing some characteristics with STANLEY SPENCER, the narrative content of his work arose from his interest in the abstract structure and the specific location of the painting.
LIT: Retrospective exhibition catalogue, RA, London, 1982; *Carel Weight*, Mervyn Levy, Weidenfeld & Nicolson, London, 1986; *Carel Weight*, R.V. Weight, David & Charles, 1994. CF

WEINBERGER, Harry (b. 1924). Painter of landscapes and figures in oils. Born in Berlin, he came to England in 1939 and studied at the CHELSEA SCHOOL OF ART and with MARTIN BLOCH. He has held solo exhibitions in London galleries including Walker's Gallery in 1953, Camden Arts Centre in 1976, and Duncan Campbell Fine Art in 1988. He taught at London, Reading and Manchester between 1952 and 1964 and from 1964 to 1983 was Principal Lecturer in Painting at Coventry Lanchester Polytechnic. His expressionist work, painted in flat areas of full colour, has been influenced by

Cubism, Van Gogh, Matisse and German Expressionism.
LIT: Catalogue, Herbert Art Gallery, Coventry, 1983; catalogue, Duncan Campbell Fine Art, London, 1988. CF

WELCH, Denton (1915–1948). Painter in oils, watercolours and pen and ink; writer. Born in Shanghai, he spent his childhood in China and England and in 1933 entered GOLDSMITHS' COLLEGE OF ART, but a serious accident in 1935 compelled him to lead an increasingly restricted life. He exhibited some work at the NEAC, the RBA and the REDFERN GALLERY and his published works included *Maiden Voyage*, 1943, and *In Youth is Pleasure*, 1945. His painting was imaginative and sometimes dream-like and his work ranged from self-portraiture to decorations and covers for his own publications.
LIT: *The Journals of Denton Welch*, ed. Michael De-La-Noy, Allison & Busby, London, 1984; *Denton Welch: The Making of a Writer*, Michael De-La-Noy, Viking, 1984. CF

WELLINGTON, Hubert Lindsay (1879–1967). Painter of landscapes, townscapes and figures in oils. After attending Gloucester and Birmingham Schools of Art he studied at the SLADE SCHOOL, where he met GORE, Wyndham-Lewis and Meynell, and in Paris. In 1906 he worked with Gore and SICKERT in Dieppe and he exhibited at the NEAC from 1916, at the LS and LG. His painting *The Big Barn, Frampton Mansell*, 1915, was purchased by the CHANTREY BEQUEST in 1961. He lectured at the National Gallery, 1919–23, taught at the RCA and the Slade, was Principal of EDINBURGH COLLEGE OF ART, 1932–42, and Examiner at the RUSKIN SCHOOL, 1949–59. Influenced by the CAMDEN TOWN painters, particularly Gore and GILMAN, his work used flat, high colour and formalized shapes.
LIT: Memorial exhibition catalogue, Gloucester Museum and Art Gallery, 1968. CF

WELLS, John (b. 1907). Painter of abstracts in oils and mixed media, and maker of relief constructions. After working as a doctor he moved to Newlyn, Cornwall, and devoted himself to painting in 1945. Co-founder of the CRYPT GROUP and the PENWITH SOCIETY, he worked with HEPWORTH from 1950 to 1951 and exhibited regularly in London, the provinces and abroad. Represented in the TATE GALLERY, his restrained geometric abstraction was influenced by Gabo, NICHOLSON and Hepworth.

LIT: *The Changing Forms of Art*, Patrick Heron, Routledge & Kegan Paul, 1955. CF

WEST, Joseph Walter, VPRWS, SMP (1860–1933). Painter of historical genre, subject pictures and landscapes in watercolours, oils and tempera; lithographer, designer of posters and book plates. Born in Hull, he studied at ST JOHN'S WOOD SCHOOL OF ART in 1883, at the RA SCHOOLS 1884–7, and at the ACADÉMIE JULIAN in Paris. He exhibited at the RA from 1885 to 1933 and at the RBSA, and he was elected RWS in 1904 and VPRWS from 1918 to 1920. His elegant historical genre pictures reveal his interest in incident and narrative content.
LIT: 'The Recent Work of Mr J. Walter West RWS', A.L. Baldry, *Studio*, Vol.XL, p.87. CF

The Westminster School of Art was founded in 1876 and located at the Royal Architectural Museum, 18 Tufton Street. The School was expanded in the 1890s when student numbers rose from about 140 to 450 and in 1903 it was taken over by the LCC and established with the LCC Technical Institute at Vincent Square. The School remained there until it was closed *c.*1939. The Art School's reputation was established by FREDERICK BROWN, who was Principal from 1877 to 1892 and who modelled the School on the French system, and by a series of distinguished teachers that included SICKERT, who taught there between 1908 and 1918, HAROLD GILMAN, NINA HAMNETT, BERNARD MENINSKY, ADRIAN ALLINSON and GERTRUDE HERMES. Later Principals of the School included W.M. Loudan (1904–18), WALTER BAYES (1918–34) and R. Kirkland Jamieson (*c.*1933–9). Many prominent artists were students at the School including Beardsley, ROBERT BEVAN, JOHN CRAXTON, TRISTRAM HILLIER and DAVID JONES. CF

WETHERED, Vernon, NEAC (1865–1952). Painter of landscapes in oils and watercolours. After studying Classics at Oriel College, Oxford, and the Law, he took up painting and on the advice of Clausen attended the SLADE SCHOOL under BROWN, STEER and TONKS, 1893–6, and studied in Italy. He held solo exhibitions in London at the GROSVENOR GALLERY in 1923, and the REDFERN GALLERY in 1928; he showed at the NEAC (member 1932) and exhibited at other London galleries and abroad. A founder member of the Oriental Ceramic Society, he was a collector of paintings, drawings and Chinese art. He sketched from nature and painted in the studio, producing poetic, impressionistic landscapes in the tradition of Turner and Constable.
LIT: Memorial exhibition catalogue, Walker Galleries, London, 1953. CF

WHEATLEY, Edith Grace, RWS, RBA, RP, RWA, NEAC, RMS (1888–1970). Painter of figures, birds, animals and flowers in oils and watercolours. She studied at the SLADE SCHOOL under TONKS and STEER, 1906–8, and at the ATELIER COLAROSSI, Paris. Married to JOHN WHEATLEY, she exhibited mainly at the NEAC (member 1921), at the RA between 1914 and 1964, and at the RMS (member 1913). She also showed at the LS, SWA, RI, in the provinces and in Scotland. Elected RWS in 1952 and RP in 1954, her work is represented in collections including Sheffield City Art Gallery. Between 1925 and 1937 she was Senior Lecturer in Fine Art at the University of Cape Town, returning to Sheffield in 1937. Her work ranged from bird studies to subjects such as *Forging Six-Pounder Shell Bodies, Kilnhurst Steel Works*, 1944, RA 1945, and paintings depicting South African scenes such as *Leopards, Rhodesia*, RA 1933. CF

WHEATLEY, John Laviers, ARA, RWS, NEAC, ARE (1892–1955). Painter of portraits and genre in oils, watercolours, tempera and ink; etcher and engraver. He studied under STANHOPE FORBES, SICKERT and at the SLADE SCHOOL 1912–13. He exhibited at the NEAC (member 1917), at the RA between 1914 and 1956 (ARA 1945), in London societies and galleries and in the provinces. Elected ARE in 1921 and RWS in 1947, his work is represented in collections including Manchester City Art Gallery. Married to EDITH WHEATLEY, he was an OFFICIAL WAR ARTIST in the First World War, working at ports and docks and producing portraits (IMPERIAL WAR MUSEUM). Director of the National Gallery of South Africa and Professor of Fine Art at the University of Cape Town, 1925–37, he was Director of the City Art Gallery, Sheffield, from 1938 to 1947. His work was influenced by Sickert and his earlier paintings shared some characteristics with those of the CAMDEN TOWN GROUP. CF

WHISHAW, Anthony, RA, LG, ARCA (b. 1930). Painter of abstracts referring to landscape and figures in acrylic. Born in London, he studied at CHELSEA SCHOOL OF ART 1948–52, winning a travelling scholarship, and at the RCA, winning a Drawing Prize, an Abbey Minor Scholarship and

a Spanish Government Scholarship to Spain 1955–6, where he was particularly influenced by Goya's Black Paintings. He held his first solo exhibition in 1957 in Madrid and in 1960 at ROLAND, BROWSE & DELBANCO, London, where he continued to exhibit until 1968, thereafter showing at a number of London galleries including the Nicola Jacobs Gallery. He has shown in group exhibitions since 1957, at the LG (member 1979) and at the RA from 1974 (ARA 1980). His work is represented internationally in public collections including the TATE GALLERY. He has won numerous prizes and scholarships, for example a Lorne Scholarship in 1982–3, and in 1986 he was joint winner of the Hunting Group National Art Competition. His early work was of figures but in the 1970s he concentrated on landscape experience, evolving a style that was both abstract and referential. Influenced by Rothko, Louis, Olitski and particularly by Tapies, the surface of his works have a variety of marks and textures, from fluid paint to specks of colour and pigment mixed with sand or earth. Recent works have included a series based on Velazquez' *Las Meninas* which unites figurative, abstract and psychological concerns.
LIT: *Anthony Whishaw: Reflections after Las Meninas*, Royal Academy of Arts, London, 1987; *The Green Book*, Vol.111, No.6, 1990. CF

WHISTLER, Rex John (1905–1944). Painter of portraits, landscapes, architectural and classical subjects in oils and watercolours; mural painter, illustrator and theatrical designer. He studied at the SLADE SCHOOL 1922–6 (where he met STEPHEN TENNANT), and in Rome. He exhibited at the RA, NEAC and in London galleries. Encouraged by TONKS as a mural painter, he painted the decorations for the TATE GALLERY Restaurant in 1926–7 and for Plas Newydd, Isle of Anglesey, in 1936–8 for Sir Philip Sassoon. His numerous illustrations include *Gulliver's Travels*, Cresset Press, 1930, and his work for the theatre included *The Tempest*, Stratford 1934, and *The Rake's Progress*, Sadler's Wells 1935 and 1942. A versatile and sensitive artist, his mural decorations combined elegance, baroque fantasy and romantic atmosphere. His paintings developed from imaginative, stylized scenes to more realistic subjects with a freer technique and stronger colour.
LIT: *The Laughter and the Urn: The Life of Rex Whistler*, L. Whistler, Weidenfeld & Nicolson, 1985; catalogue raisonné, L. Whistler and R. Fuller, Batsford, 1960. CF

WHITAKER, David (b. 1938). Painter of abstracts in oils and acrylics. He studied at Blackpool School of Art 1953–7, and at the RA SCHOOLS 1962–6, and held his first solo exhibition in 1966. He has subsequently exhibited in London, in the provinces and abroad, and his work is represented in public collections including the ARTS COUNCIL of Great Britain. He has taught widely and in 1973 was awarded the Mark Rothko Memorial Award to the USA. His abstract work is restrained and linear. CF

WHITE, Charles, FRSA, DFA (b. 1928). Painter of landscapes, animals, marines and figures in oils. He studied with CERI RICHARDS, Kurt Rieger and at the SLADE SCHOOL and in 1950 he settled in Wales. He has exhibited in Wales, England, France and Germany and his work is represented in collections including the National Museum of Wales. Former Head of Art at the United World College, he was influenced by the Barbizon artists, the Expressionists, WILL ROBERTS and JOSEF HERMAN. His work presents boldly simplified forms in expressive colour. CF

WHITE, Ethelbert, RWS, NEAC, LG (1891–1972). Painter of landscapes in oils and watercolours; wood engraver, book illustrator and poster artist. He studied at ST JOHN'S WOOD SCHOOL OF ART under Leonard Walker, 1911–12, and was a friend of GERTLER and NEVINSON with whom he painted. A member of the Royal Society of Wood Engravers, 1921–5 and 1935, in 1925 he became a member of the English Wood Engravers Society. He exhibited at the LG from 1915, at the NEAC from 1921 and held his first solo exhibition at the Carfax Gallery in 1921. He subsequently exhibited in London at the LEICESTER GALLERIES, with the RWS (from 1934), and abroad. His work is represented in collections including the TATE GALLERY. His many illustrations include *Story of my Heart* by R. Jeffries, Duckworth, 1923, and work for Penguin Illustrated Classics. His stylized river- and landscapes emphasize rhythmic lines and shapes.
LIT: 'Ethelbert White 1891–1972: An Appreciation', *The Connoisseur*, March 1974; *Ethelbert White 1891–1972: A Memorial Exhibition*, catalogue, Fine Art Society, London, 1979. CF

WHITE, Gabriel, BA, CBE (1902–1988). Painter of figures, landscapes and townscapes in oils and watercolours; etcher. Born in Rome, he studied at WESTMINSTER SCHOOL under MENINSKY, 1926–9,

where he met EDWARD ARDIZZONE, at the CENTRAL under Porter, 1928–30, and at the SLADE 1950–5, where he studied etching under GROSS. He exhibited at the LG from 1929 to 1932 and held his first solo at the MAYOR GALLERY in 1930. He later exhibited at Sally Hunter Fine Art where a retrospective was held in 1989. From 1939 to 1945 he worked in the Camouflage Organization and then became Assistant Director, 1945–58, and Director, 1958–70, of the ARTS COUNCIL. In 1979 he published a biography of Edward Ardizzone (Bodley Head). His paintings, based on observation, were influenced by SICKERT, Impressionism and Post-Impressionism.
LIT: Exhibition catalogues for Sally Hunter and Patrick Seale Fine Art, London, 1986, and Sally Hunter Fine Art, London, 1989. CF

Whitechapel Open. There were annual exhibitions of local artists work at the Whitechapel Art Gallery from 1910, which became the East End Academy in 1932, open to all artists living or working east of Aldgate Pump. After 1969 it was designated the East London Open, and in 1977 it was renamed, and the catchment area re-defined to include the Docklands and the City. From 1988 awards have been made to exhibitors. AW

WHITEHEAD, Frederick William Newton, RBA (1853–1938). Painter of landscapes and town-scapes in oils and watercolours; etcher. He studied under John Burgess at Leamington Spa, at the ACADÉMIE JULIAN, Paris, 1880–3, and he painted at Barbizon. He exhibited mainly at the RA, the RBA (member 1901), and in the provinces, and his work is represented in the Leamington Art Gallery and Museum. His landscapes, many of Dorset, were painted out of doors, capturing different atmospheric conditions.
LIT: *The Studio Magazine*, Vol.32, No.136; *Dorset Yearbook*, 1938. CF

WILD, David, DFA (b. 1931). Painter of land-scapes and flowers in oils and watercolours. He trained at Burnley School of Art 1947–52, and at the SLADE SCHOOL 1952–5, winning an Abbey Major Scholarship to study in Rome 1955–6. He has held solo exhibitions since 1957, including Nottingham University Art Gallery in 1963, and has shown at the RA since 1971. His work is represented in collections including the Walker Art Gallery, Liverpool. His representational work is concerned with realism.
LIT: 'Acquisition of Modern Art by Museums', *Burlington Magazine*, February 1971, p.113. CF

WILDE, Gerald William Clifford (1905–1986). Painter of abstracts in oils, gouache and pastels; lithographer. He studied at CHELSEA SCHOOL OF ART 1926–35, under PERCY JOWETT and GRAHAM SUTHERLAND and held his first solo exhibition at the HANOVER GALLERY in 1948. He subsequently exhibited at the ICA in 1955 and in group exhibitions. His work is represented in public collections including the TATE GALLERY. His expressive works are direct in technique, bold in colour and full of movement.
LIT: Exhibition catalogue, SERPENTINE GALLERY, 1977; *Gerald Wilde 1905–1986*, Chili Hawes, Introduction by David Sylvester, Synergetic Press, London, Oracle, Arizona, 1988. CF

WILKINSON, Norman, ROI, RSMA, RBA, PRI, PRWS, CBE (1878–1971). Painter of marines and landscapes; illustrator and poster designer; etcher. He studied at Portsmouth School of Art, worked on the *Illustrated London News* and studied with Louis Grier in St Ives in 1899. He travelled widely, exhibited mainly at the RA, the RI and the FINE ART SOCIETY, and was elected RBA in 1902, RI in 1906, ROI in 1908 and PRI in 1937. His work is represented in public collections including the IMPERIAL WAR MUSEUM and the National Maritime Museum. Inventor of dazzle camouflage in 1917, in 1944 he exhibited 53 paintings of *The War at Sea* at the National Gallery. Honorary Marine Painter to the Royal Yacht Squadron in 1919, he was awarded a CBE in 1948. He designed posters for London North Western Region Company and was best known as a realistic and atmospheric painter of ships.
LIT: *A Brush with Life*, autobiography, 1969.CF

WILLATS, Stephen (b. 1943). Conceptual artist working with documentation, photographs, light and electronic systems. He studied at Ealing College of Art and exhibited first in 1964. He has shown regularly at the Lisson Gallery and is represented in collections including the TATE GALLERY. He works actively with his audience to question aspects of social consciousness.
LIT: His own publications include *Art and Social Function*, 1976, and *Intervention and Audience*, 1986; *Studio International* (UK), December 1985. CF

WILLIAMS, Aubrey (1926–1990). Painter of non-figurative works in oils; mural painter. Born in Guyana, he initially worked in the civil service and spent two years with the Warrau, an Indian tribe. He then studied art in Guyana with De

Winter and Burrowes, was associated with the Working People's Art Group and between 1952 and 1954 travelled widely in Europe. In 1954 he settled in London and attended ST MARTIN'S SCHOOL OF ART. He held solo exhibitions at the Archer Gallery in 1954, the New Vision Centre, the Portal and Redcliffe Galleries in 1958, and subsequently at the October Gallery, internationally, and most recently at the Belgrave Gallery. Represented in collections including the City of York Art Gallery, his commissions include murals for the Guyana Museum. In 1970 he was awarded the Golden Arrow of Achievement, Guyana, and in 1980 the Cross of Merit of St Anthony of the Desert. Much of his work uses pre-Columbian motifs.
LIT: *Guyana Dreaming: The Art of Aubrey Williams*, Anne Walmsley, Dangaroo Press, 1990. CF

WILLIAMS, Jackie (b. 1947). Painter of abstracts in mixed media. She studied at MANCHESTER COLLEGE OF ART AND DESIGN 1965–9, where she was awarded the Granada Fellowship. She has exhibited since 1967 in London and the provinces, particularly at the Colin Jellicoe Gallery, Manchester. Her paintings use architectural and geometric forms with representational references. CF

WILLIAMS, John Kyffin, RA, RBA, PRCA, OBE (b. 1918). Painter of landscapes, seascapes, figures and portraits, mainly of Welsh subjects. Born in Llangefni, Anglesey, he studied at the SLADE SCHOOL 1941–4, under SCHWABE and ALLAN GWYNNE-JONES. He held his first solo exhibition at Colnaghi's, London, in 1948, exhibited at the RA from 1952, and showed regularly in London galleries (including the LEICESTER and Thackeray Galleries), and in Wales. Elected PRCA in 1969 and RA in 1974, his work is represented in collections including the National Museum of Wales. From 1944 to 1973 he taught at Highgate School, London, and retired to Anglesey in 1973. Awarded an Hon. MA from the University of Wales in 1973, he was made OBE in 1982 and Deputy Lieutenant for the County of Gwynedd in 1985. His simplified works are thickly painted with the palette knife in contrasting tones and blocks of strong colour. LIT: *Across the Straits*, autobiography, 1973; articles in *Artist* (UK), May, June and July 1984. CF

WILLIAMS, Peter (b. 1938). Painter of landscapes and country subjects in watercolours.

Born in Wales he has worked for many years in freelance illustration, graphic design and publishing and is Head of Illustration, Graphic Design Department, at Manchester Polytechnic. He has exhibited at the RA and has been a member of the Manchester Academy of Fine Arts since 1973 and he shows at the Colin Jellicoe Gallery, Manchester. His realistic style shares some characteristics with the work of Andrew Wyeth.
LIT: *Landscapes*, exhibition catalogue, Colin Jellicoe Gallery, Manchester, 1982. CF

WILLIAMS, Terrick John, RA, ROI, RWA, RBC, PRI, PRWS (1860–1936). Painter of townscapes, harbours and landscapes in oils and watercolours; pastelist. He studied under Buxton-Knight, with Verlat in Antwerp 1885–6, at the ACADÉMIE JULIAN, Paris, under Robert Fleury, Constant and Bouguereau, 1887–9, and at the WESTMINSTER SCHOOL OF ART. He travelled extensively and exhibited at the RA from 1888 (RA 1933), subsequently showing widely in societies and galleries and holding solo exhibitions at the LEICESTER GALLERIES, London, in 1908 and 1912. Awarded a silver (1908) and a gold (1911) medal at the Paris Salon, his work is represented in collections including the V & A. Influenced by Boudin, Jongkind and Monet, his impressionistic, luminous paintings sought the transient effects of light and reflections. Nevertheless he was also interested in depicting the life of ordinary people, a concern he shared with the Newlyn painters. LIT: *Landscape Painting in Oil Colour*, Terrick Williams, 1929; *Mist and Morning Sunshine: The Art and Life of Terrick Williams*, Caroline Simon, Whitford and Hughes, 1984. CF

WILLIAMSON, Harold, RWA (1898–1972). Painter of portraits and figures in oils, gouache, watercolours and tempera; draughtsman, etcher and designer. He studied at MANCHESTER SCHOOL OF ART attending evening classes, 1913–16, and full-time 1919–22. He exhibited at the RA from 1916 to 1967 and showed at the NEAC, RWA, in the provinces and the USA. Represented in collections including Southampton Art Gallery, he was a designer for Arthur Sanderson & Sons, taught at Bournemouth College of Art, 1926–47, and from 1947 to 1962 was Head of Fine Art, Manchester College of Art. His work included minutely finished oils painted in small touches in a high key and pencil portraits and drawings of war subjects such as *A Hampshire Home Guard*, RA 1945. LIT: Catalogue, Belgrave Gallery, London, 1979. CF

315

WILLIAMSON, Harold Sandys, LG (1892–1978). Painter and poster designer. He trained at Leeds School of Art (1911–14) and for one year (1913–14) at the RA SCHOOLS, where he won the Turner Gold Medal. He was wounded several times during the First World War, and painted some war pictures during periods of convalescence. *A German Attack on a Wet Morning, April 1918* (1918, IMPERIAL WAR MUSEUM) an oil painting, is typical of the harrowing and sombre records he made of his experiences in France and Belgium. The IWM also has 157 ms letters he wrote, 1915–18. He was Chairman of the LONDON GROUP from 1937–43, and Headmaster of CHELSEA SCHOOL OF ART, 1930–58. He designed posters for the GPO and others, and was commissioned to paint some pictures in London during the Second World War (IWM); his later work tended to be precise and highly detailed. AW

WILLING, Victor (1928–1988). Painter of portraits, figures, surrealistic and hallucinatory scenes in oils. He studied at the SLADE SCHOOL 1949–53, where he was influenced by Giacometti and BACON, and from 1957 to 1974 he lived in Portugal (he married PAULA REGO). He held his first solo exhibition in 1955 at the HANOVER GALLERY and has subsequently shown in London galleries including the Bernard Jacobson Gallery. Influenced by literature and philosophy, and visually by de Chirico, Matisse and Picasso, his irrational, symbolic images are simply constructed in strong colour.
LIT: Retrospective exhibition catalogue for the Whitechapel Art Gallery, London, 1986. CF

WILSON, David Forrester, RSA (1873–1950). A painter of portraits, landscapes and decorative murals. Born in Glasgow, he studied and later taught at the GLASGOW SCHOOL OF ART. He exhibited widely, at the RSA, RSW, in Liverpool and the USA. He was commissioned by Glasgow Corporation to paint a decorative panel in the Banqueting Hall of the Municipal Buildings. He painted scenes characterizing rural life, the seasons and the times of day. LP

WILSON, Douglas, R.Cam.A. (b. 1936). Painter of landscapes, townscapes, flowers and still-life in oils. He studied at the RUSKIN SCHOOL with PERCY HORTON. GEOFFREY RHOADES and LAWRENCE TOYNBEE and has held solo exhibitions in London galleries including the King Street Galleries (1983, 1986 and 1991), and in the provinces, including the Phoenix Galleries, Lavenham (1987 and 1989). He has shown at the RCA, RA, RBA and ROI and in many mixed exhibitions. His work is represented in collections including the Lord Wandsworth College, Hampshire. His landscape work is inspired in particular by the country in and around Shropshire which he depicts with mysticism and imagination.
LIT: *Wirral Visions*, Heather Wilson and Douglas Wilson, Williamson Art Gallery, 1982; *Arts Review* (UK), 10 March 1989, p.184. CF

WILSON, Frank Avray (b. 1914). Painter of abstracts in oils; writer on art. After studying Natural Sciences at Cambridge, he began to paint full-time in 1947. Mainly self-taught as an artist, apart from a year at a Norwegian Art School, he held his first solo exhibition at the Obelisk Gallery in 1954 and exhibited regularly at the REDFERN GALLERY from 1950 to 1968, subsequently showing in galleries including the Warwick Arts Trust, in Europe and the USA and most recently with the Belgrave Gallery. His work is represented in collections including Leeds and Manchester Art Galleries and his publications include *Art as Understanding*, Routledge & Kegan Paul, London, 1963, and *Art as Revelation*, Centaur Press, 1983. A founder member of the New Vision Centre Gallery and a pioneer of Abstract Expressionism in England, his work seeks autonomous, intuitive form through colour and gestural, vital marks.
LIT: *Avray Wilson*, Redfern Gallery/Centaur Press, London, 1961; *Frank Avray Wilson*, exhibition catalogue, Warwick Arts Trust, London, 1986. CF

WILSON, Scottie (Robert) (1889–1972). Painter of imaginative Surrealist works in pen and coloured inks and crayons. He also designed tapestries and pottery. Born in Glasgow, he served in the army and visited India, South Africa and France before he settled for fifteen years in Canada and began to paint in the mid-1930s; he was self-taught as an artist. His first one-man show was at the Picture Loan Gallery in Toronto in 1943; subsequently he returned to Britain and began to exhibit widely, making international contacts (Dubuffet in Paris for example). His work was obsessive and often erotic in its symbolism.
LIT: *It's All Writ Out For You: The Life and Work of Scottie Wilson*, George Melly, Thames & Hudson, 1986. LP

WISE, Gillian (Gillian Wise-Ciobotaru) (b. 1936). Born in London, she studied at Wimbledon School of Art 1954–7, and at the CENTRAL SCHOOL. She first exhibited with the 'YOUNG CONTEMPORARIES' in 1957, and in 1961 constructed a screen for the IUA Congress organized by Theo Crosby. Her first two one-man exhibitions were at the ICA in 1963 and the Axiom Gallery in 1967. She went to Prague on a UNESCO Fellowship in 1968, collaborated with ANTHONY HILL on a wall-screen for the Liner QE2 in that year and studied at the Repin Institute, Leningrad, 1969–70, on a British Council Scholarship. She married the Russian architect Adrian Ciobotaru. She has taught at the University of Illinois and at both CHELSEA and ST MARTIN'S Schools of Art, 1971–4. Interested from 1958 in the writings and work of Charles Biederman, her paintings are geometric abstractions, usually in acrylic, and often on PVC sheet. Her constructions and reliefs, often in plastics and metal, are in numerous national and international collections.
LIT: 'Notes on the Art Work as an Object', Gillian Wise, DATA, Faber, 1968. LP

WISHART, Michael (b. 1928). A painter and writer. Born in London, he studied at the CENTRAL SCHOOL (one term in 1947), at the ANGLO-FRENCH ART CENTRE, ST JOHN'S WOOD, and at the East Anglian School under CEDRIC MORRIS. He was encouraged by FRANCIS BACON and visited Paris with LUCIAN FREUD; he also worked at the ACADÉMIE JULIAN in 1948. He has travelled widely in North Africa and the East, and has lived abroad (Ireland; France) for long periods. His first one-man show was at the Archer Gallery in 1944, subsequently he showed regularly at the REDFERN and LEICESTER Galleries; in 1976 he had a retrospective at the David Paul Gallery, Chichester. He painted a portrait of Nureyev in 1968, and the ARTS COUNCIL own his Camarguais Landscape of 1956. Latterly he has painted seascapes (Etretat, 1980). There is a strong emphasis in his work on the lyrical beauty of colour. He is a Knight of St Lazarus, and has written an autobiography, High Diver.
LIT: Two Painters: F. Rose and M. Wishart, T. Hunting, unpublished MA report, Courtauld Institute of Art, 1988. LP

WISZNIESKI, Adrian (b. 1958). A painter, he first studied architecture at the Mackintosh School 1975–9, then painting at GLASGOW SCHOOL OF ART 1979–83. His first one-man show was at the Compass Gallery in Glasgow in 1984. He was Merseyside Artist-in-Residence in 1986. His large energetic canvases illustrate narcissistic private narratives: Study in Self Analysis (1984) is typical. The TATE holds three of his works. He has also expressed himself in ceramics, neon and sculpture.
LIT: A Man Tied Up In His Own Composition, Professor Duncan Macmillan. Edinburgh, 1996.
AW

WOLFE, Edward, LG, RA, NS (1897–1982). Painter of portraits, landscapes, figures, still-life and abstracts in oils and watercolours. Born in Johannesburg, SA, where he took painting lessons from George Smithard in 1914, he trained in England at the Regent Street Polytechnic in 1916, and the SLADE 1917–18, where he met NINA HAMNETT and through her ROGER FRY. He worked for the OMEGA WORKSHOPS and exhibited with them in 1918 and with the LG (member 1923). He travelled widely, returning to South Africa from 1919 to 1921 and 1956 to 1958, also working on the Continent, in the USA and Mexico. He exhibited at the RA from 1951 to 1970 (ARA 1967, RA 1972), in London galleries and abroad, and from 1926 to 1931 he was a member of the SEVEN AND FIVE SOCIETY. Represented in the TATE GALLERY, his work uses a rhythmic, painterly simplification, reflecting the influence of Matisse, the Fauves and Modigliani, and glowing, emphatic colour.
LIT: Retrospective exhibition catalogue, ARTS COUNCIL, 1967; Edward Wolfe, John Russell-Taylor, Trefoil Books for Odette Gilbert Gallery, London, 1986. CF

WOLMARK, Alfred Aaron (1877–1961). Painter of landscapes, townscapes, coastal scenes, still-lifes and portraits; he also designed stained-glass. He came to England from his native Poland in 1883, studied at the RA SCHOOLS and won the Silver medal in 1895. His first one-man show was at the Bruton Galleries in 1905 and he later exhibited at the LEICESTER, Ben Uri (a memorial exhibition was held there in 1961) and Woodstock Galleries. His early work depicted Jewish life in the East End of London, but following a stay in Concarneau, 1910–12, he began to simplify forms and intensify his colour. He befriended GAUDIER-BRZESKA, and FRANK RUTTER included him in his 'Post Impressionist and Futurist' exhibition at the Doré Gallery in 1913. He made an abstract stained-glass window for St Mary's, Slough, in 1915. His work is in the TATE GALLERY and many other public collections. LP

Women's International. Founded in France in 1899 as The Paris Club, the first British exhibition was in 1900. Membership is limited to 150 artists, and a committee selects the work for exhibitions. Lectures and demonstrations are also organized.

WONNACOTT, John (b. 1940). A painter, he studied at the SLADE, 1958–63. His first solo exhibition was at the Minories, Colchester in 1977. He lives and works in Essex, and has taught at Reading and at Norwich (1978–86). He has carried out impressive commissions involving portraiture in complex industrial settings, for example *Sir Adam Thomson in Hangar 3 with Boeing 747, Night Shift* (1985–6) AW

WOOD, Christopher (1901–1930). Painter of seascapes, harbours, landscapes, imaginative and figure compositions. He worked mainly in oil, including oil-based house paint used deliberately for a crudity of effect, and also in watercolour and gouache. He studied architecture briefly at Liverpool University, then, in 1921, worked in Paris at the ACADÉMIE JULIAN and at the Grande Chaumière. He was encouraged by AUGUSTUS JOHN, Alphonse Kahn and Antonio Gandarillas, with whom he travelled widely in Europe, North Africa, Greece and Italy. He met Picasso and was on friendly terms with Jean Cocteau and Max Jacob. His first one-man show was at Heals in 1924; in 1925 he showed with PAUL NASH at the REDFERN, and in 1926 he met the NICHOLSONS, exhibited with the SEVEN AND FIVE SOCIETY, and was encouraged by Diaghilev to design sets and costumes for the Lambert's ballet *Romeo and Juliet*, although they were eventually declined. He did design *Luna Park* for Cochran in 1930. His work showed much experimentation, as he came into contact with so many cross-currents in contemporary art in Europe, from Cubism to Surrealism (e.g. *Zebra and Parachute*, 1930), but it was always vigorous and painterly. In 1928 he and Nicholson discovered ALFRED WALLIS, who influenced Wood's style: he adopted a limited, earthy colour range, working on board and often using Ripolin house paints and primers. His mature work of 1929–30, painted in Cornwall and Brittany, is typified by such works as *Boat Builders, Treboul*, 1930 (Kettle's Yard, Cambridge). He was killed falling under a train at Salisbury station.
LIT: *Christopher Wood*, exhibition catalogue, Arts Council, 1979. LP

WORKMAN, Harold, RBA, ROI, SMA, MAFA, R.Cam.A. (1897–1975). Painter of landscapes, townscapes, interiors and marines in oils and watercolours. He studied at Oldham and MANCHESTER Schools of Art and exhibited at the RA between 1936 and 1966, the RBA (RBA 1937), the ROI, (member 1948), at the RCA, RI and NEAC, in the provinces and abroad. His work is represented in public collections including Manchester City Art Gallery. President of the United Society of Artists, he taught at the AA, at Hammersmith and ST MARTIN'S Schools of Art. Many of his townscapes show London scenes but he also painted in Brittany and Cornwall.
LIT: *An Introduction to Polymer Painting*, Harold Workman, Blandford Press, London, 1967. CF

WORTH, Leslie Charles, RBA, RWS (b. 1923). A landscape painter in oils and watercolour, born in Bideford, Devon. He studied at Bideford and Plymouth Schools of Art 1938–43, and at the RCA 1943–6. He is Vice-President of the RWS and regularly exhibits at the RA and has one-man shows at AGNEW'S. He was Head of Fine Art, Epsom and Ewell School of Art. His technically accomplished work is in many public, private and Royal collections; in 1977 he published *The Practise of Watercolour Painting*, Pitmans and Watson Guptil. AW

WYLLIE, Harold, SMA, SAA, OBE (1880–1973). Painter of marines in oils, watercolours and gouache; draughtsman, etcher and engraver. The son of W.L. WYLLIE, he studied under his father, with Sir T. Graeme Jackson in 1900, E.A. Abbey in 1906, and FRANK SHORT. He was married to the artist HILARY STRAIN and exhibited at the RA from 1905 to 1924, at the RI, the SMA (VPSMA 1958) and at the GI. His work is represented in collections including the National Maritime Museum, Greenwich. From 1914 to 1918 he served in the Royal Flying Corps, subsequently receiving a commission in the Regular Army from which he retired in 1920 as Lt.-Col. He was awarded the OBE in 1919. Much of his work depicts historical subjects and he served with his father on the committee to restore the *Victory*. CF

WYLLIE, William Lionel, RA, RI, RE, RBA, NEAC (1851–1931). Painter of marines in oils and watercolours; etcher, illustrator and writer. The son of William Morison Wyllie, brother of

Charles Wyllie and father of HAROLD WYLLIE, he studied at HEATHERLEY'S and the RA SCHOOLS 1866–9. He worked for the *Graphic*, 1870–90, and from 1883 produced etchings for Robert Dunthorne of the Rembrandt Gallery. In 1884 he settled in Chatham and formed a close association with the Royal Navy. He exhibited in London from 1868, at the RA from 1868 to 1930 (ARA 1889, RA 1907), and held his first solo at the FINE ART SOCIETY in 1884. He was elected RBA in 1875, NEAC in 1887, RI from 1882 to 1894 and 1917, ARE in 1903 and RE in 1904. His work is represented in the TATE GALLERY and his publications include *Marine Painting in Watercolour*, Cassell, 1901. Between 1924 and 1930 he worked on the Panorama of Trafalgar for the Victory Museum, Portsmouth. His work covers many aspects of the sea, historical and contemporary, and reflects some influence from HENRY MOORE (1831–95), Whistler and Turner.
LIT: *We Were One. A Life of W.L. Wyllie*, M.A. Wyllie, Bell & Sons Ltd, London, 1935; *W.L. Wyllie. Marine Artist*, Roger Quarm and John Wyllie, Barrie & Jenkins, 1981. CF

WYNTER, Bryan (1915–1975). Born in London, he entered the WESTMINSTER SCHOOL OF ART 1937–8, and the SLADE SCHOOL 1938–40. He settled in Cornwall in 1945, co-founded the CRYPT GROUP and later the PENWITH SOCIETY. His first one-man show was at the REDFERN in 1947, and he taught at the BATH ACADEMY 1951–6. After 1956 he abandoned landscapes in favour of abstracts (e.g. *The Interior*, 1956), using complex grids; in 1960 he began to make kinetic paintings he called IMOOS – Images Moving Out Onto Space, e.g. *Mobile IMOOS No.3*, 1965. Later work had landscape references (e.g. *Red and Black Streams*, 1973).
LIT: *Bryan Wynter, 1915–1975*, exhibition catalogue, Hayward Gallery, 1976. LP

Y

YATES, Hal, RI, NS, UA (b. 1907). Painter of landscapes in watercolours. Born in Manchester, he was a wealthy seed merchant who studied at Acomb Street classes run by Manchester Academy. He exhibited at the RA, RSA, RBA, RI, RWS and RSW, in the provinces and at the Paris Salon. His work is represented in some public collections including Manchester City Art Gallery. Chairman of the North-Western Federation of Art Societies, he developed an accomplished watercolour technique. Typical works are spirited Lancashire and Cheshire subjects (*In Styal Woods*, 1947, *Farm Fold*, 1948) and views in France (his drawings of the Quai Duperré, La Rochelle, for example). CF

YATES, Harold (b. 1916). He studied at Portsmouth School of Art then worked for some years in a commercial art studio. He showed at the AIA during the early 1930s, and had his first one-man exhibition at Foyles Gallery in 1935. His work was then abstract but influenced by the SURREALISTS. Some of his studies of soldiers, made during his service in the Second World War, are in the IMPERIAL WAR MUSEUM. He had a one-man show at the Belgrave Gallery in 1989. AW

YEATS, Jack Butler (1871–1957). Born in London, the son of a portrait-painter, and brother of the poet W.B. Yeats, he was brought up in Sligo, and trained in London at the WESTMINSTER SCHOOL OF ART, under FRED BROWN. At first making a career as an illustrator, he travelled in France, Germany and Italy, 1888–9, and had his first one-man show at the Clifford Gallery in 1897; he also wrote plays and poems at various times in his life. He exhibited at the Salon des Indépendants in 1912 and at the Armory Show in New York in 1913; he became a member of the Royal Hibernian Academy in 1915. Before this he had returned to Ireland to live, and drew his subject-matter from local characters in Sligo (*Music in the Train*), from the circus and the fair (*Back from the Races*, 1925, TATE GALLERY), as well as from the movement for Irish self-determination, with which he actively sympathized (*The Death of Diarmid; The Last Handful of Water*, 1945, Tate). His most successful works were in oil, typically manipulating thick, raw paint, often direct from the tube, with a palette-knife. Numerous exhibitions of his work were mounted internationally; by the ARTS COUNCIL in 1948, in the USA, 1951–2, in Paris in 1954, and most recently at the Whitechapel Gallery in 1991. He was awarded many academic and national honours.
LIT: *Jack B. Yeats, Painter and Poet*, M.G. Rose, European University Papers, 1972. LP

YHAP, Laetitia (b. 1941). Painter in oils, tempera and watercolours of beach and fishing

scenes. Born in St Albans, she studied at CAMBERWELL 1958–62, and at the SLADE SCHOOL 1963–5, subsequently winning several awards including a Leverhulme Scholarship, visiting Italy 1962–3. Her first solo exhibition was at Norwich Art School in 1964. She exhibits at the PICCADILLY GALLERY, in the provinces and is a member of the LONDON GROUP. She was Artist in Residence at Chatham House Grammar School in 1981, and a touring exhibition started from the Camden Arts Centre in 1989; she has work in the ARTS COUNCIL Collection. She is married to JEFFERY CAMP. As well as her 'heroic compositions' of fishing communities (she often uses an irregularly shaped format), she is also known for her portraits, e.g. HELEN LESSORE, and SIR WILLIAM COLDSTREAM of 1973.
LIT: *Laetitia Yhap, The Business of Beach Painting*, exhibition catalogue, Laing Art Gallery, Newcastle, 1988. LP

YOUNG, Brian (b. 1934). Painter of non-figurative work in oils; stained glass designer. He studied at ST MARTIN'S SCHOOL OF ART 1951–3, and at the CENTRAL SCHOOL where he studied stained glass 1957–60, winning the GIMPEL FILS Travelling Prize in 1960, and a BRITISH COUNCIL Travelling Scholarship to work in France and Italy. He exhibited at the YOUNG CONTEMPORARIES exhibitions from 1958 to 1960 and has shown in London galleries including the Rowan Gallery. His work is represented in the ARTS COUNCIL Collection and he has taught at CHELSEA SCHOOL OF ART and at the London School of Printing. CF

Young Contemporaries. In 1949 CAREL WEIGHT suggested that the RBA Galleries at 6¹/ 2 Suffolk Street, then empty, might be used for a show of student work. The first show and many subsequent ones were dominated by the work of students from the RCA, but students from many Schools of Art began to show there in force. The administration of the exhibition has been done by the students. Among the many artists who first exhibited with the Young Contemporaries have been AUERBACH, KOSSOFF, JACK SMITH, MIDDLEDITCH and DENNY.
LIT: *Young Contemporaries Past and Present*, A. Lambirth, London, 1986 AW

YOUNGMAN, Nan, OBE (Nancy Mayhew, 1906–1995). Born in Maidstone, Kent, she studied at the SLADE 1924–7. After working for an Art Teacher's Diploma under Marion Richardson, 1928–9, she became a leading figure

in the field of art education for children. She was art adviser to Cambridge Education Committee, 1944–54, and organized the first 'Pictures for Schools' exhibition in 1947. She regularly exhibited at the LONDON GROUP, the WIAC, AIA and the RA; she had solo exhibitions at the LEICESTER (1953) and ZWEMMER Galleries, and began to paint full-time at that period. Her landscapes, seascapes and industrial scenes have a sober directness and simplicity, often focusing on some strange or puzzling feature.
LIT: *Nan Youngman: Paintings, Drawings, Prints, 1924–83*, Kettle's Yard, Cambridge, 1986. AW

Z

ZIEGLER, Archibald, NS, ARCA (1903–1971). Painter of landscapes, figures, still-life, portraits and flowers in oils, watercolours and pen and wash; portrait sculptor and mural painter. He studied at the CENTRAL, the RA SCHOOLS and the RCA 1927–30, and held a solo at the Whitechapel Gallery in 1932. He exhibited in London galleries including the Ben Uri and at the RA from 1963 to 1970. Represented in private collections, his work includes the mural for Toynbee Hall, 1932. From 1938 he taught at ST MARTIN'S SCHOOL OF ART. His expressionistic work uses bold colour with rhythmic lines and simplified forms.
LIT: Catalogue, Iveagh Bequest, Kenwood, London, 1971; memorial exhibition catalogue, Ben Uri Art Gallery, London, 1972. CF

ZINKEISEN, Anna Katrina, RP, ROI, NS (1901–1976). Painter of portraits, flowers, murals and landscapes in oils, medical artist, illustrator and designer. Sister of DORIS ZINKEISEN, she attended the RA SCHOOLS where, on the advice of ORPEN. she studied sculpture. After training, however, she concentrated on painting, mural decoration, illustration and design. She exhibited at the RA from 1921 to 1964 and at the ROI (member 1929) and in leading galleries and societies. During the war she worked as medical artist to St Mary's Hospital, Paddington. Her commissions included murals for the Cunard liners and the portrait of HRH The Duke of Edinburgh for RAF Fighter Command, 1956. Represented in the IMPERIAL WAR MUSEUM, her work ranged from meticulously observed clinical studies to formally clear,

decisive portraiture. Not unlike her sister's, her painting was lively, assured and stylish.

LIT: Exhibition catalogue, Federation of British Artists' Galleries, London, 1962; *Anna. A Memorial Tribute*, Josephine Walpole, Royle Publications Ltd, London, 1978 (limited edition of 1,000). CF

ZINKEISEN, Doris Clare, ROI (1898–1991). Born in Gairloch, Scotland, she painted portraits, figure compositions and landscapes, although she was best known as a stage designer. She studied at the RA SCHOOLS, and exhibited at the RA, RHA, RSA and ROI; her work created a lively, amusing and stylish evocation of the world around her. She was the sister of ANNA ZINKEISEN. LP

Zwemmer Gallery. Established as an annexe (26 Litchfield Street) to the well-known art book-shop and publishers on the Charing Cross Road, the Gallery, managed by Robert Wellington, had an adventurous policy based on a modest financial background. In 1929 VICTOR PASMORE persuaded the Gallery to mount an exhibition of work by artists associated with the CENTRAL SCHOOL, 'XVII Artists': at the second exhibition, in 1931, ROBERT MEDLEY and WILLIAM COLDSTREAM made their debut. One of the most interesting exhibitions to follow was that of 1934, 'Objective Abstractions', which included GRAHAM BELL, RODRIGO MOYNIHAN, GEOFFREY TIBBLE, IVON HITCHENS, Victor Pasmore, CERI RICHARDS and THOMAS CARR. The 14th and last exhibition of the Seven and Five, also dominated by abstraction, was held there in 1935. In 1940, an important exhibition was 'Surrealism Today'. After the Second World War, up to the 1960s, the Gallery encouraged emerging artists such as HAROLD CHEESMAN. AW